The Painted Page

Royal Academy of Arts, London
27 October 1994 – 22 January 1995

The Pierpont Morgan Library, New York
15 February – 7 May 1995

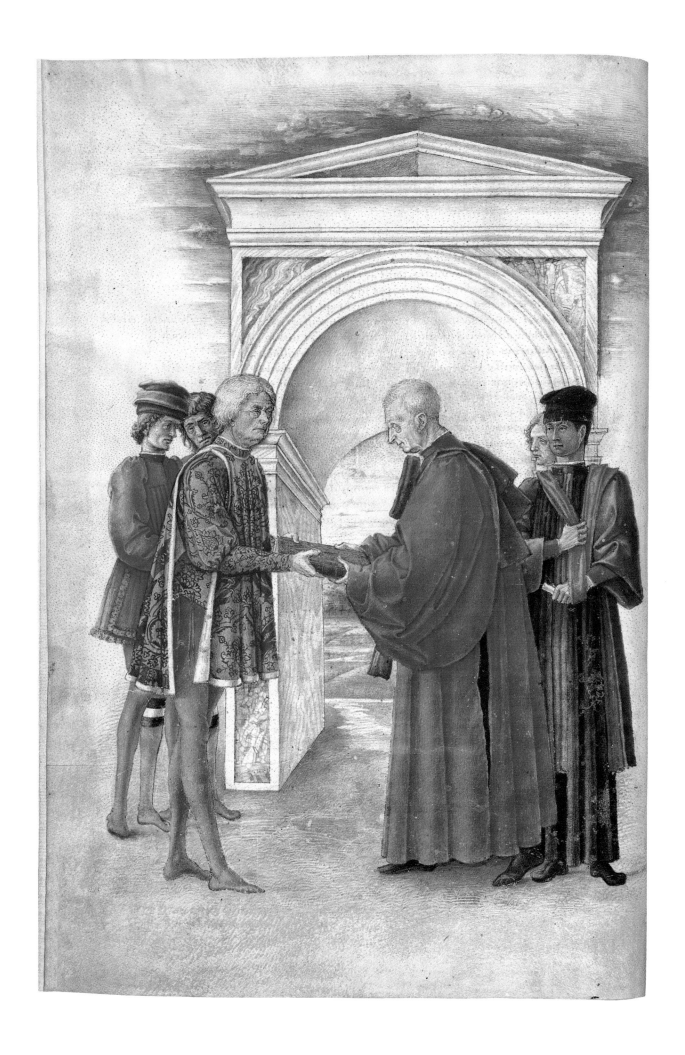

The Painted Page

ITALIAN RENAISSANCE BOOK ILLUMINATION

1450–1550

Edited by

Jonathan J. G. Alexander

With contributions by

Jonathan J. G. Alexander, Lilian Armstrong,
Giordana Mariani Canova, Federica Toniolo,
William M. Voelkle, Roger S. Wieck

ROYAL ACADEMY OF ARTS, LONDON
THE PIERPONT MORGAN LIBRARY, NEW YORK

Prestel

This catalogue was first published on the occasion of the exhibition
The Painted Page: Italian Renaissance Book Illumination 1450-1550

Royal Academy of Arts, London, 27 October 1994-22 January 1995
The Pierpont Morgan Library, New York, 15 February-7 May 1995

The exhibition was organised by the Royal Academy of Arts, London
and The Pierpont Morgan Library, New York.

The Royal Academy is grateful to Her Majesty's Government for its help in agreeing to
indemnify the exhibition under the National Heritage Act 1980 and to the Museums
and Galleries Commission for their help in arranging this indemnity.

The Morgan Library's presentation of '*The Painted Page*' was made possible by the
generous support of Fay Elliott and by a grant from the Arcana Foundation. Additional
funding was provided by the National Endowment for the Arts, a federal agency.
An indemnity for the exhibition in the United States was received from the
Federal Council on the Arts and the Humanities.

Front Cover: Liberale da Verona, Gradual of the Cathedral of Siena, detail of folio 36v.
Siena, Museo dell'Opera della Metropolitana, Cod. 20.5, Cat. 121
Back Cover: Attributed to Mariano del Buono, Livy, *Roman History*, First Decade, folio 1v.
Munich, Bayerische Staatsbibliothek, Clm 15731, Cat. 68
Frontispiece: Strabo, *Geography*, folio 3v.
Albi, Bibliothèque Municipale, Ms 77, Cat. 29

Prestel books are available worldwide. Please contact your nearest bookseller
or write to either of the following addresses for information
concerning your local distributor:
Prestel-Verlag, Mandlstrasse 26, D-80802 Munich, Germany
Tel: (89) 38 17090; Fax: (89) 38 17 09 35
Prestel-Verlag, 16 West 22nd Street, New York, N.Y. 10010
Tel: (212) 627-8199; Fax: (212) 627-9866

Copy-editing by Sheila Schwartz, New York

Catalogue designed by Michael Pächt, Munich

Colour separations by Schwitter AG, Basle
Black and white reproductions by
Reproduktionsgesellschaft Karl Dörfel GmbH, Munich
Typeset by Max Vornehm GmbH, Munich
Printed and bound by Passavia Druckerei GmbH, Passau

Die Deutsche Bibliothek – CIP-Einheitsaufnahme

The Painted Page : Italian Renaissance Book Illumination 1450-1550;
[this catalogue was first published on the occasion of the exhibition
The Painted Page: Italian Renaissance Book Illumination 1450-1550;
Royal Academy of Arts, London, 27 October 1994-22 January 1995;
The Pierpont Morgan Library, New York, 15 February-7 May 1995]/
Royal Academy of Arts, London; The Pierpont Morgan Library, New York.
Ed. by Jonathan J. G. Alexander. With contributions by Jonathan J. G. Alexander . . .
– Munich; New York : Prestel, 1994
ISBN 3-7913-1385-1
NE: Alexander, Jonathan J. G. [Hrsg.]: Royal Academy of Arts <London>;
Exhibition The Painted Page, Italian Renaissance Book Illumination 1450-1550
<1994-1995, London; New York>

Library of Congress Catalog Card Number 94-69462

Printed in Germany

Contents

Foreword

The original idea for *The Painted Page: Italian Renaissance Book Illumination 1450-1550* was generated by Jonathan Alexander, Professor at the Institute of Fine Arts, New York University, when he proposed that illuminated manuscripts created under the influence of the great Renaissance artist Andrea Mantegna might be included in the major exhibition *Andrea Mantegna*, held at the Royal Academy of Arts and The Metropolitan Museum of Art, New York, in 1992-93. When presented with the range of outstanding manuscript material for possible inclusion, however, it became apparent that the subject warranted an exhibition of its own.

The works of Mantegna as well as those by other painters, sculptors and architects of the early and high Renaissance are relatively well known. The illuminated manuscripts and printed books created by their contemporaries, on the other hand, have remained the domain of a few specialists. Giulio Clovio, for example, the illuminator of Cardinal Alessandro Farnese's magnificent Book of Hours, which was described by Vasari as one of the great sights of Rome, is little known today. Yet this Book of Hours (now in The Pierpont Morgan Library), together with other major works included in this exhibition, represents an equally potent manifestation of the achievements of the Italian Renaissance. All the manuscripts and books presented in this exhibition are distinguished not only by the sheer beauty of their designs and imagery but also by their excellent state of preservation. While their aesthetic quality derives in large measure from the fact that they were commissioned from great artists and craftsmen by highly demanding patrons, their current state of preservation, with their original colours intact in a way that is no longer the case for larger scale paintings, is attributable to the fact that they have been bound between covers and thus protected from light and atmospheric pollution.

The selection of works in this exhibition has been undertaken by Jonathan Alexander, assisted by a team of scholars on both sides of the Atlantic. We are most grateful to them for their support in the realisation of both the exhibition and its accompanying catalogue. Indeed, this has been an institutional collaboration as well, for the show is the first one to be jointly planned by The Pierpont Morgan Library, New York, itself a major repository of Italian Renaissance illuminated manuscripts, and the Royal Academy of Arts, London. Both institutions extend their deep thanks to those many libraries, museums, churches and other institutions and private lenders who have allowed their works to be shown either in London or New York, or, in many cases, both cities. These are precious objects indeed, and we are most privileged to be able to present them to our respective audiences.

<div style="text-align:center">

SIR PHILIP DOWSON
President
Royal Academy of Arts

CHARLES E. PIERCE, JR.
Director
The Pierpont Morgan Library

</div>

List of Lenders

Austria

Vienna, Graphische Sammlung Albertina

Vienna, Österreichische Nationalbibliothek,
Handschriften- und Inkunabelsammlung

France

Albi, Bibliothèque Municipale

Le Havre, Musée des Beaux-Arts André Malraux

Lyon, Bibliothèque Municipale

Paris, Bibliothèque Nationale

Germany

Berlin, Staatliche Museen zu Berlin, Preussischer Kulturbesitz,
Kupferstichkabinett

Gotha, Forschungs- und Landesbibliothek

Munich, Bayerische Staatsbibliothek

Wolfenbüttel, Herzog August Bibliothek

Ireland

Dublin, The Trustees of the Chester Beatty Library

Dublin, Board of Trinity College

Italy

Bologna, Musei Civici d'Arte Antica

Cesena, Capitolo della Cattedrale,
Biblioteca Comunale Malatestiana

Florence, Archivio Capitolare di San Lorenzo

Florence, Biblioteca Medicea Laurenziana

Modena, Biblioteca Estense

Ravenna, Biblioteca Classense

Siena, Museo dell'Opera della Metropolitana

Vatican, Biblioteca Apostolica Vaticana

Portugal

Lisbon, Arquivos Nacionais/Torre do Tombo

Spain

Madrid, Biblioteca Nacional

Valencia, Biblioteca General de la Universidad

The Netherlands

The Hague, Koninklijke Bibliotheek

United Kingdom

Birmingham, The Trustees of the Barber Institute of Fine Arts,
The University of Birmingham

Edinburgh, National Library of Scotland

Glasgow, University Library

The Earl of Leicester and the Trustees of the Holkham Estate

London, The British Library

London, Trustees of Sir John Soane's Museum

London, Society of Antiquaries

London, The Board of Trustees of the Victoria and Albert Museum

Oxford, Bodleian Library

United States of America

Bloomington, Indiana University, The Lilly Library

Cambridge, Harvard University, The Houghton Library

Cleveland, The Cleveland Museum of Art

Los Angeles, University of California, Elmer Belt Library

Malibu, The J. Paul Getty Museum

New York, Columbia University,
Rare Book and Manuscript Library

New York, The New York Public Library,
Astor, Lenox and Tilden Foundations

New York, The Pierpont Morgan Library

Philadelphia, The Rosenbach Museum & Library

Princeton, Princeton University Libraries

Authors' Acknowledgements

The authors of the catalogue would like to thank all those many institutions that have generously made their manuscripts and books available for study, as well as the members of their staffs who have facilitated our research during the preparations for this exhibition.

A very special debt of gratitude is owed to Albinia de la Mare, Professor of Palaeography at King's College, London, who so generously shares her unrivalled knowledge of Italian humanist scribes with all who work in this field. At an early stage she agreed to be available for consultation and gave advice on the plans for the exhibition. She has taken time to read, correct, and comment on a considerable number of the catalogue entries to their great benefit, contributing unpublished material of major importance.

In addition we should like to thank most warmly the following scholars who have helped us in various ways in answering questions and sharing their learning: François Avril; Ulrike Bauer-Eberhardt; Ursula Baurmeister; Samuel Beizer; Chaya Benjamin; Alessandro Bettagno; Giulio Cattin; Benjamin David; Martin Davies; Angela Dillon Bussi; Hans-Joachim Eberhardt; Peter Fergusson; George Fletcher; Richard Foley; Elizabeth Fuller; Jeremy Griffiths; Emma Guest; Lotte Hellinga; Anthony Hobson; Eva Irblich; Rachel Jacoff; Kristian Jensen; Janine Kertész; Anne Korteweg; Jill Kraye; Jens Kruse; Susan L'Engle; Martin Lowry; Susy Marcon; Ulrike Morét; Leslie A. Morris; Paolo di Pietro; Ruth Rogers; Maria Francesca P. Saffiotti; Wendy Steadman Sheard; Raymond Starr; Frauke Steenbock; Nigel Thorpe; Ranieri Varese; Gian Antonio Venturi; Rowan Watson.

Professor Lilian Armstrong wishes also to acknowledge with gratitude grants from the National Endowment for the Humanities (Fellowships for College Teachers) and Wellesley College (Committee on Faculty Awards).

Finally we wish to thank all those individuals on the staffs of the Royal Academy of Arts and of the Pierpont Morgan Library who have collaborated on the preparation of this exhibition. It has been a privilege to work alongside them. In both institutions the enthusiasm, the hard work and the commitment to the task have been an inspiration, and if ever the problems seemed insurmountable a combination of professionalism and good humour have triumphantly carried us through. Though we cannot thank them all by name, we must still mention in London Piers Rodgers, Secretary of the Royal Academy of Arts; Norman Rosenthal, Annette Bradshaw, Jane Martineau and Emeline Max in the Exhibitions Office; and MaryAnne Stevens, Education Officer and Librarian. Outside the Royal Academy we have been very fortunate to be able to rely on the copy editing of Sheila Schwartz in New York and the support of Andrea Belloli of Prestel-Verlag. Michael Pächt in Munich has produced a superb catalogue which in the high standards of its design and of its colour reproductions is worthy of its subject matter. Ivor Heal has found a way to design the exhibition in the Sackler Galleries in London so as to do justice to the beauty of the manuscripts and books and at the same time to enable them to tell the story we had in mind.

In New York we are most grateful to Charles Pierce, Director of the Pierpont Morgan Library, who supported the idea of the exhibition from the first. David Wright, the Registrar, took on all the administrative complexities of the New York loan arrangements. Bill Voelkle and Roger Wieck, in addition to their work as authors of the catalogue, dealt with many other tasks associated with a show of this magnitude. George Fletcher assisted us with the incunabula. Again it has been a privilege and a pleasure to work with them as well as with many others of their colleagues who have helped on the show in numerous ways.

J.J.G.A.

Patrons, Libraries and Illuminators in the Italian Renaissance

By Jonathan J. G. Alexander

'Nella perfectione delle figure et adornamenti . . .'
Contract for the Bible of Prince Manuel
of Portugal, 1494[1]

In 1471 Borso d'Este (*b.* 1413, *r.* 1450-1471), was to visit Pope Paul II in Rome to be invested with a long coveted honour, the Dukedom of Ferrara. Complex planning was necessary for the Duke to move with a retinue suitable to his status as well as the necessary military protection. Lavish gifts would be exchanged at solemn entries and courtly entertainments. Not only his own clothing and mounts but those of his followers would be scrutinised and needed to be of the necessary magnificence. Among all the other preparations and in addition to all his other baggage, the Duke directed that his Bible should accompany him. Its two thick, heavy volumes, measuring 675 x 486 mm, had been completed ten years before by two major illuminators, Taddeo Crivelli and Franco dei Russi, directing a team of numerous assistants (figs 3, 14-17, 13-16). Even while their work was in progress arrangements were made from time to time for ambassadors to the court in Ferrara to see the Bible. Now it would demonstrate publicly and in the heart of Christendom the Duke's piety and wealth, his liberality and discrimination.[2]

The manuscripts and printed books included in this exhibition are all objects of similar luxury produced at the top end of the market for wealthy, powerful and prestigious owners. Their textual contents were not secondary but intimately connected to their functioning as status symbols. The Bible, for example, had in a Christian society a priority over every other text, which is signified by its invariable appearance in library catalogues as the first item. In earlier centuries large scale luxury Bibles in one or two volumes had been most commonly the possession of Christian religious institutions, especially of the wealthy Benedictine monasteries of Europe.[3] Already in the 12th century in Italy, these objects were so costly to produce, however, that the laity were sometimes coopted to subscribe to the expenses, an example being the Bible of Calci near Pisa, completed in 1169 (fig. 2).[4] In the 13th century, under the impetus of Biblical studies at the University of Paris, smaller one volume portable Bibles were made for individual use by clerics and scholars in varying degrees of luxury. At the same date the enormous three volume *Bibles moralisées*, illustrated verse by verse, were made under French royal patronage.[5] Later, in the 14th century, various epitomes and translations into French were made which were often illustrated, for example the *Bible historiale* of Guyart Desmoulins. Duke Borso's Latin Vulgate Bible, like those produced for his father, Niccolò d'Este, and for other Italian Renaissance rulers, for example Federigo da Montefeltro, Duke of Urbino (1422-1482) (fig. 2), falls, therefore, into a tradition of private ownership, but now produced on a scale comparable to that of the great monastic Bibles. The Urbino Bible, now in the Vatican Library (Urb. lat. 1-2), was written in two volumes in Florence in 1476-8 and illuminated by a group of some of the most talented illuminators available, including Francesco d'Antonio del Chierico, Francesco Rosselli and the young Attavante.[6] It may be that there was in these projects a conscious historicising revival in

copying the large format of the earlier manuscripts, whether Carolingian or Romanesque, and that this was conflated with a Renaissance perception of the Vulgate translation of St Jerome as a product of early, patristic Christianity when the Roman Empire still existed.

The liturgical books used in the services of the Church, the Missals, Breviaries, Psalters, Evangeliaries and Epistolaries, were also in earlier centuries usually communal property of religious institutions. But personal ownership of books of every kind steadily increased in Europe from the 13th century on, and now in the 15th century a great prelate, whether Pope, Cardinal, Bishop or Abbot, would expect to commission his own Missal. In earlier centuries manuscripts were inscribed with the name of a saint, '*Liber Sancti . . .*', that is as the property of the particular saint who acted as patron and protector of the church or monastery in which the book was used. In the 15th century they frequently bear family

1 Calci, Certosa. Bible. Vol. I, fol. 120. Initial 'H', Exodus

2 Vatican, Biblioteca Apostolica Vaticana, Urb. lat. 1, fol. 7 Bible of Federigo da Montefeltro. Genesis. Initial I, *Creation* scenes

arms distinguished by a papal tiara, cardinal's red hat or bishop's or abbot's mitre. An example is the Missal written in Rome in 1520 by the papal *scriptor*, Lodovico Arrighi, for Cardinal Giulio de' Medici, later Pope Clement VII, which contains his arms, emblems and mottoes prominently displayed in the borders (cat. 128).

As with the Bible, lay owners might also commission liturgical books, for example the luxury Breviary started in Ferrara for Duke Ercole I d'Este (*b.* 1431, *r.* 1471–1505) and completed after his death for Duke Alfonso d'Este (*b.* 1476, *r.* 1505–1534) (fig. 4). Communal books continued to be made of course, and, as with the Calci Bible, the lay community would often be involved in their commissioning and help to pay for them. An example is the great set of Choir Books with the sung parts of the Mass and the Office commissioned by the Opera del Duomo of Siena Cathedral, written between 1457 and 1466, with the illumination completed by 1476 (cats 121, 122).[7]

Individuals also owned a range of books for private reading which answered to professional, educational and recreational needs. The professions of law and medicine both required books for their practicioners and in exceptional cases individuals might afford special illuminated copies (cat. 57). As to education, if uni-

versity and school-teachers, then as now, complained constantly at the low value put on their work by society, parents were willing to spend lavishly on school-books. A particularly famous example is the grammar book provided for the young Maximilian Sforza at age five or six by his father, Lodovico il Moro, the usurping Duke of Milan (fig. 5).[8] Its miniatures show Maximilian at work and at play and were executed *c.* 1495 by an illuminator active in commissions for the Sforza (cat. 16), Giovan Pietro Birago.

Somewhere between education and recreation come the Classical and humanist texts, the 'classics' which, thanks to the ideals of humanist education, were to form the *sine qua non* of a cultivated nobleman's education, and in some cases an educated noblewoman's too. An example of a cultivated female patron is Eleanor of Aragon (1450–1493), wife of Ercole d'Este of Ferrara, of whom a portrait was inserted in a manuscript on the duties of a ruler, dedicated to her by Antonio Cornazzano (cat. 20). The Classical texts of Ancient history, poetry and philosophy provided models of heroic action, moral behaviour and of literary style – Livy, Suetonius, Cicero, Pliny the Elder's *Natural History*, Virgil, Horace (cats 41–50, 74–76). Some patrons were even beginning to read Greek texts in the original (cats 53, 56). Certain modern texts also

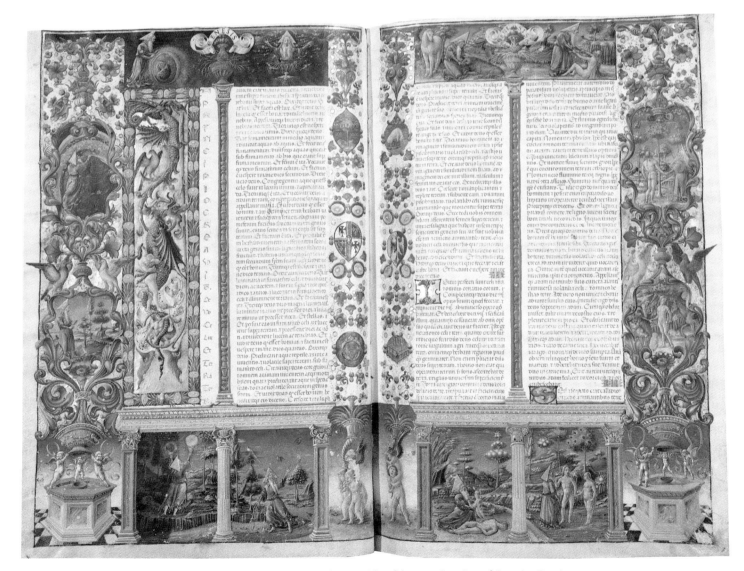

3 Modena, Biblioteca Estense, VG 12 (Lat. 422). Bible of Borso d'Este. Vol. I, fol. 5v–6. Opening of Genesis, *Creation*

achieved a classic status, and of those that were illuminated and illustrated, Dante's *Divine Comedy* (cat. 58) and Petrarch's *Trionfi* (cats 59, 60) stand out. Historical works by authors such as Leonardo Bruni (cat. 64), Poggio (cat. 62) or Flavio Biondo (cat. 61) were also frequently produced in luxury copies.

Two representations can be juxtaposed to show two of the contexts for books and two types of reading in this period. Though these contexts, which it would be oversimplifying to describe as secular and religious, might now be starting to diverge in some respects, they still continued to intersect and overlap. In a painting by the Sienese artist Sassetta of *c.* 1423, St Thomas Aquinas is shown kneeling in prayer before an altar in a chapel, thus in a religious context (fig. 6). But his work as Christian scholar and teacher is made clear by the glimpse of the adjacent library with codices laid out on the desks. In a fresco fragment of *c.* 1460 from the Medici bank in Milan, attributed to Vincenzo Foppa, a young boy is seated in a school-room, reading presumably a Classical text (fig. 7). Here there are no symbols of Christian devotion and the name '*M. T. Cicero*' is inscribed on the wall behind him. The boy's identity remains a subject of speculation, but many 15th-century observers might have recalled Jerome's dream, in which he was accused of paying more attention to Classical literature than to Holy Scripture. The words '*Ciceronianus es, non Christianus*' might be a dilemma for some, but an inspiration or a challenge for others (see cat. 28).

The humanists, a term originating in the late 15th century to describe 'a teacher in the progressive educational movement known as the *studia humanitatis*, a programme of study elaborated on the basis of what Cicero had had to say about liberal education' – these humanists, in addition to establishing a canon of approved authors, also aimed to reform spelling and to purify texts of corruption.[9] In searching for older manuscripts which might contain

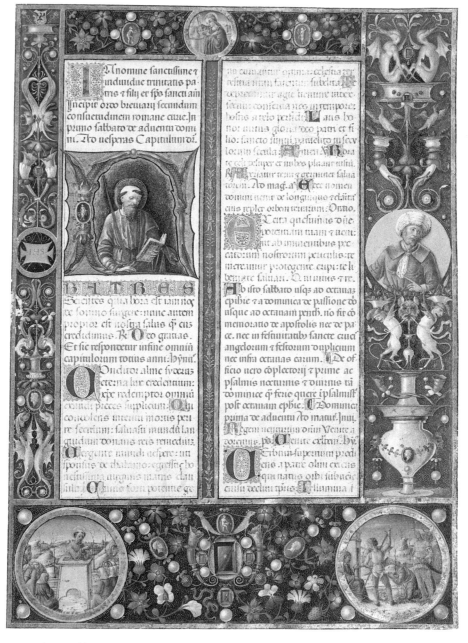

4 Modena, Biblioteca Estense, VG 11 (Lat. 424), fol. 7. Breviary of Alfonso d'Este.
Opening for the First Sunday in Advent. St Paul and scenes from his life

better texts, Poggio and others made the legendary discoveries of new texts from Antiquity which lay buried in remote monastic libraries.[10] The search for lost texts continued, but equally important was the imposition of revised rules of orthography and grammar and the establishment of better texts by improved principles of textual criticism. This effort became even more crucial with the introduction of printing where, as its critics pointed out, a false text might now be disseminated in hundreds of copies.

A distinctive feature of Italian book production from *c.* 1400 onwards, which separates it from book production everywhere else in Europe, is that a specific type of script and a specific type of decoration was developed for use in Classical and humanist texts. The script with letter forms which continue in use even in the age of electronic technology was evolved self-consciously by a small group of scholar-humanists in Florence, of whom Niccolò Niccoli and Poggio Bracciolini, with the encouragement of Coluccio Salutati, Chancellor of Florence, were the leaders.[11] The way in which the new script caught on was spectacular, and within twenty years it had spread all over Italy as a style of writing. Its adoption by the printers in Italy after 1465 assured even wider dissemination, though other countries in Europe had already begun to adopt it even before Gutenberg's invention of printing in Mainz in the early 1450s. Nevertheless the older Gothic scripts were not abandoned and continued to be used above all for the ecclesiastical service books and generally but not exclusively for other religious texts, by both scribes and printers, including of course Gutenberg himself. Though the present exhibition is not primarily concerned with script and scribes, many types of handwriting and many examples of outstanding penmanship by scribes famous in their own day are included, notably Piero Strozzi (cats 68-9, 76) and Antonio Sinibaldi of Florence (cats 31, 32, 41, 46), Bartolomeo Sanvito of Padua (cats 7, 26, 38-9, 41, 43, 62, 71-5, 77) and Lodovico Arrighi (cats 128, 130). Often they signed and dated their works, sometimes claiming credit for their skill or speed in copying or including other information.[12] Pietro Ippolito da Luni of Naples says he is writing while 'turbulent warfare grips Italy' (cat. 9). Giovanmarco Cinico of Parma, who wrote manuscripts for Ferdinand I and Alfonso II of Naples (cats 10, 61), says in his colophons that he sometimes wrote at speed, '*manu currente*', sometimes slowly, '*tranquille transcripsit*'. When he came to transcribe the *De re uxoria* of Francesco Barbaro (1390-1454) he wrote at the end '*uxoris nescius sed cupidus*' ('knows nothing of a wife but would like one')! It is interesting that among these scribes there were many non-Italians who had come to the peninsula and had learnt there to write in the new style.

With the new script went a new style of decoration also not found elsewhere in Europe, though it was to be occasionally self-consciously copied later. Its expressive Italian name is the '*bianchi girari*', in English 'white vine-stem decoration'. Contemporaries sometimes referred to it as a form of decoration '*all'antica*'. The models were in fact not Antique, for neither the letter forms nor the decorative vocabulary were to be found in Classical Roman or Early Christian manuscripts. The models were closer to hand, occurring in Tuscan 12th-century manuscripts in which a stylized plant scroll with interlacing stems and flowers, fruits and leaves was silhouetted, usually by leaving the parchment uncoloured, against coloured backgrounds, as in the already mentioned Calci Bible (fig. 2).[13] As with the script, older styles of decoration were not abandoned. Just as various compromises were made of cursive and formal, Gothic and humanistic forms, so with the decoration, white vine-stem could be infiltrated by flora and fauna from Gothic traditions of illumination. Another motif is especially

characteristic, the small naked male children known as '*putti*' in Italian.[14] Their significance may partly lie in their adaptation from Classical Roman Imperial sculpture. They occur ubiquitously in other media in Renaissance art, but particularly in sculpture. As flanking figures of a wreath or figure medallion on Classical or Early Christian sarcophagi, they were easily adapted to support the coat of arms of owners in countless borders in manuscripts (for example, cats 5, 8, 9). In this context they were perhaps thought of as implying immortality for the owner. In other contexts they may have had other meanings, signifying pagan as opposed to Christian, innocence as opposed to experience, ignorance as opposed to learning, nature implying freedom as opposed to culture implying self-control. Sometimes, as in the Berlin Jerome (cat. 28), they invade the sacred space to play hide-and-seek with the saint's lion. Satyrs, who have similar sources in pagan Antiquity and who often occur in similar contexts, may also have had an overlapping series of meanings (cats 90, 91, 101).

White vine-stem decoration soon spread from Florence all over Italy, with characteristic local variations of style. It must gradually have lost its impact as a signifier of Antiquity, however. In other areas other decorative styles or motifs were adopted to convey a similar message. For example the scribe Felice Feliciano of Verona,

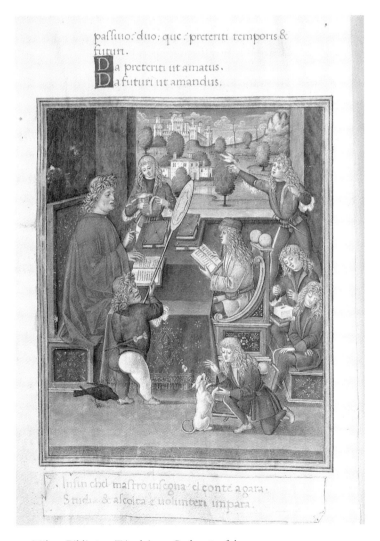

5 Milan, Biblioteca Trivulziana, Cod. 2167, fol. 13v.
Grammar Book. Maximilian Sforza at his lessons

an associate of the antiquarian Giovanni Marcanova (cats 66, 67), used knotwork and interlace for borders and initials in his manuscripts, and this is also found in manuscripts produced for the Gonzaga of Mantua (cats 21, 22).

It was in Padua and Venice, however, from the mid-century, that the most self-consciously classicising motifs were introduced into book illumination by scribes and illuminators. These included the use of membrane stained purple, green or yellow and written on in silver or gold (cat. 71), the coloured epigraphic capitals used for titles, especially by Bartolomeo Sanvito of Padua (cats 71, 73-5), and the facted initials with whose development Sanvito may also have been connected (cat. 29).[15] The illuminators Franco dei Russi, Giovanni Vendramin, the Master of the Putti and others, influenced by the interests of local antiquarians in Classical inscriptions and monuments, seen for example in Marcanova's *Silloge* (cats 66, 67), developed title-pages and frontispieces on classicising stele (cats 26, 79) or attached them to Classical triumphal arches (cats 39, 75, 78).[16] Figures, motifs and ornament from Classical remains were incorporated into borders, miniatures and initials by these artists, all of whom were in one way or another also indebted to the example of the Paduan painter Andrea Mantegna, himself famous for his antiquarianism. Well-known monuments like the Arch of Constantine or the Column of Trajan are alluded to in frontispieces by Gaspare da Padova, who often collaborated with Sanvito (cats 73, 74). It is evident that some of these motifs circulated as drawings. For example Sanvito mentions in his diary that he lent a Gaspare drawing he owned, depicting Phaethon, to the artist Giulio Campagnola (cat. 71). But these artists were also creatively inventive, producing imaginative pastiches *all'antica*. Already in the 1460s some of these scribes and illuminators moved to Rome; Gaspare da Padova was active there in the 1470s-1480s and the Master of the London Pliny from *c.* 1485. The antiquarian motifs and inventions of the Paduan-Venetian school quickly spread elsewhere in Italy, and the architectural frontispiece in particular was adopted in Naples, Milan and Florence.

Another aspect of these northern artists' work was the virtuoso display of trompe l'œil illusionism. For example artists made the central space of the page on which the title or text was written seem like a placard affixed to a building, with its edges curling up and holes in it (cats 78, 125). Another aspect of trompe l'œil is the inclusion of pearls and jewels into borders in Ferrarese illumination; Girolamo da Cremona, who worked on Borso d'Este's Bible, became particularly skilled at this type of jewelled decoration (cats 93-6, 101).

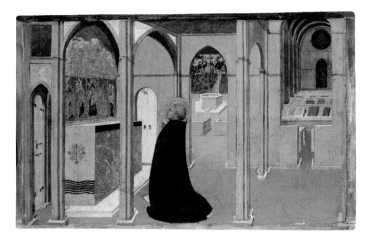

6 Budapest, Szépmüvészeti Museum, Inv. 32.
Sassetta. St Thomas Aquinas in prayer

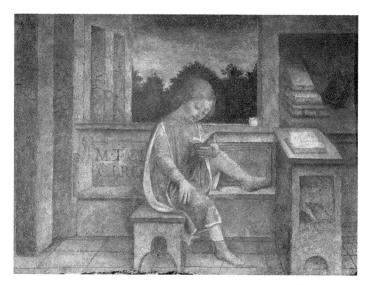

7 London, Wallace Collection. Fragment of a fresco attributed to Vincenzo Foppa. Cicero (?) as a boy reading

The Master of the London Pliny created initials as if carved from crystal with gold or silver mounts (cats 28, 46, 91). These references to the work of contemporary goldsmiths both conveyed an impression of preciousness and value to the book and demonstrated the artists' mimetic skills. It also became common to include representations of Classical cameos. Many were generalised images, but especially in Florence reference could be made to specific gems which were already famous and recognisable: the cameos from the Medici collection (cats 3, 76, 85). In the 1480s the discovery of the stuccoes and paintings in the Golden House of Nero in Rome introduced a fashion for a new form of classicising decoration, the *grotteschi*. Again motifs circulated in artists' drawings and pattern-books, for example those of Amico Aspertini, as well as in book illumination (cat. 117).

The ownership of books, as already observed, immensely increased in this period in two directions. First, particular powerful and wealthy individuals might now own books in considerable numbers, and in any case in much greater quantities than in earlier centuries. The established dynasties, the Visconti-Sforza in Milan or the Aragonese Kings of Naples, for example, built up their libraries by inheritance over several generations.[17] Thus the inventory made in 1426 of the library of the Visconti Dukes of Milan, housed at Pavia, contained 988 volumes, many of them taken as groups by military conquest. A later inventory of the personal library of Galeazzo Maria Sforza adds 126 manuscripts. The ducal library housed in the castle at Pavia was captured by the French army in 1499 and much of its contents were transferred at Louis XII's orders to the Château at Blois, so that today they are preserved in the Bibliothèque nationale in Paris. Many of these manuscripts contain the note '*de Pavye au roy Loys XII*' (cats 14, 15).[18]

The Aragonese inventories are much less complete, and the surviving manuscripts even more scattered. Tammaro de Marinis's volumes give an idea of the splendour of the library with their illustrations of the known surviving manuscripts. He also prints an inventory of 266 printed books and manuscripts which were pledged to the banker Battista Pandolfini for an intended war against the Turks in 1481. They were used to secure the huge sum of 38,000 ducats. Later, after the collapse of Aragonese rule as a result of the invasion of Charles VIII of France in 1494-5, manuscripts captured were taken to France. Among those which the

Kings of Naples still retained, 138 were sold to Cardinal Georges d'Amboise by Ferdinand III of Naples and are listed in an inventory of 1508 at the Château de Gaillon near Rouen. A portion of these are still in France in the Bibliothèque nationale in Paris (cat. 10), though others had already been lost or stolen in the 17th century (cat. 9). Even then a section of the library survived the French invasion and after being taken to Ferrara by Frederick III's queen, Isabella del Balzano, it was transported to Spain, where it was bequeathed to San Miguel de los Reyes by Ferdinand, last Duke of Calabria, in 1550. The inventory lists 795 volumes, manuscripts and printed books, a portion of which are now in the Biblioteca Universitaria at Valencia (cats 8, 9, 11, 44, 49, 65, 75, 76, 106). Once again the royal accounts give much valuable information on the sums involved in the writing, illumination and binding of manuscripts, as well as many names of those who worked as scribes and illuminators.[19]

A third library, perhaps even more remarkable since it was created by one individual in a short space of time, is that formed by Federigo da Montefeltro, Duke of Urbino. A large part of his manuscripts still fortunately survive together, having been bought for the Vatican Library in 1658 (cats 36, 58, 62, 64). Estimated by Vespasiano da Bisticci (1421–1498) in his biography of Federigo to have cost 30,000 ducats, the library was only a part of the artistic patronage made possible by Federigo's remuneration as military commander.[20] Federigo's two *studioli* in his palaces at Gubbio and at Urbino are lined with extraordinary intarsia panels with illusionistic representations of all the paraphernalia of a scholar's study, including of course manuscripts and a variety of objects associated with writing and reading them. The paintings commissioned for the same spaces from Justus of Ghent and others show Federigo as literate patron, the disciple of 'Rhetoric', who is both reader and, as attender of humanistic lectures, auditor.

There were also increasing numbers of individuals of less elevated status, though often of considerable wealth, now owning books. Some of them owned collections notable for their contents rather than their size, for example Francesco Sassetti in Florence, whose library comprised probably rather more than 120 manuscripts,[21] or Giovanni Marcanova of Padua, a doctor of medicine with a special interest in Antiquity (cats 66, 67). Printing accelerated this trend to wider ownership by making books both cheaper to produce and easier to come by, but the special copies with hand-produced illumination, which were usually printed on parchment, remained rarities and the possession of exceptional patrons, some of whom had special links to the printing industry, for example Filippo Strozzi and Peter Ugelheimer, who put up the capital for editions (cats 85, 96–101). Typically, therefore, the new technology both responded to and also fostered demand.

Information about the great libraries is forthcoming in detailed inventories, enabling us often to identify manuscripts which have since been scattered. Normally, printed and manuscript books were kept together on the shelves and are listed together in catalogues according to their texts. For smaller collections of books, archival documents such as wills and lawsuits give valuable information. For example Sassetti made an inventory of all his possessions in November 1462 and included his books with estimates of their value.

The fate of the Visconti-Sforza and Aragonese libraries underlines the lack of stability of secular as opposed to religious ownership. The churches and monasteries of Italy had also built up libraries over the centuries and continued to do so in the 15th and 16th centuries. Sometimes a new foundation or a movement for reform or the intervention of a great patron meant a spectacular increase in

library provision. Examples are the reformed Congregation of Santa Giustina of Padua, which had a major effect on libraries of the order (cat. 124), mainly in the north-east but extending down to Monte Cassino itself, or the money provided for the Badia of Fiesole by Cosimo de' Medici, il Vecchio (cat. 120).[22] These great libraries remained on the whole intact until the 18th century, when some began to sell manuscripts to rich collectors, many of them wealthy English aristocrats like Sir Thomas Coke of Holkham Hall in Norfolk (*d.* 1759), who made the Grand Tour from 1712 to 1718, purchasing over 600 manuscripts (cat. 47). These included a block from the library of the monastery of San Giovanni di Verdara in Padua.

The process of dispersal was accelerated by the French invasion of Italy under Napoleon in 1798, when many monasteries were secularised and there was considerable looting. Already at this date mutilation of illuminated manuscripts was taking place, for example of the liturgical illuminated manuscripts of the Cappella Sistina in the Vatican (cats 136, 137). An earlier interest in the acquisition of Classical texts by European collectors was now supplemented by a change of aesthetic taste as a new value was put on 'pre-Raphaelite' art.[23]

8 Venice, Biblioteca Marciana, Lat. VIII.2, fol. 1.
 Filarete, *de architectura*, Frontispiece

With so much extra demand and such huge financial resources made available in the 15th century, it is not surprising that the book trade prospered in Italy and that the numbers of those involved in it must have increased dramatically. It is not possible to estimate either the numbers of those employed, the booksellers (*cartolaii*), scribes, illuminators and binders, or the numbers of manuscripts produced. Many of those involved had other offices or occupations, such as the priests Piero Strozzi and Ricciardo di Nanni (cats 34, 68, 120), and many scribes were also notaries (cat. 105). While the numbers of printed books issued in particular editions are occasionally known, we have no reliable estimate even of the number of surviving manuscripts, and of course have no way of accurately gauging the extent of the losses.[24] But at least the major centres can be identified, that is in the first rank Florence and Milan, and in the second Naples, Venice, Padua, Ferrara, Bologna, Siena and Rome, while in other cities a production was fostered in relation to specific initiatives by particular rulers at certain times – the Malatesta in Cesena and Rimini, the Gonzaga in Mantua, and Federigo da Montefeltro in Urbino. In such cases artisans would be tempted to migrate from other centres and even travel beyond Italy – for example Italian illuminators were attracted to the court of King Matthias Corvinus of Hungary at Budapest (fig. 8).[25]

The reputation of Italy as a centre of the new learning and the entrepreneurial skill of its book trade, of which the *cartolaio* Vespasiano da Bisticci in Florence was a foremost example, now meant that many foreigners from outside Italy bought books either on personal visits or commissioned them via intermediaries. Attavante degli Attavanti, one of the leading Florentine illuminators, was an exceedingly successful and busy artist who not only worked for Pope Leo X in Rome (cat. 4), which is understandable since the Pope was a Medici, but also executed commissions for foreign notables, such as the Missal of Thomas James, Bishop of Dol in Brittany (cat. 3), and the Missal and Breviary of King Matthias Corvinus of Hungary.[26]

A particularly well-documented commission from Attavante is that of 1494 for a Bible for the Crown Prince of Portugal, who succeeded the following year as King Manuel I (cat. 1). As with the Borso Bible of some forty years earlier, a contract survives which demonstrates how such major projects were set up, how long they took and how much they cost.[27] In both cases an intermediary agent for the ruler supervised the project and disbursed the money. Interestingly, in neither project is there any stipulation in detail as to what was to be represented in the miniatures and borders. Rather the extent of the decoration, in each case a series of grand frontispieces, was laid down, and there was a general direction that it was to be done to the highest possible standards, '*nella perfectione delle figure et adornamenti*', as the Attavante contract states. A hierarchy of decoration existed as in most illuminated manuscripts to mark divisions of the text – for the King of Portugal's Bible, the prologues as well as the different books.

There are many parallels to contemporary 15th-century contracts for paintings. In particular the quality of materials was stipulated and the length of time for completion. For the Borso Bible this was to be six years, and in fact the Bible was completed in 1461, though the final payments were only made in 1465. We do not know whether the King of Portugal's Bible was completed to time or not, but it is interesting that there are detailed let-out clauses for Attavante in case the scribes did not complete their work on schedule. Even at this date it seems likely that the majority of manuscripts were still, like these, made to commission. This was of course the great difference between manuscripts and printed books.

The illumination was almost always done after the text was written. In exceptional cases where the scribe was also the illuminator, it may have been possible to do the illumination concurrently; single sheets could also be illuminated as the scribes completed them. The scribes of both the great Bibles are known. The scribe of the Borso Bible is named in the ducal accounts as Pietro Paolo Morone, while in the King of Portugal's Bible the first and second volumes are signed by Sigismondo de' Sigismondi and Alessandro da Verrazzano respectively. The scribes left the necessary and no doubt previously agreed-upon spaces for miniatures and initials according to the general scheme laid down in the contract.

In both projects the main illuminators had assistance. Since the illumination was done on the unbound bifolia (folded sheets of parchment), it was a relatively simple matter to partition the book into sections for different individuals to decorate. In the Borso Bible the main collaborators are named as Taddeo Crivelli and Franco dei Russi, and a number of other craftsmen would have worked under their supervision. In the King of Portugal's Bible only Attavante is named, but on critical stylistic grounds it seems only the opening of each volume is painted by him. He may have designed or retouched other pages, but many are clearly both different in style and much weaker in quality, executed therefore by *garzoni*, journeymen or apprentices, or perhaps by anonymous collaborators brought in for the purpose. Sometimes these were spe-

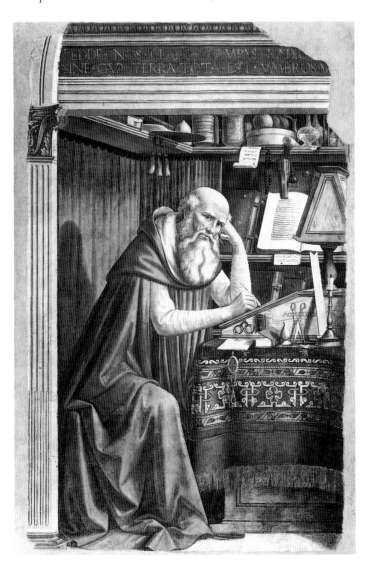

9 Florence, Church of Ognissanti. Domenico Ghirlandaio,
 St Jerome in his study

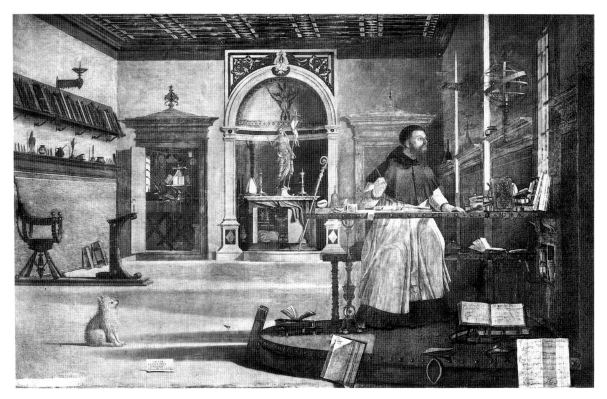

10 Venice, Scuola San Giorgio degli Schiavoni. Vittore Carpaccio, *St Augustine in his Study*

cialists in particular techniques. An example is Guinifortus de Vicomercato (Vimercate near Milan), who has left a sample book of his skills in penwork decoration (cat. 109).

All this activity and the value attached to the manuscript book and to the skills and devotion necessary to produce it are reflected in numerous images. These occur from an early period in the manuscripts themselves, the commonest and most prestigious scribes being the Four Evangelists as authors of the Gospels.

This tradition continued – there are many examples in the present exhibition of author and scribe portraits, whether writing their works like Duns Scotus, whose image in a manuscript copied by Pietro Ippolito da Luni in Naples must also be in some sense self-referential (cat. 9), or presenting their completed works, like Girolamo Mangiaria kneeling before Galeazzo Maria Sforza, Duke of Milan (cat. 14).

Books are one of the commonest attributes of holy persons, including the Godhead, throughout Christian art, but in many of the 15th-century representations they are shown with a new attention to detail, both of physical appearance and of the tools necessary for writing and rubricating. In representations of scholar saints, a new emphasis on the Four Doctors of the Church – Gregory the Great, Ambrose, Augustine and Jerome – results in such images as Domenico Ghirlandaio's fresco of 1494 in the Ognissanti in Florence, where St Jerome is seated at his desk with spectacles, inkwells, pen-case, scissors, candle for light, and textual exemplar, all shown as still-life details (fig. 9).[28] In Carpaccio's early 16th-century painting of St Augustine in the Scuola San Giorgio in Venice, codices with brightly coloured bindings are displayed in rows on the long shelf to the left, but elsewhere spill over the table and onto the floor, graphically illustrating the growth of books and libraries already described (fig. 10). Other emblems of learning, such as the astrolabes and armillary sphere represented in the painting, also occur in Attavante's portraits of St Jerome in King Manuel's Bible (cat. 1).

By 1494 there had been printers active in Italy for nearly 30 years. At first there remained work for illuminators to do in decorating special copies of printed books by hand, even if the scribes were rendered redundant. In fact a ruler like Manuel of Portugal evidently did not consider the old technology of the hand-produced book to be superseded, and the making of handwritten manuscript copies of printed books is by no means uncommon (cat. 48). The old technology did not die overnight and Vespasiano's well-known remark about the library of Federigo da Montefeltro – 'all the books are superlatively good, written with the pen, and had there been one printed volume it would have been ashamed in such company' (in fact Federigo owned many printed books) – describes a typically aristocratic and conservative attitude which in our own century similarly greeted first the typewriter and then the word processor.

In particular circumstances where a unique copy was required for a special reason or for a special occasion, mass production was unsuitable. Examples are the service books used by new Cardinals of the Curia and afterwards donated to the Cappella Sistina (cats 128, 134), or the documents of appointment of officials of the Serenissima in Venice, including the oaths of office of the Doges themselves. In other cases the cachet of the hand-produced book was such that a manuscript as well as a printed volume was produced. A striking example is the Commentary on Gratian's *Decretum* written by Giovanni Antonio di Sangiorgio. A manuscript copy with hand-painted illumination was made for presentation to Pope Alexander VI (Vatican, Biblioteca Apostolica Vaticana, Vat. lat. 2260) and a printed edition was issued contemporaneously and was similarly decorated but with a woodcut.[29]

However, until the 19th-century invention of colour lithography and, later still, of colour photographic printing processes, the earlier printers were unable to produce anything but the simplest colour mechanically and so could never rival manuscripts for their illumination. The word 'illumination' draws attention to

the lighting up of the page, most especially by the use of gold leaf, applied over gesso and then burnished, and by various forms of liquid or 'mosaic' gold. Even today this cannot be satisfactorily simulated mechanically in even the most sophisticated of facsimiles.

The splendour of the colour of the painted pages will be the most striking aspect of this exhibition to many visitors. And this is the characteristic of the illuminated manuscript which renders it unique. For not only were these manuscripts produced with the highest standards of skill and craftsmanship, using techniques evolved over a millennium, but the pigments and metals have also been uniquely preserved by their situation inside the closed volume, thus protected from both light and dirt. In opening these closed treasures for a short time to the admiration and delight of a contemporary audience, we cannot doubt that they will fulfill the expectations and desires not only of their original owners, exigent patrons like Borso d'Este, but also of their original creators, the talented and industrious artists who worked on them. In Italy in this period a significant number of the artists and scribes name themselves, and many other names have been recovered; but whether named or humbly anonymous these works are their lasting memorial.

1 'Perfect as to the figures and ornament'. The phrase is used in the contract with the illuminator Attavante degli Attavanti of Florence for the illumination of a Bible now in Lisbon (cat. 1). The contract is further discussed below.

2 Modena, Biblioteca Estense, MSS Lat. 422, 423. For the history of the commission, see Hermann 1900, pp. 249-50; and for the journey to Rome, Rosenberg 1981. The Director of the Estense, Dr Ernesto Milano, kindly informs me that the two volumes presently weigh 7,720 and 7,760 kg., but they are not in their original bindings.

3 Cahn 1982.

4 Berg 1968, pp. 151-5, 224-7; Cahn 1982, pp. 224-6, 283.

5 Branner 1977.

6 Garzelli 1977; Evans, in Cologne 1992, no. 68. It was described by the *cartolaio* Vespasiano da Bisticci, who oversaw its production, as '*tanto ricco et degno quanto dire si potessi*'.

7 Ciardi Dupré dal Poggetto 1972.

8 Milan, Biblioteca Trivulziana, MS 2167; Alexander 1977a, pls 29-32. For a facsimile, see G. Bologna 1980.

9 For the humanist movement, see the classic papers by Kristeller 1956, 1985; more recently Grafton and Jardine 1986; Dupré 1993. The quotation is from Trapp 1991, p. 2.

10 For the transmission of Classical texts, see Reynolds and Wilson 1991.

11 De la Mare 1977.

12 Such colophons are conveniently published by the Bénédictins de Bouveret 1965-79.

13 Pächt 1957; de la Mare 1973.

14 Panofsky 1960, pp. 147-51, 169.

15 Alexander 1988b.

16 Armstrong 1981 and p. 42. For the tradition of Paduan antiquarianism, see Schmitt 1974.

17 Pellegrin 1955; De Marinis 1947-52.

18 For the library at Blois, see Blois and Paris 1992.

19 De Marinis 1947-52, II, 'Documenti', pp. 227-316; Blois and Paris 1992; Toscano 1993.

20 Clough 1973, esp. p. 138.

21 De la Mare 1976, p. 171, describes Sassetti's collection as 'choice rather than large'.

22 For the Congregation of Santa Giustina, see Alzati 1982. For the library of the Lateran Canons of the Badia Fiesolana, see de la Mare, in Garzelli and de la Mare 1985, pp. 440-4.

23 Munby 1972.

24 An idea of surviving numbers can be had from the catalogues of humanistic manuscripts in Kristeller's monumental *Iter Italicum*, 1963-93.

25 Berkovits 1964; Csapodi and Csapodi-Gárdonyi 1969; Balogh 1975. For the copy of Filarete's treatise on architecture made for Corvinus (Venice, Biblioteca Marciana, Lat. VIII, 2 [=2796]), see Cogliati Arano 1979.

26 The King's Missal is now Brussels, Bibliothèque royale, MS 9008; Csapodi and Csapodi-Gárdonyi 1969, pls I-III. His Breviary is in the Vatican, Biblioteca Apostolica Vaticana, Urb. lat. 112; see Cologne 1992, no. 78.

27 The contract was printed by Milanesi 1901, pp. 164-6; see also Alexander 1993, pp. 53, 181-2.

28 For this and the corresponding portrait of St Augustine by Botticelli, see Stapleford 1994. For the 'Eyckian' portrait of St Jerome, now in the Detroit Institute of Arts and once thought to have been the property of Lorenzo de' Medici, see New York 1994b, no. 1. For its influence on Florentine imagery of the scholar in his study, see Garzelli 1984, and cats 1, 13.

29 Michelini Tocci n. d.

A note on further reading

There is no very recent general account of Italian Renaissance book illumination. The reader is reffered to M. Salmi, *Italian Miniatures*, London, 1957, now out of print, and J. J. G. Alexander, *Italian Renaissance Miniatures*, New York, London, 1977. Fore more recent general accounts of European manuscript illumination see J. Backhouse, *The Illuminated Manuscript*, Oxford, 1979; O. Pächt, *Book Illumination in the Middle Ages, An Introduction*, London, 1986; C. de Hamel, *A History of Illuminated Manuscripts*, Oxford, 1986; J. J. G. Alexander, *Medieval illuminators and their methods of work*, New Haven, 1993. For technical terms and texts M. P. Brown, *Understanding Illuminated Manuscripts: a Guide to Technical Terms*, London, 1994, may be consulted. The techniques and materials used by medieval scribes and illuminators are described by C. de Hamel, *Medieval Craftsmen. Scribes and illuminators*, Toronto, London, 1992.

The most important accounts of Italian regional schools of illumination are as follows. For Milan: Toesca, 1912 and Malaguzzi Valeri, 1913-23. For Venice: Mariani Canova, 1969; Armstrong, 1981. For Ferrara: Hermann, 1900. For Florence: Garzelli and de la Mare, 1985. For Naples: de Marinis, 1947-52 and 1969; Putaturo Murano, 1973. Full references to these works are in the Bibliography, pp. 258-67.

The Italian Renaissance Miniature

By Giordana Mariani Canova

'A ogni libro si facia uno principio magnifico
segondo che merita questa bibia'
Contract for the Bible of Duke Borso
d'Este, 1455

The Italian Renaissance not only transmitted its message through the ostentatious public display of monumental art in the squares and churches of Italian towns and in the public rooms of Italian princely palaces, but also through books destined for a much more limited, elitist consumption. The illuminators were extraordinarily successful at keeping up with the latest developments in painting, such as the use of perspective and light, narrative realism and the revival of Antique art. Even painters of the first rank worked as illuminators, thus providing highly innovative examples for the professional illuminators. The texts, both manuscripts and printed books, that were selected for illumination were above all by the Latin writers, favoured by humanist culture, and the Italian poets Dante and Petrarch, as well as the works written by humanists for their friends and patrons. The most splendid manuscripts and incunabula were illuminated in those court circles where princes were keen to establish extensive libraries that would serve as testimony not only to their culture and taste but to their ability to govern with the wisdom of the Ancients and the shrewdness of the modern world. Venice alone may be considered a real *respublica librorum* since, though lacking a court library, it nonetheless enjoyed an immense patrimony of illuminated books distributed among the most influential and cultured patricians of the city. The illuminated book in the Italian Renaissance was the manifestation of a learned and secular culture; it conferred enormous prestige and was proudly displayed by the ruling classes. Naturally small Books of Hours made for private religious devotion also started to be illuminated in the new Renaissance style and the great churches and religious orders too began to replace their service books, especially the Choir Books used for the Mass and daily Offices. Such changes were provoked not only by developments in style which made the medieval miniature seem dated, but by an acceptance on the part of religious orders of humanistic culture and art as a means of improving the strict observance of their rules. Given the wide variations in figurative art, roughly corresponding to the various *signorie* spread throughout Italy, it is possible to recognize different schools of illumination which, however, often overlap due to the illuminators' mobility and the circulation of manuscripts.

It is essential to take Florence, cradle of humanism and Renaissance art, as a starting point for an overview of the Italian Renaissance miniature. Here experiments in letters *all'antica* decorated with *bianchi girari*, the white vine-stem motif typical of Tuscan manuscripts of the 11th and 12th centuries, had been taking place since the beginning of the 15th century. Florentine Renaissance painting was already widely established by the 1440s, and the workshops of the *cartolai* were busy producing humanist manuscripts which were then entrusted to particular illuminators. The workshop owned by Vespasiano da Bisticci in particular specialised in high-quality manuscripts destined for the court of the Medici and for a vast Italian and even international clientele. Florentine humanist manuscripts are easily distinguished by their frontis-

pieces, which are characterised by well-proportioned borders of *bianchi girari* inhabited by animals and Classical putti, by the owners' coats of arms at the bottom, and by abbreviated scenes inserted in the initial letters and in the medallions within the borders. The effect is principally decorative, but even on this small scale the illuminators could also paint impressive portraits, lively narrative scenes and imaginative fantasies *all'antica*, the latter sometimes based on Roman cameos preserved in the Medici collection (cats 3, 76). This is evident in a Cicero by Ricciardo di Nanni for Giovanni de' Medici and a 1458 Pliny by Francesco d'Antonio del Chierico (cats 34, 50). A highly skilled painter of the same period, Francesco Pesellino, added superb full-page miniatures, such as that of Mars in a chariot (fig. 11), to a *De bello punico* by Silius Italicus, which is also decorated with a *bianchi girari* border.[1] Evocations of the festive life of Florence can be seen in the illuminations of copies of

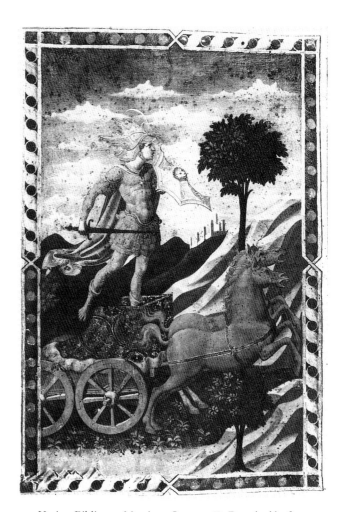

11 Venice, Biblioteca Marciana, Lat. XII.68. Detached leaf. Attributed to Francesco Pesellino. *The Triumph of Mars*

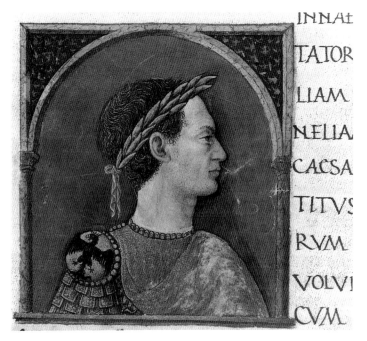

12 Cesena, Biblioteca Malatestiana, Ms. S. XV.I, fol. 29,
 Plutarch, *Lives*. Julius Caesar

Petrarch's *Trionfi* by Francesco d'Antonio del Chierico of 1456
(cat. 59) and by Apollonio di Giovanni.[2] The latter also transferred
the liveliness of Florentine cassone painting to a richly illustrated
Virgil.[3]

Panel and fresco painting often influenced the large historiated
initials of the Choir Books commissioned by the Medici for power-
ful religious communities. Zanobi Strozzi reproduced the style of
Fra Angelico, himself an illuminator, in the Choir Books for San
Marco and for the Cathedral, Santa Maria del Fiore.[4] Francesco
d'Antonio del Chierico exemplifies the extreme skill and lively nar-
rative typical of Florentine painting in the third quarter of the
Quattrocento in the Choir Books of the Badia at Fiesole[5] and those
of the Cathedral, made in collaboration with Zanobi and con-
tinued after his death.

Florence, with its permanent manuscript workshops and vast
production, was unique. In all other Italian towns the clientele and
activity of illuminators were more restricted, which resulted in the
development of an itinerant miniaturist community, moving
about the country in response to demand. In Siena, probably in the
early 1440s, Giovanni di Paolo and Sassetta illuminated a Dante for
Alfonso of Aragon, translating the text into spirited and subtly col-
oured images.[6] An analogous pathos, typically Sienese, appears in
an Antiphonary for the Augustinian hermits of Lecceto, likewise
illuminated by Giovanni di Paolo.[7]

In north-east Italy early signs of a *renovatio* in miniature painting
can be found at the court of Leonello d'Este (r. 1441-1450) in Fer-
rara. This cultured nobleman, educated by the great Veronese
humanist Guarino Guarini, admired the proto-Renaissance north-
ern Italian style of Pisanello and Jacopo Bellini. Nevertheless, he
summoned to Ferrara Agnolo da Siena, known as Maccagnino, a
Tuscan painter and probably a follower of the new style, to paint
the Muses, now lost, in his *studiolo* at Belfiore. A similar experi-
mental tendency is reflected in the miniatures Leonello commis-
sioned. For his Breviary, of which only a few fragments have sur-
vived, he employed Matteo de' Pasti, painter, medallist and
illuminator from Verona, who was a pupil of Pisanello.[8] An illumi-
nated Livy of 1450 made for Leonello by Marco dell'Avogaro, one
of his favourite illuminators, combines borders of Tuscan *bianchi*

girari with emblems of the Este derived from the medals of
Pisanello.[9] A copy of the *Noctes Atticae* by Aulus Gellius, written in
1448 near Bologna, but with illumination signed by the Ferrarese
artist Guglielmo Giraldi, combines ornamentation still in the style
of Pisanello with initials *all'antica* (fig. 13).[10] At the beginning of this
manuscript is a town painted with pure and luminous perspective
that represents a precocious example of Renaissance illumination
in north-eastern Italy. The common denominator of all these
examples is an extraordinary elegance that was to become typical
of Ferrara.

Other important centres of humanistic illumination were the
courts of the Malatesta, where Matteo de' Pasti, perhaps recom-
mended by Ciriaco d'Ancona or by Leonello, was employed in con-
nection with the Tempio Malatestiano, which was being erected at
this time to the designs of Leon Battista Alberti. Matteo's hand is
perhaps recognisable in the Pisanellesque portrait heads in a copy
of Plutarch's *Lives* executed *c*. 1450 for Domenico Malatesta
Novello, Lord of Cesena, humanist prince and friend of Leonello
(fig. 12).[11] Various copies of Basinio da Parma's *Hesperis*, written
and illuminated at the Riminese court in the 1450s and 1460s
(cat. 30), belong to the same stylistic climate.[12] By contrast, in a
superb *De civitate Dei* written in 1450, an illuminator – perhaps
Taddeo Crivelli of Ferrara – uses, for the first time in north-eastern
Italy, the perspective, Classicism and clarity of Alberti.[13]

This strongly humanistic culture came to an end in Ferrara with
the death of Leonello in 1450, as his brother and successor Borso
was more inclined to a decidedly modern yet much more courtly
and whimsical style. Between 1455 and 1461 he commissioned a
magnificent two volume Bible, illuminated by a group of artists
headed by Taddeo Crivelli and Franco dei Russi, at that time young
avant-garde masters (figs 3, 14-17).[14] The manuscript, one of the
masterpieces of Italian Renaissance illumination, exhibits lush
floral decoration in the borders with coats of arms and devices of
the Este. The countless small vignettes narrate the history of the
people and Kings of Israel as if they were the adventures of an aris-
tocratic and highly refined society, a mirror of Borso's court. The
perspectival constructions are by this time impeccable and the
elegantly dressed characters inhabit light, Alberti-style buildings
or delightful landscapes. The style is reminiscent of the part of the
studiolo at Belfiore executed for Borso, and particularly of the
paintings of Michele Pannonio an artist whom Taddeo Crivelli
emulates so closely as to be almost his alter ego. Other
illuminators, among them Giorgio d'Alemagna and Guglielmo
Giraldi, worked with the major masters. D'Alemagna had already
worked for Leonello in a style similar to Matteo de' Pasti, and had
produced a Missal for Borso.[15] Giraldi's composed youthful style
probably derived from his familiarity with Piero della Francesca's
work. We can also see in Borso's Bible the early style of Girolamo
da Cremona, an illuminator who was to enjoy a major career in
various parts of Italy. He worked on several sections, probably
among them the two for which Marco dell'Avogaro received pay-
ment. From this we can deduce that Marco was the young
illuminator's master. Girolamo's innovative Renaissance style
seems to derive from Venetian and Lombard art combined with a
new Classicism.

Borso's Bible was fundamental to the development of Renais-
sance illumination in North Italy. After the completion of the pro-
ject, masters such as Girolamo da Cremona and Franco dei Russi
moved to Lombardy and the Veneto. Guglielmo Giraldi, together
with Giorgio d'Alemagna, illustrated a magnificent Virgil tran-
scribed by the Venetian nobleman Leonardo Sanudo in Ferrara in
1458 (cat. 42). Taddeo Crivelli illuminated with great refinement

an elegant copy of the *Decameron* in 1467 for Teofilo Calcagnini, one of Borso's trusted counsellors (cat. 110), and at the same period two Books of Hours (cats 111, 112). Towards the 1460s, a style very similar to that of Cosimo Tura appeared, as is evident in a Choir Book in the Osservanza convent in Cesena, and in a series of beautiful historiated initials from Choir Books now dispersed in various collections (fig. 18).[16]

Humanistic illumination in the Veneto is remarkable for its high quality and for its antiquarian and classicising spirit, more intense than anywhere else in Italy. In the Veneto, the passion for the Antique was well established as more than a purely intellectual exer-

cise, taking the form of a search for actual physical artifacts. Already by the 14th century, when Petrarch was residing at the court of the Carrara in Padua, Antique coins and marbles were circulating. In 1436, the Bishop of Padua, Pietro Donato, brought back important Carolingian manuscripts from the Council of Basel, such as a *Chronica* by Eusebius[17] as well as copies of Late Antique illustrated texts, such as the *Notitia dignitatum*.[18] These and similar examples circulating in the Veneto probably had a great influence on the creation of early Venetian miniatures *all'antica*. An example is a Caesar from the 1440s of probable Paduan origin.[19] We also find a type of interlace initial *all'antica, a cappio intrecciato*,

13 Milan, Biblioteca Ambrosiana, Ms. Sp. 10/28, fol. 90 v. Aulus Gellius, *Noctes Atticae*

which imitated those found in Carolingian and Romanesque North Italian manuscripts and which circulated in the humanist milieu of Francesco Barbaro by the 1430s. The high quality and innovative style of Renaissance illumination in the Veneto was assured by the direct participation of famous painters. Mantegna's antiquarian researches and the drawings of Jacopo Bellini especially influenced the illuminators.

The birth of the Renaissance miniature in the Veneto is signalled by an illumination of the *Christ Child*, either by Mantegna himself or by his rival Niccolò Pizzolo, in a *Chronica* by Eusebius dated 1450 and copied from Bishop Donato's manuscript (fig. 19).[20] Two

superb manuscripts with large miniatures, given by the Venetian nobleman Jacopo Antonio Marcello to his friend King René of Anjou, are possibly by one of the Bellini, or at least from their workshop. The first, the *Passio S. Mauritii* of 1452–3[21] is very close to the style of Jacopo Bellini, and the second, a copy dated 1459 of Strabo's *Geographia*, newly translated by Guarino, may represent in its frontispieces the early work of Giovanni Bellini (cat. 29), who was working at the time with his father on the Gattamelata altarpiece in Sant' Antonio, Padua. Ptolemy's *Cosmographia*,[22] given by Marcello to King René of Anjou in 1457, inaugurates the taste for antiquarian illumination in the Veneto and contains the first dated

14 Modena, Biblioteca Estense, VG 12 (Lat. 422). Bible of Borso d'Este. Vol. I, fol. 88v. Opening of Joshua

example of the so-called *littera mantiniana*, or faceted initial, made in the form of a Roman capital letter as if cast in metal. The manuscript was copied by the great Paduan scribe Bartolomeo Sanvito, who principally produced small manuscripts destined for private reading by sophisticated connoisseurs.

The illusionism of Paduan painting resulted in the so-called 'architectural frontispiece', in which the title and the beginning of the text are written in capital letters copied from those found on Classical monuments and in Antique codices. The earliest example is Solinus' *Polystoria*, copied in 1457 by Sanvito for the Venetian humanist and nobleman Bernardo Bembo.[23] Sanvito also tran-

scribed a Petrarch, whose illuminator, perhaps the Master of Marcello's Ptolemy, worked *all'antica*, using precious metals, gold and silver, on tinted parchment in the early 1460s (cat. 71). This master's style is characterised by a delicacy reminiscent of Bellini and by a Classical style that would become typical of later Veneto illumination.

In a similar way but with a more dynamic and expressionistic style, Marco Zoppo, a painter and follower of Squarcione, also invoked Antiquity in a Virgil copied by Sanvito in 1463 probably for the humanist Leonardo Sanudo (cat. 72). Franco dei Russi, newly arrived from Ferrara in 1463-4, created whimsical, colour-

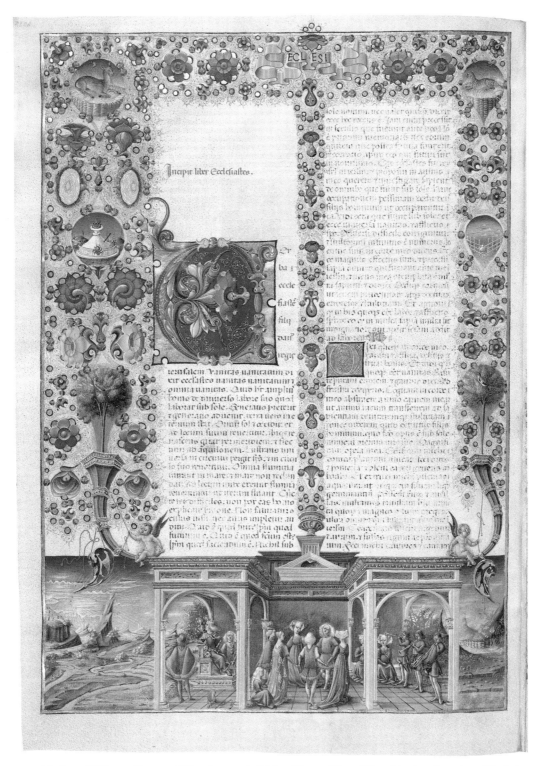

15 Modena, Biblioteca Estense, VG 12 (Lat. 422). Bible of Borso d'Este. Vol. I, fol. 280v. Opening of Ecclesiastes

ful compositions *all'antica* in, among other manuscripts, the *Oratio gratulatoria* written by Bernardo Bembo in honour of Doge Cristoforo Moro and copied by Sanvito (cat. 26). This Doge's solemn *promissione*, or oath, upon his 1462 election was illuminated on the other hand in Venice by Leonardo Bellini (cat. 27). He was very active in subsequent years (cat. 89), in a style close to that of his uncle, Jacopo, and of Giovanni Bellini. The influence of the Bellini painting style on illumination was clearly greater than has been recognised.

Towards the mid-1460s or shortly after, a group of Paduan artists executed poetic images of the constellations in a *De astronomia* by Hyginus (cat. 51). Some of these invigorate the delicate style of the Sanvito Petrarch (cat. 71) with Zoppo's dramatic power; others relate to the Squarcionesque style of Schiavone. It is possible that among the illuminators working on these manuscripts of the 1450s and 1460s was Lauro Padovano, painter of several Antique-style tinted parchment leaves which are later mentioned by Bartolomeo Sanvito as being in his possession.

Perhaps in the second half of the 1460s Girolamo da Cremona arrived in the Veneto from Mantua, where he had gone after finishing Borso's Bible. He probably came to Padua to illustrate Choir Books for the Benedictine monasteries. His only signed miniature

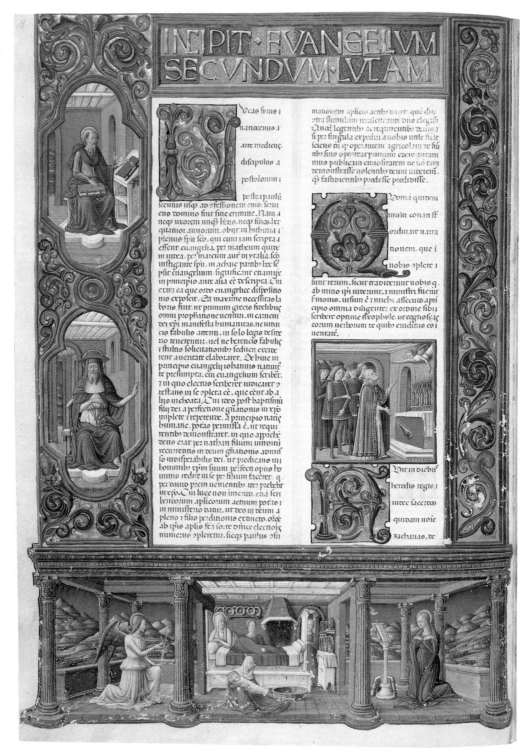

16 Modena, Biblioteca Estense, VG 12 (Lat. 423). Bible of Borso d'Este. Vol. II, fol. 157v. Opening of St Luke

probably was from one of these books (fig. 20),[24] while the Gradual and Antiphonary of SS. Cosmas and Damian (cat. 123) was probably executed for the convent of the Misericordia. The vitality and complexity of culture in the Veneto is clear from this survey.

In Milan, at the court of Francesco Sforza (r. 1450-1466), the development of new Renaissance styles was slower because of the prestige of the local late Gothic tradition. In the devout and intimate atmosphere of the Duke's family, illumination concentrated on manuscripts of dynastic history, on Prayer Books, and on Classical and educational texts which were commissioned by Francesco

Sforza and his wife, Bianca Maria, for their children, Galeazzo Maria and Ippolita. In the 1450s and 1460s the illuminators continued the graceful style and narrative of the manuscripts from the Visconti period, and continued to develop the themes of portraiture and heraldic symbolism so popular in Lombardy. These elements were somewhat hesitantly combined with perspectival rules, derived in all probability from the architectural drawings of Antonio Averulino, known as Filarete, a Tuscan architect living in Milan and working for the court since 1451. A Cicero written in 1457 for Galeazzo Maria is particularly noteworthy because of its representation of a Renaissance palace in the manner of Filarete.[25]

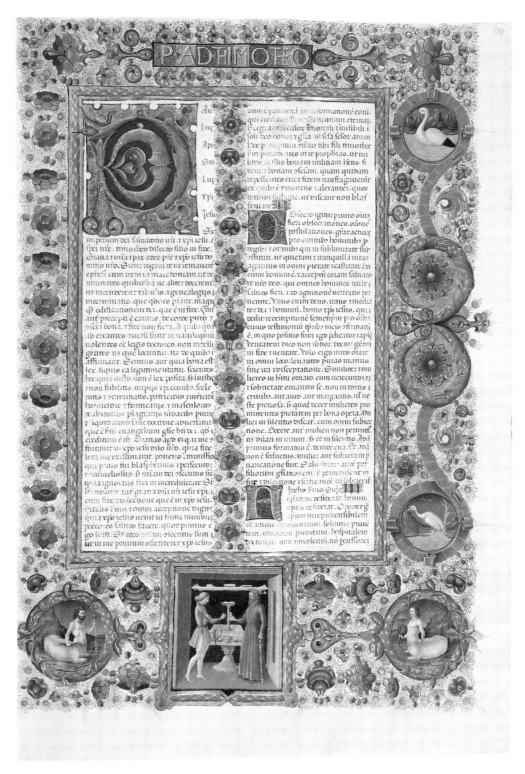

17 Modena, Biblioteca Estense, VG 12 (Lat. 423). Bible of Borso d'Este. Vol. II, fol. 208. Opening of Epistle to Timothy

18 New York, Metropolitan Museum of Art, M. 11.50.2.
Leaf from a Choir Book. All Saints

The Master of Ippolita Sforza, a refined illuminator who worked in the tradition of the Master of the Vitae Imperatorum, produced an exquisite Virgil for Ippolita Sforza on the occasion of her marriage to Alfonso of Aragon, Duke of Calabria, in 1465 (cat. 11). He illuminated Classical texts as well as an elegant copy of the dance treatise *De pratica seu arte tripudii* by Guglielmo da Pesaro for Galeazzo Maria.[26] A representation of court life soon after the election of Galeazzo Maria in 1466 can be seen in copy of Mangiaria's *De impedimentis matrimonii* illuminated by another artist (cat. 14). In a *De sphaera*, probably executed in the 1460s at the Milanese court, the influence of contemporary French manuscripts is evident, along with the use of perspective, Lombard narrative and a sophisticated taste for astrology (cat. 18).

A more vigorous realism was to come from Brescia, a Lombard border town then under Venetian dominion, the birthplace of the painter Vincenzo Foppa. There Giovan Pietro Birago, who later would enjoy great success in Milan with his strong and expressive style, a real novelty in Lombardy, executed a Pontifical in the early 1460s.[27] The Pontifical combines Lombard naturalism dear to Foppa with the innovative style of painters such as Francesco Benaglio, working in neighbouring Verona. This language – somewhat crude, but full of strength and originality – was to appear again, once more influenced by Foppa, in the Choir Books executed and signed by Birago for the Cathedral of Brescia from 1469 to 1474.[28]

In the 1460s the Renaissance style of miniature painting was also to be found at the Gonzaga court in Mantua, where Mantegna arrived in 1459. In 1461, Girolamo da Cremona replaced Belbello da Pavia, an artist working in a late Gothic style, as illuminator of the Missal of Barbara Gonzaga.[29] The Missal, completed by Girolamo over a long period of time, shows the artist growing steadily closer to Mantegna, a development culminating in the miniature of the *Ascension*, obviously influenced by the Gonzaga

triptych now in the Uffizi, Florence. In the copy of Boccaccio's *Filocolo* (cat. 22), written for Lodovico Gonzaga by Andreas de Laude in 1463–4, and in an almost contemporary Petrarch for Cardinal Francesco Gonzaga,[30] an illuminator, probably Pietro Guindaleri of Cremona, represents a monumental *urbs picta* constructed in perspective. The abundance of coloured marbles and the Classical solemnity of the architecture are evidently related to the architectural designs of Leon Battista Alberti and to his buildings in Mantua. Similar taste can be found in a Plautus illuminated for the Gonzaga by the Ferrarese artist Guglielmo Giraldi (cat. 21). A magnificent Pliny from the 1470s clearly shows the influence of Alberti's architecture as well as of Mantegna's Camera Picta and Uffizi triptych.[31] Interlace strapwork borders and letters *a cappio intrecciato*, originally from the Veneto, are characteristic of Mantuan art.

Mantegna's interest in the Ancient world was also to influence Felice Feliciano from Verona. Feliciano dedicated his life to the search for and the reproduction of Roman monuments and epigraphs, following the work of Ciriaco d'Ancona and the early antiquarians of the Veneto. He experimented, moreover, with new letter forms and ornamentation *all'antica*. His most important work is the *Collectio antiquitatum*, a collection of Roman inscriptions executed for Giovanni Marcanova, a doctor from Padua, and dedicated in 1465 to Domenico Malatesta Novello, Lord of Cesena (cats 66, 67). Veronese illumination, however, also followed a different trend. Liberale da Verona, who was working on the Choir Books for the monastery of Monteoliveto Maggiore,[32] near Siena, as well as on other works, shows a linearity and expressionism which also seem to derive from Matteo de' Pasti. This was probably combined with a knowledge of the work of the Ferrarese artists, Michele Pannonio and Taddeo Crivelli, and, most of all, with a fascination for the painting and illumination of Giovanni di Paolo of Siena. From 1469 to 1475 Liberale worked on the Piccolomini Choir Books of the Cathedral of Siena, among the greatest masterpieces of Italian illumination for their quality and sumptuousness (cats 121–2). He collaborated from 1469-70 to 1474 with Girolamo da Cremona,[33] who, arriving from Mantua, was creating a style very close to that of Mantegna's Uffizi triptych in his initials. Girolamo, who had enclosed the miniature of the *Crucifixion* in the Gonzaga Missal in a jewelled frame, and who was well aware of Mantegna's predilection for painting jewellery, was probably the inventor of a precious style of bejewelled initials. This style was to have great success over all Italy (cats 46, 49). The partnership with Girolamo seems to have increased Mantegna's influence on Liberale, yet he shows a linearism and a fantastic imagination all his own. In his later illuminations of the Sienese Choir Books the figures in the initials are depicted with greater dynamism and plasticity, and they show a greater vigour and robustness, probably due to the influence of contemporary Sienese artists, in particular Francesco di Giorgio Martini. Francesco, whom we also know as an illuminator in the 1470s, for example in a *De animalibus*,[34] was in his turn influenced by Liberale.

In 1469-70 enterprising foreign printers, Johannes and Vindelinus de Spira and Nicolaus Jenson (see cats 78, 81-89, 92-7, 102), introduced the art of printing to Venice, thus initiating a new and splendid chapter in the history of the miniature in the Veneto. For the Classical texts, often printed in large format, the illuminators created exquisite mythological scenes, elaborate architectural frontispieces with erudite images *all'antica*, and dynamic putti. The Master of the Putti, who worked for the Venetian aristocracy, seems to have been trained in the Bellini circle and influenced by Franco dei Russi, but at the same time his works

show that he had an interest in Zoppo's drawings and in the masters of the Paduan Hyginus (cat. 51). Examples in this vein are the mythological procession in a Livy printed in 1470[35] and in a Petrarch printed in 1472.[36] A Livy of 1469 (cat. 80) and a Pliny of 1472[37] contain fine examples of architectural frontispieces (see also page 42). In 1471 Johannes de Spira printed an Italian translation of the Bible by Niccolò Mallermi in two volumes. The influence of Borso's Bible is still perceptible in the miniatures of the copy signed by Franco dei Russi of Ferrara (cat. 82). In another copy (cat. 81) the Master of the Putti opens up the architectural frontispieces with perspectival and landscape views for the first time. They are reminiscent of Jacopo and Giovanni Bellini's drawings and combine with a lively narrative derived from Franco dei Russi and Girolamo da Cremona, whose work the artist had probably seen in the Gradual and Antiphonary of SS. Cosmas and Damian (cat. 123). The Master of the Putti had many followers in Venice, among whom was the Master of the London Pliny, creator of a fine Pliny *Naturalis historia* printed in 1472 (fig. 246).[38] Another work in which the Master of the Putti collaborated with other illuminators is the *Columba* (cat. 70).

Paduan illumination maintained its strongly Classical character established in manuscripts copied by Bartolomeo Sanvito despite the great scribe's departure for the papal court in Rome. At this time, Bishop Jacopo Zeno of Padua was the major patron and Giovanni Vendramin was the most important illuminator. He is documented in the studio of Francesco Squarcione in 1466. In a 1469 printed edition of Pliny (cat. 78), he creates an architectural frontispiece with a sheet of parchment 'attached' at the top, perhaps even before the Master of the Putti's use of this motif. He combines *camaïeu d'or* with the formal refinement and Bellini-like sentiment of the masters of the Paduan Hyginus and with the colour and inventiveness of Franco dei Russi. The fine scene of *Hercules and the Hydra* in a small Paduan manuscript dedicated to Ercole d'Este in 1472 (cat. 19) combines a strong taste for the Antique with a dynamic energy close to Zoppo's drawings, which were probably most admired in the early 1470s. Later he worked on an Antiphonary in the Cathedral of Ferrara signed and dated 1482 (fig. 21).

In the 1460s late Gothic imagery and courtly style persisted in Italian Renaissance illumination, despite the recent adoption of perspectival constructions. But this initial experimental period ends in the 1470s, and is succeeded by in a phase of greater maturity. Great masters such as Francesco d'Antonio del Chierico, Francesco Rosselli, Mariano del Buono, Attavante degli Attavanti, Gherardo and Monte di Giovanni di Miniato and Boccardino the Elder, were at work in Florence. At first *bianchi girari* borders were elaborated on, for example in the Livy (cat. 68) illuminated by Mariano del Buono and Ricciardo di Nanni for the Hungarian humanist Janos Vitéz. Later the style of ornamentation was to change, becoming more elaborate, with Antique foliage, jewellery, medallions and cameos. These innovations were largely due to Girolamo da Cremona's 'precious style', evident in the Sienese Choir Books and in a Breviary for the hospital of Santa Maria Nuova, on which Girolamo worked with Mariano del Buono from 1473 to 1477.[39] Francesco Rosselli, who also worked on the Sienese Choir Books, painted medallions *all'antica* and jewellery in an Aristotle belonging to Piero de' Medici (cat. 35). In the same period illustrations of increasing size appear, especially in liturgical manuscripts, which are related in style to Ghirlandaio and the circle of Verrocchio. Gherardo and Monte di Giovanni's first work, a Missal for Santa Maria Nuova, shows superb illustrated and decorated pages.[40]

Federigo da Montefeltro, Duke of Urbino, who was building up an important library in his palace, was the major patron of the Florentine illuminators in the 1470s. Copies of works by Cristoforo Landino and by Poggio Bracciolini, illuminated by Francesco d'Antonio del Chierico, contain magnificent portraits of Federigo and of the humanist authors, as does a copy of Bruni illuminated by Francesco Rosselli (cats 36, 62, 64). Giovanni d'Antonio del Chierico and other Florentine artists, probably including Domenico Ghirlandaio, painted magnificent evocations of Italian Renaissance life in a great Bible,[41] copied for Federigo da Montefeltro under the supervision of Vespasiano da Bisticci and illuminated between 1476 and 1478 (fig. 2). Other magnificent books were prepared in this period for King Ferdinand I of Naples (cat. 49). In the 1480s the Books of Hours executed for the Medici by Francesco Rosselli (cats 31, 32) show details close to Verrocchio's painting style. At the same time, opulent manuscripts with grandiose mise-en-scènes similar to those of actual paintings were produced for important foreign patrons. These include the Missal of 1483 for the Bishop of Dol (cat. 3) and the opulent Breviary for Matthias Corvinus, King of Hungary, both illuminated by Attavante, and the Didymus also for Corvinus (cat. 13), illuminated by Monte di Giovanni. Matthias Corvinus, an ardent humanist who was keen to build up a prestigious library of Italian manuscripts, commissioned a superb Bible from Gherardo and Monte in the same years.[42] Another Bible, with commentary by Nicholas of Lyra, was executed for the King of Portugal by Attavante (cat. 1). In the second half of the 15th century Florence clearly led the rest of Italy in the field of book production with such prestigious codices.

Meanwhile, the papal court had become the centre of production of manuscripts illuminated in the Classical style thanks to the great scribe Bartolomeo Sanvito. He was in Rome from *c*. 1465 onwards, when Paul II, the Venetian Pietro Barbo, was elected Pope, and joined the household of Cardinal Francesco Gonzaga there. For more than four decades, he indefatigably copied a vast number of manuscripts for Popes, Cardinals and others. The most important were illuminated by an artist who has sometimes been argued to be Sanvito himself. But since he did not illuminate the manuscripts he wrote from the beginning of his career, the artist has also been suggested to be Lauro Padovano, of whose work Sanvito owned examples. The artist in fact can now be identified as Gaspare da Padova (sometimes called Romano), documented as working on the Homer of Cardinal Francesco Gonzaga written by

19 Venice, Biblioteca Marciana, Ms. Cod. lat. IX. I. (3496), fol. 133 v. Eusebius, *Chronica*. The Infant Jesus

Sanvito (cat. 39). He is also documented in 1480–5 in connection with Cardinal Giovanni d'Aragona in Rome, for whom he also illuminated manuscripts (cat. 41). The style of this master combines typical Paduan Classicism with the brilliant colours and narrative typical of Franco dei Russi during his period in the Veneto, and especially in his 1471 Bible (cat. 82). Domizio Calderino's *Commentary* on Juvenal, executed for Giovanni de' Medici in 1474, is a particularly significant example of his work.[43] Naturally, contact with the Roman world and its ruins accentuated the erudite character of this illuminator's art, in which the monumental architectural frontispieces are lavishly embellished with Antique references, coins, arms and sculptures. In the open landscapes within his frontispieces the master represents events from the Greek and Roman world with a marked Classicism comparable only to that of Mantegna (cats 39, 75). The texts are mainly Classical authors such as Homer, Aristotle, Virgil, Suetonius and Eusebius (cats 38, 74). The same artist seems to have illuminated a beautiful Petrarch copied by Sanvito and subsequently completed by Monte and Gherardo in Florence.[44] The manuscripts of Sanvito's later years, executed upon his return to the Veneto at the end of the 1490s, are illuminated in a similar, but poorer manner, which suggests that he had, for some unknown reason, lost his great collaborator and was consequently employing a follower or else illuminating the manuscripts himself.

From the 1470s to the mid-1490s Ferdinand I of Aragon, King of Naples (*r.* 1458–1494), built an increasingly important library. The illuminator Joachinus de Gigantibus moved from Rome to Naples and decorated many manuscripts with his unmistakable style of *bianchi girari*. At the same time, many luxury manuscripts were commissioned in Florence, such as the Livys illuminated by Francesco Rosselli (cat. 48), Mariano del Buono (cat. 49) and Gherardo and Monte (cat. 76). Others were superbly executed in Rome, according to the Classical Venetian taste of Sanvito's circle, such as

21 Ferrara, Museo del Duomo, Antifonario II, fol. 4v. *Nativity*

the Josephus, the Valerius Maximus, and the Gregory the Great (cats 75, 41, 40). Another artist from the Veneto in addition to Gaspare da Padova also worked for the Aragonese court, the Master of the London Pliny, a follower of the Master of the Putti, who later updated his style after Girolamo da Cremona's period in the Veneto (cats 28, 46). Based on these foundations a Neapolitan court school arose which was somewhat eclectic and extremely decorative, exemplified above all by the artists Cola Rapicano, Cristoforo Maiorana and Matteo Felice (cats 9, 10, 12, 40–43, 55, 106).

Meanwhile in northern Italy and in Ferrara in particular, the death of Borso d'Este in 1471 and the rise to power of Duke Ercole I provoked an exodus of illuminators towards the Veneto, to neighbouring towns in Emilia and to Urbino. In Padua, an atelier of Paduan-Ferrarese illuminators illustrated a copy of the *Decretum Gratiani*, combining a Squarcionesque style with Ferrarese surrealism.[45] It was printed in Venice by Nicolaus Jenson in 1474 for the Ferrarese Abbot General of the Olivetans, Nicolò Roverella, who had close ties with Padua. The 1474 *Decretum Gratiani* is the first legal text printed in Venice, and was followed by a whole series of similar legal editions especially for use at the University of Padua. These editions were illustrated from the 1470s the 1490s in the 'Roverella' style by various illuminators, notably Antonio Maria da Villafora, a master from the countryside around Ferrara who had emigrated to Padua and who worked especially for the Bishop of Padua, Pietro Barozzi, and for local monasteries. Among his late works are the Epistolary and Evangeliary for Augustinian canons (cat. 7).

The most important illuminators from the Este court had moved elsewhere. Taddeo Crivelli and Martino da Modena, son of Giorgio d'Alemagna, illustrated the Graduals for San Petronio in Bologna, the former in 1476 and the latter in 1476–80.[46] In his initials Martino maintains his links with monumental painting, in particular with the Griffoni triptych executed for the same church in 1473 by Francesco Cossa and Ercole de' Roberti. His figures

20 London, Victoria and Albert Museum, 817–1894. Cutting. Signed by Girolamo da Cremona. Santa Giustina of Padua (?) disputing

acquire a greater freedom and dynamism at this point, anticipating the final phase of the North Italian Renaissance miniature. The next step is represented by the Choir Books of the Cathedral of Cesena, executed at the end of the 1480s, with their remarkably complex architectural frontispieces (cat. 125).

In 1478-80, Guglielmo Giraldi and collaborators illuminated a copy of Dante's *Divine Comedy* (cat. 58) in Urbino for Federigo da Montefeltro, in which the ample landscape settings of the episodes demonstrate their awareness of the Duke's Florentine Bible. Giraldi also illuminated pages in St. Paul's Epistles[47] (fig. 22) and in a Psalter.[48] . In these he seems to combine Ferrarese style with a statuesque grandeur derived from Piero della Francesca and Berruguete, then active in Urbino. A Gospels [49] should also be mentioned as well as some humanistic manuscripts[50] which constitute the Ferrarese section of Federigo's library. Other illuminators remained in Ferrara, including Jacopo Filippo Argenta, a follower of Tura and Giraldi, who executed the Choir Books of the Cathedral in the early 1480s with Martino da Modena and the Paduan Giovanni Vendramin (fig. 21).[51]

In the third quarter of the 15th century Venetian miniatures also became more varied and monumental. Once again, Giovanni Bellini seems to have been active as an illuminator, probably executing a portrait of the humanist Raffaele Zovenzoni in 1474.[52] Here Bellini combines Venetian style with an Antique taste typical of the Veneto and shows the influence of Antonello da Messina, who was in Venice that same year. Also in the same year Girolamo da Cremona arrived in Venice from Florence, obviously attracted by the abundance of work offered by the Venetian printers, who were producing legal and philosophical works to be illuminated for the best aristocratic families as well as for the printers' patrons. In a 1475 *De civitate Dei* (cat. 93), Girolamo demonstrates his 'precious style' as well his continued use of Ferrarese and Mantegnesque elements. He in turn was influenced by illuminations from incunabules from the Veneto, as in the two volume Plutarch printed in 1478 (cat. 94-5), where he embellished the Venetian-style architectural frontispieces with the richness of his 'precious style' and imaginative touches typical of the Ferrarese school, and also created a new type of jewelled faceted initial. In another copy of the same edition of Plutarch (cat. 92), the Master of the London Pliny, aligns himself with Girolamo in a pleasing, though simplified manner.

It is questionable whether it is not Girolamo himself, as I am inclined to believe, rather than the Master of the London Pliny, as has been proposed (cat. 28), who in his Venetian phase was able to steep himself in the work of Giovanni Bellini and of Antonello da Messina. In any case such a stylistic debt appears clear if one considers the magnificent copy of Clement V's *Constitutiones*,[53] printed in 1476, and the beautiful St Jerome *Letters* (cat. 28), in both of which the artist deploys space in the manner of Antonello's San Cassiano altarpiece, and also uses the perspectival views traditional in Venetian incunabula. The frame in the Jerome is decorated with cameos *all'antica*, perhaps copied from Florentine manuscripts, together with Venetian 'cut' crystals.

Certainly the Master of the London Pliny, in his 'Girolamo phase' executed illuminations for Neapolitan patrons, and possibly even transferred to Naples or Rome. It should be noted that the 1478 edition of Plutarch (cats 92, 94, 95) was dedicated to Ferdinand of Aragon. The manuscripts include a Quintilian of 1482[54] and an Ovid (cat. 46), and their style in turn influenced a splendid Horace and an unfinished Pliny by a Neapolitan artist, perhaps to be identified as Giovanni Todeschino (cats 45, 106), that combine the Classicism of the Veneto, the 'precious style' and the taste for landscapes and luminous interiors.

Girolamo and some Ferrarese illuminators of the 'Roverella' style also worked together on a superb series of legal and philosophical incunabules, illuminated between 1477 and 1483 for Peter Ugelheimer, an important patron of Venetian printers (cat. 96-101). The Venetian miniature acquired a strong scenic quality in these works, probably due to the Veneto-Ferrarese illuminators' acquaintance with Ercole de' Roberti's contemporary paintings, his San Lorenzo altarpiece, now lost, and the 1481 altarpiece of Santa Maria in Porto in Ravenna. The Paduan Benedetto Bordon, who signed two of the Ugelheimer incunabules (cat. 97), shows a close relationship to the 'Roverella' style, albeit painting in a harsher manner. Girolamo da Cremona's late masterpiece is the 1483 Aristotle for Peter Ugelheimer (cat. 101).

In the 1480s Venice was also home to an illuminator whose style anticipated that of the Brescian illuminator Giovan Pietro Birago, as evidenced in his signed Milanese works of the 1490s. We can justifiably conclude that this artist was none other than Birago himself, who had already worked on the series of Choir Books in Brescia, and who was influenced by Girolamo da Cremona, Liberale, and above all Mantegna, with whom he was probably involved in the production of prints. In fact a group of prints exists in which one may recognise the same hand. Birago's main Venetian works were a Breviary printed by Jenson in 1481, with the Venetian Barozzi crest, and a *Legenda aurea*[55] executed for the Venetian nobleman Francesco Vendramin.

22 Vatican, Biblioteca Apostolica Vaticana, Urb. Lat. 18, fol. 1v. St Paul

As far as Verona is concerned, it is intriguing that there are no marked traces of Liberale after his return to his birthplace, but his style certainly influenced the illuminators working for the town's wealthy monasteries, notably the dai Libri masters, who alternated between illumination and painting. Francesco dai Libri was probably responsible for a Psalter, as well as some detached miniatures, an *Adoration of the Magi* and two splendid pages of the *Pietà* (cat. 114).[56] In these and other fragments of Choir Books for the Olivetans of Santa Maria in Organo, he shows the influence of Mantegna's Mantuan Uffizi triptych, and of his *Deposition* engraving. His son Girolamo uses a more modern style, close to that of the Veronese painter Domenico Morone, as seen in one of his signed initials (cat. 115).

In Lombardy the most important work in the early 1470s consisted of the Choir Books realised by Giovan Pietro Birago for the Cathedral at Brescia, showing a strong style already influenced by Foppa. In Milan, the miniaturist Cristoforo da Predi, known as il Muto, combined the refined traditions of the Milanese court, the taste for portraiture, and the use of Filarete-style architecture with Ferrarese influences and Birago's robust style, which he softened by a gentler sense of narrative. A signed illumination, from the early 1470s, is particularly worthy of mention, as are a New Testament, a 1476 *Life of Joachim and Anna* and a Choir Book for the Sacro Monte in Varese.[57]

The great flowering of Renaissance miniature painting in Lombardy really began in the last twenty years of the 15th century, when Lodovico il Moro gave a new cultural and political impetus to the Dukedom. Bramante and Leonardo arrived in Milan at that time, and the arts acquired a new vitality. An *Epithalanium*[58] by Marliani for the brief betrothal (1487-90) between Bianca Maria Sforza and Giovanni, son of Matthias Corvinus, King of Hungary, has a portrait already showing the influence of Leonardo, which can be attributed to Ambrogio da Predi, Leonardo's first collaborator. A whole workshop of Milanese miniaturists apparently went to Buda for the occasion. One of them signed his name '*Francesco da Castello Italico*' in the Breviary of the Hungarian Domenico Kalmanecsehi.[59] The most important manuscripts executed for Matthias Corvinus' library contain elements of the Lombard and Ferrarese traditions combined with a formalism, a complex mise-en-scène and a decorative richness probably derived from the King's Florentine manuscripts. Examples are a beautiful copy of Filarete's *De architectura* (fig. 8) and a Cassian.[60]

After the marriage in 1491 of Lodovico il Moro to Beatrice d'Este, and Lodovico's succession to the Dukedom in 1494, the couple's strong impulse towards self-glorification and their desire for a life of pomp and high culture gave impetus to the production of panegyrics and sumptuous books of devotion illuminated by the best artists available. In line with Lombard tradition, the most common images are the ducal portraits, scenes of court and town life, coats of arms and crests. In terms of style, two often interconnecting tendencies are discernible. One of these is markedly Mantegnesque and classicising in the manner of Birago, active at the court after his highly innovative period probably spent in the Veneto. The other shows the naturalism of the Lombard tradition of Cristoforo da Predi and of painters like Zenale and Bergognone, who were working in the style of Foppa. At first the influence of Bramante and Leonardo is merely suggested, but it becomes more apparent at the end of the century. Birago seems to have started his Milanese career with the illustration of three copies, one of which is signed, of the Italian translation of the *Sforziada*, printed in Milan in 1490 (cat. 16).[61] The signed fragment showing Francesco Sforza with Classical warriors was probably part of a lost, perhaps manuscript copy.[62] Other important works include Bona Sforza's opulent Book of Hours,[63] Birago's masterpiece which he left unfinished in 1495 on the Duchess' departure for France, and a very small Book of Hours[64] executed for Charles VIII of France when he arrived in Milan in 1494. The 1491 marriage contract between Lodovico il Moro and Beatrice d'Este combines Biragesque ornamentation with echoes of Leonardo.[65] The *Romance of Paolo and Daria*[66] of 1493-4 and the copy of Lodovico's *Donations* (cat. 17) to the convent of Santa Maria delle Grazie exhibit a narrative fluency in the manner of Bergognone and an architectural illusionism derived from Bramante and Bramantino. In the Missal of Archbishop Arcimboldi,[67] many masters are at work, among them probably Matteo da Milano, who enjoyed great success later in Ferrara and Rome.

In 1496-7 Birago, in his mature phase, worked with another illuminator on two manuscripts which continue the Sforza tradition of commissioning educational works. The first is a grammar book (fig. 5) for Massimiliano, Lodovico's young son.[68] In the *Liber Jesus*, also executed for Massimiliano, the softness of the painting and the idealisation of the refined portraits are much closer to the style of Leonardo.[69] We can only speak of the emergence of a real Leonardesque style much later, in the first decades of the 16th century, with the Choir Books of the monastery of Villanova Sillaro, illuminated by a Master B. F., supposedly Francesco Binasco. Initials cut from these Choir Books are now scattered in many collections (cat. 116).[70]

In 1494, Charles VIII came to Italy for the first time with the French army, and in 1499 Louis XII invaded the Dukedom of Milan. In 1527 Rome was sacked by the mercenary soldiers of Emperor Charles V. This tormented period was the last Golden Age of the Italian Renaissance miniature. Humanistic culture was already on the wane, and the new interest in spiritual and religious matters was responsible for a revival of liturgical manuscripts and of books for private prayer. Books increasingly became precious objects, to be looked at with awe and admiration, and as the workshops of the manuscript book trade declined, the illuminators became painters of the exquisite on a miniature scale originally developed for the pages of books. The origins of the new North Italian style coincided with the *maniera moderna* imported by artists who increasingly travelled to papal Rome; the style was augmented by the presence of Pietro Perugino and of his work in Emilia from just before the middle of the 1490s. Perugino himself and the Bolognese painters Amico Aspertini and Lorenzo Costa worked together on the Ghislieri Book of Hours (cat. 117), executed in Bologna towards the end of the century. In these miniatures, the style becomes freer and softer, but the older Emilian expressionism is still strong. The illuminator Matteo da Milano, who fled from Milan probably after il Moro's fall in 1499, also worked on the Ghislieri Book of Hours, transforming his Milanese style into something more flexible and modern. Almost contemporary is the Book of Hours illuminated by Girolamo Pagliarolo for Giovanni II Bentivoglio (cat. 24). The idiosyncratic style of the Book of Hours illuminated probably in Ferrara towards the end of the century for Galeotto Pico della Mirandola (cat. 25) suggests that it was made by Francesco Maineri. Matteo da Milano is also documented at the court of Ferrara, where he executed a large Breviary commissioned by Ercole d'Este and finished for his brother Alfonso.[71] In this splendid manuscript he used Flemish-style decoration and an imaginative style close to that of Birago, yet interpreted in the *maniera moderna* (fig. 4). He also produced an extraordinary Book of Hours for Alfonso I,[72] and in collaboration with other illuminators executed a Missal for Cardinal Ippolito d'Este.[73]

One of his late works has recently been identified in a Missal for Cardinal Giulio de' Medici (cat. 128).

Towards the end of the 15th century Francesco Marmitta of Parma, one of the most brilliant Italian illuminators, worked in a way comparable, although more sophisticated and aristocratic, to that of Aspertini. His works include a Book of Hours, a copy of Petrarch's Triumphs and a Missal donated to Turin Cathedral by Cardinal Domenico della Rovere.[74] Francesco Bettini of Verona, who signed some illuminations in another volume of this Missal (cat. 6), was probably part of the same circle. His style echoes that of Liberale da Verona and Francesco dai Libri with links to that of Marmitta, but seems close to that of the Paris *Cassian* executed by the illuminators of Francesco da Castello's Lombard workshop. Some documents even seem to associate him with this group.

Fra Antonio da Monza, who worked in the Franciscan convent of Santa Maria in Aracoeli, Rome, signed a page with the *Pentecost*

(cat. 119), still very much in the vein of the Milanese followers of Leonardo, while his Antiphonary of the same convent shows a greater acceptance of the contemporary Roman style (cat. 126). In the Veneto the *maniera moderna* began to appear somewhat timidly in a Lucian printed in 1494 (cat. 104), illustrated in Venice by the Paduan miniaturist Benedetto Bordon. Subsequently Bordon shows a familiarity with 16th-century painting, as seen in the Evangeliary for Santa Giustina in Padua (cat. 118). But the true protagonist of the new developments was the Dalmatian Giulio Clovio. Working for Cardinals Grimani and Farnese, he went beyond the *maniera moderna* to reach new expressiveness in a style which is truly that of Mannerism (cats 132–5). It was his impassioned and dramatic style which anticipated the spiritual crisis that was to trouble Europe in the years to come, and which was destined to put an end to a period in the history of illumination which had begun in the serene climate of humanism.

1 Venice, Biblioteca Marciana, Lat. XII, 68 [=4519]. For Pesellino, see Florence 1990.
2 Florence, Biblioteca Riccardiana, 1129; Garzelli and de la Mare 1985, pp. 41-8.
3 Florence, Biblioteca Riccardiana, 492; Garzelli and de la Mare 1985, pp. 41-8.
4 Florence, Biblioteca di San Marco, esp. nos 515, 516, 521, 524; Florence, Biblioteca Medicea-Laurenziana, Edili 149, 150, 151; Garzelli and de la Mare 1985, pp. 11-24.
5 Florence, Archivio Capitolare di San Lorenzo, Corali 201 B, 202 C, 203 D, 205 F, 207 H, 208 I, 209 K; Garzelli and de la Mare 1985, pp. 11-24.
6 London, British Library, Yates Thompson MS 36; Pope-Hennessy 1993.
7 Siena, Biblioteca Comunale, MS G. I. 8; Vailati Schoenburg Waldenburg 1990, pp. 331-572. For Sienese illumination, see also New York 1988.
8 Cambridge, MA, Houghton Library, Harvard University, MS Typ 301; Milan 1991, no. 49.
9 Private collection; Milan 1991, no. 30 and pp. 129-40.
10 Milan, Biblioteca Ambrosiana, MS S.P. 10/28 (formerly Gallarati Scotti 1); Milan 1991, nos 9, 31, pp. 70-2, 141-6.
11 Cesena; for Cesena, Biblioteca Malatestiana, S. XV.1 and S. XV.2, see esp. Lollini, 'Le *Vitae* di Plutarco alla Malatestiana', in *Libraria Domini*; forthcoming; Milan 1991, pp. 121-9.
12 Paris, Bibliothèque de l'Arsenal, MS 630; Vatican, Biblioteca Apostolica Vaticana, Vat. lat. 6043.
13 Cesena, Biblioteca Malatestiana, D. XI.1; Milan 1991, no. 80.
14 Modena, Biblioteca Estense, MS Lat. 422, 423; Venturi 1937, 1961; Rosenberg 1981; Toniolo 1990-3; Mariani Canova in Milan 1991, pp. 87-117
15 Modena, Biblioteca Estense, MS Lat. 239; Milan 1991, no. 86.
16 Cesena, Biblioteca Malatestiana, Bessarione 4; New York, Metropolitan Museum of Art, 11.50.1-4. For the Choir Books, see Mariani Canova 1977; Cesena 1989, nos 2, 4, 6. For the dispersed initials, see Milan 1991, no. 82.
17 Oxford, Merton College, MS 315; London and New York 1992, no. 7.
18 Oxford, Bodleian Library, MS Canon. Misc. 378; Alexander 1976, pp. 11-19.
19 London, British Library, Harley MS 2683; Conti 1979, pp. 67-76.
20 Venice, Biblioteca Marciana, Lat. IX,1 [=2436]; see note 17 above.
21 Paris, Bibliothèque de l'Arsenal, MS 940; Meiss 1957; London and New York 1993, no. 10.
22 Paris, Bibliothèque nationale, latin 17542; Meiss 1957, pp. 57-9. For the *littera mantiniana*, see also Alexander 1988b.
23 Oxford, Bodleian Library, MS Canon. Class. Lat. 161; Pächt and Alexander 1970, no. 603. For the architectural frontispiece, see Corbett 1964.
24 London, Victoria and Albert Museum, 817-1894; Mariani Canova 1984 a.
25 Paris, Bibliothèque nationale, latin 8523; Paris 1984, no. 132.
26 Paris, Bibliothèque nationale, ital. 973; Paris 1984, no. 135.
27 Brescia, Biblioteca Queriniana, Lat.III.11; Wescher 1968; Mariani Canova 1985, pp. 171-92; Casato 1990-1.
28 Brescia, Pinacoteca Tosio Martinengo, Corali 20-35.
29 Mantua, Archivio Capitolare; Pastore and Manzoli 1991.
30 London, British Library, Harley MS 3567. Malibu, New York and London 1983-4, no. 11.
31 Turin, Biblioteca Nazionale, I-I, 22-23; Conti 1988-9, pp. 264-77.
32 Chiusi, Cathedral, Corali A, Q, Y; see the 'Codici Olivetani' in Florence 1982, pp. 253-536.
33 Siena, Cathedral, Libreria Piccolomini, esp. Corale 23.8.
34 Siena, Museo Aurelio Castelli, inv. 3. For Francesco di Giorgio, see Siena 1993.
35 Vienna, Österreichische Nationalbibliothek, Inc. 5.C.9; Mariani Canova 1969, no. 40, fig. 39; Armstrong 1981, no. 3, figs 3-5.
36 Milan, Biblioteca Trivulziana, Inc. Petr. 2; Mariani Canova 1969, no. 45, pl. 7, fig. 53; Armstrong 1981, no. 21, figs 54, 55.
37 Padua, Biblioteca del Seminario; Mariani Canova 1969, no. 42, pl. 6, figs 42-52; Armstrong 1981, no. 14, figs 23-7.
38 London, British Library, IC. 19662; Armstrong 1981, no. 36, figs 74-87.
39 Florence, Museo Nazionale del Bargello, MS 68; Garzelli and de la Mare 1985, pp. 203-4.
40 Florence, Museo Nazionale del Bargello, MS 67; Garzelli and de la Mare 1985, p. 285.
41 Vatican, Biblioteca Apostolica Vaticana, Urb. lat. 1-2; Garzelli 1977.
42 Florence, Biblioteca Medicea-Laurenziana, 15, 17; Garzelli and de la Mare 1985, pp. 303-4.
43 Florence, Biblioteca Medicea-Laurenziana, 53, 2; Bauer-Eberhardt 1989, no. 9, fig. 5.
44 Baltimore, Walters Art Gallery, MS 755; Bauer-Eberhardt 1989, no. 24.
45 Ferrara, Museo Civico d'Arte Antica di Palazzo Schifanoia; Mariani Canova 1988 b, pp. 14-69.
46 Bologna, Museo di San Petronio, Corali I-X; Mariani Canova 1984 c, pp. 249-68.
47 Vatican, Biblioteca Apostolica Vaticana, Urb. lat. 18; Hermanin 1900, pp. 342, 356, 372, fig. 13; Bonicatti 1957, pp. 21-3, 174-5, fig. 35.
48 Vatican, Biblioteca Apostolica Vaticana, Urb. lat. 19.
49 Vatican, Biblioteca Apostolica Vaticana, Urb. lat. 10; Cologne 1992, no. 70.
50 For example Vatican, Biblioteca Apostolica Vaticana, Urb. lat. 308, 337, 411.
51 Ferrara, Museo del Duomo; Giovannucci Vigi 1989.
52 Milan, Biblioteca Trivulziana, no shelf mark; Fletcher 1991.

53 Paris, Bibliothèque nationale, Vélins 390; Mariani Canova 1969, no. 75, fig. 69; Armstrong 1981, no. 42, fig. 116.

54 Valencia, Biblioteca Universitaria, MS 292 (G. 1903); Armstrong 1981, no. 50, figs 102, 119.

55 Vienna, Österreichische Nationalbibliothek, Inc. 4. H. 63; Warsaw, Biblioteka Narodowa, MS B.O.Z. 11; Mariani Canova 1969, pp. 136-40; Alexander 1969a, pp. 13-16.

56 Milan, Biblioteca Trivulziana, MS 2161; Paris, Musée Marmottan, Wildenstein Collection; London, Courtauld Institute Galleries, Princes Gate Collection 346. For Francesco dai Libri, see Verona 1986, pp. 32-34.

57 London, Wallace Collection, M. 342; Alexander 1980, no. 21, pl. II. Turin, Biblioteca Reale, MS Varia 124; Rome 1953, no. 649. Varese, Sacro Monte.

58 Volterra, Biblioteca Guarnacci, MS 49.3.7; Suida 1959, pp. 67-73; Cogliati Arano 1979, pp. 53-62.

59 Budapest, Országos Széchényi Könyvtár, Clmae 446; Daneu Lattanzi 1972; Csapodi-Gárdonyi 1978.

60 Venice, Biblioteca Marciana, Lat. VIII.2 [=2796]; Paris, Bibliothèque nationale, latin 2129. See also notes 58-9, above.

61 Paris, Bibliothèque nationale, Vélins 724, for Galeazzo Maria Sforza; Warsaw, Biblioteka Narodowa, Inc. F. 1347, signed, for the Sanseverino.

62 Florence, Galleria degli Uffizi, Gabinetto di Disegni e Stampe, 4423-4430, 843; Milan 1958, no. 453.

63 London, British Library, Additional MS 34294; Evans 1992.

64 Venice, Fondazione Cini, 2502; Mariani Canova 1978a, pp. 70-72.

65 London, British Library, Additional MS 21413; Malibu, New York and London 1984, no. 14.

66 Berlin, Staatliche Museen, Kupferstichkabinett, MS 78 C27; Mulas 1991, pp. 133-212.

67 Milan, Biblioteca Capitolare, MS II.D.1.13; Lodigiani 1991.

68 Milan, Biblioteca Trivulziana, MS 2167; G. Bologna 1980.

69 Milan, Biblioteca Trivulziana, MS 2163; G. Bologna 1980.

70 For example Lodi, Museo Diocesano d'Arte Sacra; Berlin, Staatliche Museen, Kupferstichkabinett: 626, 1246, 4213-4, 14610. Alexander 1991b.

71 Modena, Biblioteca Estense, MS Lat. 424, and Zagreb, Strossmayerova Galerija; Alexander 1992, pp. 32-4; Toniolo 1993; Bauer-Eberhardt 1993.

72 Lisbon, Museu Calouste Gulbenkian, LA 149. Zagreb, Strossmayerova Galerija; Toniolo 1989.

73 Innsbruck, Universitätsbibliothek, Cod. 43; see note 71.

74 Genoa, Biblioteca Berio, MS s.s.; Kassel, Landesbibliothek, Cod. poet. 4.6; Turin, Museo Civico, no shelf mark (Messale del Duomo); Quazza 1990.

The Hand-Illumination of Printed Books in Italy 1465–1515

By Lilian Armstrong

'Pell'arte mia non si fa più niente . . .
Pell'arte mia è finita per l'amore de' libri,
che si fanno in forma che non si miniano più'
Bernardino di Michele Cignoni,
Siena, 1491[1]

One of the least well-known artistic phenomena of the Italian Renaissance is the hand-illuminated printed book. The splendid examples in the present exhibition rival the most spectacular illuminated manuscripts of the same period, and indeed show some formal innovations that appear only later in the monumental arts. Understanding the hand-illuminated printed book requires knowledge of the history of printing; of the miniaturists who decorated incunables (that is, all books printed before the end of 1500); and of the patrons who acquired these beautiful books.

Printing in Italy, especially in Venice

In 1465 the German invention of printing with movable types was brought to the Benedictine monastery at Subiaco, outside of Rome.[2] Conradus Sweynheym and Arnoldus Pannartz printed four editions there before moving to Rome, where they were active until 1473. Another German, Johannes de Spira, obtained a privilege in 1469 to be the sole person permitted to print in Venice, and brought out his first book there in that year.[3] The privilege expired with Johannes' death in 1470, but his brother Vindelinus continued the printing business. Almost immediately other printers established themselves in Venice, the most successful of whom was a Frenchman named Nicolaus Jenson (*c.* 1435–1480), who printed from 1470 to 1480.[4] Printing presses soon began operating elsewhere; Milan, Florence, Naples and Bologna all record a book printed in 1471, and other cities down the length of the peninsula followed.[5] The industry grew with amazing rapidity, especially in Venice. Between 1469 and 1474 some 15 firms had printed over 130 editions in Venice; by 1480 about 50 printers are recorded; by 1500 about 3,500 editions had appeared there, making Venice the most important center for printing in all of Europe.[6]

Initially the printers in Rome and Venice specialised in editions of Classical and Patristic texts. Multiple editions of the works of Cicero (cat. 79; figs 23, 24a), Livy (cats 80, 83; fig. 25), Pliny the Elder (cat. 78; fig. 24b), Quintilian, Caesar, Suetonius, Virgil (cat. 90), Martial, Juvenal, Macrobius, Augustine (cat. 93), Eusebius, Lactantius, and others poured onto a market formerly accustomed to far fewer copies of such works.

After the mid-1470s the situation changed substantially in Venice. Successful printers such as Nicolaus Jenson had realised the limitations of printing the classics, and had shifted to editions of law and theology for which the universities provided a ready market.[7] Bibles, liturgical books, and books in Italian emerged as popular items (cats 84–7, 89, 103; fig. 30). Though never absent from the offerings of the Italian presses, editions of Classical writers, such as Jenson's impressive 1478 edition of Plutarch's *Parallel Lives* (cats 92, 94, 95, 102; figs 24c, 24d), were overshadowed by books for which there was greater demand. In the 1480s and 1490s many printers specialised in particular genres of text, often reprinting editions previously printed by themselves or others.

Nicolaus Jenson was not only the most successful printer in Venice in the 1470s, but his books set a very high standard for typographic design. Although Sweynheym and Pannartz in Rome and the de Spira brothers in Venice used Roman type, Jenson's Roman fonts were of unequalled beauty both for the lower case and capitals letters (cats 84–6, 92–5, 102; fig. 23). Classical texts printed in the handsome Roman fonts were laid out in single blocks of text on folios with wide margins. After Jenson's death in 1480 few printers could match the beauty of his editions, and some who tried used

23 The Hague, Rijksmuseum Meermanno-Westreenianum, 2 D 42, fol. 1. Cicero, *Epistolae ad Brutum* (Venice, Nicolaus Jenson, 1470). Frontispiece with Priuli arms, attributed to the Putti Master

24a Trento, Biblioteca Comunale, Inc. 408, fol. 99. Cicero, *Orationes* (Venice, Cristoforo Valdarfer, 1471). Putto and a dog, attributed to the Putti Master

24b London, British Library, IC 19662, Book XXXV. Pliny, *Historia naturalis* (Venice, Nicolaus Jenson, 1472). Sculptor, attributed to the Master of the London Pliny

Jenson's own fonts. Johannes Herbort and Andrea Torresanus de Asula in Venice emulated Jenson's type and lay-out, as did Antonio Zarotto in Milan (cats 16, 99–101).

In the 1490s, printing innovations lay with the design of woodcuts for book illustration, which had been resisted earlier by Venetian printers (see pp. 45–6). Towards the end of the decade, Aldus Manutius (*c.* 1450–1515) revived many aspects of fine printing, and his fame to this day rests not only on his editions in Greek, but also on his refined italic fonts and on the small 'pocket-book' format for Classical texts (fig. 32).[8]

Hand-Work in Italian Incunables

The layout of early printed books imitated that of manuscripts: margins were wide and blank spaces were reserved for capital letters by indenting lines of text at the beginnings of books and chap-

ters (cats 78–80; figs 23, 25). Initially not even the book and chapter headings were printed, but were meant to be added by a professional rubricator (cats 81, 83; fig. 23). Printers assumed that rubrication and decoration would be executed by hand after the pages had emerged from the press.[9] The magnitude of this assumption is staggering since even the earliest printed editions ran from 100 to 300 or 400 copies, and by 1476 there were editions of over 1,000 copies. In the first decades of printing in Italy, thousands and thousands of books had red and blue capital letters added by hand throughout the text. Sometimes these initials were flourished in coloured inks of contrasting colours (cats 89, 96), while others were painted in colours on rectangles of gold, or in gold on coloured grounds (cats 87, 99).

Beyond having their books 'finished' with the appropriate initials added by hand, many buyers wanted decoration on the first page of text, that is a frontispiece. Painted borders were the most common enhancement, plus the coat of arms of the owner usually painted in the lower margin. Two patterns of borders prevailed, both adapted from contemporary manuscript illumination. The so-called 'white vine-stem' or *bianchi girari* was most common in the early 1470s, both for Venetian and for Roman incunables.[10] Second in popularity were borders consisting of red and blue flowers, gold dots, and scrolling penwork, sometimes contained by rectangular frames of gold (cat. 89). The former owed its origins to Florentine manuscript illumination (cat. 34) and the latter to Ferrarese (figs 3, 14–17).

Throughout the 1470s and 1480s it was common practise to print up to twenty copies of a given edition on parchment, further emphasising the parallel to manuscripts. As the manuscript tradition had amply demonstrated, the application of gold leaf and tempera paint (or glair) was technically well suited to parchment,[11] although tempera and gold were also used for books printed on paper, by far the most common support for incunables (cat. 86). A second medium, which was technically more appropriate for paper, was sepia ink applied with a quill pen or a fine brush. For books printed both on paper and on parchment, drawings in pen and ink were combined with areas of water-colour wash, and with touches of gold or silver, the latter often now blackened by oxidation (cats 80, 102; figs 23, 24a, 24b, 24d). The monochromatic effect of ink drawings was appreciated for its harmony with the black and white block of the printed text. Additionally, the miniaturists were faced with decorating many more books than before. The pen and ink technique was thus advantageous since it is somewhat less time consuming than painting in tempera and applying gold leaf.[12]

The addition of painted or drawn frontispieces and historiated initials to printed books naturally required planning by the artist, even if the spaces into which his work must fit were strictly predetermined. Preliminary designs were sketched into the reserved spaces and margins with metalpoint. Such metalpoint sketches are sometimes visible under the penstrokes of finished sepia compositions (fig. 24d). Changes in the decorative programme can be detected by observing the metalpoint underdrawings. For example, the copy of Plutarch's *Parallel Lives* printed on parchment by Nicolaus Jenson in 1478 and decorated for Giovanni Pico della Mirandola was probably meant to have been painted with tempera and gold (cat. 102). The miniaturist, named the Pico Master,[13] sketched the frontispiece and historiated initials, anticipating that they would subsequently be painted in gold and colours. His metalpoint underdrawings are visible throughout the volume (fig. 24d). The edges of the compositions were neatly ruled, the figures positioned, the flower patterns indicated in the margins.

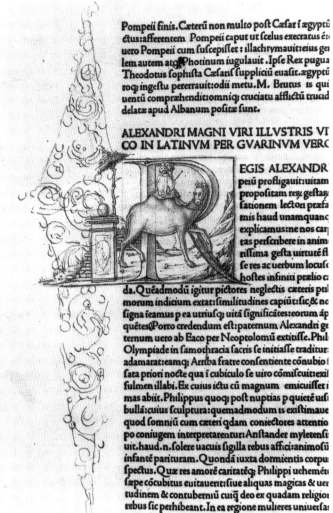

24c, 24d Berlin, Staatliche Museen, Kupferstichkabinett, 78 D 16, fol. PP2v and G6v Plutarch, *Vitae virorum illustrium* (Venice, Nicolaus Jenson, 1478). Demosthenes; Turbaned man on a camel, attributed to the Pico Master (cat. 102)

Next the Pico Master painted one initial and partial border in full colours, perhaps to show the patron what the finished effect would be (fig. 24 c). Demosthenes is depicted at the beginning of Plutarch's Life of the philosopher; he holds a high 'Greek' hat and stands on a podium addressing other scholars. No other historiated initial in the book was painted in tempera. Instead, the scenes were completed by reinforcing the metalpoint drawings with pen and ink; the floral borders were never completed. The present decoration thus reveals the ghosts of the original intent.

As printers and booksellers groped for ways to 'finish' the thousands of books which were emerging from the Venetian printing presses, a number of artistic experiments were attempted to speed the process of decoration.[14] Miniaturists traced figurative motifs, and they standardised white vine-stem and floral borders for more efficient execution. They may also have copied motifs by the process known as 'pouncing'. Tiny holes were pricked along the outlines of a drawing, and then a fine dark dust was applied which would transfer the image to the underlying page. A Venetian incunable of 1471 with historiated initials drawn by the Master of the Putti clearly shows such pricking marks (fig. 24 a), but the questions remain as to when they were made and whether they were actually used for transfer.[15]

An experiment more intrinsic to printing, however, was the design of woodcut border motifs which could be stamped onto frontispieces and used as a guide for miniaturists.[16] This technique should not be confused with woodcuts which were printed simultaneously with the text and thus appeared in every copy of a given edition (see pp. 45-6). The individually stamped woodcut borders consisted of units of varying widths suitable for upper, lower, or side margins. The decorative patterns – a sequence of lozenges or vine motifs – could be repeated one or more times depending on the length of the margin, and then painted over by the miniaturist.

If the frontispiece of the Livy printed in 1470 by Vindelinus de Spira and now in the Morgan Library (cat. 83) is compared with a second copy of the same edition (fig. 25), it is immediately apparent that the same decorative woodcut units have been employed. A roughly square unit of symmetrically arranged vines is repeated three times in both lower borders. However, in the British Library copy, the space at the left is filled by an additional narrow unit of lozenges extending down from the side margin. The narrow unit is necessary because the empty circular wreath occupies less space than the coat of arms, two putti and dolphins in the Morgan copy. The splendid Morgan copy demonstrates that well-known

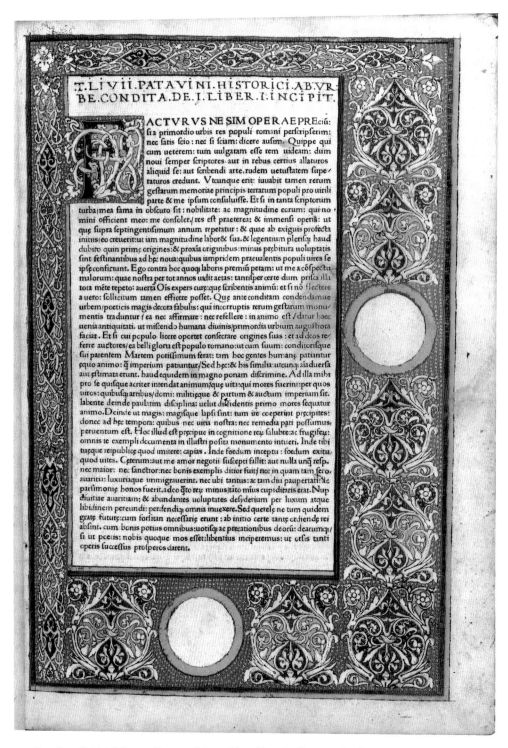

25 London, British Library, G. 9029, fol. 25. Livy, *Historiae Romanae decades*
(Venice, Vindelinus de Spira, 1470). Frontispiece with painted woodcut borders

miniaturists did not disdain to use this technique, since the putti can be attributed to Franco dei Russi (see cats 26, 82, 113).

The individually stamped woodcut borders were used in a large number of books printed by Vindelinus de Spira, and a special campaign may have been mounted for the 1470 Livy, since eight copies exist with woodcut borders similar to the Morgan and British Library copies.[17] Despite the fact that this technique was probably intended to be labour-saving, it was rarely used after 1474. Ultimately, a well-trained miniaturist could execute a standard white vine-stem border almost as fast without the extra woodcut process as a guide.

The Miniaturists

The examples of hand-illuminated printed books in this exhibition are at the top of a continuum extending from the thousands of books 'finished' with simple rubrication, through hundreds with standardised painted borders, to the fewer examples with individually commissioned decoration. Many more illuminated examples appear in Venetian imprints than in books printed elsewhere in Italy. In fact it is likely that miniaturists were drawn to Venice precisely because it had become a great center for printing. Miniaturists who illuminated these spectacular books have been

gradually identified over the past two decades, either by actual name or by groups of works.[18] Since incunables are usually dated and illumination would normally have been done soon after printing, the chronology of miniaturists' careers is often clearer than when considering undated manuscripts.[19]

The patterns of these careers vary considerably with regard to the phenomenon of printing. Some artists who were established illuminators of manuscripts accepted occasional commissions to decorate the new kind of book, the printed book, simply as if it were another manuscript. Such a characterization would fit Franco dei Russi, who worked in Ferrara and Padua in the 1450s and 1460s, then illuminated a few printed books in Venice in the early 1470s before returning to manuscript illumination under the patronage of Federigo da Montefeltro, Duke of Urbino (cats 26, 58, 71, 82, 83, 113).[20] Leonardo Bellini (*fl.* 1443–*c.* 1485), cousin of the well-known painters Giovanni (*fl. c.* 1460–*d.* 1516) and Gentile Bellini (*fl. c.* 1460–*d.*1507), was the dominant miniaturist in Venice throughout the 1460s, and his successful career continued into the 1480s (cat. 27).[21] His illumination of the important Hebrew manuscript known as the Rothschild Miscellany (Jerusalem, Israel Museum, MS 180/51) has been disputed, but is supported by comparison to a frontispiece he painted in an incunable of 1478.[22] After decades of work exclusively in manuscripts, Leonardo illuminated two copies of the Breviary printed by Nicolaus Jenson in 1478 (cat. 89).[23] The motif of an eagle and a dead stag in the Edinburgh frontispiece exactly matches an image in the Rothschild Miscellany, as if they had been traced from the same model (fig. 26). Overall, however, Leonardo Bellini represents a category of miniaturists little affected by the coming of printing.

In Florence, where the strong traditions of manuscript illumination inhibited the production of luxury hand-illuminated printed books, exceptional dedicatory copies were decorated by miniaturists who otherwise also continued careers only as manuscript illuminators. In 1481 Niccolò di Lorenzo printed a famous edition of Dante's *Divine Comedy* in Florence with a new commentary by Cristoforo Landino and with spaces reserved for engravings by Baccio Bandini after designs by Botticelli. A copy on paper in the Houghton Library, Harvard not only received an engraving

26 Jerusalem, The Israel Museum, MS 180/51, fol. 164. Rothschild Miscellany.
The Battle of Sihon and Og, Jacob and the Angel, attributed to Leonardo Bellini

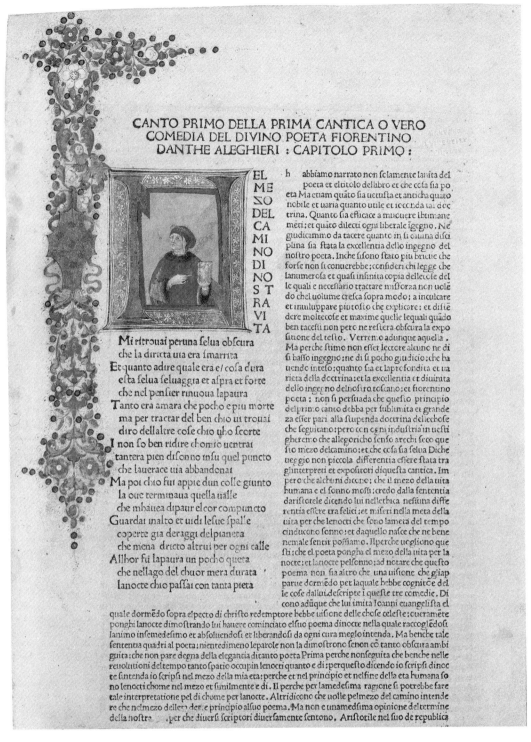

27 Cambridge, Mass. Houghton Library, Harvard University, Inc. 6120A, fol. a1 (Detail).
Dante, *La Commedia* (Florence, Niccolò di Lorenzo, 1481). Portrait of Dante and Medici arms

on the folio opening the *Inferno*, but also an author portrait and floral border with the Medici arms painted by a miniaturist in the circle of Francesco d'Antonio del Chierico (fig. 27).[24] Only two copies on parchment are known, one undecorated and the other illuminated by Attavante degli Attavanti (1452–*c.* 1517) for presentation to the Signoria.[25] Otherwise Attavante and Francesco d'Antonio continued to illuminate primarily manuscripts.[26] The Florentine banking firm of Filippo Strozzi (1428–1491) financed an edition of the *Natural History* of Pliny the Elder, translated into Italian by Cristoforo Landino and printed in Venice by Nicolaus Jenson in 1476.[27] Strozzi paid the Florentine miniaturist Monte di

Giovanni di Miniato to illuminate his copy (cat. 85).[28] Monte and his brother Gherardo, however, remained far better known for the manuscripts they illuminated than for any other printed books.[29] Similarly in Milan, Giovan Pietro Birago illuminated several ducal copies of the *Life of Francesco Sforza* printed by Antonio Zarotto in 1490 (cat. 16), but his career too is predominantly devoted to manuscript illumination.[30]

The case of Girolamo da Cremona contrasts to that of the miniaturists who only illuminated two or three printed books. Girolamo had a distinguished career as an illuminator of manuscripts in the 1460s and early 1470s, but after coming to Venice

in the mid-1470s, he almost exclusively illuminated printed books.[31] Girolamo worked primarily for patrons connected to the new industry, particularly for members of the Agostini family and for Peter Ugelheimer of Frankfurt (see pp. 43–4, below), and the commissions he fulfilled are exceptionally magnificent (cats 93–6, 99, 101).

Yet other miniaturists belonged to a generation that came to maturity just as printing was introduced, and their careers are inextricably tied to the industry of printing. Giovanni Vendramin, the Master of the Putti, the Master of the London Pliny, and especially the Pico Master thrived in the 1470s by executing painted and drawn frontispieces for printed books (cats 78–81, 90, 92, 102; fig. 23). The precise business arrangements linking miniaturists to

printers are not clear, but they doubtless differed considerably from the contracts between single patrons and miniaturists which must have pertained in the cases cited above. The printers Nicolaus Jenson and Vindelinus de Spira funnelled dozens of books to a few miniaturists who could be counted upon for attractive decoration speedily provided. The Pico Master illuminated nine copies of Jenson's 1472 Pliny, some for known patrons and others apparently executed on speculation, since the spaces for coats of arms remain empty.[32] Similarly, the Master of the Putti and the Master of the London Pliny, who collaborated in the early 1470s, decorated five copies of the same Pliny edition, one in tempera and gold, and the others with pen and ink frontispieces (fig. 24 b).[33]

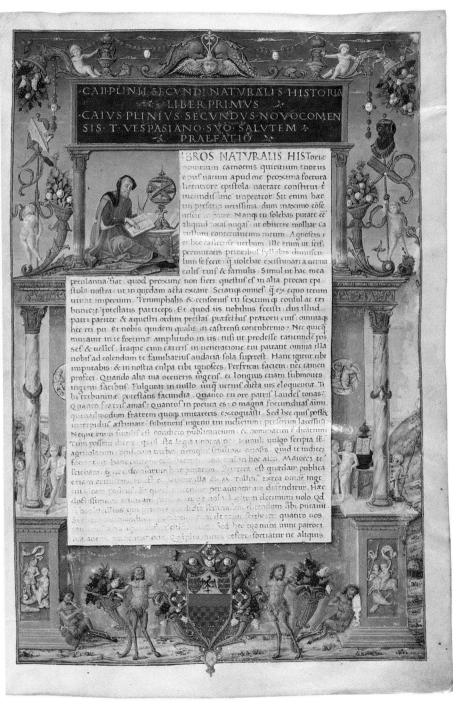

28 Venice, Biblioteca Marciana, MS Lat. VI, 245 (= 2976), fol. 3. Pliny, *Historia naturalis*.
Frontispiece with Pico della Mirandola arms, attributed to the Pico Master

29
Rome, Museo Capitolino.
Pan, Roman,
2nd Century AD

Frontispieces

In addition to decorative painted borders, the Veneto-Paduan miniaturists developed distinctive frontispiece compositions that exploited the new Renaissance fascination with Classical Antiquity. One may be called the 'historiated-initial-and-coat-of-arms' formula. A pen and ink drawing or painted composition with an *all'antica* subject was supplied for the first initial, and the owner's coat of arms in the lower margin was suitably supported by mythical creatures of Antiquity – putti, satyrs, or sea creatures – usually adapted from Roman sarcophagi (fig. 23). Particularly appropriate for the newly edited Classical texts, these handsome but modest opening folios acknowledged the owner's noble status and subtly flattered his knowledge of the Antique revival.

The most important composition developed to decorate the opening of Venetian incunables was the so-called 'architectural frontispiece'.[34] The illusionistic devices and classicising components of this composition were present in North Italian manuscript illumination of the 1460s, but the compositional type was popularised by the Veneto-Paduan illuminators in the early years of printing. Two slightly different versions of the composition both appear in books printed in 1469, one painted in tempera by Giovanni Vendramin of Padua (cat. 78), the other drawn in pen and ink by the Master of the Putti (cat. 80). In the latter, the composition surrounding the printed text imitates a Roman triumphal arch, painted to look as if it existed in a space behind the page. The space at the base of the edifice is open and filled with struggling putti. Heightening the illusion is the treatment of the area just beside the text; it resembles the ragged edge of a piece of parchment suspended in front of the triumphal arch.

Giovanni Vendramin's frontispiece presents a giant commemorative monument, a stele. Columns supporting a cornice with a curved pediment occupy the side and upper margins, and the lower margin is filled with a high base on which the monument appears to rest. The base in turn is decorated with monochromatic reliefs. Variations of these two compositions are repeated in numerous North Italian frontispieces of the 1470s and 1480s, including a 'two storey' version developed by the Pico Master and seen in his eponymous manuscript, the Pliny written and decorated for Giovanni Pico della Mirandola in 1481 (fig. 28). These compositions also became popular with miniaturists working in Rome and Naples (cats 37, 39, 40, 73, 75, 106).

The Veneto-Paduan architectural frontispiece revels in the Albertian illusion of three-dimensional space, so prized by Renaissance artists, while at the same time acknowledging the inherent flatness of the printed page. The imagery invokes the world of Classical Antiquity, and suggests the 'triumph' of the written word – archways through which one enters the glorious history of Rome, or memorials raised to the learning of the past.

The figures and objects that cluster around the architectural structures show the miniaturists' virtuoso adaptations of Classical themes and contemporary motifs, sometimes anticipating developments in the monumental arts. The putti fighting below the triumphal arch in the Albertina Livy show that the Master of the Putti had studied the *Hercules and the Twelve Giants*, an engraving from the circle of Antonio Pollaiuolo (*fl.* 1457–*d.* 1489) which circulated in North Italy by the end of the 1460s.[35] On a Suetonius frontispiece of 1471, Giovanni Vendramin painted niches holding warriors in Roman armour, an arrangement of architecture and figures which startlingly prefigures Pietro Lombardo's *Tomb of Pietro Mocenigo* in SS Giovanni e Paolo in Venice of the later 1470s.[36]

Other groups depend upon Roman sarcophagi, such as the repeated allusion to the *Tormenting of Pan* by the Master of the London Pliny (cats 90, 91).[37] Particular Classical statues were also admired by individual artists; for example Girolamo da Cremona several times incorporated vivid adaptations of the over life-sized Roman statues of Pan carrying a basket on his head, now in the Capitoline Museum (cats 94, 101; fig. 29).[38] Both in incunables and in contemporary manuscripts, the architectural structures became a framework on which to display a whole panoply of Classical objects.[39] Trophies, vases, bucrania, and particularly medallion portraits based on Roman coins appear applied to the surfaces or hanging from cords draped over the cornices (cats 74, 80, 81; fig. 28). Finally, fictive cameos imitating those so avidly collected by Renaissance patrons became a vehicle for elaborating the symbolic content of the frontispieces (cats 28, 92, 94).[40]

Ownership of Hand-Illuminated Printed Books

In books printed all over Italy, the most common decorative additions to the printed page, aside from an illuminated first initial, are coats of arms and insignia of the owners. These provide a huge body of information about ownership of early printed books which is only beginning to be investigated. Despite the impossibility of conclusive statements about ownership of hand-illuminated incunables, some inferences based on present observations of Venetian books may be summarised.

The list of families whose coats of arms appear on handsomely decorated incunables reads like the roll-call of the Venetian Golden Book: Barbarigo, Barbaro, Barozzi, Basadona, Bembo, Boldù, Bollani, Bragadin, Canale, Cappello, Contarini, Conti, Cornaro, Dolfin, Donà, Erizzo, Foscarini, Foscolo, Gabrieli, Garzoni, Gius-

tiniani, Gritti, Guidotti, Lorodano, Marin, Mocenigo, Moro, Morosini, Muazzo, Pasqualigo, Pisani di Santa Marina, Priuli, Querini, de Soverin, Surian, Torriani, Trevisan, Zeno.[41] To these may be added a few non-noble *cittadini*, important families with 'citizen' status in Venice, who also were entitled to have coats of arms – Agostini, Frizier, Macigni. A sprinkling of noble families in the Veneto, Lombardy, and Emilia are also identifiable: Granfioni and Buzzacarini of Padua, Tirelto of Treviso, di Thiene of Vicenza; Botta, Lampagnani, and Trivulzio of Milan; Giovanni Pico della Mirandola. What these names make clear is that ownership of decorated Venetian incunables was widespread among the aristocracy of Venice and not concentrated in the hands of a few collectors. A large proportion of the books were in Latin, and thus they imply the ability of this class to read Latin. Many Venetian patricians were involved in mercantile activities, and ownership of incunables probably also indicates their investment in the new industry.

In some cases there are more than two or three books extant with the same coat of arms, enough to talk about the 'library' of the owner. Since the heraldic blazoning rarely verifies the specific member of a family, additional evidence is needed to confirm the owner. For example, twenty incunables printed either by Nicolaus Jenson or Vindelinus de Spira between 1469 and 1472 bear the coat of arms of the Priuli family. Almost all of these are decorated with *all'antica* drawings in pen and ink by the Master of the Putti (fig. 23), the Pico Master, or by a miniaturist working in the style of Girolamo da Cremona, probably indicating the particular taste of a single owner. It has been pointed out that the dedication by Giorgio Merula in Nicolaus Jenson's edition of the *Scriptores rei rusticae* is to Piero di Marco di Priuli; Piero di Marco thus becomes the likely candidate as the owner of these illuminated incunables.[42]

A few detailed studies of similar collections have appeared, principally on books owned by ecclesiastics. Jacopo Zeno, Bishop of Padua (r. 1460-1481), first collected manuscripts in Rome, decorated with the white vine-stem or floral borders typical of Roman illumination of the 1460s. He then turned to Venetian printed books more ambitiously decorated with architectural frontispieces by the Paduan miniaturist Giovanni Vendramin.[43] A later Bishop of Padua, Pietro Barozzi (1441-1507), also came from a patrician Venetian family, and acquired a large collection of illuminated Venetian incunables. His volumes of canon law and theology were decorated with monochromatic ink and wash drawings by a distinguished Paduan minaturist, Antonio Maria da Villafora.[44] Another ecclesiastic whose collection has been documented is Gioachino Torriano (c. 1416-1500), a humanistically trained Dominican theologian who was Vicar General of the Order from 1487 to 1500. His modestly decorated incunables were bequeathed to SS Giovanni e Paolo in Venice, and then passed to the Biblioteca di San Marco.[45] Yet another striking collection of hand-illuminated printed books is that of Girolamo Rossi (c. 1445-1517), from a noble family of Pistoia. Girolamo was a friend of the humanist Marsilio Ficino (1433-1499), and apparently functioned as an agent for various Florentines during a prolonged residence in Venice from 1480 to 1497. In 1504 he entered the Dominican Order and was eventually elected prior of San Marco in Florence and then Vicar General of the Order. Rossi's arms appear on books printed in various cities in the late 1470s and 1480s – Milan, Parma, Reggio Emilia, and Venice – but they were all decorated with ink and wash frontispieces and historiated initials by miniaturists working in Venice, the Pico Master and the Master of the Seven Virtues.[46]

Groups of hand-illuminated incunables can be traced to monasteries in the Veneto, particularly to Benedictine houses in the family of Santa Giustina of Padua. Much work remains to be done on

this issue, but a surprisingly large number of Classical as well as liturgical texts bear an inscription or a miniature referring to the Benedictine monastery of San Giorgio Maggiore in Venice.[47]

Two collections of illuminated Venetian incunables stand out, however, both for the extraordinary quality of the painted decorations, and because the owners were so closely allied with the new industry of printing. These are the incunables owned by members of the Agostini family, and those bearing the coats of arms of Peter Ugelheimer of Frankfurt.

Over twenty illuminated manuscripts and books printed in the 1470s are known to have belonged to the Agostini family, including five volumes in this exhibition (cats 90, 92 [a and b], 94, 95).[48] Most are identified by the Agostini coat of arms, but others by a fascinating detail. Since parchment varied in quality, the printer Nicolaus Jenson seems to have reserved certain special lots of parchment for designated future owners. Evidence for the practise consists of names informally written in the extreme lower edge of some rectos, an area of the bifolium that would normally have been trimmed off before binding. The word '*agustini*' or '*B. agustini*' thus appears in a number of books reserved for the Agostini.

A few tantalising documents testify to the business liaison between the Agostini and Nicolaus Jenson. The family traced its origins to Fabriano, a city famous for paper production, and the Agostini are documented as the providers of paper for one of Nicolaus Jenson's most prestigious editions, the Italian translation of Pliny's *Natural History* printed in 1476.[49] In Jenson's will of 1480, Pietro and Alvise Agostini, 'brothers from Fabriano', are named as executors, but the name appearing in several of the incunables with Agostini arms is 'B. Agostini'. By the 1490s, the family were called Agostini dal Banco, and documents again show that they had dealings with booksellers.[50]

Illuminated incunables may well have been partial payment for financial backing of particular editions. Members of the Agostini family owned the New York-Paris copy of Nicolaus Jenson's Plutarch of 1478 painted by Girolamo da Cremona (cats 94, 95) and the two volume set now in Dublin, painted by the Master of the London Pliny (cat. 92); furthermore, their arms appear on a less elaborately decorated copy on paper now in the Spencer Library of the University of Kansas in Lawrence (Summerfield Collection, G. 125, on paper).[51] This exceptional grouping suggests that the Agostini invested in the edition, and received a certain number of copies as partial payment. The taste of the recipients, however, is strongly marked, since a review of the twenty volumes shows that most were illuminated either by Girolamo da Cremona or the Master of the London Pliny.

Similar business arrangements probably also account for the most spectacular group of incunables to have been illuminated in Venice in the Quattrocento, those belonging to Peter Ugelheimer, a nobleman of Frankfurt who conducted business in Venice in the 1470s and later in Milan, where he died in 1487.[52] From 1473 on, Nicolaus Jenson was associated with Ugelheimer, and when Jenson made his will shortly before his untimely death in 1480, Ugelheimer was designated one of the executors. Called by Jenson his 'beloved partner', Peter was to inherit what Jenson clearly perceived as his most precious belongings, the punches from which his famous types were made.

Fortunately, Peter Ugelheimer was not only a businessman, but also a collector of splendidly bound hand-illuminated incunables. Fourteen incunables and one manuscript survive with his coat of arms either on the binding or on illuminated folios.[53] With one exception, these incunables were printed by Jenson or by the associates who continued his firm and used his fonts after his

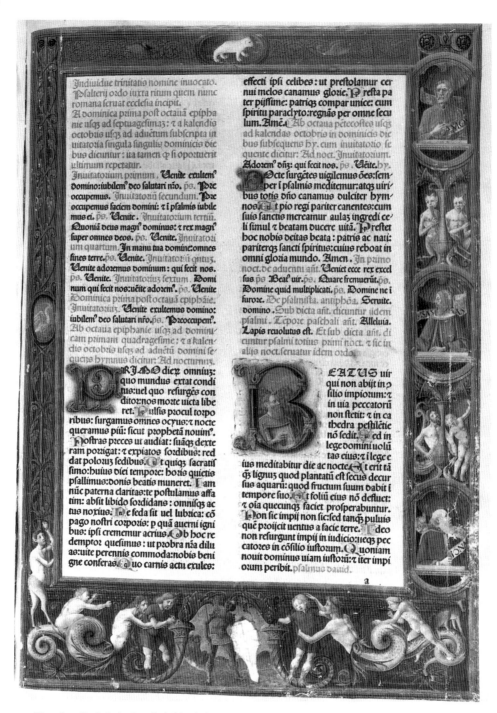

30 Dresden, Sächsische Landesbibliothek, Ink. 2872 (2°), fol. 7(a1). *Breviary*
(Venice, Nicolaus Jenson, 1478). Frontispiece with Prophets, attributed to Antonio Maria da Villafora

death. From 1477 to 1483 a team of miniaturists worked on three volumes of canon (ecclesiastical) law and one of civil law; three philosophical texts; a Bible, a Breviary, and the complete works of Aristotle – resulting in the most sumptuous frontispieces ever to appear in any Venetian Renaissance book (cats 96-101). Girolamo da Cremona is likely to have been the dominant artist in the group,[54] joined by the Master of the Seven Virtues, the youthful Benedetto Bordon, the Pico Master, and Antonio Maria da Villafora, who illuminated the little known Jenson Breviary of 1478 now in Dresden (fig. 30). In the borders of this last named volume, Antonio Maria mixes images of Old Testament prophets with mythical satyrs and sea creatures. A dark-faced Roman soldier supports a shield awaiting a blazon, but above his head the Ugelheimer motto 'MIT ZITT' ('with time') assures the ownership.

Most of the Ugelheimer books begin with a full-page miniature on a verso facing an architectural frontispiece on the opposite recto. They are distinctive in the incorporation of elaborate figural groups and for the lavish explicit and implicit praise of Ugelheimer himself. The law books follow Bolognese manuscript traditions in showing the ecclesiastical and secular authors and commentators, but are original in the settings portrayed (cats 96-98). Aristotle, Averroës and Petrus de Abano are exquisitely rendered stereotypes of the Greek philosopher, the Arab scholar and the medieval Christian cleric (cats 99-101). The Ugelheimer arms are everywhere, repeatedly placed as the central motif under a triumphal arch or in a commemorative niche. Most unusual of all are the inscriptions naming the patron, and praising him for his enabling of the publications, presumably through his financial backing.

Woodcut Designs by Miniaturists

As the quotation at the beginning of this essay documents, miniaturists complained that printing put an end to their careers. While this would not actually have been true in the 1470s when the need to 'finish' the new printed books meant that there was more work than ever, by the 1490s the cry would indeed have been justified. The impossibility of rubricating and decorating hundreds of thousands of books had prodded Italian printers to use mechanical means of embellishment. The technology of printing woodcuts simultaneously with the text was well developed in Germany in the 1470s, but with a few notable exceptions Italian printers had resisted incorporating many woodcuts into their publications until the end of the 1480s.[55] In the 1490s, however, many Venetian books were decorated with woodcut frontispieces and dozens of narrative woodcuts.

Miniaturists habituated to designing decorative motifs and narrative miniatures for books turned to woodcut designs. The identification of these designers has been inhibited by the sometimes indifferent quality of the cutters who necessarily were employed to translate the designs into the actual woodblocks. Nevertheless, the painter and miniaturist Liberale da Verona (cat. 121) has long been postulated as the designer of narrative scenes for the Aesop's *Fables*

printed in Verona by Giovanni and Alberto Alvise in 1479.[56] In Venice, three miniaturists can be linked with distinctive groups of woodcuts. A number of decorative and narrative woodcuts from 1487-8 may be attributed to a miniaturist known as the Master of the Rimini Ovid, including the first woodcut illustrations for Petrarch's *Triumphs* (Venice, Bernardinus Rizus, 1488).[57] A second anonymous master, the Pico Master, appears to have been the designer of several very popular architectural frontispieces, translated into woodcuts and reproduced in a wide variety of texts (cat. 103).[58] And by 1493, Benedetto Bordon had probably begun what was to be a substantial body of designs for woodcuts that were used by many printers throughout the 1490s and into the next century.[59]

The case of Benedetto Bordon is particularly interesting, in part because his name has been repeatedly associated with the woodcuts of the *Hypnerotomachia Poliphili (The Strife in the Dream of Poliphilus)*, the curious archaeological romance printed by Aldus Manutius in Venice in 1499.[60] The *Hypnerotomachia Poliphili* is the most beautiful illustrated book printed in Italy in the Quattrocento. Its dozens of woodcuts harmonise perfectly with the layout of the text, creating page after page of arresting design (fig. 31). Despite recent arguments that the text was written in Rome rather than Venice, it is still likely that the overall lay-out would have

31 Wellesley, Mass., Wellesley College, Clapp Library, *81W-5q, fol. k8v-L1. [Francesco Colonna],
 Hypnerotomachia Poliphili (Venice, Aldus Manutius, 1499). Mythological scenes, woodcuts

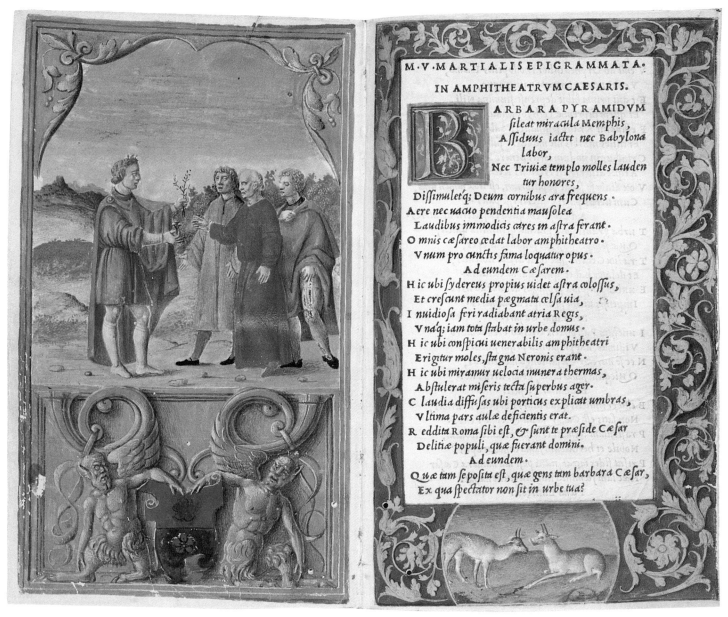

32 London, British Library, C.4.d.11, verso of leaf inserted between fol. a1 and a2; and fol. a2. Martial, *Epigrammata*
(Venice, Aldus Manutius, 1501). Martial and the Emperor Domitian, attributed to Benedetto Bordon

needed supervision in Venice by an experienced artist working with Aldus, whose press did not specialise in illustrated books. Similarities between the miniatures attributable to Bordon, such as those in the 1494 Lucian in Vienna (cat. 104), and many of the woodcuts support the hypothesis that Bordon was indeed the supervising artist.

Beyond the stylistic evidence linking Bordon to the controversial *Hypnerotomachia Poliphili*, there is documentary evidence that he designed woodcuts for a *Triumph of Caesar*, in all probability cut by the German woodcutter Jacob of Strassburg in 1504.[61] Thus while continuing to be active as miniaturists, Bordon and his contemporaries pursued new artistic activities more likely to be viable in the age of printing.

Hand-Illuminated Aldines: A Coda

By the late 1490s the phenomenon of hand-illuminated printed books was distinctly in decline. However, in the Classical and vernacular texts printed in Venice by Aldus Manutius around 1500, there was a last flowering.[62] Aldus' books were small-format octavos, printed in elegantly designed Italic type on folios with wide margins. Aldus revived the tradition of printing copies on parchment, and like Jenson and de Spira in the early 1470s, seems to have realised that attractive painted borders would enhance the value of individual copies.

Illuminated Aldines show the styles of several Venetian miniaturists, and copies sent to other cities were also illuminated by non-Venetian miniaturists. In Florence several volumes of Aldus' edition of Aristotle (Venice, 1495-7) were illuminated by Attavante for Matteo Battiferri of Urbino.[63] Most impressive, however, are the copies on parchment illuminated in the style of Benedetto Bordon that follow the format he established for his edition of Lucian in 1494 (cat. 104). Each first page of text receives a handsome border of metallic vines contrasted to solid coloured backgrounds, while opposite is a miniature representing an event in the life of the author.[64] In a Martial of 1501, now in the British Library, the miniaturist paints the Emperor Domitian receiving oak, laurel and ivy from the poet (fig. 32); the slightly stiff gestures of the figures and the beautiful landscape recall the compositions of the Lucian miniatures.

Although heretofore the evidence linking Bordon and Aldus has rested primarily on stylistic evidence,[65] a recently noted document supports the connection. One of Aldus' friends and editors, to whom he dedicated more than one edition, was the Venetian nobleman Andrea Navagero.[66] In a letter of 13 January 1515, Navagero wrote to Giambattista Ramusio complaining about the price of having a Virgil bound by one 'Alberto'.[67] He specifies that the mini-ature in the book is by 'Benetto'. Given that Navagero edited Aldus' edition of Virgil, it is hard to imagine that the book is other than a copy of this recent issue, illuminated by none other than Benedetto Bordon. Thus Benedetto Bordon continues into the 16th century not only as the documented miniaturist of liturgical manuscripts (cat. 118), but also as one of the last great illuminators of printed books.

1 'For my art, one does nothing any more – For my art has ended, for the love of books, because they make [books] in a form that they no longer illuminate' (Gaye 1839-40, I, p. 267, quoted in Bühler 1960, p. 92).
2 Carosi 1982; Feld 1982, pp. 283-4.
3 On Venetian printing, see Castellani 1889; Brown 1891; Gerulaitis 1976; Pozza *et al.* 1984.
4 Lowry 1991.
5 On Florentine printing, see Rhodes 1988; for Milan, Rogledi-Manni 1980; Ganda 1984; for Naples, Fava and Bresciano 1911-13. For these and other centers, see also BMC, IV-VII, XII, 1916-35, 1985, Introductions.
6 Scholderer 1924; and information from ISTC, kindly supplied by M. Davies.
7 Lowry 1991, chap. 6.
8 Lowry 1979; Fletcher 1988.
9 Issues of decoration in printed books are surveyed in Goldschmidt 1950; Bühler 1960; Hirsch 1974; Armstrong 1991.
10 For Roman examples, see Florence 1989, pls X, XII, XVI, XIX; Rouse and Rouse 1988, pls 3, 4. For Venetian examples, see Mariani Canova 1969, pls 25-6, 73.
11 Alexander 1992, chap. 2.
12 Dillon Bussi 1989, p. 35; Armstrong 1991, pp. 190-1.
13 Armstrong 1990a.
14 Armstrong 1991.
15 Borrelli 1989. For cautionary remarks about the technique, see Alexander 1992, pp. 50-1.
16 Donati 1972-3; Armstrong 1981, pp. 26-9; Armstrong 1991, pp. 195-200.
17 Marcon 1986a, seven copies noted on pp. 179-82; plus Cambridge University Library, Inc. 1.B.3.1b [1330].
18 Indispensable for the study of Venetian book decoration is Mariani Canova 1969. For subsequent studies, see later publications by Mariani Canova listed in the Bibliography, and those by Alexander, Armstrong, Cionini Visani, and Dillon Bussi.
19 Bühler 1960, p. 86.
20 Mariani Canova 1969, pp. 26-30, 104-6, 145-6; Michelini Tocci 1965.
21 Moretti 1958; Mariani Canova 1968; Mariani Canova 1969, pp. 22-3, 103-4, 144-5.
22 Narkiss 1969, p. 152; Bauer-Eberhardt 1984; Mortara Ottolenghi 1989; Mariani Canova 1990, pp. 168-70.
23 The second copy in Paris, Bibliothèque nationale, Vélins 129.
24 Jacoff 1994; see cats 36, 50, 59, 62, 69 and 120 for Francesco d'Antonio del Chierico.
25 The Attavante Dante is reproduced in colour in Florence 1992b, pp. 116-17.
26 Garzelli and de la Mare 1985, I, pp. 101-70, 219-45.
27 Edler de Roover 1953.
28 Borsook 1970, pp. 9, 13-14, 20.
29 Garzelli and de la Mare 1985, pp. 267-330.
30 Evans 1987; Evans 1992.
31 Mariani Canova 1969, pp. 58-62, 117-21, 154-5; Mariani Canova 1984a.
32 Armstrong 1990a, pp. 31-2.
33 Armstrong 1981, pp. 108-13, 125-6.
34 Pächt 1957; Corbett 1964; Mariani Canova 1966; Alexander 1969a; Alexander 1985a; Armstrong 1981, pp. 19-26; Armstrong 1990a, pp. 18-21.
35 Anderson 1968.
36 Mariani Canova 1969, pl. 16; Pope-Hennessy 1985, fig. 155.
37 Armstrong 1981, pp. 53-9; Scalabroni 1988.
38 Bober and Rubinstein 1986, pp. 109-11, no. 75.
39 Alexander 1985a.
40 Weiss 1988, chap. 13; Florence 1972.
41 Identified in the catalogue sections of Mariani Canova 1969; Armstrong 1981; Armstrong 1990a; Armstrong 1990b; Armstrong 1993b; Hermann 1931; BMC, V, 1924.
42 Lowry 1991, pp. 68, 83-4.
43 Mariani Canova 1978b, pp. 46-55; Mariani Canova 1988b, pp. 81-109.
44 Cionini Visani 1967; Mariani Canova 1969, pp. 80-96, 130-6, 159-67; Mariani Canova 1976, p. 158, for correction of the name from 'Sforza' to 'Villafora'. See also cat. 7.
45 Marcon 1986b, pp. 223-48; Marcon 1987-9.
46 Dillon Bussi 1989. For the Pico Master, see cats 99, 102, 103; fig. 28. For the Master of the Seven Virtues, see cats 96, 100.
47 For example, see nos 3, 7, 31, 36-8 in Armstrong 1990a, pp. 31-3.
48 To those listed in Armstrong 1986 may be added Cicero, *Orationes*, Venice, Cristoforo Valdarfer, 1471 (Trento, Biblioteca Comunale, Inc. 408; Borrelli 1989); Bonifacius VIII, *Decretales*, Venice, Nicolaus Jenson, 1476 (London, British Library, IC 19688); Plutarch, *Vitae virorum illustrium*, Venice, Nicolaus Jenson, 1478 (University of Kansas, Lawrence, Spencer Library, Summerfield Collection, G. 125).
49 Edler de Roover 1953, p. 110.
50 Lowry 1979, pp. 98, 129.
51 Lowry 1991, p. 135 n. 38.
52 Motta 1884; Lowry 1991, *passim*.
53 To the twelve listed by Armstrong (1990a, p. 20 n. 53) should be added: Biblioteca Apostolica Vaticana, Pal. lat. 697, *Supplementum pisanelle*; Dresden, Sächsische Landesbibliothek, Ink. 2872 (2°), *Breviarium romanum*, Venice, Nicolaus Jenson, 1478, and Ink. 2876 (2°), *Biblia latina*, Venice, Nicolaus Jenson, 1479 (all noted in Hobson 1989, pp. 38-41).
54 Mariani Canova 1988a, pp. 53-63.
55 Hind 1935, pp. 273-379, 396-421, 456-506.
56 Mardersteig 1973; Eberhardt 1977.
57 Armstrong 1993b.
58 Armstrong 1990a, pp. 27-30, 37, figs 7, 37, 40-4.
59 For recent surveys of this material, see Dillon 1984; Castiglioni 1989.
60 For the enormous bibliography on the *Hypnerotomachia Poliphili*, consult Casella and Pozzi 1959; Pozzi and Ciapponi 1980; Calvesi 1983; Calvesi 1987; Danesi Squarzina 1987; Szepe 1991.
61 Massing 1977; Massing 1990.
62 Lowry 1979; Lowry 1983; Szepe 1991; Szepe 1994.
63 Florence 1989, no. 83, pls IV-VI.
64 Szepe 1994.
65 Lowry 1983; Szepe 1991; Szepe 1994.
66 Lowry 1979, pp. 161, 165, 190, 204-5, 231-3, 242-3, 246-7; Fletcher 1988, pp. 17-18, 39, 112, 123-4, 133.
67 Cicogna 1853, pp. 322-5. I am very grateful to Dr Gabriele Mazzucco for bringing this important document to my attention.

Catalogue

Liturgical and Biblical Manuscripts

Manuscripts containing texts of the Bible and for Church services continued in the Renaissance to be the most richly illuminated both in the scale of their decoration and in terms of materials, for example gold leaf and valuable pigments such as lapis lazuli. An exceptional luxury copy of Holy Scripture is the Bible written in Florence in seven volumes for King Manuel of Portugal and illuminated by one of the most successful and busy miniaturists in Europe, Attavante degli Attavanti (cat. 1). The contract for this enormous and expensive project was drawn up in Florence on 23 April 1494. Splendid copies of the texts for the Masses and Offices of the Church were commissioned for the particular churches in which they were used, though they might be individually donated,

as was no doubt the Paduan Epistolary and Evangeliary (cat. 7), or bequeathed on the death of a prelate, such as the Missal of Thomas James, Bishop of Dol in Brittany (cat. 3a, 3b). This latter manuscript was another foreign commission signed and dated 1483 by Attavante. By this period many wealthy prelates owned their own service books and inserted their personal arms and mottoes in them (cats 3-6). The practice of making special Mass books for use by Popes and Cardinals in the Cappella Sistina in the Vatican in Rome, among them the Preparation for the Mass of Leo X (cat. 4), ensured the continuation of the hand-produced, hand-illuminated manuscript long after the invention of printing, as will be shown also in the concluding section of the exhibition.

I

Bible with *Postillae* of Nicholas of Lyra

Volume II: 387 fols. Volume IV: 502 fols. 410 × 283 mm; 408 × 277 mm. On parchment

The set of eight volumes was written in Florence, 1494-7, by Sigismondo de' Sigismondi, Alessandro da Verrazzano and other scribes and illuminated by Attavante degli Attavanti

LISBON, ARQUIVOS NACIONAIS, TORRE DO TOMBO, MS 161/2,4

This extraordinarily sumptuous Bible was commissioned in Florence for Prince Manuel of Portugal, who succeeded to the throne on his father's death in 1495, while it was still being copied. The contract between his agent, Chimenti di Cipriano di Sernigi, citizen and merchant of Florence, and the illuminator, Attavante degli Attavanti, was signed on 23 April 1494. It is a long and detailed document which was first printed by Milanesi in 1901. The Bible and Commentary were to comprise seven volumes, each with a frontispiece; there was to be an additional volume of Peter Lombard's *Sentences*. The rate of payment for the illumination is clearly established, for example 25 gold ducats for each '*principio*', and there are stipulations as to the time taken to complete the project, with a system of fines if Attavante fails to deliver. Provision is also made should the scribes fall behind, which indicates that Attavante was at work at the same time as the scribes. The latter are not named in the contract, but volume I is signed and dated 11 December 1495 by Sigismondo de' Sigismondi and volume II is signed and dated August 1495 by Alessandro da Verrazzano. Volume III bears the date 1496 and volume VII the date July 1497. Volumes III, IV and VII appear to be in the hand of the priest Niccolò Mangona, whose signature appears on only one manuscript (Florence, Biblioteca Riccardiana 1503, Boccaccio, *Ninfale fiesolano*, dated 1482; Garzelli and de la Mare 1985, p. 518, no. 51 [12-14]). Volume V seems to be by the same hand as the Peter Lombard *Sentences*, whose scribe is identified by the contract as '*frater Jacobus Carmelitanus*'. He is almost certainly identical with the Carmelite '*frater Jacobus Johannes Alamannus Crucenacensis*' who signed Florence, Biblioteca Medicea-Laurenziana 21,8, another Peter Lombard manuscript, made for King Matthias Corvinus of Hungary in 1490 (Garzelli and de la Mare 1985, p. 507, no. 35 [3]; also written communication).

Volume II here exhibited contains the Books of Joshua, Judges, Ruth, and I-IV Kings. In the frontispiece, folio 1v, the list of contents is written in gold on blue on a plaque enclosed by four columns. In front is an altar with a reclining female figure rendered as if carved on it. A number of male figures stand on either side inside the portico. The arms of Manuel of Portugal are upheld by female figures in the centre of the border below and repeated on each side; at the top of the page are the arms of the Order of Christ, a silver and red cross on blue. The border to each side, with gold acanthus, putti, simulated cameos and pearls on blue and red, encloses six haloed but unidentifiable figures of saints or prophets in roundels. The whole is enclosed by a gold filigree border. On folio 2 at the top St Jerome, adoring a crucifix, kneels outside a cave in which books on shelves can be seen. His red cardinal's hat lies beside him and a city in the distance evokes both Jerusalem and Florence with its domed cathedral. A seated figure, also probably St Jerome, appears in the initial 'T' below, and there is a similarly ornate border matching that on folio 1v. The opening script is written in gold. The succeeding books are introduced by historiated initials, with a painted or in one case a historiated initial for the prologue. The historiated initials are as follows (the manuscript is not foliated): Judges, 'P', Judas as a soldier with a group of figures; Ruth, 'I', with Ruth kneeling before Boaz; Prologue to Kings, 'V', with a half-length figure of Jerome; I Kings, 'P', standing figure, probably Samuel; II Kings, 'F', messenger before King David; III Kings, 'E', with King David and a kneeling woman; IV Kings, 'P', King Hezekiah in bed with the prophet Elijah, who gives him God's promise of another 25 years of life; Prologue to I Chronicles, 'T', with a seated figure of St Jerome; I Chronicles, 'A', showing Adam digging with a spade; II Chronicles, 'C', Solomon kneeling before an altar with a seven branched candlestick on it. There are accompanying borders, often enclosing the Portugese royal arms, and a number of other painted or historiated initials. In III Kings VII, a small miniature represents the Palace of Solomon as a contemporary three storeyed Florentine palazzo.

Volume IV, also exhibited, contains the Wisdom Books – Proverbs, Ecclesiastes, Song of Songs, Wisdom and Ecclesiasticus – as well as Isaiah, Jeremiah, Lamentations and Baruch. The frontispiece again has the list of contents written in gold under an arch with a circular altar in front of it and flanking figures. A child, seated as if on a step at the front, feeds cherries to a monkey. A framing border, as in volume II, contains saints or prophets similarly enclosed in roundels and has a similar acanthus scroll inhabited by putti, which is painted again in

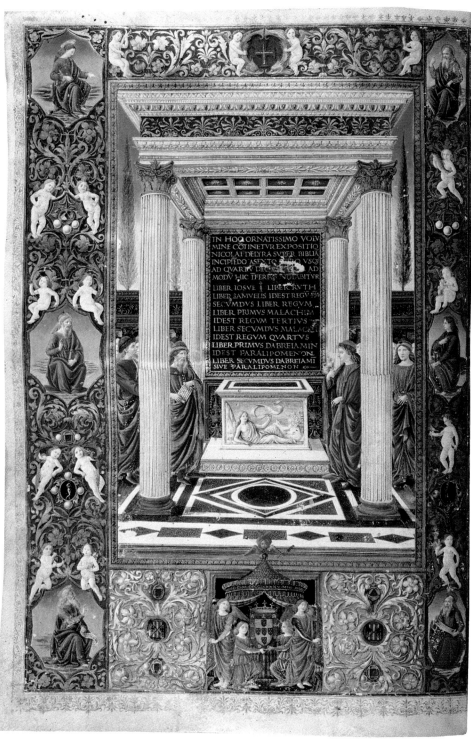

1　Volume II, folio 1v

gold on blue or crimson and, above, in silver on gold. On folio 3 oppo-site, Jerome's prologue to Eliodorus, the saint is shown writing on a scroll on his knee in a study with shelves filled with books. His lion in front of him holds his inkwell in a raised paw. Two figures flank Jerome at left and right. The far wall is inscribed: '*Initium sapientiae timor Domini*' ('The beginning of wisdom is the fear of the Lord'). The border is similar to that on the verso, and on both pages the arms of Portugal are in the lower and upper borders. The initial 'I' of the text is accompanied by a small miniature of St Jerome seated. On folio 5v another prologue is introduced by a 'P' with a half-length figure of Solomon and a three sided border. On folio 6 an initial 'P' shows probably Nicholas of Lyra, and in an 'M' for the prologue of Ecclesiastes a half-length St Jerome. The openings of the Wisdom books have a prologue initial with St Jerome half-length, the text initial with King Solomon enthroned and usually a painted initial for the commentary: Ecclesiastes, 'M', 'V' and 'V'; Song of Songs, 'O', 'O'; Wisdom, 'L', 'D', 'L'; Ecclesiasticus, 'M', 'O'. For Isaiah and Jeremiah there are the usual prologue and commentary initials and a 'V' with the prophet enthroned in each case. Jeremiah is also shown grieving in an 'E' for Lamentations. Baruch is shown seated wearing a turban in an 'E'. The major initials have three sided painted borders with arms.

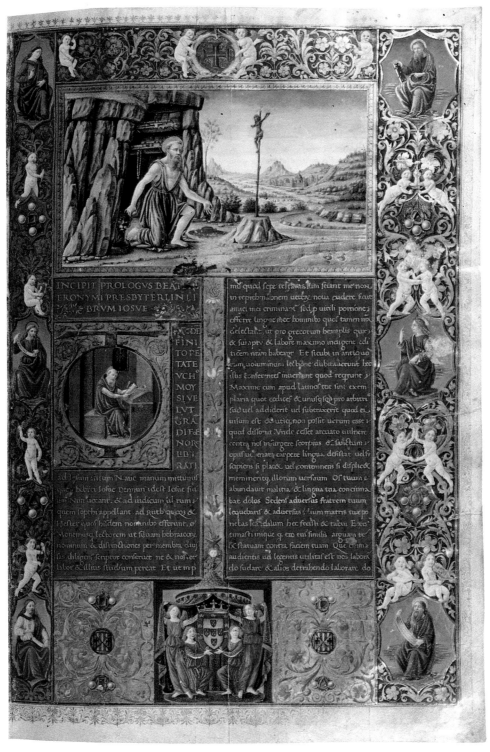

1 Volume II, folio 2r

Though the frontispieces are of high quality and certainly painted by Attavante himself, many of the initials are much weaker and evidently the work of assistants. The frontispieces are comparable to other commissions executed by Attavante in the 1490s, such as the Breviary of Matthias Corvinus in the Vatican and the Missal of the Bishop of Dol (cats. 3a, 3b). The manuscripts must have been intended for the royal monastery at Belem served by Hieronymites, since the brothers are evidently referred to in the figures who accompany St Jerome in the frontispieces. The king was buried in the monastery church.

Provenance: Commissioned by Manuel I, King of Portugal (1495–1521) and bequeathed to the Royal Hieronymite Monastery of Belem; removed to Paris by Marshal Junot in 1807, but recovered and returned to the monastery by King John VI; entered the Arquivos Nacionais with the suppression of the monasteries in 1834.

Bibliography: Milanesi 1901, pp. 164–6; D'Ancona 1913, pp. 205–12; D'Ancona 1914, I, pp. 81, 84, 91, 100–1, pl. XCIX, II, no. 1579; Dos Santos 1930, pp. 19–21, pls XXIII–XXIV; Levi d'Ancona 1962, pp. 256–7; Garzelli and de la Mare 1985, pp. 233–4, 480, 507, 518, 535, figs 821–31; Alexander 1993, pp. 53, 181–2.

J. J. G. A.

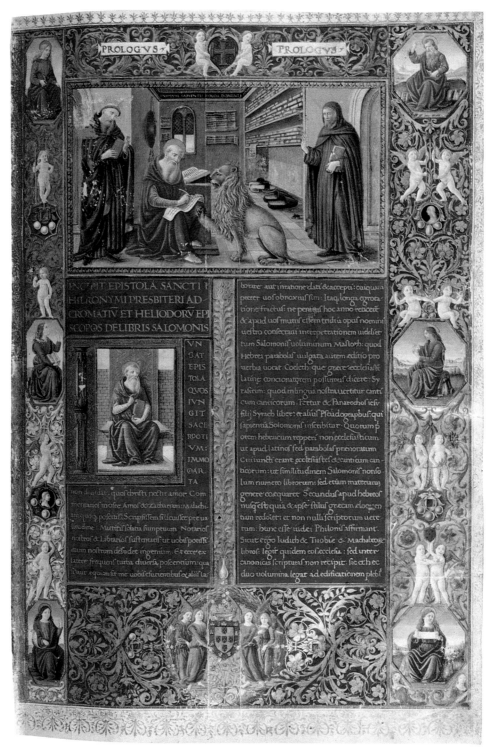

1 Volume IV, folio 3r

2

Origen, *Homilies on Genesis, Exodus, Leviticus*

161 fols. 510 × 370 mm. On parchment

Written in Gothic script in Florence, c. 1480-90, with illumination attributed to Francesco Rosselli

MODENA, BIBLIOTECA ESTENSE, MS Lat. 458

This large manuscript has a richly illuminated opening page, folio 1, with a series of roundels in the border with Genesis scenes. The eight roundels in the left border start at the top left with the enthroned figure of God holding the universe and run down to the scene of the *Creation of Eve*. In the right border are another eight scenes, running from the *Temptation* at the bottom right to the *Expulsion* at the top. In the lower border four angels flank the arms of Matthias Corvinus, King of Hungary (*d.* 1490) and of his wife, Beatrice of Aragon, whom he married in 1474 and for whom the manuscript was probably made. In the upper border three half-length figures in roundels are, from left to right, David, Moses and Solomon. Moses and Solomon hold scrolls with partly decipherable inscriptions. There is a historiated initial 'D' with a half-length figure, no doubt intended for Origen, and a large

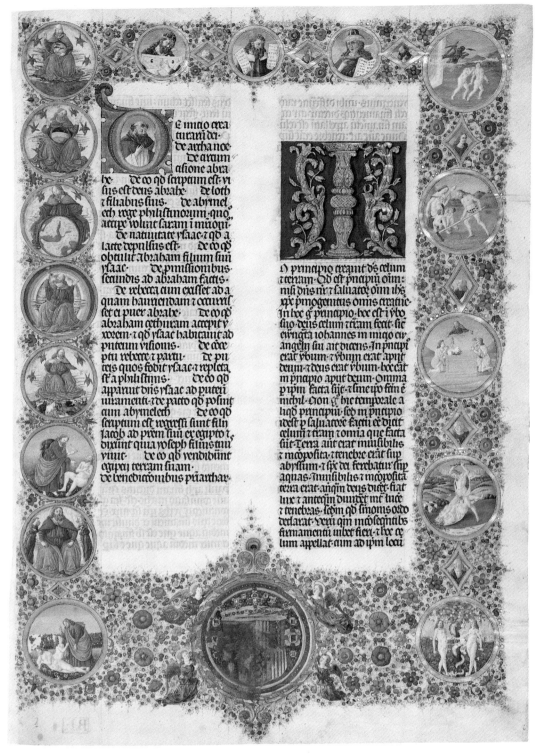

2 folio 1r

initial 'I' in gold on blue for '*In principio*', the opening words of Genesis. Spaces are left in the text at the beginning of each homily which seem too large for rubrics and imply that miniatures were intended. Perhaps the commission was interrupted by Matthias Corvinus' death in 1490. There are 48 large initials in gold with gold filigree on blue or crimson grounds.

The illumination has been attributed by Annarosa Garzelli (1977) to Francesco Rosselli, a prominent Florentine illuminator who produced the two Hours written for Lorenzo de' Medici in 1485 (cats 31-2). The design and iconography of the page recalls that of the Genesis page illuminated by Francesco d'Antonio del Chierico in the great Bible made for Federigo da Montefeltro, Duke of Urbino, in 1476-8 (Vatican, Biblioteca Apostolica Vaticana, Urb. Lat. 1).

Provenance: Arms of Beatrice of Aragon (1457-1508) and of her husband, Matthias Corvinus, King of Hungary (1443?-1490).

Bibliography: D'Ancona 1914, I, pp. 49, 50, 63, II, no. 814; De Hevesy 1923, pp. 69-70, no. 65; Csapodi and Csapodi-Gárdonyi 1969, p. 58, no. 85, pl. XL; Csapodi 1973, p. 301, no. 462; Fava, Salmi and Pirani 1973, pp. 77-8, no. 143, pl. XXX; Garzelli 1977, pp. 50-1, pls 18, 20; Garzelli and de la Mare 1985, p. 182, fig. 541.

J. J. G. A.

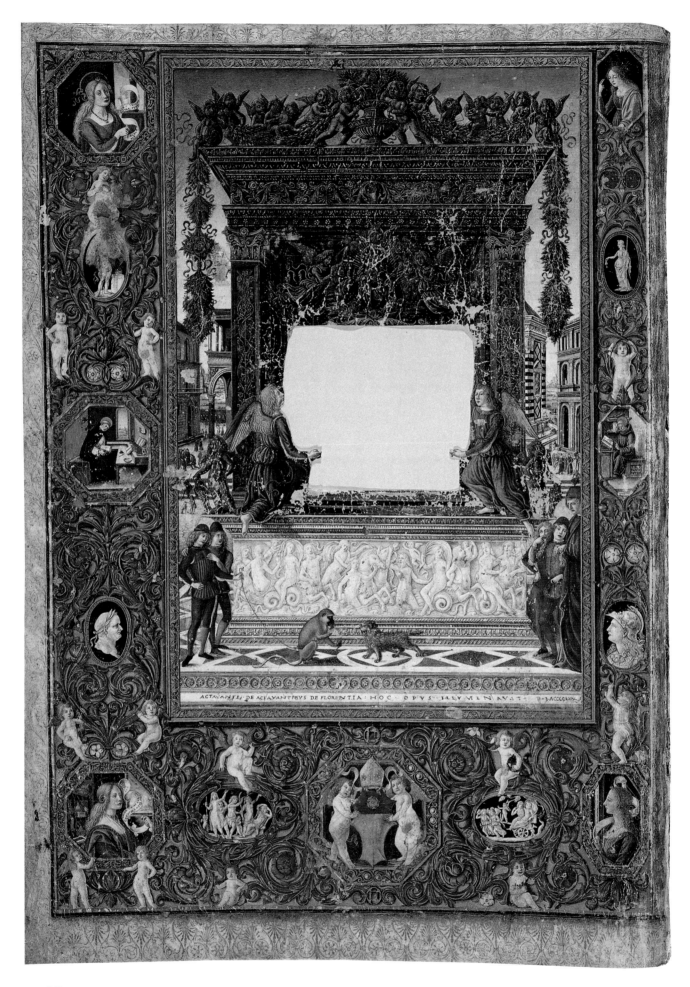

3a folio 6v

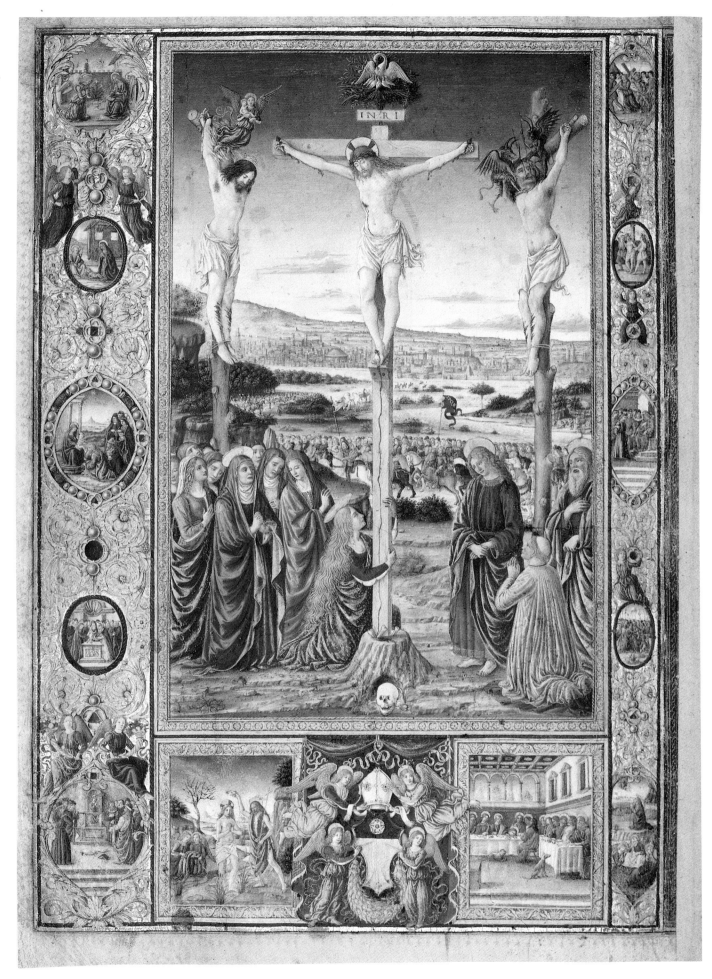

3a and 3b

Missal of Thomas James, Bishop of Dol

434 fols. 392 × 280 mm. On parchment [London only]

Written in Florence, 1483, and illuminated by Attavante degli Attavanti

3a LYON, BIBLIOTHÈQUE MUNICIPALE, MS 5123

3b LE HAVRE, MUSÉE DES BEAUX-ARTS ANDRÉ MALRAUX

This magnificent Missal was made for Thomas James, Bishop of Dol in Brittany from 1482 to his death in 1504. It is dated 1483 by the illuminator, Attavante degli Attavanti, who was one of the most successful entrepreneurs in the Florentine book trade in obtaining commissions from patrons outside Florence, working for King Matthias Corvinus of Hungary and King Manuel of Portugal (cat. 1) among others. Unfortunately the Missal has suffered mutilation and several folios are missing, one following folio 5 at the end of the Calendar, one after folio 6 at the beginning of the Sanctorale, one at Easter, after folio 210, one at the opening of the Sanctorale, after folio 280, and one for Masses of St Marcellinus and other saints, after folio 305. These must all have been lavishly illuminated.

On folio 6v is an illuminated frontispiece which has also been mutilated – the centre of the page has been cut out. Two angels flank this space, which presumably enclosed a dedicatory text. The angels kneel as if on an altar with a tabernacle behind it. This is set not in a church, however, but in a cityscape with buildings half visible behind and with figures standing to either side. The altar is rendered like an Antique sculpted frieze or sarcophagus carved with nereids and tritons. This is in fact a copy of the famous Della Valle-Medici sarcophagus, a Roman work of the 2nd century AD which was already fragmentary in the Renaissance and is now divided between Berlin and the Villa Medici, Rome (Bober and Rubinstein 1986, no. 100). There is an acanthus leaf border on three sides of the page and this encloses medallions with four female bust-length figures at the corners and two seated writing saints to left and right. There are also simulated cameos, including heads of the Emperor Vespasian and of Athena (see cat. 133); below on the left are Dionysus and Ariadne and on the right the Triumph of Dionysus. They copy four of the famous Antique gems in the collection of Lorenzo de' Medici (Dacos, Giuliano and Pannuti 1980, nos 8, 22, 30, 33). In the centre below are the arms of Thomas James surmounted by a mitre. Attavante's signature is in capitals, written as if on the step of the pavement before the altar: '*Actavante de Actavantibus de Florentia hoc opus illuminavit [A] D MCCCCLXXXIII*'.

On folio 203 is a miniature of the *Last Judgement* with scenes of the Passion and Resurrection in medallions on either side in the border. The miniature of the *Crucifixion* which originally faced this folio as a verso is now housed in Le Havre. It shows the *Crucifixion* in a landscape with a distant view of the city of Jerusalem. The kneeling figure of the Bishop is included at lower right. Medallions in the frame show, on the left, the *Annunciation*, *Nativity*, *Presentation in the Temple* and *Christ and the Doctors in the Temple*, and, on the right, the *Carrying of the Cross*, *Flagellation*, *Christ before Pilate*, *Betrayal* and *Agony in the Garden*. The Bishop's arms below are flanked by somewhat larger scenes of the *Baptism* on the left and the *Last Supper* on the right. The last miniature, folio 358, showing Heaven, is possibly not by Attavante, according to Leroquais (1924). There are also 163 historiated initials (listed by Leroquais) with borders, often with figure medallions. These are of varying quality and evidently Attavante had assistants (see cat. 1).

With this early work Attavante set a pattern for many of his later productions, particularly close being the Missal of King Matthias Corvinus of Hungary of 1487 (Brussels, Bibliothèque royale, Ms. 9008).

Provenance: Thomas James, Bishop of Dol (1482-1504), with his arms; in the Treasury of the Cathedral of Dol until the French Revolution; sold *c.* 1846 by M. Chevrier, Archpriest of Dol; shortly after bought by Cardinal de Bonald, Archbishop of Lyons, who bequeathed it to the Cathedral of Lyons; in 1906 to the Bibliothèque de la Ville de Lyon as a result of the *loi de séparation*.

Exhibition: Lyons 1920, pp. 34-6, pls XLV-XLVI.

Bibliography: Delisle 1882, pp. 311-15; Bertaux and Birot 1906; D'Ancona 1914, I, pp. 91, 93-5, II, no. 1578, pls 97-8; Leroquais 1924, III, pp. 223-5, pls CII-CIV; Joly 1936; Garzelli 1985a, fig. 3; Garzelli and de la Mare 1985, pp. 222-7, figs 781-4, 788-9, 791; Bober and Rubinstein 1986, p. 132, fig. 15.

J. J. G. A.

4

Preparatio ad missam pontificalem

19 fols. 396 × 266 mm. On parchment

Written, signed, and dated 1520 in Rome (?) by Fredericus, with illumination attributed to Attavante degli Attavanti

NEW YORK, THE PIERPONT MORGAN LIBRARY, H. 6

This *Preparatio ad missam* contains the psalms and prayers recited by the Pope as he prepares himself for the celebration of Mass. Among the prayers are those he recites while vesting himself with ecclesiastical garments, the first being his liturgical stockings and pontifical sandals. Appropriately, the manuscript's frontispiece depicts the seated Pontiff, having just donned his stockings, presented with his liturgical shoes.

The manuscript, which is dated 1520, was made for Pope Leo X (*r.* 1513-1521); both the date and the Pope's name appear on the sides of the dais. Leo's papal arms are painted in the bottom border, and two of his *imprese* appear in the left border: a diamond ring accompanied by three feathers and a scroll inscribed 'SEMPER' ('always') and a yoke interlaced with a scroll inscribed 'SUAVE' ('sweet'), a reference to Matthew XI, 30, 'For my yoke is sweet and my burden light.' In the borders are SS. John the Baptist and Lawrence (flanking the miniature) and Peter at the top left. The other three figures are typical of the rather generic saints who populate the borders of manuscripts made for Leo and his cousin Pope Clement VII (*r.* 1523-1534). The top border shows Christ in the heavens, flanked by groups of angels, sending forth the Dove of the Holy Spirit upon Leo below.

The manuscript includes 18 other elaborate borders containing the Pope's arms and emblems and 29 historiated initials. The latter generally contain a bust-length portrait of the Pope, but a few refer specifically to the text, showing, for example, Leo washing his hands or having just donned his stole.

The miniature can be attributed to the Florentine artist Attavante degli Attavanti. Born in 1452, Attavante established a busy workshop in Florence (see cats 1, 3), whose production, however, can sometimes achieve a rather routine level. Dated 1520, this manuscript is among the artist's last works and, commissioned for the worldly but discerning Leo, is one of his finest. A Medici, Leo might have also enjoyed Attavante's work because of their common Florentine roots (the inscription mentioned above refers to Florence as Leo's home). The Pope owned other manuscripts illuminated by Attavante, including works by Cassiodorus (formerly Major J. R. Abbey, MS 2579) and Appianus (Florence, Biblioteca Medicea-Laurenziana, 68, 19). The latter had been begun for Matthias Corvinus (see cat. 13) but, unfinished at the time of the Hungarian king's death in 1490, was subsequently acquired by Leo.

This manuscript can be identified in an unpublished 18th century inventory of the papal sacristy serving the Sistine Chapel. Manuscript number B.I.1 shelved in the fifth armoire in the second room of the vestry was a '*Canone ò Preparazione di Leone X*', described as having nineteen leaves and illuminated on the first, second, and all the other leaves. The Sistine Chapel was looted in 1798 by Napoleon's troops and this book was probably one of the many papal manuscripts taken.

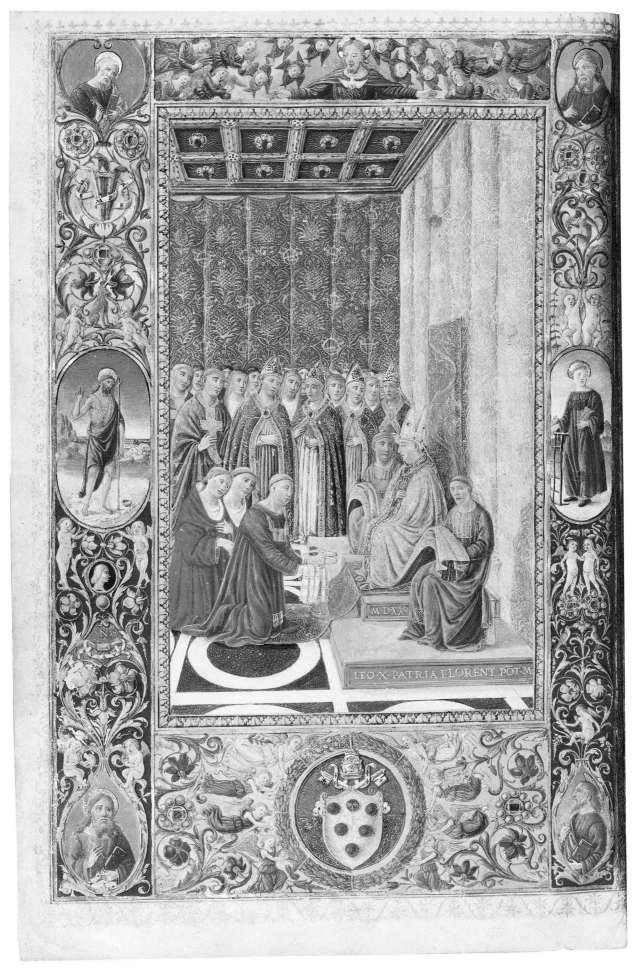

LEO·X·PATRIA·FLORENT·PŌT·M·

M·D·XX

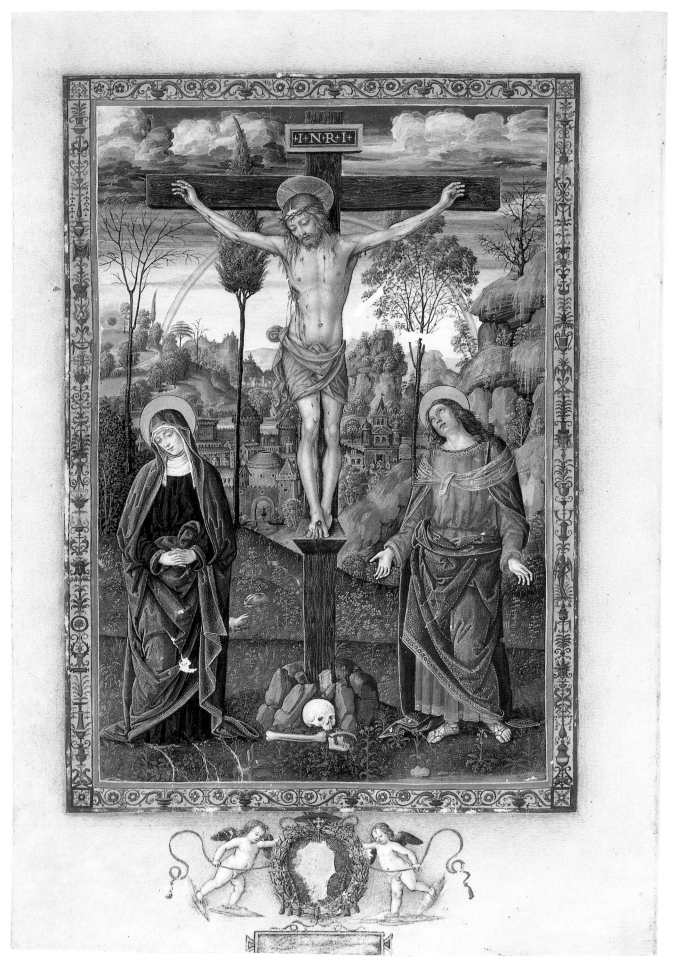

5 folio 219v

6 folio 118v

Provenance: Pope Leo X (*r.* 1513-1521); Hamilton Palace Library manuscript sale, London, Sotheby's, 1882, lot 531; Frédéric Spitzer (1815-1890); Edouard Kann sale, Paris, Hôtel des Commissaires-Priseurs, 14 November 1930, lot 107; Dannie (1872-1962) and Hettie (*d.* 1974) Heineman Collection; given to the Pierpont Morgan Library in 1977.

Exhibitions: New York 1963, pp. 13-15, illus.; New York 1964, no. 35; New York 1984, no. 51, illus.

Bibliography: Müntz 1890-2, V, pp. 132, 145-6, pl. V; Levi d'Ancona 1962, p. 255; Ryskamp 1978, pp. 26, 54-5.

<div align="right">R. S. W.</div>

5

Missal, Use of Rome

385 fols. 394 x 279 mm. On parchment. Original gold tooled binding
<div align="right">[New York only]</div>

Written and illuminated in Rome in the late 15th century, with a miniature attributed to Bernardo Pinturicchio

VATICAN, BIBLIOTECA APOSTOLICA VATICANA, Barb. Lat. 614

The leaf showing the *Crucifixion* from the Canon of the Mass has been detached from the Missal to which it belongs and is shown without the manuscript. The Missal begins with a Calendar on folios 1-11, and the Temporale starts on folio 13, which is decorated with a four sided foliage border with an erased coat of arms supported by two angels in the centre below. In an initial 'A' is a half-length King David. Other historiated initials are on folio 38v, initial 'P', *Nativity*, four sided border with prophet heads in roundels and erased arms again in the centre below; folio 58, initial 'E', *Adoration of the Magi*, border in left margin with roundel head; folio 220, '*Te igitur*', God with a crystal globe in the initial 'T', four sided border with, in the roundels, an angel, left, a priest with chalice at an altar, right, and St Jerome, below, kneeling in a landscape; folio 234, Sanctorale, initial 'D', St Andrew, border in left margin; folio 381, *Mass of the Dead*, initial 'R', with skull, border in left margin. The *Crucifixion* was folio 219v, with the miniature, as usual, facing the '*Te igitur*' for the Canon of the Mass.

The initials are by an artist related in style to the Master of the della Rovere Missals (cat. 6), except for folio 234 which is by a weaker assistant. The *Crucifixion* is by a third artist who is clearly an outstanding master. The miniature was convincingly attributed to Pinturicchio by Ricci in 1912 and there can be no doubt that the attribution is correct; it has been followed by Gnoli (1923) and Carli (1960). Pinturicchio was at work on the Borgia Apartments in the Vatican in 1493-4. Ricci suggested a date a few years later, *c.* 1496-9. Giovanni Morelli (in Denver 1993) has pointed out the similarity in pose of the St John to the same figure painted by Perugino in the *Crucifixion* in the Chapterhouse of Santa Maria Magdalena de' Pazzi, Florence, in 1496, which may confirm the dating. A signed miniature by Perugino appears as cat. 117 in the present exhibition. At the bottom of the page there was a coat of arms and inscription. A cardinal's hat remains, but the inscription and arms are both unfortunately very thoroughly erased, so that the original owner cannot be identified.

Provenance: Unidentified erased arms, folios 13, 38v, 219v; from the Biblioteca Colonna and subsequently to the Biblioteca Barberini, Rome.

Exhibitions: Vatican 1950, no. 157; Vatican 1975, no. 256, pl. LIII; Vatican 1985, no. 30, colour pl.; Denver 1993, no. 38, illus.

Bibliography: Ricci 1912, p. 13, illus.; Gnoli 1923, p. 297; Carli 1960, pp. 17, 57, pl. 103

<div align="right">J. J. G. A.</div>

6

Missal of Cardinal Domenico della Rovere

158 fols. 360 x 260 mm. On parchment. Contemporaneous gold tooled red morocco binding, Rome, with silver gilt clasps added later

Written in Rome, probably in the mid-1490s, with illumination by Francesco Bettini and attributed to the Master of the della Rovere Missals

NEW YORK, THE PIERPONT MORGAN LIBRARY, M. 306

This manuscript is the first part of a four volume Missal made for Cardinal Domenico della Rovere. All four volumes contain the della Rovere arms and the initials SD for '*Soli Deo*' ('to God alone'), the Cardinal's motto. The three other volumes are in Turin's Archivio di Stato (MSS J. II. b. 2-4). The Morgan volume is the first and contains Masses for part of the Temporale plus some Prefaces and the Canon. Each Mass is given two illustrations, a historiated initial at the Introit and a second at the Gospel reading: folio 2v, *David Lifting up his Soul*, in 'A', and folio 7, *Christ Preaching*, in 'I', for the First Sunday of Advent; folio 11v, *Isaiah Prophesying*, in 'P', and folio 14, *Christ Preaching*, in 'I', for the Second Sunday of Advent; folio 16v, *St Peter*, in 'G', and folio 18, *John the Baptist Questioned by Jews*, in 'I', for the Third Sunday of Advent; folio 20v, *God Sending Forth Christ*, in 'R', and folio 22v, *John the Baptist Preaching*, in 'A', for the Fourth Sunday of Advent; folio 24v, *St Andrew*, in 'M', and folio 27, *Christ Calling Peter and Andrew*, in 'I', for the Feast of St Andrew; folio 29, *Meeting of Joachim and Anna at the Golden Gate*, in 'S', and folio 32v, *David with his Progeny* (?), in 'L', for the Conception of the Virgin; folio 36v, *Annunciation to the Shepherds*, in 'D', and folio 38v, *Caesar Augustus Decreeing the Census*, in 'I', for the First Mass on Christmas; folio 42, *Nativity*, in 'P', and folio 45v, *Christ Child Adored by Angels*, in 'I', for the Third Mass on Christmas; folio 48v, *St Stephen Preaching*, in 'E', and folio 51v, *Christ Preaching*, in 'I', for the Feast of St Stephen; folio 54, *St John on Patmos*, in 'I', and folio 57, *Christ Addressing Peter and John*, in 'I', for the Feast of St John; folio 60, *Circumcision*, in 'P', and folio 62, the *Virgin Receiving the Christ Child after the Circumcision*, in 'I', for the Circumcision; folio 63v, *Adoration of the Magi*, in 'E', and folio 66, *Adoration of the Magi*, in 'I', for Epiphany; folio 78v, *Presentation in the Temple*, in 'S', and folio 81v, *Presentation in the Temple*, in 'I', for the Purification of the Virgin; folio 139, a *Pope Giving Cardinal Domenico Blessed Wax Medallions of the Agnus Dei*, in 'E', and folio 144, *Peter, John, and Mary Magdalene*, in 'I', for the Saturday after Easter. The Canon has a large *Crucifixion* (folio 118v), as was traditional, and a half-page miniature of the *Elevation of the Host* (folio 119).

Two distinct artists were involved with this commission. The three Turin volumes and much of the Morgan manuscript are illuminated by the Master of the della Rovere Missals, a French artist working in Rome in the late 1470s and '80s, after which point he returned to France and continued his career there (see cat. 37). The second artist, whose hand is only to be found in the Morgan volume, is the Veronese Francesco Bettini, who drew or painted illuminations on at least twelve folios (2v, 14, 16v, 18, 29, 32v, 42, 48v, 51v, 78v, 81v, 118v). His signature and motto '*Ab olympio*' ('from Olympus') are to be found in the manuscript. The relationship between the work of the two artists, including their sequence as well as their dates, remains a subject of dispute. Gino Castiglioni (1986), theorises that Bettini came in at the end of execution, in the mid-1490s, after the Master of the della Rovere Missals had left the commission. This postulation, however, might be contradicted by three folios (14, 32v, and 51v) that seem to have been painted by the della Rovere Master over drawings by Bettini. An elusive artist, Bettini can be found on only one other leaf, in an Antiphonary in Verona (Biblioteca Civica, MS 739.1, fol. 1).

Bettini's style is both unique and extraordinary. He does not so much paint as he draws. His miniatures are executed in nervous but highly descriptive and decorative pen lines which are then coloured with washes. Numerous putti, lush acanthus and balustrades reveal Bettini's debt to Antiquity, while his style is clearly based on a knowledge of Mantegna. Bettini's style, however, is anything but derivative,

DOMINICA·RESVR
RECTIONIS·DOMINI·

Lectio Epistole Beati Pauli
Apostoli ad Corinthios.

RATRES:
Expurgate uetus
fermentum: ut sitis
noua conspersio: si
cut estis azimi. +

Etenim pasca nostrum immolatus
est Christus. Itaq, epulemur: non in
fermento ueteri: neque in fermento

and, in their attenuated proportions, energetic drapery and exagger-
ated facial expressions, his figures are precursors to Mannerist
developments of the next generation.

The manuscript's present ghostly condition is misleading. Owned
in the 19th century by the collector Derek Jarman, the mansucript was
seriously damaged in a freak flood in his house in 1846. Much of Bet-
tini's delicate colouring has washed away from the outer edges of most
leaves.

Provenance: Cardinal Domenico della Rovere (r. 1478-1501); (?) Edward,
2nd Baron Thurlow sale, London, Christie's, 25 April 1804, lot 296;
Edward Astle sale, London, 10 January 1816, lot 246; William Esdaile sale,
London, Christie's, 15 March 1838, lot 358; John Boykett Jarman sale, Lon-
don, Sotheby's, 13 June 1864, lot 96; purchased by John Pierpont Morgan
(1837-1913) in 1907.

Exhibitions: New York 1924, pl. 6; Paris 1926, no. 222; New York 1934,
no. 142, pl. 94; New York 1964, no. 29; New York 1982, no. 102, fig. 102;
New York 1984, no. 57.

Bibliography: De Ricci 1935-40, II, p. 1424 (with earlier literature); Harrsen
and Boyce 1953, no. 60, pl. 48; Bond and Faye 1962, p. 340; Munby 1972,
pp. 9, 58-61, 75, pl. 9; Needham 1979, pp. 114-17, no. 32, illus.; Voelkle
1980, p. 16, fiche 4C12-4D3; Dykmans 1983, pp. 205-38; Alessio 1984,
pp. 228-9; Quazza 1985, pp. 661, 678; Castiglioni 1986, pp. 76-8, 225, pls
III.35-41; Quazza 1990, pp. 20, 24, 33-5, illus. pp. 28, 33, 34, pl. 11; Paris
1993, p. 290.

<div align="right">R. S. W.</div>

7

Epistolary

48 fols. 282 x 180 mm. On parchment

*Script attributed to Bartolomeo Sanvito of Padua, probably at Padua, early
16th century, with illumination attributed to Antonio Maria da Villafora*

NEW YORK, NEW YORK PUBLIC LIBRARY, ASTOR, LENOX AND TILDEN
FOUNDATIONS, Spencer Collection, MS 7

This Epistolary is the first volume of a two volume set with an Evan-
geliary (both volumes with the same number in the Spencer Collec-
tion). They were written by the famous calligrapher Bartolomeo San-
vito (c. 1435-1512) late in his life, after he had returned from Rome to
his native Padua, where he is documented in 1509. This is the date he
attended to another similar Epistolary and Evangeliary, which were
written for the Canons of Santa Giustina at Monselice (Padua, Bib-
lioteca Capitolare, E. 26-27).

The illuminator can be identified as Antonio Maria da Villafora,
who was very active in Padua in the later part of the 15th century. The
two volumes with the Epistles and Gospels for the major Feasts of the
liturgical year contain miniatures introducing the most important

Feasts. In the Epistolary these are: folio 1v, *Nativity*; folio 7, *Resurrec-
tion*; folio 16v, *Birth of St John the Baptist*. For the Feast of the Birth of
St Augustine, '*patris nostri*', folio 21v, St Augustine is shown enthroned
with his book on his knee and canons in white habits kneeling around
him. In the Evangeliary the miniatures are: folio 2v, for St John, the
Evangelist writing his Gospel; folio 9, for Easter, the *Three Marys at
the Sepulchre*; folio 20, for the Feast of St John the Baptist, again the
Birth of the Baptist. For the Feast of St Augustine, folio 24v, the minia-
ture shows the death of the saint, with the canons kneeling around
dressed in white habits with black cloaks and small cowls. Since St
Augustine is also commemorated in the Antiphons which follow the
Gospel passages, it is clear that the manuscripts were made for a com-
munity of Augustinian Regular Canons. The emphasis on St John the
Baptist suggests that the place in question was San Giovanni di Ver-
dara, which was one of the most important religious houses in Padua
during the Renaissance until its suppression in 1783 by the Venetian
Republic. It remains to be established, however, whether the canons
wore exactly the habit shown in the miniatures.

The attribution to Antonio Maria da Villafora, son of Bartolomeo,
who is mentioned in numerous documents, is based on a comparison
with other works by him, especially the Missal of Bishop Pietro
Barozzi, printed in 1491, but for which the artist was paid in 1494
(Padua, Biblioteca Capitolare, Inc. 260). His style derives from the
'second master' of the Spencer Hyginus (cat. 51), who in turn is close
to Squarcione. It has a more direct relationship to that of the *Decretum
Gratiani* (Ferrara, Museo Civico di Palazzo Schifanoia), illuminated in
1474, probably in Padua, for the Ferrarese monk Niccolò Roverella,
Abbot General of the Olivetan Order, by a group of illuminators also
linked to the same artist of the Hyginus, but more influenced by Fer-
rarese art. Since Villafora is near to Ferrara it is possible that the
illuminator is the same as the Antonio Maria da Ferrara who witnessed
the will of Squarcione in 1468, the fact that he is said to be the son of
Giovanni being explicable as a mistake by the notary.

The miniatures are surrounded by curvilinear foliage frames with
fantastic animals, another link to the animal paintings by the 'second
master' of the Hyginus. Since Antonio Maria, according to the docu-
ments, died in 1511 the two niello medallions on the binding of the
Epistolary with portraits and coat of arms of Pope Leo X (r. 1513-1521)
must be a later addition. The same is true of the similar medallions of
Pietro Bembo, secretary of Leo X from 1513 to 1519 and Cardinal in
1539, on the Evangeliary. It may be noted that San Giovanni di Verdara
had a very rich collection of medals and other metalwork.

Provenance: Leopoldo Cicognara, Venice; sold to Zonzi, London,
Sotheby's, 20 June 1860, lot 316; Sir William Tite sale, London, Sotheby's,
1874, lot 1769, to Quaritch; bought by Henry Huth (catalogue, 1880, III,
p. 829); bought by Quaritch at the Huth sale, London, 1914, IV, lot 4269;
bought from Quaritch by Spencer, 1919.

Bibliography: De Ricci 1935-40, II, p. 1337; Alexander and de la Mare 1969,
p. 109; Mariani Canova 1969, pp. 96, 134-5, 163, no. 117, figs 181-2, 184-5.

<div align="right">G. M. C.</div>

Renaissance Patrons and Libraries

Italy in the 15th century was a mosaic of small territorial areas under differing political control, and many of these were ruled by patrons who encouraged the production of manuscripts by personally employing scribes and illuminators at their courts. Such were the d'Este of Ferrara (cats 18-20), the Gonzaga of Mantua (cats 21-2), the Malatesta of Rimini (cat. 30), the Bentivoglio of Bologna (cat. 24), and, most remarkably of all, Federigo da Montefeltro of Urbino (cats 36, 60, 62, 64). The largest and most prosperous centres of population, for example Venice, Milan, Rome and Naples, were homes to large numbers of independent craftsmen of the book trade, who might supply illuminated manuscripts to patrons throughout the peninsula and even to an international clientele. This was above all true of Florence, as in the manuscripts supplied to Matthias Corvinus, King of Hungary (cat. 13), to King Manuel of Portugal (cat. 1) and to Thomas James, Bishop of Dol (cat. 3).

These leading patrons signalled their ownership by inserting their heraldic coats of arms, their mottoes and their emblems (*imprese*). They also made use of existing pictorial conventions of presentation scenes of a new text or translation, in order to preface their copies with portraits of themselves, their wives, families and courtiers (cats 8, 10, 13, 14, 20, 24, 27, 29, 36, 37).

The size and splendour of the libraries built up by the greatest patrons, abaove all the Visconti-Sforza Dukes of Milan (cats 14-17) and the Aragonese Kings of Naples (cats 8-12), as well as the scale of expenditure by all these patrons was unprecedented. It was typical of the Medici in Florence that their patronage was more indirect, such as Cosimo de' Medici's funding of the library at the Badia Fiesolana (cat. 120). Individual Medici, however, owned important libraries (cats 34, 35), and Lorenzo de' Medici in particular commissioned a remarkable series of Books of Hours to celebrate his daughters' weddings (cats 31-3).

8

Filelfo, *Satires*

201 fols. 342 × 245 mm. On parchment [London only]

Written in Milan, c. 1453, by the scribe 'G.G.', with illumination attributed to the Master of the Vitae Imperatorum

VALENCIA, BIBLIOTECA GENERA DE LA UNIVERSIDAD, MS 398 (G. 1791)

The humanist Francesco Filelfo (1398-1481) finished the text of the *Satires* in 1448 according to the colophon on folio 198v of this manuscript ('*extremam manum ... apposuit ... MCCCXLVIII*'). He had been appointed to a chair at Florence in 1429 but left in 1434 for Milan, where he enjoyed the patronage of the Visconti-Sforza.

The Valencia copy of the *Satires*, made for presentation to Alfonso V of Aragon (Alfonso I of Naples; *d.* 1458) and sent to him in 1453. On folio 2 his arms are framed at the top of the page and flanked by putti as if in a landscape. In the initial 'I' below, Filelfo is shown kneeling before the enthroned King, who receives the book from him. The upright of the letter is formed of an armed crowned figure, no doubt also in compliment to Alfonso. Below in the border are Filelfo's arms and initials.

The style is that of the artist named by Pietro Toesca in 1912 after a manuscript of Suetonius in Paris, the Master of the Vitae Imperatorum. The larger initials of eight to eleven lines for each Decade make use of a type of frilly white vine-stem scroll typical of this artist: folio 21v, 'H'; folio 41v, 'I'; folio 61, 'Q'; folio 80v, 'M'; folio 100v, 'N'; folio 120, 'S'; folio 139v, 'D'; folio 159v, 'I'; folio 179 'L'. The letters in gold are constructed imaginatively of a variety of motifs, among them a tower, angels, a dragon, and a naked human. Albinia de la Mare (1983) has attributed the script to the scribe 'G.G.'.

Provenance: Arms of Alfonso V of Aragon and I of Naples (*d.* 1458). De Marinis 1947-52, II, inventories B, no. 84, G, no. 438; bequeathed to San Miguel de los Reyes, Valencia, by Ferdinand of Aragon, Prince of Taranto, in 1550.

Bibliography: Gutiérrez del Caño 1913, no. 1791; Bordona 1933, II, no. 2069; De Marinis 1947-52, I, p. 7, II, p. 73, pl 100 (as Valencia, MS 772); I. Toesca 1969, p. 76 n. 11; de la Mare 1983, pp. 404, 406 n. 27; Melograni 1990, pp. 298, 314 n. 173.

J. J. G. A.

8 folio 2r

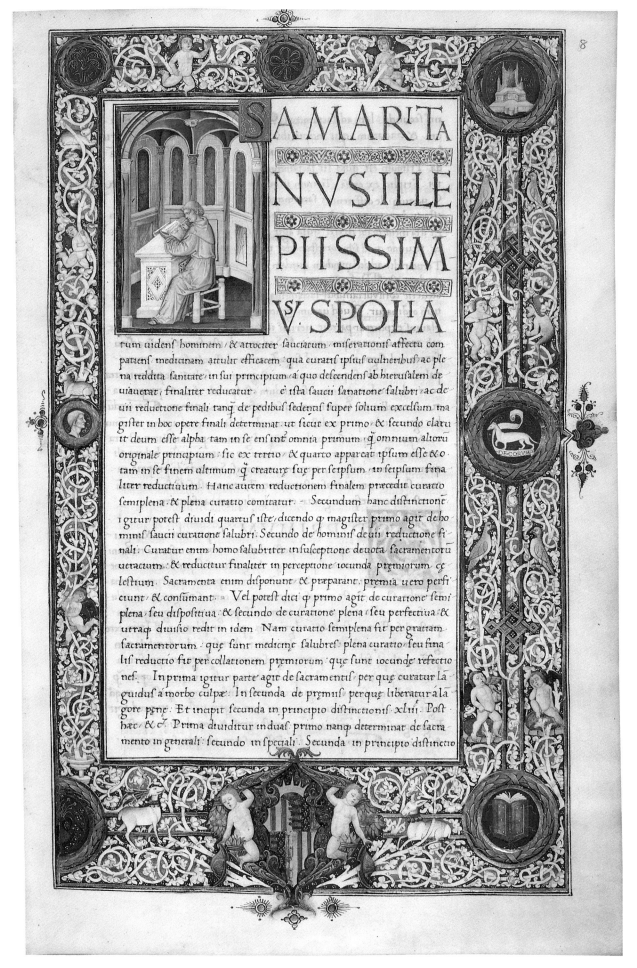

SAMARITA NVS ILLE PIISSIMVS SPOLIA

rum uidens hominem / & atrociter fauciatum miferationis affectu com
patiens medicinam attulit efficacem qua curatis ipfius ualneribus ac ple
na reddita fanitate in fui principium / a quo defcendens ab hierufalem de
uiauerat / finaliter reducatur · è ifta faucii fanationis falubri / ac de
uii reductione finali tanq̃ de pedibus fedentis fuper folium excelfum ma
gifter in hoc opere finali determinat / ut ficut ex primo & fecundo claru
it deum effe alpha / tam in fe ens int omnia primum q̃ omnium alioru
originale principium / fic ex tertio & quarto appareat ipfum effe & o
tam in fe finem ultimum q̃ creature fue per feipfum / in feipfum fina
liter reductiuum · Hanc autem reductionem finalem præcedit curatio
femiplena · & plena curatio comitatur · Secundum hanc diftinctione
igitur poteft diuidi quartus ifte / dicendo q̃ magifter primo agit de ho
minis faucii curatione falubri: Secundo de hominis deuii reductione fi
nali: Curatur enim homo falubriter in fufceptione deuota facramentoru
ueracium · & reducitur finaliter in perceptione iocunda premiorum ce
leftium · Sacramenta enim difponunt & præparant / premia uero perfi
ciunt & confumant · Vel poteft dici q̃ primo agit de curatione femi
plena feu difpofitiua / & fecundo de curatione plena feu perfectiua · &
utraq̃ diuifio redit in idem · Nam curatio femiplena fit per gratiam
facramentorum / que funt medicine falubres: plena curatio feu fina
lis reductio fit per collationem premiorum que funt iocunde refectio
nes · Inprima igitur parte agit de facramentis per que curatur la
guidus a morbo culpæ · In fecunda de premis perque liberatur a la
gore pene · Et incipit fecunda in principio diftinctionis xliii · Poft
hæc & c̃ · Prima diuiditur in duas: primo nanq̃ determinat de facra
mento in generali / fecundo in fpeciali · Secunda in principio diftinctio

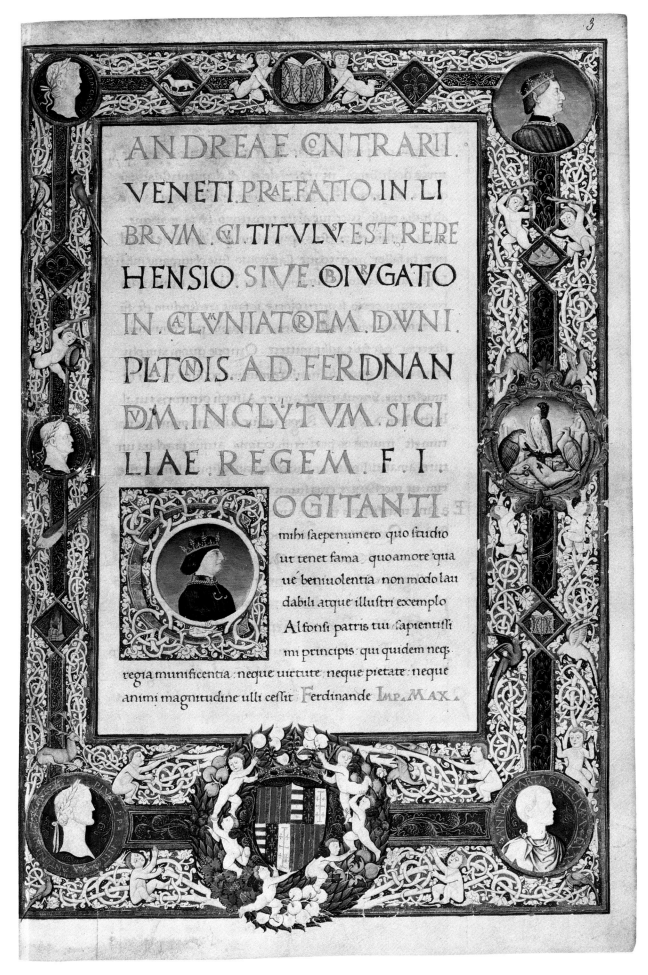

ANDREAE·CNTRARII·
VENETI·PRAEFATIO·IN·LI
BRVM·CI·TITVLV·EST·RERE
HENSIO·SIVE·ɔIVGATO
IN·CCLVNIATᴿEM·DVNI·
PLꜰTOIS·AD·FERDNAN
DM·INCLYTVM·SICI
LIAE·REGEM·F·I·
OGITANTI·
mihi saepenumero quo studio
ut tenet fama· quo amore·qua
ue beniuolentia· non modo lau
dabili atque illustri exemplo
Alfonsi patris tui sapientissi
mi principis·qui quidem neq;
regia munificentia· neque uirtute· neque pietate· neque
animi magnitudine ulli ceßit Ferdinande IMP·MAX·

10 folio 2r

9

Duns Scotus, *Quaestiones* on the *Sentences* of Peter Lombard, Book IV: *Distinctiones* 1-16

269 fols. 423 x 279 mm. On parchment

Written in Naples, c. 1480-5, by Pietro Ippolito da Luni, and illuminated by Cola Rapicano

LONDON, THE BRITISH LIBRARY, Additional MS. 15273

This is one volume of a set of which another four volumes survive, three in the British Library (Additional MSS 15270-15272), and the fourth in Paris (Bibliothèque nationale, latin 3063; De Marinis 1947-52, II, pp. 147-8, IV, pls 217-8). They were all finely illuminated, though the illuminated opening folios of volumes II and III in London are missing. In the present volume a circular title-page, rendered as if suspended on ropes, folio 7v, is placed opposite the beginning of the text, folio 8, where a miniature shows a tonsured scribe in a white habit writing at a table in a vaulted interior. In roundels in the four sided white vine-stem border framing the text are the emblems of King Ferdinand of Naples, the ermine with '*Decorum*', the flaming throne, the open book and the vase of flowers. His arms surmounted by a crown are supported by putti in the centre of the lower border. There are white vine-stem initials eight or nine lines high to the remaining *Distinctiones* and numerous other white vine-stem initials of five lines.

Payments to Pietro Ippolito da Luni (Lunense) for writing the volumes occur in the royal accounts in 1480-1 (De Marinis 1947-52, I,

pp. 271-7, docs 571, 617, 621). He signs his name on the present title-page and says he is writing on the order of King Ferdinand 'while turbulent warfare grips Italy', presumably referring to the successful Turkish campaign of Alfonso, Duke of Calabria, in 1481. The putti are characteristic of the illuminator Cola Rapicano, documented as active in Naples from 1451 and responsible for the illumination of many manuscripts for the Royal Library. A payment in 1488 to Filippo Rapicano, Cola's son, refers to work done on the set of volumes and particularly to an initial 'Q' with '*Scotto che sta studiando*', that is the first initial in the Paris volume, for which 3 ducats 3 *tari* are to be paid (Delisle 1868-81, III, p. 360; De Marinis 1947-52, II, p. 288, doc. 723).

Provenance: King Ferdinand I of Naples (r. 1458-1494); De Marinis 1947-52, II, inventories A, no. 388, C, nos 93, 95-7; acquired from King Frederick III of Naples (d. 1504) by Cardinal Georges I d'Amboise (d. 1510); listed in his inventory of 1508 at the Château de Gaillon (Delisle 1868-81, I, pp. 226, 237, nos 92-7), 'De Gaillon' on the endleaf of the present volume; Jesuit College of Clermont in Paris, *paraphé* mark and catalogue of 1764; Jan Meerman catalogue, IV, 1824, p. 80, no. 482; acquired by the British Museum at the sale of the library of the Duke of Sussex, London, Sotheby's, 31 July 1844, lot 226.

Bibliography: *Reproductions from Illuminated Manuscripts* 1925, pl. XXXVIII; De Marinis 1947-52, II, p. 147.

J. J. G. A.

10

Andrea Contrario, *Reprehensio sive objurgatio in calumniatorem divini Platonis*

149 fols. 325 x 225 mm. On parchment [New York only]

Written in Naples, 1471, by Giovanmarco Cinico, and illuminated by Cola Rapicano

PARIS, BIBLIOTHÈQUE NATIONALE, latin 12947

This text is an attack on the Latin translations of Plato made by George of Trebizond and is the dedication copy to Ferdinand I, King of Naples (r. 1458-1494). Payments in the royal accounts for 1471 name the scribe, Giovanmarco Cinico of Parma, who signs the manuscript on folio 145v: '*Ioannes Marcus*'. A later payment in November of the same year names the illuminator, Cola Rapicano, as responsible for three openings. Works by him for the King are known from payments as early as 1451 (see cats 9, 106). He died in 1488. The illumination cost rather over 4 ducats and the writing rather over 9 ducats.

The manuscript is prefaced by a bifolium of purple-stained parchment. On folio 2 is painted on the purple vellum an equestrian portrait of the King. This recalls both Antique monuments like the famous Marcus Aurelius in Rome and also contemporary equestrian portraits, cast in bronze like Donatello's *Gattamelata* in Padua, or painted like Uccello's *Sir John Hawkwood* in Florence Cathedral. Another equestrian portrait of the King, also on purple vellum, occurs in a Cicero in Vienna (Österreichische Nationalbibliothek, Cod. 3). On folio 2v the title of the work is written in Greek with decoration and putti surrounding it. There is a four sided white vine-stem border on folio 3, with six figure medallions. Reading from top right, clockwise, they show a portrait bust of King Alfonso of Naples, Ferdinand's father, an eagle with a fawn and other birds of prey, and then Classical coin-type or cameo busts of Hannibal, Antoninus Pius, Galba and Nero. Ferdinand is addressed on the last line of the text of this page as '*Imp. Max*'. In the white vine-stem initial 'C' of the text, the King is again shown half-length in a roundel. The portrait of Alfonso and the scene with the eagle below are copied from the medal of the King by Pisanello (Hill 1930, no. 41). The portrait of Ferdinand resembles that on an anonymous medal (Hill 1930, no. 326). The border is inhabited by putti, animals and birds, and in the lower border the royal arms are surrounded by six putti. Royal *imprese* – the ermine, the flaming throne and an open book – are also included in the border.

On folio 10v is a second title written in coloured capitals in Greek, and on folio 11 is an initial 'C' which encloses a portrait of Contrario, also based on a medal (Hill 1930, no. 503). The four sided border is decorated with foliage and flowers with a hair-line scroll inhabited again by putti. In roundels are seven portraits of philosophers, including at the top right Cardinal Bessarion, the author of *In calumniatorem Platonis*, another attack on George of Trebizond. On folio 127 an Epilogue also has a four sided border with scroll and putti and an initial 'T'. Here and on folio 11 the arms in the lower border are no doubt those of Contrario, who was of a Venetian family and had come to Naples in 1471 after the death of the Venetian Pope Paul II (see King 1986, pp. 352-3). De Marinis notes that two contemporaries refer to Contrario as an artist and suggests he may have participated in the decoration of the present manuscript. However, the style seems uniform and characteristic of Rapicano. For some manuscripts with illumination in a different style attributed to Contrario, see Mantovani, Prosdocimi and Barile 1993.

Provenance: King Ferdinand I of Naples (r. 1458-1494) with his arms, folio 3; De Marinis 1947-52, II, inventories B, no. 140, C, no. 83; acquired from King Frederick III of Naples (d. 1504) by Cardinal Georges I d'Amboise; listed in his inventory of 1508 at the Château de Gaillon (Delisle 1868-81, I, p. 236, no. 83); René, comte de Sanzay; Chancelier Pierre Séguier; bequeathed in 1732 by Henri-Charles du Cambout, duc de Coislin, Bishop of Metz, to St-Germain-des-Près, Paris; thence to the Bibliothèque nationale during the French Revolution, 1795-6.

Exhibition: Paris 1984, no. 154, illus.

Bibliography: Couderc 1908, pl. XCI; De Marinis 1947-52, I, pp. 48, 146, II, pp. 53, 255 (docs 381-2), III, pls 74-8; Putaturo Murano 1973, p. 26, pl. XIc, d.

J. J. G. A.

11

Virgil, *Eclogues, Georgics, Aeneid,* with Servius' commentary

328 fols. 433 x 285 mm. On parchment [New York only]

Written in Milan, 1465, with illumination attributed to the Master of Ippolita Sforza

VALENCIA, BIBLIOTECA GENERAL DE LA UNIVERSIDAD, MS 891 (G. 2401)

On folio 1 the Life of Virgil is introduced by an initial 'P' with a three-quarter length profile portrait of Ippolita Maria Sforza (1446-1488), daughter of Francesco Sforza and Bianca Maria Sforza, Duke and Duchess of Milan. She was betrothed to Alfonso, Duke of Calabria, son of Ferdinand of Aragon, King of Naples, in 1455 and the couple were married in 1465. The upright of the letter is a column and the bowl a biting dragon in reference to the *biscia* (dragon) of the Visonti. Ippolita holds a phoenix by a leash. The border is filled with repeated white doves with the motto 'A bon droit' and crowns with palms, both Visconti-Sforza *imprese*. Below in the centre are the Visconti-Sforza arms and crests with the name '*Hyppolita Maria*' and another *impresa*, the *morso* (bridle), painted in gold.

On folio 4v the commentary of the 4th-century grammarian Servius opens with an initial 'B' in which is another similar profile portrait of Ippolita. For the *Eclogues* the opening initial 'T' shows two shepherds, Tityrus and Meliboeus, with their flocks of sheep and cows. Initials for each succeeding *Eclogue* are decorated with further Visconti-Sforza *imprese* and Milanese style white vine-stem scroll: folio 8, 'F'; folio 10, 'D'; folio 13v, 'S'; folio 17, 'P'; folio 19v, 'F'; folio 21v, 'P'; folio 24, 'Q'; folio 25, 'E'. The interior of the initial 'Q' of *Georgics* I, folio 28v, is divided into four sections in which are scenes of ploughing with a pair of oxen, of pruning the vines, of a figure riding a horse and another with an ox, and of bee-keeping. The other three books are introduced by similar initials: folio 41v, 'H'; folio 55, 'T'; folio 68, 'P'.

An 'I' on folio 81 introduces Servius' preface to the *Aeneid* and on folio 82, Book I opens with an initial 'A' in which, above, a seated Virgil is shown frontally, writing; below a warrior rides a horse on whose caparison the Visconti-Sforza emblems again appear. A smaller initial 'R' below contains another *impresa*, the dog and tree. The initials of the other eleven books include various of the family *imprese* and mottoes (folios 110, 129v, 149v, 167, 185v, 212v, 231, 250v, 268, 288v, 310).

The manuscript is dated '*1465 V Kalendas Iunii*', folio 328, and listed as among the wedding gifts with which Ippolita left Milan for Naples on 10 June 1465, arriving in Naples on 14 September. It was valued at 80 ducats. From this and other manuscripts owned by Ippolita, the illuminator is named the Master of Ippolita Sforza. His style owes much to the Master of the Vitae Imperatorum (cat. 8).

Provenance: Ippolita Maria Sforza (1446-1488), with her arms and *imprese*; De Marinis 1947-52, II, inventories B, no. 74, G, no. 310; Cherchi and De Robertis 1990, inventory of 1527; bequeathed to San Miguel de los Reyes, Valencia, by Ferdinand of Aragon, Prince of Taranto, in 1550.

Bibliography: P. Toesca 1912, p. 539; Gutiérrez del Caño 1913, no. 2401, pl. XXX; Bordona 1933, II, no. 2114, figs 729-32; De Marinis 1947-52, I, pp. 98-9, II, p. 173, pls 266-8 (as Valencia, MS 780); Pellegrin 1955, pp. 401-2; de la Mare 1983, pp. 404, 406 nn. 27, 30.

J. J. G. A.

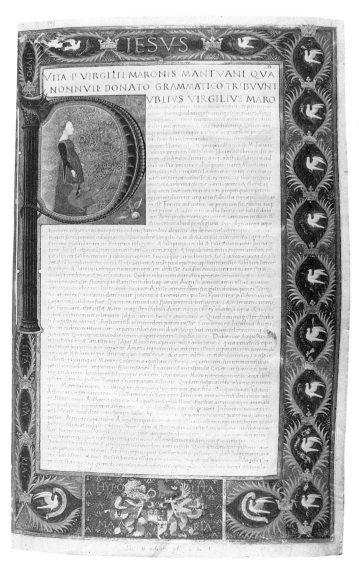

11 folio 1

12

Book of Hours, Use of Rome

411 fols. 253 x 175 mm. On parchment

Written in Naples, c. 1480, with illumination attributed to Matteo Felice

LONDON, VICTORIA AND ALBERT MUSEUM, L. 2387-1910

The manuscript is richly illuminated with miniatures, borders and historiated initials. The larger miniatures, of which there are 14, are inserted in the upper part of the folio, each with a four sided white vine-stem or flower and foliage border inhabited by putti, animals, birds and insects. Fine quality gold filigree work is featured in these borders. There are also 21 historiated initials with single sided borders.

On folios 400, 402v, 403 and 403v the name '*Galiacius*' is included in prayers. The suggestion that this is Galiaccio Tarsia made in 1908 (London 1908, no. 184) is not supported by the traces of the original coat of arms, visible on folio 14v, which contained a *fess*, not part of the Tarsia arms. The present arms painted over the original shield are those of Alfonso, Duke of Calabria, who succeeded as Alfonso II of Naples in 1494 and died in 1495. Many of his manuscripts are now in Valencia (see cats 65, 75-6, 106).

The Hours begin after the Calendar on folio 14 with a miniature of the *Annunciation* for Matins; in the border below, the arms of Calabria-Aragon are painted over an earlier, smaller shield. There are historiated initials for the different Hours: folio 20, Lauds, 'D', *Visitation*; folio 27, Prime, 'D', *Adoration of the Magi*; folio 32, Terce, 'D', *Resurrection*; folio

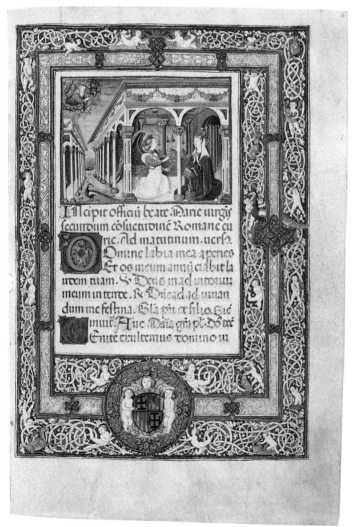

34v, None, 'D', *Ascension*; folio 36v, Vespers, 'D', *Pentecost*; folio 41, Compline, 'C', *Assumption of the Virgin*. On folio 54 a miniature prefacing the Penitential Psalms shows David killing Goliath and, in a roundel below, David in penance. On folio 68 for Matins of the Hours of the Passion, the *Betrayal* is depicted; in a roundel below is the *Agony in the Garden*. Historiated initials for the various Hours again follow: folio 73v, Lauds, 'D', *Christ before the High Priest*; folio 76v, Prime, 'D', *Flagellation*; folio 79v, Sext, 'D', *Crucifixion* with the two thieves; folio 82v, None, 'D', *Crucifixion* with Mary and John; folio 86, Vespers, 'D', *Deposition*; and folio 88v, Compline, 'C', *Entombment*. For the Office of the Dead, folio 91, a miniature shows the vigils over the coffin inside a church with two small roundels in the border with figures of Death. From folios 117 to 393 are Breviary Offices of the Temporale. On folio 117, Matins of the Office of the Nativity is introduced by a miniature of the *Nativity* in a cave with the shepherds adoring the child; this is followed by a historiated initial for Lauds, folio 139v, 'D', *Annunciation to the Shepherds*. The Passion narratives of the Four Gospels have initials with small minatures of Saints Matthew, Mark, Luke and John, folios 157, 167, 175v, and 183v. Three miniatures for the Offices for Holy Week on folios 191, 221 and 249 are unusual in showing the siege and capture of Jerusalem by Titus. No doubt they refer to the recurrent plans for a Crusade and more specifically to the title of King of Jerusalem claimed by the Kings of Naples. On folio 274 for Easter Saturday there is a miniature of the *Creation* and for Easter Day, folio 297, another of the *Resurrection*. On folio 303v for Lauds, the *Resurrection* is shown in a 'D'. On folio 311 there is a miniature of the *Ascension*, on folio 327 of the *Pentecost*, on folio 336 of the *Trinity*, and on folio 351, Corpus Christi, a miniature of the Passover with the *Last Supper* in a small roundel in the border. The Athanasian Creed has an initial 'D' with St Athanasius as Bishop shown half-length, folio 393v.

The illumination can be attributed to the Neapolitan, Matteo Felice, first documented in 1467 with payments in the royal accounts recorded in 1491-3.

Provenance: Arms of unidentified original owner, Galiacius, painted over with those of Alfonso II of Aragon (*d.* 1495); in the Spitzer collection (Müntz 1890-2, V, p. 146, pl. VI); bequeathed in 1910 to the Victoria and Albert Museum by George Salting, no. 1224.

Exhibitions: London 1908, p. 92, no. 184, pl. 123; London 1980, no. 35, illus; Brussels 1985, no. 45, illus.

Bibliography: De Marinis 1947-52, I, p. 158, pls 40-3, II, pp. 113, 324, pl. 14; Ker 1969, p. 389.

J. J. G. A.

13

Didymus Alexandrinus, *De spiritu sancto,* and eleven other texts

225 fols. 345 x 230 mm. On parchment

Written, signed and dated 4 December 1488 in Florence by Sigismondo de' Sigismondi, with illumination attributed to Monte di Giovanni di Miniato

NEW YORK, THE PIERPONT MORGAN LIBRARY, M. 496

Matthias Corvinus (1443?-1490), King of Hungary, himself a great bibliophile, is credited with the introduction of humanism into that country. His large library at Buda probably contained several thousand volumes, and his goal, as related by his Italian librarian, Bartholomaeus Fontius, was to outshine every other monarch. His early death doubtless left the claim unrealised. To date, 216 codices from the Bibliotheca Corviniana, mostly manuscripts, have been identified. Of these, the Morgan Library owns two, a Cicero (M. 497) acquired by Matthias second-hand, and this volume, which was made for him. It was written by Sigismondo, who also wrote another manuscript for Corvinus the same year (Vienna, Österreichische National-

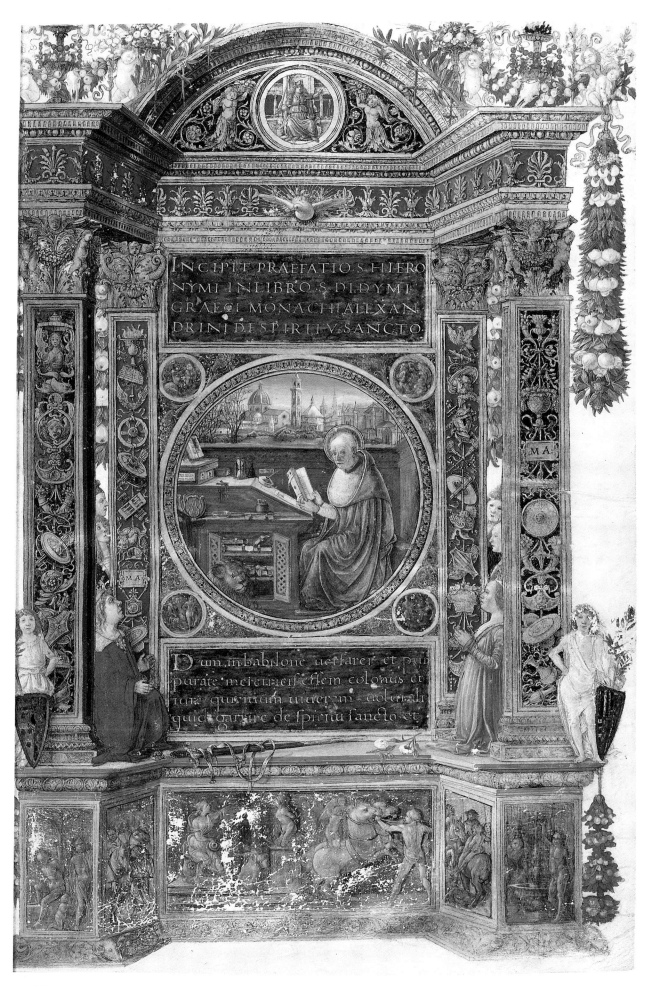

INCIPIT PRAEFATIO S HIERO
NYMI IN LIBRO S DIDYMI
GRAECI MONACHI ALEXAN
DRINI DE SPIRITV SANCTO.

Dum in babilone uerfarer et pur
purate meretricis essem colonus et
iure quiritium uiuerem colui ali
quid garrire de spiritu sancto et

bibliothek, Cod. 930), and illuminated by Monte di Giovanni di Miniato (1448-1529), who, with his brother Gherardo (*c.* 1444-1497), was responsible for at least five manuscripts made for the King.

The opening text (folio 2), St Jerome's preface to the Didymus work, is embellished by a grand trompe-l'œil architectural frame decorated with gilt Classical trophies, Antique reliefs and medallions, and garlands. At the centre, depicted as a humanist scholar, Jerome peers at the viewer through a circular window; the subject echoes the famous Eyckian *Jerome* then in the Medici collection (Garzelli 1984). Behind Jerome rises a view of Florence, including the Cathedral, its campanile and baptistery, and San Lorenzo. Above and below the window, simulating carved inscriptions, are the title and opening words of the preface written in gold. Above the top panel hovers an illusionistically rendered dove emitting flames, symbol of the Holy Spirit and subject of the Didymus text; in the roundel above sits Justice. Peering from behind the column at the left is Matthias Corvinus, whose sword is displayed in front of him and whose initials, 'M[atthias] A[ugusto],' appear on the pilaster. Behind him are his son, John, and his tutor, Taddeo Ugoleto, the King's librarian before Fontius. At the right column is Queen Beatrice, possibly accompanied by her father (King Ferdinand I of Naples) and Ferdinand's second wife (Juana of Aragon). Beatrice wears the golden sash of the Dragon Order chartered by King Sigismund in 1408. Two youths on either side of Corvinus and Beatrice hold shields with their respective arms. Below are Classical reliefs: Apollo and Marsyas, an allegory of the conflict between flesh and spirit; Earthly Love purified by the fires of Celestial Love; and

Apollo at the Castalian Fountain. The Apollo and Marsyas is based on a famous Medici cameo, the one worn by a young woman in her portrait from Botticelli's workshop (Frankfurt, Städelsches Kunstinstitut). The second allegory is very close to a cassone fragment in the Wallace Collection (London) now attributed to the Master of Santo Spirito (formerly given to Piero di Cosimo) and a medal in Berlin attributed to Bertoldo di Giovanni.

The rest of the manuscript's decoration is modest: a circular table of contents (folio 1v) with four roundels containing emblems of Corvinus (a crow [*corvus*] with a gold ring, an hour-glass, a flint and steel, and a fountain); a historiated initial with a dove emitting rays above St Didymus and a border with Apollo and Marsyas (folio 37); and four large illuminated initials with borders, all but the first with a blue shield with a crow (folios 38, 51, 92, 93).

Provenance: Matthias Corvinus, King of Hungary; (?)Beatrice of Aragon; Louise Charlotte de Bourbon, daughter of Lodovico, Duke of Parma, who bequeathed it in 1855 to the Jesuit College at Wien-Lainz; purchased by John Pierpont Morgan (1837-1913) in 1912.

Exhibitions: New York 1923, no. 112; New York 1924, p. 15, pl. 7; Paris 1926, no. 281; New York 1934, no. 123, pl. 85; Brooklyn 1936, no. 72, pl. 72; New York 1939, no. 29; New York 1940, no. 33; New York 1980, no. 17; Schallaburg 1982, no. 408 (photo exhibited); New York 1984, no. 47; Budapest 1990, no. 56, pl. XCIX.

Bibliography: De Ricci 1935-40, II, p. 1461 (with earlier literature); Harrsen and Boyce 1953, no. 71, pl. 49; Bond and Faye 1962, p. 347; Csapodi 1973, pp. 203-4, no. 224; Voelkle 1980, pp. 28-9, fiche 7C2-7C4; Garzelli 1984, p. 349; Garzelli and de la Mare 1985, pp. 310-12, 467-8, 534-6, pl. XII, figs 919-23; Ingamells 1985, p. 315; R. M. San Juan 1989, pp. 76-7, pl. 22b; Cologne 1992, p. 356.

W. M. V.

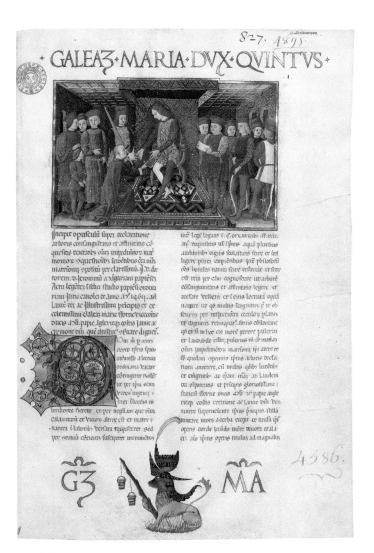

14 folio 1r

14

Girolamo Mangiaria, *De impedimentis matrimonii*

58 fols. 340 x 235 mm. On parchment [New York only]

Written by Jeronimus de Murigiis and illuminated in Milan, c. 1465-76

PARIS, BIBLIOTHÈQUE NATIONALE, latin 4586

This is a dedicatory copy of a text on the Church's regulations concerning matrimony, the rules as to who can and cannot marry if they are related by blood (consanguinity) or by marriage (affinity). The miniature on folio 1 shows the presentation of the manuscript by the author, Girolamo Mangiaria, a jurist at the University of Pavia, to Galeazzo Maria Sforza, Duke of Milan (r. 1466-1476). The work is dated 1465, but this copy must have been made after the death of Francesco Sforza in March 1466, since his son, Galeazzo Maria, is referred to as Duke in the dedication in gold letters above the miniature. Since the manuscript does not appear in the inventory of the library at Pavia taken in 1469, it may be even later. Both dedicatee and author appear to be portrait likenesses. The boy on the left is presumably Galeazzo's son, Gian Galeazzo (1469-1494), perhaps with his tutor, which also implies a later date for the manuscript. There is an initial 'D' formed of the twisted '*Biscia*', the blue dragon swallowing a red giant, emblem of the Visconti of Milan. Below in the border is one of Galeazzo's *imprese*, the helmed lion seated on a brazier with the motto '*Hic Hof*' and flanked by his initials 'GŽ MĀ. At the end of the manuscript on folios 55 and 56 are the diagrams known as the Tables of Consanguinity and Affinity, which list the prohibited degrees, and which had been set out in this form already in canon law texts from the 11th century.

Scenes of the presentation of books by authors or translators to secular rulers become frequent in the 14th and 15th centuries. Many show members of the French royal family, especially Charles V, a notable patron of scholars and translators, and his Valois brothers. The scene

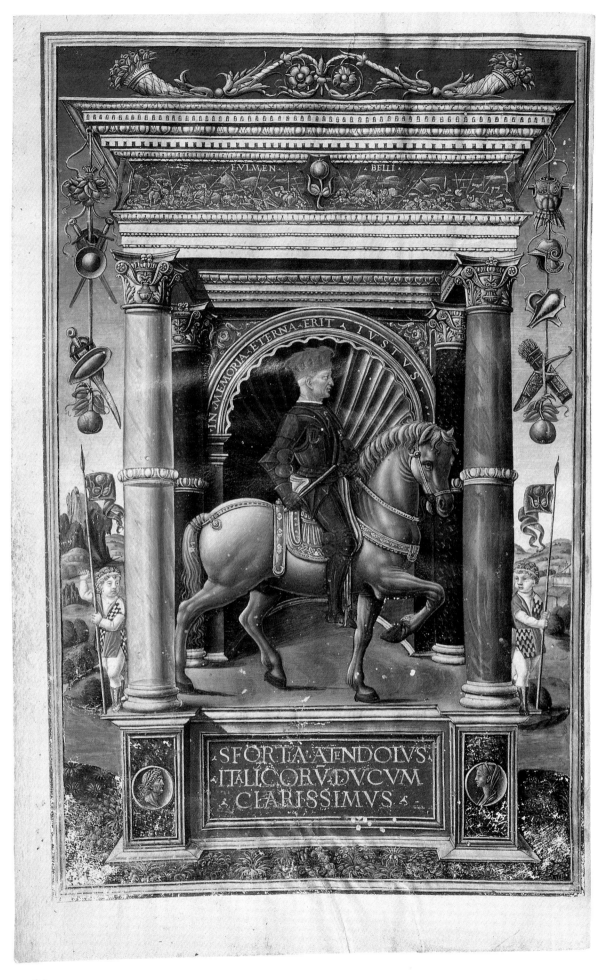

FVLMEN BELLI

IN MEMORIA ETERNA ERIT IVSTVS

SFORTIA ATENDOLVS
ITALICORV DVCVM
CLARISSIMVS

15 folio 4v

here follows in this tradition. It is shown in an interior space with a coffered ceiling. The illuminator's style is recognisable from his facial types and his palette. A number of other works by him are known, including the Hours of Cecilia Gonzaga (cat. 23), a Book of Hours formerly in the Major J. R. Abbey collection (MS 6960) and an Hours in the Bibliothèque nationale, Paris (Smith Lesouëf 22), where he collaborates with another artist. So far he remains anonymous. The text is written in a Gothic script and on folio 54 at the end of the text is: '*Ego Jeronimus de Murigiis scripsi*'.

Provenance: Galeazzo Maria Sforza, Duke of Milan (r. 1466-1476); taken from the ducal library at Pavia by Louis XII of France and the French invading army in 1499 ('*de Pavye au roy Loys XII*', folio 54).

Exhibitions: Milan 1958, no. 275; Paris 1984, no. 137.

Bibliography: Couderc 1908, p. 36, pl. LXXXVI; Malaguzzi Valeri 1913-23, I, p. 359, fig. 3, III, p. 128; Pellegrin 1955, pp. 393-4; Samaran and Marichal 1962, II, p. 229, pl. CXXXV; Alexander and de la Mare 1969, p. 149 n. 6; Pellegrin 1969, p. 44, fig. 35, pl. 142.

<div align="right">J. J. G. A.</div>

15

Antonio Minuti da Piacenza, *Vita di Muzio Attendolo Sforza*, in Italian

114 fols. 330 x 220 mm. On parchment [London only]

Written in Milan, 1491, by Bartolomeo Gambagnola of Cremona with illumination attributed to the Master B. F. and Antonio da Monza (?)

PARIS, BIBLIOTHÈQUE NATIONALE, ital. 372

The life of the founder of the Sforza family fortunes, the celebrated *condottiere*, Muzio Attendolo (*d.* 1424), was written by Antonio Minuti in 1458 for Muzio's son, Francesco Sforza (1401-1466). In 1441 Francesco married Bianca Maria, the daughter of the last Visconti Duke, Filippo Maria, and seized the Duchy in 1450 after Filippo Maria's death in 1447. This copy of the life was made in 1491 for Lodovico il Moro, Francesco's younger son, who was born in 1451 and who at this moment was acting as regent for his nephew, Gian Galeazzo Sforza (*b.* 1469). Lodovico became Duke himself on Gian Galeazzo Sforza's death in 1494, and in 1499 he was expelled from the Duchy by the French army. He died in exile in France in 1508.

The Prologue, folio 1, has a panel frame with candelabra on each side and in the lower border a medallion portrait of Lodovico il Moro, as Duke of Bari, supported by two putti. His arms, emblems and mottoes decorate the border and the initial 'H' (see Pellegrin 1955, for the emblems). On folio 4v an architectural triumphal arch set in a landscape frames an equestrian figure of Muzio Attendolo Sforza. Putti on either side hold his banners. On the architrave is a gold chiaroscuro frieze inscribed '*Fulmen belli*' showing the aftermath of battle, with the dead and their horses lying on the ground. Inscriptions below read: '*In memoria eterna justus*' and '*Sfortia Atendolus Italicorum ducum clarissimus*'. On the opposite recto, folio 5, a foliage border with putti, dragons, birds, etc. has Lodovico's coat of arms held by putti in the centre below; his emblems and mottoes appear in the centre above with the Moor's head with turban, alluding to his nickname. A portrait bust of Muzio Attendolo in a small square with the letters in gold 'SF. ATE' introduces the text, with the initial 'P' in gold above to the right.

Larger initials of between four and seven lines are rendered as faceted capitals on green, blue and crimson grounds, two with gold scroll letters ('M', folio 12v, and 'D', folio 15) and others plain (folio 34, 'Q', folio 43, 'S', folio 88, 'A', folio 93, 'Q', and folio 107v, 'S'). There are numerous smaller two line initials in gold on coloured grounds.

A colophon on folio 111v gives the name of the scribe, Bartolomeo Gambagnola of Cremona, who completed the manuscript on the order of Marchisino Stangha, secretary to Lodovico il Moro, on 20

September 1491. The attribution of the illumination has proved problematic and a number of suggestions have been put forward. There appear to be two illuminators involved, one responsible for folio 1, the other for folios 4v-5. The second illuminator has been thought to be Giovan Pietro Birago, who is documented from his work on the Sforza Hours (London, The British Library, Additional MS 34294). However Birago's style is more sculptural and Mantegnesque both there and in other generally accepted works (cat. 16). Another more recent suggestion (Lodigiani 1991) is to identify the artist with the young Matteo da Milano (cat. 128). A third (Avril, in Paris 1984) is to see him as the illuminator who signs his name B. F. on a cutting in the Pierpont Morgan Library (cat. 116). This last proposal is the most convincing. The putti on folio 4v can also be compared to those in the second frontispiece of a Missal made after 1495, still in the Biblioteca Capitolare of Milan Cathedral, which shows Archbishop Arcimboldi presented to St Ambrose by St Martin, though the attribution of this is equally disputed. The illumination on folio 1 is softer in style and shows links to Venetian illumination. This artist also seems to be recognisable in the Sforza Hours and he may possibly be identifiable as the young Antonio da Monza (cats 108, 119, 126).

Provenance: Lodovico il Moro as Duke of Bari, later Duke of Milan (1451-1508); '*de Pavye au Roy Loys XII*', folio 111v, that is it was among the manuscripts housed in the ducal library at the Castle of Pavia and transported to France to the Château of Blois by order of King Louis XII in 1499.

Exhibitions: Milan 1958, no. 459; Paris 1984, no. 139, illus.; Austin, Berkeley, and New Haven 1988-9, no. 52; Blois and Paris 1992, no. 54, illus.

Bibliography: D'Adda and Mongeri, 1885, pp. 772-4; Warner 1894, pp. xxxi-xxxii; Venturi 1898, p. 155; Couderc 1908, p. 51, pls CXV (2), CXVI; Malaguzzi Valeri 1913-23, I, pp. 478-9, II, p. 466, fig. 517, III, pp. 155, 157, 168-9, figs 179-80; Pellegrin 1955, pp. 389-90; Pellegrin 1969, p. 48, pls 156-7; Lodigiani 1991, pp. 291-3, 296, figs 13, 14; Alexander 1993, p. 45 n. 63.

<div align="right">J. J. G. A.</div>

16

Giovanni Simonetta, *Life of Francesco Sforza*
Giovanni Simonetta, *La historia delle cose facte dallo invictissimo duca Francesco Sforza (La Sforziada)*

Italian translation from the Latin *Commentarii rerum gestarum Francisci Sfortiae* by Cristoforo Landino, edited by Francesco Puteolano, printed in Milan by Antonius Zarotus, 1490. Roman type (HC 14756)

202 fols, of which folios 6 and 202 are blank. 353 x 242 mm. On parchment. Late 15th-century Milanese binding, red velvet with eight silver gilt bosses at the corners, two central bosses and clasps in silver with devices of the Sforza family on them in niello

Illumination attributed to Giovan Pietro Birago, Milan, c. 1490

LONDON, THE BRITISH LIBRARY BOARD, G. 7251 (IB. 26059)

The text of Giovanni Simonetta's *Life of Francesco Sforza* was composed as early as 1482, probably at the behest of Francesco Sforza's second son, Lodovico il Moro (1451-1508); it was printed in Latin in that year by Antonio Zarotto in Milan. Eight years later the Italian translation was printed by the same printer, also dedicated to Lodovico. Francesco Sforza (1401-1466) had claimed the Duchy of Milan after the death of his father-in-law, Filippo Maria Visconti, and came into power in 1450. His eldest son, Galeazzo Maria Sforza, succeeded as Duke of Milan, but was assassinated in 1476, leaving only his seven-year-old son Gian Galeazzo (1469-1494) to claim the Duchy. Lodovico il Moro essentially usurped the rule, but maintained the fiction of Gian Galeazzo's position as Duke. The commission of a biography praising the deeds of his father Francesco would reinforce Lodovico's reputation as a dutiful son and cultured patron, as well as support the claims of the Sforza to the Duchy.

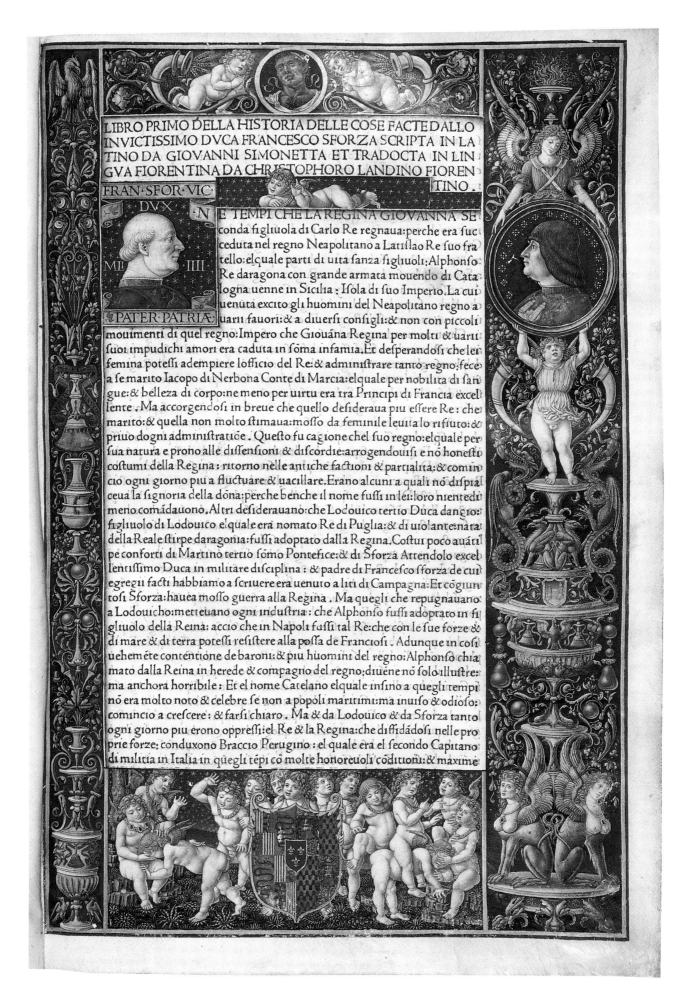

LIBRO PRIMO DELLA HISTORIA DELLE COSE FACTE DALLO INVICTISSIMO DVCA FRANCESCO SFORZA SCRIPTA IN LATINO DA GIOVANNI SIMONETTA ET TRADOCTA IN LINGVA FIORENTINA DA CHRISTOPHORO LANDINO FIORENTINO.

FRAN. SFOR. VIC DVX

MII IIII

PATER PATRIÆ

NE TEMPI CHE LA REGINA GIOVANNA SEconda figliuola di Carlo Re regnaua:perche era succeduta nel regno Neapolitano a Latislao Re suo fratello:elquale parti di uita sanza figliuoli:Alphonso Re daragona con grande armata mouendo di Catalogna uenne in Sicilia : Isola di suo Imperio. La cui uenuta excito gli huomini del Neapolitano regno a uarii fauori:& a diuersi consigli:& non con piccoli mouimenti di quel regno:Impero che Giouana Regina per molti & uarii suoi impudichi amori era caduta in soma infamia. Et desperandosi che lei femina potessi adempiere lofficio del Re:& administrare tanto regno:fece a se marito Iacopo di Nerbona Conte di Marcia:elquale per nobilita di sangue:& belleza di corpo:ne meno per uirtu era tra Principi di Francia excellente. Ma accorgendosi in breue che quello desideraua piu essere Re: che marito:& quella non molto stimaua:mosso da feminile leuita lo rifiuto:& priuo dogni administratioe. Questo fu cagione chel suo regno:elquale per sua natura e prono alle dissensioni & discordie:arrogendouisi e no honesti costumi della Regina : ritorno nelle antiche factioni & partialita:& comincio ogni giorno piu a fluctuare & uacillare.Erano alcuni a quali no dispiaceua la signoria della dona:perche benche il nome fussi in lei:loro nientedimeno comadauano.Altri desiderauano:che Lodouico tertio Duca dangio: figliuolo di Lodouico elquale era nomato Re di Puglia:& di uiolante:nata della Reale stirpe daragonia:fussi adoptato dalla Regina. Costui poco auati pe conforti di Martino tertio somo Pontefice:& di Sforza Attendolo excellentissimo Duca in militare disciplina : & padre di Francesco sforza de cui egregii facti habbiamo a scriuere era uenuto a liti di Campagna:Et cogiuntosi Sforza:hauea mosso guerra alla Regina . Ma quegli che repugnauano a Lodouicho:metteuano ogni industria : che Alphonso fussi adoptato in figliuolo della Reina: accio che in Napoli fussi tal Re:che con le sue forze & di mare & di terra potessi resistere alla possa de Franciosi . Adunque in cosi uehemete contentione de baroni:& piu huomini del regno:Alphonso chiamato dalla Reina in herede & compagnio del regno:diuene no solo illustre: ma anchora horribile : Et el nome Catelano elquale insino a quegli tempi no era molto noto & celebre se non a popoli maritimi:ma inuiso & odioso: comincio a crescere : & farsi chiaro . Ma & da Lodouico & da Sforza tanto ogni giorno piu erono oppressi:el Re & la Regina:che diffidadosi nelle proprie forze: conduxono Braccio Perugino : elquale era el secondo Capitano di militia in Italia in quegli tepi co molte honoreuoli coditioni: & maxime

The four copies of Giovanni Simonetta's *Life of Francesco Sforza* printed on parchment and illuminated by the Milanese illuminator Giovan Pietro Birago have been studied in detail by Mark Evans (1987, pp. 232–47). Evans's analysis of the British Library copy demonstrates that it must have been decorated for Lodovico il Moro himself. The frontispiece of a second copy, probably also intended for Lodovico, survives only in fragments in the Uffizi, Florence (inv. nos 843, 4423–4430). The other two illuminated copies were destined for Gian Galeazzo (Paris, Bibliothèque nationale, Vélins 724; see Blois and Paris 1992, pp. 216–7, no. 55) and for Galeazzo da Sanseverino, who in 1490 was the fiancé of Lodovico Sforza's daughter Bianca (Warsaw, Biblioteka Narodowa, Inc. F. 1347). Portraits, coats of arms, and personal emblems permit these identifications.

In the British Library frontispiece (folio 10[b1]), the portrait of Francesco Sforza is painted in the space reserved for the first initial, carefully identified by inscriptions, 'PATER PATRIA' ('Father of the Country') and 'DUX MIL IIII' ('4th Duke of Milan'), thus proclaiming his legitimate succession from the Visconti Dukes. In the border opposite Francesco, the profile portrait of Lodovico appears in a roundel. On his breastplate are two towers with water between them, emblematic of the city of Genoa, of which he was the Duke. The same towers appear on a shield further down the same border, and his full blazon is painted on a shield in the lower margin. In the upper margin, the head of a dark Moor is also painted in roundel. Lodovico's nickname, 'il Moro', was either derived from the fact that he was swarthy, or that his middle name was Mauro, but in any case images of blacks were used to represent Lodovico allegorically. A well-known Visconti emblem appears in the right border, a pair of blue dragons or vipers with red

human figures emerging from their mouths; the motif is also repeated in the coat of arms below.

The attribution to Giovan Pietro Birago is supported by his signature, which appears in the Warsaw copy of *La Sforziada*, illuminated in a style identical to the London one (Evans 1983–4, pp. 107–12). Birago's figures are robust, his putti vigorous, and his decorative vocabulary exquisite. Intense reds and blues alternate in the backgrounds, and in several areas the blue is sprinkled with gold stars. Delicate gold modelling appears on many objects, from the bronze harpies, griffons, vases, and eagles to the angels' wings; even the grass on which the putti stand is touched with gold. Birago was a priest who was active as a miniaturist in Brescia and probably in Venice before settling in Milan, where he worked from about 1490 to 1513 (Evans 1992, pp. 17, 24). In Venice he may have been influenced by the homoerotic drawings of Marco Zoppo (1433–1478), famed for his representations of nude putti (Dodgson 1923, pl. XVIII; Armstrong 1976, pp. 313–14). The suggestive behaviour of the putti in the lower margin may reflect such an encounter.

Each of the 31 books of *La Sforziada* begins with a seven line faceted initial, usually in gold with joints of green or blue on a decorated rectangle of a contrasting colour. The decorative richness ensures the appreciation of the owner.

Provenance: Lodovico Sforza, *c.* 1490–9; possibly acquired by Louis XII of France; Charles de Rohan, prince de Soubise (by 1788); Count MacCarthy-Reagh; George Hibbert (until *c.* 1829); Philip Augustus Hanrott (until 1833–4); Thomas Grenville; his bequest to the British Museum, 1846.

Exhibitions: Malibu, New York and London 1983–4, no. 14; Austin, Berkeley and New Haven 1988–9, no. 53.

Bibliography: BMC, VI, 721; Evans 1983–4, no. 14, pp. 107–12 (with earlier literature); Evans 1987, pp. 232–47.

L. A.

17 folio 1r

17

Lodovico Maria Sforza, *Litterae ducales donationis ad monasterium S. Mariae Gratiarum*

43 fols. 265 x 187mm. On parchment. Brown morocco monastic binding stamped with a Madonna of the Apocalypse, 16th-century Italian

Written by Joannes Jacobus de Lazaronibus and others in Milan, c. 1499 and later (to 1541), with illuminations by a Milanese artist

NEW YORK, THE PIERPONT MORGAN LIBRARY, M. 434

This manuscript contains copies of various documents of donations made by Lodovico Maria Sforza (1451–1508), called 'il Moro', to the Dominican monastery of Santa Maria delle Grazie in 1497 and 1498, as well as some other documents pertaining to the church. As the court church and burial place for Lodovico's family, the monastery was the recipient of numerous privileges and the object of several major building and decorative programmes, the most famous of which is the fresco of the *Last Supper* painted by Leonardo da Vinci in the refectory between 1494 and 1498. Some of the benefactions were specifically made for the benefit of Lodovico's wife, Beatrice d'Este, who died on 2 January 1497, and was buried there. While the original documents of 1497 and 1498 were signed by Lodovico and Bernardo Calco (1434–1508), his chancellor, the copies in this manuscript required notarial attestations. The first of these attestations is dated July 1499, thus providing an approximate date for the frontispiece (D'Adda 1874, pp. 33–53, has transcribed the text of the donations).

In the frontispiece (folio 1) Lodovico, dressed in mourning, hands the document of donation, complete with red seal, to Vincenzo Baldelli di Castelnuovo, prior of Santa Maria delle Grazie. The miniature and text are on a single piece of parchment illusionistically suspended from cords and nails before an open doorway. The prior and accompanying friar are seen a second time approaching from behind the

18 folio 11r

parchment. To either side of the doorway, cartouches with devices of the Sforza family are suspended from cords (caduceus, axe chopping wood [motto: '*Tuto il torto vain*'], whisk broom [motto: '*Merito et tempore*']), sifter [motto: '*Tale a ti quale a mi*']), while the impaled arms of Lodovico Sforza and his wife, Beatrice d'Este, are strapped above the doorway. In a second miniature the prior discusses with the friars how they could best repay the Duke's generosity (folio 9).

Paul Wescher (1960) has attributed these miniatures to the Lombard artist who signed many of his works with the initials B. F. (see cat. 116) and illuminated Gasparo Visconti's poem, *Di Paole e Daria amanti* (Berlin, Staatliche Museen, Kupferstichkabinett, MS 78 C 27), also made for Lodovico. While there are similarities among these works, some of the differences – especially the painting technique and enamel-like colours – have led others (Mariani Canova 1978a; Alexander 1991b) to question the attribution. If these works are all by the same artist, his style could not have been rigid, as both the *Adoration of the Magi* by Master B. F. (cat. 116) and the present manuscript were made about the same time.

Provenance: Marchese Girolamo d'Adda (1815-1881); Charles Fairfax Murray (1849-1919); purchased by John Pierpont Morgan (1837-1913) in 1910.

Exhibitions: New York 1984, no. 28; Austin, Berkeley and New Haven, 1988-9, no. 58.

Bibliography: De Marinis 1908, no. 1, pls II,III; D'Adda 1874, pp. 25-53, pl. opp. p. 24; D'Adda and Mongeri 1885, p. 775; Murray 1902, p. 12, no. 16; Malaguzzi Valeri 1913-23, I, illus. p. 409; De Ricci 1935-40, II, p. 1448; Harrsen and Boyce 1953, no. 100, pl. 71; Pellegrin 1955, p. 411; Wescher 1960, pp. 84-5, fig. 4; Wescher 1968a, p. 488; Levi d'Ancona 1970, pp. 99, 102, 104; Lopez 1978, p. 76, fig. 76; Mariani Canova 1978a, p. 63, n. 35; Voelkle 1980, p. 23, fiche 6B3; Thomas 1981, pp. 30-3, figs 1-2; Moffatt 1986, p. 59, fig. 26; Zuffi 1990, p. 51, fig. 2; Alexander 1991b, pp. 229, 234 n. 29; Mulas 1991, pp. 139-42, 162, pl. XXXIII.

W. M. V.

18

De Sphaera, in Italian

16 fols. 245 x 170mm. On parchment [London only]

Written and illuminated in Milan, c. 1450-60

MODENA, BIBLIOTECA ESTENSE, MS Lat. 209

The manuscript contains astronomical and astrological texts and diagrams and is famous for its fourteen full-page miniatures of the *Seven Planets and their Children*, folios 5v-12. The planets are shown as per-

sonifications with accompanying Zodiac signs on the versos. In landscapes below and also on the rectos opposite the 'children' are represented those born under their planetary influence who therefore are destined to particular pursuits or possess particular aptitudes. For example on folio 10v the Planet Mercury, who presides over labourers and craftsmen, is accompanied by the Zodiac signs Gemini and Virgo and is shown with peasants labouring in the fields below. On the recto opposite, folio 11, artists and craftsmen are depicted at work. From top right clockwise, these are a painter, a sculptor, a man making an organ, two men making armour, two men making clocks, and a scribe. In the centre are two cooks working at an oven with two spits roasting on top; above at the top is the banquet for which they are preparing. Both the texts and the representations have a long ancestry extending back through the Middle Ages to Roman and Greek sources. But here they are transformed into contemporary 15th-century contexts familiar to the artist and patron.

The manuscript bears the arms of Francesco Sforza, Duke of Milan (r. 1450-1466) and his wife, Bianca Maria, daughter of Filippo Maria, last Visconti Duke of Milan. They married in 1441 and the manuscript must have been made before Francesco's death in 1466. The artist has not been identified, an earlier suggestion that he is the Lombard illuminator, Cristoforo da Predi, being unconvincing. Both his landscape and his figural conventions are close to those of the Master of Ippolita Sforza (see cat. 11). He uses perspectival recession for his buildings and interiors and paints distant landscapes as settings for his scenes, but his main interest and skill is in the lively narrative details and observations of contemporary court and civic activities.

Provenance: Arms and emblems of Francesco Sforza, Duke of Milan (r. 1450-1466) and Bianca Maria Visconti, whom he married in 1441; included in the 17th-century library catalogue of the d'Este of Ferrara, perhaps as a result of the marriage of Anna Sforza to Alfonso I d'Este in 1491.

Exhibitions: Rome 1953, no. 653; Milan 1958, no. 347; Brussels 1969, no. 86, pl. 31.

Bibliography: Hermann 1900, pp. 90 ff., pls 19-22; Bertoni and Bonacini 1914; Malaguzzi Valeri 1913-23, I, illus. pp. 173, 177, 228-9, 596, 608-9, III, pp. 144-7, figs 147-8, IV, pp. 30, 72, figs 33, 107; Wittgens 1934, pp. 368-70; Pellegrin 1955, p. 384; Samek Ludovici 1958; Puliatti 1969; Fava, Salmi and Pirani 1973, II, pp. 25-7, pl. XI; Alexander 1977a, pp. 92-5, pls 27-8; Milano 1987, pp. 146-53, pls XCVI-CIII.

J. J. G. A.

19

Giovanni Camfora, *De immortalitate animae*

62 fols. 132 x 202 mm. On parchment

Written in Ferarra, c. 1472, illuminated by Giovanni Vendramin

LONDON, THE BRITISH LIBRARY, Additional MS 22325

The colophon (folio 62) informs us that this little manuscript was dedicated to Ercole d'Este, Duke of Ferrara, in 1472, by Naimerio Conti, a Paduan nobleman whose family had received great favours from the d'Este family. Giovanni Trotti, who signed the manuscript, folio 62, was certainly from a Ferrarese family, but the illuminator was just as certainly Paduan. The text treats the immortality of a soul, in the form of a discussion between the author, the Genoese Dominican Giovanni Camfora, and the celebrated Paduan humanist Giovanni Marcanova (see cats 66-7). The frontispiece shows Hercules, in a Classical niche of violet marble with purple cornices, portrayed as a gilded Classical statue. With vigorous movement he struggles amidst the flames with the Hydra of Lerna, brandishing a club and wearing the head of the Nemean lion. Obviously this energetic figure of Hercules the conqueror symbolises the courage and strength of the Duke of the same name. On the curved tympanum of the building the painter has placed

the Duke's emblem, a ring with a carnation. On the architrave appears the following inscription: A DEO FORTITUDO MEA. Down below there are two blue Este coats of arms with the imperial eagle, the fleur-de-lis of France and the crossed keys of the papacy which the family had been given permission to use in 1470 when the Pope awarded them the freedom of the city.

The illuminator has been identified (Alexander 1970) as the Paduan Giovanni Vendramin, who decorated the 1469 Pliny (cat. 78) that has close links with this manuscript. The anatomy here is much more articulated, more restless than in other of Vendramin's works. The attribution is plausible if we remember that, at the time he was working on *De immortalitate animae*, Giovanni Vendramin was influenced not only by the illuminators of Hyginus' *De astronomia* (cat. 51), especially the artist responsible for the Serpent Holder, but also by Marco Zoppo's drawings and above all by the contemporary engraving of Hercules fighting the giants (London, British Museum), probably executed in Padua at this same date.

Curiously enough the figure of Hercules in a Classical niche appears in one of the illustrations for the months of the year in the famous calendar of Filocalus of 354 AD, of which several copies were made during the Renaissance. It is not impossible that the Paduan humanists may also have had a similar copy in their possession in about 1470.

19 folio 1v

Provenance: Ercole I d'Este, Duke of Ferrara (r. 1471-1505); Ferrara, Marchese Costabili; sold Paris, 18 February 1858, lot 180; acquired from Boone, 27 March 1858.

Bibliography: *Catalogue of Additions* 1875, p. 633; Hermann 1900, p. 250; Saxl and Meier 1953, III, p. 65; Alexander 1970b, p. 274; Zapperi 1974, pp. 581-4; Armstrong 1981, pp. 61, 129; Mariani Canova 1988b, pp. 97-8; Mariani Canova 1993, pp. 131-2.

<div align="right">G. M. C.</div>

20

Antonio Cornazzano, *Del modo di regere e di regnare*, in Italian

36 fols. 240 × 160 mm. On parchment

Written in Ferrara, 1476-84, with illumination attributed to a Ferrarese artist

NEW YORK, THE PIERPONT MORGAN LIBRARY, M. 731

This is the presentation copy of Antonio Cornazzano's poem, *The Art of Ruling and Reigning*, dedicated to Eleanor of Aragon (1450-1493), wife of Duke Ercole I d'Este of Ferrara. The work was composed between 1476, the year of the birth of Alfonso I d'Este, who is mentioned in the poem, and 1484, the date of Cornazzano's death. An elegant volume written in burnished silver and alternating gold and blue capitals, the manuscript is decorated with fine white vine-stem initials marking the table of contents, prologue, and each of the eight cantos. Folio 2v contains a dedicatory inscription to the 'most illustrious and excellent Eleanor of Aragon, duchess of Ferrara' and a profile portrait that shows her receiving a gold wand from a celestial hand.

The portrait has been attributed to the Ferrarese artist Cosimo Tura. The nature of the profile portrait, however, makes it difficult to accept or reject the attribution to the artist himself (as opposed to his shop). The emphasis placed on the two hands recalls Tura's penchant for awkward gestures, while the face, devoid of any of his distinctive exaggerations, seems atypical of his work.

Provenance: Eleanor of Aragon, Duchess of Ferrara (1450-1493), described in her 1493 inventory; Antoine-Augusti Renouard (1765-1853); Robert S. Holford (1808-1892); Sir George L. Holford (1860-1926); purchased from the Holford estate by John Pierpont Morgan, Jr (1867-1943) in 1927.

Exhibitions: London 1908, no. 267, pl. 162; Paris 1926, no. 243, illus.; New York 1934, no. 129; Paris 1935, no. 2345; New York 1939, no. 30; New York 1940, no. 32; New York 1984, no. 40, cover illus.

Bibliography: De Ricci 1935-40, II, pp. 1490-1 (with earlier literature); Harrsen and Boyce 1953, no. 78, pl. 2; Bond and Faye 1962, p. 355; Gundersheimer 1973, p. 242, fig. 14; Molajoli 1974, p. 91, no. 68; Voelkle 1980, p. 46, fiche 11 C7; Gundersheimer 1993, fig. 15.

<div align="right">R. S. W.</div>

21

Plautus, *Comedies*

319 fols. 359 × 238 mm. On parchment

Written in Mantua, c. 1460-70, with illumination attributed to Guglielmo Giraldi

MADRID, BIBLIOTECA NACIONAL, MS Vit. 22-5

The Roman playwright Titus Maccius Plautus lived in the later 3rd to early 2nd century BC and based his comedies on Greek models. The first of the twenty plays in this manuscript, the *Amphitrio*, is introduced by a miniature of a bedchamber with a woman in bed and a baby in a cot in the foreground. He is the infant Hercules strangling the serpent sent by the jealous goddess Juno. The event is observed by two men with 'Greek' headgear in the right foreground, and four women,

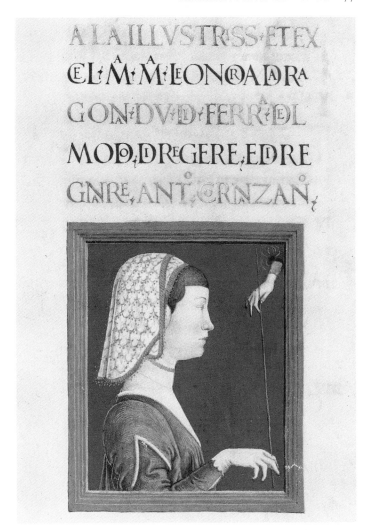

20 folio 2v

of whom the one on the left, seen from behind, appears to be trying to flee. The border and initial 'I' are composed of interlaced knotwork. The original coat of arms in the lower border has been defaced, but in the lower roundel of the right border is a Gonzaga *impresa*, the dove with a dead tree trunk and the motto '*Vrai amour ne se change*'. In the upper roundel is a triple headed dragon.

The remaining nineteen plays included in this manuscript are each introduced by a similar three sided border and an initial of white vine-stem scroll, the initials including animals and in some cases other Gonzaga *imprese* (for which see Meroni 1966, pls 45-56), such as the fiery mountain, folio 20, and the tower with dog, folio 35v.

The miniature has been convincingly attributed by Battisti (1955) followed by Salmi (1961) to Guglielmo Giraldi, one of the leading illuminators of the Ferrarese school, who worked for both Leonello and Borso d'Este and who is documented until 1489. He signed and dated the Aulus Gellius of 1448 (Milan, Biblioteca Ambrosiana, S.P. 10/28). Later he was also employed by Federigo da Montefeltro, Duke of Urbino, for example on his Dante (cat. 58). The type of interlace knotwork border is found in other Gonzaga manuscripts, including the Boccaccio in Oxford (cat. 22), whose miniatures are not by Giraldi. It may be that the border is by a second illuminator specialising in this type of decoration.

Provenance: *Imprese* of Lodovico Gonzaga, Marquess of Mantua (r. 1444-1478); arms erased and replaced by an unidentified coat roughly sketched in ink.

Bibliography: Paz y Mélia 1902, pp. 17-20; Bordona 1933, I, pp. 394-5, no. 946, figs 335-6; Battisti 1955, pp. 19-20, figs 1, 3; Salmi 1957, p. 61; Salmi 1961, p. 21, pl. 14; Meroni 1966, pp. 35, 58, 61, 66, pls 99, 100.

<div align="right">J. J. G. A.</div>

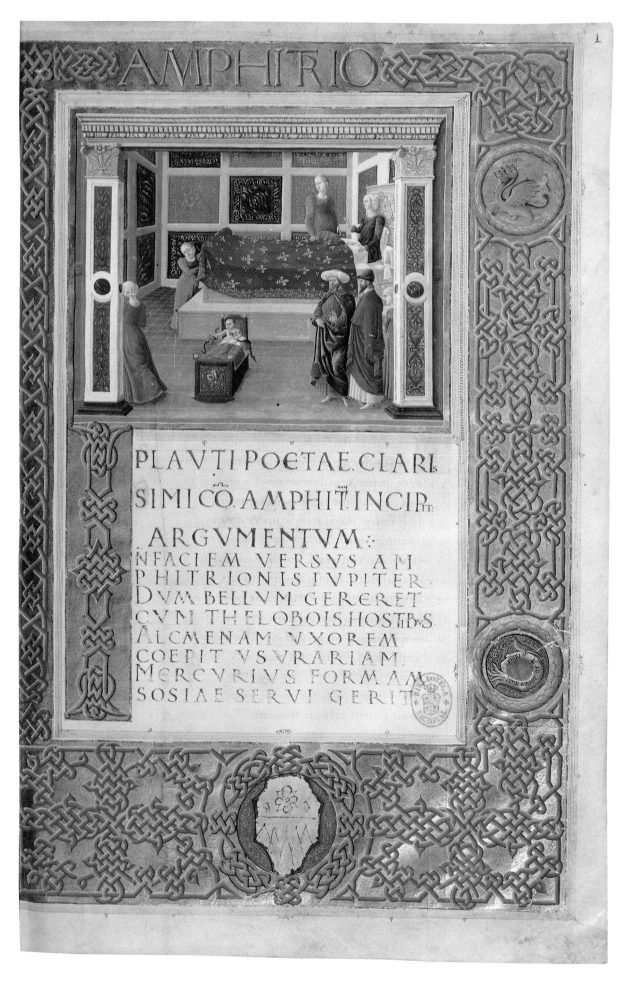

22

Giovanni Boccaccio, *Il Filocolo*

242 fols. 364 × 242 mm. On parchment [London only]

Written, c. 1463-4, by Andreas de Laude in Mantua, with illumination perhaps by Pietro Guindaleri

OXFORD, BODLEIAN LIBRARY, MS. Canon. Ital. 85

Giovanni Boccaccio's vernacular romance of the story of Florio, who takes the name of Filocolo as a disguise, and his beloved, Biancofiore, was written in 1336-8. The present manuscript has five half-page miniatures prefacing the five books, each with a coloured strapwork interlace border in gold, with the Gonzaga arms in the centre below, and an initial composed of strapwork or foliage. The miniatures illustrate episodes described or referred to early in each book. Book I, folio 1, shows the goddess Juno, in a chariot drawn by peacocks in the sky, addressing her vicar, 'the man who held the Holy Office on her behalf', shown on the right below as the Pope with a Cardinal, a Bishop and a fourth figure. To the left are two youths, perhaps the 'valorous youth' whose birth the goddess announces, and a companion, or perhaps the youths apostrophised by the text in chapter 2. There is a strapwork border and initial 'H'. For Book II, folio 25, the miniature shows Venus who, 'wrapping her glorious body in crimson violet', has come down off the peak of Cytheron to find her son, Cupid. He is shown with his bow, 'tempering new arrows in the sacred waters', beside an altar on which the Gonzaga arms are again painted. There is a strapwork border and initial 'A'. For Book III, folio 67, a young man, the hero Florio, is shown with a dog with three other youths behind him, one of whom has a falcon on his wrist. This, no doubt, refers to the words of the text, 'At times he pursued the timid deer in dark forests with his dogs and mighty bow; and in the open fields the flying birds showed him delightful sport'. There is another strapwork border with arms and initial 'R'. Book IV, folio 114v, shows a group of horsemen in a city square with border and initial 'I'. This seems to refer to the closing words of Book III: 'upon leaving the city of Marmorina, they called for their horses and mounted them'. Book V, folio 190v, shows the parting of Filocolo from his royal parents by the seashore; there is a strapwork border and initial 'A'.

A letter from the scribe, Andreas de Laude, to Lodovico Gonzaga, Marquess of Mantua, asking for payment of '*vi fiorini e iii sachi*' in order to continue writing the text, survives and is dated 30 January 1464. It is an appeal to the Marquess to send the money owed so that the scribe's family may have something to eat. Andreas promises that the text will be '*piu justo, et piu correcto de quanti ne ho mai scripto*'. Though the Marquess is known to have attached importance to textual accuracy, the text is not especially accurate. For other manuscripts copied by Andreas, almost certainly identifiable with Andrea Morena da Lodi, see de la Mare and Reynolds (1991-2).

The illuminator also executed the miniatures in a Petrarch written by Matteo Contugi of Volterra for Cardinal Francesco Gonzaga (for whom see cat. 39; British Library, Harley MS 3567; Evans 1983-4, no. 11). Meroni (1966) suggested that he be identified with Pietro Guindaleri, an illuminator working at this time for the Gonzaga. Conti (1988-9), on the other hand, argues that Guindaleri is a different artist, identifiable in the Gonzaga Pliny in Turin (Biblioteca Nazionale, MS. I.I, 22-3, unfortunately damaged in the Turin fire). A letter of 1506 refers to '*Principi*' ('frontispieces') by '*Maestro Pietro*' in a Pliny, taken to be the Turin manuscript. However, there appear to remain uncertainties of attribution that require further research into the relations between this group of illuminators, who worked for the Gonzaga in the 1460s to the 1480s.

Similar style strapwork borders and initials occur in other Gonzaga manuscripts, notably the Plautus in Madrid (cat. 21), which is illuminated by a different artist, Guglielmo Giraldi. This may suggest that the borders and initials were executed by a separate illuminator (see also de la Mare and Reynolds 1991-2).

Provenance: Arms of Lodovico Gonzaga, Marquess of Mantua (r. 1444-1478), folios 1, etc.; acquired by Oxford University with the library of the Venetian Jesuit, Abate Matteo Luigi Canonici (1727-1805) in 1817.

Exhibitions: Oxford 1948, no. 37, pl. XI; Florence 1975, no. 9; London 1981, no. 20.

Bibliography: Saxl and Meier 1953, p. 334, fig. 41; Pächt 1957, pp. 190-1, pl. 7; Wardrop 1963, p. 51; Meroni 1966, pp. 35, 57, pl. 98; Branca 1966, I, pp. 173, 267, II, pp. 335, 427 illus.; Pächt and Alexander 1970, no. 393, frontispiece and pl. XXXVII; Hassall and Hassall 1976, pl. 31; Alexander 1977b, pp. 303-4; Conti 1988-9, pp. 265-6; de la Mare and Reynolds 1991-2, pp. 53-6.

J.J.G.A.

23

Hours of Cecilia Gonzaga, Use of Rome

224 fols. 185 × 132 mm. On parchment

Written and probably illuminated in Milan, c. 1470

NEW YORK, THE PIERPONT MORGAN LIBRARY, M. 454

This Book of Hours is thought, with reason, to have belonged to Cecilia Gonzaga (1451-1472), daughter of Lodovico II and Barbara of Brandenburg. The name Cecilia appears in one of the prayers and the book contains the Gonzaga arms and devices: a white doe with the motto '*Bi d[er] Graph*' ('righteous power'), a dove perched on a coiled

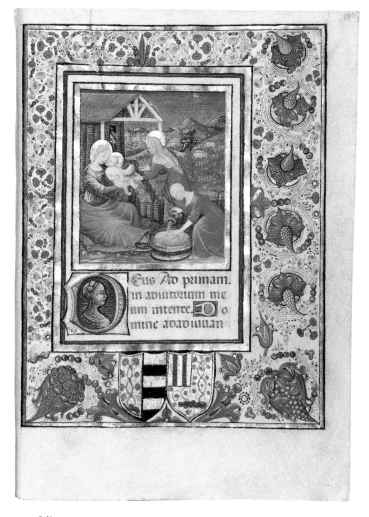

23 folio 190r

and smoking tree trunk inscribed '*Vrai amor non se cang*' ('true love does not change'), and a muzzled and leashed hound. On one folio the Fogliani arms are impaled with Gonzaga, a reference, apparently, to the marriage of Cecilia's sister Gabriella to Corrado Fogliani. The name of their daughter Constantia appears tucked inside many initials.

The manuscript is rich both textually and iconographically, and bespeaks a reader with particular and refined taste. In addition to the expected contents there are, somewhat unusually for an Italian Book of Hours, both the long and short Hours of the Cross and a rich variety of prayers. The latter include an unusual and long litany of the Passion followed by a special litany to the Virgin. The illumination includes the following miniatures: folio 1, *David with Nathan* for the Penitential Psalms; folio 21, a *Funeral* for the Office of the Dead; folio 58, *Agony in the Garden*, for the Hours of the Cross; folio 62, *Betrayal*, folio 67v, *Christ before Herod*, folio 72v, *Christ before Pilate*, folio 75, *Christ Carrying the Cross*, folio 77, *Crucifixion*, folio 79v, *Soldiers Sleeping at the Tomb*, and folio 83, *Three Marys at the Tomb*, all for the long Hours of the Cross; folio 86, *Pentecost*, folio 90v, *St Jerome in Penance*, folio 92, *Mary Magdalene in Prayer*, folio 93v, *Martyrdom of St Lawrence*, folio 95, *Martyrdom of St. Sebastian*, folio 96v, *St Roch*, and folio 98, *St Michael Battling a Demon*, all for the Hours of the Holy Spirit; folio 100, *Man of Sorrows*, which begins a long series of prayers; folio 179, *Visitation*, folio 190, *First Bath of Christ*, folio 195, *Adoration of the Magi*, folio 200, *Circumcision*, folio 205, *Flight into Egypt*, folio 210, *Salvator Mundi* and folio 217, *Return from Egypt*, all for the Hours of the Virgin; and folio 223, *Virgin and Child*, for the Advent Hours. Some of these subjects are quite unusual: the touching *First Bath of Christ* instead of the customary *Nativity* for Prime of the Hours of the Virgin; and the *Return of the Holy Family from Egypt* for Compline, in which Christ is shown as a toddler walking with the assistance of his mother. The illustration of the Hours of the Holy Spirit by a series of saints blessed by special inspiration is also unusual. In addition, the book contains numerous historiated or *d'or brun* initials within the long series of miscellaneous prayers and the Hours of the Virgin.

Although the Ferrarese artist Guglielmo Giraldi is documented as having received a commission from Lodovico and Barbara for a Book of Hours as a gift to Cecilia, this is probably not that book; neither of the two distinct hands in this manuscript is close to Giraldi's style. One of them is the Milanese artist who painted all but one of the miniatures in a Book of Hours formerly in the Major J.R. Abbey collection (MS 6960), a Columella in the Pierpont Morgan Library (M. 139) and cat. 14. This artist's short, at times even dumpy figures can be found in all three manuscripts. The second hand in Cecilia's Hours, who painted, for example, the *First Bath of Christ*, worked in a much more elegant, if somewhat retardataire, style. Similar to the work of Bartolomeo Rigossi, a native of Gallarate near Milan, the style of this second hand is characterised by a glowing, subtle palette and attention to detail.

Provenance: (?) Cecilia Gonzaga (1451-1472); bought by James Dennistoun of Dennistoun (1803-1855) in Rome in 1838; Bertram, 4th Earl of Ashburnham sale, London, Sotheby's, 1 May 1899, lot 70; Louis Lebeufe de Montgermont (1841-1918); purchased by John Pierpont Morgan (1837-1913) in 1911.

Exhibitions: New York 1957, no. 40, pl. 26; New York 1984, no. 39.

Bibliography: Ashburnham 1861, n.p., no. LXV; De Ricci 1935-40, II, p. 1452; Harrsen and Boyce 1953, no. 77, pls 56, 57; Bond and Faye 1962, p. 345; Meroni 1966, pp. 38, no. 36 (2), 59, 61, no. 8, 63, pl. 103; Alexander and de la Mare 1969, p. 149.

R. S. W.

24

Hours of Giovanni II Bentivoglio, Use of Rome

192 fols. 195 x 126 mm. On parchment

Written, signed and dated 1497 in Bologna by Girolamo Pagliarolo, with illumination also possibly by him

NEW YORK, THE PIERPONT MORGAN LIBRARY, M. 53

Giovanni II, the most important member of the Bentivoglio family, was Lord of Bologna from 1462 to 1506. Although a stern ruler, he is also known for the brilliance of his court and his patronage of the arts. In this, his Book of Hours, he left his imprint in a number of ways. Most striking is his portrait – inscribed with his name – on folio 16v, where he is shown kneeling before the Virgin and Child in the book's most important miniature, that marking the beginning of the Hours of the Virgin. Giovanni's personal devotion to St George is evident in an unusual pair of facing miniatures that, along with a *Crucifixion* (folio 129v), introduce a long series of prayers beginning with the Our Father: a *Nativity* with St George adoring the Christ Child (folio 127v) and a *St George Slaying the Dragon* (folio 128). St George also features prominently in the litany: his name heads the list of male saints and is written in larger letters. Two other full-page miniatures are *St Jerome* (folio 1v) serving as frontispiece, and *David in Penance* (folio 110v) at the start of the Penitential Psalms. Giovanni's name appears in a number of the prayers, and all six miniatures are surrounded by borders incorporating numerous Bentivoglio devices.

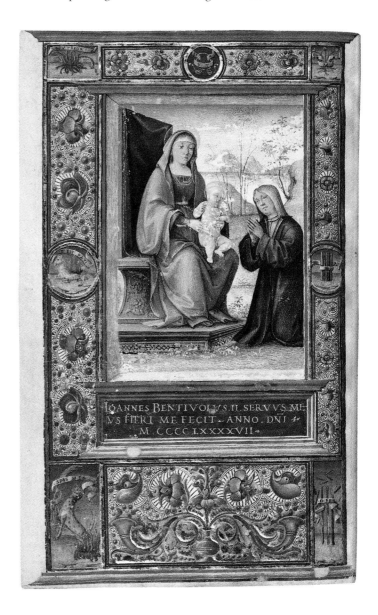

24 folio 16v

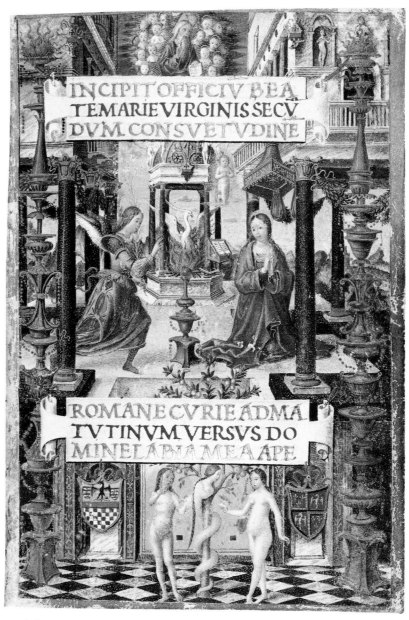

25 folio 13r

Girolamo Pagliarolo (1474-1539?) was the son of the illuminator Domenico, who signed a miniature of the *Resurrection* also in the Morgan Library (M. 444). At fourteen, Girolamo was apprenticed to the illuminator Giovanni di Francesco Cavalletto and the bookbinder Felice di Agnolo. From 1507 to 1514 he taught illumination at the University of Bologna. Girolamo signed and dated the colophon of this Hours, where he also tells us that it took him 25 days to write the 160 folios of text. An illuminator as well as a scribe, it may have also been Girolamo who executed the miniatures and the decoration, but this attribution remains a problem. Bernard Berenson ascribed the *St Jerome* to an unknown pupil of Lorenzo Costa and the *Virgin and Child with St John* to the young Amico Aspertini. Tosetti Grandi (1985), on the other hand, attributed the *Nativity* to Costa himself.

Provenance: Giovanni II Bentivoglio (1443-1508); Octaviano Cusani of Milan in 1594; purchased by John Pierpont Morgan (1837-1913) in 1905.

Exhibitions: New York 1934, no. 128, pl. 86; New York 1984, no. 44, illus.

Bibliography: De Ricci 1935-40, II, p. 1375; Wardrop 1946, pp. 18, 29, figs 19, 21; Harrsen and Boyce 1953, no. 83, pls 60, 61; Mariani Canova 1978a, pp. 34-5, fig. 72a; Voelkle 1980, p. 4, fiche 1F12-1G4; Tosetti Grandi 1985, pp. 331-3, 348-51, fig. 2.

R. S. W.

25

Hours of Galeotto Pico della Mirandola, Use of Rome

116 fols. 165 x 114mm. On parchment

Written by an anonymous scribe, probably in Ferrara or Mantua, late 15th century, with illumination attributed to Giovanni Francesco Maineri

LONDON, THE BRITISH LIBRARY, Additional MS 50002

The manuscript opens with a Calendar; on each recto are Zodiac signs and Labours of the Months. An unusual feature is the addition for January to July of representations of the Seven Planets in chariots. On folio 13 at the opening of the Hours of the Virgin the *Annunciation* is shown in a complex architectural fantasy, as if in a space between the loggie of two neighbouring palaces. Symbolic representations, a phoenix rising from the flames in a small tempietto and the *Temptation of Adam and Eve*, are fitted in behind and below the main scene. The *incipit* is written in capitals as if on two scrolls attached to the tall candelabra which flank the scene. Above is God the Father blessing, surrounded by angels and the moment of the Incarnation is symbolised by the small praying baby hovering above the Virgin.

The different Hours of the Virgin are introduced by miniatures with imaginative borders, including coats of arms, plant scrolls, candelabra and in the lower margin animals. The miniatures depict: folio 21, Lauds, *Presentation in the Temple*; folio 28v, Prime, *Nativity*; folio 32, Terce, *Epiphany*; folio 35, Sext, *Resurrection*; folio 37v, None, *Ascension*; folio 40v, Vespers, *Pentecost*; folio 46, Compline, *Death of the Virgin*. There are also historiated initials with borders, all showing David playing the harp: folio 16, 'C'; folio 17, 'D'; folio 50, 'E'. For the Seven Penitential Psalms a miniature (folio 63) shows David playing a stringed instrument with angels playing the organ below, the whole under an arched frame with two figures in gold with scrolls in the spandrels. Again texts are written on plaques which are illusionistically shown as if superimposed on the structure. For the Hours of the Cross another miniature (folio 79) shows the *Crucifixion* with a medallion of St Helena's discovery of the True Cross below. The border contains putti with the instruments of the Passion and candelabra. On folio 85, the Office of the Dead, a particularly striking image shows Death with a scythe and a fantastic border of skulls, bones, writhing snakes, crowns, books, two cardinal's hats, a bishop's mitre, etc. In the roundel below, an angel (not winged) blows the last trumpet; the heads of the resurrected appear in a group below him. Other historiated initials – folio 91v, 'V', folio 96, 'D' and folio 101, 'E' – represent David. There are numerous minor initials of knotted branches in the Hours of the Virgin and in the later part of the manuscript in gold, some plain, some faceted, on coloured grounds with foliage.

The illumination has been convincingly attributed by Ursula Bauer-Eberhardt (1991) to Giovanni Francesco Maineri, who worked mainly as a painter. He is documented in 1489 in Ferrara and also worked in Mantua. The depiction of the *Annunciation* in an architectural placement resembles that in many North Italian paintings, for example those by Carlo Crivelli. The arms of the owners, Galeotto Pico della Mirandola, elder brother of the philosopher Giovanni, and his wife, Bianca d'Este, illegitimate daughter of Niccolò III d'Este, are included on folio 13. Jacopo Forresti of Bergamo included Bianca d'Este among his biographies of famous women, *De claris mulieribus*, published in Ferrara in 1497. She was born in 1440 and died in 1506. Galeotto was born in 1442 and died in 1499. The latter date provides a *terminus ante* for the manuscript. The scribe, who writes a rather artificial formal humanist hand, clearly influenced by printing types, is so far unidentified (Albinia de la Mare, written communication).

Provenance: Arms of Galeotto Pico della Mirandola (1442-1499) and of his wife, Bianca d'Este, folio 13; John Ruskin (1819-1900), Brantwood (bookplate); C.W. Dyson Perrins, MS. 95; acquired by the British Museum in 1959 before the Dyson Perrins sale.

Exhibition: London 1908, no. 262, pl. 158.

Bibliography: Warner 1920, I, pp. 210-15, pl. LXXXII; *Reproductions from Illuminated Manuscripts* 1965, pl. XLIII; Dearden 1966, p. 148, no. 59, pl. X; Backhouse 1985, pl. 53; Bauer-Eberhardt 1991, figs 3, 4, 6, 7, 9-11.

J. J. G. A.

26

Bernardo Bembo, *Oratio gratulatoria*

36 fols. 105 x 162 mm. On parchment

Script attributed to Bartolomeo Sanvito of Padua, c. 1463, with illumination attributed to Franco dei Russi

LONDON, THE BRITISH LIBRARY, Additional MS 14787

The *Oratio* was composed in 1462, the same year as the election of Doge Cristoforo Moro, on behalf of the law faculty at the University of Padua, where the young Bembo, later to become a famous humanist and politician, was studying law in the company of other Venetian aristocrats. Padua at the time was under Venetian rule and the university had become the leading seat of learning in the Republic.

This copy of the *Oratio* bears a dedication to Cardinal Ludovico Trevisan, one of the most important figures in religious and political life in Venice in the early 1460s. Mantegna painted an excellent portrait of him (Berlin, Staatliche Museen). He died in 1465 and this manuscript must have been dedicated to him in 1463 because Bembo states that the *Oratio* had been composed somewhat earlier. In the two frontispieces, the purchasers and the people to whom the manuscript is offered are honoured with a magnificent representation of their coats of arms and their names in elaborate architectural title-pages. On folio 1 a brightly coloured architectural structure bears the dedication to Cardinal Trevisan at the top, written as an inscription and flanked by two energetic, nude figures in the Classical style, in trompe l'œil relief. On the tympanum a small Pegasus, symbol of good repute, has the Trevisan coat of arms hanging round its neck. Below, the Bembo coat of arms is held up by two winged putti. On folio 6v a very decorative architectural pastiche carries the first words of the text as an inscription; this contains both names, Bembo and Moro. At the top the Trevisan coat of arms bears the motto '*ex alto*'; this is flanked by two little angels in flight and surmounted by a cardinal's hat carried by two other angels. The Moro coat of arms at the bottom is accompanied by the Doge's 'horn' and flanked by two lions, symbolising Venice. Two peacocks signify immortality.

The scribe responsible for this little gem was the great Paduan calligrapher Bartolomeo Sanvito who, in the 1460s, wrote and edited a number of exquisite manuscripts for top members of the Venetian aristocracy who had connections with Padua (cat. 71). These were illumi-

26 folio 6v

nated by various artists. The relationship between text and illustrations is always close, and they reflect the sophisticated tastes of Paduan Classical humanism. The illuminator of this manuscript is identifiable as Franco dei Russi, one of the great masters of the d'Este court; he must have moved to Padua after completing the Bible of Borso d'Este. In this *Oratio* the combination of Classicism and painted architecture is typical of Padua, under the influence of Donatello and Mantegna. The bright colours and imaginative decoration are typically Ferrarese. This volume was executed before 1465, the year Trevisan died.

Sanvito also transcribed a copy of Solinus' *Polystoria*, dated 1457 and illuminated in humanist style (Oxford, Bodlean Library, MS Canon. Class. 161), for Bernardo Bembo, whose illegitimate baby, born in Padua, was Sanvito's godchild. He also wrote the superb Petrarch (cat. 71), perhaps for Cardinal Trevisan, and an exquisite small, purple manuscript of St Jerome's *Vitae Malchi et Pauli* (Venice, Biblioteca Marciana, Lat. II, 39 [=2999], in which Trevisan's motto 'ex alto' reappears. Franco dei Russi, in Padua, was probably the author of other works signed 'Franchi': an illuminated page depicting a *Triumph of an Academic* (cat. 113); a Bible printed in 1471 (cat. 82); an illuminated initial for a Choir Book with the *Martyrdom of St Stephen*; another identical initial with the *Resurrection* (Venice, Fondazione Cini); and another initial letter with the *Madonna and Child* (London, Victoria and Albert Museum, E. 1275-1991). More problematic is the question of his intervention in the Gradual of SS. Cosmas and Damian (cat. 123) and other manuscripts. In any case he seems to have been at the centre of a small school of miniaturists in the Veneto.

Provenance: Acquired from Payne, 1844.

Bibliography: *Catalogue of Additions* 1850, p. 5; Levi d'Ancona 1960, pp. 35-36; Salmi 1961, pp. 46-7; Bonicatti 1964, p. 11; Mariani Canova 1969, pp. 26, 104-6, 145; Alexander 1970a, p. 32; Alexander 1977a, p. 25; Mariani Canova 1984a, pp. 341-2; Mariani Canova 1987, p. 119; Toniolo 1990-3, pp. 228-30.

G. M. C.

27

Promissio of Doge Cristoforo Moro

30 fols. 340 x 232 mm. On parchment

Written in Venice, 1462, and illuminated by Leonardo Bellini

LONDON, THE BRITISH LIBRARY, Additional MS 15816

In Venice the official documents of the Republic were commonly illuminated with portraits of the Doges and magistrates from the Middle Ages onwards. This manuscript of the *Promissio* of Doge Cristoforo Moro, elected in 1462, contains his oath and the rules of office. At the bottom of the first page (folio 5) is the coat of arms of the noble Moro family surmounted by the Doge's 'horn'. There is a small miniature above of the Madonna and Child sitting on a golden throne under a canopy, with the Doge kneeling before her in a delightful garden full of fruit trees. The canopy is surrounded by a wall, and the marble floor is drawn in perspective. Flanking are St Mark, patron saint of Venice, and San Bernardino of Siena, whose presence can be explained by his great friendship with the future Doge, which developed when they were both in Padua. This friendship is recorded by Bernardo Bembo in the *Oratio gratulatoria* he composed for Moro's election (cat. 26).

Fortunately, documentary evidence exists of payment made to Leonardo Bellini, 'painter and miniaturist' on 7 December 1463. Further documentary evidence informs us that the painter was a nephew of the great Venetian painter Jacopo Bellini and had been brought up in his uncle's studio as if he had been his son (see cat. 89). Leonardo's style resembles that of his uncle, and his work as an illuminator testifies to the interest of the Bellini family in book illustration. Leonardo probably collaborated with his uncle on the mosaics of

the Cappella dei Mascoli in San Marco. As an illuminator he was especially active in the 1470s and 1480s, working above all on state documents and for the religious and lay confraternities.

The perspective design and the gracefulness of the figures in the present illumination are reminiscent of the panel depicting St Anthony Abbot and San Bernardino of Siena in a landscape (New York, private collection), assumed to be part of the Gattamelata altarpiece in Sant'Antonio, Padua, signed and dated by Jacopo Bellini and his sons in 1460. In that painting, however, as in Mantegna's San Zeno altarpiece, the traditional divisions of the altarpiece are respected, whereas here for the first time in Venice we have a *sacra conversazione* in a single space and in the open air. It is possible that the Bellini family painted a similar altarpiece between 1460 and 1462. The flower and filigree border around the page are in Ferrarese style and closely resemble the borders painted by Giorgio d'Alemagna for the Virgil illuminated in 1458 in Ferrara for the Venetian diplomat Leonardo Sanudo (cat. 42). Leonardo Bellini must have known Sanudo's collection of books quite well, in fact, since he had worked on the illumination of a Lactantius for him in 1457 (Venice, Biblioteca Marciana, Lat. II, 75[=2198]. The medallions with animals are also in Ferrarese style. The lion tearing the roe apart on the right may be a symbol of royalty, and the other animals near the coat of arms probably refer to the Virtues and Vices.

Provenance: Bought from a Mr Herz, 25 April 1846.

Bibliography: *Catalogue of Additions* 1864, p. 34; *Reproductions from Illuminated Manuscripts* 1907, pl. 48; Herbert 1911, p. 294; Moretti 1958, pp. 58-60; Moretti 1965, pp. 712-13; Mariani Canova 1968, pp. 9, 10, 15; Mariani Canova 1969, pp. 24, 103-4, 143; Alexander 1977a, pp. 20-21; Armstrong 1981, pp. 79, 82; Bauer-Eberhardt 1984, pp. 231-2; Bauer-Eberhardt 1989, p. 63.

G. M. C.

28

St Jerome, *Letters*

344 fols. 297 x 195 mm. On parchment [New York only]

Script attributed to Johannes Nydenna, c. 1478-80, with illumination attributed to the Master of the London Pliny

BERLIN, STAATLICHE MUSEEN ZU BERLIN, PREUSSISCHER KULTUR-BESITZ, KUPFERSTICHKABINETT, MS 78 D 13

The full-page miniature opening the Berlin *Letters* of St Jerome (folio 5) is a work of exceptional beauty. Framed by a superbly designed *all'antica* border, the prinicipal scene reveals St Jerome dressed in red, seated in a lofty interior preceded by a Classical portico. He welcomes a group of five men, two dressed in black hooded robes and one wearing a blue robe and red hat, a costume probably indicating that the wearer is a *cancelliere grande* (Venetian Grand Chancellor; Newton 1988, p. 19). Beyond the group a door opens to reveal the façade of a church and a landscape with a winding river, a bridge and distant buildings. In the foreground, two dignified putti stand on high column bases, holding St Jerome's cross and cardinal's hat, while others play a fiddle and tease his mascot, a gentle lion. Refined handling of light and judicious placement of figures in space are two striking formal characteristics of the miniature. The men at the left are subordinated by shadow, while full light falls on the brilliantly robed saint. The view into the landscape is also reminiscent of 15th century Flemish painting; it probably reflects the miniaturist's familiarity with the works of Antonello da Messina, whose oil paintings executed in Venice in 1475 heightened awareness there of Flemish techniques (Alexander 1969a, p. 20; Armstrong 1981, p. 46).

The meaning of the informal composition is not known. The saint appears either to be welcoming visitors or to be instructing them, especially since the hooded figures stand with eyes downcast as if listening. The delegation may represent the officers and members of a confraternity, perhaps of the Scuola di San Girolamo, whose patron

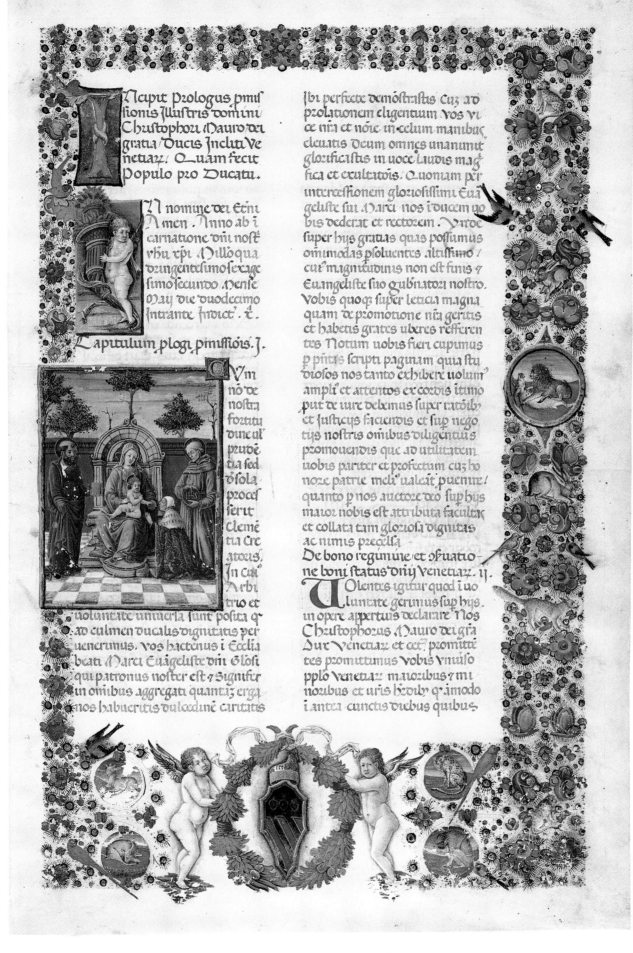

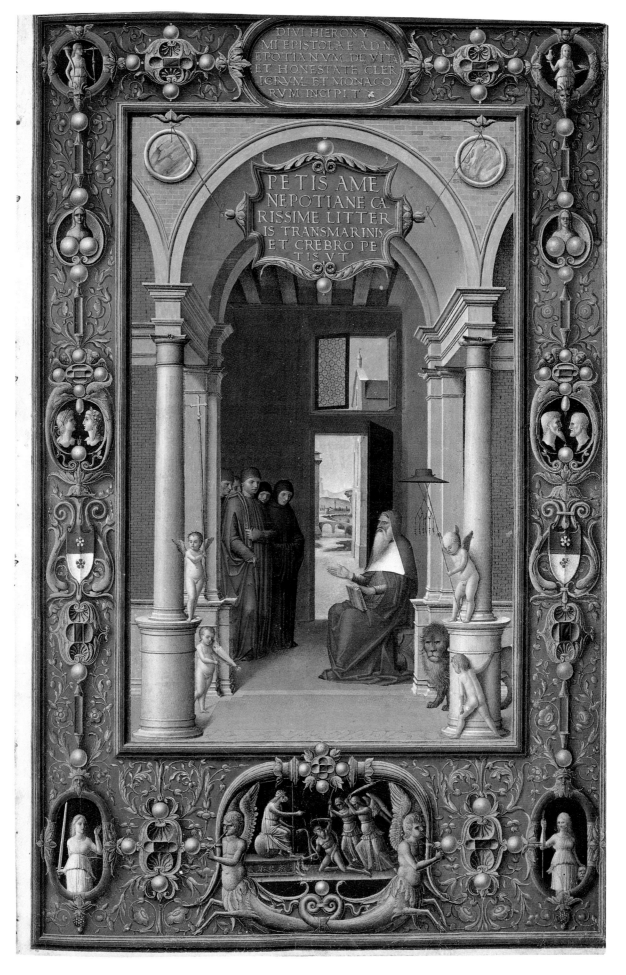

DIVI HIERONY
MI EPISTOLAE AD N
EPOTIANVM DE VITA
ET HONESTATE CLER
ICRVM ET MONACO
RVM INCIPIT

PETIS AME
NEPOTIANE CA
RISSIME LITTER
IS TRANSMARINIS
ET CREBRO PE
TIS VT

28 folio 5r

saint they confront. In the 1470s the members of the Scuola di San Girolamo included the printers Nicolaus Jenson and Johannes de Colonia, sculptors Bartolomeo Buon and Pietro Lombardo, the painter Lazzaro Bastiani, and four members of the ducal chancellery (Lowry 1981). They owned a cycle of narrative paintings of the *Life of St Jerome* by Bastiani and others; these included a *St Jerome Discursing with his Followers* by Giovanni Bellini, dated 1464 but now lost (Humfrey 1985, p. 45), a subject near to that of the Berlin miniature.

The Mocenigo coat of arms is twice painted in the frontispiece borders of the Jerome *Epistolae*; both shields appear to have been overpainted, but close inspection suggests that this was done by the same miniaturist who executed the rest of the border and the principal scene. The book may first have been destined for a member of the Scuola, but even before completion changed for presentation to a Mocenigo, perhaps the newly elected Doge, Giovanni Mocenigo (r. 1478-1485).

The borders of the folio presume the classicising taste of the recipient, complete with winged tritons and cameo heads in profile. In addition, the spiritual content of the text is enhanced by four grisaille figures representing Virtues: counter-clockwise from the lower left, they are Justice with sword and scales, Fortitude with a spear and a severed head, Temperance(?) with a vase and a flaming bowl, and Charity(?) with a cornucopia and a distaff(?) (Armstrong 1981, pp. 45, 88 n. 20). The *Dream of St Jerome*, in which Jerome is chastised by angels for his excessive devotion to Classical writers, is the probable subject of the grisaille scene in the lower margin. Faith, carrying a cross and seated on a sphere, oversees the flagellation of a kneeling bearded nude. The intriguing relationship of the composition to drawings and prints of the *Death of Orpheus* from the circle of the great Paduan artist Andrea Mantegna (c. 1428-1506) has also been pointed out (Anzelewsky 1983, p. 21).

The numerous painted initials are primarily of the faceted *camaïeu d'or* type with monochromatic floral motifs (folios 11v, 15, 21v, 26, 35 etc.), although one includes the profile portrait of a Roman emperor. Together with the full-page miniature, the initials should in all probability be attributed to the Master of the London Pliny, a miniaturist who decorated a number of incunables and manuscripts in Venice in the 1470s, and after 1480 worked for the Aragonese, the ruling family of the Kingdom of Naples (Armstrong 1981; see cat. 90 for further discussion). Formal similarities to works by Girolamo da Cremona (cats 93-96) have also led to an alternative attribution to this miniaturist (Mariani Canova 1969, p. 64; Mariani Canova 1988a, pp. 49-50; p. 31).

Provenance: Coat of arms of the Mocenigo of Venice (*per fess azure and argent, two roses palewise counterchanged*), perhaps overpainted; 1826, Harding and Co., London; Comte Alexis de Golowkin; Hamilton Palace Library manuscript sale, London, Sotheby's, 1882, lot 297; acquired 1882.

Exhibitions: Stockholm 1962, no. 35, p. 44; Berlin 1975, no. 169, illus. p. 262; Berlin 1994, no. I. 14.

Bibliography: Wescher 1929, pp. 345-7; Wescher 1931, pp. 114-16; Levi d'Ancona 1967a, pp. 21-2; Mariani Canova 1969, pp. 64, 154-5, pl. 24, figs 97, 99; Alexander 1969, p. 20 n. 31; Armstrong 1981, pp. 43-6, 131, figs 117, 122; Anzelewsky 1983, p. 21; Mariani Canova 1988a, pp. 49-50.

L. A.

29

Strabo, *Geography*, translated from Greek by Guarino of Verona

389 fols. 370 × 250 mm. On parchment [New York only]

Written in Venice or Padua, 1458-9, with illumination attributed to the Circle of Jacopo Bellini (Giovanni Bellini?), Venice, 1458-9

ALBI, BIBLIOTHÈQUE MUNICIPALE, MS 77 (formerly Bibliothèque Rochegude, MS 4)

The Albi Strabo is doubtless one of the most famous Italian Renaissance manuscripts, important for its provenance, text, script, painted initials, miniatures, and for its position in the historiography of manuscript illumination. In 1957, Millard Meiss published a small book on the Strabo and a related manuscript, the *Passio Mauritii et sociorum eius (Passion of St Maurice and his Colleagues)* of 1453, now in Paris (Bibliothèque de l'Arsenal, MS 940). Bearing the challenging title *Andrea Mantegna as Illuminator*, Meiss's book still stands as a model for studying individual works of art in their full historical context.

The *Geography* in seventeen books written by the Greek historian and geographer Strabo (64 BC-after 20 AD) was translated into Latin by the humanist Guarino of Verona (1374-1460), a translation begun at the request of Pope Nicolas V (r. 1447-1455), but not yet complete when the Pope died. Guarino vainly sought the patronage of the Medici in order to continue, and then succesfully petitioned Jacopo Antonio Marcello (1398/99-1464) for support of the humanistic endeavour. Guarino finished his work and presented a manuscript to Marcello on 13 July 1458 (Meiss 1957, pp. 32-3).

Jacopo Antonio Marcello was a noble Venetian whose admirable military career and literary interests have been explored in a recent monograph by Margaret L. King (1994). Marcello not only had a residence in Venice, but also maintained a stronghold at Monselice, outside of Padua, where he often spent long periods of time when not holding office for the Republic. His acquaintances and clients included a circle of humanists mainly working in the university town of Padua. Marcello repeatedly served as *provveditore*, or military supervisor, of the Venetian armies; the *condottieri* (mercenary generals) with whom he served included Francesco Sforza, later Duke of Milan (r. 1450-1466); and Erasmo de' Narni, known as 'Il Gattamelata' (honeyed cat), famed for his equestrian monument by Donatello. Both Marcello and Sforza supported René of Anjou (1409-1480) as the rightful King of Naples, a claim disputed by Alfonso of Aragon (1395-1458). Unsuccessful in ousting Alfonso in the early 1440s, René tried again in 1449. To encourage the support of Sforza and Marcello, he named them members of the chivalric Order of the Crescent in that same year (King 1994). Renewed efforts in 1453 and 1458-64 did not dislodge Alfonso from Naples, but René never relinquished his claim or his title.

Despite King René's failure to win his kingdom, and the on-again-off-again policies of Venice and Milan in the next decade, Jacopo Antonio Marcello maintained relations with René through gifts of several illuminated manuscripts which reveal their shared interest in Classical texts. These included the Albi Strabo of 1458-9, which opens with Marcello's dedicatory letter invoking the ancient custom of offering gifts to princes, and explaining the history of Guarino's translation (Meiss 1957, pp. 34-5). Two beautiful unframed full-page miniatures show *Guarino Presenting the Strabo to Marcello* (folio 3v), and *Marcello Giving the Strabo to King René* (folio 4). Both the settings and the groups of personages are remarkable. The aged Guarino stands framed by a severe monumental arch, suggesting the triumphal arches of Antiquity. His brilliant red robe contrasts to the courtly gold brocade tunic worn by Marcello in both miniatures. Younger scholars stand behind Guarino, and two young gentlemen balance them, standing behind Marcello (see frontispiece).

The solemn exchange between apparent equals differs from the livelier composition in which Marcello kneels in homage before King René (folio 4). The King sits on a classicising marble throne at the right; on its base the inscription 'CLEMENTIAE AUGUSTAE' is reinforced by a relief showing a lion peacefully seated with a rabbit. René wears a black and gold brocade tunic, a hat encircled by a crown, and fashionable shoes with impossibly long pointed toes. Young and old courtiers crowd in on either side. Directly over Marcello's head is an exotic palm tree, indicating Provence as the setting for the fictive meeting. Behind the figures are delicately delineated buildings, drawn with the sure knowledge of Albertian perspective also exhibited in the triumphal arch.

The authorship of the two miniatures and of the twenty initials in the Albi Strabo has been a much debated topic, which still resists resolution. In the earlier manuscript given to René in 1453, the *Passion of St Maurice*, the undeniable monumentality of the profile bust-length por-

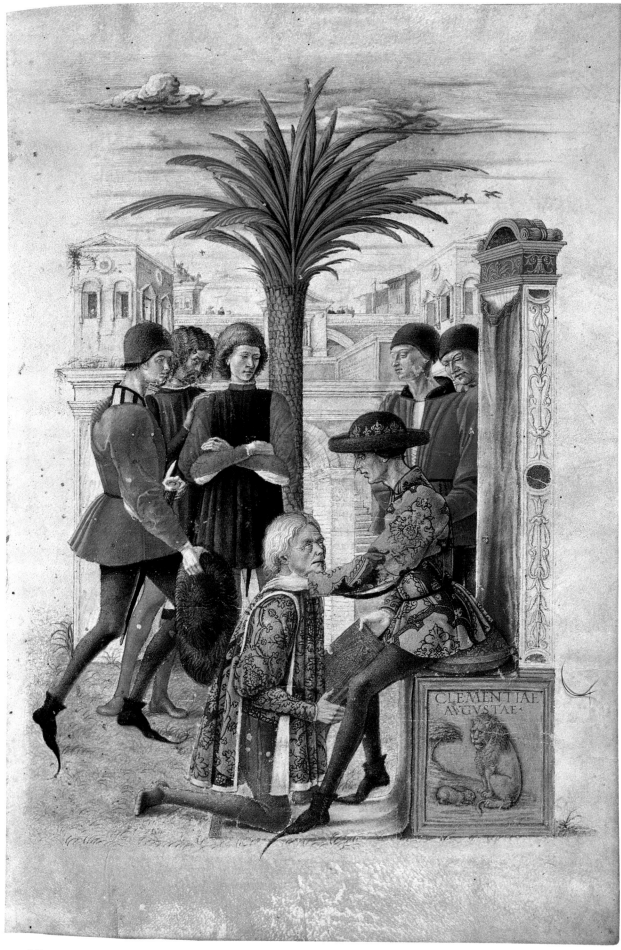

STRABONIS DE SITV ORBIS LIBER·X·TOTA DE EVROPA FINITVR·

XI·DE ASIAE SITV HÆC ISVT CP·

Initium asiæ a partibuſ a quiloniſ a tanai tã europæ q asiæ
termino
Tauri montiſ longitudo & latitudo
Genteſ uariæ barbaræ caucaſi montiſ accolæ in quibꝫ ſunt
Amaꝫoneſ Maſſagetæ Scythæ Albani Iberi Bactriani
Caſpii Medi pſc Armenii duæ Heniochi caoni Aſſyrii
Polyphagi Abiani Siraci Tapyri Iaſoniſ & Medeæ mentio &
urbium abilliſ conditæ Tigraniſ mithridatiſ Alexandri a
p̃peii
Luculli Attauanꝫe Antonii de dcã tanaidiſ cultu·

STRABONIS LIBER VNDECMVS·

VROPAE
CONTINE
NS ASIA
EST AD TA
NAIM ILLI
CONIVNC
TA·DE IPSA
igitur deinceps diſſerendum: pnaturaleſ quoſdam termi
noſ euidentiæ gratia diuidentiꝫ. Quod at eratoſthenes
de toto fecit orbe hoc anobiſ de aſia faciundum uidetur
Tauruſ enim mediam hanc tellurem quodam mõ circumcin
git ab occidentem protenſuſ inortum. partem quidem
eiuſ ad boream partem uõ relinquit ad meridiem. earum
partium unam quidem intra taurum alteram uõ extra
taurum greci uocitant Hæc aũt a nobiſ inſuperioribus ex

Tauri longitudo & lati
tudo & ſitus

trait of Marcello has led some scholars to accept Meiss's attribution of that portrait to the Paduan painter Andrea Mantegna (London and New York 1992, pp. 129-34). But the rich colours, delicacy of figures, and intensity of expression in the Strabo miniatures do not find convincing counterparts in Mantegna's works around 1458-9, and Meiss's attribution of them to the 'Mantegna workshop' has been almost universally rejected. Instead, scholars have pointed to the circle of Jacopo Bellini (*c.* 1398-1470/71), head of a thriving workshop in Venice that included his sons Gentile and Giovanni Bellini, and his nephew, the miniaturist Leonardo Bellini (Joost-Gaugier 1979; Eisler 1989, pp. 534-5); Giovanni Bellini's associate, Lauro Padovano, has also been proposed as the artist of the Strabo miniatures (G. Robertson 1968, p. 50; Bauer-Eberhardt 1989, pp. 59, 67). Formal parallels can be drawn between the Strabo miniatures and the architectural settings of Jacopo Bellini's drawings and also between them and the figure types and colours in early paintings by Giovanni Bellini. Jacopo Bellini's famous drawings include antiquities in Monselice, Marcello's domain outside of Padua, and he was associated with Marcello in several other artistic endeavours, so the formal evidence is enhanced by documentary links (Eisler 1989, pp. 534-5).

The painted initials of the Albi Strabo have also been the subject of debate. The initials are among the first to simulate faceted three-dimensional, free-standing letters based on Roman epigraphic capitals. Meiss attributed their design to Mantegna; he christened them '*littere mantiniane*', and eulogized the great beauty of their colours as they appeared entwined by scrolling leafy vines set on rectangular grounds with tiny circular indentations simulating the nail-holes by which the whole might be attached to the written page (folio 230v, 'E'). Acknowledging the importance of their design if not their absolute priority as a type, Jonathan Alexander (1989) has elucidated the emergence of the faceted initial in Padua at the very end of the 1450s in the circle of humanists, patrons, and scribes enthusiastic about the revival of the Classical inscription.

The scribe who wrote the Albi Strabo has not yet been identified, but A. C. de la Mare has recognised an imposing group of manuscripts written by the same hand (to those listed in London 1991, pp. 50-1, she now adds Cambridge, Fitzwilliam Museum, MS J. 255 and the manuscripts noted below). Most significant in this context is a manuscript of consolatory texts by many humanists addressed to Jacopo Antonio Marcello on the death of his son (Glasgow, University Library, MS Hunter 201 [U.1.5]; Thorp 1987, no. 107). Valerio Marcello died on 1 January 1461, shortly before his ninth birthday; and the Glasgow manuscript was prepared shortly after 1463 for an unknown dedicatee, pos-

sibly King René. In the second half of the 1460s, the same scribe wrote several manuscripts for Janos Vitéz, who became Archbishop of Esztergom in 1465 (Paris, Bibliothèque nationale, latin 7803; Vatican, Biblioteca Apostolica Vaticana, Pal. lat. 1711; Vienna, Österreichische Nationalbibliothek, Cod. 644). The decoration of these manuscripts is localisable to Padua or Venice.

The geographical location of the principal characters in the story of the Albi Strabo will not alone determine whether it was made in Venice or Padua. From October 1458 through June 1459 Marcello was a member of the powerful Venetian Council of Ten, even serving several one month terms as its head; from 31 October 1459 through May 1460 he served as a ducal counsellor (*consigliere*) (King 1994, chap. 4). Thus throughout the period when the Albi Strabo was being prepared, Marcello must have been in Venice almost continuously, not acting as Governor of Padua as has been mistakenly asserted previously. Though also based in Venice, Jacopo, Gentile and Giovanni Bellini in 1459 were all working on an altarpiece for the Gattamelata funerary chapel in Sant'Antonio, Padua, a commission they received from the *condottiere*'s widow, who in other matters was advised by none other than Jacopo Antonio Marcello (Eisler 1989, pp. 46, 60, 517). And although the activity of the scribe seems to have been localised in Padua, it is also possible that he came to nearby Venice to participate in creating the Strabo manuscript, a magnificent gift from a distinguished nobleman to a like-minded humanistic King.

Provenance: Presented to René of Anjou (1409-1480) by Jacopo Antonio Marcello (1398/99-1464) in 1459; Louis d'Amboise, Bishop of Albi, end of the 15th century.

Exhibition: Paris 1984, no. 112.

Bibliography: Durrieu 1895, pp. 2-5, 17-21; Durrieu 1929, pp. 15-20; Meiss 1957 (as workshop of Mantegna); Fiocco 1958, p. 57 (as Marco Zoppo); Moretti 1958, p. 58 (as Marco Zoppo); Meiss 1960; G. Robertson 1968, p. 50, pl. XXXVI (Lauro Padovano?); Mariani Canova 1969, pp. 18-29, 141-2, figs 6-9 (Ferrarese-Paduan master); Joost-Gaugier 1979, pp. 48-71 (as Giovanni Bellini?); Lightbown 1986, pp. 494-5 (not by Mantegna); Alexander 1988b, pp. 145-55; Bauer-Eberhardt 1989, pp. 59, 67, no. 3 (as Lauro Padovano); Eisler 1989, pp. 534-5 (as Circle of Jacopo Bellini [Giovanni Bellini?]); London 1991, pp. 50-1 (citing A. C. de la Mare on the script); London and New York 1992, pp. 129-34; Hargreaves 1992, pp. 15-34; Erdreich 1993, pp. 134, 147-9; King 1994, chap. 4 and app. III, Texts (typescript graciously made available by the author before publication).

L. A.

30

Basinio da Parma, *Hesperis*

143 fols. 343 x 237 mm. On parchment [London only]

Written in Rimini, c. 1457-68, with illumination attributed to Giovanni di Bartolo Bettini da Fano

OXFORD, BODLEIAN LIBRARY, MS Canon. Class. Lat. 81

This is one of three illustrated copies known of Basinio da Parma's epic poem in praise of Sigismondo Malatesta, Lord of Rimini (1417-1468). Basinio came to Rimini in 1449 as court poet and modelled his account of Sigismondo's struggle with Alfonso of Aragon, King of Naples, on the Classical epics of Homer and Virgil. When Basinio died in 1457 he left an unrevised autograph version which still survives in Rimini and which Sigismondo ordered to be transcribed and illustrated. All three illustrated manuscripts are thought to have been made before Sigismondo's death in 1468. The second and third copies, which are in Paris (Bibliothèque de l'Arsenal, MS. 630; Ricci 1928; Rimini 1970, no. 157) and the Vatican (Biblioteca Apostolica Vaticana, Vat. lat. 6043; Vatican 1950, no. 64), have a similar but not identical set of miniatures (listed by Pächt and Campana 1951, app. II); these are clearly by the same hand

as the present manuscript. In both the Paris and the Vatican manuscripts the last miniature of the series, showing the building of the Tempio Malatestiano in Rimini, is signed: '*Opus Ioannis Pictoris Fanestris*'. The artist's full name was Giovanni di Bartolo Bettini da Fano. His ability as a narrative artist and in representing landscapes and seascapes has been stressed by Otto Pächt (Pächt and Campana 1951).

There are nineteen miniatures placed in marbled frames and accompanied by gold initials with white vine-stem ornament inhabited by putti (folios 2, 16, 16v, 27, 37v, 49v, 50, 60v, 61, 70, 70v, 82v, 83, 91, 100v, 112v, 122v, 123, 137). That on folio 137 shows the Tempio Malatestiano, of which Leon Battista Alberti was the architect, in process of construction.

Provenance: Probably from the library of Sigismondo Malatesta; by the 18th century in the library of the Franciscans in Bologna, where it was used for the engravings of the 1794 edition of Basinio's poems; acquired by Oxford University with the library of the Venetian Jesuit, Abate Matteo Luigi Canonici (1727-1805) in 1817.

Exhibitions: Oxford 1948, no. 38, pl. XI; Rimini 1970, no. 157, figs 52-3.

Bibliography: Affo 1794, II/1, pp. 26, 33; Pächt and Campana 1951, pp. 91-111, figs 1, 3, 5, 7, 8; Saxl and Meier 1953, p. 323, fig. 33; Pächt and Alexander 1970, no. 830, pl. XVIII; Pasini 1987, pp. 154-5, figs 16-17.

J. J. G. A.

30 folio 137r

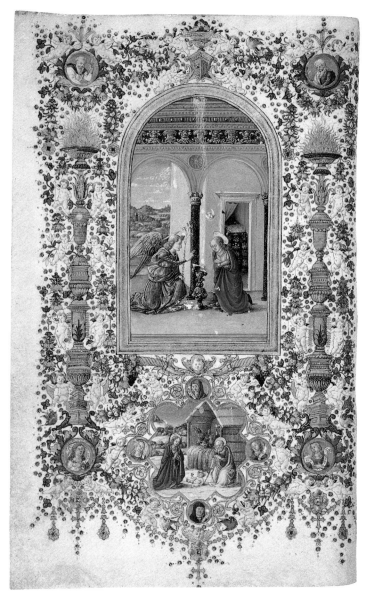

31 folio 13v

31

Book of Hours, Use of Rome

234 fols. 152 × 100 mm. On parchment [London only]

Written in Florence, 1485, by Antonio Sinibaldi, with illumination attributed to Francesco Rosselli

FLORENCE, BIBLIOTECA MEDICEA LAURENZIANA, Ashburnham 1874

This famous Book of Hours bears the Medici arms and is one of four Hours with such arms (see cats 32–3), at least two of which were clearly made for the marriages of daughters of Lorenzo de' Medici, as deduced from heraldic evidence (see cat. 32 and Waddesdon Manor, MS 16, Rothschild Hours). Mark Evans (1991, p. 200) has conjectured that since some of the coats of arms in the present Hours are blank (they have been covered in plain gold) it might have been made for the projected marriage of Lorenzo's third daughter, Luisa, who, however, died at the age of eleven in 1488, before her planned marriage to her cousin, Giovanni de' Medici, could take place.

The illumination begins with minute roundels with Labours of the Months in the Calendar. There are four major openings, each having a miniature with a round topped frame on the verso, opposite a historiated initial on the recto, both pages framed with flower and foliage borders peopled with putti and containing roundels with bust heads; in the lower centre of the pages are scenes or larger figures. At the beginning of the Hours (folios 13v–14), the *Annunciation* is shown on the verso with the *Nativity* outside the stable seen below; on the recto opposite is a 'D' with the Virgin and Child and *Adoration of the Magi* below. The opening of the Seven Penitential Psalms on folios 162v–163 shows David in prayer in a landscape; in a 'D' opposite he is enthroned and being reproved by the prophet Nathan. The opening of the Hours of the Cross on folios 193v–194 shows the *Crucifixion*; in a 'D' opposite is Christ as Man of Sorrows. Fourthly, the opening of the Little Office of the Cross on folios 228v–229, shows the *Lamentation* and Christ kneeling in a roundel below; in a 'P' opposite is the *Betrayal*. Further historiated initials with single sided borders of flower scroll introduce the various Hours on folios 36v, 50v, 56, 61v, 66v, 71, 79v. They contain half-length figures of women carrying lamps, thus the Seven Wise Virgins. On folio 106a 'D' introducing the Office of the Dead shows the

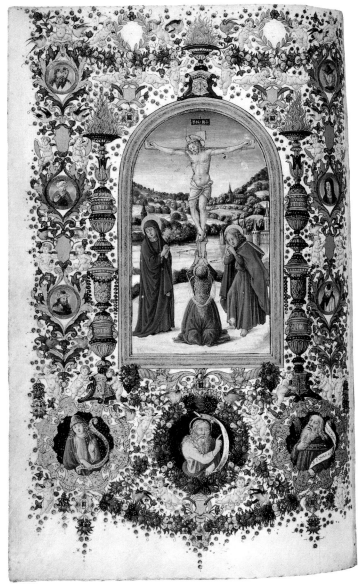

31 folio 193v

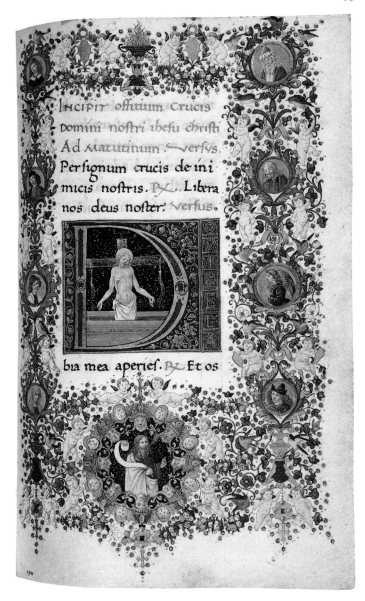

31 folio 194r

Raising of Lazarus, with the scene of the *Three Living and the Three Dead* in a roundel below. Probably a miniature, as in the other openings, has been lost here.

The illumination has been attributed to Francesco Rosselli (1445–1513), one of the most gifted illuminators in Florence of his generation. His brother was the painter Cosimo Rosselli and there are many links in his work to monumental art. The images in the Hours are framed like altarpieces and the candelabra flanking the *Annunciation*, *Crucifixion* and *Lamentation* emphasise this aspect, as if the reader kneels before a devotional image in a chapel.

The script is by Antonio Sinibaldi (1443–c. 1528), a prolific Florentine scribe, who signs on folio 104v: '*Antonius Sinibaldus Florentinus scripsit. Anno christi MCCCCLXXXV*'. In a tax return filed in 1480 he complained of lack of work due to the new invention of printing. But the list of manuscripts copied by him shows that he continued to be employed by important patrons (see cats 32, 41, 46, 64).

Provenance: Arms of the Medici, mostly painted over, but visible on folio 194; emblems including the ring, the feathers and the laurel, of Lorenzo de' Medici, appear in the borders; Maximilian, Count of Merode, 17th century, long note, scribbled over, concerning the children of '*seigneur baronne et conte de Merode et de Hamforte*', folio 232v; bought by Bertram, 4th Earl of Ashburnham, from the notorious book thief Guglielmo Libri; bought back with Lord Ashburnham's most important Italian manuscripts by the Italian state in 1884.

Exhibitions: Rome 1953, no. 499 (with misprint of date as 1458); Brussels 1969, no. 54; Florence 1992a, pp. 167–8, illus.

Bibliography: *Palaeographical Society* 1884–94, II, pl. 19; Biagi 1914, p. 12, pls XXIV–XXVIII; D'Ancona 1914, I, pp. 61–2, II, no. 801; Salmi 1957, p. 50, pl. XLIIIb; Ullman 1960, pp. 119–20; Alexander 1977a, p. 16, pl. 3; Levi d'Ancona 1962, p. 110; Garzelli 1980; Garzelli and de la Mare 1985, pp. 179–80, 186–7, 485, pl. VII, figs 531, 533; Evans 1991, pp. 179, 182–202, illus. pp. 187–91.

J. J. G. A.

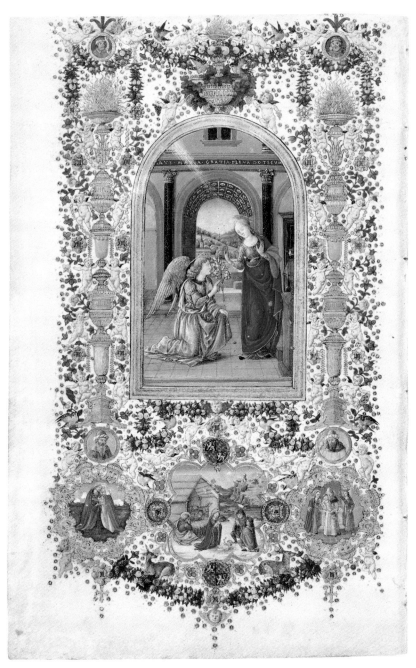

32 folio 13v

32

Hours of Lucretia de' Medici, Use of Rome

228 fols. 108 x 70 mm. On parchment. Original silver gilt metalwork and enamel binding with emblems and mottoes of Lorenzo de' Medici

Written in Florence, 1485, by Antonio Sinibaldi, with illumination attributed to Francesco Rosselli

MUNICH, BAYERISCHE STAATSBILBIOTHEK, Clm 23639

This sumptuous Book of Hours is a pair to the famous Ashburnham Hours in the Biblioteca Medicea-Laurenziana (cat. 31). Both were written in 1485 by the Florentine scribe Antonio Sinibaldi (1443- *c.* 1528), who signs and dates the present Hours on folio 223, and both were illuminated with a very similar programme by Francesco Rosselli (1445-1513). The present Hours bears the arms of Medici and Salviati and can therefore be linked to the marriage of Lorenzo de' Medici's eldest daughter, Lucretia, who was born *c.* 1470 and died in 1550, to Jacopo Salviati in 1488.

The Calendar on folios 1-12v is illuminated with small roundels showing the Labours of the Months. There are then five openings with full-page miniatures on the versos and historiated initials on the rectos, each framed with ornate borders. The first for the Hours of the Virgin shows, as is usual, the *Annunciation* on folio 13v and within the initial 'D' on folio 14 the *Virgin and Child* half-length. For the Hours of the Dead the miniature on folio 91v shows the *Raising of Lazarus* and within the initial 'D' on folio 92 the *Temptation of Adam and Eve*. For the Seven Penitential Psalms on folio 155v, the miniature shows *David in Penitence* and within the initial 'D' on folio 156 *David and Goliath*. On folio 185v for the Hours of the Cross the miniature shows the *Crucifixion* and within the initial 'D' on folio 186 *Christ before Caiaphas*. Finally on folio 219v for the Little Hours of the Cross, the *Deposition* is shown and within the initial 'P' on folio 220 the *Agony in the Garden*. The borders of the openings are richly ornamented with flower, fruit and foliage ornament with gold discs, all on a minute scale. They are inhabited by putti, often holding shields with arms, animals and little birds; other motifs include flaming candelabra. There are roundels with figures of unidentified saints and prophets. On folio 13v in the lower border are three subsidiary scenes in roundels, the *Visitation*,

Nativity and *Presentation in the Temple*, and on folio 14 the *Adoration of the Magi*. There are also historiated initials for the various Hours: folio 27v, Lauds, 'D'; folio 41v, Prime, 'D'; folio 47, Terce, 'D'; folio 51v, Sext, 'D'; folio 56, None, 'D'; folio 60v, Vespers, 'D'; folio 69, Compline, 'C'. For Prime, St Agnes is shown with a lamb, and for Compline a female saint with a book. The other initials show young females with lamps, thus the Wise Virgins as in the Ashburnham Hours.

The mise-en-page of the openings and the compositions of the various scenes are very similar to those in the Ashburnham and two other Medici Hours, as Mark Evans (1991) has demonstrated, for example in the Calendar scenes or in the type of Virgin Annunciate standing in a portico, seen also in the Cleveland leaf (cat. 33). The latter composition can be compared with Baldovinetti's *Annunciation* in the Uffizi and Filippo Lippi's *Annunciation* for San Lorenzo, Florence.

Evans considers the Munich Hours the earliest of the group, the one which set the pattern for the other manuscripts. He also shows how widely influential certain of Rosselli's compositions were, for example that of the penitent David in a landscape, which was copied by other later illuminators.

Provenance: Arms of Medici and Salviati survive on folio 185v but are mostly overpainted with those of Wittelsbach; Medici *imprese* and mottoes in the borders and on the binding; arms of Wittelsbach of Bavaria with the chain of the Order of the Golden Fleece, either of Duke Albrecht V (r. 1550-1579) or of Duke Wilhelm V (r. 1579-1597); inventory of the ducal Kunstkammer of 1598, perhaps already there by 1574 (Arnold *et al.* 1991).

Exhibition: Florence 1992a, pp. 166-8, illus.

Bibliography: Dibdin 1829, III, pp. 271-2; Herbert 1911, p. 296; D'Ancona 1914, I, pp. 62-3, II, no. 836; De Marinis 1960, I, p. 115, no. 1147, pl. CLXXXIII; Steingräber 1964, pp. 303-13; Garzelli 1980, pp. 475-90; Garzelli and de la Mare 1985, pp. 179, 186-7, 485, figs 532, 534; Arnold *et al.* 1991 (facsimile).

J. J. G. A.

33

Single leaf from a Book of Hours, *Annunciation*

151 × 92 mm. On parchment [New York only]

Illumination attributed to the Master of Riccardiana 231(?), Florence, c. 1485

CLEVELAND, THE CLEVELAND MUSEUM OF ART, 53.280

The leaf must come from a Book Hours in which it preceded Matins of the Hours of the Virgin, as in the two Hours also with Medici arms in Munich and Florence (cats 31, 32). In the lower border is a small scene of the *Adoration of the Shepherds* and two flanking roundels have half-length prophets. As in other Florentine manuscripts of the period the border is composed of ornate candelabra, flower and foliage scroll with gold discs and inhabited by putti and birds. The illumination has been tentatively attributed by Annarosa Garzelli (in Garzelli and de la Mare 1985) to the artist of Riccardiana 231.

Provenance: The Medici arms are repeated eight times in the border.

Exhibition: Cleveland 1971, no. 49.

Bibliography: D'Ancona and Aeschlimann 1969, pl. 128; Garzelli and de la Mare 1985, pp. 187, 298, pl. 535; Evans 1991, pp. 177, 195, 199, colour pl.

J. J. G. A.

34

Cicero, *Orationes*

330 fols. 356 × 255 mm. On parchment [London only]

Written in Florence, probably before 1459-60, by a scribe perhaps identifiable as 'Messer Marco', with illumination attributed to Ser Ricciardo di Nanni

FLORENCE, BIBLIOTECA MEDICEA LAURENZIANA, 48, 8

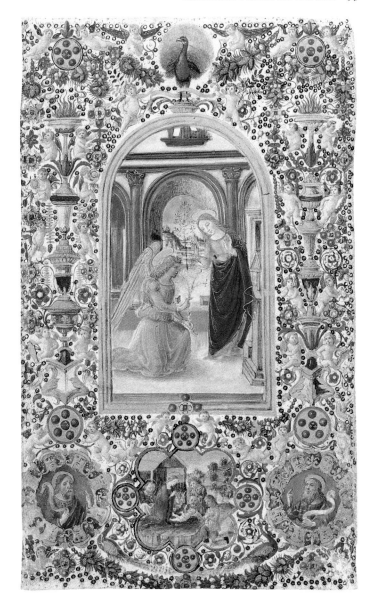

33

The manuscript has a title written in gold capitals set in a rectangular decorated frame, folio 1v. These 'title-pages' were an innovation probably introduced on the suggestion of the Florentine *cartolaio* Vespasiano da Bisticci, the earliest dated example being of 1456. Opposite on folio 2 a small miniature of a figure holding a book standing in a portico, presumably Cicero, is surrounded by an ornate white vine-stem border inhabited by animals, birds and butterflies. There are four medallion heads, two male heads in the left border, a female head in the top border, and a putto head in a band of white vine-stem which fills a space beside the miniature. There are also six small scenes with nude figures based on Classical prototypes, for example the motif of the putti holding a sail while riding on a dolphin, upper right, the Venus figure at middle left, and the profile seated male nude, at each lower corner, based on an Antique gem of Diomedes with the palladium in the Medici collection. There are smaller, five line, white vine-stem initials for the various speeches (folios 10v, 23v, 45v, 46, 60, 77v, 88, 95, 104, 122, 128v, 134, 146, 160v, 190v, 195, 199, 203v, 211).

The illumination has been attributed by Francis Ames-Lewis (1984) and Annarosa Garzelli (1985b) to Ser Ricciardo di Nanni (see cats 68, 120) who was a priest at Castel Fiorentino, where he lived for more than fifty years, from about 1430 to 1480. Payments to him are recorded by Battista di Niccolò da Padova from 1449 to 1452 and by Filippo di Matteo Torelli in 1465 and 1467 (Levi d'Ancona 1962, pp. 229-32). Most of his dated works are from the 1460s to early 1470s.

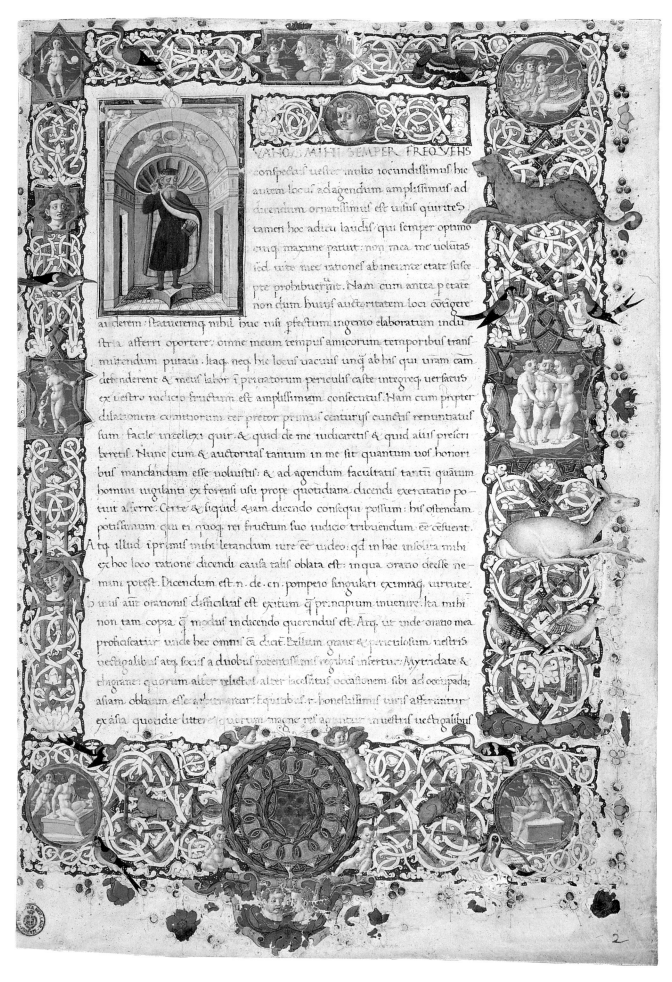

VANOS MIHI SEMPER FREQVENS
conspectus vester multo iocundissimus hic
autem locus ad agendum amplissimus ad
dicendum ornatissimus est visus quirites
tamen hoc aditu laudis qui semper optimo
cuiq; maxime patuit non mea me voluntas
sed vite mee rationes ab ineunte etate susce
pte prohibuerunt. Nam cum antea per etatem
non dum huius auctoritatem loci contingere
auderem statueremq; nihil huc nisi perfectum ingenio elaboratum indu
stria afferri oportere: omne meum tempus amicorum temporibus trans
mittendum putaui. Itaq; neq; hic locus vacuus unq; ab his qui vram cam
defenderent & meus labor in priuatorum periculis caste integreq; versatus
ex vestro iudicio fructum est amplissimum consecutus. Nam cum propter
dilationem comitiorum ter pretor primus centuris cunctis renuntiatus
sum facile intellexi quir. & quid de me iudicaretis & quid aliis prescri
beretis. Nunc cum & auctoritas tantum in me sit quantum vos honori
bus mandandum esse voluistis & ad agendum facultatis tantum quantum
homini vigilanti ex forensi usu prope quotidiana dicendi exercitatio po
tuit afferre. Certe & siquid etiam dicendo consequi possum: his ostendam
potissimum qui ei quoq; rei fructum suo iudicio tribuendum ee censuerit.
Atq; illud in primis mihi letandum iure ee video qd in hac insolita mihi
ex hoc loco ratione dicendi causa talis oblata est: in qua oratio deesse ne
mini potest. Dicendum est. n. de. cn. pompeio singulari eximiaq; virtute.
huius aut orationis difficilius est exitum q principium inuenire. Ita mihi
non tam copia q modus in dicendo querendus est. Atq; ut inde oratio mea
proficiscatur unde hec omnis ea ducit. Bellum graue & periculosum vestris
vectigalibus atq; sociis a duobus potentissimis regibus infertur Mytridate &
Tigrane: quorum alter relictus alter lacessitus occasionem sibi ad occupada;
asiam oblatam esse arbitrantur. Equitibus r. honestissimis viris afferuntur
ex asia quotidie litterae quorum magne res aguntur in vestris vectigalibus

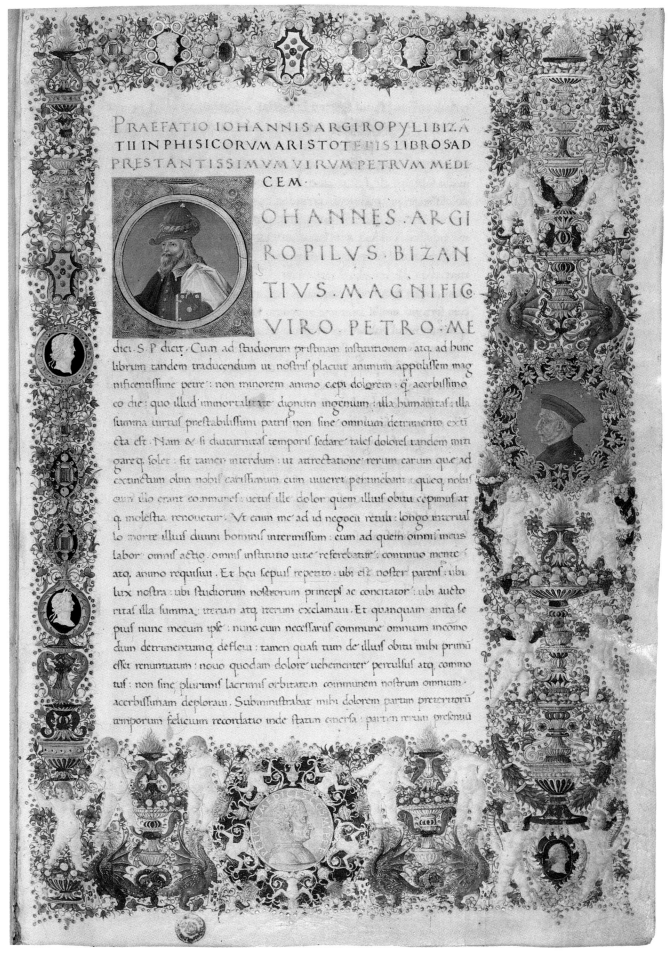

His facial types are easily recognisable, though the influence of Torelli, with whom he collaborated and with whom he is sometimes confused, is clear. He used the same Classical sources, particularly adaptations of the famous Medici gems (for which see also cats 3, 76, 85) in other of his manuscripts.

Albinia de la Mare (in Garzelli and de la Mare 1985) has attributed to the same scribe a group of twelve manuscripts, including five written for Piero de' Medici. One of the latter is a Plutarch (Montpellier, Bibliothèque de l'Ecole de médicine, H. 106) and the scribe may therefore be identifiable with 'Messer Marco', mentioned as the scribe of Piero's Plutarch by Vespasiano da Bisticci in a letter to Piero of 1458. The present manuscript is included in the inventory of Piero's possessions of 1456, but the section on the books there cannot date from before 1458 and most probably dates *c.* 1459-60 (Ames-Lewis 1984a, pp. 118-9).

Provenance: Medici arms on folio 2 and ownership note of Piero di Cosimo de' Medici (*d.* 1469), folio 330v; inventories of '1456' (53) and 1464-5 (55).

Bibliography: D'Ancona 1914, I, p. 53, II, no. 359, pl. LX, 2; Ames-Lewis 1984a, pp. 161, 264, no. 27, pls 32, 68; Garzelli 1985b, p. 444, pl. 9; Garzelli and de la Mare 1985, pp. 56, 72, 245, 435-6, 512, figs 129, 131-2, 139-42.

J. J. G. A.

35

Aristotle, *Physics, Metaphysics, On the Soul, On the Heavens, Nicomachean Ethics*, translated from Greek by Janos Argyropoulos

356 fols. 380 x 268 mm. On parchment [London only]

Written in Florence, c. 1473-8, by Gonsalvo Fernandez de Heredia (Gundisalvus de Heredia Hispanus), with illumination attributed to Francesco Rosselli

FLORENCE, BIBLIOTECA MEDICEA LAURENZIANA, 84, 1

Three of the translations of Aristotle's philosophical works from Greek into Latin by Janos Argyropoulos (1415-1487) included here were dedicated to Cosimo de' Medici (*d.* 1464); and others were dedicated to Piero di Cosimo de' Medici (*d.* 1469) and Janus Pannonius. Argyropoulos first came to Italy from Constantinople for the Council of Florence in 1435, and after the fall of Constantinople settled in 1456 in Florence, where he held a chair at the university and lectured with great success until 1471, when he moved to Rome.

A circular wreath frontispiece on folio 1v lists the works included in five roundels, with the Medici arms in a sixth roundel at the top. Opposite, on folio 2, an ornate border encloses the text, which is introduced by an initial 'I' with a portrait of Argyropoulos. In the border to the right is a portrait medallion of Piero's father, Cosimo de' Medici, and in the centre below of Piero di Cosimo de' Medici. They are shown as if on gold medals, and resemble the extant medals of Cosimo and Piero (Hill 1930, nos 908-9), although they are not exact replicas. The Medici arms with the blue '*palla gigliata*' granted by Louis XI of France in 1465 are in a roundel at the top and also are held by paired female gryphons in the lower border. The manuscript was almost certainly made for Piero's son, Lorenzo il Magnifico (*d.* 1492), as argued by Angela Dillon Bussi (1992).

The border is made up of foliage and flowers with classicising motifs, such as candelabra, putti and simulated cameos of Roman Emperors on black grounds. Six to eight line initials in gold on blue and green with fine quality gold filigree decoration as well as foliage and flower border extensions introduce the various works: folio 8, *Physics*, 'C'; folio 88, *Metaphysics*, 'O'; folio 181, *De anima (On the Soul)*, 'I'; folio 215, *De caelo (On the Heavens)*, 'I'; folio 258v, *De moribus (Nicomachean Ethics)*, 'I'. Smaller initials, five or six lines, are used for different books and three line initials for chapters.

The scribe signs on folio 355v, '*Gundisalvus Hispanus*'. He is identifiable as Gonsalvo Fernandez de Heredia, who was studying canon law at the University of Pisa in 1473-4. He became Bishop of Barcelona in 1478 and of Tarragona in 1490, and died in 1511. The illumination has been attributed to Francesco Rosselli (see cats 2, 31, 32).

Provenance: Arms and emblems of the Medici after 1465, probably Lorenzo il Magnifico (*d.* 1492), folios 3, 181, 215.

Exhibitions: Florence 1949, no. 224, illus; Rome 1953, no. 500, pl. LXIIIb; Florence 1987, no. 21, pl. V; Florence 1992c, nos 1.10, 4.4, illus.

Bibliography: D'Ancona 1914, I, p. 63, II, no. 797; Gombrich 1960 (1966), p. 50, pl. 72; Levi d'Ancona 1965, p. 63, fig. 5; Garzelli and de la Mare 1985, pp. 82, 141, 183, 462, 503, figs 501, 503, 504; Langedijk 1981-7, I, pp. 15, 18, 24, 392-3, no. 26.16, illus.; Dillon Bussi 1992, p. 152.

J. J. G. A.

36

Cristoforo Landino, *Disputationes Camaldulenses*

201 fols. 270 x 186 mm. On parchment. Original blind stamped leather binding with interlace panels, two clasps on silk, original foredge painting
 [New York only]

Script attributed to Gabriel de Pistorio in Florence, probably late in 1472, with illumination attributed to Francesco d'Antonio del Chierico

VATICAN, BIBLIOTECA APOSTOLICA VATICANA, Urb. Lat. 508

A miniature of Duke Federigo da Montefeltro, half-length and in profile, holding a book and accompanied by another figure, has been stuck down onto parchment, which in turn is stuck onto the inner cover of the binding. The two figures are silhouetted as if in a window opening, with a rich Turkish carpet thrown over the front ledge. It seems that the miniature is cut down and thus it may have come from another context, though Annarosa Garzelli's suggestion (1986) that this was a Choir Book seems unlikely, for the miniature would then surely be too small.

The manuscript itself is the presentation copy to Federigo da Montefeltro, whom Landino addresses as 'Prince', that is prior to the conferral of the Dukedom by Pope Sixtus IV in August 1474. Cristoforo Landino (1424-1492) was appointed to a chair of poetry and rhetoric at Florence in 1458 and was an important figure among the Florentine Neo-Platonists. The *Disputationes* were written between April and December 1472. They consist of a series of conversations, which are set in the woods around Camaldoli, concerning the active and contemplative lives between such figures as Lorenzo de' Medici, Leon Battista Alberti and Marsilio Ficino. The work was printed in 1480 in Florence. Landino also wrote an influential commentary on Dante which was printed in 1483.

On folio 1 is a foliage and flower scroll with gold balls inhabited by putti, animals and birds. In a series of roundels are a winged nude female, God enthroned with two cherubim, a woman nursing a baby and holding a distaff, the presentation of a book, the arms of Federigo da Montefeltro before the conferral of the Dukedom in 1474 (see also cat. 62), his *imprese* of the ostrich and the ermine with the motto '*Non mai*', and lastly, a scholar in his study. The title of the work is written in gold, and the initial 'E' contains a gold scroll on blue with two putti heads. There are six line gold initials on coloured grounds with borders: folio 5v, Book I, 'I'; folio 37, Book II, 'N'; folio 40v, 'V'; folio 84v, Book III, 'C'; folio 144, Book IV, 'P'. Albinia de la Mare (in Garzelli and de la Mare 1985) has suggested that the manuscript may have been copied by Gabriel de Pistorio, who signed the manuscript now in Florence, Biblioteca Nazionale, Nuovi acquisiti 1276.

The attribution of the pasted-down portrait miniature has been much discussed, as has also the identity of the second figure. Some

36

authorities (Venturi 1925; Weller 1943) had earlier attributed the minia-
ture to Francesco di Giorgio of Siena (1439-1501) and seen the second
figure as a self-portrait. The comparisons with other representations
of Francesco are hardly conclusive, however. In any case Annarosa
Garzelli has argued (in Garzelli and de la Mare 1985) that both the por-
trait page and the decoration of the remainder of the manuscript are by
the Florentine illuminator Francesco d'Antonio del Chierico, even
though she considers the portrait not to have been originally part of
the manuscript. The Duke is recognisable without question from his
nose wound, received in a tournament in 1450, but if the double por-
trait was not intended for this manuscript, there is no cogent reason to
identify the second figure as Landino, as has often been done.

On the other hand the juxtaposition of the two figures, with the
Duke holding the book and the other figure looking up to him, fits
into the pattern of author's or artist's dedicatory portraits, some of
which are half-length, for example the English Dominican illu-
minator, John Siferwas, with his patron, Lord Lovell, *c.* 1405 (Alexan-
der 1993, fig. 45). More recently Bellosi (1993) has compared the por-
trait of the second figure to the supposed portrait of Landino in the
frescoes by Ghirlandaio in Santa Maria Novella, Florence. The likeness
does not seem conclusive, but the figure's dress in the miniature

suggests an academic doctor, not a cleric or an artist. Federigo himself
was represented in such scholarly attire in the *intarsie* of his studiolo.
Bellosi has also, following an earlier suggestion of Berenson, attri-
buted the miniature to Botticelli. This is testament to the undoubtedly
high quality of the miniature, but Francesco d'Antonio's skill as a por-
traitist is clear from other manuscripts painted by him (see cats 50, 59,
62, 69, 120) and Garzelli's attribution is convincing.

Provenance: Federigo da Montefeltro (1422-1482), as Count of Urbino,
therefore before August 1474 when he became Duke, with his arms and
emblems, folio 2; bought with the rest of the Urbino library for the Bib-
lioteca Apostolica Vaticana, 1658; at the top left of the frame of the paste-
down is the number '.119', which looks early, even 15th century, in date.

Exhibitions: Vatican 1950, no. 53, pl. VI; Vatican 1975, no. 181, pl. XXXII;
Vatican 1985, no. 20, colour pl.; Washington 1993, pl. 45.

Bibliography: D'Ancona 1914, II, p. 425, no. 827; Stornajolo 1902, II, p. 10;
Venturi 1925a, pp. 191-2; Weller 1943, pp. 192-4, fig. 51; De Marinis 1960,
I, p. 87, no. 965, pl. CLXVI; Lohr 1980, pp. ix-xiii, xxxi-xxxii; Garzelli and
de la Mare 1985, pp. 141-2, 496, figs 378, 427-9; Garzelli 1986, pp. 116-7,
127, fig. 2; Bellosi 1993, pp. 71, 75, fig. 88.

J. J. G. A.

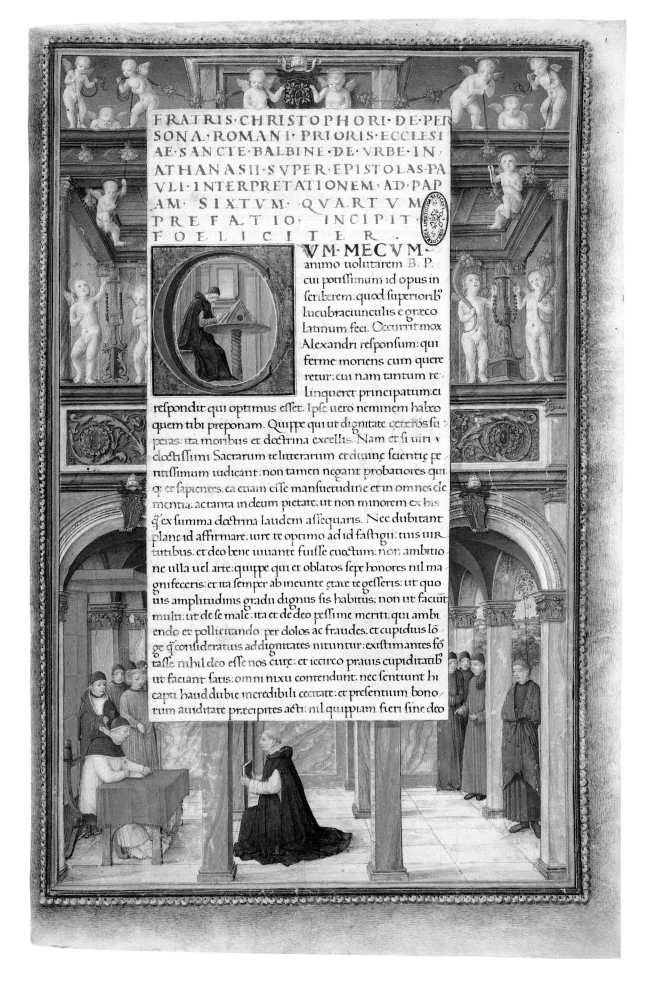

FRATRIS·CHRISTOPHORI·DE·PER
SONA·ROMANI·PRIORIS·ECCLESI
AE·SANCTE·BALBINE·DE·VRBE·IN
ATHANASII·SVPER·EPISTOLAS·PA
VLI·INTERPRETATIONEM·AD·PAP
AM·SIXTVM·QVARTVM·
PREFATIO·INCIPIT·
FOELICITER·

VM·MECVM·
animo uolutarem.B.P.
cui potissimum id opus in
scriberem:quod superioribᵇ
lucubraciunculis e graeco
latinum feci. Occurrit mox
Alexandri responsum:qui
ferme moriens cum quere
retur:cui nam tantum re
linqueret principatum:et
respondit qui optimus esset. Ipse uerò neminem habeo
quem tibi preponam. Quippe qui ut dignitate ceteros su
peras:ita moribus et doctrina excellis. Nam et si uiri
doctissimi Sacrarum te litterarum et diuinę scientię pe
ritissimum iudicant:non tamen negant probatiores qui
qᵉ et sapientes. ea etiam esse mansuetudine et in omnes cle
mentia. ac tanta in deum pietate. ut non minorem ex his
qᵉex summa doctrina laudem assequaris. Nec dubitant
plane id affirmare:iure te optimo ad id fastigii tuis uir
tutibus. et deo bene iuuante fuisse euectum:non ambitio
ne ulla uel arte. quippe qui et oblatos sepe honores nil ma
gnifeceris:et ita semper ab ineunte ętate te gesseris:ut quo
uis amplitudinis gradu dignus sis habitus. non ut faciūt
multi. ut de se male:ita et de deo pessime meriti.qui ambi
endo et pollicitando:per dolos ac fraudes. et cupidius lō
ge qᵉ consideratius ad dignitates nituntur:existimantes fō
tasse nihil deo esse nos curę:et iccirco prauis cupiditatibᵇ
ut faciant satis:omni nixu contendunt. nec sentiunt hi
capti haud dubie incredibili cecitate:et presentium bono
rum auiditate precipites acti:nil quippiam fieri sine deo

37

Theophylact, *Commentary on the Epistles of St Paul,* translated from Greek by Cristoforo da Persona

389 fols. 432 x 287 mm. On parchment [London only]

Written in Rome, 1478, by Oddo de Bk (Beka), with illumination attributed to the Master of the della Rovere Missals

VATICAN, BIBLIOTECA APOSTOLICA VATICANA, Vat. lat. 263

This commentary on St Paul's Epistles, attributed in the Renaissance to Athanasius, is now recognised as one of a series of commentaries on certain books of the Old Testament and on the whole of the New Testament (except the Apocalypse) written by Theophylact, an 11th-century Byzantine exegete. The *Commentary on St Paul's Epistles* was translated from Greek into Latin by Fra Cristoforo da Persona, Prior of Santa Balbina, who became librarian of the Vatican Library. Sixtus IV can be considered the 'second founder' of the Vatican Library: in his bull *Ad decorem* of 1475 he continued and extended Nicholas V's establishment of the *Bibilotheca Graeca* and the *Bibliotheca Latina*. This is the dedication copy presented to Sixtus in 1478, signed and dated by the scribe, Oddo de Bk (Beka), on folio 388. He also signed with his full name in Vat. lat. 617, written for Giovanni Arcimboldi, Cardinal Archbishop of Milan, who died in 1488 (Bénédictins de Bouveret 1965-79, IV, p. 336).

On folio 1, Fra Cristoforo's Preface, the border is turned by the illuminator into a complex architectural structure, before which the block of script seems to float, though it is grasped by the two putti holding the papal arms above and by one of the other putti to the left. The lowest level of the building shows a vaulted interior in blue with columns marbled in pink and blue. To the left the Pope is seated at a table with a green cloth. Behind him stand a Cardinal grasping his red hat and a group of courtiers. The translator in black habit presents his book on his knees before the Pope, and another four figures stand to the right, where a distant landscape can be seen between the pillars. The artist's underdrawing is visible here, which indicates that he has changed the position of these figures and the profile of the base of the pillars. The blue, faceted initial 'C' encloses a black-habited figure writing at a circular lectern in a room with open window.

On folio 1v a scribe, St Athanasius, is represented in the lower left corner seated in a columned interior with open windows. Above and beside this scene and also in the upper and right margins is a foliage and flower scroll with gold discs. In the centre above and below are two winged putti, the one above reclining and the one below plucking a stringed instrument. On folio 2 another architectural structure encloses the text, which again is made to seem to overlap it and is held by winged putti above, to the left, and below. In the niche to the left a standing figure of St Paul in gold and green holds sword and red book. To the right in the centre two winged putti play pipe and drums. In the centre below, the arms of Sixtus IV with triple crown and crossed keys are held by two clothed, haloed and winged angels. A laurel garland is draped over their shoulders. In the gold pediment above, on a blue ground, a wreath encloses a bearded figure looking down, perhaps representing God, though there is no halo. There are two painted initials, 'S' and 'P', on folios 2v and 3 respectively.

Each of the Epistles has a painted eight line initial with partial border: folio 58v, I Corinthians, 'C'; folio 118, II Corinthians, 'S'; folio 184v, Ephesians, 'E'; folio 213v, Philippians, 'P'; folio 231v, Colossians, 'E'; folio 252v, I Thessalonians, 'T'; folio 266, II Thessalonians, 'S'; folio 275v, I Timothy, 'E'; folio 298, II Timothy, 'C'; folio 312v, Titus, 'T'; folio 321v, Philemon, 'N'; folio 325, Hebrews, 'G'. There are other smaller initials in gold on blue or dark pink.

The illuminator is anonymous and often referred to either as the Master of the della Rovere Missals or the Master of the Vatican Theophylact. Among works known by him several are for the della Rovere, including the Missal of Cardinal Domenico della Rovere, nephew of Sixtus IV, divided between Turin and the Pierpont Morgan Library (cat. 6). His style is a mixture of French and Italian characteris-

tics, the figures and landscapes being related to Jean Fouquet's work. At the same time he uses Italian motifs, such as the architectural frontispieces with trompe l'œil features. Mirella Levi d'Ancona (1959) proposed a name for him, that of Jean Percenaul, who was born in Avignon and died in 1540. He, however, seems too late in date. Recently a new name, that of Jacopo Ravaldi, has been proposed by Ada Quazza (1990). Ravaldi is described as a Frenchman in Rome in a notarial document of 1469, in which he takes as an apprentice Jean Letiboniet, described as also a Frenchman from the diocese of Bayeux. Ravaldi is also a prominent figure among artists mentioned in the *Statuta artis picturae* in Rome of 1478 and the frontispiece miniatures of the manuscript of the *Statutes* (Rome, Accademia di San Luca, Archivio Storico, MS 1) can be attributed to our artist. No works executed in Italy after *c.* 1485 are known, and it seems he moved to southern France, where he collaborated on a Book of Hours (New York, Pierpont Morgan Library, M. 348) with Georges Trubert, and later went to Tours (see New York 1982, no. 103; Paris 1993, no. 160).

Provenance: Arms of Pope Sixtus IV (*r.* 1471-1484), folio 2.

Exhibitions: Vatican 1950, no. 72, pl. XI; Vatican 1975, no. 58, pl. VIII; Washington 1993, frontispiece and pl. 59.

Bibliography: Vattasso and De' Cavalieri 1902, pp. 189-90; Levi d'Ancona 1959, pp. 259, 261, fig. 69; Dykmans 1983, pp. 229, 231; Quazza 1985, pp. 655-78, fig. 6; Quazza 1990, pp. 20-33, illus. pp. 22, 23.

<div align="right">J. J. G. A.</div>

38

Aristotle, *Historia animalium, De partibus animalium, De generatione animalium,* translated from Greek by Theodore of Gaza

317 fols. 366 x 260 mm. On parchment [London only]

Written in Rome, c. 1473/4-80, with illumination attributed to Gaspare da Padova

VATICAN, BIBLIOTECA APOSTOLICA VATICANA, Vat. lat. 2094

The present Latin translation of Aristotle's works concerned with natural history – *History of Animals, Parts of Animals* and *Generation of Animals* – was made by Theodore of Gaza (*d.* 1475/6). If this is a dedication copy presented to Pope Sixtus IV by the author, it would date *c.* 1473-4, but on stylistic grounds it may be somewhat later. Theodore was attempting to supersede earlier translations, that of William of Moerbeke of *c.* 1260, and especially that by his bitter rival, George of Trebizond, which had been made for Pope Nicholas V. His own translation was originally started for Nicholas V.

For the Preface an initial 'L', folio 1, shows a scribe, presumably Theodore, writing. There are coloured capitals and a border of pink 'shredding' with foliage and putti. The della Rovere arms are in a wreath below, supported by two winged putti. The text begins on folio 8 with a magnificent frontispiece with the title and the opening words written in coloured epigraphic capitals by the great Paduan calligrapher, Bartolomeo Sanvito (see cats 26, 39, 41). A gold medallion portrait of Pope Sixtus IV almost covers the faceted capital initial 'A' of the text. Above the initial a miniature shows a figure with a tall exotic hat, representing Aristotle. He is seated on a throne at a lectern with a book and an architectural portico behind him. Before him in a landscape with a river full of fish are a naked man and woman and a group of various animals, reptiles and birds. The scene is very similar to the Genesis Creation scenes in which Adam names the animals and birds. The page has an architectural frame with Classical motifs; oak branches with acorns are prominent at the top on either side in allusion to the della Rovere arms of Sixtus IV. These are also contained in a wreath below flanked by two angels. Initials and borders introduce each book.

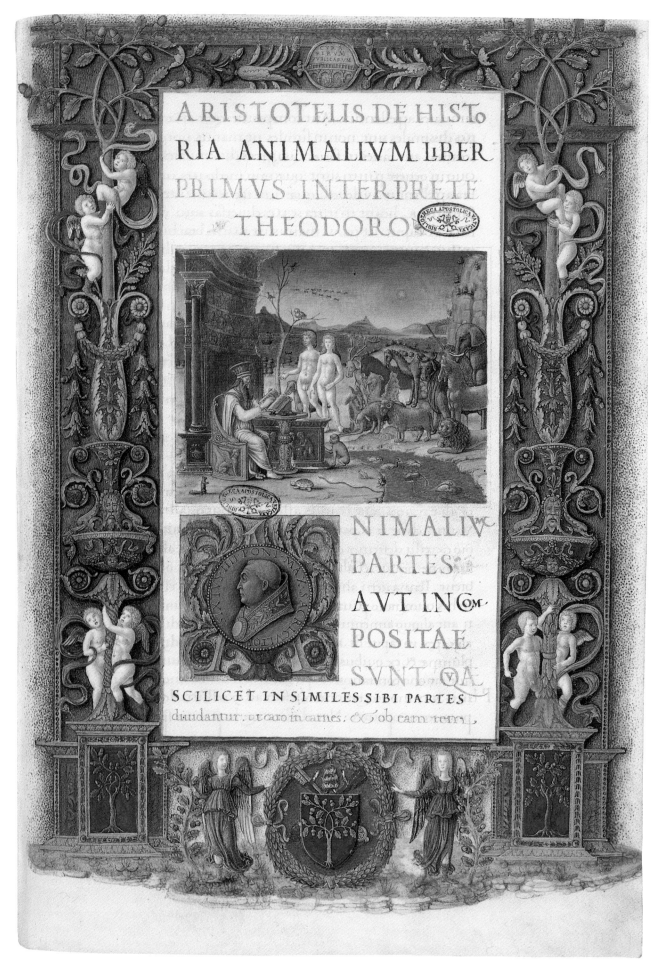

ARISTOTELIS DE HISTo
RIA ANIMALIVM LIBER
PRIMVS INTERPRETE
THEODORO

NIMALIVM
PARTES·
AVT INComM
POSITAE
SVNT QAE
SCILICET IN SIMILES SIBI PARTES
diuidantur. vt caro in carnes. & ob eam rem.

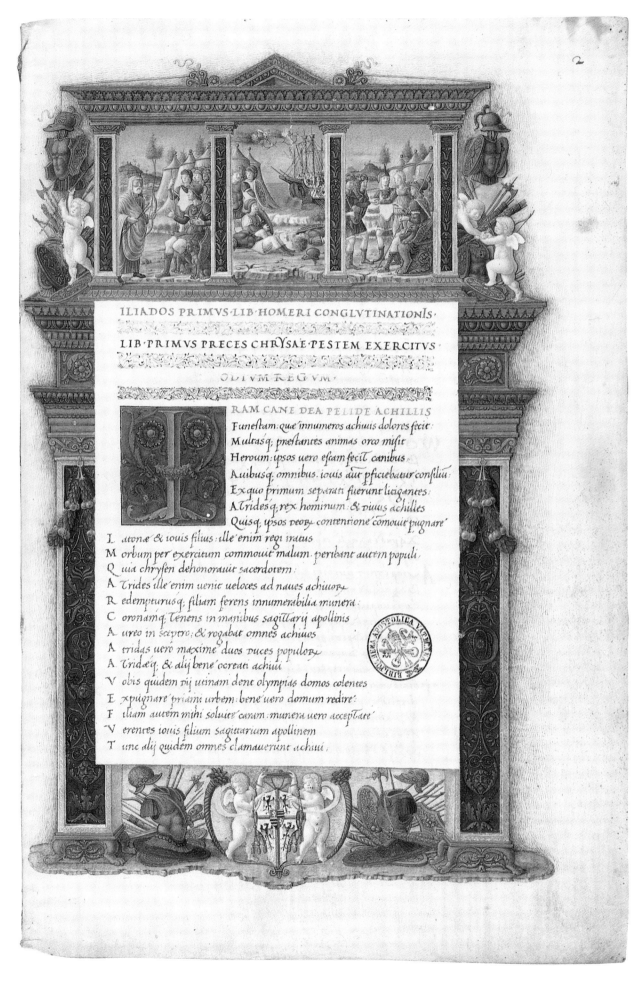

ILIADOS PRIMVS LIB HOMERI CONGLVTINATIONIS

LIB PRIMVS PRECES CHRYSAE PESTEM EXERCITVS

ODIVM REGVM

RAM CANE DEA PELIDE ACHILLIS
Funestam que innumeros achiuis dolores fecit:
Multasq; prestantes animas orco misit
Heroum ipsos uero escam fecit canibus
Auibusq; omnibus iouis aut pficiebatur consiliu:
Ex quo primum separati fuerunt litigantes.
Atridesq; rex hominum & diuus achilles
Quisq; ipsos deoz contentione comouit pugnare

L atonæ & iouis filius ille enim regi iratus
M orbum per exercitum commouit malum peribant autem populi.
Q uia chrysen dehonorauit sacerdotem:
A trides ille enim uenit ueloces ad naues achiuoz
R edempturusq; filiam ferens innumerabilia munera
C oronamq; tenens in manibus sagittarij apollinis
A ureo in sceptro & rogabat omnes achiuos
A tridas uero maxime duos duces populoz
A tridesq; & alij bene ocreati achiui
V obis quidem dij utinam dent olympias domos colentes
E xpugnare priami urbem bene uero domum redire:
F iliam autem mihi soluite caram munera uero acceptate
V erentes iouis filium sagittarium apollinem
T unc alij quidem omnes clamauerunt achiui.

The illumination can be attributed to an outstanding illuminator who worked for curial patrons in Rome from the 1470s to the mid-1480s (cats 39-41, 73-5). Among these patrons was Cardinal Francesco Gonzaga, for whom the artist illuminated a manuscript of Homer which is dated 1477 by the scribe, Johannes Rhosos (cat. 39). This commission documents the illuminator as Gaspare da Padova, who was a member of the Cardinal's household. Other manuscripts illuminated by Gaspare for Sixtus IV are listed by Ruysschaert (1986) and Erdreich (1993). The main scribe of the Aristotle is unidentified.

Provenance: Arms of Pope Sixtus IV (r. 1471-1484).

Exhibitions: Vatican 1950, no. 25, pl. III; Washington 1993, p. 177, pl. 130.

Bibliography: Levi d'Ancona 1967b, p. 13, fig. 3; Alexander and de la Mare 1969, p. 109; de la Mare 1984, p. 290, no. 39; Ruysschaert 1986, p. 45; Bauer-Eberhardt 1989, p. 71, no. 23, fig. I; Erdreich 1993, p. 388.

J. J. G. A.

39

Homer, *Iliad*, in Greek and Latin

422 fols. 410 × 267 mm. On parchment [New York only]

Written in Rome, 1477, the Greek signed by the scribe Johannes Rhosos, the Latin attributed to Bartolomeo Sanvito of Padua, with illumination by Gaspare da Padova

VATICAN, BIBLIOTECA APOSTOLICA VATICANA, Vat. gr. 1626

The text of Homer's *Iliad* is written in Greek on the versos, with the Latin version on the recto opposite. The Greek scribe, Johannes Rhosos, signs the manuscript on folio 404v and again on folio 422v, giving the date of 31 May 1477 in the former colophon and 30 May 1477 in the latter. The scribe of the Latin text does not sign his work, but is identifiable as the noted Paduan scribe Bartolomeo Sanvito (c. 1435-1512). He must have left his native Padua around 1463 to join the household of Cardinal Francesco Gonzaga in Rome. He remained in Rome after the Cardinal's death in 1483, but returned to Monselice, near Padua, where he held a canonry, at the end of his life. The illumination was planned to include a frontispiece and miniature for each of the 24 books, but was never completed. Long sections of the Latin text were also never written.

The completely painted miniature for Book I, folio 1v, show three scenes: Chryses, priest of Apollo, holding a bow and arrows, standing before Agamemnon; the plague striking the Greek army, with soldiers dying, tents and ships behind and two angels of the plague shooting arrows into the sky; and Bryseis led from Achilles' tent for sacrifice. The same three scenes with some variations are shown for the Latin text, folio 2. On the verso page is a border at the top and on both sides with mosaic type patterns; below on the dado is a frieze of arms in gold on green and brown. On the opposite page, folio 2, the frame is an architectural structure with a pediment at the top flanked by putti with trophies of arms, and there are more arms below as if on an island of turf which supports the structure. In the centre below on both pages are the arms of Cardinal Francesco. The initial 'M' on folio 1v is in Greek style, while the 'I' on folio 2 is a faceted Roman seriphed capital with a Classical foliage scroll on a red ground. Purple 'shredding' surrounds the frame on folio 2.

For Book II on folio 17v a drawing inserted in the middle of the page shows, on the left, a figure sleeping in a tent with a half-figure appearing above in his dream (Achilles sulking in his tent?); in the centre a general (Agamemnon?) addressing troops; and on the right a general gesturing to a fleet of ships. The gold has been inserted on this page, but there is no colouring. On folio 18 there is an architectural frame fully painted with the same three scenes above. On folio 29v for the catalogue of the ships in Book II there is again only a drawing for the Greek text, but the same scene showing the Greek ships at anchor with

a very Venetian barge in their midst is fully painted, together with an architectural frame on the recto, folio 30, for the Latin text. The miniatures are inserted into the text three-quarters of the way down the page.

For Book III on folio 39v there is no miniature or initial for the Greek text, but on the recto, folio 40, for the Latin text there is a fully painted architectural frame and a miniature in the middle of the page showing the lists for single combat. For Book IV, there is no decoration for the Greek text, folio 51v, but a drawing on the Latin side, partly in pencil, partly in ink, is inserted on folio 52. The border here is completely painted. On folio 66, Book V, the border for the Latin text, an architectural frame with two eagles below, is completed except for the arms, but there is only a blank space left for the miniature in the middle of the page, and no decoration at all on the Greek side. On folio 89 there is only a drawing of an architectural frame in pencil with ink ruling for the Latin text. On folios 130, 148, 163, 184, Books IX, X, XI, XII, and folios 251, 273, 292, and 308, Books XVI, XVII, XVIII, XIX, there are also pen outline drawings for the architectural frames. From folio 319 on, Book XX, the decoration is absent altogether. The companion volume containing the *Odyssey*, Vat. gr. 1627, has no illumination.

There has been much discussion as to the identity of the illuminator of the Vatican *Iliad*. Though many problems remain, the recent publication of the correspondence of Cardinal Francesco and his executors by David Chambers seems to make it certain that the illumination of the Homer is the work of Gaspare da Padova. After the Cardinal's death he wrote on 28 February 1484 to the Marchese Federico, Francesco's brother, claiming an unpaid salary for eleven months of 22 ducats (Chambers 1992, pp. 193-4). He says that he has served the Cardinal for more than sixteen years, which takes us back to 1467 or 1468. He wrote again on 29 March and in this letter he mentions a manuscript of Homer for which he claims not to have been paid for either the writing or the illumination ('*Homero . . . et non n'è fornito di scrivere nè di miniare*'; Chambers 1992, pp. 196-7). This can surely only refer to the present manuscript, and presumably the illumination was still in train and was unfinished due to the Cardinal's non-payment.

Both Gaspare and Sanvito are mentioned in Cardinal Francesco's will of 20 October 1483 (Chambers 1992, p. 136). It is clear from the correspondence that Gaspare was also involved in finding and buying antiquities and medals for the Cardinal. Sanvito also mentions in his daybook of 1505-11, written when he was back in Padua, that he lent a drawing of Phaethon by Gaspare to Giulio Campagnola ('*el phetonte de man de Gasparo tochato d'aquarella*'; De Kunert 1907, p. 6; see cat. 71). Other manuscripts attributed to Gaspare in the present exhibition are cats 38, 40, 41, 73-5.

A number of scholars (Ruysschaert 1969; Ruysschaert 1986; Erdreich 1993) have argued that Sanvito was himself an illuminator, based on the colophon of the Evangeliary and Epistolary written in 1509 by Sanvito for Monselice (Padua, Biblioteca Capitolare; De Kunert 1930). This says that the two manuscripts were made '*manu sua impensaque conscripta ornataque*'. The 'ornamentation' could, however, refer to their bindings, rather than to their illumination, as De Kunert already suggested, and the Latin remains in any case ambiguous. Though there is certainly a close marriage between script and illumination in many manuscripts written or rubricated by Sanvito (see cat. 73), there are very real differences in the quality of the illumination in the large group of manuscripts whose illumination Ruysschaert (1986) and more recently Erdreich (1993) are willing to give to Sanvito. Ulrike Bauer-Eberhardt (1989), recognising these differences, identified the artist of the finer quality manuscripts with Lauro Padovano, who is also mentioned in Sanvito's daybook, and who was also in Rome at the right time. In view of the documentation of the Homer, this proposal must now be abandoned.

Unfortunately there is no evidence as to the date of death of Gaspare. One possibility is that Sanvito learnt to copy Gaspare's style and executed decoration and perhaps even figured miniatures in his style. The style of later manuscripts written by Sanvito in the 1480s-1490s and the early 16th century, such as the Kings Virgil of c. 1490 (cat. 43) and the Evangeliary and Epistolary in Padua, undoubtedly show a decline in quality, the painting of the decoration being less refined and

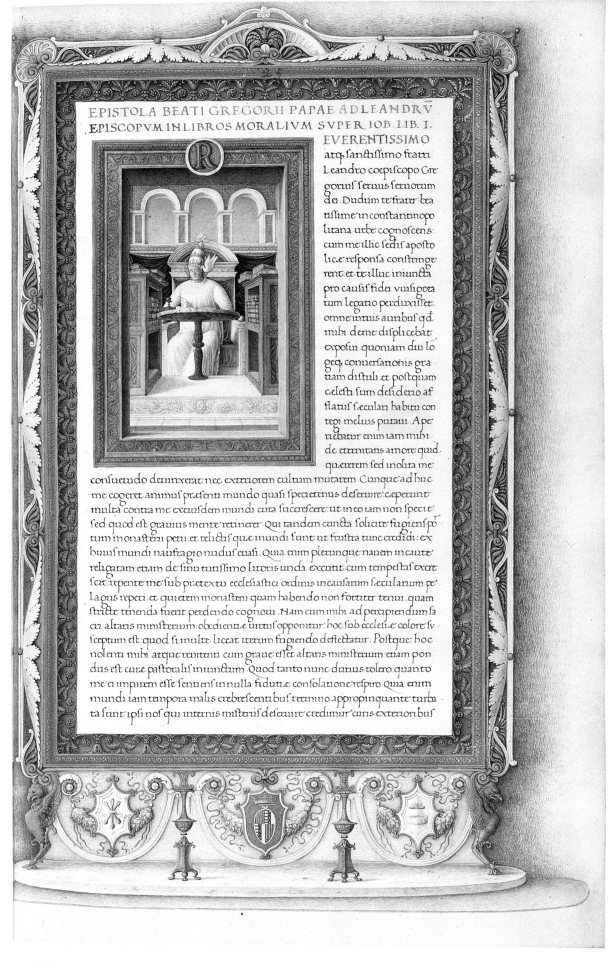

EPISTOLA BEATI GREGORII PAPAE AD LEANDRV
EPISCOPVM IN LIBROS MORALIVM SVPER IOB. LIB. I.

EVERENTISSIMO
atq̃ sanctissimo fratri
Leandro coepiscopo Gre
gorius seruus seruorum
dei. Dudum te frater bea
tissime in constantinopo
litana urbe cognoscens:
cum me illic sedis aposto
licae responsa constringe
rent: et te illuc iunicta
pro causis fidei uusigota
rum legatio perduxisset.
omne intuis auribus q̃d
mihi de me displicebat
exposui. quoniam diu lo
geq̃. conuersationis gra
tiam distuli. et postquam
celesti sum desiderio af
flatus seculari habitu con
tegi melius putaui. Ape
riebatur enim iam mihi
de eternitatis amore quid
quererem sed inolita me
consuetudo deuinxerat nec exteriorem cultum mutarem. Cunque ad huc
me cogeret animus presenti mundo quasi specie tenus deseruire: ceperunt
multa contra me exeiusdem mundi cura succrescere: ut in eo iam non specie
sed quod est grauius mente retinerer. Qui tandem cuncta solicite fugiens pot
tum monasterii petii. et relictis que mundi sunt ut frustra tunc credidi: ex
huius mundi naufragio nudus euasi. Quia enim plerunque nauem incaute
religatam etiam de sinu tutissimo litoris unda excutit: cum tempestas exce
serit: repente me sub pretextu ecclesiastici ordinis in causarum secularium pe
lagus reperi: et quietem monasterii quam habendo non fortiter tenui: quam
stricte tenenda fuerit perdendo cognoui. Nam cum mihi ad percipiendum sa
cri altaris ministerium: obedientiae uirtus opponitur: hoc sub ecclesie colore su
sceptum est: quod si inulte liceat iterum fugiendo deflectatur. Postque hoc
nolenti mihi atque renitenti cum graue esset altaris ministerium etiam pon
dus est cure pastoralis iniunctum. Quod tanto nunc durius tolero quanto
me a imparem esse sentiens in nulla fiducie consolatione respiro. Quia enim
mundi iam tempora malis crebrescentibus termino appropinquante turba
ta sunt ipsi nos qui internis misteriis deseruire credimur: curis exterioribus

less rich, the figures and compositions more stilted and mannered. But even in the Homer itself it is possible to wonder if two artists are not at work together, if the finished miniature on folio 40, which appears of feebler quality, is compared to the earlier miniatures and drawings. Sanvito might thus have collaborated in the illumination or, alternatively, completed Gaspare's work even at this early stage.

The use of Greek style decoration, or what was taken to be such, in the present manuscript is unusual, but is found as well in a Gospels also written by Rhosos in Greek in 1478 (London, British Library, Harley MS 5790).

Provenance: Arms of Cardinal Francesco Gonzaga, born 1444, created Cardinal 1460, died 1483.

Exhibitions: Vatican 1950, no. 25, pl. 1; Washington 1993, pl. 2.

Bibliography: Gianelli 1950, pp. 298-300; Salmi 1957, p. 68, pl. 87; Wardrop 1963, pl. 16; Meroni 1966, p. 60, pl. 112; Alexander and de la Mare 1969, p. 108; Alexander 1977a, p. 20, fig. XIII; Petrucci 1979, pl. 12; de la Mare 1984, pp. 287-8, no. 16; Daneu Lattanzi 1985, p. 784, pls IV, V; Ruysschaert 1986, pp. 39, 44, figs 4, 5; Bauer-Eberhardt 1989, pp. 52, 69, no. 15, fig. 9; Erdreich 1993, pp. 174-88 and *passim*.

J. J. G. A.

40

Gregory the Great, *Moralia in Job*

182 fols. 410 x 275 mm. On parchment [London only]

Written, signed and dated 1485 in Naples, by Gianrinaldo Mennio of Sorrento, with illumination attributed to Gaspare da Padova, Giovanni Todeschino and Cristoforo Maiorana

PARIS, BIBLIOTHÈQUE NATIONALE, latin 2231/1

This is the first part of a manuscript, which was divided into three volumes in the 16th century, of Pope Gregory the Great's treatise on the Book of Job. Written in the late 6th century, the *Moralia in Job*, as it was known, was read throughout the Middle Ages as a text of spiritual enlightenment and continued to be printed in frequent editions in the 15th and 16th centuries. The present copy was made, according to Albinia de la Mare (1984), from either the Rome 1475 or the Venice 1480 edition. It was written for Cardinal Giovanni d'Aragona, son of King Ferdinand I of Naples (r. 1458-1494). Giovanni was made Cardinal by Pope Sixtus IV in 1477 and died at age 29 in 1485. The scribe, Gianrinaldo Mennio, signs and dates the manuscript at the end of volume III. He was active as a copyist for the King of Naples, receiving a pension from him after his retirement, and for other patrons of the court. His dated manuscripts extend from 1465 to 1494.

The opening of the text on folio 25, after the list of contents ends on folio 24v, is surrounded with an ornate frame supported on a circular plinth flanked by gryphons. In the centre below are the arms of Naples with a royal crown painted over Cardinal Giovanni's red hat. Evidently this, like other of the Cardinal's manuscripts, passed after his death to his father's library (see cats 41, 46). The Cardinal's emblems are displayed on the two flanking shields. The small initial 'R' of the text is placed above a miniature of Pope Gregory in his study, seated writing at a circular table which is flanked with bookcases. A blue curtain hangs behind his stately marble throne and three rear windows let in the light, so that cast shadows fall on the floor. On the Pope's shoulder is the Dove of the Holy Spirit, which according to legend inspired his writings.

The illumination can be attributed to Gaspare da Padova, who worked for Pope Sixtus IV (cat. 38) and a group of curial patrons, especially Cardinal Francesco Gonzaga, to whose household he belonged and for whom he illuminated the documented Vatican Homer (cat. 39). Another manuscript illuminated for the Cardinal d'Aragona

by Gaspare is the Valerius Maximus (cat. 41). The pink 'shredding' surrounding the frontispiece and the Classical reminiscences in the laurel swags and candelabra are typical of his works, as are the reminiscences of Mantegna. The round table at which the Pope writes, for example, recalls that in Mantegna's *St Luke*, now in the Brera, Milan. The figure of the Pope is also stylistically very similar to some of the popes painted beside the windows in the Sistine Chapel at the same moment.

There are initials for the prefaces and the various books: folio 1, 'S'; folio 1v, 'Q'; folio 41v, Book II, 'S'; folio 58v, Book III, 'B'; folio 71, Book IV, 'Q'; folio 88, Book V, 'C'; folio 107, Book VI, 'S'; folio 121v, Book VII, 'Q'; folio 135v, Book VIII, 'P'; folio 158v, Book IX, 'P'. The text breaks off on folio 181v and the last page is written in a 16th-century hand to complete the text after the manuscript was divided. Many of the initials, each of which has a frame painted to simulate marble, are represented as if made of carved crystal with gold mounts, and there are also naturalistic leaf forms which suggest familiarity with contemporary trompe l'œil painting in Flemish manuscripts. François Avril (in Paris 1984, no. 146) has attributed these larger initials to Giovanni Todeschino (see cat. 45), who copied the style of Gaspare da Padova. The crystal initials also can be compared to work by the so-called Master of the London Pliny (cats 28, 46, 90-2). The smaller initials are attributed by Avril to the Neapolitan illuminator Cristoforo Maiorana (see cats 53, 55), a combination of illuminators found in other manuscripts belonging to the Cardinal.

Provenance: Cardinal Giovanni d'Aragona (1456-1485); King Ferdinand I of Naples (d. 1494); De Marinis 1947-52, II, inventories B, no. 370, E, no. 476; library of Cardinal Georges I d'Amboise (d. 1510) at the Château de Gaillon, inventory of 1508 (Delisle 1868-81, I, p. 237, no. 101); Cardinal Charles II de Bourbon-Vendôme (d. 1594); entered the French royal library under Henri IV.

Exhibition: Paris 1984, no. 146, pl. XXIV.

Bibliography: De Marinis 1947-52, I, pp. 59, 157, II, p. 79, III, pl. 109; Samaran and Marichal 1962, p. 111, pl. CLXV; Alexander and de la Mare 1969, p. 108; Ruysschaert 1969, p. 267; de la Mare 1984, pp. 252, 270-1; Bauer-Eberhardt 1989, p. 75, no. 47, fig. 36; Erdreich 1993, pp. 201-3.

J. J. G. A.

41

Valerius Maximus, *Facta et dicta memorabilia*

197 fols. 336 x 228 mm. On parchment [New York only]

Script attributed to Antonio Sinibaldi of Florence, with rubrics by Bartolomeo Sanvito of Padua, and illumination attributed to Gaspare da Padova in Rome, c. 1480-5

NEW YORK, NEW YORK PUBLIC LIBRARY, ASTOR, LENOX AND TILDEN FOUNDATIONS, Spencer MS 20

Valerius Maximus' *Memorabilia* was dedicated to the Roman Emperor Tiberius. With its anecdotes drawn from earlier Roman historians, it was a popular work in the Middle Ages and the Renaissance. It was translated into French for Charles V of France, and went through many printed editions. These latter include one printed in Venice in 1482, a copy of which was owned, like the present manuscript, by Cardinal Giovanni d'Aragona (d. 1485), son of King Ferdinand I of Naples (see cat. 40). The Naples arms are painted on a globe held by a kneeling putto, referring directly to the Cardinal's motto, '*Sustinire*', and indirectly to the myth of Hercules holding up the heavens. Cardinal Giovanni's devices, three maces and a tassel of pearls, as well as his motto with a pedestal appear in the frontispiece. The present manuscript, like the rest of the Cardinal's manuscripts (see also cats 40, 46) seems to have passed on his death to his father. A cardinal's hat still faintly visible above the arms was then replaced with a crown.

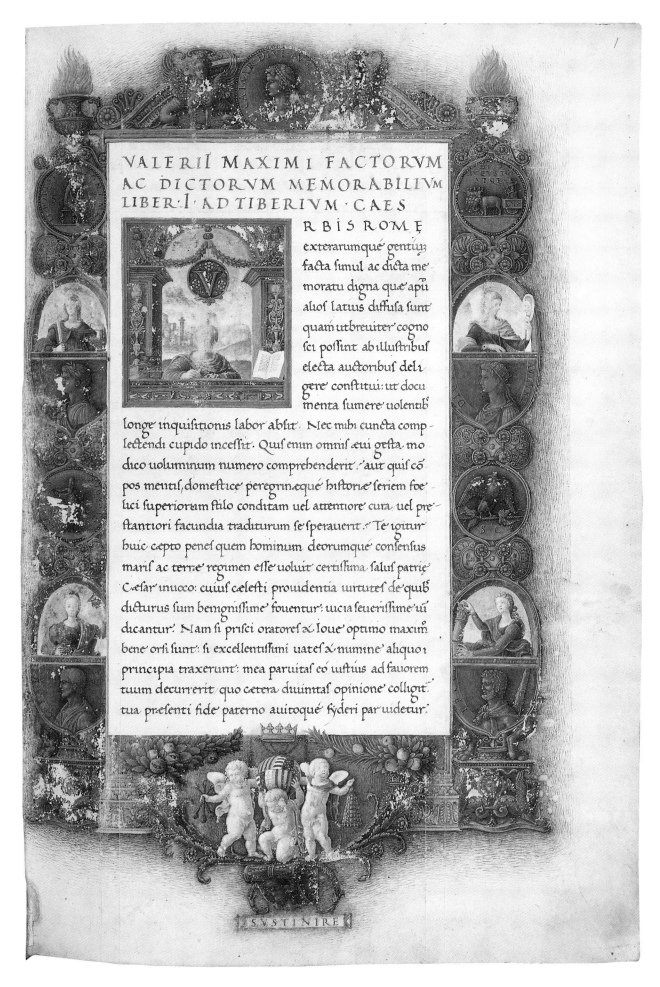

The script was first identified by Sydney Cockerell (in London 1908), confirmed by Alfred Fairbank (1961) and Albinia de la Mare (1984), as that of the prominent Florentine scribe Antonio Sinibaldi (see cats 31, 32), one of a group of Florentine scribes patronised by the Cardinal. The epigraphic coloured capitals for the headings of the books and the rubrics of the chapters were added, presumably in Rome, by Bartolomeo Sanvito of Padua (see cat. 38), whose hand was identified by Fairbank. Sanvito also made some additions to the text, e. g. folios 190v-191.

The ornate frontispiece on folio 1, unfortunately somewhat damaged, shows the author, his face very abraded, writing as if at a window, with a view of Ancient ruins visible in the distance and with the initial 'V' of the text inserted above him. The text is placed in front of a pedimented structure and surrounded by Classical and other motifs, simulated coins, sphinxes, pelta shields etc. The larger coin in the centre at the top represents the Emperor Tiberius, to whom the text was dedicated. There are four half medallions of the Virtues, from the top right, clockwise: Prudence with a mirror; Fortitude with a column; Temperance pouring water from one jug to another; and Justice with sword and scales. Three of the half-figures painted in gold on green are identifiable from their inscriptions as Augustus, Hercules with a club and Q. Fabius (Cunctator). The fourth inscription is too damaged to be read.

There are initials to each of the ten books: folio 1v, 'M'; folio 21, 'D'; folio 42, 'A'; folio 64, 'T'; folio 86v, 'L'; folio 110, 'V'; folio 131, 'V'; folio 150, 'N'; folio 172, 'B'; folio 194, 'D'. These are faceted capitals of four to six lines with a variety of Classical motifs, accompanied by single sided borders with further Classical motifs and surrounded by coloured 'shredding'. For the chapters there are numerous four line initials without borders.

The artist is Gaspare da Padova, who illuminated the Vatican Homer for Cardinal Francesco Gonzaga (cat. 39) and a group of other manuscripts illuminated for curial patrons in Rome in the period *c.* 1475-85 (cats 38-40, 73-5). He frequently worked with Bartolomeo Sanvito and was, like Sanvito, a member of Cardinal Francesco's household. Another manuscript illuminated for Cardinal Giovanni by Gaspare is the Paris Gregory (cat. 40). In the initial 'L' on folio 86v, he uses again the motif of the masked putto seen in another of his manuscripts, the Bembo Eusebius (cat. 73). As in all his works, the influence of Mantegna is clear. For example the author portrait here can be compared to Mantegna's *St Mark* (now in Frankfurt), who similarly holds a book on the ledge beside him.

Provenance: Cardinal Giovanni D'Aragona (1456-1485) with his arms, motto and emblems, folio 1; King Ferdinand I of Naples (*d.* 1494); bought from the executors of Sir George Holford (*d.* 1926) by Rosenbach; acquired in 1929.

Exhibitions: London 1908, no. 199; Baltimore 1949, no. 190, illus.; New York 1991, no. 1, figs 1, 2.

Bibliography: Paltsits 1929, pp. 847-53 pls 1-5; De Ricci 1935-40, II, p. 1339; De Marinis 1947-52, II, pp. 166-7, pl. 248; Fairbank 1961, p. 12; Alexander and de la Mare 1969, p. 108; Ruysschaert 1969, p. 267; de la Mare 1984, pp. 260, 275, no. 28, 289, no. 24; Garzelli and de la Mare 1985, p. 486, no. 38; Ruysschaert 1986, p. 45; Bauer-Eberhardt 1989, p. 72, no. 39, fig. 34.

J. J. G. A.

Classical and Humanist Texts

This section comprises some of the main texts which humanistically inclined patrons chose to have specially decorated or illustrated. We still speak of 'the classics' to designate the most admired works by the most valued authors of Ancient Greece and Rome. In the Renaissance these same authors were read as exemplary not just of literary style but of social, moral and political action. Among the Latin poets Virgil was preeminent (cats 42-4), followed by authors such as Horace (cat. 45) and Ovid (cat. 46). Among prose writers Livy (cats 47-9, 68, 76), Cicero (cat. 34), Suetonius (cat. 74) and Pliny the Elder (cat. 50) were all essential texts. Many Greek writers were still read in translation, such as Plutarch (cat. 52) and Ptolemy (cats 54-5), but texts copied in the original Greek include Aesop (cat. 56), Homer (cat. 39) and Aristotle (cat. 53). A very few Italian authors had established similar status by this time, above all Dante (cat. 58) and Petrarch (cats 59, 60, 71) and among humanist writers Poggio (cat. 62) and Leonardo Bruni (cat. 64).

42

Virgil, *Eclogues, Georgics, Aeneid*

228 fols. 260 x 170 mm. On parchment [New York only]

Written by Leonardo Sanudo in Ferrara, 1458, with illumination by Guglielmo Giraldi and Giorgio d'Alemagna

PARIS, BIBLIOTHÈQUE NATIONALE, latin 7939 A

As the colophon (folio 216v) states, this manuscript was copied by the Venetian nobleman Leonardo Sanudo in 1458 while he was in Ferrara as representative of the Republic of Venice at the court of Borso d'Este. The Sanudo coat of arms appears on the first page of the *Aeneid* (folio 60) supported by two naked putti. Leonardo belonged to an aristocratic family with a long tradition of literary studies. One of his ancestors, Marino Sanudo, had been among the most important literary figures and bibliophiles in Venice in the early 14th century and his son, also Marino, was to become a leading historian of the Venetian Republic and the owner of a vast collection of books. Leonardo copied texts for himself on several occasions, as shown by the note in a copy of Lactantius dated 1457 (Venice, Biblioteca Marciana, Lat. II, 75[=2198]) and he was one of the most important patrons of Renaissance illumination in Venice. This copy of Lactantius was illuminated by Leonardo Bellini, nephew of Jacopo.

Marco Zoppo illuminated another superb Virgil for Sanudo; it was transcribed by the Paduan calligrapher Bartolomeo Sanvito in the early 1460s (cat. 72). By great good fortune a detailed account book, kept by Sanudo between 1457 and 1460, has survived (Venice, Archivio di Stato, Giudici di Petizion, Busta 955; Lowry 1991, pp. 35-6); in this Sanudo noted all expenditures made in connection with his library and all the books borrowed from it. Several times between 1458 and 1459 he refers to a copy of Virgil which can be identified as the manuscript exhibited here. He notes several payments made to 'Vielmo' and 'Zorzo', illuminators in Ferrara. This confirms the attribution (Avril, in Paris 1984) of the illumination to Guglielmo Giraldi and Giorgio d'Alemagna, two of the most celebrated illuminators at the court of Borso d'Este.

Giorgio d'Alemagna decorated the introductory pages to various books of the *Aeneid* (folios 60, 72, 85, 96v, 108, 149v, 161) with coloured borders of flowers and filigree, while Guglielmo Giraldi was responsible for the decorated capital letters in the *Eclogues* and the *Georgics*, and also the extraordinarily delicate little water-colour paintings in the lower margins of almost every page of the *Aeneid*. The artist shows a perfect mastery of the rules of perspective and unusual skill with the handling of space. Virgil's poetry is interpreted with precision and at the same time with high dramatic tension and intense imagination. Although there are a few superficial Classical details, in general the adventures of Aeneas and his friends are recounted as if they had taken place in ducal palaces in the Po Valley; this makes the illumination of the Sanudo Virgil among the most vivid documentary accounts of Italian Renaissance civilisation. Giraldi's representations of cities provide marvellous examples of Renaissance architecture and his pure landscapes are fascinating. Similar use of perspective, though somewhat more tentative, appears in the illuminations to an Aulus Gellius signed by Giraldi in 1448 (Milan, Biblioteca Ambrosiana, S. P. 10/28 *olim* Gallarati Scotti, fig. 12). This manuscript, whose decoration is of great importance for Bolognese Renaissance illumination, contains ornament which still owes a debt to Pisanello, and the figures show a typically Emilian expressiveness. In the Virgil there is greater command of perspective and greater drama, reminiscent of Cosimo Tura. One can also suggest a connection to Marco Zoppo, who was in Bologna in the second half of the 1450s; the exceptional elegance of the figures and their gestures show the influence of the paintings of Piero della Francesca.

The pages decorated by Giorgio d'Alemagna, whose most important works were a *Spagna in rima* of 1453 (Ferrara, Biblioteca Ariostea, MS II, 32), and a Missal (Modena, Biblioteca Estense, MS Lat. 239), both commissioned by Borso d'Este, are evidently strongly influenced by Giraldi, and it is possible that d'Alemagna's work was executed to some extent after Giraldi's designs.

Provenance: Library of Leonardo Sanudo; entered the French royal library in 1669 with various manuscripts from the Petau collection.

Exhibitions: Paris 1984, no. 122; Milan 1991, no. 31.

Bibliography: Hermann 1900, p. 201; Conti 1989, p. 11; Lollini 1989, p. 110; Lowry 1991, pp. 35-36; Toniolo 1990-3, pp. 244-5; Mariani Canova 1993, pp. 125 ff.

G. M. C.

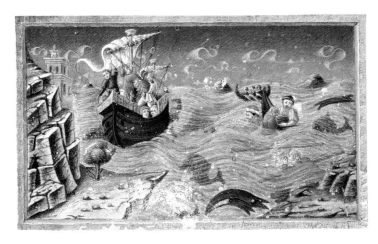

42 folio 60r

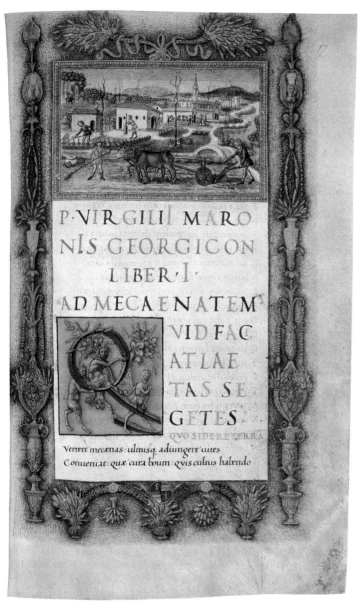

43 folio 17r

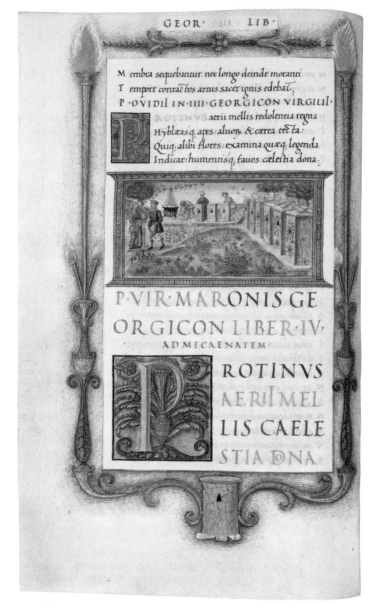

43 folio 47v

43

Virgil, *Eclogues, Georgics, Aeneid*

244 fols. 286 x 181 mm. On parchment

Script attributed to Bartolomeo Sanvito of Padua in Rome, c. 1490, and perhaps also illuminated by him

LONDON, THE BRITISH LIBRARY, Kings MS 24

The illumination of this Virgil consists of miniatures, borders and initials: for the beginning of the *Eclogues*, folio 1, Tityrus and Meliboeus; for each of the four books of the *Georgics*, folio 17, ploughing, folio 26v, vintage, folio 37, sheepshearing, and folio 47v, bee-keeping; and for each of the twelve books of the *Aeneid*, folios 59, 73v, 88, 101v, 115, 131v, 148v, 164, 178, 193v, 210v and 227v (all fully described by Warner and Gilson 1921). There are smaller four line initials for each *Eclogue* and for the short verse summaries of the different books.

The script can be attributed to the outstanding calligrapher Bartolomeo Sanvito, who moved to Rome in the mid-1460s and worked for a series of prominent patrons in the Curia, including Pope Sixtus IV and Cardinal Francesco Gonzaga (see cats 38, 39). Sanvito here writes in his Roman hand and uses the coloured epigraphic capitals for which he was famous (see cats 38, 41). The manuscript bears the arms of Lodovico Agnelli as apostolic protonotary. Agnelli was *chierico di camera* of Pope Sixtus IV and secretary to Cardinal Francesco Gonzaga, in whose household Sanvito also lived until the Cardinal's death in 1483. The manuscript must date before Agnelli was made Archbishop of Cosenza in 1497. He died in 1499.

The identity of the illuminator is controversial. First it is not clear if he is the same artist who worked on a group of manuscripts written for

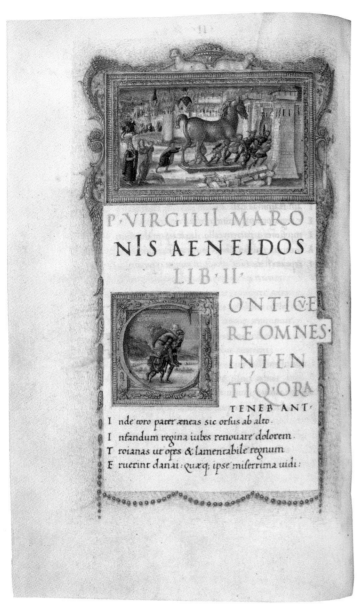

43 folio 73v

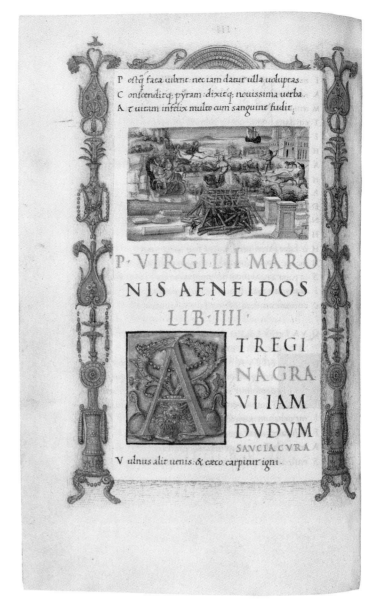

43 folio 101v

curial patrons by Sanvito and other scribes in the 1470s and 1480s (see cats 38-41, 73-5). Some scholars have wished to attribute the illumination in these manuscripts and also in a group of later manuscripts of the 1490s to the early 16th century – most of them, like the present Virgil, also written by Sanvito – to Sanvito himself (Ruysschaert 1986; Erdreich 1993). An alternative, favoured by the present writer, is that there are two illuminators, of whom the second, less accomplished hand imitates the work of the first. The former is now identifiable from the Homer of Cardinal Francesco Gonzaga as Gaspare da Padova (cat. 39), like Sanvito a member of the Cardinal's household. The latter is possibly to be identified as Sanvito himself on the basis of the inscription in the Epistolary and Evangeliary (Padua, Biblioteca Capitolare; De Kunert 1907; De Kunert 1930), which were written in 1509 by Sanvito for Monselice, near Padua, an Augustinian priory of which he was a canon and to which he seems to have retired at the end of his life. The miniatures there are similar in style to those in the Virgil, and the inscription states that the two manuscripts were written and ornamented by his hand and at his expense, '*manu sua impensaque conscripta ornataque*'. On this hypothesis Sanvito would have copied Gaspare's style, both for the ornamental motifs and the figure style. While the ornament is less easy to distinguish, the figures are generally less well drawn than Gaspare's with a tendency to elongation and stiffness. Sanvito records in his daybook, published by De Kunert in 1907, that he owned a drawing of Phaethon by Gaspare (see cat. 71).

Comparing the iconography of the scenes in the various Virgils included in the present exhibition, it is noticeable that the artist here, unlike the illuminator of cat. 44, for example, includes many Classical details in both miniatures and borders, to give the whole an Antique feel. However, the way in which 15th-century Italian illuminators responded to the text of Virgil and the possible links between the different cycles of illustration still await detailed investigation.

Provenance: Acquired from Consul Joseph Smith (1682-1770) of Venice by King George III in 1765; given with the rest of George III's library to the British Museum in 1826 by King George IV.

Exhibition: London 1982, illus.

Bibliography: Warner and Gilson 1921, III, p. 9, pl. 123; Wardrop 1963, p. 51, pl. 34; Alexander and de la Mare 1969, pp. 107, 109; Vivian 1971, pp. 84, 92, pls 94-7; Alexander 1978, pl. 38; Bauer-Eberhardt 1989, pp. 77-8, no. 63, fig. 18; Erdreich 1993, p. 390; Courcelle 1984, pp. 255-61, figs 490-501 (*Addenda*, p. 267).

J.J.G.A.

44

Virgil, *Eclogues, Georgics, Aeneid*

274 fols. 314 x 226 mm. On parchment. Original (?) binding with central portrait medallions and gold tooled foliage bands, Rebacked, repaired and remounted. [London only]

Written and illuminated in Naples, c. 1470–1500

VALENCIA, BIBLIOTECA GENERAL DE LA UNIVERSIDAD, MS 837 (G. 2400)

This copy of Virgil's works is undocumented, since the coat of arms of the original owner on folio 1 has been erased in the two lower roundels. The decoration comprises a frontispiece for the *Eclogues* with a white vine-stem border, a miniature of shepherds in the lower border, and figures of Tityrus and Meliboeus accompanying the initial 'T' of the first *Eclogue*. Miniatures the width of the text filling about a third of the page introduce *Georgics*, Book I, folio 19, ploughing; Book II, folio 29v, putti in the wine-press; and Book IV, folio 51, bee-keeping. There is no miniature for Georgics, Book III.

In the *Aeneid* there are frontispiece miniatures for each of the twelve books. These are usually full-page on versos; for many books there are also smaller miniatures on the recto opposite above the text: Book I, folios 64v-65; Book II. folios 80v-81; Book III, folio 96v; Book IV, folio 111v; Book V, folios 126v-127; Book VI, folios 145v-146; Book VII, folio 168v; Book VIII, folio 185v; Book IX, folios 200v-201; Book X, folio 217v-218; Book XI, folios 236v-237, Book XII, folios 255r and v, 256. In Book VI there are fifteen additional miniatures, illustrating Aeneas' descent into the underworld, inserted into the text (folios 150v, 151, 152, 152v, 153, 155, 155v, 156, 156v, 157v, 159, 161, 161v, 163v, 167).

A number of illuminators worked on the miniatures though it is not easy to distinguish their hands. There seem to be three main artists and perhaps as many as four others. One artist, active in the earlier part of the manuscript, paints in the Italo-Flemish style common in Naples from the mid-century onwards. A second illuminator, mainly active in Book VI, seems to copy, especially in landscape features, mannerisms of the Milanese Ippolita Master (see cat. 11). A third works also in the Italo-Flemish style but is more up-to-date. There are clear signs of interruptions and the borders are either unfinished or were never inserted for many miniatures. Some miniatures seem to be retouched or repainted. There are also many different styles of white vine-stem initials used to introduce the different *Eclogues, Georgics* and of the *Aeneid*, perhaps as many as seven in all. It is also possible that the manuscript was written earlier in Rome, *c*. 1460-70, with the illumination completed later in Naples (Albinia de la Mare, written communication).

The artists seem to have invented their images, perhaps from written instructions, and are quite oblivious of any historicising Classical references. The miniatures of Book VI, if they look to any models, would appear to be connected with illustrations of Dante's *Inferno*, of which many illustrated copies were made in Naples in the 14th century particularly. Since they are by the more Milanese looking hand, however, they may perhaps depend on a Milanese Dante, like the famous example by the Master of the Vitae Imperatorum in Paris (Bibliothèque nationale, ital. 2017).

Provenance: Bequeathed to San Miguel de los Reyes, Valencia, by Ferdinand of Aragon, Prince of Taranto, in 1550; De Marinis 1947-52, II, inventory G, no. 305; Cherchi and De Robertis 1990, pp. 198-9, inventory of 1527, no. 130.

Bibliography: Guatiérrez del Caño 1913, no. 2400, pl. XXIX; Bordona 1933, II, no. 2113, fig. 728; De Marinis 1947-52, II, p. 172 (as MS 748), pls 255-63; Courcelle 1984, pp. 219-30, figs 389-420 (*Addenda*, p.267).

J.J.G.A.

45

Horace, *Odes*

135 fols. 400 x 258 mm. On parchment [London only]

Written in Naples, c. 1490-5, probably by Gianrinaldo Mennio of Sorrento, with illumination attributed to Giovanni Todeschino

BERLIN, STAATLICHE MUSEEN ZU BERLIN, PREUSSISCHER KULTUR-BESITZ, KUPFERSTICHKABINETT, MS 78 D 14

The title-page is written in alternating lines of blue and gold capitals on folio 1 and folio 1v is blank. On folio 2 the text begins. It is framed by an architectural frontispiece decorated above and on the columns with cameo heads and jewels. On the socle at each side are standing figures; on the left Charity, a woman nursing two infants, with the inscription below '*Saluti Reipublicae*'; on the right a soldier in Roman armour with a standard, '*Divus Augustus Pater*'. In the centre below two figures stand in a landscape, on the right a peasant holding a spade and on the left a clerk in academic dress. Their relevance to the text is unclear, but they recall frontispiece images of the debate between peasant and priest in copies of Alain Chartier's *Quadrilogue*. The initial 'M' is accompanied by a small miniature of the Three Graces. There are initials with candelabra borders and coloured 'shredding' on folios 17v, 27v, 45, 55, 68, 85, 103 and 127v.

The illumination can be attributed to the same artist as the Pliny in Valencia (cat. 106) and the Flavio Biondo in Munich (cat. 61). The artist has been convincingly identified as Giovanni Todeschino, referred to as '*miniatore del senyor Rey*' in payments between 1487 and 1492. Here too he shows awareness of the style of Gaspare da Padova, whose work the humanist Pietro Summonte says Giovanni imitated (see cats 38, 39 etc.).

Albinia de la Mare has suggested (written communication) that the manuscript may have been written by Gianrinaldo Mennio of Sorrento, whose last dated manuscript was copied for Alfonso II of

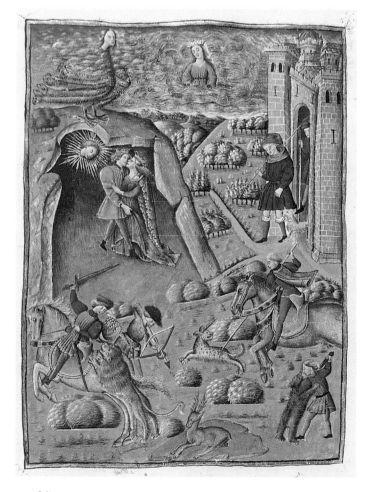

44 folio 111v

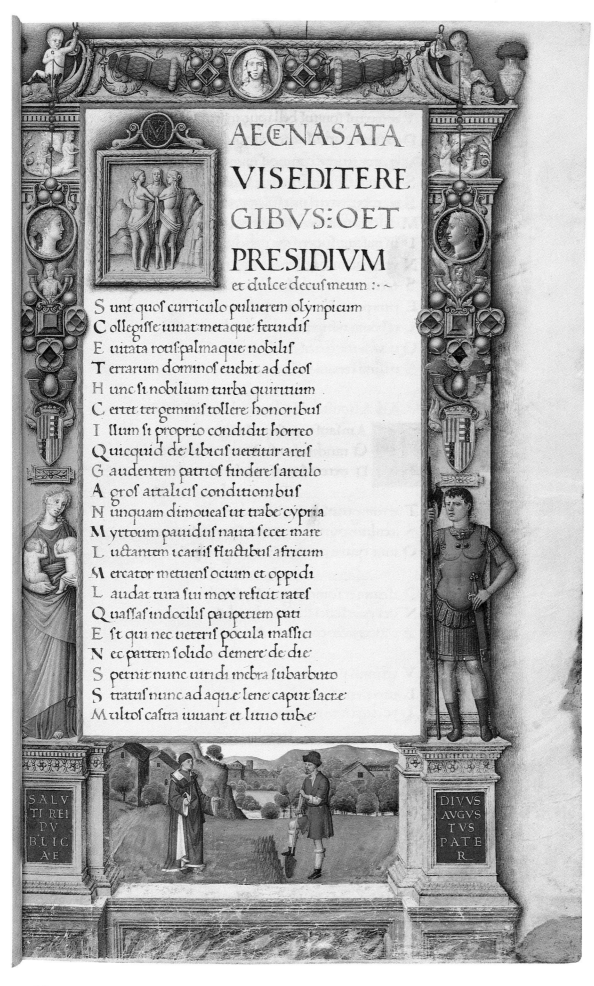

AECNASATA
VISEDITERE
GIBVS:OET
PRESIDIVM
et dulce decus meum :·~

S unt quos curriculo puluerem olympicum
C ollegisse iuuat metaque feruidis
E uitata rotis palmaque nobilis
T errarum dominos euehit ad deos
H unc si nobilium turba quiritium
C ertet tergeminis tollere honoribus
I llum si proprio condidit horreo
Q uicquid de libicis uertitur areis
G audentem patrios findere sarculo
A gros attalicis conditionibus
N unquam dimoueas ut trabe cypria
M yrtoum pauidus nauta secet mare
L uctantem icariis fluctibus africum
M ercator metuens ocium et oppidi
L audat rura sui mox reficit rates
Q uassas indocilis pauperiem pati
E st qui nec ueteris pocula massici
N ec partem solido demere de die
S pernit nunc uiridi mebra subarbuto
S tratus nunc ad aquae lene caput sacre
M ultos castra iuuant et lituo tube

SALV
TI REI
PV
BLIC
AE

DIVVS
AVGVS
TVS
PATE
R

Naples in 1494. She further suggests that it might be the Horace for which Mennio was paid for executing '*lettere majuscule d'azzuro e horo*' on 28 March 1492 (De Marinis 1947-52, II, p. 296, doc. 808).

Provenance: Royal arms of Naples, perhaps of King Alfonso II (*r.* 1494-1495); the bookseller James Edwards (1757-1816); William Beckford of Fonthill (1759-1844), no. 163; bought with other manuscripts from the library of the 10th Duke of Hamilton (1767-1852) by the Prussian government in 1882, no. 334.

Bibliography: Dibdin 1817, I, p. cxiv, illus.; Wescher 1931, pp. 113-4, pl. 103; De Marinis 1947-52, I, 86, pp. 156-7, II, pp. 84-5, III, pl. 118; Alexander 1969a, p. 20 n. 36; Toscano 1993, p. 280.

<div align="right">J. J. G. A.</div>

46

Ovid, *Metamorphoses*

147 fols. + 2 blank. 318 x 189 mm. On parchment. Red morocco, French 16th-century binding for Henry II of France (*r.* 1547-1559)

<div align="right">[New York only]</div>

Script attributed to Antonio Sinibaldi, c. 1480, Rome or Naples, with illumination attributed to the Master of the London Pliny

PARIS, BIBLIOTHÈQUE NATIONALE, latin 8016

The painted frontispiece and fourteen historiated initials of the Paris Ovid testify to the movement of miniaturists from one area of Italy to another in the late Quattrocento. On the frontispiece (folio 1), the initial space is filled by the author Ovid writing in a study; in the background a canopied bed is partially visible in a second room. The tranquil scene appears to be seen through an opening cut out of the parchment page. The colour and light are exceptionally beautiful. The intense red and blue of Ovid's costume contrasts with the cool purples and greys of the walls and door frames, all delicately illuminated by light coming through the leaded window.

In contrast to the studied illusionism of the author portrait, the classicising motifs of the border are set off from the text by an area of 'shredded' blue colour. Surrounded by golden dolphins, trophies, cornucopias, winged putti heads, a harpy, and vases with foliage, are eight busts of men and women in grisaille, who suggest the characters in Ovid's poem. In the lower margin two putti support the arms of the royal family of Naples.

Opening each of the other fourteen books of the *Metamorphoses* are faceted epigraphic initials on square plaques with monochromatic figures appearing as if in raised relief (subjects listed in Armstrong 1981, p. 133). The letters are purple or grey-blue on gold plaques, or gold against plaques and reliefs of green or again purple. A few of the scenes relate to the text, such as *Pegasus on Mt Helicon* (folio 67v, Book VII); the *Birth of Adonis* (folio 80, Book VIII); *Vulcan Forging the Wings of Cupid* (folio 136v, Book XIII) (Armstrong 1981, figs 106, 107, 104), but others merely allude to the Classical past more generally (folio 93, Book IX, *Satyr Carrying a Vase*; Armstrong 1981, fig. 103). The historiated initials link this manuscript to incunables and manuscripts decorated by the same artist. For example, the unusual episode of the *Birth of Adonis* was earlier drawn in pen and ink in a *Scriptores rei rusticae*, printed in Venice by Nicolaus Jenson in 1472 (Armstrong 1981, fig. 72). The composition also parallels a *Birth of Aesculapius* in a Pliny, *Natural History*, printed by Jenson in 1472 (Armstrong 1981, fig. 86).

Several scholars have proposed that this gifted miniaturist was Gaspare da Padova, documented in Rome in the 1480s, but recently published documents link Gaspare to an entirely different group of manuscripts (see cat. 39). Other candidates are Jacometto Veneziano and Lauro Padovano, both named as miniaturists and painters in Venice (see cats 71, 90, 91). But lacking fully convincing evidence, the anonymous artist may retain the name of the Master of the London Pliny. Like many monumental artists, the Master of the London Pliny

was influenced by the presence of Antonello da Messina (*fl. c.* 1445-1479) in Venice around 1475. Antonello had mastered the rendering of light so important in Flemish painting, and the Ovid author portrait echoes this quality (see cat. 28).

In 1480 Cardinal Giovanni d'Aragona (1456-1485), son of King Ferdinand I of Naples (*d.* 1494), stopped in Venice on his return from a legation to Hungary. While in Venice, he joined the Scuola Grande di San Marco, a membership shared with the printer Nicolaus Jenson, miniaturist Leonardo Bellini (cats 27, 89) and Leonardo's famous cousins, the painters Giovanni and Gentile Bellini (Lowry 1991, pp. 112-13). At this time Cardinal Giovanni may have engaged the Master of the London Pliny to go south with his entourage, since no works for Venetian patrons are known by the miniaturist after 1480. In the Paris Ovid manuscript, the crown above the Aragonese arms has probably been painted over a cardinal's hat, supporting the thesis that the book was originally owned by Cardinal Giovanni (de la Mare 1984, p. 293; see also cat. 40). The scribe who wrote it was Antonio Sinibaldi, a Florentine who worked intermittently in Naples for the Aragonese court, but who seems to have returned definitively to Florence in 1480 (de la Mare 1985). Several other manuscripts produced either for King Ferdinand or for Cardinal Giovanni evidence the miniaturist's continuing presence in Rome or Naples (de la Mare 1984; see also cat. 41).

Provenance: Cardinal Giovanni d'Aragona (1456-1485); King Ferdinand I of Naples (*r.* 1458-1494); King Henry II of France (1519-1559).

Exhibitions: Paris 1984, no. 147; Urbino 1992, no. 69.

Bibliography: De Marinis 1947-52, II, p. 119, IV, pl. 183; Munari 1957, p. 52, no. 255; Alexander 1969a, p. 18 and n. 33; Putaturo Murano 1975, pp. 95-110; Armstrong 1981, pp. 38-47, 133, pl. IV, figs 103-7, 115; de la Mare 1984, pp. 281, no. 48, 293; Garzelli and de la Mare 1985, p. 486.

<div align="right">L. A.</div>

47

Livy, *Roman History*, First and Third Decades

235 and 238 fols. 340 x 232 and 327 x 220 mm. On parchment

<div align="right">[London only]</div>

Script attributed to Giovanfrancesco Marzi, Florence, c. 1460-70, with illumination attributed to the Master of the Naples Virgil

HOLKHAM HALL, NORFOLK, THE EARL OF LEICESTER AND THE TRUSTEES OF HOLKHAM ESTATE, MS 351/1-2 (ML C 46)

These are two volumes of a three volume set of the surviving books of the *Roman History* (*Ab urbe condita*) written by Titus Livius (59 BC-17 AD). The *History* was originally written in 142 books, but only Books I-X and XXI-XLV survive.

The first volume, the First Decade, which reaches the beginning of the Punic Wars, opens with a white vine-stem border inhabited by putti, birds, butterflies and animals; in the lower border in the centre is the coat of arms of Capponi of Florence, with a cock below. There are nine medallions in the border, of which three show Labours of Hercules: Hercules wrestling with Antaeus, lower left; Hercules and the Hydra, lower right; and Hercules and the Nemean Lion, lower centre right. These follow famous compositions by Pollaiuolo and other Florentine artists. Other roundels contain male and female bust figures, a mounted warrior and a dragon and lion. The initial 'F', a plain gold capital, is placed beside a small scene of a soldier on a rearing horse beside a bridge. This probably represents the vision of Romulus descending from the sky, reported by Proculus Julius in Book I, chapter xvi. There are white vine-stem initials, usually five line, for each of the ten books: folio 1v, 'I'; folio 26v, 'L'; folio 53, 'A'; folio 81v, 'H'; folio 105v, 'P'; folio 129v, 'Q'; folio 149v, 'A'; folio 169v, 'I'; folio 188, 'S'; and folio 212v, 'L'.

The second volume, containing the Third Decade, the account of the Second Punic War, opens with a similar white vine-stem border with eight roundels, one with a battle scene of opposing riders, top

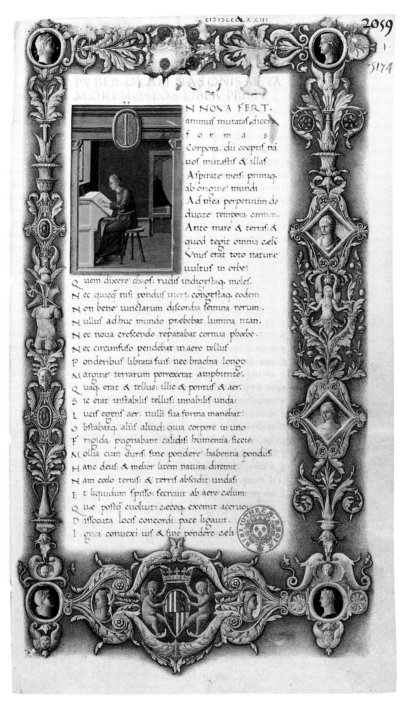

46 folio 1r

left, one with a youth dancing while a woman plays a portative organ, lower centre, two with the Capponi arms, lower left and right, the remainder female bust figures. The initial 'I' is accompanied by a scene of Hamilcar making his nine-year-old son Hannibal swear enmity to the Roman people at the altar. There are again white vine-stem initials to the various books: folio 24v, 'I'; folio 50, 'H'; folio 73, 'V'; folio 95, 'D'; folio 118, 'C'; folio 143v, 'H'; folio 171v, 'D'; folio 197v, 'S'; folio 217, 'C'.

The script in these two volumes and also in the third volume, containing the Fourth Decade (Holkham Hall, ML C4b MS 351/3, not exhibited), has been identified by Albinia de la Mare (1971) as by the prolific scribe Giovanfrancesco Marzi of San Gimignano, who was notary of the archiepiscopal court in Florence. He seems to have been born in 1440 and was still alive in 1494. In all three volumes, as in the Munich Livy (cat. 68), there are annotations by the Florentine scholar and humanist Bartolomeo Fonzio (*c.* 1446-1513). The illumination has been attributed by Annarosa Garzelli (in Garzelli and de la Mare 1985)

to the so-called Master of the Naples Virgil and is a typical example of good quality Florentine work of the period.

Provenance: The three volume set, each volume with the arms of Capponi of Florence, was separated by the early 18th century, and was only recently reunited when Albinia de la Mare recognised that the First and Fourth Decades belonged with the Third Decade already at Holkham. MS 351/2 was bought by Thomas Coke of Holkham (1698-1759), perhaps from the Augustinians in Lyons, in 1713. MSS 351/1 and 3 probably belonged to Anthony Askew (1722-1772); his sale, London, Christie's, 7-16 March 1785; Sir George Shuckburgh-Evelyn (1751-1804), thence by descent to Lady Christian Martin; sold, London, Christie's, 25 June 1986, lot 219, and bought by Viscount Coke.

Bibliography: Holkham 351/2: Hassall 1970, pp. 13 n. 2, 37, pl. 106; de la Mare 1971, pp. 194 n. 58, 198; Garzelli and de la Mare 1985, pp. 50, 459, 488, 501, fig. 110. Holkham 351/1-3: J. Griffiths, unpublished typescript description from catalogue in progress.

J. J. G. A.

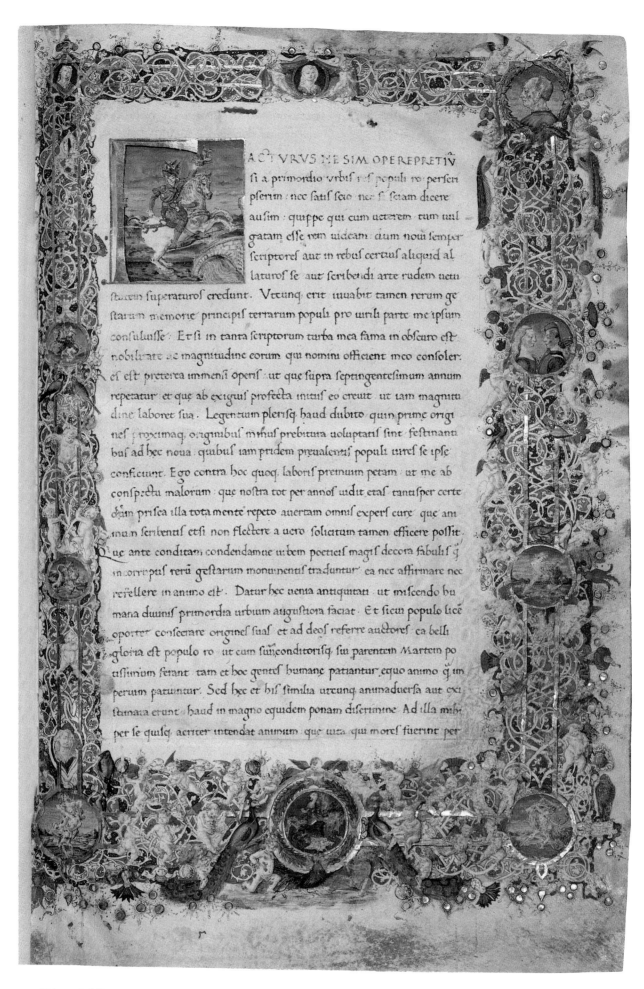

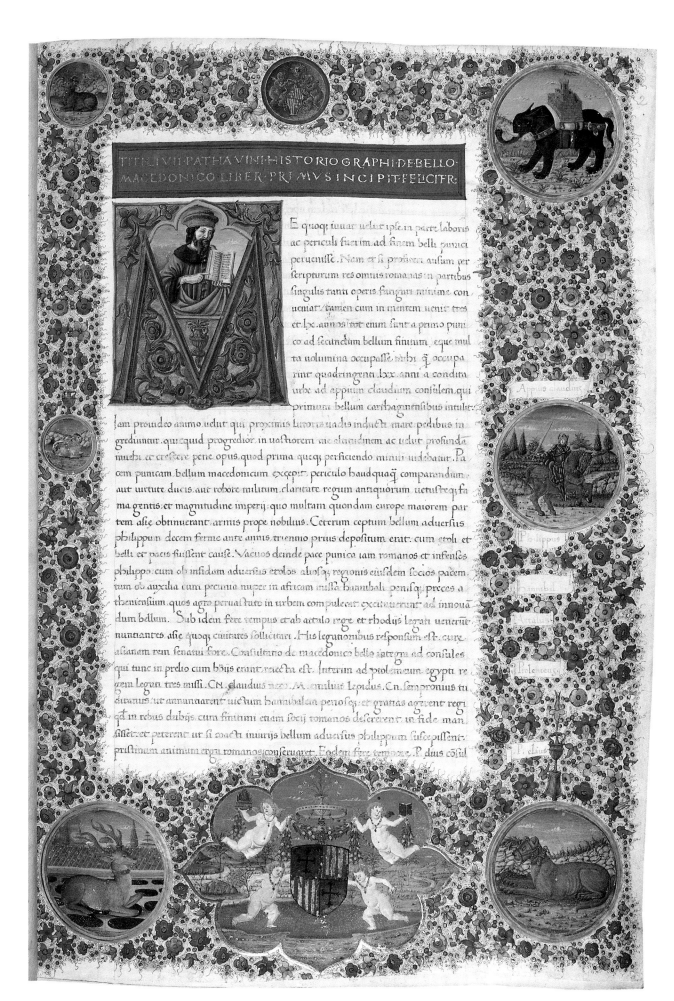

E quoq; iuuat uelut ipse in parte laboris
ac periculi fuerim ad finem belli punici
peruenisse. Nam et si profitei ausim per
scripturum res omnis romanas in partibus
singulis tanti operis fangui minime con
ueniat tamen cum in mentem uenit tres
et lx. annos tot enim sunt a primo puni
co ad secundum bellum finitum eque mul
ta uolumina occupasse nihi q̃ occupa
rint quadringenti lxx anni a condita
urbe ad appium claudium consulem qui
primum bellum carthaginensibus intulit

Iam prouideo animo uelut qui proximis litoris uadis inducti mare pedibus in
grediuntur quicquid progredior in uastiorem me altitudinem ac uelut profunda
inuehi et crescere pene opus quod prima queq; perficiendo minui uidebatur Pa
cem punicam bellum macedonicum excepit periculo haudquaq̃ comparandum
aut uirtute ducis aut robore militum claritate regum antiquorum uetusteq; fa
ma gentis et magnitudine imperij quo multam quondam europe maiorem par
tem asie obtinuerant armis prope nobilius Ceterum ceptum bellum aduersus
philippum decem ferme ante annis triennio prius depositum erat cum etoli et
belli et pacis fuissent cause Vacuos deinde pace punica iam romanos et infensos
philippo cum ob infidam aduersus etolos aliosq; regionis eiusdem socios pacem
tum ob auxilia cum pecunia nuper in africam missa hannibali penisq; preces a
theniensium quos agro peruastato in urbem compulerat excitauerunt ad innoua
dum bellum Sub idem fere tempus et ab attalo rege et rhodijs legati uenerũt
nuntiantes asie quoq; ciuitates sollicitari His legationibus responsum est curę
alianam rem senatui fore Consultatio de macedonico bello integra ad consules
qui tunc in pretio cum bellis erant reiecta est Interim ad ptolemeum egypti re
gem legati tres missi Cn. claudius nero M. emilius Lepidus Cn. sempronius tu
ditanus ut annuntiarent uictum hannibalem penisq; et gratias agerent regi
qd in rebus dubijs cum finitimi etiam socij romanos desererent in fide man
sisset et peterent ut si coacti iniurijs bellum aduersus philippum suscepissent
pristinum animum erga romanos conseruaret Eodem fere tempore P. elius cõsul

48

Livy, *Roman History*, Fourth Decade; Florus, *Epitome* of Livy; *Epitoma XIIII Decadum Livii*

216 fols. 376 x 261 mm. On parchment

Script attributed to 'Hubertus', Florence, c. 1470-80, with illumination attributed to Francesco Rosselli

LONDON, THE BRITISH LIBRARY, Harley MS 3694

Though illuminated for a Neapolitan patron, Alfonso of Aragon (1448-1494), Duke of Calabria, son of Ferdinand I, King of Naples, the script and illumination are Florentine. A circular title-page on folio 1v shows the Duke's arms held by angels above a gold wreath, with floral decoration containing the list of contents written in gold capitals on blue. On folio 2 is a historiated initial 'M' with a figure probably intended to be an author portrait of Livy. The four sided border, composed of a flower scroll, contains roundels of animals and, to the right, an armed warrior on horseback. Names mentioned in the text are regularly written in the margin by the scribe in pink, and on this folio they are incorporated as if on scrolls in the border. Below the horseman is written the name '*Philippus*', and it was this that presumably motivated the image.

There are plain gold initials on coloured grounds of nine or ten lines with white vine-stem one sided borders to each of the ten books of Livy: folio 9v, 'C'; folio 17v, 'C'; folio 31, 'I'; folio 49v, 'P'; folio 65v, 'P'; folio 79v, 'L'; folio 99v, 'D'; folio 120v, 'D'; folio 139, 'P'. In the Florus there are initials in the same rather unusual style to each of the four books: folio 158, 'P'; folio 159, 'D'; folio 167v, 'H'; folio 174, 'S'; In the 'P' on folio 158 a spider's web is included, and there is also a border with interlace motifs and floral terminals. A similar border and initial 'A' introduces the second epitome, the *Epitoma XIIII Decadum Livii*, folio 188. Here the Naples arms are again repeated.

The illumination has been attributed to Francesco Rosselli (see cats 31, 32, 35) by Annarosa Garzelli (in Garzelli and de la Mare 1985, p. 175). The scribe is identifiable with 'Hubertus', a scribe probably from northern Europe, who was active in Florence from at least 1462 until the mid-1470s. He was closely associated with the *cartolaio* Vespasiano da Bisticci (de la Mare, in Garzelli and de la Mare 1985, p. 505). Alfonso of Calabria was a client of Vespasiano's and the manuscript of Livy, Third Decade, in the Vatican (Biblioteca Apostolica Vaticana, Ottob. lat. 1450) with the Duke's arms, presumably came from the same set, though illuminated by a different artist (Albinia de la Mare, written communication). The text of the Fourth Decade in the present manuscript was copied from or derives from the edition printed in Rome, *c.* 1470 by Ulrich Han (Reeve 1986).

Provenance: Arms of Calabria and Aragon quartered; Alfonso of Aragon, Duke of Calabria (1448-1494), as King Alfonso II of Naples (r. 1494-1495); on folio 215v, '*Selectus per D. regem*', 15th-16th century; De Marinis 1947-52, II, inventory G, no. 385 (?); on folio 1v, '*Codex MS Biblioteca Buherianae B. 10 MDCCXXII*', the library formed by Jean Bouhier I (1605-1671) and his grandson, Jean Bouhier II (1673-1746); the manuscripts passed by descent first to the marquis de Bourbonne, then to the comte d'Avaux, by whom they were sold to the Abbey of Clairvaux in 1781; many are today in Troyes and Montpellier; the present manuscript was acquired by Robert Harley, 1st Earl of Oxford (*d.* 1726) or Edward Harley, 2nd Earl of Oxford (*d.* 1741) sometime between 1721 and 1741; sold to the British Museum by Lady Oxford in 1753.

Bibliography: *Reproductions from Illuminated Manuscripts* 1907, pl. 50; D'Ancona 1914, I, pp. 61-2, II, no. 831; De Marinis 1947-52, II, pp. 98-9, pls 151-2; Wright 1972, pp. 48, 52, 86-7, 433; Garzelli and de la Mare 1985, pp. 174, 505, pl. 572; Reeve 1986, p. 167.

J. J. G. A.

49

Livy, *Roman History*, Fourth Decade, in Italian

356 fols. 342 x 236 mm. On parchment [New York only]

Script attributed to 'Sinibaldus C.', in Florence, c. 1475-8, with illumination attributed to Mariano del Buono

VALENCIA, BIBLIOTECA GENERAL DE LA UNIVERSIDAD, MS 386 (G. 1317)

The illumination consists of a frontispiece, folio 6v, with the title written in gold on purple as if within a carved frame. Above, putti flank the royal arms of Naples; below, they tug at a wreath enclosing one of Ferdinand I's *imprese*, the '*balconcino arabo*', with the motto '*Amor min[c]iende e struggie*'. The flanking ornament to left and right is supported by two other putti and encloses at the top two wreaths with female profile heads labelled '*Cornelia*' and '*Giulia Augusta*'. Four other such heads in the outer frame are labelled '*Domitia*' and '*Faustina*', left and right top, and '*Sabina Adriana*' and '*Agrepina*' [*sic*] in the centre sides. On folio 7 the text begins with an initial 'L' with a three-quarter length military figure. The border is made up of foliage and flower scroll with medallions, with deer at the corners, a figure labelled '*Mario consulo*' to the right, and four classicising figures, two bust heads and two cameo types, a nude female with cornucopia and a nude male with shield and staff. The royal arms of Ferdinand I are supported by four putti below and one of his *imprese*, the ermine, with his motto above.

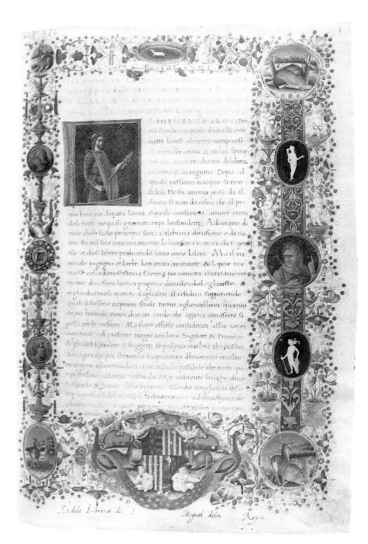

49 folio 7r

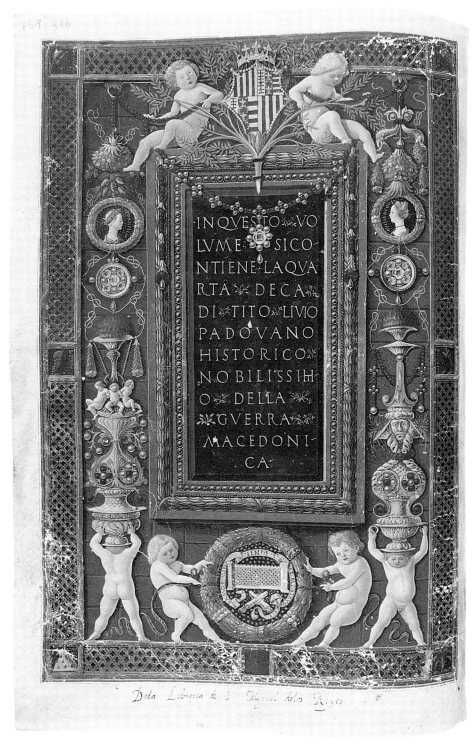

49 folio 6v

There are initials of six lines, gold capitals with flower scroll and gold discs, to each of the remaining nine books: folio 10v, 'C'; folio 28, 'S'; folio 47, 'I'; folio 79, 'F'; folio 120v, 'N'; folio 157, 'E'; folio 189, 'N'; folio 239, 'M'; folio 287v, 'M'; folio 329, 'N'; The illumination has been attributed by Annarosa Garzelli (in Garzelli and de la Mare 1985) to the Florentine illuminator Mariano del Buono, who was born in 1433 and died probably in 1504 (see also cat. 68). The design of the title-page appears to copy the similar lay-out adopted by Francesco Rosselli in the Urbino Bible and other manuscripts made for Federigo da Montefeltro.

The manuscript was copied by 'Sinibaldus C.', a scribe close to Vespasiano da Bisticci, and may have been produced by Vespasiano before he gave up his shop in 1478. It probably belongs with Valencia MSS 382 and 383, the former dated 27 January 1475/6 (see cat. 76).

Provenance: Arms, *impræse* and motto of King Ferdinand I of Naples (r. 1458-1494); De Marinis 1947-52, II, inventory G, no. 776; Cherchi and De Robertis 1990, p. 259, inventory of 1527, no. 261; bequeathed to San Miguel de los Reyes, Valencia, by Ferdinand of Aragon, Prince of Taranto, in 1550.

Bibliography: Gutiérrez del Caño 1913, no. 1317; Bordona 1933, II, no. 2043, figs 692-4; De Marinis 1947-52, I, pp. 74 n. 29, 137, II, p. 101, pls 157-8 (as Valencia, MS 757); Garzelli and de la Mare 1985, p. 193, fig. 732.

J. J. G. A.

50

Pliny the Elder, *Natural History*

425 fols. 418 x 277 mm. On parchment [New York only]

Written in Florence, 1458, by Ser Benedetto, with illumination attributed to Francesco d'Antonio del Chierico with another illuminator

FLORENCE, BIBLIOTECA MEDICEA LAURENZIANA, 82, 3

Pliny the Elder's *Historia naturalis*, an encyclopaedic compilation, written before his death in the eruption of Vesuvius in 70 AD, was a much studied text in the Renaissance and was also issued in numerous printed editions (cats 84-5). The title is written after the chapter list on folio 1, the *argumentum* on folio 2, and the *incipit* to the preface, on folio 3v, in blue and gold capitals inside a plain rectangular frame of pink, blue and green scrolls. On the recto opposite, folio 4, is a large initial 'L', 21 lines high, filled with white vine-stem and including three Medici rings. Similar rings also surround the Medici arms at the bottom of the page. The rich white vine-stem four sided border is filled with fighting men, centaurs and monsters, with putti, including two jousting and riding on boars, and with animals, birds and butterflies. There are roundels with human heads, of which that with the affronted couple in the right margin, the man with bright red hat, the woman in green, perhaps represents the patron and his wife. On folio 6v the white vine-stem initial 'M' with border for Book II is accompanied by a representation of the globe surrounded by the firmament. There are other white vine-stem initials for each of the books, usually nine lines high.

The manuscript has been identified as the Pliny which Vespasiano da Bisticci refers to in letters to Piero de' Medici as being written by Ser Benedetto and already partly illuminated in April 1458 and completed in June (Garzelli and de la Mare 1985, p. 570). The illumination has been attributed by Francis Ames-Lewis (1984a) and Annarosa Garzelli (in Garzelli and de la Mare 1985) to Francesco d'Antonio del Chierico, one of the leading illuminators in Florence from *c*. 1452 until his death in 1484 (see cat. 36; Levi d'Ancona 1962, pp. 108-16). He is undoubtedly the main illuminator, responsible for the opening decoration. However, the initials are in two styles, suggesting the intervention of a second illuminator who mainly worked on the initials from Book XXVII on, using larger forms for his white vine-stem ornament and a darker pink.

Provenance: Arms of the Medici, folio 4, and ownership inscription of Piero di Cosimo de' Medici, folio 426; his inventories of '1456' (75) and 1464/5 (72) (Ames-Lewis 1984a).

Exhibition: Florence 1987, no. 93.

Bibliography: D'Ancona 1914, II, no. 468; Biagi 1914, pl. XXXIII; Alexander and de la Mare 1969, p.40 n. 1; Ames-Lewis 1984a, pp. 330-1, no. 84, pls 31, 83-4; Gombrich 1960 (1966), p. 51, pl. 83; Garzelli and de la Mare 1985, pp. 101, 118, 134, 428, 570, figs 386-8, 390.

J. J. G. A.

51

Hyginus, *De astronomia*

80 fols. 234 x 150 mm. On parchment [London only]

Written and illuminated in Padua, c. 1465-70

NEW YORK, NEW YORK PUBLIC LIBRARY, ASTOR, LENOX AND TILDEN FOUNDATIONS, Spencer MS 28

This manuscript, copied in an elegant humanist script, is assumed to be Paduan in view of the style of its illumination and the '*littera mantiniana*' at the beginning of the text. The transcription of a treatise on astronomy, written by a Latin author of the 1st centuryy AD, into a sumptuous illuminated manuscript demonstrates the interest of Paduan intellectuals in Classical learning. The manuscript follows the lay-out of late Classical texts, which then passed into medieval copies; the descriptions are followed in each case by a representation of the constellation in its traditional anthropomorphic or zoomorphic form. Thirty-eight constellations are illustrated and the representations are each surrounded by an aureole of blue, which both increases their three-dimensionality and suggests the sky. The positions and movements of the figures almost invariably correspond to similar ones in the copy of Hyginus' *De astronomia* made in Florence by Coluccio Salutati in the late 14th century (Vatican, Biblioteca Apostolica Vaticana, Vat. lat. 3110); but here the Classical style of the nudes and the dress of the clothed figures presupposes the influences of Paduan Classicism and also probably a familiarity with other Hyginus illustrations much closer to the Classical tradition. The constellations are painted by diverse artists from the same studio and great attention is paid to the representation of both humans and animals. This manuscript is the primary example of a whole Paduan tradition of animal representations.

The series opens with the beautiful figure of the constellation Arctophylax represented as an Antique hero, nude, armed and in diagonal movement (folio 41). Still more elegant is the figure of Engonasin or Hercules (folio 42), as if in flight in the sky, nude and holding club and lion's skin. To the same group belong the Crown (folio 41v), the Lyre (folio 42v) and the exquisite Swan (folio 43). These are all surrounded by a coloured ribbon giving a hint of a stage curtain. The style has evident links with Mantegna, but the exquisite painting of the figures and the sentimental sweetness of atmosphere point more in the direction of the drawings of Jacopo Bellini, reflecting the refinement of the *Passio S. Mauritii* (Paris, Bibliothèque de l'Arsenal, MS 940), executed for Jacopo Marcello. The Petrarch written by Sanvito shows a similar taste (cat. 71). At the same time the linear dynamism reflects the style of the Paduan painter Marco Zoppo, who worked as an illuminator in Venice and Padua in the 1460s (cat. 72). These first constellations, probably attributable to the same master, though the Arctophylax and the Hercules differ in some ways, is of great importance for the future of Paduan illumination, pointing the way to a more classicising style represented above all by Giovanni Vendramin, who in 1466 was working in Squarcione's workshop (see cats 78-9).

The second master painted the next cluster of constellations in quite a different style. His are the figures of Cepheus (folio 43v), Cassiopeia (folio 44), Andromeda (folio 44v), Perseus (folio 45v) and Auriga the charioteer (folio 46). The Eagle (folio 47v) and the Dolphin (folio 48) may also be by him. His work is less Classical, his colours are more brilliant and he works with an expressionism very reminiscent of the Paduan painter Francesco Squarcione, in whose studio all the most important Paduan painters of the early Renaissance received their training. The expressive realism of some of these figures suggests the influence of Ferrara, but it is more likely to be a question of a Paduan style that influenced the Ferrarese. At any rate this illuminator, who might be named the Master of the Charioteer and who is very close to Squarcione himself and to his pupil, the painter Giorgio Schiavone, established a tradition that was to be very important in Paduan miniature painting and whose major representative was to be Antonio Maria da Villafora (cat. 7).

A third master painted another small but exquisite group of constellations, including the Serpent Holder (folio 46v), the Arrow (folio 47), the Horse (folio 48v), the Triangle (folio 49), the Bull (folio 49v) and the Twins (folio 50). His style is extremely close to that of the first master, but more nervous and excitable. He might be named the Master of the Serpent Holder and he too had a great influence on Venetian illumination of the 1470s. The fourth master, the Master of the Virgo, paints in a similar fashion, though with greater sweetness, with larger forms and more varied and blended colours. His constellations are Cancer (folio 50v), Leo (folio 51), Virgo (folio 51v), Scorpio (folio 52), Sagittarius (folio 52v), Capricorn (folio 53), Aquarius (folio 53v) and Orion (folio 55v). The last master, the Master of the Centaur (folios 53, 55, 56v, 57, 57v, 58, 58v, 59v) paints in a more timid manner and in a style somewhere between that of the second master and the others. Typical are the Centaur (folio 57v) and Eridanus (folio 55).

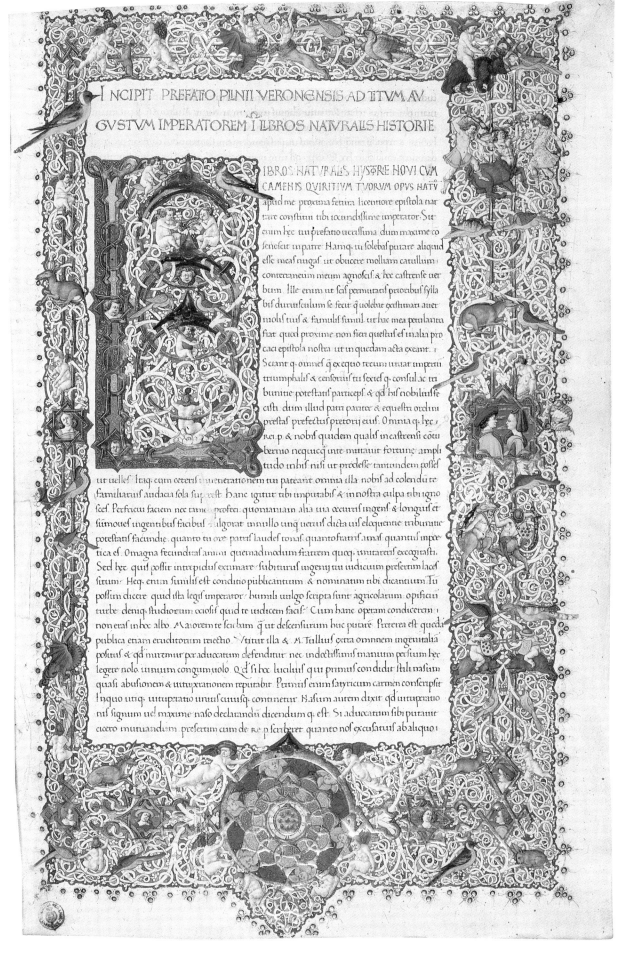

tef. Jn manu finiftra unam: Jn dextro cubito
unam: Jn utrocq latere fingulaf: fed clariove
in finiftro: Jn dextro femore duaf: Jn genu
unam: in poplite unam: in crure duaf
Jn pede unam: quæ dicitur clara: Jn finiftra
manu quatuor: quaf pellem leonif nonnul-
li effe dixerunt: ita funt omnino decem
& nouem: —

L̄yra autem pofita eft contra regionem eiuf
loci: qui eft inter genu & manum finiftram:
& engonafim uocatur: cuiuf ipfa teftudo fpec-
tat ad ārcticum circulum: fummū aut colu-
men ad polum notium contendere uidetur:

stella coniungitur: i. una manu ut loua tenef
figuratur. Cuiuf in humero finiftro capra: Jn
manu autem duo ædi duabuf ftellif formari
dicuntur. Totuf autem pedibuf perfei fubiectuf
Caput habenf contra maiorif urfæ afpectum:
Hic occidere fagittarij & capricorni exortu ui-
detur. exoriri autem ophiocho & engonafi oc-
cidentibuf. Habet præterea in capite ftellam
unam: Jn utrocq humero unam: fed in finiftro
clariorem: quæ uocatur capra: Jn utrocq cubi-
to unam: Jn manu duaf quæ ædi appellant̄
ftellif prope occidentibuf formari: ita omnino
funt numero feptem:

In ceruicibus quatuor obscuras sed maxime luret
quae proxima capiti apparet. In humero claram
unam. In pectore unam. Inter scapulos unam. In
umbilico nouissimam unam. duas andromede uo
catur. In genibus utrisq̃ singulas. In utrisq̃ poplii
bus singulas. Ita sunt omnino uiio decem & septe

De toton autem ut triangulum deformatur æ
quis quoddam modo lateribus duobus. uno bre
uiore sed prope æquali reliquis inter æstiuu
& æquinoctialem circulum supra caput aduens
no ab andromedae dextro cruce. & persei ma
nu sinistra collocatum: cum ariete toto occide
exories autem cum eiusdem dimidia parte priore
ore: Habet aut stellam i uno quoq̃ angulo una.

Orionem autem a zona & reliquo corpore æq
noctialis circulus diuidit. cum tauro decertan
tem collocatum. Dextra manu clauam tenente
& incinctum ense. spectantem ad occasum &
occidentem. exortu scorpionis posteriore par
te. & sagittario exoriente. cum cancro dutez
toto corpore pariter exurgentem. Hic habet
in capite stellas tres claras. In utrisq̃ humeris
singulas. In cubito dextro obscuram unam. In
manu similem unam. In zona tres. In eo q
gladius eius deformatur tres obscuras. In utris
que genibus singulas claras. In pedibus singu
las obscuras. Omnino sunt decem & septem

fabulum quoddam protraxit. incipientem iam se ictu recipere.

bi quum Zopirus ceruicem incisurus gladium eduxisset ita torue respexit eum pyrrhus: ut illum ad tremorem prae metu

52 folio 166

Though a late date has been suggested recently for the *De astronomia*, it seems likely that the manuscript belongs to the second half of the 1460s. It is plausible to think that it came from the workshop of Squarcione, who died in 1468. We know that a number of artists worked together there, and we may plausibly ask whether this team of miniaturists were not also painters and whether among them might have been Lauro Padovano, whom the sources name as one of the most important illuminators in Renaissance Padua.

Provenance: Naples, Duke of Cassiano Serra (*c.* 1800); sold to Thorpe (London, 5 February 1828, no. 128); Sir Thomas Phillipps, no. 6972 (*c.* 1830–5); sold privately to Sir Alfred Chester Beatty; his sale, London, 9 May 1933, lot 60; to Bernard Quaritch; sold to Spencer, 9 June 1933.

Exhibition: Baltimore 1949, no. 192, pl. LXIX.

Bibliography: De Ricci 1935–40, II, no. 1341; Faye and Bond 1962, p. 331; Armstrong 1981, p. 67, fig. 143; Mariani Canova 1993, pp. 132–3.

G. M. C.

52

Plutarch, *Parallel Lives*, translated from Greek by Leonardo Bruni and others

240 fols. 336 × 240 mm. On parchment

Script attributed to Laurentius Dolobella, with illumination by three anonymous artists in Milan, c. 1450–60

LONDON, THE BRITISH LIBRARY, Additional MS 22318

Plutarch (46–*c.* 120 AD) wrote his *Parallel Lives* of famous Greeks and Romans in Greek in Athens. It was virtually unknown in the medieval West, but the text was preserved in Byzantium. A large number of translations into Latin of individual Lives were made in the 15th century in Italy by various humanist scholars, including Jacopo Angeli, Leonardo Bruni and Pier Candido Decembrio. The majority of the translations in the present manuscript are by Bruni, who had got possession of a Greek text in around 1405 and made his versions over the next fifteen years. The Life of Mark Antony was dedicated to Coluccio Salutati, whose protegé Bruni was, and that of Cicero to Niccolò Niccoli.

The present manuscript is a particularly luxurious copy, suggesting an important patron. Albinia de la Mare (written communication) has observed that marginal annotations, often including the word '*attende*', may link with the humanist Pier Candido Decembrio, who copied the usage from Petrarch's annotations in manuscripts found in the Visconti-Sforza library. One note reads '*Attende imperator*', folio 104. The manuscript could possibly have been intended as a gift from Decembrio to Emperor Frederick III when he came to Italy to be crowned in 1452. The black eagle displayed on gold on the standard of Mark Antony on folio 2 might then have a direct imperial reference.

Historiated initials introduce each of the Lives: folio 2, 'M', Mark Antony; folio 45, 'E', Pompey; folio 90v, 'C', Sertorius; folio 106, 'E', Emilius; folio 125, 'D', Tiberius Gracchus; folio 135v, 'C', Caius Gracchus; folio 144v, 'T', Pyrrhus; folio 167, 'C', Cato. Additional historiated initials show a battle scene, 'M', folio 4, and Sertorius swimming a river, 'Q', folio 92v. There are also miniatures placed at or near the end of each Life, usually showing the death of the particular hero, for example on folio 105v the murder of Sertorius at a banquet. Other similarly placed miniatures are on folio 44v, Mark Antony's suicide;

pręsensibus exinde merentis alii uti pompeium deducti maneati
cumq; uehitur lybia uti prosequerent. Mauritiis interfecti fuerunt.
Hec quisq; eorum euasit. prster unum Aufidium Manlium ti
palens. Hec enim siue latens siue neglectus in quadam pro
uintia iniuriis consenuit.

FINIS VBI LOSCIT OMNI

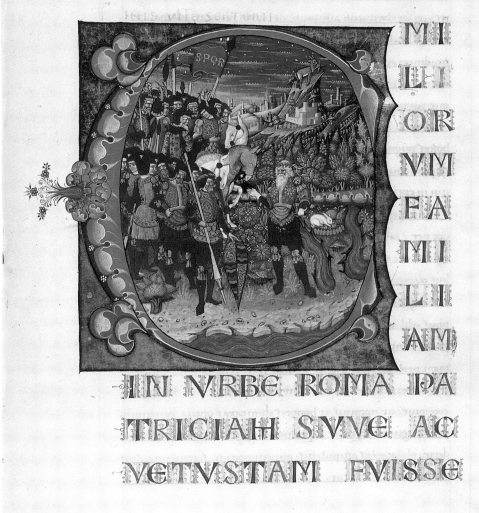

MI
LI
OR
VM
FA
MI
LI
AM

IN VRBE ROMA PA
TRICIAH SVVE AC
VETVSTAM FVISSE

folio 90, the murder of Pompey; folio 121, a triumph scene; folio 134v, the stoning of Tiberius Gracchus; folio 143v, the death·of Caius Gracchus; and folio 166, a battle scene. The illumination was unfinished and there are spaces for the initials to the Lives of Cicero and Demosthenes, folios 202v and 228, and for miniatures of the deaths of Cato, Cicero and Demosthenes, folios 201, 227v and 239v.

The script has been attributed to Laurentius Dolobella of Trento by Albinia de la Mare (1971). Dolobella signed a number of other manuscripts, including Verona, Biblioteca Capitolare, MS CCXXIX; Oxford, Bodleian Library, MS Add. B. 55, with a date, partly erased, of perhaps 1451; Vatican, Biblioteca Apostolica Vaticana, Chig. H. VII. 258, where he describes himself as '*Tridentinus*'; and Linköping, Stifts og Landsbibliotek, Kf. 23, another Plutarch.

Three artists were responsible for the illumination of the present manuscript. The first is a rather weak hand who paints small, doll-like figures in a landscape. He may be the same artist who illuminated a Plutarch now in Siena (Biblioteca Comunale, MS I. VII. 23; Salmi 1957, pl. LXXA). The second illuminator is close in style to Belbello da Pavia, and like Belbello is still using the curvilinear drapery forms of the International Gothic style. The third artist shows knowledge of Ferrarese illumination (Taddeo Crivelli, Franco dei Russi; see cats 110-12, 26, 71, 82, 113).

The iconographic program owes something to the pictorial tradition of *Uomini famosi*, showing the heroes as standing figures, and similar standing figures of Emperors are used in manuscripts of Suetonius' *Lives of the Emperors*, illuminated in Milan (e. g. Princeton University Library, MS Kane 44, by the Master of the Vitae Imperatorum). The narrative scenes are likely to have been invented by the illuminators, however. In some miniatures by the second artist there are interesting and detailed representations of contemporary townscapes, for example folios 125, 166.

Provenance: Marchese Giovanni Battista Costabili; his sale, Paris, 18 February 1858, lot 89; bought by the British Museum from the bookseller Boone in 1858.

Bibliography: *Reproductions from Illuminated Manuscripts* 1907, pl. 46; Mitchell 1961, pls 1-10; de la Mare 1971, p. 195 n. 71.

J. J. G. A.

53

Aristotle, *Physics, On Generation and Corruption, On the Heavens, On the Soul*, in Greek

162 fols. 422 x 290 mm. On parchment [London only]

Written in the Abruzzi, 1496, by the priest Rombertus Maioranus da Malepigniano, with illumination attributed to Cristoforo Maiorana and another unidentified illuminator

VIENNA, ÖSTERREICHISCHE NATIONALBIBLIOTHEK, Cod. phil. gr. 2.

The illumination consists of four framed folios introducing respectively the *Physics*, folio 1, *On Generation and Corruption*, folio 72, *On the Heavens*, folio 92, and *On the Soul*, folio 123. The first is an architectural frame to the text, which is made to seem as if written on torn and curling parchment. In the centre below are the arms of the patron, Andrea Matteo III Acquaviva, Duke of Atri (1458-1529). Both he and his father were prominent members of the court of Naples, and he had received a humanist education and was a patron of humanists (see cat. 55). His collection of manuscripts, many of them with fine illumination, and including a number of Greek manuscripts, is today divided between Vienna and the Biblioteca dei Gerolomini in Naples.

In the frame above is a decorative frieze with putti, rams, a unicorn and a Classical wreathed head in a medallion. To the sides are trophies and putti, and below to each side is a woman, one with a cornucopia and the other with a book. The initial 'E' frames a nude female figure who presses her breasts to release her milk onto a globe on her lap. This is Aristotle's Physis, or Nature, who nourishes the world. The humanist Pietro Summonte refers to a Pliny illuminated by Gasparo Romano, that is Gaspare da Padova (see cat. 39), with a figure of Nature pressing milk from her breasts. No doubt the image on folio 1 copies this lost work.

The second frontispiece, folio 72, is framed with classicising motifs and foliage; a medallion with a Pegasus is in the right border and the Acquaviva arms appear again below, flanked by two putti and two sphinxes. The initial 'P' shows a landscape with dead animals and human corpses, illustrating the corruption of Nature. The third frontispiece, folio 92, again has a framed border with foliage and medallions of a rabbit and a deer to left and right. Above are a merman and mermaid flanking a portrait bust; below two satyrs offer fruit to two women riding on a pair of hippocamps. In the initial 'H' two philosophers are seated in discussion and above is the Zodiac circling the earth. The last frontispiece, folio 123, is again an architectural structure with trophies of arms hanging at each side and the arms of Acquaviva supported by sphinxes in the centre below. The arms are also repeated to the right. The initial 'T' is inserted in a small miniature which shows a rocky landscape with a group of tomb slabs and above in the sky a group of winged souls flying upwards. There are also six line initials accompanied by candelabra borders in the left margin for the various books of the four main works: folio 8, 'T'; folio 15, 'E'; folio 21v, 'O'; folio 35, 'M'; folio 41, 'E'; folio 51, 'A'; folio 56, 'P'; folio 84, 'P'; folio 104v, 'O'; folio 117v, 'P'; folio 131, 'T'; folio 142, 'O'; folio 146, 'E'.

The scribe signs in Greek on folio 150v. The illumination has been attributed to two artists by Hermann (1898). The first works in a style related to that of Reginaldus Piramus Monopolitanus, who signed one of the miniatures in the Duke's companion copy of Aristotle's *Nicomachean Ethics* (Vienna, Österreichische Nationalbibliothek, Cod. gr. 4). He was responsible for folios 1, 92 and the initial on folio 8. The second illuminator, working on folios 72, 123 and the remaining initials, is identifiable as Cristoforo Maiorana (see cats 40, 55), who appears in the Naples royal accounts from 1480 to 1492 and whose style derives from that of Cola Rapicano (cats 9, 10).

Provenance: Andrea Matteo III Acquaviva, Duke of Atri (1458-1529), with his arms, folios 1, 72 and 123; bought probably in Naples, *c*. 1562-3, by Johannes Sambucus (1531-1584), inscription on folios 1, 150v; acquired with his library for the Hofbibliothek in Vienna.

Bibliography: Hermann 1898, pp. 155-62, 201, pl. V, figs 1-4; Beer 1913, pp. 36-7, 46, pl. XLI; Hermann 1933, pp. 60-68, pls XXIV-XXVIII.

J. J. G. A.

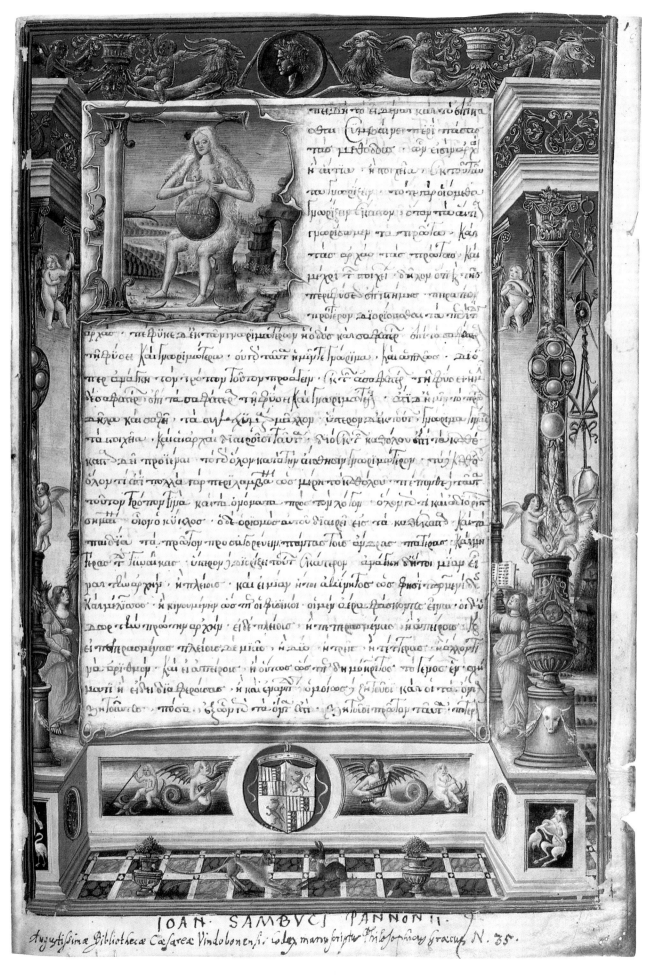

54 pages 18-9

54

Ptolemy, *Geography*, translated by Jacopo di Angelo da Scarperia

114 fols. 412 × 284 mm. On parchment [New York only]

Written and illuminated in Florence, c. 1460-70

NEW YORK, NEW YORK PUBLIC LIBRARY, ASTOR, LENOX AND TILDEN
FOUNDATIONS, Rare Books and Manuscripts Division, MS 97

The geographical treatise on the known world written in Greek by
Claudius Ptolemy (*c.* 90-168 AD) in Alexandria was translated in Flor-
ence into Latin by Jacopo di Angelo da Scarperia, who dedicated it
after its completion in about 1406 to the Antipope Alexander V
(*r.* 1409-10). The work is in eight books and the present manuscript
belongs with the so-called Group A manuscripts, which contain a
world map and twenty-six other regional maps, ten of Europe, four of
Africa, and twelve of Asia extending as far east as India. These maps
belong to the first recension of the maps, made by Donnus Nicolaus
Germanus before 1470 (see cat. 55). This recension was used in the
early editions printed at Rome in 1478 and 1490, at Ulm in 1482, and
at Strassburg in 1513, etc.

It has been suggested that this particular manuscript was used as
model by the German cartographer Nicolaus Germanus of Reichen-
bach for the Ulm edition of 1482, but apparently on no firmer evi-
dence than that it was later at Nuremberg in the library of Hieronymus
Guilelmus Ebner (see Raidelius 1737). The arms with the initials
'L. B.' of presumably the original owner are so far unidentified. A con-
siderable number of other Florentine copies of similar or somewhat
later date survive, including copies made for major patrons such as
Borso d'Este, Duke of Ferrara, Federigo da Montefeltro, Duke of
Urbino, and Alfonso, Duke of Calabria.

There are white vine-stem initials of six to nine lines on folio 2, 'A',
as well as for each of the books: folio 2v, Book I, 'Q'; folio 10, Book II,
'Q'; folio 19, Book III, 'I'; folio 28v, Book IV, 'M'; folio 35, Book V, 'P';
folio 43v, Book VI, 'A'; folio 49v, Book VII, 'Q'; folio 55, Book VIII,
'Q'. The maps extend across openings from verso to recto with the
succeeding verso usually blank and the explanatory text written on the
recto opposite, which is then followed by another map and so on. The
present manuscript is foliated to folio 55 and then the maps are sepa-
rately paginated from 1 (= folio 56) to 96.

Provenance: Arms: *or on a triple mountain a tree vert*, with initials 'L. B.';
belonged to Hieronymus Guilelmus Ebner; sale of his library, Nuremberg,
1813, lot 384; Count Louis Aponyi, sale, London, 1892, lot 1016; bought
for the Lenox collection in 1892.

Exhibition: New York 1975, no. 204.

Bibliography: Raidelius 1737; Fischer 1913; Fischer 1932, pp. 215, 340-2
(L. 16); Stevenson and Fischer 1932 (all maps reproduced); De Ricci 1935-
40, II, p. 1330; E. Rosenthal 1944, pp. 135-47; C. E. Armstrong 1962.

J. J. G. A.

55

Ptolemy, *Geography*

296 fols. 267 x 145 mm. On parchment [New York only]

Written in Naples, c. 1490, with illumination attributed to Cristoforo Maiorana and others

PARIS, BIBLIOTHÈQUE NATIONALE, latin 10764

The text is prefaced by a miniature (folio 1v) showing a female figure seen as if through a rectangular window frame floating above a land-scape. She holds an astrolabe and must represent Geography. On folio 1*bis* the title is written and then on folio 2 Ptolemy is represented stand-ing in a landscape under an arch. There are five line initials – 'E', 'T', 'P' and 'Q' – for Books III, IV, V and VIII (folios 69v, 85v, 130v and 207), with candelabra borders in typical Neapolitan style.

The usual set of maps in the edition of Donnus Nicolaus Germanus (see cat. 54) follows the text: folios 234v-235, the world map, then the ten maps for Europe, folios 238v-257, twelve for India, folios 260v-283, and four for Africa, folios 286v-293, are painted on verso to recto with blank openings between. According to Fischer (1932) they copy the maps in one or another of the two editions of Ptolemy printed in Rome, either that of 1478 or that of 1490. On the last of the maps, folios 292v-293, is the inscription: '*Ex officina Bernardi Ebolite. In anno 1490*'. This is the cartographer Bernardo Silvano d'Eboli, who pub-lished in Venice in 1511 a printed edition of Ptolemy dedicated to the same patron for whom the present manuscript was made, Andrea Matteo III Acquaviva, Duke of Atri (1458-1529). Acquaviva had had a humanist education and was a major collector of illuminated manu-scripts (see cat. 53). His arms and those of his wife, Isabella Piccolo-mini, occur frequently throughout the manuscript.

In addition this copy contains allegorical and symbolic representa-tions of the three Continents inserted at the relevant places. For Europe, folios 236v-237, the opening shows on the verso Europa seat-ed on the bull into which Jupiter had transformed himself to carry her off, with Neptune, the sea god, holding his trident to the left and hip-pocamps blowing shells and dolphins all around. The latter recall a famous engraving by Andrea Mantegna, which was also copied by Dürer in 1494. On the recto Europa's female companions gather flow-ers on the seashore. There is an architectural frame with flanking trophies of arms. For India, folios 258v-259, on the verso a woman rides on a crocodile and on the recto is a figure of the River Indus ('*Indus fluvius*'). Again there is an architectural frame. Lastly, for Africa, on folios 284v-285, a woman (Medusa?) is seated on an elephant grasping a bunch of snakes with a palm tree beside her, and on the recto are figures of a nude Hercules supporting a Zodiac-encir-cled globe. This alludes to the Labour which he undertook for the giant Atlas at the columns of Hercules (the Straits of Gibraltar). Above in the sky Perseus flies with his winged sandals, holding the head of the Gorgon, Medusa. An architectural frame encloses the whole, again with trophies hanging on each side. On the columns to left and right are the initials 'AM' and 'MS'.

The illumination can be attributed to at least three hands, the first on folios 1v and 2 being identifiable as Cristoforo Maiorana, who is documented in the Naples royal accounts between 1480 and 1492 (see cats 40, 53). The second illuminator painted the three frontispieces of the Continents and some of the maps, e. g. folios 290v-291, and the third worked on the remaining maps, e. g. folios 238v-239. The manu-script is copied by a skilled humanistic scribe, perhaps to be identified with Jacobus Laurentianus (or de San Laurentio), who was active in Naples and who signed four manuscripts, of which two were for King

55 folio 258v

Ferdinand and one for Iñigo d'Avalos (see Derolez 1984, I, no. 166; De Marinis 1947-52, III, pls 49, 309A; Albinia de la Mare, written com-munication).

Provenance: Andrea Matteo III Acquaviva, Duke of Atri (1458-1529), with his arms, folios 2, etc. and those of his wife, Isabella Piccolomini, whom he married in 1480, folio 276v, etc.; King François I of France (r. 1515-1547).

Exhibition: Paris 1984, no. 156, illus.

Bibliography: Fischer 1932, I, pp. 215, 251, 342-3, II, p. X, pl. [L. 16]; De Marinis 1956; Samaran and Marichal, 1974, p. 203, pl. CCVII; Bianca 1985.

<div align="right">J. J. G. A.</div>

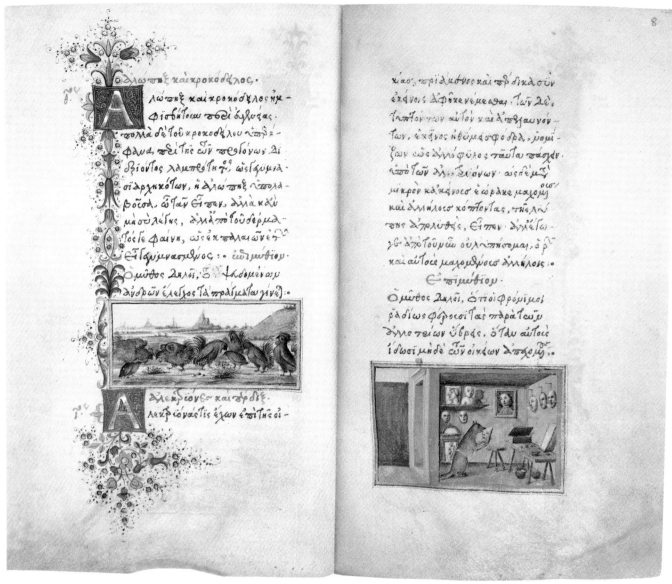

56 folios 7v, 8r

56

Aesop, *Fables*, in Greek

75 fols. 200 x 120 mm. On parchment [New York only]

*Illumination attributed to Gherardo di Giovanni di Miniato,
Florence, late 15th century*

NEW YORK, NEW YORK PUBLIC LIBRARY, ASTOR, LENOX AND TILDEN
FOUNDATIONS, Spencer Collection, MS 50

The Greek text of the *Fables* traditionally attributed to Aesop was
transmitted to the West from Byzantium in a version by Maximus
Planudes (*d.* 1310). The present text is copied from an edition printed in
Milan, *c.* 1480, by Bono Accursio. The identity of the scribe is so far
unknown, but the 131 miniatures are certainly Florentine in style. They
are framed by a plain gold band, but they are not regular in shape, fill-
ing irregular spaces of the script and often extending into the margins
on both sides. They are accompanied by gold initials and one sided
borders. On folio 1 is a three sided border with gold acanthus on red

and on blue with a half figure in a roundel below, presumably the
author, and above deer in a landscape. The manuscript has been dam-
aged by damp at some time, causing offsets on many pages and wrink-
ling of the parchment, particularly on the lower part of the page and on
later pages in the manuscript.

The miniatures have been attributed to the Florentine artist and
illuminator Gherardo di Giovanni di Miniato (*d.* 1497; see cats 13, 76)
by Everett Fahy (1989). They are certainly of very high quality, using
a sophisticated range of poses and figure types as well as a variety of
settings both urban and landscape. The landscapes are remarkable,
particularly in the sense of distance and in the painting of water with
subtle reflections. However, the style is to some extent a generic one
in Florentine miniature painting of the period, and the possibility that
this is an associate working in a similar style to Gherardo cannot be
entirely ruled out.

The miniatures represent the fables as contemporary events with
many images of Florentine shops, private houses, and social events.
There are several references to artistic practices: for example the minia-
ture of the fox and the mask (moral: too often a handsome face masks
an empty head!) seems to show a contemporary artist's workshop,

even though the fable says the fox entered an actor's room. Objects in the room include a carved bust, a relief sculpture of the Virgin and Child and a portrait painting, folio 8, in addition to the actor's masks. On folio 7v is a fable about a partridge placed among roosters who persecuted it (moral: often people are as cruel to each other as they are to strangers). This scene show the artist's skill in landscape.

The beginning of the manuscript is incomplete, and it is possible that a coat of arms of the original owner is missing. It is known that Piero de' Medici, son of Lorenzo, owned a Greek Aesop with miniatures, which is listed in an inventory taken after he fled from Florence in 1495. The inclusion of the Medici arms on a well-head in the miniature on folio 68 may be significant, therefore, even though it cannot be taken as conclusive proof of Piero's ownership. Piero died in 1503.

Provenance: Rev. Theodore Williams; his sale, London, 1827; Sir Thomas Phillipps, MS 23609; sold with residue of his library, Sotheby's, London, 1 July 1946, lot 26a.

Exhibition: Baltimore 1949, no. 191, pl. LXXV.

Bibliography: Bond and Faye 1962, p. 333; Fahy 1989 (all miniatures reproduced in colour).

J. J. G. A.

57

Tacuinum Sanitatis

38 fols. 265 x 175 mm. On parchment　　　　　　[London only]

Written and illuminated in Venice, c. 1480

VIENNA, ÖSTERREICHISCHE NATIONALBIBLIOTHEK, Cod. 2396

The text originates with a health handbook written by an Arabic physician, Ibn Botlân, who died *c.* 1064 in Antioch. The Latin translation was made for King Manfred of Sicily between 1254 and 1266. A number of richly illustrated 14th-century copies survive, but the relationship of the present manuscript to these and also to those of the 15th century remains to be established. The page lay-out is different here, with four miniatures to a page, rather than one as in the earlier manuscripts. The illumination is unfinished: to folio 16v the miniatures are coloured with pale wash; then a few are painted with some colour; only ink drawings exist for the rest of the manuscript. The illumination is certainly Venetian and has been argued to be by Leonardo Bellini (see cat. 27) by Ulrike Bauer-Eberhardt (1989), but even as a very late work the attribution does not appear convincing. A title-page on folio 1 was added in the 16th century.

The text lists benefits and disadvantages of varying seasons, places, foods, humours, etc., illustrated with scenes which show aspects of Italian city and country life and social customs. For example on folios 34v–35 summer and winter rooms are shown as small houses with wood being carried in for the latter. In the scene of sleep, a couple lie in bed with a baby being rocked in a cot beside them, and for vigils a scholar works at his desk in his study. The text explains that sleep is best if you get eight hours in the middle part of the night, but is damaging when you have too much because it dehydrates you. Vigils help you earn your living, but in excess lead to exhaustion, for which sleep is the cure. On the same opening are depictions of shame (*verecundia*), a group of men on the left with two women who hang their heads, and of vomit, a boy being sick while a woman holds his head.

Provenance: Prince Eugene of Savoy (*d.* 1736); to the Hapsburg Hofbibliothek, Vienna, by 1737–8.

Exhibitions: Vienna 1969, no. 78; Vienna 1975, no. 264; Vienna 1986, no. 105, fig. 30.

Bibliography: Hermann 1931, no. 139, pp. 200ff.; Rössl and Konrad 1984; Bauer-Eberhardt 1989, p. 81, no. Be. 8, figs 25, 26.

J. J. G. A.

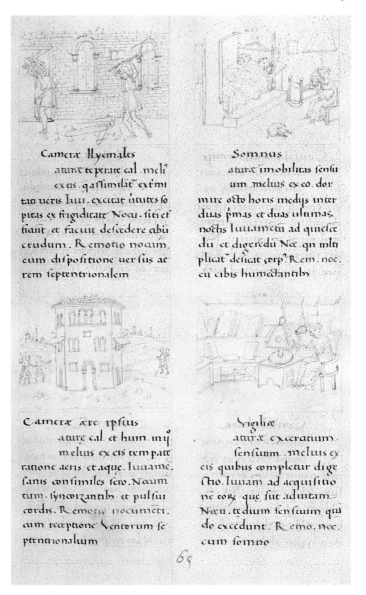

57　folio 35r

58

Dante Alighieri, *Divine Comedy*

297 fols. 378 x 241 mm. On parchment　　　　　　[London only]

Written by Matteo Contugi of Volterra in Urbino, 1477-8, with illumination attributed to Guglielmo Giraldi and collaborators in Ferrara, possibly continued in Urbino, 1478-82; illumination completed by an anonymous artist in the early 17th century

VATICAN, BIBLIOTECA APOSTOLICA VATICANA, Urb. lat. 365

This copy of the *Divine Comedy* was made for Federigo da Montefeltro, Duke of Urbino, whose coat of arms, together with various papal insigniae and the English Order of the Garter, conferred on the Duke in 1474, appears on folios 1 and 97. The manuscript is signed by Matteo Contugi of Volterra, a skilled scribe who worked first for the Gonzaga in Mantua, then for Federigo da Montefeltro, and later moved to Ferrara after the Duke's death. Each canto of the text is introduced by a large miniature illustrating important scenes from Dante's poem. However, the original illumination ends on folio 170 and was later completed by an early 17th-century artist.

nel mondo fufo anchora io tene cangi
S e quella con chio parlo nonfi feccha,

58 folio 89v

A letter from Contugi dated 1478 informs us that the manuscript, for the illumination of which a budget of 130 ducats had been set aside, was in Ferrara waiting to be decorated. The main hand can certainly be identified as Guglielmo Giraldi from Ferrara, whose earliest dated work is the Aulus Gellius of 1448 (Milan, Biblioteca Ambrosiana, MS S. P. 10/28). His interpretation of Dante's poem is highly imaginative. The meetings of Dante and Virgil with the dead souls in Hell and Purgatory take place in bare, rocky, surreal landscapes, to which the painter gives depth by combining rigorous linear perspective with a bird's-eye view from above. Giraldi captures the sullen sky of Dante's Inferno perfectly in his miniatures, showing it as colourless, lit only by the flames that flash out of the rocks. The landscape here for the first time matches the action of the poem. The damned, naked and desperate like Paolo and Francesca, folio 14v, or Count Ugolino, folio 89v, are highly dramatic and Giraldi graphically represents Dante's vivid descriptions of their torments.

Giraldi here completes the stylistic journey he began in the Sanudo Virgil of 1458 (cat. 42), the Gonzaga Plautus (cat. 21), and the Bible in the Certosa of Ferrara dating from 1470 (Museo Civico di Palazzo Schifanoia). Besides the influence of the late work of Cosimo Tura, there are reminiscences of the rocky landscapes of Francesco del Cossa and possibly also of Piero della Francesca's feeling for atmosphere. Giraldi participated only as far as folio 72, towards the end of the *Inferno*. He collaborates with a successor for a gathering, and then this second gifted artist, very similar to Giraldi himself, takes over for two gatherings, folios 80v-100, including the opening folio of *Purgatorio*. He seems to be identifiable as Alessandro Leoni, nephew of Giraldi,

who was also an illuminator. A third artist works for two gatherings, folios 111-120, then another, folios 131-140, and then two more, folios 151-170. This artist has been suggested to be Franco dei Russi, a Ferrarese miniaturist who worked on the Bible of Borso d'Este and in the Veneto and later, having transferred to the court in Urbino, decorated a copy of the *Epistles* of Libanius (Biblioteca Apostolica Vaticana, Urb. lat. 333). This is doubtful, however, and the artist is more likely to be another of Giraldi's collaborators, working independently. A fourth artist worked on two gatherings, folios 121-130 and 141-150, in a manner which is again very similar to Giraldi's but less vivid.

It is probable that the *Divine Comedy* was at least begun in Ferrara; there is documentary evidence, however, showing that Giraldi was in Urbino in 1480 working in the Duke's library. The illumination of the Dante may have been interrupted by the death of Federigo in 1482. Giraldi's most significant works done in Urbino are the magnificent folio inserted in a Florentine Virgil (Biblioteca Apostolica Vaticana, Urb. lat. 350), the Evangelist portraits in a Gospels (Urb. lat. 10) and two miniatures of St Paul and King David enthroned, inserted in 13th-century manuscripts (Urb. lat. 18 [fig. 22] and Urb. lat. 19).

Provenance: Federigo da Montefeltro, Duke of Urbino (r. 1444-1482); in the Biblioteca Apostolica Vaticana from 1658.

Exhibition: Vatican 1950, no. 42.

Bibliography: Hermanin 1900, pp. 341-73; Hermann 1900, pp. 178-79; Bonicatti 1957, pp. 195-210; Michelini Tocci 1965 pp. 3-145; Brieger, Meiss and Singleton 1969 (with earlier literature); Alexander 1977a, pp. 33, 84-90, pls 23-6.

G. M. C.

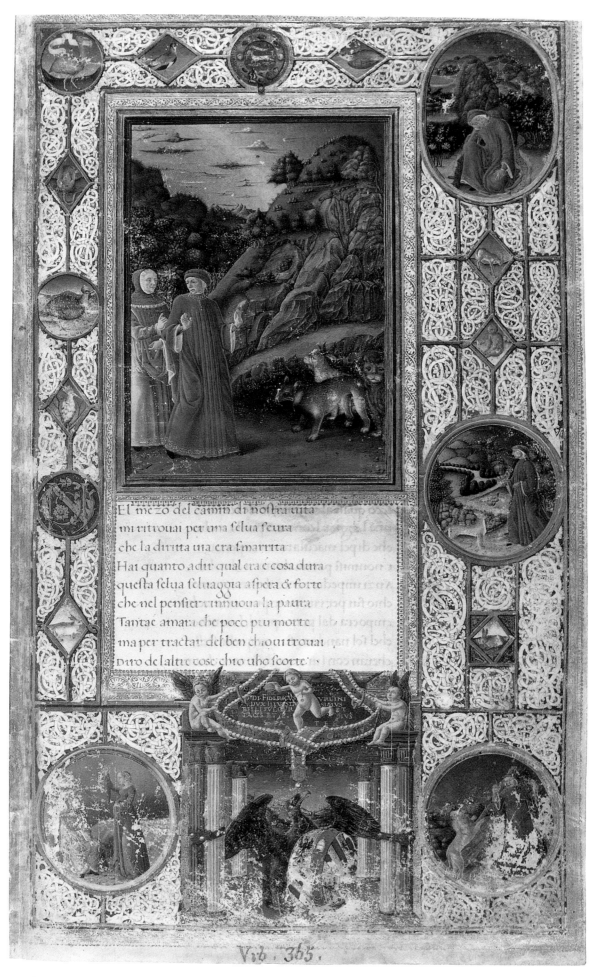

El mezo del camin di nostra uita
mi ritrouai per una selua scura
che la diritta uia era smarrita
Hai quanto adir qual era e cosa dura
questa selua seluaggia aspera & forte
che nel pensier rinnoua la paura
Tantae amara che poco piu morte
ma per tractar del ben chioui trouai
puro de laltre cose chio uho scorte

Vrb. 365.

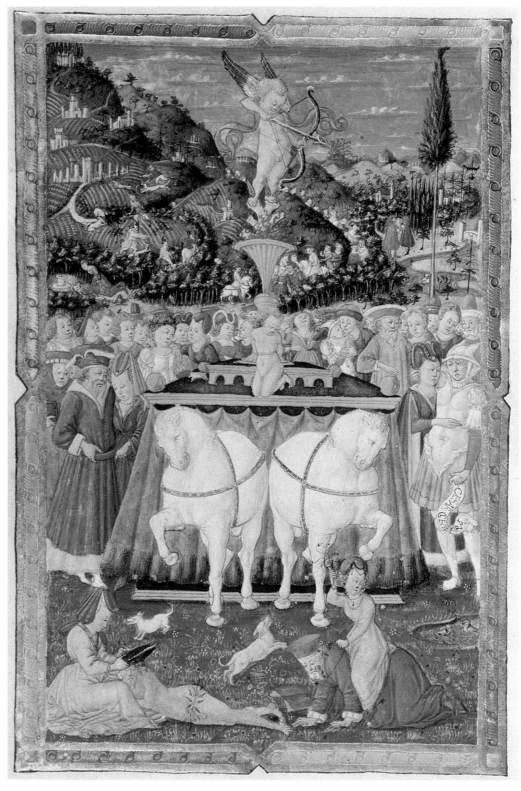

59 folio 11v

59

Petrarch, *Trionfi, Canzoniere*, in Italian

243 fols. 270 × 170 mm. On parchment [London only]

Script attributed to Ser Gherardo del Ciriagio, Florence, dated 1457,
with illumination attributed to Francesco d'Antonio del Chierico

PARIS, BIBLIOTHÈQUE NATIONALE, ital. 545

The vernacular works of Francesco Petrarca (1304-1374), the *Trionfi* (*Triumphs*) and the *Canzoniere* (*Sonnets*), were extremely popular in the 15th century and were very often combined as here into a single small codex. The seven *Trionfi* were usually each prefaced by a miniature. The *Canzoniere* were not usually illustrated, though there are a few exceptions (see cat. 71). *Canzoniere* manuscripts were, however, occasionally prefaced by an author portrait, sometimes showing Petrarch accompanied by Laura, his beloved (see cat. 71).

This copy is prefaced by an index of the poems, introduced by a white vine-stem initial 'A' on folio 3. Other white vine-stem initials

VELLA.LEGGIADRA
ET.GLORIOSA.DŌNA
CHÉ.OGGI.VN.NVDO.
SPIRTO.ET.POCA.TERA
ET.FV.GIA.DI.V.ALOR
ALTA.COLONNA.Q

Tornaua con honor da la sua guerra.
Allegra, hauend uinto il gran nimico,
che con suo ingegni tuttol mondo atterra;

occur on folios 15, 18, 21, 34, 37 and 42v. The first of the *Trionfi*, that of Love, folio 11v, shows the winged, blindfold Cupid with bow and arrows, on a chariot drawn by two white horses. The chariot approaches the viewer head-on, as is usual in Florentine iconography, as opposed to the profile procession shown in the North (see cat. 71). Around the chariot are the prisoners of Love, led on the right by Caesar and Cleopatra, identified by a scroll, and on the left by an older couple, perhaps Solomon and the Queen of Sheba. On the ground in front Delilah cuts off Samson's hair and Phyllis mounts Aristotle; thus the strong man and the wise man are both subdued. In the landscape behind, the story of Pyramus and Thisbe is shown, as well as a hunting scene and two male figures. All the miniatures have similar patterned frames, often with spiral ribbon ornament.

On the recto, folio 12, a white vine-stem border surrounds the page, and in an initial 'N' Petrarch is shown in his study. To the right a female figure, perhaps Laura, looks towards him. A medallion to the right repeats the scene of the Triumph. The coat of arms below is very thoroughly erased. It is flanked by reclining figures of a nude woman and a clothed man, accompanied by putti, a theme also found on marriage cassoni, as Annarosa Garzelli (1977) has noted. The vine-scroll is inhabited by putti (one of whom excretes gold coins), animals, birds and butterflies. In the centre above an eagle stoops on a hare.

Over Love triumphs Chastity, who is shown on folio 25v as a female figure carrying a banner on a chariot drawn by two unicorns. The chaste women who surround the chariot are led by Lucretia, identified by a scroll. Opposite on folio 26 is a white vine-stem initial 'Q' and border.

On folio 30v Death triumphs over Chastity, the former a skeleton with scythe on a profile chariot drawn by a pair of black bulls. The dead lying around include a Pope, a Cardinal, rulers and fashionably dressed women. In the landscape behind men flee, and in the sky above two angels and two devils carry away the souls of the departed. On folio 31 is a white vine-stem initial 'Q' and border.

Over Death triumphs Fame, folio 40, a seated female with trumpet and globe on a frontal chariot drawn again by two white horses. Among the bound figures are Hercules with his club to the left, and, to the right, Samson with the jawbone of an ass and a column. On folio 40v is a white vine-stem initial 'D' and border.

On folio 48 is the Triumph of Time, represented as a winged old man with crutch on a chariot drawn by two deer. His companions, including a group of three young boys, are unidentified. On folio 48v is a white vine-stem initial 'N' and border. Lastly comes the Triumph of Eternity, folio 51, a representation of the Trinity as the Throne of Grace, God the Father holding the crucified Christ with the Dove between them and surrounded by an aureole of angels. The cross is placed on a globe upheld by two haloed figures, prophets (?), and the symbols of the Four Evangelists, the angel of Matthew larger in the centre, the eagle of John shown in rear view like a falcon perched on a book.

The *Canzoniere* part of the manuscript starts on folio 54 with an initial 'V' with a profile portrait of Petrarch and a three sided white vine-stem border. Sonnets by Dante are introduced on folio 191 by a white vine-stem initial 'A' and partial white vine-stem border. On folio 243v a colophon gives the date 19 February 1456 (Florentine style), but the owner's names have been unfortunately heavily erased. The script has been attributed by Albinia de la Mare (in Garzelli and de la Mare 1985) to the prolific Ser Gherardo del Ciriagio, a distinguished Florentine notary, and the illumination has been attributed by Annarosa Garzelli (1977) to Francesco d'Antonio del Chierico, for whom see cat. 50.

Provenance: Offered to Pope Clement XI (Albani; r. 1700-1721) by M. Vidman, Governor of Fermo, July 1708, inscription on folio 2; probably acquired by the Bibliothèque nationale in 1798 with the manuscripts of Pope Pius VI.

Exhibition: Paris 1984, no. 100, illus.

Bibliography: Essling and Müntz 1902, pp. 117, 130, 153, 160-1; Van Moé 1931, pp. 3-15; Pellegrin 1966, pp. 145-7; Garzelli 1977, p. 86 n. 7; Garzelli and de la Mare 1985, pp. 119-21, 497, no. 42. figs 261-9.

J. J. G. A.

60

Petrarch, *Canzoniere*, *Trionfi*, in Italian

193 fols. 358 x 231 mm. On parchment. Blind stamped and gold tooled leather binding, central medallions missing, four remaining metal clasps, perhaps Spanish, early 16th century

Written and signed in Urbino c. 1474-82, by Matteo Contugi of Volterra, with illumination attributed to Bartolomeo della Gatta

MADRID, BIBLIOTECA NACIONAL, MS Vit. 22-1

This copy of Petrarch's vernacular poems, the *Sonnets* and *Triumphs*, originally bore the arms of Federigo da Montefeltro, Duke of Urbino (r. 1448-1482). They have been overpainted in the border on folio 11 with those of a later owner, Gonzalez Ruiz de Figueroa, Spanish Ambassador to Venice in 1503. Federigo's *imprese*, however, the crane with the motto 'Ich han vordait en grot ysern', the ermine with the motto 'Non mai' and the brush, here hanging around the necks of the putti, are still visible in this and other borders. The border on folio 11, the beginning of the *Sonnets*, is composed of candelabra forms and foliage scroll with birds, apes and putti. There is an initial 'V' with a half-length portrait of Petrarch and a foliage scroll in blue, pink and green on black with gold discs. On the verso opposite, folio 10v, there is a wreath frontispiece with flowers enclosing the title. There are small initials in gold on blue, green and red for each sonnet. They, like the wreath frontispiece, are typically Florentine in style. On folio 147, the initial 'V', '*Vergine bella*', has white vine-stem decoration, also Florentine in style.

The *Sonnets* end on folio 150, folio 150v is blank, and the text of the *Trionfi* begins on folio 151 with the Triumph of Love. A catafalque is pulled by four white horses; on it a group of bound female lovers surround a central column to which a group of male lovers, a king in their centre, are bound. On the top of the column Amor shoots an arrow from his bow. He stands on one foot on a flaming pyre in which are three putto heads. Six flaming torches are also attached to the top of the column. The scene is surrounded by a ribbon frame, and there is a painted flower border with Federigo's emblems in the corners and a white vine-stem initial 'N'.

The Triumph of Chastity, folio 162v, shows two unicorns pulling another catafalque. This time Amor is bound to a column while Chastity, a white-robed maiden with shield and palm, stands beside him. Five winged putti holding laurel boughs stand on candelabra placed in a circle around the central column. The scene is framed by two large gold candelabra. There is an initial 'Q' composed of gold plant scroll. The foliage border above has been drawn in but not painted, and may be a later addition, made in Venice to judge from its style. In the centre below are the initials 'F. D.' (*Federicus Dux*) surrounded by the Garter, which was awarded to Federigo by Edward IV of England in 1474.

On folio 166v, the Triumph of Death is shown as another catafalque, this time drawn by two black oxen who are about to trample three prone figures, a woman, a youth and an older man. On the catafalque figures are enthroned on two levels. On the higher level sit a Cardinal, an Emperor, two Bishops and a King, while on the lower are three scholars, an armed soldier, four women of various ages, one of whom holds a baby, another of whom is a nun, and a boy. Death wields his scythe above. The scene is again framed with gold candelabra which here seem to support a damask canopy. The initial 'Q' is made of foliage on black.

On folio 176, the Triumph of Fame shows another catafalque, drawn this time by two white horses with rich woven caparisons. A circle of famous women ranged around below include Judith in the centre holding the head of Holofernes. Above them another circle of famous men includes a saint with book in the centre, a King and soldiers on the left, and scholars and philosophers on the right. The figure of Fame is enthroned at the top, holding a sceptre, with two trumpets extending on either side of her head. The scene is framed again by candelabra and there is an initial 'D' with foliage. There are smaller three line initials on folio 169v, 'L', folio 173, 'N', folio 178v, 'P', and folio 181, 'I'. Folios

with the miniatures for Time and for Eternity and sections of the text are missing between folios 182–183 and 184–185.

The colophon of the scribe is on folio 187: '*Manu Matthaei Domini Herculani de Wulterris*'. Matteo Contugi wrote a number of manuscripts for Federigo da Montefeltro from the 1470s to 1480s, including his Gospel Book (Vatican, Biblioteca Apostolica Vaticana, Urb. lat. 10; Cologne 1992, no. 70). Folios 187v and 188v–189 are blank.

Earlier the name of Francesco di Giorgio was proposed for the artist by Venturi (1923, 1925a; see also Salmi 1957). More recently the miniatures have been attributed to Bartolomeo della Gatta by M. G. Ciardi Dupré dal Poggetto (1992), followed by Luciano Bellosi (1993). Pietro d'Antonio de Dei, a Florentine who became a Camaldulese monk at Arezzo under the name of Don Bartolomeo 'della Gatta', is described by Vasari as miniaturist, painter and architect. However, there are no documented works, and attribution proceeds from paintings ascribed by Vasari which still survive. The application of thick paint in these miniatures may indeed suggest an artist not normally practising as an illuminator, but until a securely documented work can be found the identification must remain plausible but unproven. Though at first sight somewhat different in style, the illumination on folio 11 seems to be by the same hand, particularly if the putti are compared.

Provenance: Federigo da Montefeltro, Duke of Urbino (*r.* 1448–1482), with his emblems, mottoes and the Order of the Garter granted him in 1474; formerly no. 552 in the Urbino library; Bartolomeo Chalepio of Venice, who gave the manuscript to the Spanish Ambassador, Gonzales Ruiz de Figueroa, in 1503, at the time of the Peace of Venice, inscription on folio i, and on folio 190 a poem of congratulation on the Spanish victory by Chalepio; arms of Figueroa, Mendoza and Enriquez inserted on folio 11; Don Lorenzo de Figueroa y Fonseca, 1530, inscription on folio i; Don Sancho Fonseca, 1571, inscription on folio i v.

Exhibitions: Barcelona 1988; Urbino 1992, pp. 127, 167–8, no. 31, figs 10, 11.

Bibliography: Paz y Mélia 1902, pp. 17–20; Essling and Müntz 1902, pp. 164–5, 270; Venturi 1923, p. 228; Venturi 1925a, p. 191; Bordona 1933, I, pp. 387–8, no. 942, figs 330–1; Battisti 1955, pp. 21–6, figs 2, 4–6; Salmi 1957, p. 55, fig. 68; Salmi 1973–5, p. 170; Via 1986, pp. 50–1, figs 10–12; Ciardi Dupré dal Poggetto 1992, pp. 326–7; Bellosi 1993, p. 75, pl. 91.

J. J. G. A.

61 folios 2v, 3r

61

Flavio Biondo, *Decades*

130 fols. 250 x 154 mm. On parchment

Written in Naples, 1494, by Giovanmarco Cinico, with illumination attributed to Giovanni Todeschino

MUNICH, BAYERISCHE STAATSBIBLIOTHEK, Clm 11324

Flavio Biondo (1392–1463) was attached to the papal court beginning in 1433. He wrote the *Decades*, a survey of European history from the 5th to the 15th centuries, between 1437 and 1442. In the present copy the *Prohemium* to '*Alfonso II Neapolitanorum regi*' is introduced by a faceted initial 'N' in blue on a red ground decorated with gold rinceaux. There is a border in the left margin with candelabra motifs. The text opens on folio 2v with an architectural frame for the title, which is written on a circular plaque supported by putti. Above this a seated female personifies Rome as an armed warrior, with a triumphal procession in the landscape in the background. At the top of the frame is the motto '*Concordia parvae res crescunt*' ('small things grow through peace'). On folio 3 the decline of the city is shown below the inscription '*Vis concilii expers mole sua corruit*' ('lacking the strength of counsel she falls through her own size'). Rome now sits with broken arms and armour with the Tiber and the city visible behind her. Recognisable are the Column of Trajan, the Pantheon and a triumphal arch, probably that of Constantine. The artist has made the text look as if written on a scroll tied by cords to the architecture. There is a faceted initial 'F' and below are the arms of the Aragonese Kings of Naples. There are initials with simple candelabrum borders to each of the ten books of the two *Decades*: Decade 1, folio 8, 'P'; folio 10, 'T'; folio 12v, 'C'; folio 14v, 'I'; folio 16, 'S'; folio 19, 'D'; folio 22, 'A'; folio 24, 'P'; folio 32v, 'I'; Decade 2, folio 36v, 'P'; folio 41v,'P'; folio 47v, 'O'; folio 58v, 'N'; folio 66v, 'B'; folio 75v, 'A'; folio 83, 'A'; folio 92, 'E'; folio 102v, 'P'; folio 112v, 'H'.

The scribe signs with the date 1494: '*Ioannes M. Parmensis Cynicus coclea Christi Alfonsi II Neapolitanorum regis indignus assecla indefessa dextera primo regnorum suorum anno in castello novo tranquille transcripsit*'. Giovanmarco Cinico of Parma is mentioned at Naples between 1458 and 1498 and wrote many manuscripts for the Royal Library. He says he was a pupil of the noted Florentine scribe Messer Piero Strozzi (cats 68, 69, 76). His dated manuscripts extend from 1463 to 1494 (cat. 10). The illumination is by the artist of the Berlin Horace (cat. 45) and the Valencia Pliny (cat. 106). The frames of the inserted miniatures in the Hours of Frederick III (Paris, Bibliothèque nationale, latin 10532) are also by him, as François Avril (in Paris 1984, no. 158) has recognised. It seems likely that he moved to France with King Frederick after the latter's deposition in 1501. This would explain his collaboration on the King's Book of Hours with Jean Bourdichon of Tours (Nicole Reynaud, in Paris 1993, no. 163).

The illuminator's style depends on that of the Paduan-Venetian artists, the Master of the London Pliny (cats 28, 46, 90–2) and Gaspare da Padova (cats 38–41, 73–5), working in Rome in the 1480s for curial patrons, including Cardinal Giovanni d'Aragona, Alfonso II's brother (cats 40, 41, 46). After the Cardinal's death in 1485, his manuscripts seem to have passed to his father, King Ferdinand I of Naples, and no doubt became accessible to Neapolitan illuminators. De Marinis (1947–52) suggested the illuminator be identified with Giovanni Todeschino, praised as an outstanding illuminator by the humanist Pietro Summonte, who says that he imitated works by 'Gasparo Romano'. A single leaf of unknown origin in the British Library (Additional MS 46365A) is attributable to Gaspare da Padova and shows a figure, who is labelled '*Urbs Roma*', similarly in profile and holding a winged Victory. This could well have been the model for the representation of Rome in the present manuscript, as Ulrike Bauer-Eberhardt (1989) has suggested.

Giovanni Todeschino seems to have been the son of the prolific scribe and illuminator, Joachinus de Gigantibus of Rothenburg, hence his appellation 'Todeschino', the German. His father, Gioacchino, worked first probably in Florence, then in Rome and finally in Naples, where he is documented from 1471 to 1480. Giovanni is referred to in payments in the Naples royal accounts between 1487 and 1492 as '*miniatore del senyor Re*'. According to Summonte he was born in Lombardy and not only excelled in his art but led a saintly life.

Provenance: King Alfonso II of Naples (*d.* 1495); De Marinis 1947–52, II, inventories E, no. 1500 (Blois, 1518) and F, nos 514–6 (Fontainebleau, 1544).

Bibliography: De Marinis 1947–52, I, pp. 42, 46, 50, 102, 138 n. 8, 156–7, II, p. 31, pl. 33; Ruysschaert 1969, p. 271; Bauer-Eberhardt 1989, p. 61, fig. 13; Toscano 1993, p. 280.

J. J. G. A.

62

Poggio Bracciolini, Collected Works

272 fols. 352 x 239 mm. On parchment [London only]

Script attributed to Nicolaus Riccius Spinosus, Florence, late 1450s (after 1455), with illumination attributed to Francesco d'Antonio del Chierico

VATICAN, BIBLIOTECA APOSTOLICA VATICANA, Urb. lat. 224

This manuscript principally contains a collection of works by the Florentine humanist, Poggio Bracciolini (1380–1459), beginning with the *De varietate fortunae*, which he completed *c.* 1450. In it he describes the archaeological sites of the city of Rome and recalls its former glories. There is a title written in lines of gold and coloured capitals on folio 1v, and a white vine-stem border on folio 2 for the beginning of Poggio's Preface. The border contains putti, animals, and birds on pink, blue and green grounds, with gold balls. Below in the centre are the added arms of Federigo da Montefeltro with the initials 'F. C.' below the border. The initials are apparently written by Bartolomeo Sanvito (Garzelli and de la Mare 1985; de la Mare 1986; for Sanvito, see also cats 26, 38, 75). Medallions contain from top left, clockwise: an angel, the Virgin and Child, another angel, and then figures of the Four Virtues – Temperance, pouring water from one cup to another, Fortitude, with shield and club, Prudence with mirror and a snake, and Justice, with sword and globe (for the Virtues, see also cat. 41). In the initial 'M' is a profile portrait of Poggio which seems so realistic it could perhaps have been done from life. There are white vine-stem initials of five to seven lines and smaller gold initials on coloured grounds of two to four lines for the very numerous short texts included in the manuscript.

The illumination has been attributed by Annarosa Garzelli (in Garzelli and de la Mare 1985) to Francesco d'Antonio del Chierico, one of the leading Florentine illuminators of his generation, who was active from *c.* 1452 to his death in 1484 (see also cats 36, 50, 59, 69, 120). Stylistically it belongs to the late 1450s. Albinia de la Mare (1986) has attributed the script to Nicolaus Riccius Spinosus, a very productive Florentine scribe. She conjectures that the manuscript may have been made for Poggio himself before his death in 1459 and could be the manuscript of his works which was sold by his heirs with the help of Vespasiano da Bisticci, the Florentine bookseller, to Federigo da Montefeltro in 1471. The manuscript has headings and corrections by Poggio's son, Jacopo (see Merisalo 1993).

Provenance: Family of Poggio Bracciolini (?); arms of Federigo da Montefeltro (1422–1482), as Count of Urbino, therefore before August 1474, when he became Duke, added on folio 2; bought with the rest of the Urbino library for the Biblioteca Apostolica Vaticana, 1658.

Exhibitions: Vatican 1950, no. 62; Washington 1993, pl. 75

Bibliography: Stornajolo 1902, I, pp. 217–19; D'Ancona 1914, II, no. 666; Garin 1981, p. 386; Garzelli and de la Mare, 1985, pp. 140–1, 520, figs 424–6; de la Mare 1986, p. 94; Garzelli 1986, pp. 115–7, 126, fig. 1; Merisalo 1993, no. 22 and frontispiece.

J. J. G. A.

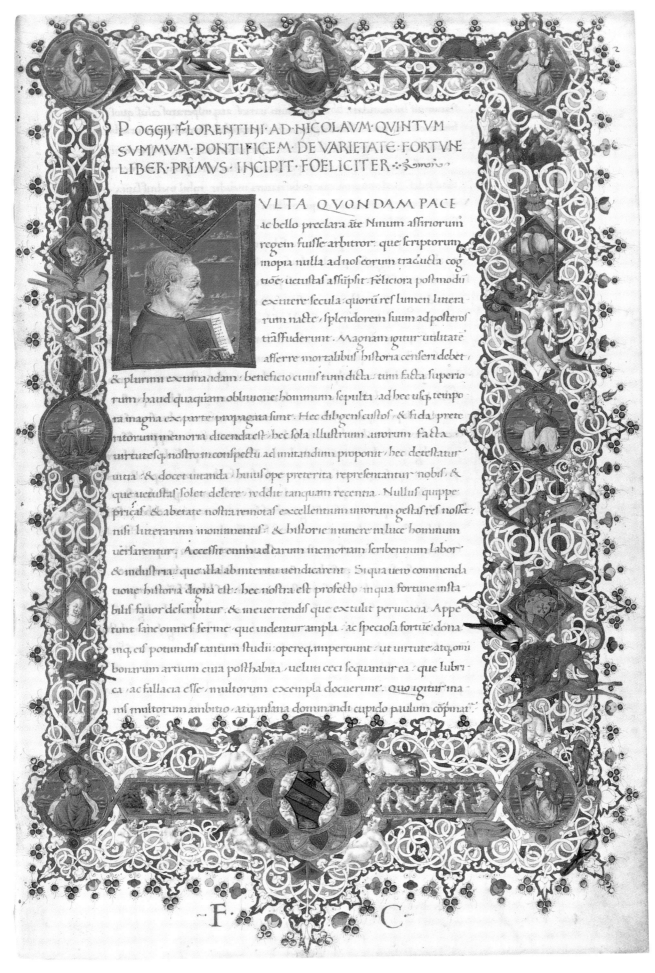

POGGII·FLORENTINI·AD·NICOLAVM·QVINTVM
SVMMVM·PONTIFICEM·DE·VARIETATE·FORTVNE
LIBER·PRIMVS·INCIPIT·FOELICITER·

VLTA QVONDAM PACE
ac bello preclara ate Ninum assiriorum
regem fuisse arbitror que scriptorum
inopia nulla ad nos eorum tracucta cog
tioe uetustas assūpsit. Feliciora postmodū
extitere secula quorū res lumen littera
rum nacte splendorem suum ad posteros
trāssuderunt. Magnam igitur utilitate
afferre mortalibus historia censeri debet
& plurimi extimandam beneficio cuius tum dicta tum facta superio
rum haud quaquam obliuione hominum sepulta ad hec usq tempo
ra magna ex parte propagata sunt. Hec diligens custos & fida prete
ritorum memoria dicenda est hec sola illustrium uirorum facta
uirtutesq nostro in conspectu ad imitandum proponit hec detestatur
uitia & docet uitanda huius ope preterita representantur nobis &
que uetustas solet delere reddit tanquam recentia. Nullus quippe
pricas & abetate nostra remotas excellentium uirorum gestas res nosset
nisi literarum monimentis & historie munere in luce hominum
uersarentur. Accessit enim ad earum memoriam scribentium labor
& industria que illa ab interitu uendicarent. Si qua uero commenda
tione historia digna est hec nostra est profecto in qua fortune insta
bilis fauor describitur & meuertendis que extulit pernicacia. Appe
tunt sane omnes ferme que uidentur ampla ac speciosa fortue dona
inq eis potiundis tantum studii opereq impertiunt ut uirtute atq omni
bonarum artium cura posthabita ueluti ceci sequantur ea que lubri
ca ac fallacia esse multorum exempla docuerunt. Quo igitur ina
nis multorum ambitio atq insana dominandi cupido paulum cōpriŭ

63

Roberto Valturio, *De re militari*

212 fols. 424 × 253 mm. On parchment

Written in Rome or perhaps Naples, c. 1475-80, by Pietro Ursuleo and another scribe

MUNICH, BAYERISCHE STAATSBIBLIOTHEK, Clm 23467

Roberto Valturio (1405-1475) was a humanist at the court of the successful and notorious *condottiere* Sigismondo Malatesta, Lord of Rimini (1417-1468). He was given the honour of burial in one of the external niches of the Tempio Malatestiano in Rimini (see cat. 30). His treatise on the art of war was written in about 1450 and published with a series of 82 woodcut illustrations in Verona in 1472.

There are a considerable number of manuscripts in existence, but their texts and illustrations have not been fully studied, though Rodakiewitz (1940) made a start in grouping them and relating their illustrations to those in the woodcut edition. Her suggestion that the woodcuts were designed by Fra Giocondo da Verona has not been further pursued.

Many of the manuscripts have line drawings which resemble the woodcuts, but the present manuscript is of exceptional richness and has fully painted illustrations as well as frontispieces and initals. It

opens on folio 2, the list of contents, with an architectural frame and an initial 'E' with a soldier standing between two trophies of arms. The centaur shown in the centre below the text, pointing out a pile of arms and armour to a youth, is no doubt Chiron with his pupil, Achilles. At the top of the arch are the arms of the Emperor Maximilian (d. 1519). On folio 5v the text of the dedication to Sigismondo is framed by another architectural frontispiece with two sphinxes below flanking a roundel that shows two horsemen attacking a foot soldier. To the left is a standing female and above her a roundel with a Victory figure. The initial 'C' is accompanied by an armed figure leaning on a shield. There are faceted initials to each book: folio 13v, Book II, 'M'; folio 24, Book III, 'R'; folio 31v, Book IV, 'C' (*recte* 'E'); folio 41v, Book V, 'O', with Pegasus; folio 55, Book VI, 'S'; folio 70v, Book VII, 'H'; folio 84, Book VIII, 'Q'; folio 101, Book IX, 'Q'; folio 113, Book X, 'L'; folio 160, Book XI, 'A'; folio 193, Book XII, 'I'.

The illustrations, the majority of which are in Book X, consist of representations of weapons, war chariots, siege engines, cannons, flags, water floats, bridges and pontoons, and much else. There are 67 subjects and a number of pages are left blank, as in the printed edition, which led Rodakiewitz to conclude that the manuscript is a direct copy of the printed edition. The illustrations also are clearly copied from the woodcuts. They depend on a tradition of military illustration, which extends from the late Roman Empire, the best-known text being the *De rebus bellicis* of the 4th century, to Byzantine and Western medieval texts. The text of the *De rebus bellicis* was rediscovered in an illustrated manuscript of 9th- or 10th-century date in the library of the Cathedral of Speyer, and it was copied for the humanist Bishop of Padua, Pietro Donato, during the Council of Basel in 1436 (Alexander 1979). These illustrations, in one or another of the various copies made of them, are likely to have been among the sources for the illustrations in the Valturio text. Two other relevant texts concerning military equipment, both illustrated, are those by Konrad Kyeser of Eichstätt, written shortly after 1400, and Mariano Taccola of Siena, known in various versions dating from *c.* 1427 to 1449 (for the latter, see Degenhart and Schmitt 1982). The pictorial representation in relation to Valturio's text, however, still awaits a full study.

The original owner of the present manuscript is unknown, since the arms of the Emperor Maximilian must be a later addition. A running title from folios 2v to 165, reads '*jussu Syxti IIII*', which suggests the manuscript was intended for Pope Sixtus IV (*r.* 1471-1484). The script of this part has been attributed by Luisa Banti (1939) to Pietro Ursuleo, who worked as a scribe for Sixtus IV, by whom he was made Bishop of Satriano in 1474. However since Sixtus IV wrote in July 1484, just months before his death, to arrange for a copy of Valturio's text to be made in Rimini, it seems that the present manuscript may never have reached him. Ursuleo had died before that, between 14 April and 6 June 1483. The Munich manuscript, interrupted for whatever reason, was completed by another scribe.

The illumination is by an artist who clearly belonged to the same stylistic current as the illuminators in the Paduan antiquarian tradition, many of whom, for example Gaspare da Padova, were working in Rome by the 1470s for curial patrons, including Sixtus IV (cats 38, 39). The illumination does not seem to be by Gaspare, however, even though on folios 75 and 84 there are initials which recall those in manuscripts illuminated by him and copied by Bartolomeo Sanvito of Padua (cats 73, 74). Such initials were also copied by artists working in Naples, especially by Giovanni Todeschino (see cats 45, 61). For the moment the identity of the illuminator remains unknown.

Provenance: Arms of Austria superimposed on the double-headed Imperial eagle, black on gold, i.e. the Emperor Maximilian of Austria (1459-1519), added on folio 2; acquired from Gasparo Visconti in Italy by Duke Wilhelm V of Bavaria (1579-1597), according to a letter of 31 December 1573 (Hartig 1917).

Exhibition: Munich 1983, no. 62.

Bibliography: Hartwig 1917, p. 344; Banti 1939, p. 389; Rodakiewitz 1940, pp. 15-82, pls 12, 20, 24, 29, 37, 46.

J. J. G. A.

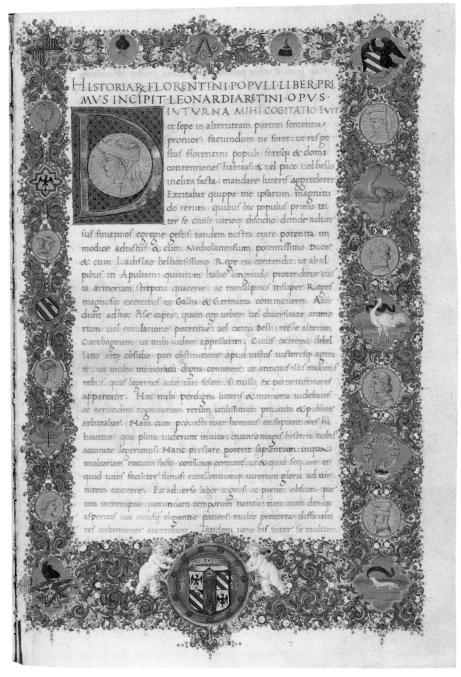

64 folio 2r

64

Leonardo Bruni, *Historia florentini populi*

276 fols. 329 × 223 mm. On parchment [New York only]

Written in Florence, c. 1440-50, with script partly attributable to Ser Gherardo del Ciriagio. The first page rewritten, c. 1475-82, with illumination attributable to Francesco Rosselli

VATICAN, BIBLIOTECA APOSTOLICA VATICANA, Urb. lat. 464

Leonardo Bruni (1370-1444) served as Chancellor of Florence from 1427 to his death, having earlier been secretary to Pope Innocent VII and his successors in Rome from 1405. He was one of the most influential humanists of his generation. He began his *History of Florence* in 1415. It had an enormous success and was translated from Latin into Italian by Donato Acciaiuoli for Federigo da Montefeltro at the suggestion of Vespasiano da Bisticci and printed in 1473. The present copy of the Latin text was begun in Florence *c.* 1440-5; from folio 233 on, the text is the work of Ser Gherardo del Ciriagio, *c.* 1445-50, a well-known scribe, according to Albinia de la Mare (1986). Much later the opening folio of the text was rewritten, perhaps by Antonio Sinibaldi (see cats 31, 32, 41) and illumination was inserted with the arms of Federigo da Montefeltro as Duke of Urbino, thus after August 1474, when Pope Sixtus IV conferred on him the Dukedom of Urbino.

On folio 1v is a circular title-page as in many Florentine manuscripts (see cats 35, 69) and opposite on folio 2 is a flower and foliage border with gold discs in which a series of medallions are inserted, containing the arms and emblems of the Duke, for instance the ostrich and the ermine, and also a series of gold coin type portraits. These show famous 15th-century rulers and *condottieri*; on the left, from top to bottom: Alfonso of Aragon (King Alfonso I of Naples); unidentified; Alessandro Sforza of Pesaro; on the right: Filippo Maria Visconti, Francesco Sforza, Pandolfo Malatesta and Niccolò Piccinino. The busts of Visconti, Malatesta and Piccinino appear to be based on medals by Pisanello (Hill 1930, nos 21, 34, 22), but Francesco Sforza's

bust is closer to a later medal ascribed to Enzola (Hill 1930, no. 281) than to the Pisanello medal (Hill 1930, no. 23). A similar but larger portrait of Leonardo Bruni, of whom no medal appears to be known, is placed inside the initial 'D'. This illumination has been attributed by Annarosa Garzelli (in Garzelli and de la Mare 1985, p. 183) to Francesco Rosselli with the collaboration of the Master of the Medici Iliad. Rosselli worked in Florence for the Medici and other important patrons, including Duke Federigo, in the 1470s and 1480s (see cats 31, 32, 35, 48).

There are white vine-stem initials with some flower decoration with birds, butterflies etc. for the twelve books: folio 24v, Book II, 'P'; folio 51v, Book III, 'T'; folio 71v, Book IV, 'I'; folio 101, Book V, 'C'; folio 134 Book VI, 'P'; folio 162, Book VII, 'L'; folio 185v, Book VIII, 'A'; folio 212v, Book IX, 'E'; folio 233, Book X, 'B'; folio 245, Book XI, 'P'; folio 262, Book XII, 'I'. These belong to the original decoration.

Provenance: Federigo da Montefeltro, Duke of Urbino (1422-1482), with his ducal arms, folio 2; bought with the rest of the Urbino library for the Biblioteca Apostolica Vaticana, 1658.

Exhibitions: Vatican 1950, no. 76; Washington 1993, pl. 42.

Bibliography: Stornajolo 1902, I, p. 470; D'Ancona 1914, II, no. 1310; Garzelli and de la Mare 1985, pp. 183, 486, no. 45, 497, no. 45, figs 507, 509-12; de la Mare 1986, p. 86; Garzelli 1986, pp. 121, 130.

<div align="right">J. J. G. A.</div>

65 folio 4r

65

Pietro da Eboli, *De balneis Puteoli*

38 fols. 298 × 217 mm. On parchment. Original blind stamped and gold tooled leather binding, rebacked and remounted [New York only]

Written by Virgilio Ursuleo in Naples in the third quarter of the 15th century, with illumination by an anonymous artist

VALENCIA, BIBLIOTECA GENERAL DE LA UNIVERSIDAD, MS 838 (G. 2396)

Peter of Eboli (*d.* 1220) wrote his poem in hexameters on the medicinal benefits of the different hot springs in the area of Pozzuoli and Baia near Naples in the early 13th century and dedicated it to Emperor Frederick II. The baths had been famous for their curative powers since Antiquity and remained in use into the Renaissance. The poem had a great success and was translated both into Neapolitan dialect and into French. At least twenty manuscripts survive, half of them illustrated. The pictorial transmission has been studied by Michael Kauffmann (1959), who concludes that the full cycle of illustrations of a presentation miniature and scenes of 35 different baths was created for the original text. Kauffmann links the illustrations to the South Italian tradition of illustrated medical texts connected with the University of Salerno, famous for medical studies. He also notes stylistic debts to Byzantine art. One scene, that of the Balneum Trituli at Baia, may be based on an actual surviving Antique image preserved in the bath.

The present manuscript begins with a list of contents, folio 1, followed by the text proper, here erroneously attributed to Arnoldus de Villanova as author, folio 3. A white vine-stem initial 'I' and partial border in the left margin is accompanied by the arms below of Alfonso of Aragon, Duke of Calabria (1448-1495). The full cycle of 35 miniatures (listed by Gutiérrez del Caño 1913) is likely to be a direct copy of a manuscript of the third quarter of the 14th century in the Biblioteca Bodmeriana, Geneva, according to Kauffmann. The miniatures are painted on rectos opposite the texts on the versos, and the latter are always introduced by a four line white vine-stem initial. The miniatures contain lively representations of groups of naked men and women using the baths, with varied figures in the landscapes.

The scribe signs on folio 38: '*Duci inclyto Calabrie Virgilius Ursuleus*'. Virgilio Ursuleo, brother of Pietro Ursuleo, who, it seems, was the copyist of the Munich Valturio (cat. 63), is first documented in 1455 (De Marinis 1947-52, I, pp. 19-20). In 1483 he was imprisoned in Naples and Pope Sixtus IV wrote to King Ferdinand on his behalf. His date of death is not known. De Marinis, followed by Kauffmann, dates the present manuscript to *c.* 1455, thus inferring that the Duke of Calabria is Ferdinand of Aragon, before his accession as King of Naples in 1458. However on the grounds of script and decoration, Ferdinand's son, Alfonso of Aragon, is the more likely owner.

Payments in connection with '*II libres de pergamini*' are recorded in 1471 to the illuminator Cola Rapicano of 11 ducats, 2 terrins, 10 grans for 23 '*banys*' (bagni, baths) at the rate of 2 terrins 10 grans for each '*bany*'. The two manuscripts were then consigned to the binder Baltasar Scarrilla. De Marinis connects this document with the copy of the text which is now Milan (Biblioteca Ambrosiana, MS I.6 inf.) and which has 23 miniatures (De Marinis 1947-52, I, pp. 212-13, pls 13, 68, II, p. 254, doc. 351). The present miniatures are by a rather weak hand, certainly not Cola himself, and so it is unlikely that the present manuscript is the second copy referred to in the document.

Provenance: Arms of Alfonso of Aragon, Duke of Calabria (*b.* 1448), succeeded as King Alfonso II of Naples (*r.* 1494-1495); De Marinis 1947-52, III, inventories B, no. 349, G, no. 601; Cherchi and De Robertis 1990, p. 237, inventory of 1527, no. 208; bequeathed to San Miguel de los Reyes, Valencia, by Ferdinand of Aragon, Prince of Taranto, 1550.

Bibliography: Gutiérrez del Caño 1913, no. 2396; Bordona 1933, II, no. 2112, fig. 726; De Marinis 1947-52, I, pp. 8, 103 n. 5, 148, 161 n. 12, II, p. 18, pls 17-19 (as Valencia MS 869); Kauffmann 1959, pp. 10, 22, 33, 35-7, 42, 49, 72, 82-3, pls 62-6, 102.

<div align="right">J. J. G. A.</div>

'All'antica'

In the first years of the Quattrocento a new form of script, humanistic script, or *'lettera antica'*, as contemporaries called it, was introduced by Niccolò Niccoli and Poggio Bracciolini in Florence. The alphabet of this type of script, which differed in its letter forms from the Gothic alphabet developed from the 12th to the 14th centuries, had been originally invented in the late 8th or early 9th century during the reign of the Emperor Charlemagne. The specific models of the early humanists, however, were Italian manuscripts of the 11th to 12th centuries. Since the revived letter forms were also adopted by the early printers in Italy they are those we are still familiar with. They are often referred to in printer's terms as the 'lower case' alphabet, as opposed to the capital 'upper case' letters based on the inscriptions of Roman Imperial monuments. These capitals were also used by Renaissance scribes, most famously by Bartolomeo Sanvito of Padua (cats 26, 38, 39, 41, 43, 62, 71, 73-5).

To correspond to the new script, initials in early humanist manuscripts in Florence were copied from the same Italian Romanesque sources, in which a plain vine scroll was set against coloured grounds. This so-called white vine-stem or *'bianchi girari'* decoration was soon widely adopted elsewhere in Italy and used also for borders of increasing complexity (cat. 68), mainly in non-liturgical and non-religious texts. Varying flora and fauna, which had been part of the earlier 'Gothic' vocabulary of decoration, were added, and a new feature, the 'putti', nude young male children drawn from Classical models, especially sculpture, became ubiquitous. In certain contexts they were given wings and so became cupids.

In northern Italy, especially in Padua, artists who were aware of contemporary antiquarian studies of Classical inscriptions and sculpture (cats 66, 67) adopted a more self-consciously Classical vocabulary of motifs – faceted Roman capitals as initials (cats 29, 71, 73-5), Classical acanthus foliage, and Classical coins, candelabra, arms and armour – to create an Antique flavour. Above all the architectural frontispiece that copied the Roman triumphal arch was developed in the 1460s-1470s (cats 70, 71, 73-5, 77-80). There were often allusions made to well-known Roman monuments such as the Column of Trajan or the Arch of Constantine (cats 73, 74).

66

Giovanni Marcanova, *Collectio antiquitatum*

233 fols. 231 x 240 mm. On parchment [New York only]

Written by Felice Feliciano, Bologna, 1465, with illumination attributed to Felice, Marco Zoppo and another artist

MODENA, BIBLIOTECA ESTENSE, MS Lat. 992

This richly illuminated manuscript, made for Domenico Malatesta Novello, Lord of Cesena (*d.* 1465), is one of the most significant examples of the Italian humanistic interest in the collection and study of Classical inscriptions and antiquities. It contains a description of the most important monuments of Rome, divided into different categories; this is followed by a series of eighteen highly unusual, imaginary views of Rome relating to the different categories of buildings described. After the illustrations the text continues with the inscriptions from all over Italy. The script in the last part of the description of the monuments of Rome and in the catalogue of inscriptions is by the Veronese humanist and calligrapher Felice Feliciano (1433-1480). He also executed the pen-and-ink drawings of the Classical monuments (on which the inscriptions are to be found) and sculpture. Of particular interest is the monument to Metellus, folio 141v, and the altar of Priapus, folio 162.

An inscription on a sarcophagus on folio 1 informs us that the *Collectio*, begun in Padua, was completed in 1465 in Bologna under the patronage of the Paduan doctor and humanist Giovanni Marcanova. His coat of arms and emblems are illustrated on a purple-stained folio at the end of the book. On folio 10v is the dedication to Malatesta Novello, and the information about the production of the manuscript is repeated virtually word for word. Marcanova taught medicine in Padua from about 1443 to 1452, and then philosophy in Bologna until just before his death in 1467 in Padua. His Classical education began in the circle of the humanist Bishop of Padua, Pietro Donato (*r.* 1428-1448), and he was probably also acquainted with the celebrated antiquarian and traveller Ciriaco d'Ancona, founder of humanist epigraphy. Later Marcanova was a friend of the young Andrea Mantegna,

66 folio 25r

passing on to him his Classical culture, and of Felice Feliciano, whom he employed as librarian in his house in Bologna. Felice's famous description of the journey undertaken to study Classical remains on Lake Garda in 1464 may be largely imaginary, but gives a vivid idea of the cultural climate of this group of friends and of the influence over them of Ciriaco d'Ancona, who retold his adventures in the same colourful manner.

That Marcanova not only paid for the production of the manuscript, but also collected the inscriptions is clear from the dedication on folio 11. Most were probably passed on to him by Ciriaco d'Ancona. The first manuscript of the *Collectio*, begun in Padua, was written by Marcanova himself in 1457 in Cesena and completed in Bologna in 1460 (Bern, Burgerbibliothek, B. 42). The length of time spent in Cesena can be accounted for by the quantity of Roman remains in the area around Ravenna.

Marcanova must have had the protection at this time of Domenico Malatesta Novello, a prince with a passion for Antiquity, to whom he was probably introduced by Ciriaco d'Ancona or by Cardinal Bessarion, papal legate in Bologna from 1450 to 1455. This would explain the dedication of the Modena edition. Since the manuscript was completed in October 1465, however, just before Malatesta's death in November, it remained in Marcanova's possession and shared the fate of the rest of his library.

The views of ancient Rome illustrated here include various parts of the city: the gates, Caesar's palace, the Forum, a street with the houses of Cicero and Crassus, the Roman Campagna, a triumphal arch, the Vatican obelisk, the baths of Diocletian, Castel Sant'Angelo and its bridge, an amphitheatre. The first view, folio 25, depicts soldiers entering the city by one of the gates. It has been attributed to Marco Zoppo, a talented Bolognese painter who came to Padua in 1453 to work in the studio of Francesco Squarcione, teacher of Mantegna and other painters, and who returned to Bologna at the end of the 1450s, remaining there until the early 1460s when he went back to Venice. He was an expert draughtsman, as is clear from many single sheets and also a book of drawings now in the British Museum. The Classical architecture here is very similar to that in a drawing by Zoppo in the Colville collection. Also unmistakable are his bald putti above the gate to the city, which are similar to those in a copy of Cicero illustrated by Zoppo, who was also an illuminator, for the Venetian Marcantonio Morosini in 1463 (Biblioteca Apostolica Vaticana, Vat. lat. 5208) and also in the Virgil probably illuminated for Leonardo Sanudo (cat. 72). Since Zoppo thus appears to have been in Venice in 1463, it may be that he returned briefly to Bologna in 1465. But it is also quite likely that the section of the manuscript containing the description of the Classical monuments of Rome (and the first part is not in Feliciano's handwriting) was begun before 1463.

The artist responsible for the other views of Rome visualises it as a city alive with activity and people in modern dress, hurrying about the markets, baths, arenas and zoos. There are of course Ancient buildings, though often reduced to romantic ruins. The decoration of the buildings is rich in bas reliefs and statuary as in the drawings by Zoppo. The architecture, however, is largely conceived in a modern style typical of the Italian Renaissance. This combination of imagination and realism, far removed from the strict Classicism typical of Mantua and the Paduans, fits neatly into the 14th- and early 15th-century Bolognese tradition; it also bears some relation to the courtly world of the Bible of Borso d'Este, and anticipates in certain respects Taddeo Crivelli's *Decameron* of 1467 (cat. 110). These drawings may be the work of a Bolognese artist of the 1460s, from Zoppo's immediate circle; in Zoppo's book of drawings there are similar figures shown deep in conversation, another feature found also in Emilian art. Another copy of the *Collectio* with similar drawings is in Princeton (cat. 67).

Provenance: From 1465 presumably in the library of the Paduan humanist Giovanni Marcanova in Bologna; at his death in 1467 transferred to the monastery of San Giovanni di Verdara, Padua, with the rest of his library;

in the 18th century in the collection of Lorenzo Patarol; then in the collection of Tommaso Obizzi at Catalo near Padua, from whom it passed with the rest of his library into the Biblioteca Estense in Modena in 1817.

Exhibitions: Rome 1988, pp. 29-30, 38-42; Venice 1994, no. 52.

Bibliography: Huelsen 1907, p. 46; Lawrence 1927, pp. 127-31; Van Mater Dennis 3d 1927, pp. 113-16; Weiss 1959, p. 172; Meiss 1960, p. 108; Mitchell 1960, p. 479; Bruschi 1967, p. 43; Weiss 1969, p. 148; Fava, Salmi and Pirani 1973, pp. 44-8, no. 122; Fiorio 1981, p. 66; Vitali 1983; Brilliant 1984, p. 225; Chiarlo 1984, p. 286; King 1986, pp. 392-3; Gunther 1988, p. 16; Armstrong 1993a, p. 86; Mariani Canova 1993, pp. 122-3.

G. M. C.

67

Giovanni Marcanova, *Collectio antiquitatum*

218 fols. 360 x 265 mm. On parchment [New York only]

Written and illuminated in north-east Italy, perhaps in Bologna, after 1465 and probably after 1473

PRINCETON, PRINCETON UNIVERSITY LIBRARIES, MS Garrett 158

The main part of the text is a collection of Roman inscriptions compiled by Giovanni Marcanova, citizen of Venice, who describes himself as '*artium et medicinae doctor*'; he was born *c.* 1410-18 and died in Bologna in 1467. The manuscript opens with a series of fifteen fullpage drawings of Roman monuments and scenes (folios 1-5, 6v-9v, 9a, 10-12, 13v-14v), all identified and reproduced by Lawrence (1927). Their subject-matter has not, however, been studied in detail. They represent famous buildings and sculptures, such as the Arch of Titus, folio 5, the Mausoleum of Hadrian (Castel Sant'Angelo), folio 9v, and the statue of Marcus Aurelius, folio 10. These are shown with varying degrees of licence and combined with ahistorical happenings such as the tournament on folio 11 or the execution on the Campidoglio, folio 3. The latter is reminiscent of Mantegna's *Execution of St James* in the Eremitani Chapel, Padua.

On folio 17 is an architectural frontispiece for the author's Preface, in which the work is dedicated to Domenico Malatesta Novello, Lord of Cesena (*d.* 1465). This is coloured with brown wash and there is a very thoroughly erased coat of arms on a blue ground in the lower border. The date 1465, which occurs at the end on folio 17v, is the date of the text. There is then a description of Rome on folios 17v-35, followed by the collection of inscriptions (often referred to as a *Silloge*) on folios 35v-176v. They are arranged according to the place where they were found, and the names of the cities are framed by circles or sometimes more complex decoration. Thus Florence and Venice have their arms added, and for Padua, folio 136v, there is a more ornate frame with an inscription '*Clarus fias Marcanova*' with Marcanova's arms. However, the most complex frame is for Pesaro, folio 144v, where the design includes the name of Costanzo Sforza, who succeeded his father, Alessandro, as Lord of the city in 1473 and died in 1483. The design incorporates three rings, his *impresa*, and is accompanied by his motto, '*A bonne foy*'. In view of this, the present manuscript may have been made for him, as suggested by Albinia de la Mare (written communication) and indeed the letters '*Sfor*' are legible to the eye of faith above the arms on folio 17. There are further texts copied by the original hand on folio 204v, and then some entries by later hands on folios 206-207, 208v-209.

The present manuscript belongs with three other copies, one in Bern (Burgerbibliothek, B. 42, without the drawings of Rome), one in Modena (cat. 68, contains eighteen drawings), and one in Paris (Bibliothèque nationale, latin 5825 F, with the drawings of Rome removed; see Paris 1984, no. 114). Textual study shows that the Garrett manuscript was copied from the Paris manuscript, which in turn was copied from the Modena manuscript. This last is the most lavish copy and was made for presentation to Malatesta Novello of Cesena in 1465, though

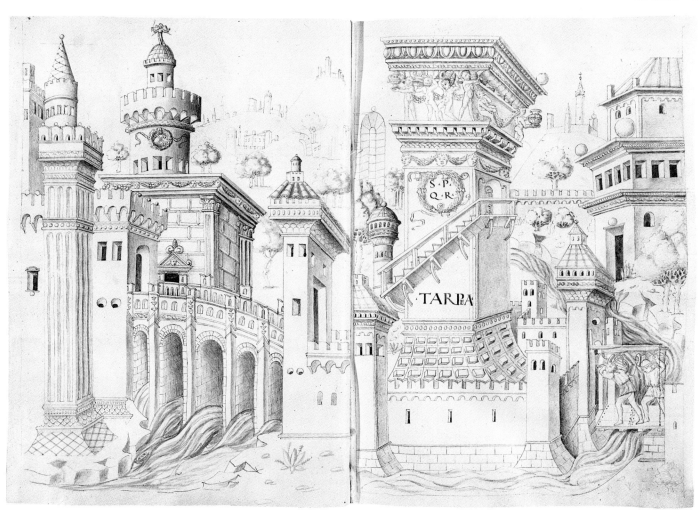

67 folio 9v–10r

since he died in the same year it probably never reached him. The date of 1465 for the present manuscript should therefore be seen as a *terminus post*. The textual relationship to the other manuscripts and the later history of the present manuscript has been traced by Van Mater Dennis 3d (1927), drawing on the earlier work of Mommsen for the *Corpus inscriptionum latinarum*, of Huelsen (1907) and of others.

There seem to be three or four artists involved in the present manuscript. The first, responsible for the drawings on folios 1 and perhaps 2, is close in style to Marco Zoppo (see cats 67, 72) and may even be identifiable as him. Zoppo, like Mantegna, was a student of the Paduan painter Squarcione, and so belonged to the same artistic and antiquarian circle. Lawrence (1927) has shown that the Garrett manuscript drawings are similar to and certainly derive ultimately from those in the Modena manuscript, which has three extra drawings not copied here. The Paris manuscript, which acted as model for the text and whose drawings have at some time been removed, may have been an intermediary, however. It has also been suggested that the subject-matter of the drawings may derive in some way from the earlier antiquary, Ciriaco d'Ancona (*c.* 1391–1455), as do many of the inscriptions. As Wendy S. Sheard argues (in Northampton 1978), however, Ciriaco's approach was more archaeological, less inclined to fantasy.

The second artist is responsible for the remaining thirteen drawings of Rome. A third artist did the drawings in the text where certain inscriptions are placed on monuments, aedicules, vases, etc. and are sometimes accompanied by human or mythological figures, e. g. folio

141v, Priapus (partly defaced); folio 142, a man kneeling before a lion; folio 167, a centaur in the labyrinth at Crete. A fourth artist, unless he should be identified with the third, was responsible for the architectural frontispiece on folio 17. The scribe is unidentified, but there is no sign of the participation of Felice Feliciano of Verona, who worked for Marcanova (see Mitchell 1961) and whose idiosyncratic hand can be easily recognised in the Modena and Paris manuscripts, most of which he wrote, and who also added marginalia in the Bern manuscript. Felice himself often seems to have done drawings in manuscripts he wrote, for example in the Modena manuscript, though his rather inexpert style makes it difficult to attribute work to him. The relationship of the drawings in the *Silloge* here to those in the Modena manuscript by Felice has not been examined.

Provenance: Erased arms, folio 17, perhaps of Costanzo Sforza, Lord of Pesaro (*r.* 1473–1483); Marc Antoine Muret (Muretus), born near Limoges in 1526, a noted scholar humanist, who resided in Rome until his death in 1585; bequeathed by his son to the Collegio Romano, Rome, where it remained until *c.* 1870; bought from the dealer Voynich by Robert Garrett in 1925; presented to Princeton University in 1942.

Exhibitions: Baltimore 1949, no. 185, pl. LXXII; Baltimore 1965, no. 44; Northampton 1978, no. 4, illus.; Baltimore 1984, no. 52.

Bibliography: Lawrence 1927; Van Mater Dennis 3d 1927; De Ricci 1935–40, I, p. 897; Mitchell 1961, pp. 208, 211; Fiorio 1981, pp. 65–73, fig. 17; J. Preston, unpublished typescript description.

J. J. G. A.

AD TITVM LIVIVM LA
CTEO ELOQVENTIE
FONTE MANATEM DE
VLTIMIS HISPANIE
GALLIARVM QVE FI
NIBVS QVOSDAM
VEHISSE NOBILES
LEGIMVS ET QVOS
AD CONTEMPLACON
EM SVI ROMA NON
RAXERAT VNIVS
HOMINIS FAMA
PER DVXERIT

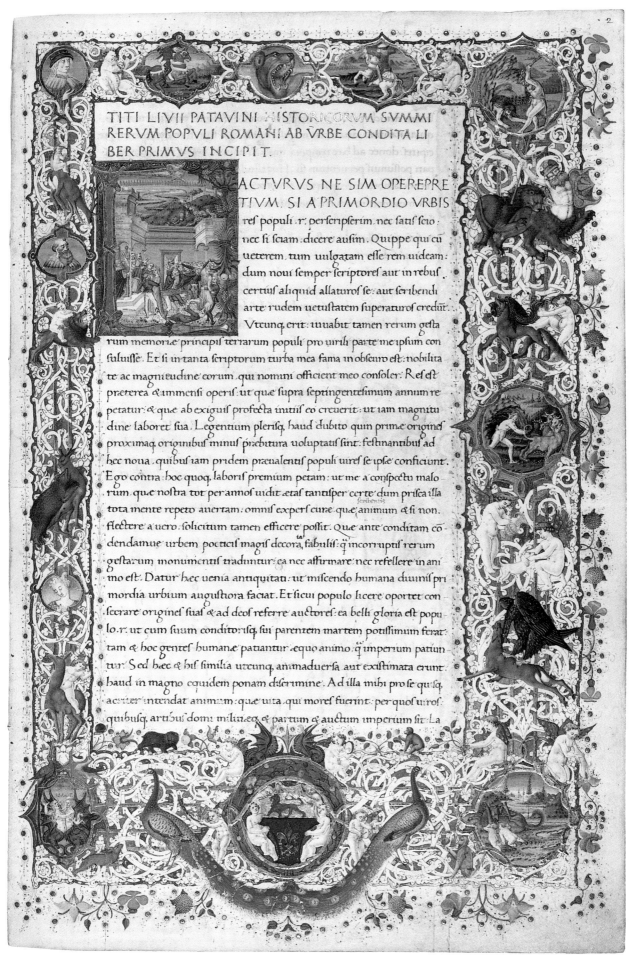

TITI LIVII PATAVINI HISTORICORVM SVMMI
RERVM POPVLI ROMANI AB VRBE CONDITA LI
BER PRIMVS INCIPIT.

ACTVRVS NE SIM OPEREPRE
TIVM. SI A PRIMORDIO VRBIS
res populi r. perscripserim. nec satis scio
nec si sciam. dicere ausim. Quippe qui cu
ueterem. tum uulgatam esse rem uideam:
dum noui semper scriptores aut in rebus
certius aliquid allaturos se: aut scribendi
arte rudem uetustatem superaturos credut.
Vtcunq. erit: iuuabit tamen rerum gesta
rum memoriæ principis terrarum populi pro uirili parte meipsum con
suluisse. Et si in tanta scriptorum turba mea fama in obscuro est: nobilita
te ac magnitudine eorum qui nomini officient meo consoler. Res est
præterea & immensi operis: ut quæ supra septingentesimum annum re
petatur: & quæ ab exiguis profecta initiis eo creuerit: ut iam magnitu
dine laboret sua. Legentium plerisq. haud dubito quin primæ origines
proximaq. originibus minus præbitura uoluptatis sint: festinantibus ad
hæc noua. quibus iam pridem prænalentis populi uires se ipse conficiunt.
Ego contra hoc quoq. laboris premium petam: ut me a conspectu malo
rum quæ nostra tot per annos uidit ætas tantisper certe dum prisca illa
tota mente repeto auertam: omnis expers curæ quæ animum et si non.
flectere a uero solicitum tamen efficere possit. Quæ ante conditam co
dendamue urbem poeticis magis decora. fabulis q incorruptis rerum
gestarum monumentis traduntur ea nec affirmare nec refellere in ani
mo est. Datur hæc uenia antiquitati: ut miscendo humana diuinis pri
mordia urbium augustiora faciat. Et sicui populo licere oportet con
secrare origines suas & ad deos referre auctores: ea belli gloria est popu
lo.r. ut cum suum conditorisq. sui parentem martem potissimum ferat
tam & hoc gentes humanæ patiantur æquo animo q imperium patiun
tur. Sed hæc & his similia utcunq. animaduersa aut existimata erunt.
haud in magno equidem ponam discrimine. Ad illa mihi pro se quisq,
acriter intendat animum: quæ uita. qui mores fuerint: per quos uiros
quibusq, artibus domi militiæq. & partum & auctum imperium sit La

AVGVSTINI
SANCTISSIMI DOCT
ORIS EGREGII DECIVIT
ATE DEI ADMARCELLINV
M LIBER PRIMVS CONT
RA GENTILES INCIP
IT FOELICITER

69 folio 28v

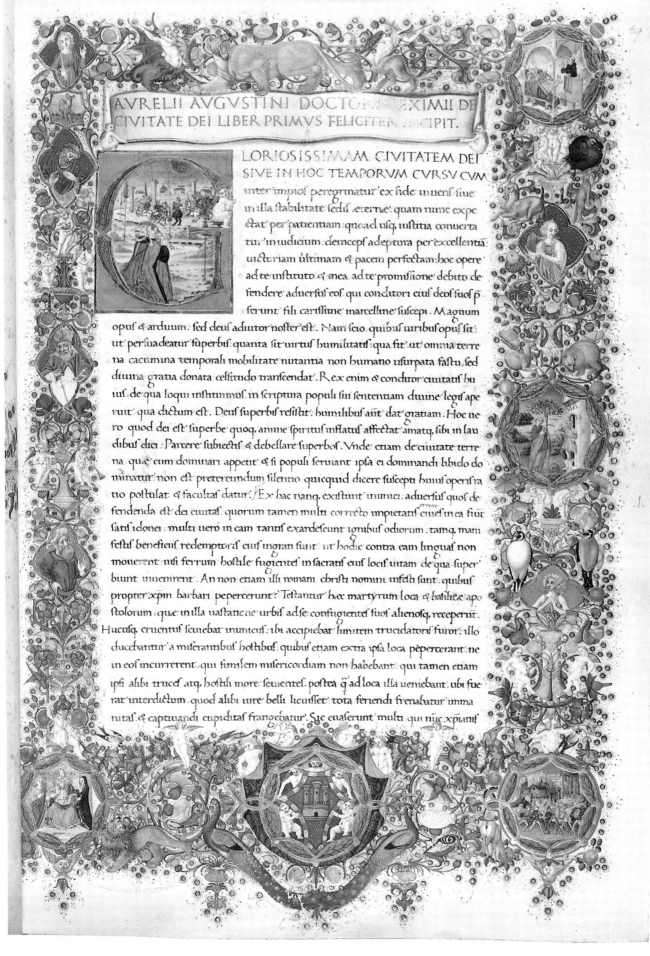

AVRELII AVGVSTINI DOCTORIS EXIMII DE
CIVITATE DEI LIBER PRIMVS FELICITER INCIPIT.

LORIOSISSIMAM CIVITATEM DEI
SIVE IN HOC TEMPORVM CVRSV CVM
inter impios peregrinatur ex fide uiuens siue
in illa stabilitate sedis eterne: quam nunc expe
ctat per patientiam: quoad usq. iustitia conuerta
tur in iudicium. deinceps adeptura per excellentia
uictoriam ultimam et pacem perfectam: hoc opere
ad te instituto et mea ad te promissione debito de
fendere aduersus eos qui conditori eius deos suos p̄
ferunt fili carissime marcelline suscepi. Magnum
opus et arduum. sed deus adiutor noster est. Nam scio. quibus uiribus opus sit
ut persuadeatur superbis: quanta sit uirtus humilitatis: qua fit: ut omnia terre
na cacumina temporali mobilitate nutantia non humano usurpata fastu, sed
diuina gratia donata celsitudo transcendat. Rex enim et conditor ciuitatis hu
ius de qua loqui instituimus. in scriptura populi sui sententiam diuine legis ape
ruit: qua dictum est. Deus superbis resistit. humilibus aut dat gratiam. Hoc ue
ro quod dei est superbe quoq. anime spiritus inflatus affectat amatq. sibi in lau
dibus dici. Parcere subiectis et debellare superbos. Vnde etiam de ciuitate terre
na: que cum dominari appetit: et si populi seruiant ipsa ei dominandi libido do
minatur: non est pretereundum silentio quicquid dicere suscepti huius operis ra
tio postulat et facultas datur. Ex hac nanq. existunt inimici aduersus quos de
fendenda est dei ciuitas. quorum tamen multi correcto impietatis errore ciues in ea fiut
satis idonei. multi uero in eam tantis exardescunt ignibus odiorum. tamq. mani
festis beneficiis redemptoris eius ingrati sunt: ut hodie contra eam linguas non
mouerent nisi ferrum hostile fugientes in sacratis eius locis uitam de qua super
biunt inuenirent. An non etiam illi romani christi nomini infesti sunt. quibus
propter xpm barbari pepercerunt? Testantur hec martyrum loca et basilice apo
stolorum. que in illa uastatione urbis ad se confugientes suos alienosq. receperut.
Hucusq. cruentus seuiebat inimicus: ibi accipiebat limitem trucidatoris furor: illo
ducebantur a miserantibus hostibus. quibus etiam extra ipsa loca pepercerant. ne
in eos incurrerent. qui similem misericordiam non habebant. qui tamen etiam
ipsi alibi truces atq. hostili more seuientes. postea q̄ ad loca illa ueniebant. ubi fue
rat interdictum. quod alibi iure belli licuisset. tota feriendi frenabatur imma
nitas et captiuandi cupiditas frangebatur. Sic euaserunt multi qui nunc xpianis

68

Livy, *Roman History*, First and Third Decades

2 volumes: 220 and 211 fols. 385 × 258 and 384 × 258 mm. On parchment. Both volumes have their original bindings of red leather, blind stamped with gold studs and metal clasps

Script attributed to Messer Piero di Benedetto Strozzi in Florence, c. 1469-70, with illumination attributed to Mariano del Buono and Ser Ricciardo di Nanni

MUNICH, BAYERISCHE STAATSBIBLIOTHEK, Clm 15731, 15732

These two volumes are part of a three volume set of Livy (volume III, Clm 15733, is not shown) which belonged to Janos Vitéz (*d.* 1472), the celebrated patron of humanists and friend of Pier Paolo Vergerio and Aeneas Silvius Piccolomini (Pope Pius II). Vitéz served as chancellor to Johannes Hunyadi, Matthias Corvinus' father, and to Ladislas V of Hungary. He was made Archbishop of Esztergom in 1465 and died in 1472 after his plot to overthrow King Matthias Corvinus (see cat. 13), who had been his pupil and protegé, failed. In the Third and Fourth Decades the arms of Vitéz are accompanied by those of Garàzda. Petrus Garàzda, a relation of Vitéz, is documented in Florence in 1469 and may perhaps have commissioned this set either as a present for or on behalf of his distinguished relation (Garzelli and de la Mare 1985, p. 455).

The First Decade opens on folio 1v with a framed text in praise of Livy, presented as if it were an architectural wall tabernacle with a textile backing. A haloed figure, St Jerome (?), is above. The arms of Vitéz are below. Such 'tabernacle' frontispieces, resembling contemporary tomb monuments, are found in a number of Florentine manuscripts of this period. On folio 2 the initial 'F' has a scene with the *Rape of the Sabine Women* and a rich white vine-stem border. In roundels are scenes of Romulus and Remus at bottom right, Cacus drawing the stolen cattle into the cave, and Hercules clubbing Cacus. In other roundels are bust heads, equestrian figures and a pair of grotesques embracing. There are also putti with animals, etc. in the white vine-stem scroll. There are typical Florentine white vine-stem initials with borders to the ten books: folio 2v, 'I'; folio 25, 'L'; folio 49v, 'A'; folio 77, 'H'; folio 100, 'P'; folio 121, 'Q'; folio 139, 'A'; folio 157, 'I'; folio 174v, 'S'; folio 196, 'L'.

The beginning of the Third Decade, volume II, folio 1v, also has an architectural frame, with a figure above of Quintilian, from whom the passage in praise of Livy is taken, and the arms of Garàzda below. On folio 2 there is an initial 'I' with a scene of sacrifice and a full white vine-stem border framed with outer flower and foliage borders. There are medallions with further Labours of Hercules – taming the mares of Diomedes, fighting the Nemean Lion, and wrestling with Antaeus – as well as other unidentified scenes and figures. Putti, animals and angel heads again are placed in or outside the border. Below are the arms of Janos Vitéz. There are again white vine-stem initials with borders, some with putti or roundels with bust heads, to the ten books: folio 23, 'I'; folio 46v, 'N'; folio 66v, 'V'; folio 85v, 'D'; folio 105, 'C'; folio 128, 'H'; folio 151v, 'C'; folio 174, 'S'; folio 190v, 'C'.

Annarosa Garzelli (in Garzelli and de la Mare 1985) has attributed the illumination of the first and third volumes to Mariano del Buono (see cat. 49) and of the second to Ser Ricciardo di Nanni (see cat. 34). Albinia de la Mare (1971) has attributed the script to the noted Florentine scribe, Messer Piero di Benedetto Strozzi (1416-c. 1492), who wrote two other sets of Livy. He often worked for the Florentine *cartolaio*, Vespasiano da Bisticci, from whom Vitéz no doubt acquired this particular set (see also cats 69, 76). Vespasiano da Bisticci included Vitéz in his *Vite*, saying that he had manuscripts transcribed in Florence 'regardless of cost, provided they were fine and carefully revised'. He also commented that 'there were few Latin books of which Vitéz did not possess a copy'. Like the Holkham Livy (cat. 47) this set is annotated and corrected by the Florentine humanist Bartolomeo Fonzio, who may have been working for Vespasiano in the late 1460s (Garzelli and de la Mare 1985, pp. 446, 488).

Provenance: Archbishop Janos Vitéz of Esztergom (*d.* 1472), with his arms and those of Petrus Garàzda.

Exhibition: Munich 1983, no. 60.

Bibliography: De Hevesy 1911, p. 14, illus. p. 9; D'Ancona 1914, II, nos. 738-9; de la Mare 1965, p. 66; de la Mare 1971, pp. 182-3, 197; Csapodi-Gárdonyi 1984, pp. 115-16, nos. 62-4, figs 47-9; Garzelli and de la Mare 1985, pp. 75, 192-3, 431, 446, 455, 488, 531, figs 156-62, 678-81, 685.

J. J. G. A.

69

St Augustine, *The City of God*

365 fols. 405 × 278 mm. On parchment. Contemporary Florentine stamped leather binding

Script attributed to Messer Piero di Benedetto Strozzi in Florence, probably c. 1470-5, with illumination attributed to Mariano del Buono and Francesco d'Antonio del Chierico

LONDON, THE BRITISH LIBRARY, Additional MS 15246

This magnificent copy of one of the most widely read of Augustine's works was illuminated in Florence, albeit for a Neapolitan patron, Iñigo d'Avalos (*d.* 1484) grand chamberlain of King Ferdinand I of Naples, made a Knight of the Order of the Garter by Edward IV in 1467. His fine library, '*libri bellissimi di miniatura*', is referred to by the Florentine *cartolaio* Vespasiano da Bisticci in the life he wrote of him. Vespasiano was probably responsible for the present manuscript.

The title, on folio 28v, is written in a circular roundel surrounded with foliage and flowers, by the owner's arms repeated four times and by putti. Such title-pages, deriving from examples in Early Christian codices, are especially common in Florentine manuscripts from the 1460s onwards (see cats 34, 64). The text starts on the recto opposite, folio 29, where in the initial 'G' St Augustine kneels before God, in the sky above, with a city in a landscape beyond. Four roundels in the border show unidentified scenes from Augustine's life, a preaching scene, a young and an older man by a gate, a battle before a city, and an enthroned Bishop, perhaps St Ambrose, flanked by a young man and a woman, probably St Augustine and his mother, St Monica. There are also six smaller medallions with figures. The border of leaves and flowers with gold discs is inhabited by birds, putti and at the top a fierce lioness attacked by a pair of grotesques. There are initials and borders for each of the 22 books: folio 42, 'S'; folio 54, 'I'; folio 66v, 'D'; folio 78v, 'Q'; folio 92v, 'Q'; folio 101, 'D'; folio 114, 'N'; folio 127v, 'E'; folio 136, 'O'; folio 152v, 'C'; folio 166, 'A'; folio 178, 'E'; folio 189v, 'D'; folio 204v, 'D'; folio 221v, 'P'; folio 241, 'P'; folio 256v, 'D'; folio 281, 'Q'; folio 297v, 'D'; folio 320, 'C'; folio 338v, 'S'.

The illumination as been attributed by Annarosa Garzelli (in Garzelli and de la Mare 1985) to the Florentine illuminator Mariano del Buono, who was born in 1433. However, Albinia de la Mare (written communication) attributes the title-page on folio 28v to Francesco d'Antonio del Chierico (cats 36, 50, 59, 62, 69, 120). The manuscript was copied by the notable Florentine scribe, the priest Piero di Benedetto Strozzi, a friend of the *cartolaio* Vespasiano da Bistici (see also cats 68, 76). Folios 1-8v, on paper and containing a list of contents ending in Book XVII, chapter xxiii, are of a smaller format and have been inserted from a different manuscript. The note on folio 8v concerning the purchase for 8 gold ducats by the Prior of San Mathias de Muriano in 1472 does not therefore apply to the present manuscript.

Provenance: Arms of Iñigo d'Avalos, Count of Monte Oderisio (*d.* 1484); acquired by the British Museum at the sale of the library of the Duke of Sussex, London, 31 July 1844, lot 91.

Bibliography: Warner 1903, pl. 57; De Laborde 1909, II, pp. 394-7, pl. XXXIX; D'Ancona 1914, II, no. 1365; *Reproductions from Illuminated Manuscripts* 1925, pls 39, 40; de la Mare 1965, p. 66, no. 19; Garzelli and de la Mare 1985, pp. 208, 453, 531, no. 31, fig. 686; Gullick 1990, pl. 21.

J. J. G. A.

70 folio 43r

70

Johannes de Deo (?), *Columba, Tractatus asceticus*

120 fols. 172 x 250 mm. On parchment. Late 15th-century Venetian bind-
ing: reddish brown leather over board, blind stamped and gold tooled
motifs, plaquettes of St John the Baptist (?), upper cover, and St Bruno (?),
lower cover [New York only]

Written in Venice, c. 1475, with illumination attributed to the Master of the
Putti, Master of the Pico Pliny, and the Douce Master

VIENNA, ÖSTERREICHISCHE NATIONALBIBLIOTHEK, Cod. 1591

At least three miniaturists provided the complex pictorial program for
the Christian allegorical and meditational treatise in Vienna known by
the title of its first book, *Columba*, or *The Dove* (detailed description of
text and miniatures in Hermann 1931, pp. 109-200). The text was com-
posed for Carthusian monks, and it is thought that the author was
Johannes de Deo of Padua, a Carthusian at the monastery of Sant'
Andrea della Certosa (or Sant' Andrea al Lido) in Venice.

Understanding the sequence of the texts makes the distribution of
the hands somewhat more explicable than might seem at first glance.
Book I, called the *Columba*, parallels the parts of the Dove to the qual-
ities of the Seven Virtues. The Prologue of Book I begins with a nearly
full-page miniature of the Dove surrounded by the Virtues (folio III),
and the text proper begins on a folio which also has on it a large minia-
ture of *St John the Baptist* (folio 1). Book II of the treatise, which
allegorises the colt of the she-ass on which Christ rode on Palm Sun-
day as a model for the life of Carthusian monks, starts with a partially
completed frontispiece (folio 16v). Like Book I, Book II should also
have received an additional miniature before its first section, but the
space reserved for the miniature on folio 17 was not filled. Book III
treats of prayer and is divided into two parts, each of which is initiated
with an architectural frontispiece (folios 43, 84). The subdivisions of
the three books – parts and chapters within the parts – begin with
elaborately historiated and decorative initials.

All the miniatures and historiated initials except for the first frontis-
piece can be attributed to two Venetian miniaturists, the Master of the
Putti and the Master of the Pico Pliny. The Putti Master was active in

Venice from about 1466 to 1475, and the Pico Master's career spanned the years 1468 to 1495 (Armstrong 1981; Armstrong 1990a). On the architectural frontispiece initiating part 2 of Book III (folio 84), the vigorous putti carrying palm and olive branches and banderoles inscribed SOLA VIRTUTE and ΓΝΩΘΙ/ΣΕ/ΑΥΤΟΝ, are certainly in the distinctive style of the Putti Master, as is his hallmark 'putto-on-a-dolphin' at the bottom of the monument (Armstrong 1981, fig. 61). The Putti Master also contributed the striking miniature of *St John the Baptist* at the beginning of the text proper of Book I (folio 1). The saint stands alone in a barren landscape, punctuated only by a few trees and a distant ruined circular building. His bony features, emaciated limbs, and the pale grey colour of his animal-skin garment all show the influence of the contemporary painter Marco Zoppo (1433-1478), who also executed miniatures (cat. 72). The otherwise unexplained prominence of the saint may be due to the Christian name of the author, Johannes de Deo, or John the Carthusian.

The Putti Master also executed most of the inventive historiated initials in gatherings 5, 6, and 10, as well as scattered initials elsewhere (Mariani Canova 1969, pls 12, 13, figs 55a, b; Armstrong 1981, figs 63-66). The initials are of two kinds, both associated with the Putti Master. In all cases the actual letter is treated as if it were a three-dimensional object, the so-called *littera mantiniana*. In the simpler initials, the Putti Master contrasts faceted initials to monochromatic plaques on which putti, or putti-tritons, are outlined and modelled in gold as if they were reliefs. These are sometimes called by the French name *camaïeu d'or*, or golden cameo, initials (Armstrong 1981, fig. 64; Mariani Canova 1969, pl. 7). In the more sophisticated initials by the Putti Master, they appear to be attached to architectural structures – altars, stelae and even arcades – accompanied by naturalistically coloured putti with musical instruments, or with instruments of the Passion. In one example, an *Annunciation* is enacted in an airy loggia, and the initial 'D' hangs from strings tied to the torn parchment above the Virgin. These initials are painted in vivid colours with exquisite detail, tiny masterpieces of Renaissance art (Mariani Canova 1969, pls 12, 13, fig. 55a; Armstrong 1981, figs 63, 65-66).

The Pico Master also played a major role in the work. The beautiful architectural frontispiece executed for part 1 of Book III (folio 43; Alexander 1977a, pl. 16) is painted on a single folio added at the front of the gathering on which Book III, part 1 begins. Two slender putti support the white disc of the Host framed by golden bronze dolphins and putti heads. This ensemble is balanced above an architectural monument with a high base supporting a charming loggia on which stands a nude putto waving a staff. The delicate harmony of the colours – pink, lavender, green, white and bronze – is typical of the finest work of the Pico Master and relates closely to his later miniature in the Petrus de Abano of 1482 for Peter Ugelheimer (cat. 99).

The Pico Master also executed many fine historiated initials in the Vienna manuscript (Hermann 1931, pl. LXIII, 2), while other initials appear to be weaker compositions in his style, perhaps by an assistant. In addition the Pico Master partially finished an architectural frontispiece for Book II (folio 16v; Hermann 1931, pl. LIX), but did not complete it with the same refinement as is found on folio 43.

A third artist provided the frontispiece to the Prologue of Book I of the treatise, celebrating the allegory of the Dove (folio III; Alexander 1977a, pl. 16). Sometimes attributed to the documented Paduan miniaturist Antonio Maria da Villafora, it seems likelier that the *Columba* frontispiece is the work of the Douce Master, a miniaturist who sometimes collaborated with Antonio Maria and other artists in Padua and in Venice (Alexander 1970b, p. 275; Alexander 1977a, p. 68; Mariani Canova 1987; Armstrong 1990b; see also cat. 88). The centrally placed monument resembles a Renaissance tomb; two tiers of monochromatic reliefs represent stories of St Bruno, founder of the Carthusian Order. A Dove is frontally posed on top of the sarcophagus, framed by a curved purple apse. To the sides of the Dove are fragile figures of the Cardinal Virtues: Fortitude holding a column; Prudence with a mirror; Justice with a sword; and Temperance pouring water from one jar into another. They are dressed in gowns of purple and green, modelled with gold. On top of the curving wall behind the Dove are Faith, with an anchor, Charity, pouring coins from a purse, and Hope, gazing upwards. These Theological Virtues hold

aloft a circular red canopy, also modelled in gold. The blond hair, hipless bodies, and barely articulated features are unlike the other figures in the Vienna *Columba*, but do compare well with miniatures by the Douce Master.

Given the observations noted above, can one postulate how the Vienna *Columba* was actually made? It would seem that the text was laid out in such a way as to permit 'distribution' of the folios on which major frontispieces were to be painted. Folios III, 1, and 43 are single leaves inserted in front of more regular gatherings, and folio 84 is the first leaf in its gathering, hence also easily available to a miniaturist for illuminating. Only the frontispiece to Book II is buried in the middle of a gathering, and it is significant that this composition and the intended space for a miniature on the opposite folio were never finished (folios 16v-17). It is likely that the commission went jointly to the Putti Master and the Pico Master, since their historiated initials appear commingled in a number of gatherings. For some reason, however, the most important first miniature was entrusted to the Douce Master. The Putti Master and the Pico Master undoubtedly knew each other in the early 1470s, since both decorated large numbers of incunables printed by Nicolaus Jenson. Their collaboration on the Vienna *Columba* is therefore not surprising. A final factor contributing to the complexity of the *Columba* decoration is the probable death of the Putti Master around 1475. No securely attributed works by the master can be dated after 1474, and it may thus be assumed that the Vienna *Columba* was the last work in his short but important career.

Provenance: A Carthusian monastery in Venice, perhaps Sant' Andrea al Lido; Hofbibliothek, Vienna, in the 18th century.

Exhibition: Stockholm 1962, no. 33.

Bibliography: Hermann 1931, no. 138, pp. 190-200, pls LVIII-LXIII; Salmi 1957, p. 67; De Marinis 1960, II, no. 1679 (binding); Mariani Canova 1969, pp. 36-37, 149, pls 11-13, figs 55a, b; Alexander 1970b, p. 275; Alexander 1977a, pp. 68-71, pls 16-17; Armstrong 1981, pp. 18-9, 75, 118-19; Hobson 1989, pp. 105, 225 (binding); Armstrong 1990a, pp. 21, 32, fig. 28.

L. A.

71

Petrarch, *Canzoniere, Trionfi*

189 fols. 233 x 142 mm. On parchment. Stamped, gilded leather binding with central plaquettes of Diana and Septimius Severus, Rome, *c.* 1515-25.

Script attributed to Bartolomeo Sanvito of Padua in Venice or Padua, probably c. 1463-4, with illumination attributed to Franco dei Russi and an anonymous artist

LONDON, VICTORIA AND ALBERT MUSEUM, L. 101-1947

This copy of Petrarch's two most popular vernacular works is written by one of the great scribes of the Renaissance, Bartolomeo Sanvito of Padua (see cats 26, 39, 43, 71, 73-5, 77). Sanvito wrote the text in his influential cursive ('italic') script and the headings in the beautifully designed epigraphic coloured capitals for which he must have been famous, since he was even employed to add them in numerous manuscripts that he did not himself write (see cats 38, 41, 62). He probably wrote the manuscript while in Padua either before leaving for Rome in *c.* 1463-4 or possibly on a brief return in 1466-9.

The manuscript is illuminated by two important artists in the new antiquarian manner associated with Padua. Typical features are the use of parchment stained purple or green, the architectural frontispieces and the debts to Antique sculpture. The first illuminator, still anonymous, contributed the three frontispieces. The first of these, to the *Canzoniere*, folio 9v, is on the last verso of a bifolium stained green, and shows Apollo playing the lyre with Petrarch and Laura represented half-length as if carved on a Classical stele. The second is on the plain parchment and prefaces the first of the famous series of sonnets on the

FRANCISC
PETRARCÆ
FLORENT·
POETAE CLA
RISS · TRI
VMPHI IN
CIPIVNT

71 folio 149v

death of Laura, 'Io vo pensando', folio 106. It shows a figure, painted in gold and silver on a black ground, falling from a chariot. The third frontispiece, on the last verso of a purple stained bifolium, is to the *Trionfi* and shows the Triumph of Love, folio 148v. A winged Amor shoots an arrow from his chariot, which is surrounded by lovers with their arms bound in submission. One of these is even crushed between the wheels. In the foreground are a river god and two swans. The illuminated pages are somewhat damaged with some paint flaking and offsets probably due to damp.

In common with other artists of this circle, the first illuminator shows awareness of the work of Donatello in Padua, especially the altar of the Santo, and of the paintings of the most famous Paduan artist of the 15th century, Andrea Mantegna. He uses gold in his miniatures in a technique referred to by Matteo de' Pasti in a letter from Venice in 1441 (Ames-Lewis 1984b). He also demonstrates a wide knowledge of Antique motifs and compositions in the various works attributable to him. The scene evoking Laura's death is based on a composition found on Roman sarcophagi of the Fall of Phaethon, for example that now in the Uffizi, Florence, and recorded at Santa Maria in Aracoeli, Rome, c. 1500 (Bober and Rubinstein 1986, no. 27). This was copied in a number of the antiquarian pattern-books and it or another similar source was also used in three famous drawings of 1533 by Michelangelo. The first frontispiece depends on Roman tomb sculpture for the stele figures, very possibly on an actual surviving relief, already famous in the Renaissance, and today in the Vatican (Alexander 1970a, p. 30, fig. 4).

Sanvito records in his daybook kept in the years 1505-11 (De Kunert 1907, p. 6) that he had lent a drawing by 'Gasparo' of Phaethon '*tochato d'acquarella*' to Giulio Campagnola. It seems, however, that the illuminator of the Petrarch, to whom a Book of Hours and a Caesar,

both in the Biblioteca Ambrosiana, Milan (A. 243. inf. and S. P. 13), can also be attributed, is a separate personality from the Master of the Vatican Homer of Cardinal Francesco Gonzaga, now documented as Gaspare da Padova (cats 38–41, 73–5).

The second illuminator executed the architectural frames for the text opposite the frontispieces on folios 10 and 150, and the historiated initials which preface each of the other five *Trionfi*, folios 162, 166, 175, 182, 184v. These latter initials and also those on folios 10, 106 and 150, are of the type known as 'faceted', that is painted illusionistically so as to seem as if carved in three dimensions. It is possible that Sanvito designed these letters (Alexander 1988b). The second illuminator is recognisable by his style as Franco dei Russi, who worked on two of the most prestigious commissions for illuminated manuscripts in the Quattrocento, the Bible of Borso d'Este (see figs 3, 14–17) and the Dante for Federigo da Montelfeltro (cat. 58). For other works by him, see cats 26, 82, 83, 113.

Unfortunately the patron's arms, surmounted by a red cardinal's hat, are heavily erased, but one possible identification is Lodovico Trevisan, Patriarch of Aquileia, who owned two other early manuscripts written by Sanvito (Venice, Biblioteca Marciana, Lat. II, 39), also on stained vellum, and the copy of Bembo's *Oration* illuminated by Franco dei Russi (cat. 26). The Cardinal, famous for his wealth and for his avarice, died in Rome in 1465. This identification now seems preferable to my earlier suggestion that the arms were those of Cardinal Francesco Gonzaga, Sanvito's patron in Rome.

Another copy of the same two texts by Petrarch (Madrid, Biblioteca Nacional, MS611) is also written by Sanvito and contains copies of the miniatures in the present manuscript. It would seem to be a replica with illumination by a different hand, no doubt made for a patron who had admired the present manuscript (Alexander 1993, p. 138, fig. 234). It is possible that the Madrid Petrarch is illuminated by Gaspare. Ellen Erdreich, who has identified the arms in the Madrid manuscript as those of Pizzacomini, has argued, however, that it and the present manuscript are both by the same artist, whom she identifies as Sanvito himself.

Provenance: Erased arms of a Cardinal, folio 9v; Robert Hoe sale, New York, 1–24 April 1911, lot 2170; C. W. Dyson Perrins book label; C. H. St John Hornby, from whom acquired by J. R. Abbey, 1946; bought for the Victoria and Albert Museum at the Abbey sale, London, Sotheby's, 16–18 December 1946, lot 560, pl. X.

Exhibitions: London 1980, no. 48; London 1981, no. 25.

Bibliography: Wardrop 1963, pp. 34, 51; Alexander 1970a, pp. 27–40, figs 1–3, pl. 1; Levi D'Ancona 1972, pp. 41–2; Mann 1975, no. 138; Armstrong 1981, p. 17, fig. 128; Mariani Canova 1988, pp. 86–8; Hobson 1989, pp. 5, 8, 10, 12, 96, 216 (3f), 223–4 (27b), figs 4, 184; Alexander 1993, p. 138, fig. 233; Erdreich 1993, pp. 137–47.

J. J. G. A.

72

Virgil, *Eclogues, Georgics, Aeneid*

236 fols. 260 x 155 mm. On parchment [London only]

Script attributed to Bartolomeo Sanvito of Padua, c. 1466–8, with illumination attributed to Marco Zoppo

PARIS, BIBLIOTHÈQUE NATIONALE, latin 11309

The Paris Virgil imitates many characteristics understood by Renaissance patrons to be those of a Classical manuscript. Three full-page miniatures initiate the *Eclogues* (folio 4v), the *Georgics* (folio 21v), and the *Aeneid* (folio 64v); each scene is peopled by the mythological denizens of Antiquity. Two are drawn in metalpoint on the second leaf of a dyed bifolium (folios 3–4, 63–4), as in a number of Late Antique and Carolingian manuscripts. The scribe, Bartolomeo Sanvito, provided beautifully balanced epigraphic capitals, alternating letters in gold with those in blue, pale red or green; the text is written in a cursive

script modelled on Carolingian and Romanesque models thought to be Roman (folio 5; Mariani Canova 1993, illus. pp. 203–7).

The miniatures of the Paris Virgil are highly original, the works of a monumental artist rather than one who worked primarily as a miniaturist. Jonathan Alexander first recognised them as the work of Marco Zoppo (1433–1478), a painter active in Padua, Bologna, and Venice (Alexander 1969b; Armstrong 1976). More recently Giordana Mariani Canova (1993) has discussed the manuscript in great detail, pointing out its relationship to contemporary manuscripts and paintings. In the unusual composition preceding the *Eclogues* (folio 4v), Orpheus stands off centre to the left, dressed in a short tunic and soft boots, and holding a lyre. Behind him looms a rocky cliff on which are perched a monkey and a rabbit. Clustered behind Orpheus are a lion, a goat, three deer, a nymph and two satyrs. To the left and right are an eagle and a dragon. The overall tonality of the page is golden: the drawing is executed in metalpoint on the yellow dyed parchment, while the modelling lines are purple and silver which has oxidised.

Background figures who turn to converse with each other also appear in many of Zoppo's compositions in his *Parchment Book of Drawings* in the British Museum, dating from the early 1470s; Orpheus' soft boots and the bunched drapery of his tunic, fastened by a round button below the hip, can also be found in this book (Dodgson 1923, pls III, IV, VII, VIII, XX). Particularly reminiscent of Zoppo are the angular chins and deep-set eyes of Orpheus and the satyrs; similar features are found in a nude bound *Prisoner of Love* drawn by Zoppo in an incunable printed in Bologna in 1472 (Armstrong 1993, illus. p. 208).

Orpheus Taming the Beasts was not a scene frequently represented in the early Renaissance, although the hero does appear in World Chronicles. There are parallels between Zoppo's miniature and the *Orpheus* drawing in the so-called *Florentine Picture Chronicle* of Maso Finiguerra, a scene with a standing Orpheus and many animals, including a monkey and a dragon (Colvin 1898, pls XXVIII–XXIX). Any search for iconographical prototypes for the *Orpheus Taming the Beasts* should not exclude medieval or Late Antique manuscripts. Mariani Canova (1993, p. 128) has noted similarities to the miniatures of shepherds playing flutes in the presence of animals found in the famous *Vergilius Romanus* (Vatican, Biblioteca Apostolica Vaticana, Vat. lat. 3867), a 6th-century manuscript, known in Italy by the mid-15th century. A 12th-century North Italian Cicero *Rhetorica ad Herennium*, now in the Vatican, also contains a full-page miniature of *Orpheus* with surprising parallels to the Zoppo scene (Biblioteca Apostolica Vaticana, Ottob. lat. 1190, folio 68v; Pellegrin 1975, I, p. 470, and colour pl.).

The two other full-page miniatures in the Paris Virgil also evoke the mood of the Classical past, rather than provide literal illustrations to Virgil's text, as in Sanvito's Virgil for Bishop Lodovico Agnelli (cat. 43). Opening the *Georgics* is the *Worship of Bacchus and Ceres* (folio 21v; Mariani Canova 1993, illus. p. 205), in which the god and goddess appear as nude figures standing on a high altar before a landscape. In contrast to the full range of colours used on the *Bacchus and Ceres* folio, the *Triumph of Mars* initiating the *Aeneid* is drawn in silver (now darkened) and gold on a leaf dyed purple (folio 64v). The frontal pose of the armed god and the four dark horses drawing his chariot towards the framing triumphal arch echo compositions found in contemporary manuscripts of the *Trionfi* of Petrarch (cats 59, 60), but are unique in Virgil manuscripts, again underlining the originality of the artist.

The putti who fight with dragons by the large opening capital 'T' of the *Eclogues*, equivalent to the height of eleven lines of text, are more slender than the robust putti in most of Zoppo's drawings (folio 5; Mariani Canova 1993, illus. p. 203). Their exaggerated poses, however, do resemble the fighting putti in one of his earliest drawings of about 1455, the *St James Led to Execution*, in which Zoppo reinterprets Andrea Mantegna's fresco in the Eremitani Chapel, Padua (Ruhmer 1966, fig. 10). The other *Eclogues* are each provided with a decorative opening initial. These appear to be free-standing faceted bronze letters; cornucopias or dragons in contrasting green coil around them (folios 6v, 7v, 9v, 10v, 12v, 13v, 15, 16v, 18; Mariani Canova 1993, illus.

72 folio 4v

p. 207). Likewise the *Georgics* and each book of the *Aeneid* begin with a large painted initial (folios 22, 31, 40v, 50, 62v, 69, 78, 91v, 104, 116, 131, 146v, 161, 173v, 187v, 203, 219).

Bartolomeo Sanvito, the scribe of the Paris Virgil, was active in Padua in the early 1460s, went to Rome in 1464–5, and was again in Padua from about 1466 to 1469; by 1470 at the latest he had transferred again to Rome (Albinia de la Mare, verbal communication). He wrote a number of manuscripts for the Venetian nobleman Marcantonio Morosini, including a Suetonius, *Vitae Caesarum* dated 1461 (Pellegrin 1975, I, p. 144), and a Cicero *Epistolarum ad Atticum* dated 1463, the latter also with putti attributable to Zoppo (Alexander 1969b). Thus although the oxidised field of the Virgil might be assumed to have been silver, and therefore the arms would be those of the Sanudo family (Paris 1984, no. 115; Mariani Canova 1993, p. 121), Albinia de la Mare believes that the field was gold, appropriate for Sanvito's important

patron, Marcantonio Morosini. Regardless of the patron, formal comparisons to Zoppo's works indicate that the manuscript was most likely executed after 1466, when Sanvito was again in Padua, and Zoppo was in near-by Venice.

Provenance: Coat of arms of the Morosini of Venice (*or a bend azure*), or Sanudo of Venice (*argent a bend azure*); Andrea de Minuccius to Maximus de Maximi (1614); Simeon Difnico, Bishop of Feltre (r. 1649–1662); Pope Pius VI (r. 1775–1799; arms on binding).

Exhibition: Paris 1984, no. 115.

Bibliography: Alexander 1969b, pp. 514–17; Mariani Canova 1969, pp. 107–8, 147–8; Armstrong 1976, pp. 424–6; Florio 1981, pp. 66–7; Blume 1986, pp. 185–6; Erdreich 1993, pp. 126, 381; Mariani Canova 1993, pp. 121–35.

L. A.

73

Eusebius, *Chronica*, translated from Greek by St Jerome

152 fols. 334 × 233 mm. On parchment

Script attributed to Bartolomeo Sanvito of Padua in Rome, c. 1485-8, with illumination attributed to Gaspare da Padova

LONDON, THE BRITISH LIBRARY, Royal MS 14 C. III

The text is a comparative world chronology of Biblical, Roman and other events, composed in the early 4th century by Eusebius, Bishop of Caesarea (*d. c.* 340), and translated from Greek into Latin at the end of the same century by St Jerome. The manuscript opens with a striking architectural frontispiece, folio 2. The text, written in gold and coloured capitals, is flanked by two gold colums with bands of military scenes, rendered as if carved, thus evoking Trajan's Column in Rome. A small miniature shows St Jerome accompanied by his lion and sitting in a landscape beside an altar, on which a faceted initial 'E' is placed as

if it were a three-dimensional object. In the border below, a putto in a bearded mask frightens his two companions. The arms of Bernardo Bembo (1433-1519) are painted on the imposts of the two columns on either side. The whole is surrounded by brown-coloured paint stippled or shredded onto the vellum. Throughout the manuscript drawings in purple, green and pink frame the chronology headings at the top of each page with half circles and also frame many of the headings of the text with classicising motifs, such as trophies of arms, vases, altars, sphinxes, etc. (e. g. folios 58v, 91v, 94, 138).

A particularly ornate stele which fills the whole page on folio 17 contains an adjuration, written in gold capitals, to careful copying to the scribe. In fact the script is attributable to one of the most skilled and also prolific of Italian scribes of the period, Bartolomeo Sanvito of Padua (*c.* 1435-1512). He here uses both his famous cursive ('italic') script and his formal hand (see cats 26, 39, 43, 71-4, 77), and writes in the same coloured inks as used for the drawings – brown, purple, green, blue, pink, red and yellow. There are also faceted initials with classicising acanthus on folios 4, 6, 8, 9v, which are typical of those in other manuscripts written by Sanvito and decorated by the same artist. Sanvito made three other copies of this text between *c.* 1470 and 1490

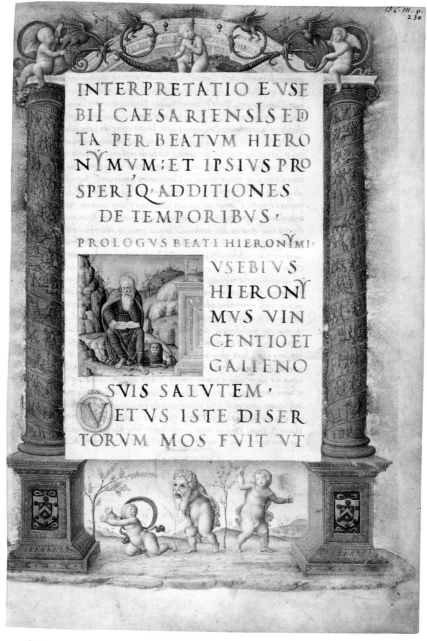

73 folio 2r

with identical lay-out, including the use of coloured inks for the text and almost identical iconography for the decorative drawings, which suggests he devised and kept an exemplar (Albinia de la Mare, written communication).

Sanvito also wrote at least four other surviving manuscripts (see also cat. 74) for Bernardo Bembo, who described him as 'my honoured compatriot'. Bembo, member of a Venetian aristocratic family, a humanist educated at the University of Padua, and diplomat for the Venetian state, was in Rome in 1485 and again in 1487 and 1488. These are likely dates for the making of the present manuscript.

A second miniature illustrates the text where the *Chronicle* reaches the year of Christ's nativity, folio 119v. It is simply framed and shows the Virgin adoring the Child with St Joseph, the saddle of the donkey beside him. It seems that here the miniature was executed before the script since the latter appears to overlap it.

The same illuminator also worked on a group of manuscripts made for curial patrons in Rome in the 1470s to 1480s, for example for Sixtus IV (cat. 38) and for Cardinal Giovanni d'Aragona (cats 40, 41). A number of suggestions as to his identity have been made in the past. From recently published documents it seems that he is identifiable from the Homer made for Cardinal Francesco Gonzaga (cat. 39, dated 1477) as Gaspare da Padova, like Bartolomeo Sanvito a member of the Cardinal's household from the early 1460s to the Cardinal's death in 1483. Gaspare includes many allusions to works of Classical Antiquity in his miniatures and borders. He is also stylistically indebted particularly to Andrea Mantegna, trained in Padua and court painter of the Gonzaga from 1460 onwards. Another connection with Mantegna is through Jacopo Sannazaro's *Arcadia*, written after 1491, which describes in an ekphrastic passage a vase purportedly painted by Mantegna with the motif of the putto and the mask. The motif, which is of Classical origin, is widespread, however, being found on a bronze plaque of perhaps the 1460s, in other manuscripts, including the Valerius Maximus of Cardinal Giovanni d'Aragona (cat. 41) and in paintings and drawings (Evans 1985; London 1992, no. 149).

Provenance: Arms of Bernardo Bembo (1433–1519), folio 1; Pietro Bembo (d. 1547); given with the Old Royal Library to the British Museum by King George II in 1757.

Exhibitions: Malibu, New York and London 1983–4, pp. 103–6, no. 13.

Bibliography: Warner and Gilson 1921, II, p. 133, pl. 82; Fairbank and Wolpe 1960, pl. 8; Wardrop 1963, pp. 24–5, 29, 32, 51, pl. 18; Fairbank 1966, pp. 3–5, pl. 3; Alexander and de la Mare 1969, p. 108; Ruysschaert 1969, p. 267; Clough 1971, p. 4, pl. 1; de la Mare 1984, p. 286, no. 6; Evans 1985, pp. 123–30, fig. 1; Giannetto 1985, esp. p. 352; Ruysschaert 1986, p. 45; Alexander 1988a, p. 123; Settis 1988, p. 174, fig. 26; Bauer-Eberhardt 1989, pp. 73–4, no. 43, fig. 15; Erdreich 1993, pp. 190–4.

J.J.G.A.

74

Suetonius, *Vitae duodecim Caesarum*

164 fols. 276 x 180 mm. On parchment [London only]

Script attributed to Bartolomeo Sanvito of Padua in Rome, c. 1475–85, with illumination attributed to Gaspare da Padova

PARIS, BIBLIOTHÈQUE NATIONALE, latin 5814

The *Lives of the Twelve Caesars* written by Caius Tranquillus Suetonius (75–160 AD) was a particularly popular text in the 15th century and numerous finely illuminated copies survive. It was also one of the first books to be printed. This is one of the most richly illuminated manuscript examples, and it is also written by the outstanding Paduan calligrapher Bartolomeo Sanvito of Padua (c. 1435–1512), who at this period was living in Rome in the household of Cardinal Francesco Gonzaga, until the Cardinal's death in 1483 (see cat. 39). He only returned to his hometown, where he was a canon of Monselice, at the end of his life. He wrote two other copies of the text, one for Lodovico

Agnelli (for whose Virgil see cat. 43), which was formerly in the library of the Duke of Wellington (Wardrop 1963, pl. 17), the other now in Göttingen (Niedersächsische Staats- und Universitätsbibliothek, MS 2° Philol. 161 Cim; Schröter 1987-8), both similarly illustrated with coin portraits of the Emperors.

The frontispiece for the first Life, that of Julius Caesar, folio 1, consists of epigraphic Roman capitals written in coloured inks by Sanvito and framed by a structure of trophies of arms to either side with flanking putti; below is a plaque with the crossing of the river Rubicon which initiated Caesar's march on Rome; the giant who appeared as a portend blowing a trumpet is in the foreground (for this legend, see Wyss 1957). The initial 'A' is flanked by winged Victories writing on shields. The artist probably had in mind the well-known figures on the Arch of Constantine or, less likely, the Column of Trajan (Bober and Rubinstein 1986, no. 170).

There are faceted decorated capital initials for each of the twelve Lives: folio 22v, Octavius Caesar, 'G'; folio 54, Tiberius, 'P'; folio 75v, Caligula, 'G'; folio 94, Claudius, 'P'; folio 109, Nero, 'E'; folio 127v Galba, 'P'; folio 134v, Otho, 'M'; folio 138v, Vitellius, 'V'; folio 144v, Vespasian, 'R'; folio 152, Titus 'T'; folio 155v, Domitian, 'D'. They are accompanied by narrative scenes, for example Nero harping while Rome burns, or, often, the death of the Emperor. The artist inserts in the borders at the beginning of each Life representations of relevant Roman Imperial coins, for example on folio 75v for the Emperor Caligula. He thus draws on an antiquarian tradition of the study of Roman coins with its origins in the Trecento (Schmitt 1974).

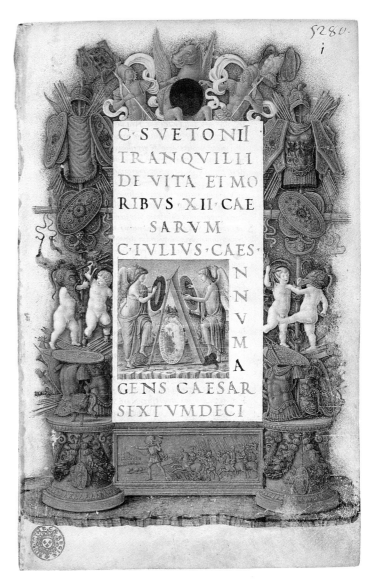

74 folio 1r

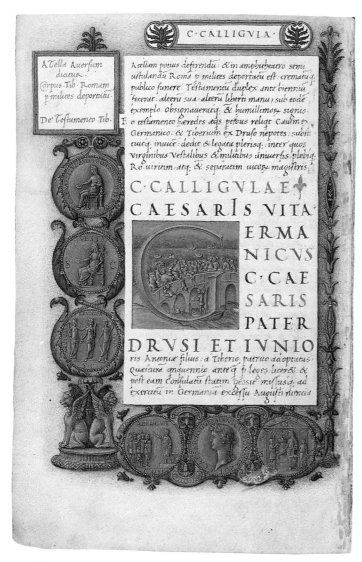

74 folio 75v

The original owner of this copy is unfortunately unknown, since the arms which were probably once in the central shield below the initial 'A' are erased. The winged horse, Pegasus, shown above holding the silver coin type of Julius Caesar, may, however, indicate that it was the Venetian patrician, Bernardo Bembo (Erdreich 1993, p. 386), since a Sallust in the Houghton Library, Harvard University (MS Richardson 17) contains Bembo's arms and motto accompanied by such a Pegasus. A Eusebius (cat. 73) written for Bembo by Sanvito and decorated by the same illuminator, who is now to be identified from the Vatican Homer of Cardinal Francesco Gonzaga as Gaspare da Padova (cat. 39), also uses the motif of the putto who pushes his hand though a helmet's mouthpiece to frighten his companion, as on folio 1. The present manuscript is an outstanding example of Gaspare's learned and antiquarian style of decoration, which stems from the Paduan artistic milieu of Mantegna, to which he was clearly indebted (see also cats 40, 41, 73).

François Avril (in Paris 1984, no. 145) has pointed out that the frontispieces of the various Lives in the present manuscript were copied in the following century, probably at Rome, for Cardinal Georges d'Armagnac (d. 1585), in a manuscript now in Paris (Bibliothèque nationale, nouv. acq. lat. 637).

Provenance: Reached the French Royal Library with the numismatic collections of Louis XIV (1638-1715), who acquired it from a Roman collector, the cavaliere Gualdo; while still in his collection it was described by the English royalist and antiquary Richard Symonds (1617-1692?), during his visit to Rome in 1651.

Exhibition: Paris 1984, no. 145.

Bibliography: Alexander 1977a, 64, 67, pls 13-14; Cook 1980, pp. 5-6; de la Mare 1984, p. 287; Bober and Rubinstein 1986, p. 202; Ruysschaert 1986, pp. 42, 45; Schröter 1987-8, p. 86, figs 15-25; Bauer-Eberhardt 1989, pp. 54, 75-6, no. 49, fig. 16; Erdreich 1993, pp. 208-12, 386.

J.J.G.A.

75

Flavius Josephus, *Bellum Judaicum*

245 fols. 306 x 204 mm. On parchment. Original blind stamped binding with metal clasps and foredge painting of the arms of Naples (replaced with a modern binding) [New York only]

Written by an anonymous scribe in Rome, c. 1475-85, with rubrics attributed to Bartolomeo Sanvito and illumination attributed to Gaspare da Padova

VALENCIA, BIBLIOTECA GENERAL DE LA UNIVERSIDAD, MS 836 (G. 1217)

Flavius Josephus was born c. 37/8 AD into an upper-class Jewish family and was a priest and Pharisee. After the Jewish Revolt, in which he himself took part and was captured, he lived for the remainder of his life in Rome, receiving citizenship. His account of the Revolt, written in seven books in Aramaic, was translated into Greek c. 75-9. It deals in the first one and a half books with the period of Jewish history from the revolt of the Maccabees to 66 AD, and then describes in greater detail in the remaining books the Revolt itself, which ended with the capture of Jerusalem by Titus in 70 AD, at which Josephus was himself present. A Latin version of the text circulated throughout the Middle Ages.

The Prologue opens (folio 1) with the title and first words written in coloured epigraphic capitals as if on a plaque, held at the corners by putti who stand or sit on the architectural structure framing the page. Below is a frieze of putti, one of whom in the centre supports the arms of Alfonso of Aragon, Duke of Calabria (1448-1495). The arms are repeated to either side, held by putti, and in the centre above are accompanied by an eagle. There are trophies of war on the side pilasters. A small miniature inserted in the text contains a scene of a priest with soldiers sacrificing at an altar, on which is a standing figure with spear and shield, probably intended for Mars, god of war. An initial 'Q' dangles from a ribbon.

The opening of Book I (folio 4) is introduced by another frontispiece in which the title is written again in coloured epigraphic capitals as if on a plaque held from above by putti on each side. Classicising motifs are combined to form a structure with sphinxes, putti and vases; below are two trompe l'œil reliefs, one of a putto wrestling with a lion, the other of two putti embracing. In the centre below, and also repeated above, are Alfonso's arms. Below they are flanked by putti and trophies of arms. A small miniature, with a faceted initial 'C' dangling on a ribbon, shows the presentation of the book by Josephus, wearing a pastiche of Roman military dress, to two seated crowned figures, no doubt Vespasian and his son Titus.

There are faceted initials with architectural frames to each of the remaining seven books: folio 57, 'T'; folio 103v, 'P'; folio 132, 'Q'; folio 149v, 'A'; folio 167, 'T'; folio 198v, 'C'. A variety of classicising motifs are incorporated into the frames and accompany the initials. They include putti sacrificing at an altar, centaurs flanking a trophy of arms (see also cat. 78), fauns and hippocamps. The illumination is of uniformly high quality and can be attributed to Gaspare da Padova, documented as the artist of the Vatican Homer of Cardinal Francesco Gonzaga written in 1477 (cat. 39). The illumination in a Caesar in the Biblioteca Casanatense, Rome (MS 453), and in a *Scriptores historiae Augustae* in the Biblioteca Nazionale, Rome (V. E. 1004), is very simi-

lar in style and content. The rubrics on folio I are probably by Bartolomeo Sanvito of Padua, with whom Gaspare often collaborated (see cats 38-41, 73-4). The other title-pages, perhaps by an imitator of Sanvito, are magnificent examples of epigraphic coloured capitals. The main scribe is so far unidentified, but he also copied a Quintus Curtius for Giovanni Pietro Arrivabene (Vatican, Biblioteca Apostolica Vaticana, Ottob. lat. 1741).

Since the Kings of Naples incorporated the arms of the Kingdom of Jerusalem into their arms by virtue of their hereditary claim (see also cat. 12), it is understandable that Alfonso should have commissioned such an especially sumptuous copy of this particular text.

Provenance: Arms of Alfonso of Aragon, Duke of Calabria (*b.* 1448), succeeded as King Alfonso II of Naples (*r.* 1494-1495); De Marinis 1947-52, II, inventories A, no. 113, B, no. 164, and G, no. 140; Cherchi and De Robertis 1990, p. 219, inventory of 1527; bequeathed to San Miguel de los Reyes, Valencia, by Ferdinand of Aragon, Prince of Taranto, in 1550.

Bibliography: Gutiérrez del Caño 1913, no. 1217; Bordona 1933, II, no. 2026, figs 676-7; De Marinis 1947-52, I, p. 74 n. 29, II, p. 88, pls 121-6 (as Valencia MS 819); Alexander and de la Mare 1969, p. 108; Ruysschaert 1969, pp. 266-7; de la Mare 1984, p. 290, no. 38; Ruysschaert 1986, p. 45; Bauer-Eberhardt 1989, p. 72, no. 37, fig. 14; Erdreich 1993, p. 384.

J. J. G. A.

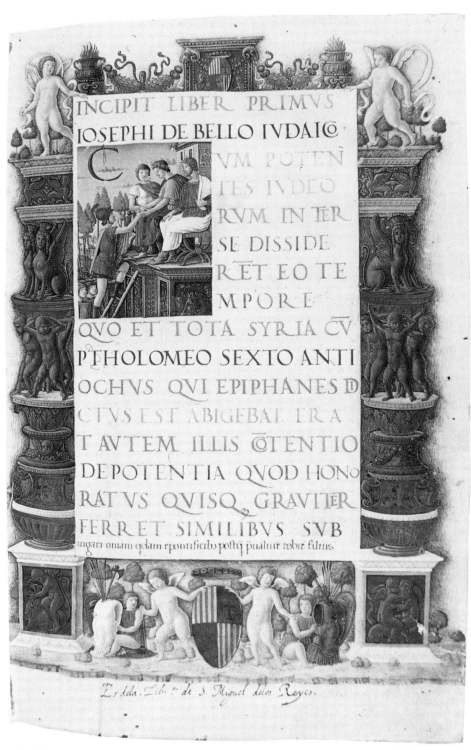

75 folio 4r

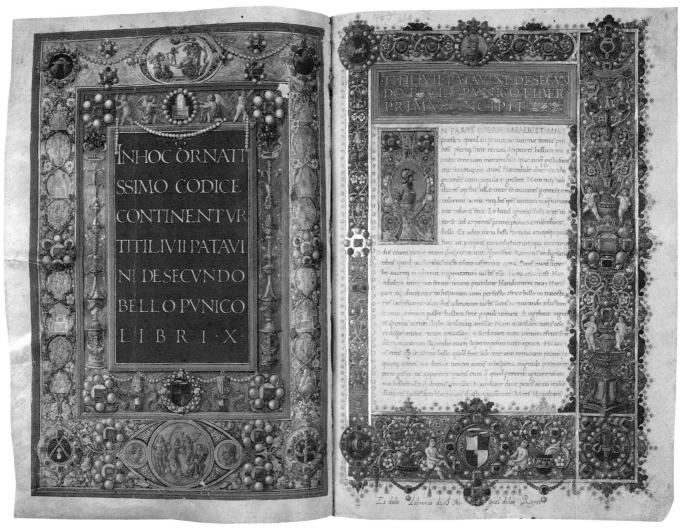

76 folios 2v, 3r

76

Livy, *Roman History*, Third Decade

244 fols. 367 x 255 mm. On parchment [London only]

Script attributed to Messer Piero di Benedetto Strozzi in Florence,
c. 1480-90, with illumination attributed to Gherardo di Giovanni di Miniato

VALENCIA, BIBLIOTECA GENERAL DE LA UNIVERSIDAD, MS 384
(G. 1314)

The illumination consists of an ornate framed page with the title writ-
ten in gold capitals on blue in the centre. An inner border is decorated
with simulated pearls and jewels as well as flanking candelabra. A
broader outer border of foliage and flowers and also with simulated
jewels and pearls contains medallions with simulated cameos based on
the famous Medici gems of the chariot of Dionysus and of Dionysus
and Ariadne on Naxos (Dacos, Giuliano and Pannuti 1973, nos 8, 33;
see also cats 3, 85). In the centre of the inner border below are the arms
of the patron, Alfonso, Duke of Calabria (1448-1495) flanked by his
motto 'No son tales amores', and his *imprese* are contained in roundels in
both borders. On folio 3 a half-length military figure, no doubt repre-
senting the Carthaginian general Hannibal, is in the initial 'I', and
there is a border of foliage, pearls, a candelabrum to the right, and
putti. Roundels again contain the *imprese* of the Duke and his arms are
in the centre below, flanked by putti. Initials of seven to nine lines with
borders, in which Alfonso's *imprese* are included, for the other nine
books are: folio 27v, 'I'; folio 54v, 'H'; folio 78, 'V'; folio 100v, 'D';
folio 123, 'C'; folio 149, 'H'; folio 176, 'C'; folio 202v, 'S'; folio 222, 'C'.

The illumination is attributed by Annarosa Garzelli (in Garzelli and
de la Mare 1985) to the Florentine illuminator, Gherardo di Giovanni
di Miniato, brother of Monte, who died in 1497. The brothers assisted
Ghirlandaio in various projects and Gherardo also worked in mosaic,
as we know from Vasari. In the Pliny illuminated by Gherardo for
Filippo Strozzi (cat. 85) the same two Medici gems are represented. De
Marinis suggested that the present manuscript be connected with the
payment to Vespasiano da Bisticci in Florence via the merchant Juliano
Gondi from the royal accounts in 1479 (De Marinis 1947-52, II, p. 267,
doc. 531). However De Marinis himself included the present Livy with
manuscripts made for Alfonso as Duke, not King, and Albinia de la
Mare connects the 1479 payment with the vernacular Livy, Valencia
MS 382 (formerly 755), for which see cat. 49 (Garzelli and de la Mare
1985, p. 451). The present manuscript forms part of a set with Valencia
MSS 385 and 482, both also copied by Piero Strozzi (see also cat. 69).

Provenance: Arms, *imprese* and motto of Alfonso of Aragon, Duke of
Calabria (*b.* 1448), succeeded as King Alfonso II of Naples (*r.* 1494-1495);
De Marinis 1947-52, II, inventory G, no. 384; Cherchi and De Robertis
1990, pp. 210-11, inventory of 1527, no. 152; bequeathed to San Miguel de
los Reyes, Valencia, by Ferdinand of Aragon, Prince of Taranto, in 1550.

Bibliography: Gutiérrez del Caño 1913, no. 1314, pl. 15 (mislabelled); Bor-
dona 1933, II, no. 2040, figs 687-8; De Marinis 1947-52, I, pp. 144 n. 61,
157, II, p. 98, pls 148-50 (as Valencia, MS 63); Garzelli 1985a, fig. 6; Garzelli
and de la Mare 1985, pp. 295-6, 532, figs 944-9.

J. J. G. A.

LAVDES BELLICAE

ILIACAS ALII
FLAMMAS THE
BANAQVE FRA
TRVM ARMA
ET IASONIIS
INSIGNEM HEROIBVS ARGO

A strox cursus & ditis inania regna.
F ictaq; pierio referant miracula cantu:
N os proprys spectanda oculis. nos inclyta dextrae
F acta tuae canimus: quibus aurea sydera vivus
T angis: & aetherias fama petis arduus arces:
S ed sine Te nunq; tenues ad carmina tanto
S ubsistant uires oneri. Tu numine toto
D exter ades: da maeoniam tua facta canenti
M atthia coruine chelyn: si delphica parent
T empla Tibi: sentitq; frequens tua nomina cyrrha
S i musae si phoebus amant hoc tempore solus
C arminibus si digna facis: quae nulla uetustas

77

Alexander Cortesius, *Laudes bellicae*

34 fols. 275 x 175 mm. On parchment. Late 15th-century binding, crimson
silk with goffered gilt edge [London only]

Script attributed to Bartolomeo Sanvito of Padua in Rome, c. 1487-8,
with illumination attributed to Petrus V--- (?)

WOLFENBÜTTEL, HERZOG AUGUST BIBLIOTHEK,
Cod. Guelf. 85.1.1. Aug. 2°

The text of this small but well-known manuscript, *In Praise of Military
Virtues*, was composed in Rome by a papal secretary, Alexander Cor-
tesius (*c.* 1460-1490), for presentation to Matthias Corvinus, King of
Hungary (*c.* 1443-1490), as part of a campaign to obtain Corvinus'
support for Pope Innocent VIII's military campaigns (Wolfenbüttel
1989, p. 233). The script is that of the most famous contemporary
scribe, Bartolomeo Sanvito (*c.* 1435-1512), who was active in Rome in
the late Quattrocento (see cats 39, 73-75).

The illumination of the frontispiece and the folio opposite it (folios
2v-3) has many North Italian characteristics, but by the late 1480s
when the text was written, the Veneto-Paduan style had been carried
to Rome by miniaturists seeking work from members of the papal
entourage. The illusionistic devices developed on folio 3 are literally
multilayered. The cursive text appears to be written on an ex-
aggeratedly torn piece of parchment; holes in the parchment along
the right side reveal bits of candelabrum base and bodies of putti. This
'folio' appears to be nailed to an irregular shaped plaque supported by
a putto; a second plaque, edged in pink rather than green, hangs above
the first, in turn suspended by strings from the bright green cornice of
an architectural monument. Other significant objects are also 'hung'
from the monument and plaques. The portrait of Matthias Corvinus
on a bronze medallion hangs in the space reserved for the first initial.
A second smaller medallion with the Corvinus crow, and another
small plaque with the capital 'I' on it also dangle in the same reserved
space. The candelabra/columns in the side margins bristle with

attached weapons and shields, while putti on the upper cornice sup-
port other trophies. On the bronze base of the architectural monument
is a relief of a city gate, a visionary Queen in glory holding a chalice
and standing on a crescent moon, and military men on horseback.
Compared to this bewilderingly complex composition, the opposite
verso is an area of calm (folio 2v; Wolfenbüttel 1989, pl. 112). The
rhymed text is surrounded by a simple pink frame. Two putti above sit
on the frame and support an oval plaque inscribed 'AD LIBRUM', while
in the bottom margin putti with flowering fish-tails flank the King's
coat of arms.

The architectural composition and the putti are probably a late
developement in the style of Petrus V---, the miniaturist whose par-
tially legible name is inscribed on the frontispiece of a Pliny printed in
Venice in 1476 (cat. 86). Petrus illuminated several Venetian incunables
and manuscripts in the late 1470s, and around 1480 was probably
drawn to Rome, perhaps as the result of having illuminated a copy of
Eusebius' *Chronica* (Geneva, Bibliothèque publique et universitaire,
MS lat. 49) for Celso Maffei (1415/25-1508), member of a noble Ver-
onese family who rose to great prominence as a member of the Augus-
tinian Reformed Lateran Canons (Armstrong 1990b, pp. 402-3). The
Geneva Eusebius and other manuscripts of the 1480s closely related to
the Wolfenbüttel Cortesius had earlier been attributed by Maurizio
Bonicatti to the monumental painter Giorgio Schiavone (*fl. c.* 1450-
1504), but Bonicatti did not consider the extensive documentation that
places Schiavone virtually continuously in Sebenico in this period
(Bonicatti 1964, pp. 45-6, 185-6; Kolendic 1920, pp. 117-90). The
links of style and patronage instead argue for Petrus V---.

Provenance: Matthias Corvinus, King of Hungary (*c.* 1443-1490); George
of Brandenburg; gift to Vincentius Obsopoeus; before 1627 in the collec-
tion of Herzog August of Braunschweig-Lüneburg (1579-1666).

Exhibitions: Budapest 1983, no. 71; Wolfenbüttel 1989, p. 233 (with earlier
exhibitions and literature).

Bibliography: Heinemann 1894-1903, IV, pp. 88-90, no. 2884; Csapodi and
Csapodi Gárdonyi 1969, pp. 76, no. 186, 298-9, pl. CIX (folio 3); Alex-
ander and de la Mare 1969, p. 109; Armstrong 1990b, pp. 404-9, 412,
fig. 24 (folio 3).

L. A.

The Hand-Illuminated Printed Book

The German invention of printing with movable types was introduced into Italy in 1465 at Subiaco, near Rome, and then in Venice in 1469. The new industry developed with remarkable rapidity, especially in Venice; by 1500 about 3,500 editions had been printed there, issued by over 100 different printers. For more than two decades, printers in Italy resisted decorating their books with woodcut borders or illustrating them with narrative woodcuts. Instead, thousands and thousands of individual printed books were 'finished' by hand. Trained scribes provided chapter headings and capital letters; professional illuminators painted decorative and historical initials, and also beautiful borders. The books exhibited in this section represent the most splendid known examples of this transitional phenomenon, printed on parchment, with elaborate frontispieces painted by well-known illuminators for wealthy patrons. By the 1490s, however, the hand-illuminated printed book became a rarity, superseded by books decorated with woodcuts printed simultaneously with the texts, signalling the end of the illuminator's profession in Italy.

78

Pliny the Elder, *Natural History*

Gaius Plinius Secundus, *Historia naturalis*, printed in Venice by Johannes de Spira in 1469. Roman type (HCR 13087; IGI 7878)

Volume I: 196 fols. 269 x 398 mm. On parchment [London only]

Illumination attributed to Giovanni Vendramin in Padua, c. 1469

RAVENNA, BIBLIOTECA CLASSENSE, Inc. 670/I

The first page of this incunable, one of the first to be printed in Venice, is a monumental architectural title-page; the printed text appears to have been handwritten on parchment on an ancient *volumen* which hangs from the top of a Classical edifice and is unfurled by winged putti. A deep blue aureole behind the architectural structure throws the whole edifice into relief. The building is of coloured marble, and is flanked by two tall, dead trees; it is populated by cherubs playing musical instruments, and there are Classical bas reliefs painted in grisaille on the structure. At the bottom the coat of arms of the original owner has unfortunately been long since erased. At the beginning of the text there is a large 'littera mantiniana' looking as if it were painted on the parchment of the old *volumen*; it is done in fake carving on a green marble medallion which is richly decorated with Classical reliefs, also in monochrome.

The trompe l'œil and the Classical imagery are typical of the illusionism and the interest in Antiquity fashionable in Paduan painting in the second half of the 15th century. Simpler architectural title-pages and fake Antique parchment appear in many Paduan illuminated manuscripts of the 1450s and 1460s, but it is possible that the inventor of this superb combination of architecture and parchment, a combination which later enjoyed widespread popularity in Venetian and Italian miniature painting of the Renaissance, may have been the Paduan miniaturist Giovanni Vendramin, to whom this page is generally attributed (see also cat. 79). In style it resembles the page from one of the Choir Books of Ferrara Cathedral, for which Vendramin was paid in 1482 (Ferrara, Museo del Duomo, Antiphonary 2).

Vendramin is first mentioned in 1466 as a painter and the adopted son of Francesco Squarcione, in whose studio the leading painters of Padua, including Andrea Mantegna, Marco Zoppo and Giorgio Schiavone, were trained. Vendramin's real father was a university bookseller (*bidello*); his son later devoted his career to book illustration. The idea of painted architecture as a backcloth derived from Donatello's altar in Sant' Antonio, Padua; the figures of the saints were displayed like actors on a stage, or relics in a reliquary. Mantegna's painted architecture in the San Zeno altarpiece employs the same principle. On the page exhibited here Vendramin borrows several ideas from Donatello's altar, including the carved tympanum. Pliny's text is displayed like a Classical relic. Vendramin was certainly influenced by masterpieces of Venetian Renaissance illumination, the *Passio Mauritii* (Paris, Bibliothèque de l'Arsenal, MS 940); the Strabo *Geographia* (cat. 29) executed in the 1450s for Jacopo Marcello as well as the masters associated with Bartolomeo Sanvito (cats 39, 71), both in his taste for painted architecture and the delicacy of his painting. The work of the illuminators of Hyginus' *De astronomia* (cat. 51) must also have

78 page I

been familiar to him. The figure of Arctophylax can be compared to the warriors on the reliefs in the Pliny. He learned his taste for strong colours and imaginative decoration from Franco dei Russi (cats 71, 82, 83, 113).

We do not know for sure whose coat of arms was erased, but it may have been that of the Bishop of Padua, Jacopo Zeno (*r.* 1460-1481), whose superb library was broken up immediately after his death. The remains of the library, now in the Biblioteca Capitolare in Padua, show that Giovanni and his collaborators were heavily involved in the illumination of printed volumes. The second volume of this *Historia naturalis* also has a beautiful title-page, and both volumes have admirably decorated initial letters at the beginning of each book.

Provenance: Acquired from Abate Pietro Canneti in 1719.

Exhibitions: Rome 1953, no. 602; Brussels 1969, no. 74.

Bibliography: Cappi 1847, pp. 92-8; Salmi 1961, pp. 47-48; Bonicatti 1964, pp. 47 n. 2, 51, 180; Puppi 1968, p. 324; Mariani Canova 1969, pp. 110, 146-7; Mariani Canova 1988 b, pp. 83-5.

<div style="text-align: right">G. M. C.</div>

79 folio 2r

79

Cicero, *Orations*

Marcus Tullius Cicero, *Orationes*, edited by Ludovicus Carbo, printed in Venice by Christophorus Valdarfer, [not after 9 November] 1471. Roman type (HRC 5122; Goff C-452)

275 fols., of which fol. y3 wanting, substituted by an inlaid leaf from a different edition (text not joining). 330 x 220 cm On parchment

<div style="text-align: right">[New York only]</div>

Illumination attributed to Giovanni Vendramin, Padua or Venice, c. 1471

PHILADELPHIA, THE ROSENBACH MUSEUM AND LIBRARY, Inc 471ci (1062/24)

Dozens of editions of Cicero's writings were printed in Italy in the 15th century, reinforcing the high position awarded to the author by the humanist movement. Great excitement had attended the 1415 discovery by Poggio Bracciolini at Cluny of a manuscript containing five of Cicero's *Orations*, up to then unknown to the humanists (Reynolds and Wilson 1974, pp. 121-2; GW, VI, col. 542, on *Orations* known in the 15th century). These *Orations* are included among the 32 in the edition printed by Conradus Sweynheym and Arnoldus Pannartz in Rome, 1471, edited by Johannes Andreae (Giovanni Andrea Bussi, 1417-1475), Bishop of Aleria (HR 5121), and among the 28 in the Venetian version of Cristoforo Valdarfer, dated in the same year and edited by Lodovico Carbo (*c.* 1436-1482), a humanist at the Este court in Ferrara (Gundesheimer 1973, pp. 165-7; Lowry 1991, pp. 61-2).

The architectural frontispiece of the Rosenbach Library Cicero is a delightful addition to the œuvre of a prolific miniaturist, Giovanni Vendramin (*fl.* 1466-*c.* 1509), who also later worked in Ferrara (Mariani Canova 1988b). Son of a *bidello* (official bookseller) of the University of Padua, Giovanni painted one of the first great architectural frontispieces to appear in a Venetian printed book, the opening folio of the 1469 *Natural History* of Pliny now in Ravenna (cat. 78; see p. 42). From 1471 to 1475 he illuminated eight more Venetian incunables and two manuscripts, mostly for Jacopo Zeno, Bishop of Padua (*r.* 1460-1481) (Mariani Canova 1988b; Armstrong 1990a, p. 15 n. 31; Paris, Bibliothèque nationale, Vélins 563, Plautus, *Comoediae*, Venice, Vindelinus de Spira, 1472). His sole documented work is an elaborately illuminated folio in an Antiphonary for the Cathedral of Ferrara, dated 1482, but the miniatures, historiated initial and decorative motifs of this folio are sufficiently distinctive so as to permit the many additional attributions.

The opening text of the 1471 Valdarfer *Orations* (folio 2) appears to have been printed on a piece of parchment unrolled in front of a stele, purple at the base and deep red on the sides. Gold letters spell out the title across a mottled green and red frieze, and two putti standing on the cornice hold strings 'supporting' the parchment page. Like their blond counterparts at the bottom of the monument, these brown-haired putti have strings of red beads around their necks and wear delicately outlined Classical sandals. These features remain a standard part of Vendramin's vocabulary as late as the 1482 Antiphonary folio. The partially dead tree and the peacock in the left margin also reappear in other securely attributable works.

In addition to the faceted capital 'Q' of the frontispiece, the Rosenbach Cicero contains thirteen other large gold initials on alternating blue and pink grounds accompanied with vine motifs.

Provenance: Coat of arms of the Fratta di Porcia e Brugnera in Friuli (Morando di Custoza 1985, pl. DVII), or Portia of Milan (*azure six fleurs-de-lys or, a chief or*); De Angeli; Sir Thomas Phillipps; T. Fitzroy Fenwick; purchase by Rosenbach Co., 1923.

Exhibition: Philadelphia and New York 1988, no number.

Bibliography: Armstrong 1990a, p. 15 n. 31.

<div style="text-align: right">L. A.</div>

T· LIVII PATAVINI HISTORICI PRECLARISSIMI DE SECUNDO BELLO PUNICO DECADIS III LIBER I

IN parte operis mei licet prefari mihi: quod in principio summe totius professi sunt plerique rerum scriptores: bellum maxime memorabile omnium: quae unquam gesta sunt: me scripturum. Quod Annibale duce: Carthaginenses cum Populo Romano gessere: Nam neque ualidiores opibus ulle inter se Ciuitates: gentesque contulerunt arma: Neque his ipsis tantum unquam uirium: aut roboris fuit: et haud ignotas belli artes inter se: Sed expertas primo punico coferebant bello: et adeo uaria belli fortuna: ancepsque Mars fuit: ut propius periculo fuerint: qui uicerent: Odiis etiam prope maioribus certarunt: quam uiribus: Romanis indignantibus: quod uictoribus uicti ultro inferrent arma: Poenisque quod superbe auareque crederent imperitatum uictis esse. Fama etiam est Annibale annorum ferme noue: pueriliter blandientem patri Hamilcari: ut duceretur in Hispaniam: cum perfecto Africo bello: exercitum eo traiecturus sacrificaret: altaribus admotum: tactis sacris iureiurando adactum: se cumprimum posset: hostem fore Populi Romani. Angebat ingentis spiritus uirum: Sicilia Sardiniaque amisse. Nam et Siciliam nimis celeri desperatione concessam: et Sardinia inter motum Africe fraude Romanorum: stipendio etiam superimposito interceptam. His anxius curis ita se Africo bello: quod fuit sub recentem Romanam pacem per· v· annos: ita deinde nouem annis in Hispania augendo Punico Imperio gessit: ut appareret maius eum: quod quod gereret agitare in animo bellum. et si diutius uixisset Hamilcare duce Poenos arma Italie inlaturos fuisse: qui Annibalis ductu intulerunt. Mors Hamilcaris peropportuna: et pueritia Annibalis distulerunt bellum. Medius Hasdrubal inter patrem et filium octo ferme annos Imperium obtinuit: Flore etatis uti ferunt: primo Hamilcari conciliatus. Gener inde ob aliam indolem profecto animi adscitus: et qua gener erat factionis Barchine: opibusque apud milites plebemque plus quam modice erant: haud sane uoluntate principum in Imperio positus. is plura consilio quam ui gerens: auspitiis Regulorum magis conciliandisque per amiciciam principum nouis gentibus quam bello: aut armis Rem Carthaginensem auxit: Ceterum nihilo ei pax tutior fuit. Barbarus eum quidam ob iram palam interfecti ab eo domini obtruncauit: comprehensusque a circunstantibus: haud alio quam si euasisset uultu: tormentis quoque cum laceraretur eo fuit habitu oris: ut superante leticia dolores: ridentis etiam spem prebuerit: Cum hoc Hasdrubale qua mire artis in sollicitandis gentibus: impioque iungendis suo fuerat: fedus renouauerat Po. Ro. ut finis utriusque imperii esset amnis Hiberus. Saguntinisque medius inter imperia duorum populorum libertas seruaretur.

In Hasdrubalis locum haud dubia res fuit: qn prerogatiuam militarem: qua extemplo iuuenis Annibal intra Pretorium delatus: Imperatorque ingenti omnium clamore atque assensu appellatus erat: Fauor etiam plebis sequebatur. Hunc uix dum puberem Hasdrubal ad se accersierat: Actaque res in Senatu etiam fuerat: Barchinis nitentibus ut assuesceret militie Annibal. atque in paternas succederet opes. Hanno alterius factionis princeps: et equum postulare uidetur inquit: Hasdrubal: et ego tamen non censeo quod petit: tribuendum: Cum admiratione tam ancipitis sententie in se omnes conuertisset: Florem etatis inquit Hasdrubal: quem ipse patri Annibalis fruendum prebuit: Iusto iure eum a filio repeti censet: Nos tamen minime decet iuuentutem nostram: pro militari rudimento assuefacere libidini Pretorum. An hoc timemus ut Hamilcaris filius nimis sero imperia immodica: et regni spem uideat? Et cuius Regis genero hereditarii sint relicti exercitus nostri: eius filio parum mature seruiamus:

80

Livy, *Roman History*, Third Decade

Titus Livius, *Historiae Romanae decades*, edited by Johannes Andreae Bishop of Aleria; printed in Rome by Conradus Sweynheym and Arnoldus Pannartz, [1469]. Roman type (HC 10128*)

Detached folio (Part II, fol. 167). 382 x 251 mm. On parchment
[London only]

Illumination attributed to the Master of the Putti, Venice, c. 1469

VIENNA, GRAPHISCHE SAMMLUNG ALBERTINA, Inv. 2587

A favourite motif for decorating Venetian books was the so-called 'architectural frontispiece' (see p. 42), and the leaf from a 1469 Livy in the Albertina is one of the earliest datable examples in an incunable, rivalled only by the 1469 Pliny now in Ravenna (cat. 78). The Albertina folio contains the initial text of the Third Decade of Livy's *Roman History*, from the *editio princeps* printed in Rome by Conrad Sweynheym and Arnoldus Pannartz, the first printers to be active in Italy (Feld 1985, 1986; see cat. 83). The Albertina frontispiece suggests that the copy from which it came was originally bound in two or three volumes, with the First and perhaps the Fourth Decades initiated by a similar frontispiece.

Delicately drawn in pen and sepia ink, and touched with watercoloured wash, the composition surrounding the printed text imitates a Roman triumphal arch, on which is hung a ragged piece of parchment. Counterbalancing the 'weight' of the parchment page are trophies, cornucopias, vases, bucrania, and roundels with portraits, all suspended on a red string beside the structure.

The anonymous miniaturist who created the Livy frontispiece is named the Master of the Putti because of the omnipresence of cherubs in his compositions (Mariani Canova 1966; Mariani Canova 1969, pp. 32-8, 108-9, 148-9; Armstrong 1981). In the Albertina Livy frontispiece, putti sit on the cornice flanking a roundel on which is inscribed the title of the book; at the sides of the supporting piers they play curving horns or investigate a vase of fruit; and at the bottom of the archway, ten of them engage in a furious battle over the coat of arms held aloft by yet another of their kind. As in several other frontispieces, the Master of the Putti here draws inspiration from a famous engraving derived from the Florentine artist Antonio Pollaiuolo (*fl.* 1457-*d.* 1498), the so-called *Hercules and the Giants* (Anderson 1968). A document of 1474, referring to an event which took place in Padua in 1462, litigates a dispute over the ownership of a Pollaiuolo drawing and thus provides secure evidence that Pollaiuolo designs were prized objects in northern Italy.

It is remarkable that the Albertina folio is one detached from a book printed in Rome, but illuminated by a Venetian miniaturist for a member of a noble Venetian family; the coat of arms of the Querini appear in the lower margin. The folio suggests that the earliest printed books were rapidly disseminated throughout Italy, and in this case illuminated in the city of the owner, far from the original place of production.

Provenance: Coat of arms of the Querini of Venice (*gules, on a chief azure three mullets or*); Duke Albert of Saxony-Teschen.

Bibliography: Schönbrunner and Meder 1901, VI, no. 601; Stix and Spitzmüller 1941, p. 36, no. 388; Anderson 1968, pp. 156-7; Mariani Canova 1969, pp. 32-8, 108-9, 149; Armstrong 1981, pp. 21-2, 102.

L. A.

81

Bible

Biblia [Italian], translated from Latin by Niccolò Mallermi, printed in Venice by Vindelinus de Spira, 1 August 1471. Roman type (HC 3150, Goff B-640; GW 4311)

Volume I: 327 fols of which 268-272 added in manuscript. 387 x 273 mm.
[New York only]
Volume II: 324 fols of which 188-195 added in manuscript. 415 x 280 mm. Both volumes on parchment

Illumination attributed to the Master of the Putti, Venice, c. 1471

NEW YORK, THE PIERPONT MORGAN LIBRARY, PML 26983, 26984 (ChL ff722)

The Bible printed by Vindelinus de Spira in Venice in 1471 is the first edition in Italian. The translation was made by Niccolò Mallermi (*c.* 1422-1481), a Camaldolite monk successively abbot at San Matteo and at San Michele in Murano. Surprisingly, another printer, Adam de Ambergau, also finished an Italian edition in 1471, the second half of which uses the Mallermi translation (HC 3148; GW 4321). These two Venetian publications are among the earliest Bibles to appear in the vernacular, preceded only by two editions in German printed in Strassburg (GW 4295, GW 4296).

Although the miniatures in both volumes of the Morgan Bible may be attributed to the anonymous miniaturist known as the Master of the Putti (Armstrong 1981), the two books may not originally have belonged together. Volume I presently includes the coat of arms of the Abbadessa family of Florence, but the shield is painted over another blazon, possibly Corner (or Cornaro) of Venice (folio 13). The arms in volume II are those of the Macigni family (folio 3v), also originally from Florence but citizens of Venice since 1429 and owners of several other hand-illuminated Venetian incunables. Further evidence of provenance is a colophon on the last of eight manuscript folios intruded into volume II (folio 195). It reads in part: '*scripta in sancto / mathia de murano*', indicating that the volume was once at the Camaldolite monastery with which the translator, Niccolò Mallermi, was associated. Whatever their origin, the two Morgan volumes were brought together by the early 19th century.

The first volume of the Morgan Bible is less elaborately decorated than the second, but nevertheless contains a frontispiece with an inventive miniature (folio 13), a historiated initial with *King David Praying* at the beginning of the Psalms (folio 275v), and numerous painted and flourished initials. Left blank by the printer, the upper third of the folio on which Genesis begins shows the *Creation of Eve*. Garments and details of the landscape are modelled in gold, to create the illusion of light. Framing the narrative is a brilliantly coloured arch decorated with profile portraits and enlivened by a putto holding a palm of victory; above his head is a scroll with the motto SOLA VIRTUTE. The archway draws inspiration from the monumental arts. The segmented shape of the arch is highly reminiscent of the new Arco Foscari in the courtyard of the Palazzo Ducale in Venice (Pincus 1976, p. 200, fig. 60).

An image of *David Praying* at the beginning of the Psalms (folio 275v) is closely related to a youthful King Solomon in a copy of the 1471 Italian Bible printed by Adam de Ambergau, now in Vienna (Österreichische Nationalbibliothek, Inc. 6. B. 2, volume II, folio 1), and the decorative motifs of the Morgan volume I frontispiece are virtually the same as the Vienna copy as well (Hermann 1931, no. 46, pl. XXVI).

The frontispiece to volume II is one of the most ambitious architectural and pictorial illusions to have been painted in any Venetian Renaissance book (folio 3v). The basic components of an 'architectural frontispiece' are depicted in dazzling colours (see p. 42). As in the frontispiece for the 1469 Livy (cat. 80), the Master of the Putti creates the illusion that the text is printed on a curling and frayed piece of parchment 'hung' on the architectural monument. A string of beads falls between the two columns of text; curling around this are two scrolls with the motto 'Know thyself' inscribed in Latin and Greek: NOSCE TE IPSVM and ΓΝΩΘΙ CE AYTON.

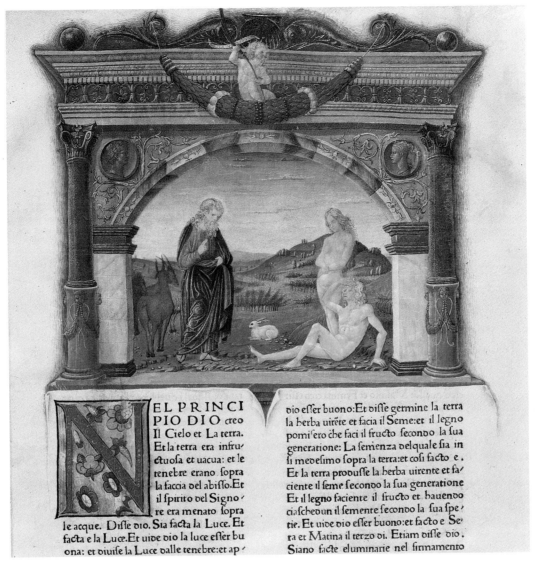

81 Volume I, folio 13r (detail)

More startling than this already complicated ensemble is the illusionism of the miniature occupying the upper quarter of the page. A scene with many figures in a landscape setting is surrounded by a rectangular frame with blue and green mouldings; it appears to be an independent 'picture' held up in front of the architectural monument by two winged putti who stand on the cornice. Such sophisticated *trompe l'œil* motifs are more reminiscent of the *quadri riportati* in Annibale Carracci's ceiling paintings at the end of the 16th century (Wittkower 1982, pp. 65–8) than of any 15th-century paintings, and they demonstrate the exceptional genius of the anonymous miniaturist, the Master of the Putti.

The choice of subject matter and the detailed landscape setting of the miniature also show the artist's progressive abilities. Identified as *The Shooting at Father's Corpse* by Wolfgang Stechow (1942), the miniature represents an apocryphal judgement of Solomon. A recently deceased man has willed his wealth to his son, but two (or possibly three) young men have claimed to be the heir. The youthful King Solomon, surrounded by his counsellors, has ordered the claimants to shoot arrows at the corpse of their father, suspended from a tree at the right. One false son has just loosed an arrow, but the true son kneels in the center, refusing to desecrate his father's body. Behind the figures a winding river and bridge as well as the distant hills touched with gold recall the famous landscape in Giovanni Bellini's *Agony in the Garden* of the mid-1460s (Goffen 1989, pl. 73), while the casual array of domestic buildings outside the town anticipates Carpaccio's scenes from the *Life of St Jerome* painted three decades later (Perrocco 1964, pl. IV).

Not only is the frontispiece of volume II more elaborate than volume I, but the book contains many more historiated initials as well. Miniatures of *St Jerome in Penitence* and of a deer in a landscape appear in the borders of folio 1v, and 30 initials contain images of prophets or saints at the beginnings of the appropriate books of the Bible (Armstrong 1981, figs 20–21).

Provenance: Volume I: Coat of arms of the Abbadessa of Florence (*argent, a roundel within two concentric rings sable*) painted over Corner of Venice (?) (*per pale or [?] and azure*; fol.13); Conte Gaetano Melzi of Milan, by whom united with volume II before 1820; Tammaro de Marinis; purchased by John Pierpont Morgan, Jr (1867–1943), 1929. Volume II: Coat of arms of the Macigni of Venice (*gules, three crescents palewise or that in chief facing dexter base the others facing dexter chief, overall on a bend azure three fleurs-de-lys or*; fol. 3v); Corsini Library; Count Gaetano Melzi of Milan, by whom united with volume I before 1820; Tammaro de Marinis; purchased by John Pierpont Morgan, Jr (1867–1943) in 1929.

Exhibitions: New York 1939, no. 222; New York 1947, no. 58; New York 1949, no. 127; New York 1957, no. 47; New York 1984, no. 34; New York 1992–3 (no catalogue); New York 1994a, p. 25.

Bibliography: Thurston and Bühler 1939, no. 722; Stechow 1942, pp. 213–25; Salmi 1961, p. 51; Armstrong 1981, pp. 15–6, 25–6, 106–7, pl. I, figs 18–21 (with earlier literature).

L. A.

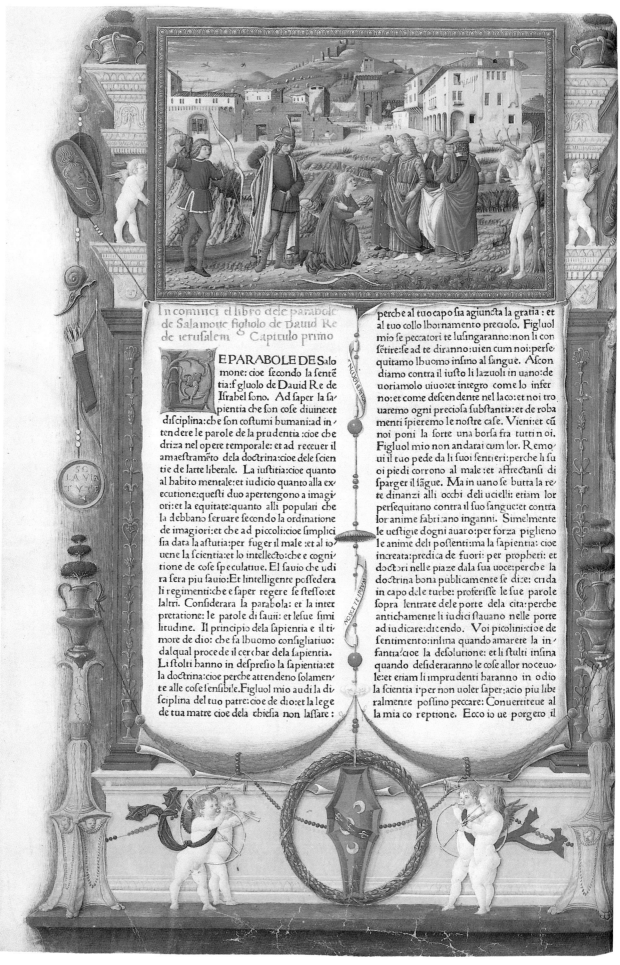

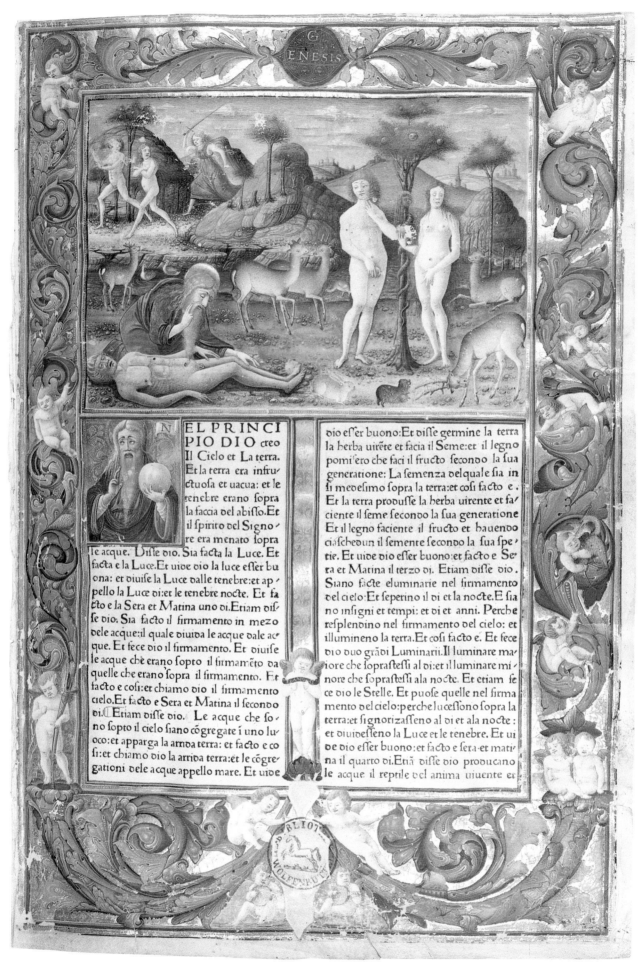

EL PRINCIPIO DIO creo Il Cielo et La terra. Et la terra era infructuosa et uacua: et le tenebre erano sopra la faccia del abisso. Et il spirito del Signore era menato sopra le acque. Disse dio. Sia facta la Luce. Et facta e la Luce. Et uide dio la luce esser buona: et diuise la Luce dalle tenebre: et appello la Luce di: et le tenebre nocte. Et facto e la Sera et Matina uno di. Etiam disse dio. Sia facto il firmamento in mezo dele acque: il quale diuida le acque dale acque. Et fece dio il firmamento. Et diuise le acque che erano sopto il firmameto da quelle che erano sopra il firmamento. Et facto e cosi: et chiamo dio il firmamento cielo. Et facto e Sera et Matina il secondo di. Etiam disse dio. Le acque che sono sopto il cielo siano congregate i uno luoco: et apparga la arida terra: et facto e cosi: et chiamo dio la arida terra: et le congregationi dele acque appello mare. Et uide dio esser buono: Et disse germine la terra la herba uirete et facia il Seme: et il legno pomifero che faci il fructo secondo la sua generatione: La semenza del quale sia in si medesimo sopra la terra: et cosi facto e. Et la terra produsse la herba uirente et faciente il seme secondo la sua generatione Et il legno faciente il fructo et hauendo ciaschedun il semente secondo la sua spetie. Et uide dio esser buono: et facto e Sera et Matina il terzo di. Etiam disse dio. Siano facte eluminarie nel firmamento del cielo: Et seperino il di et la nocte. E siano insigni et tempi: et di et anni. Perche resplendino nel firmamento del cielo: et illumineno la terra. Et cosi facto e. Et fece dio duo gradi Luminarii. Il luminare maiore che soprastessi al di: et il luminare minore che soprastessi ala nocte. Et etiam fece dio le Stelle. Et puose quelle nel firmamento del cielo: perche lucessono sopra la terra: et signorizasseno al di et ala nocte: et diuidesseno la Luce et le tenebre. Et uide dio esser buono: et facto e sera et matina il quarto di. Etia disse dio producano le acque il reptile del anima uiuente er

82

Bible

Biblia [Italian], translated by Niccolò Mallermi, printed in Venice by Vindelinus de Spira, 1 August 1471. Roman type (HC 3150; GW 4311)

Volume I: 325 fols. 390 x 280 mm. On parchment [London only]

Illuminated probably in Padua by Franco dei Russi

WOLFENBÜTTEL, HERZOG AUGUST BIBLIOTHEK, Bibelsammlung 2° 151 (vol. I)

This is the first volume of a superb specimen of the first Bible printed in Venice in Mallermi's Italian translation. At the beginning of Genesis a vignette depicts the Garden of Eden inhabited by docile wild beasts and enlivened with green trees. Within this delightful landscape can be seen the Creation of Adam, the Temptation, and the Expulsion from Paradise. At the bottom an angel between the two columns of text carries a scroll signed '*Franchi*', and the miniature painter responsible must certainly be identified with Franco dei Russi, one of the leading illuminators of the Bible of Borso d'Este (see figs 3, 14-17); Russi moved to Padua in the 1460s and there carried out a large number of commissions (cats 26, 71, 113). Echoes of the scenes of the Creation painted by Taddeo Crivelli to illustrate the Book of Genesis in the Borso Bible (fig. 3) are strongly in evidence here, but Franco's style is more peaceful. The mythological atmosphere in these scenes harks back to late Gothic taste, but the impeccable use of perspective, the plastic molding of the figures and the clarity of the light already presage the Renaissance. At the bottom the coat of arms of the original owner has long since been erased, but it would be no surprise to learn that it had belonged to Jacopo Zeno, Bishop of Padua from 1460 until his death in 1481, whose marvellous library of illuminated manuscripts was largely dispersed after his death. This hypothesis is supported by the border with small angels among the foliage, which seems to have been repeated by Giovanni Vendramin, the illuminator who did the most work for Jacopo Zeno, in the page he decorated in one of the Choir Books for Ferrara Cathedral in 1481. The second volume of the Bible depicts a *Judgement of Solomon* by the same hand. The master of the Putti illuminated another copy of the same book (cat. 81).

Provenance: Herzog August of Braunschweig-Lüneburg (1579-1666).

Exhibition: Wolfenbüttel 1981, no. 62.

Bibliography: Habicht 1932, pp. 263-4; Mariani Canova 1969, pp. 28, 104-5, 146; Alexander 1970a, pp. 32-3; Mariani Canova 1987, p. 119; Born 1990, no. 501; Toniolo 1990-3, p. 231.

G. M. C.

83

Livy, *Roman History*, First and Fourth Decades

Titus Livius, *Historiae romanae decades*, edited by Johannes Andreae, Bishop of Aleria, printed in Venice by Vindelinus de Spira, 1470. Roman type (HC 10130, Goff L-238)

Volume I: 1 + 150 fols (fols 1-4 substituted in manuscript; printed fols 2-24 displaced to the back of volume II). 255 x 377 mm. On parchment. Venetian late 15th-century binding; blind stamped brown calf [New York only]

Illumination attributed to Franco dei Russi, Venice, c. 1470

NEW YORK, THE PIERPONT MORGAN LIBRARY, PML 266 (ChL ff719a)

Livy's *Roman History* was one of the first Classical Latin texts to be printed in Venice, but it had been preceded by an edition printed in Rome in 1469, also edited by Johannes Andreae (Giovanni Andrea

Bussi, 1417-1475), Bishop of Aleria (cat. 80). Both editions contain the First, Third and Fourth Decades of Livy's *History*; the Second Decade did not survive the Classical period, and fragments of the Fifth Decade were found only in 1527 (Reynolds and Wilson 1974, pp. 114-15, 124). The two volume Morgan Library copy on parchment is lacking the Third Decade; the beginnings of the First and Fourth Decade have hand-illuminated borders surrounding the printed text, and the missing Third Decade was probably similarly decorated.

As was usual for the earliest books printed in Venice, the copies of the 1470 Livy left the press without initials in the spaces indented at the beginnings of books. Vindelinus de Spira did not even print the book and chapter headings in the Livy, presuming these would be added by a scribe (see p. 36). In fact, in the Morgan copy the prefatory material on the first four folios has been written out by hand: folio 1, in gold letters except for a title in blue ink; folio 1v, in blue ink with a title in gold; folio 2, in gold; folio 2v, finally in black ink, but with capitals supplied in gold and blue. Folios 3 and 4 continue the pattern of folio 2v.

At first inspection, the border at the beginning of volume I appears to be simply a hand-painted one with intense green vine motifs contrasting to gold ground (folio 5 [= folio 25]). In the right margin is a profile portrait of a king, dressed in a red tunic shaded with gold lines. Despite the man's naturalistic features, it is likely that he is Romulus, lauded by Livy as the founder and first King of Rome. Militaristic deeds are also invoked by the blue soldier in Roman armour whose outstretched left arm and horizontally placed sword transform him into the letter 'F', providing the initial letter of the text, *[F]acturus*.

The most unusual aspect of the decorations is essentially invisible. Underneath the painted borders are woodcut patterns, stamped into the margins after the printing to serve as a guide to the miniaturist (see p. 37). Over 75 woodcut motifs have been catalogued by Lamberto Donati in the borders of incunables (1972, pp. 304-27), and their appearance in several hundred books printed between 1469 and 1474 can be established. A unit of seven lozenges is used in the upper and left margins of the Livy; a shorter unit of three lozenges extends the left margin. The square symmetrical unit in the other two margins is repeated seven times. The same lozenge and square patterns were similarly stamped into copies of the 1470 Livy in the Biblioteca Marciana, Venice (Inc. Ven. 101, 103; Marcon 1986a, figs 50, 52), in the Biblioteca Corsiniana, Rome (Donati 1972, fig. 11), and in the British Library, London (fig. 25; Donati 1972, figs 17, 19). Comparing the Morgan frontispiece with that of the British Library copy demonstrates the identity of the woodcut patterns, but shows that minor shifts in their placement and colouring produce the individualized effect prized by their aristocratic owners.

Throughout the Morgan Livy, large capitals have been painted at the beginning of each book. These are gold letters enmeshed in white vine-stem patterns against coloured grounds; under these patterns too woodcuts were stamped in order to expedite the illumination.

Both volumes of the Morgan Livy have the coat of arms of the noble Venetian Donà, or Donado, family painted in the bottom margin of their frontispieces. Supporting the shield are putti whose physical characteristics permit attributing them to the well-known miniaturist Franco dei Russi (Mariani Canova 1969, pp. 26-30, 104-6, 145-6). The poses with hips exaggeratedly shifted to one side and the carefully curled hair of the putti very closely resemble the putti of the signed frontispiece of a 1471 Bible in Wolfenbüttel, an incunable also printed by Vindelinus de Spira (cat. 82). The fact that a distinguished artist such as Franco did not disdain to be 'assisted' by woodcut patterns suggests that these devices were perceived as an appropriate experiment facilitating the decoration of the new kind of book.

Provenance: Coat of arms of the Donà, or Donado, family of Venice (*argent, two bars and in chief three roses gules*, fol. 5); Sunderland Library; Theodore Irwin collection; purchased by John Pierpont Morgan (1837-1913) in 1900.

Exhibitions: New York 1939, no. 240; New York 1957, no. 49; New York 1992-3 (no catalogue).

Bibliography: Thurston and Bühler 1939, no. 719a; Armstrong 1991, pp. 195-200, fig. 6.11.

L. A.

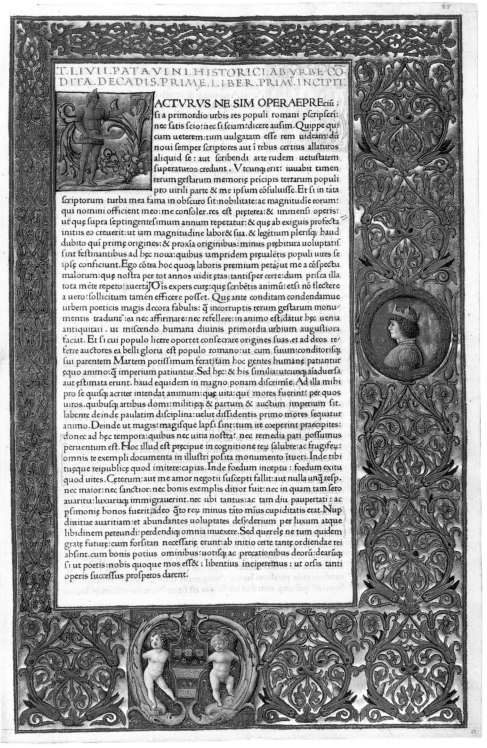

83 folio 5r

84

Pliny the Elder, *Natural History*

Gaius Plinius Secundus, *Historia Naturalis*, translated into Italian by Cristoforo Landino, printed in Venice by Nicolaus Jenson in 1476. Roman type (H. * 13105)

415 fols (not signed or foliated). 415 x 279 mm. On parchment

[London only]

Illuminations perhaps by Giovanni Vendramin in Padua, c. 1476

The best documented printing venture in Quattrocento Venice resulted in Nicolaus Jenson's edition of Pliny's *Natural History* in 1476 (see cat. 85; Edler de Roover 1953, pp. 107-15). Some twenty copies of the edition were printed on parchment, including the magnificent Holkham Hall volume, with its painted architectural frontispiece and 37 intriguing historiated initials. This copy was probably prepared especially for Giovambattista Ridolfi, since the Ridolfi coat of arms appear on its frontispiece (Armstrong 1983 b, p. 99). Giovambattista was an associate of the Florentine banking firm of Filippo Strozzi, which financed the edition. He stayed in Venice while the commissioned edition was being printed, and either he or Nicolaus Jenson could have arranged for the decoration.

The principal frontispiece appears at the beginning of Book II of the text, since Book I is largely devoted to an extended table of contents and sources. Typical of the Veneto-Paduan architectural frontispiece (see p. 42), the text appears to hang from a monumental structure consisting of four great Corinthian columns of delicately mottled marble resting on a base decorated with tritons and nereids. High on the entablature are two elegant peacocks, and on the ledges below two deer and several leggy putti play musical instrumentes. In the space left blank for the opening initial 'E' is a picture of the author Pliny in his study, surrounded by a red moulded frame. Fortified by his books and by a bowl of fruit on a shelf, Pliny points at a golden armillary sphere, symbol of his universal scientific interests.

Each of the 37 books of the Holkham Hall *Historia naturalis* begins with a large historiated initial, twelve lines in height. Following a tradition begun about 1300, each image relates to the principal topic of the book which follows (Armstrong 1983 a, pp. 19-39). An elephant is

84　Detail from Book XXXVI

depicted to initiate Book VIII on animals; roses, lilies and violets for Book XXI on flowers; a surgeon amputating the arm of a female corpse for Book XXVIII on physicians; and a sculptor carving a column for Pliny's Book XXXVI on different kinds of stone. Most distinctively, however, the animals, plants and figures appear to be carved in relief on Classical monuments to which are attached the appropriate epigraphic capital in gold. Pediments or acroteria of paired bronze dolphins or cornucopias often extend the image beyond the twelve line indentation, giving it added monumentality. Like the frontispiece, each initial composition is also painted as if seen through a square torn out of the parchment page. The intense naturalism of many of the 'specimens' is in keeping with the study of medicine and natural science for which the University of Padua was famed. Thus both the Mantegnesque style of the compositions and their content connect the miniaturist to Padua.

The full listing of the initials emphasises the artist's command of natural and Classical imagery. Most of the persons or natural phenomena appear to be carved reliefs of the same colour as the monument they decorate; the colour of the monument is noted here as well. Prologue: bust portrait of a king, grey monument; Book I, Preface: a kneeling scholar presents a book to a king, pale blue monument; Book II: Frontispiece (see above); Book III: a seated geographer points to a map, red relief, natural coloured map; Book IV: a geographer in a Greek hat points to map of Greece, green; Book V: a standing geographer in a turban points to a map of Africa, tan; Book VI: a seated geographer in a turban points to a map of Asia, bright pink; Book VII: a swaddled baby, a lion, a bull, a horse, purplish grey; Book VIII: an elephant in profile, grey; Book VIIII (mistakenly printed XIIII): a two tailed mermaid, pink; Book X: birds, including a phoenix, an ostrich, a peacock, a heron, an eagle, grey; Book XI: insects naturalistically coloured against a tan monument, three ants, a fly, two dragonflies (?), two bees; Book XII: ten tall green trees against a purple red monument; Book XIII: standing man with mortar and pestle, grey; Book XIV: a

brown vine curled around a green fig tree, pink monument; Book XV: an olive tree and an apple tree in natural colours against grey; Book XVI: a misshapen tree in natural colours against a purple monument; Book XVII: two trees in natural colours, tan monument; Book XVIII: man cutting grain, grey relief and monument; Book XVIIII: woman with spindle, purple; Book XX: white turnips and raddish, green cabbage, grey monument; Book XXI: rose bushes, a clump of violets, and lilies in natural colours, grey monument; Book XXII: standing youth in a tunic crowns a kneeling poet(?) wearing a long robe with a floral wreath, pink; Book XXIII: man harvesting grapes, grey relief and monument; Book XXIV: tree, vine and shrub in natural colours against purple monument; Book XXV: herbalist gathering herbs, intense green; Book XXVI: doctor with urine flask, tan; Book XXVII: green plants, purple red monument; Book XXVIII: physician amputating the arm of a nude female corpse, grey; Book XXVIIII: physician taking the pulse of an elderly standing patient, purple; Book XXX: magician-king with two standing devils, green; Book XXXI: a fountain, grey; Book XXXII: aquatic aanimals in a landscape – a crab, a turtle, frogs – all tan; Book XXXIII: man at a forge, purple red (only six lines high); Book XXXIV: a nude male statue on a pedestal flanked by two candelabra, grey; Book XXXV: a painter seated at an easel, deep green; Book XXXVI: a sculptor carving a slab of marble, tan; Book XXXVII: a man showing rings to another, purple red.

In addition to the spectacular sequence of historiated initials, there are hundreds of gold letters surrounded by rectangles of red, green and blue, initiating every chapter within the 37 books.

The attribution of the Holkham Hall Pliny remains a puzzle. The great originality of the historiated initials, inventively merging scientific observation with the new Classical vocabulary, points to a major talent. Elements of the frontispiece and of the initials recall the style of Giovanni Vendramin (*fl.* 1466-*c.* 1509), a miniaturist trained in Padua and actively illuminating Venetian incunables in the early 1470s (cats 78, 79; Mariani Canova 1988 b, pp. 81-109). In other works Vendramin employed mottled marble architectural components, monochromatic reliefs, strings of fruit, and exotic peacocks similar to those of the Holkham Hall frontispiece. On the other hand, the putti of the frontispiece are taller and more slender than those usually attributed to Vendramin. Nevertheless, the format of the historiated initials closely resembles one by Vendramin in the 1469 Pliny now in Ravenna, which shows a reclining nude female painted in monochrome, apparently a relief on the surface of a small architectural monument (cat. 78, volume II, folio 1; Mariani Canova 1988 b, fig. 8). Further similarities may be found between the adult figures in the Holkham Hall Pliny initials and the heroes painted in a Suetonius of 1471, also printed by Nicolaus Jenson (Mariani Canova 1969, pl. 16). The fact that Vendramin was the son of a *bidello* (official bookseller) of the University of Padua also means that the miniaturist might have had access to faculty who were investigating exactly the natural phenomena that feature so prominently in the Holkham Hall Pliny.

Provenance: Coat of arms of the Ridolfi of Florence on frontispiece (*azure a mount [of three] or and in chief a crown of the second and two palm branches proper overall a bend gules*); Thomas Coke (1698-1759) in Italy, 1712-18.

Exhibition: Stockholm 1962, no. 31.

Bibliography: Mariani Canova 1969, pp. 42-4, 111-12, 150, figs 57-64; Hassall 1970, pp. 29-30, figs 145-9; Armstrong 1983b, pp. 99-100.

L. A.

LIBRO SECONDO DELLA HISTORIA NATVRALE DI.C.PLI
NIO SECONDO TRADOCTA DI LINGVA LATINA IN
FIORENTINA PER CHRISTOPHORO LANDINO FIOREN
TINO AL SERENISSIMO FERDINANDO RE DI NAPOLI.

SEL MONDO HA TERMINI ET SE E VNO : CAPITOLO PRIMO.

L MONDO ET QVESTO ELQVALE PER
altro nome Anoi piacie chiamare Cielo : elquale
intorno gyrando tutte lechose chuopre : E giusta
chosa credere che sia deita etherna & infinita : Ne
mai generata : Ne mai da douere perire. Ricerchar
lechose extriseche di chostui ne sapptiene alhuo
mo : ne comprendere lepuo la congectura delhūa
na mente. Sacro e & etherno & saza misura. Tut
to nel tutto : Anzi esso e tutto & e infinito : ma si
mile al finito . Di tutte lechose e certo & simile a
lincerto. Difuori & dentro ogni chosa i se Abbrac
cia. Lui medesimo e opera della natura : & e essa
natura. Furore saza fallo mosse alchuni A pesare la misura sua : & dipoi Ardire expor
la. Furono etiam mossi da furore quegli equali prendendo occasione di qui innumera
bili mondi essere affermorono : Onde altrettante nature delle chose fussi necessario cre
dere. Et pure se in una natura tutti si posassino : Saraño constrecti credere che altrettā
ti sieno esoli : Altretante lelune & laltre immense & innumerabili stelle similmente sie
no multiplicate. Ilperche rimanghono occupati nella medesima inuestigatione : non
hauendo per questo trouato el fine che disiderano . Et se pure uoglamo attribuire alla
natura : laquale e artefice delluniuerso che essa habbi prodocto lechose in infinito : q̄to
e piu facile intenderlo in uno mondo solo : maxime essendo quello si grande opera : Fu
rore e per certo : Furore non piccholo Vscire di quello : Et chome se gia lechose dentro
allui poste anchora anoi incerte ci sieno note Inuestigare quelle difuori : Stimando che
chi non sa lamisura dise possi conseguire quella dalchuna altra chosa. O che lamente
humana possi uedere quello che ilmondo inse non cape.

DELLA FORMA DEL MONDO. CAPITOLO. II.

L nome in prima & dipoi il consenso di tutti glhuomini equali dicono elmōdo
orbe cioe tondo : Dimostrano laforma del mōdo essere ridocta in tondo p̄fecto.
Ne mācono glargomenti aprouare questo medesimo : perche tale figura da tutte le sue
parti richade in se medesima : & da se medesima puo essere sostentata : & in se si chiude
& contiene : ne dalchuna commissura o cōgiunctura ha dibisogno : ne fine o principio
in alchuna sua parte sente. Preterea al moto elquale ha affare elmondo chome pocho
disotto dimostrerremo : Tale figura e aptissima. Et finalmente glocchi ne danno uero
giudicio : Conciosia che ilconuexo & ilmezo della forma spericha da ogni parte siuede :
Ilche in altra figura non puo addiuenire che nella sperica cioe tonda.

DEL MOTO SVO. CAPITOLO. III.

L nascimēto & loccaso del sole manifestamente Cidimostrano : che in spatio di
xxiiii. hore Questa sperica machina fa tutta la sua circulare reuolutione : laquale
ethernalmente senza alchuno riposo & con celerita inenarrabile Gyra. Ne si puo facil
mēte intēdere se elsuono : elquale nascie dellassiduo uoltare ditanta machina e ímēso :
& per questa chagione uincendo elsenso dellaudito non altrimenti si possa udire che

85

Pliny the Elder, *Natural History*

Gaius Plinius Secundus, *Historia naturalis*, translated into Italian by Cristoforo Landino, printed in Venice by Nicolaus Jenson, 1476. Roman type (H* 13105)

415 fols. 415 × 280 mm. On parchment. Late 15th-century Florentine binding: olive green morocco over boards, blind tooled except for a single gold filet, fleurons, and within a circular silver ornament, the letters PLINIO (top cover), DE NA.ISTO. (lower cover) in gold; clasps with arms of the Di Nobili and nielli with Strozzi emblems [London only]

Illumination attributed to Gherardo (or Monte?) di Giovanni di Miniato, Florence, 1479-83

OXFORD, BODLEIAN LIBRARY, Arch. G.b.6 (formerly Douce 310)

Both the printing history of Nicolaus Jenson's 1476 edition of Pliny's *Natural History* and the hand-illumination of the copy now in the Bodleian Library are exceptionally well documented, yet issues about the business venture and about the attribution of the miniatures have been disputed – a lesson about the need for cautious interpretation of apparently obvious documentation. The Pliny is the result of Florentine entrepreneurial instincts and the technical skills of a printer in Venice (Edler de Roover 1953). Documents preserved in the Florentine Archivio di Stato show that the firm of Filippo e Lorenzo Strozzi e Compagni di Firenze e Napoli paid the Florentine humanist Cristoforo Landino (1424-1492) in 1476 for a translation of the *Natural History* from Latin into Italian. Girolamo di Carlo di Marco Strozzi and Giovambattista di Luigi di Messer Lorenzo d'Antonio Ridolfi went to Venice on behalf of the Strozzi firm to seek a printer, and decided on Nicolaus Jenson. Jenson agreed to print 1,000 copies on paper provided by the merchant bankers named the Agostini (see p. 43) plus a number printed on parchment. Copies were to be sold through booksellers in several Italian cities – Venice, Florence, Siena, Rome, Pisa, Naples – as well as being sent to Bruges and London.

The *Prohemio* of the 1476 Pliny opens with: '*Historia Naturale di G. Plinio Secondo tradocta di Lingua Latina in Fiorentina per Christophoro Landino Fiorentino al Serenissimo Ferdinando Re di Napoli*', indicating that the translation was made for King Ferdinand I of Naples (r. 1458-1494); and Books I and II repeat the same dedication. That Landino indeed had already made his translation of Pliny for Ferdinand rather than for the Strozzi firm is suggested by payments for a manuscript illuminated by Cola Rapicano in Naples in 1473, and by letters of Giovanni Brancati, a humanist at the court of Ferdinand (Pugliese Carratelli 1950).

In turn, doubt exists about the miniaturist who illuminated the extraordinarily sumptuous copy of the 1476 Pliny now in the Bodleian. Payments were made by Filippo Strozzi (1428-1491) to Monte di Giovanni di Miniato (1448-1529) for miniatures, hundreds of illuminated initials, and a binding with silver nielli for 'mio Plinio' from April 1479 to March 1483 (Borsook 1970). Despite the payments, Annarosa Garzelli has argued (in Garzelli and de la Mare 1985, pp. 293-5) that Monte received the payments on behalf of his company, and that the miniatures must be attributed to his brother, Gherardo di Giovanni di Miniato (c. 1444-1497).

The Strozzi Pliny has two frontispieces with wide decorative borders incorporating portraits. As in other copies of Pliny, the author is represented as a scholarly scientist (cats 84, 86; fig. 28); he sits at his desk pointing to an armillary sphere (folio 5). Other portraits of Renaissance personages are naturalistically rendered in the borders. King Ferdinand I of Naples is portrayed in profile in the lower left of the Book I frontispiece. Much less perfunctory are the images of Filippo Strozzi and his son (Garzelli and de la Mare 1985, fig. 931), doubtless well known to the miniaturist. They are shown in an interior with sky and clouds visible beyond the window; Filippo's features closely resemble his well-known bust portrait by Benedetto da Maiano (1442-1497) executed about 1475. The humanist Cristoforo Landino appears in a roundel at the bottom margin of the *Prohemio*; he

is portrayed three-quarter length, holding an open book (folio 1; Garzelli and de la Mare 1985, fig. 930). In the distance the miniaturist has painted the Duomo of Florence.

The broad borders of the frontispieces are edged in gold; vases, putti, candelabra, curving vines and flowers form a dense pattern against alternating blue and red grounds. Additional roundels encircle animals such as the emblematic Strozzi lambs, as well as mythological scenes rendered in monochrome. The mythological compositions copy gems from the collection of Lorenzo de' Medici (Garzelli and de la Mare 1985, p. 294): Bacchus and Ariadne in a chariot pulled by Psyche, driven by Cupid; Bacchus and Ariadne on Naxos; Apollo, Olympus and Marsyas (Florence 1972, no. 8, pl. VI, no. 33, fig. 26, no. 25, fig. 18); and Mercury. Thus Strozzi paid homage to the first family of Florence as well as acknowledging the patronage of King Ferdinand.

The historiated initials of the Strozzi Pliny follow the tradition of relating to the subject of the book they initiate, in this respect paralleling the copies of the 1481 *Natural History* illuminated for Giovanni Pico della Mirandola (Venice, Biblioteca Marciana, Lat. VI, 245 [=2976]) and Giovambattista Ridolfi (cat. 84). Each folio on which a book begins also has at least a partial border extending down the left margin, often including Strozzi arms and emblems. The images emphasise animals and figures in natural settings, and are thus less classicising than the 'reliefs' on monuments in the Ridolfi Pliny.

The following list mentions border motifs only when they are unusual. Book I (folio 5): Pliny in his study (see above); Book II (folio 21): the earth encircled by eight spheres, border in left margin with portrait of Ferdinand of Naples; Book III (folio 41): bird's-eye map of Italy, border with eagle, portrait of Ferdinand; Book IV (folio 49v): map of Spain; Book V (folio 57v): map of the north coast of Africa, eagle in border; Book VI (folio 67): the Black Sea, left border with three red balls in glory, lilies, oak branch with acorns, portrait of Ferdinand; Book VII (folio 79v): birth of twins; Book VIII (folio 93v): an elephant, uniquely represented in a three-quarter frontal position, *all'antica* head in border; Book VIIII (mistakenly printed XIIII; folio 108): fish in the sea; Book X (folio 119v): birds – an ostrich, a peacock, a crane, a magpie, and arms of Aragon and of the Strozzi, plus an owl in the border; Book XI (folio 132v): beehives, in the border a worm, a snail, a butterfly; Book XII (folio 148v): a grove of eleven trees; Book XIII (folio 156); a palm tree, in the distance a city, Strozzi arms in the border; Book XIIII (folio 163): a grape arbor in a walled enclosure; Book XV (folio 170): a boy knocking olives from a tree, in the border other olive trees; Book XVI (folio 177v): an oak tree, in the border other trees; Book XVII (folio 190v): two men planting trees; Book XVIII (folio 205): a man sowing grain; Book XVIIII (folio 224): a symmetrically laid out garden with roses on a fence, rows of plants, and trees with other plants growing under them, distant hills; Book XX (folio 233v): a kitchen garden with cucumbers and gourds, a shed; Book XXI (folio 247v): a girl sits in a flowery open space between woods and makes floràl wreaths, portrait of Ferdinand in border; Book XXII (folio 257v): herbs in a field, portrait of Ferdinand in border; Book XXIII (folio 267): an herbalist in an interior holds and points to medicinal herbs; Book XXIV (folio 275v): an herbalist holds a leafy branch, behind him grow other similar trees, in the border an Emperor's bust in gold; Book XXV (folio 285v): a doctor with a view of a city behind him, in the margin an Emperor's bust (Titus?) in gold; Book XXVI (folio 295): a physician in an interior; Book XXVII (folio 303v): a field with low-growing plants, a forest beyond; in the border an Emperor's head, gold; Book XXVIII: a physician consulting books in his study; Book XXVIIII: a physician in an interior, in the border an Emperor's bust, gold; Book XXX: a magician in a high brimmed hat; Book XXXI: a physician holding a fish, in the border a roundel with three putti with vats on a boat, all in gold; Book XXXII: a physician holding a turtle; Book XXXIII (folio 358v): two men in a goldsmith's shop, on the counter bars of gold and silver, plates of coins; Book XXXIIII (folio 368v): a coppersmith at a forge; Book XXXV (folio 378): a painter painting a portrait on an easel, another portrait hangs on the wall (Garzelli and de la Mare 1985, fig. 932); Book XXXVI (folio 390v): a stonecarver carving a Corinthian capital, elsewhere in the shop the

LIBRO PRIMO DELLA NATVRALE HISTORIA DI. C.
PLINIO SECONDO TRADOCTA IN LINGVA FIOREN
TINA PER CHRISTOPHORO LANDINO FIORENTI
NO ALSERENISSIMO FERDINANDO RE DI NAPOLI.
PREFATIONE

ITERMINAI O GIOCONDISSIMO
imperadore con epistola forse di troppa licétia
narrarti elibri della historia naturale: opera no
uella alle muse romane: nata apresso di me nel
lultima genitura. Sia adunq; questa prefatióe
uerissima di te métre che gia inuecchia nel grã
dissimo tuo padre: per che usando el uerso di
Catullo mio compatriota tu soleui pure stima
re qualche chosa le mie ciácie. Tu conosci que
sta castrense & militare parola. Et lui chome tu
sai mutando le prime syllabe si fece alquanto
piu duro che non uolea essere stimato da tuoi
familiari & serui. Per questo adunq; determi
nai scriuerti: & áchora per che le nostre chose apparischino & sieno manifeste p questa
mia audacia maxime dolédoti tu che pel passato non lhabbi facto in una altra nostra
procace epistola. Et accio che tutti glhuomini sappino quanto di pari lomperio techo
uiua: Tu elquale hai triomphato & se stato censore & sei uolte cósolo & participe del
la tribunitia potesta: Se stato prefecto del pretorio: ilche hai facto piu nobile che tutti
glaltri magistrati: perche per piacere a tuo padre & allordine equestre lacceptasti: Et
tutte queste cose per rispecto della republica hai facto: Et me chome nel contubernio
castrense tractasti? Et certo niéte ha mutato inte lamplitudine & grandezza della tua
fortuna: se non che tanto piu possi & uogla giouare: quáto quella e maggiore. Adũq;
béche a tutti glaltri huomini sia aperta la uia a impetrare ogni chosa da te uenerádoti:
Niente di meno solo laudacia fa che io piu familiarmente te honori. Questa audacia
adunq; imputerai a te medesimo: & a te medesimo nel nostro fallo perdonerai. Io mi
stroppicciai la faccia: & niente di meno nessuno proficto ho facto: perche per unaltra
uia mapparisti grande: & di lontano mi rimuoui con le faccelline del tuo ingegno. Et
certo in nexuno piu ssolgora quella: laquale piu ueramente & decta in te in altri for
za deloquentia. In te e quella facundia che alla tribunitia potesta si conuiene: Con ãta
risonantia tuoni tu le laude paterne? Có quanta (non sanza amore) dimostri quelle di
tuo fratello? Quanto se excellente & sublime nella poetica faculta? O gran fecondita
danimo. Certo hai trouato inche modo possi imitare tuo fratello. Ma queste chose
chi potrebbe sanza paura considerare: hauendo a uenire al giudicio dellongegno
tuo: maxime essendo quello dame prouocato? Certamente non sono in simile
conditione quegli che publicano alchuno libro: & quegli che ate glintitolano. Impero
che se io lo publicassi & non lo intitolassi ate: potrei dire perche leggi tu queste chose o
imperadore: lequali sono scripte albasso uulgo & alla turba de glagricultori & de glar
tefici & a quegli che cósumano elloro otio negli studii? Perche adunq; ti fa tu giudice:
concio sia che quando io scriueuo questa opera: non thaueuo posto nella tauola doue
sono descripti egiudici: Et eri di tanta excellentia: che non stimauo che tu ti degnassi
scendere si basso? Preterea quando bene non fussi si excelso grado: nientedimeno gli
scriptori comunemente fuggono el giudicio de docti. Questo fa Cicerone: elquale e
di tanta eloquentia: che puo sottomettere longegno al giuocho della fortuna: & quel

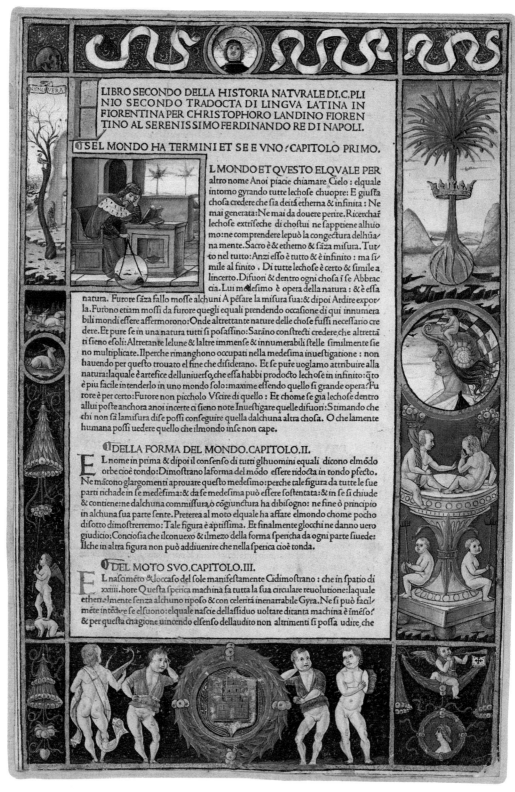

86 folio from Book II

bust of a boy, a corbel, two columns, slabs of stone (Garzelli and de la Mare 1985, fig. 933); Book XXXVII (folio 402v): a brooch with gems.

Provenance: Filippo Strozzi (1428–1491) of Florence, portrait on folio 5, coat of arms (*or on a fess azure three increscents argent*) and emblems on many folios; coat of arms of Giulio d'Antonio di Nobili (*azure two bendlets argent the space between semé-de-lys*) painted over Strozzi on many folios; Francis Douce, by whom bequeathed.

Exhibition: Oxford 1948, no. 83, pls XVIII–XIX.

Bibliography: Sheppard, n. d., no. 3273; De Marinis 1947–52, I, pp. 72–3, II, p. 326; Edler de Roover 1953, pp. 107–15; De Marinis 1960, II, no. 1574, pl. CCLXVI (binding); Borsook 1970, pp. 9, 13–4, 20; Pächt and Alexander 1970, p. 109, pr. 48; Garzelli and de la Mare 1985, pp. 293–5, figs 928–33; Hobson 1989, pp. 72–3, fig. 62 (binding); Lowry 1991, pp. 129–32.

L. A.

86

Pliny the Elder, *Natural History*

Gaius Plinius Secundus, *Historia naturalis*, translated into Italian by Cristoforo Landino, printed in Venice by Nicolaus Jenson, 1476. Roman type (H 13105*; Goff P-801)

Detached folio (first leaf of Book II). 393 x 267 mm. On paper
[New York only]

Illumination by Petrus V---, Venice, c. 1476

LOS ANGELES, ELMER BELT LIBRARY OF VINCIANA, UNIVERSITY OF CALIFORNIA AT LOS ANGELES

The single leaf from the Nicolaus Jenson edition of Pliny the Elder's *Natural History* of 1476 was doubtless preserved because of its contemporary illumination. The detailed imagery of the borders and first initial demonstrates that incunables printed on paper were sometimes as elaborately decorated as those on parchment. As on other Pliny frontispieces (cats 84, 85; fig. 28), the author is represented as a scholar at his desk. At his feet is a disc with a tiny seascape painted on it; Pliny leans down to measure the distance between two islands with a compass, thus demonstrating his credentials as a geographer. In the outer margin, the profile bust in a fantastic *all'antica* helmet is probably the Roman Emperor Titus, to whom Pliny dedicated his long work on natural phenomena in 77 AD.

The miniaturist's Christian name was Petrus, and his surname began with the letter 'V', as can be ascertained from the partially legible inscription 'OPVS PETRI V-M------', under the bust of Titus, and from the letters 'O.P.V.' on the crown around the date-palm tree above. Milanese characteristics of his style, such as the bell-shaped garlands and the illusionistic perspective of the roundels in which the portrait heads appear, support the Lombard origins of this intriguing artist. The letters of Petrus' surname suggest Vimercate, the name of a town midway between Milan and Bergamo, earlier the *patria* of another illuminator, Guinifortus de Vicomercato (cat. 109). The style of the portraits and putti links this frontispiece to some ten other illuminated incunables and manuscripts produced in Venice and Rome between about 1466 and 1488, including three in the exhibition (cats 77, 87, 88).

The date-palm in the upper right margin is clearly emblematic since its roots encircle a golden sphere; its fertility contrasts to the barren tree in the upper left margin. In the latter vignette, a woman and child walk by a ruined building, and in the upper corner a skull seems to emphasise death and ruin. However, a scroll inscribed 'RENO/VERO' may refer to renewal, or possibly to the 'true reign'. Although it cannot be proved, the symbolic imagery may refer to the assassination of the Duke of Milan, Galeazzo Maria Sforza, in 1476, and to the new reign of the seven-year-old Gian Galeazzo Sforza under the regency of his mother, Bona da Savoia Sforza (Armstrong 1990b, pp. 386-93, 409-10).

Provenance: Perhaps Gian Galeazzo Sforza (1469-1494); original coat of arms excised and replaced with *azure a castle argent and two lions rampant or*; Rodolfe Kann collection, Paris; Arabella (Mrs. Henry E.) Huntington, San Marino, CA; Duveen; Norton Simon Foundation, by whom given to the Elmer Belt Library, 1966.

Exhibition: Los Angeles, University of California at Los Angeles, University Research Library, Department of Special Collections, 1987 (no catalogue).

Bibliography: Rahir 1907, p. 66, no. 84; Suida 1947, pp. 22-3; Rouse and Rouse 1988, pp. 106-7, colour pl.; Armstrong 1990b, pp. 386-93, 409-10, fig. 2.

L. A.

87

Breviary, Use of Rome

Breviarum romanum, corrected by Georgius de Spathariis, printed in Venice by Nicolaus Jenson, [before 6 May] 1478. Gothic type, red and black inks (H 3896; GW 5101)

404 fols (lacking the register on 1v). 328 x 234 mm. On parchment
[London only]

Illumination attributed to Petrus V---, Venice, c. 1478

GLASGOW, UNIVERSITY LIBRARY, Bf.1.18

Over twenty copies of Nicolaus Jenson's 1478 edition of the Breviary were printed on parchment, but none were so richly decorated as the copy now in Glasgow. Nine folios in the Psalter and the Temporale sections of the Breviary are painted with full or partial historiated borders (listed by Armstrong 1990b, p. 410), and the margins of the Calendar folios are supplied with twelve pen and ink drawings of heads *all'antica* (folios ii-vi). The illumination is the work of a miniaturist named Petrus V---, whose partially legible name appears on the frontispiece of a *Natural History* of Pliny the Elder printed by Jenson two years earlier in 1476 (cat. 86). Curiously, the decoration of the Glasgow Breviary ceases after folio 146; the incomplete copy was probably filled out with folios from a second copy in the 18th century (see Provenance).

Like the copy illuminated by Leonardo Bellini now in Edinburgh (cat. 89), the decoration of the Glasgow Breviary mixes Christian imagery with Classical; however, the Glasgow borders are even more copiously filled with putti and *all'antica* decorative motifs. Both the Psalter (folio 1) and the Temporale (folio 39) begin with fully painted borders replete with clusters of putti in the outer margins. Contrasting to these borders are the landscape scenes across the lower margins. On the Psalter folio (folio 1), a white-haired King David sits playing a cythera; beside him a row of angels in flowing gowns play other musical instruments. Initiating the Temporale is a more disparate group also in a barren landscape. St Paul clutches a book and holds his sword upright; he speaks to Elijah, who stands at the far right, one hand held aloft as if admonishing the onlookers. Casually gathered around these two principal figures are six young men, elegantly dressed in Italian Quattrocento costumes; an older man stands back from the foreground figures.

Evidence of ownership is most clear on folio 39; the original coat of arms has been overpainted with those of Du Prat d'Auvergne (Alexander 1969a, pp. 12-13), but beside them are the initials of the first owner: LEO BO. On two folios elsewhere in the Breviary, the name *Leonardus* is written at the bottom of the lower margin, an area normally trimmed away after printing. This indicates that the copy was being reserved by the printer for a person of this name (see p. 43). The recipient was doubtless Leonardo Botta (c. 1431-1513), member of a noble Cremonese family who was active at the Sforza court in Milan (Zapperi 1971, pp. 374-9). Botta was a pupil of the humanist Francesco Filelfo (1398-1481), and also collaborated with another humanist, Pandolfo Collenuccio, in copying a description of the Greek Peloponnesus by the famous antiquarian Ciriaco d'Ancona (c. 1391-1455) (Sabbadini 1910). More important for Nicolaus Jenson, the printer of the 1478 Breviary, Leonardo Botta was the Milanese ambassador to Venice from 1470 to 1480. In January 1478 Botta intervened on Jenson's behalf to recuperate a large sum of money swindled from the printer by a bookseller in Pavia, in Milanese territory. It is likely that the elaborately decorated Breviary in Glasgow was the gift of the grateful printer to the powerful and learned Milanese diplomat (Armstrong 1990b, pp. 394-7).

The most unusual feature of the Glasgow Breviary decorative programme is the series of twelve heads accompanying the Calendar. Usually this section of a service book is illustrated with the Labours of the Months or the signs of the Zodiac, but in the case of the Glasgow Breviary, Petrus V--- caters to the Classical training of the recipient. The heads allude to the Latin names of the months: a two headed Janus

88 folio 5r

for January (folio ii); a militaristic Mars for March (folio ii verso; Mariani Canova 1988b, fig. 28); profile portraits of Julius Caesar (folio iv) and Augustus (folio iv verso; Armstrong 1990b, fig. 9) for July and August respectively.

Provenance: Leonardo Botta (*c.* 1431–1513), Milanese ambassador to Venice 1470–80 (initials on folios 1, 39; Christian name on folios 34, 309); Antoine du Prat, Chancellor of France (1514) and of the Duchy of Milan (coat of arms on folios 1, 39); Martinus Spifanius, ex-libris (inscribed, folio 1); Louis-Jean Gaignat, incomplete, missing parts supplied from a copy owned by Cardinal de Loménie (Van Praet 1822, I, p. 75); bought at the Gaignat sale, Paris, 10 April 1769, lot 174, for Dr William Hunter (1718–1783), by whom bequeathed to the University of Glasgow.

Exhibitions: Brussels 1963, no. 59, pl. 26 (folio 45); Dublin 1964, no. 66; Toronto *et al.* 1987–9, no. 101, pl. 29 (folio 14), illus. p. 160 (folio 146v).

Bibliography: Alexander 1969a, pp. 10, 12–3, fig. 5 (folio 146v); Armstrong 1990b, pp. 394–7, figs 9–12 (folios iii verso, 1, 39, 16); Mariani Canova 1988b, pp. 99–100, fig. 28 (folio ii verso).

L. A.

88

Breviary, Use of Rome

515 fols. 290 × 200 mm. On parchment [New York only]

Written in Padua or Venice, Gothic script, c. 1478-80, with illumination attributed to Petrus V--- and to the Douce Master

CAMBRIDGE, MASSACHUSETTS, HOUGHTON LIBRARY,
HARVARD UNIVERSITY, MS Typ 219

The magnificent Breviary in Houghton Library is less well known than it deserves to be. Three frontispieces with full borders painted in gold and rich colours initiate the Temporale (folio 8), the Psalter (folio 215), and the Common of Saints (folio 484), while the Sanctorale (folio 269) also begins with a miniature and partial borders (Armstrong 1990b, figs 13, 16, 14; Meiss 1957, fig. 69). The Temporale, Psalter and Common of Saints frontispieces are each preceded by a leaf stained purple in imitation of Imperial Classical manuscripts. Further con-

tributing to the sumptuous effects are 102 historiated initials (subjects listed in Wieck 1983, pp. 70, 129) and 103 medallions with birds and animals, usually on folios with some marginal floral and gold dot motifs as well. Finally, the rubrication and flourishing in blue, red and purple inks throughout is exceptionally fine and includes over 350 heads delicately drawn in pen (Armstrong 1990b, figs 14, 15). The overall richness of the decorative programme assures that the work was executed for a patron of the highest rank, although to date this person has not been identified.

In 1969 Jonathan Alexander (1969a) recognised that the principal miniaturist of the Houghton Breviary was the artist who illuminated the printed Breviary of 1478 now in Glasgow (cat. 87). For example, the motif of the capital 'B' formed out of the bodies of a putto and a snail is virtually identical on the Psalter frontispiece of the Houghton (folio 215) and Glasgow (folio 1 [a 1]) Breviaries. A second miniaturist known as the Douce Master painted many of the other historiated initials. Subsequently the present author (1990b) added miniatures in other manuscripts and Jenson incunables (cats 77, 86) to the group identified by Alexander, including one frontispiece on which was inscribed a partially legible name, Petrus V---. The earlier attribution of the decoration to Ferrarese miniaturists (Cambridge 1955, no. 81; Wieck 1983, p. 70) is outweighed in favour of Padua and Venice, because of the Paduan and Aquileian saints emphasised in the Calendar and because of the activities in Venice of both Petrus V--- and the Douce Master (on the latter, see cat. 70 Mariani Canova 1987, pp. 126-30). Particularly characteristic of Veneto-Paduan Renaissance miniaturists are the illusionistic devices apparent in the three major frontispieces: these include architectural monuments from which hang ragged sheets of parchment (folios 215, 484), a fly walking on the page of text (folio 484), and roundels revealing vaults seen from below (folio 8).

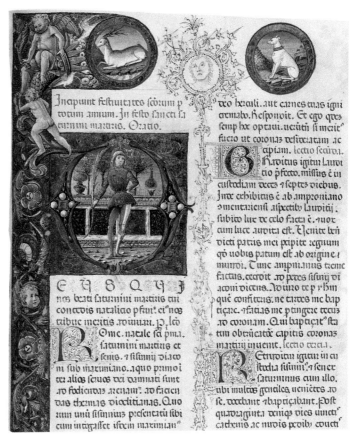

88 folio 269 (Detail)

The use of gold leaf and gold paint is particularly lavish in the Houghton Breviary: architectural cornices and piers, edges of borders, mosaic backgrounds checkered in gold all contribute to the dazzling effects.

Petrus V--- illuminated books for several prestigious patrons, including Celso Maffei (1415/25-1508), learned Augustinian canon and member of a noble family of Verona. Maffei in turn was closely connected to Marco Barbo, a noble Venetian, Cardinal (1467-1491), Patriarch of Aquileia (1470-1491), and Cardinal Protector of the Augustinian Regular Lateran Canons. Emphasis on St Augustine (folio 8, 405v) and the *duplex maius* status of the Aquileian saints in the Calendar opens the possibility that Cardinal Barbo was the intended recipient of the Houghton Breviary (Armstrong 1990b, pp. 397-400, 410-11).

Provenance: Count Alexis de Golowkin; Prince Galitzine; his sale, Paris, 3 March 1825, lot 10; bought by Payne and Foss; Southgate sale, London, 6 November 1826, lot 2843; bought by Triphook; Duke of Newcastle; Clumber sale, London, Sotheby's, 6 December 1937, III, lot 939, pls 63-4; bought by Philip Hofer from H. P. Kraus in 1954 and presented to the Houghton Library in 1966 in memory of Thomas Stilwell Lamont.

Exhibitions: Cambridge 1955, no. 81; Cambridge 1983, no. 34.

Bibliography: Meiss 1957, pp. 61-3, 93, n. 24, fig. 69 (folio 484); Alexander 1969a, pp. 10, 12-13; Kraus 1978, no. 77; Armstrong 1990b, pp. 397-400, 410-11, figs 13-16.

L. A.

88 folio 8

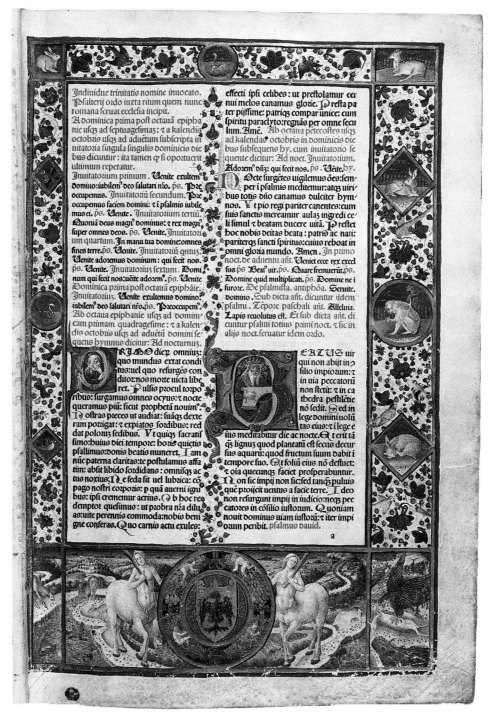

89 folio a1r

89

Breviary, Use of Rome

Breviarium romanum, corrected by Georgius de Spathariis, printed in Venice by Nicolaus Jenson, [before 6 May] 1478. Gothic type (H 3896; GW 5101)

404 + 1 fols, lacks the register on folio 1v. 348 x 239 mm. On parchment
[London only]

Illumination attributed to Leonardo Bellini, Venice, c. 1478

EDINBURGH, NATIONAL LIBRARY OF SCOTLAND, Inc. 118

Nowhere is the borderline between manuscript and printed book more skilfully blurred than in copies of the Breviary printed in Venice by the distinguished French printer, Nicolaus Jenson, in 1478. Jenson's

edition includes the five parts of the Roman Breviary, the service book used for the Daily Offices throughout the liturgical year: the Calendar, Psalter, Temporale, Sanctorale and the Common of Saints. The text is beautifully laid out in two columns, printed in Gothic fonts with both black and red ink. The generous dimension of the folios suggests that the book was intended to be read at a lectern in church or monastery, rather than to be hand-held for individual use.

Evident on the Psalter frontispiece (folio a1) are exquisite painted borders, and also red and blue initials with flourishing in red and purple ink added by hand after the text had been printed. When one considers that similar red and blue flourished initials were added to a high proportion of the 404 folios (or 808 pages) in this copy and in about twenty other known copies on parchment, the enormity of Nicolaus Jenson's endeavour becomes evident (see also cat. 87). The printer must have organized the rubrication and lesser illumination in order to

'finish' the books. More elaborate frontispieces could be added depending on the buyer's pleasure and pocketbook. Jenson's aim would be to convince ecclesiastics that his printed version, enhanced by hand-painted decorations, was a worthy rival to the older manuscript Breviaries already in their sacristies.

In the Edinburgh Breviary the border surrounding the opening text of the Psalter (folio a 1) is composed of red and blue flowers, birds, gold dots, and delicate penwork scrolls edged with gold lines. Punctuating the decorative motifs are tiny framed scenes of birds and animals in landscapes. Most surprising is the pair of thoroughly pagan female centaurs in the lower margin. Behind them recedes a deep landscape with deer and ducks disporting on a river, and in the right-hand corner the landscape extends to reveal an eagle perched on a dead deer. In the larger painted initial 'P' in the left column, a white-haired God the Father turns to bless King David, who is depicted crowned and playing a psaltery in the 'B' at the beginning of the first Psalm, the *Beatus vir*.

As in many other parchment copies of Jenson's 1478 Breviary, decorative borders also initiate the Temporale (folio e 1), the Sanctorale (folio aa 1), and the Common of Saints (folio A 1). On all three folios the top and left margins are partially filled with blue and pink floral motifs, penwork, and gold dots. In each lower margin is a delicately rendered seated deer.

The illuminations are attributable to the Venetian miniaturist Leonardo Bellini (*c*. 1423–*aft*. 1484), cousin of the better-known painters Giovanni and Gentile Bellini (Alexander 1969a, p. 19 n. 2). Leonardo Bellini's earliest documented manuscript is also exhibited here, the *Promissio* of Doge Cristoforo Moro, 1462 (cat. 27). The floral and gold dot motifs, typical of Leonardo Bellini's borders, are derived from Ferrarese manuscripts such as the famous Bible of Borso d'Este, illuminated between 1455 and 1461 (fig. 15). One of Leonardo Bellini's patrons was Leonardo Sanudo, a Venetian nobleman who served as Venetian representative in Ferrara in 1458-9 (Lowry 1991, pp. 29-35), exactly the years when the Borso Bible was being illuminated. This connection may have stimulated Leonardo Bellini's imitation of Ferrarese illumination. By 1478, however, when the Edinburgh Breviary was illuminated, the avant-garde miniaturists had turned to classicising architectural frontispieces (cats 78-81), but Leonardo Bellini remained true to the conservative style he knew best, only adding centaurs as an acknowledgement of the new fashions.

The heretofore little-known frontispiece of the Edinburgh Breviary contributes surprising visual evidence to a much debated attribution: the authorship of the miniatures in the so-called Rothschild Miscellany (Jerusalem, Israel Museum, MS 180/51). The Miscellany is an extensively illustrated compilation of Hebrew texts which scholars agree was created in northern Italy in the second half of the 15th century (Narkiss 1969, p. 152, no. 56). Efforts to localise precisely where in northern Italy have not, however, met with consensus. Ursula Bauer-Eberhardt (1984, pp. 229-37), later supported by Giordana Mariani Canova (1990, pp. 168-70), urged that Leonardo Bellini was the miniaturist, while in the facsimile edition of the manuscript published in 1989, Louisella Mortara Ottolenghi argued instead for the workshop of Cristoforo da Predi, a miniaturist active in Milan. Comparison between the Edinburgh Breviary frontispiece and the images on folio 164r (fig. 26) and elsewhere in the Rothschild Miscellany lend additional support to the Leonardo Bellini attribution. The motif of the eagle attacking the deer is virtually identical on both folios; the curving road lined by trees in the landscape of each is the same; and the bearded Jacob wrestling with the angel is a physical type familiar from the Edinburgh David.

Provenance: Coat of arms of the Bragadin of Venice, or the Rogati of Padua (*or an eagle displayed sable*); David Steuart (1747-1824); by whom sold to the Advocates' Library, Edinburgh, in 1810.

Exhibition: Edinburgh 1979, no. 20.

Bibliography: Alexander 1969a, p. 19 n. 2; Bauer-Eberhardt 1984, p. 237 n. 42.

L. A.

90

Virgil, *Eclogues*, *Georgics*, *Aeneid*

Vergilius Maro, *Opera* (with commentary of Servius), printed in Venice by Antonio di Bartolomeo da Bologna, 14[7]6. Roman type (C. 6044)

279 fols (imperfect, that is 292 less 13; wanting fols 1, [6-10] 9, 10, [11-15] 1-6, [25-28] 2-4, and the last blank). 328 x 266 mm. On parchment

Illumination attributed to the Master of the London Pliny, Venice, c. 1476.

LONDON, THE BRITISH LIBRARY BOARD, C. 19.e.14 (IB. 20488)

Venetian miniaturists decorating individual copies of printed books employed two techniques: painting in colours with tempera, frequently accompanied by gold leaf; and drawing with pen or a fine brush in ink and modelling with coloured washes. The architectural frontispiece of the British Library Virgil is an exceptionally fine example of the latter technique (folio a2). Some details on the reliefs and figures have darkened with age; these would have been highlights in white or silver which have oxidised. The columns and frieze are decorated with elegant *all'antica* designs, including trophies and palm trees, motifs found earlier in the fresco of *St James Led to Execution*, painted in Padua by Andrea Mantegna about 1454 (Lightbown 1986, fig. 14).

Beneath the text, four winged putti harass a fallen satyr, a scene, based on Roman Bacchic sarcophagi, usually called the *Tormenting of Pan* (Armstrong 1981, p. 58; Scalabroni 1988, pp. 161-71). Not precisely copied, but freely interpreted, the composition evokes the Classical past without actually illustrating the text. An almost identical scene was surprisingly drawn by the same miniaturist in a religious book also shown in this exhibition, the small Carthusian Breviary from the Bodleian Library (cat. 91).

The frontispiece of the London Virgil is attributable to the Venetian miniaturist known as the Master of the London Pliny (Armstrong 1981, pp. 30-49). This anonymous artist is named for his decoration of a copy of Pliny's *Natural History* (Venice, Nicolaus Jenson, 1472) now in the British Library (IC. 19662; fig. 24b). The miniaturist's elegantly proportioned human beings and mythical creatures are delicately drawn in sepia and enact scenes from Classical literature.

After working about a decade in Venice, the Master of the London Pliny seems to have gone to Rome or Naples about 1480, where he illuminated manuscripts for Cardinal Giovanni d'Aragona (1456-1485) (see cat. 46). It was earlier thought that this distinguished miniaturist might have been named Gasparo Padovano or Gasparo Romano (Putaturo Murano 1975, pp. 95-110; Paris 1984, p. 168; Urbino 1992, no. 69), but recently published documents show that Gaspare da Padova was already working for Cardinal Francesco Gonzaga by about 1468, and hence away from Venice during the years of the Master of the London Pliny's activity there (Chambers 1992, pp. 193-4, 196-7).

The London Virgil had a fascinating early series of owners. It must originally have been illuminated for a member of the Venetian merchant-banking family, the Agostini, whose coat of arms appears twice on the frontispiece; in addition the name 'B. Agustini' is inscribed in the upper corner of folio a 5 (Armstrong 1986, p. 87; p. 43). Subsequent to the Agostini, the Virgil was owned by Giovanni Pietro Arrivabene (1439-1504), humanist secretary to Cardinal Francesco Gonzaga (1444-1483) and later Bishop of Urbino (Chambers 1984), who inscribed his name 'Io. Pe. Arrivabene' on the first leaf (folio 1). By 1520 the book belonged to Giulio Romano (1492-1546), pupil and artistic heir of Raphael, who in turn wrote on the first page 'Giulio Romano hoc deliniavit anno 1520. Aetatis 28°'. The inscription confirms the often questioned date which Giorgio Vasari assigned to Giulio's birth (Ferrari 1992, p. xxiv), but also led to the mistaken notion that Giulio had illuminated the frontispiece (BMC, V, 240).

Provenance: Coat of arms of the Agostini family of Venice (*per fess dancetty or and azure each point terminating in a roundel counterchanged*); Giovanni Pietro Arrivabene (1439-1504), folio 1; Giulio Romano, in 1520, inscription on folio 1; Mr West, sale, 3 April 1773; King George III.

Bibliography: BMC, V, 240, xvii; Armstrong 1986, p. 87, fig. 59.

L. A.

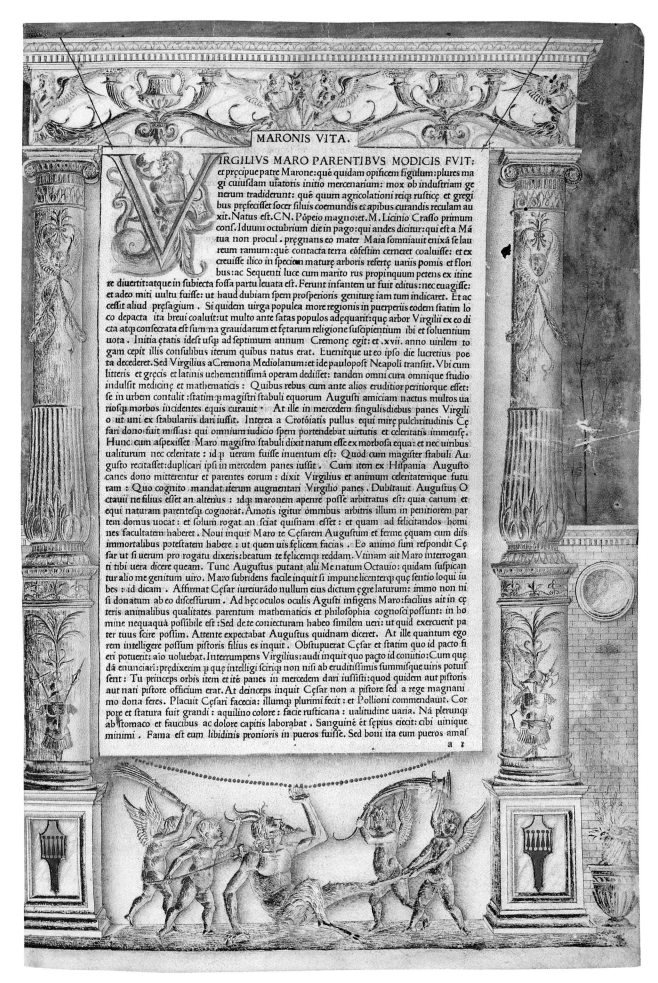

MARONIS VITA.

VIRGILIVS MARO PARENTIBVS MODICIS FVIT: et præcipue patre Marone: qué quidam opificem figulum: plures ma gi cuiusdam uiatoris initio mercenarium: mox ob industriam ge nerum tradiderunt: qué quum agricolationi reicῳ rusticæ et gregi bus præfecisset socer siluis coemundis et apibus curandis reculam au xit. Natus est. CN. Pópeio magno: et. M. Licinio Crasso primum conf. Iduum octubrium die in pago: qui andes dicitur: qui est a Mã tua non procul . prægnans eo mater Maia somniauit enixã se lau reum ramum: qué contacta terra eófestim cerneret coaluisse: et ex creuisse ilico in speciem maturæ arboris refertæ uariis pomis et flori bus: ac Sequenti luce cum marito rus propinquum petens ex itine re diuertit: atque in subiecta fossa partu leuata est. Ferunt infantem ut fuit editus: nec euagisse: et adeo miti uultu fuisse: ut haud dubiam spem prosperioris genituræ iam tum indicaret. Et ac cessit aliud præsagium . Si quidem uirga populea more regionis in puerperiis eodem statim lo co depacta ita breui coaluit: ut multo ante satas populos adæquarit: quæ arbor Virgilii ex eo di cta atqῳ consecrata est summa grauidarum et fœtarum religione suscipientium ibi et soluentium uota . Initia ætatis idest usqῳ ad septimum annum Cremonæ egit: et .xvii. anno uirilem to gam cepit illis consulibus iterum quibus natus erat. Euenitque ut eo ipso die lucretius poe ta decederet. Sed Virgilius a Cremona Mediolanum: et ide paulopost Neapoli transiit. Vbi cum litteris et grecis et latinis uehementissima operam dedisset: tandem omni cura omnique studio indulsit medicinæ et mathematicis : Quibus rebus cum ante alios eruditior peritiorque esset: se in urbem contulit : statim ῳ magistri stabuli equorum Augusti amiciam nactus multos ua riosῳ morbos incidentes equis curauit • At ille in mercedem singulisdiebus panes Virgili o ut uni ex stabulariis dari iussit. Interea a Crotóiatis pullus equi miræ pulchritudinis Cæ sari dono fuit missus: qui omnium iudicio spem portendebat uirtutis et celeritatis immensæ. Hunc cum aspexisset Maro magistro stabuli dixit natum esse ex morbosa equa: et nec uiribus ualiturum nec celeritate : id ῳ uerum fuisse inuentum est : Quód cum magister stabuli Au gusto recitasset: duplicari ipsi in mercedem panes iussit . Cum item ex Hispania Augusto canes dono mitterentur et parentes eorum : dixit Virgilius et animum celeritatemque futu ram : Quo cognito mandat iterum augmentari Virgilio panes . Dubitauit Augustus O ctauii ne filius esset an alterius : idῳ maronem aperire posse arbitratus est: quia canum et equi naturam parentesῳ cognorat. Amotis igitur ómnibus arbitris illum in penitiorem par tem domus uocat : et solum rogat an sciat quisnam esset : et quam ad felicitandos homi nes facultatem haberet . Noui inquit Maro te Cæsarem Augustum et ferme æquam cum diis immortalibus potestatem habere : ut quem uis felicem facias . Eo animo sum respondit Cæ sar ut si uerum pro rogatu dixeris: beatum te felicemqῳ reddam. Vtinam ait Maro interrogan ti tibi uera dicere queam. Tunc Augustus putant alii Me natum Octauio: quidam suspican tur alio me genitum uiro. Maro subridens facile inquit si impune licenterqῳ quæ sentio loqui iu bes : id dicam . Affirmat Cæsar iureiurãdo nullum eius dictum ægre laturum: immo non ni si donatum ab eo discessurum. Ad hæc oculos oculis Agusti insigens Maro: facilius ait in cæ teris animalibus qualitates parentum mathematicis et philosophia cognosci possunt: in ho mine nequaquã possibile est : Sed de te coniecturam habeo similem ueri: ut quid exercuerit pa ter tuus scire possim. Attente expectabat Augustus quidnam diceret. At ille quantum ego rem intelligere possum pistoris filius es inquit . Obstupuerat Cæsar et statim quo id pacto si eri potuerit: aio uoluebat. Interrumpens Virgilius: audi inquit quo pacto id coniitio: Cum quæ dã enunciari: prædixerim ῳ quæ intelligi sciriqῳ non nisi ab eruditissimis summisque uiris potuis sent : Tu princeps orbis item et itê panes in mercedem dari iussisti: quod quidem aut pistoris aut nati pistore officium erat. At deinceps inquit Cæsar non a pistore sed a rege magnani mo dona feres . Placuit Cæsari facecia: illumqῳ plurimi fecit : et Pollioni commendauit. Cor pore et statura fuit grandi : aquilino colore : facie rusticana : ualitudine uaria . Nã plerumqῳ ab stomaco et faucibus ac dolore capitis laborabat . Sanguiné et sæpius eiecit: cibi uinique minimi . Fama est eum libidinis pronioris in pueros fuisse. Sed boui ita eum pueros amas

a ı

91

Breviary, Carthusian Use

311 fols. 180 x 125 mm. On parchment [London only]

*Written in Gothic script, with illumination attributed to the Master of the
London Pliny, Venice c. 1476-80*

OXFORD, BODLEIAN LIBRARY, MS Canon. Liturg. 410

The extraordinary quality of the tiny Bodleian Breviary testifies to the
avant-garde taste of its unknown patron (Armstrong 1981, pp. 32-8,
49, 127-9). Breviaries contained the daily offices for the entire liturgi-
cal year, modified for use by particular monastic orders. In the Bod-
leian Breviary, Carthusian saints are named in the Calendar (folio viii
verso, St Bruno; folio xii verso, St Hugh), and the rubric for the Psal-
ter (folio 1) indicates that it was made for use in a Carthusian monas-
tery, perhaps Sant'Andrea della Certosa, Venice (Martin Lowry, verbal
communication). The two column text is written in a clear Gothic
script with hundreds of red and blue one and two line capitals in red
and blue ink, flourished respectively in purple and red inks. The over-
all richness of the decorative programme is confirmed by the inclusion
of four folios with fully painted borders, thirteen historiated initials,
fourteen initials decorated with jewels, pearls or urns, and five simpler
gold initials (listed Armstrong 1981, pp. 127-9). These exquisite
illuminations should be attributed to the anonymous miniaturist
known as the Master of the London Pliny (see cat. 90).

Although some images in the Carthusian Breviary follow tradi-
tional Christian iconography, such as the representations of David in

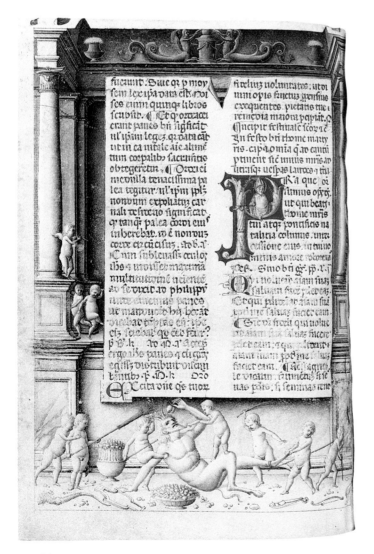

91 folio 234v

the Psalter, three of the fully illuminated borders include mythological
creatures more appropriate for a Classical text than a religious one
(folios 1, 234v, 289v). The Sanctorale, or the offices appropriate for
specific saints days throughout the year, normally opens with the Feast
of St Andrew (November 30), but in the Carthusian Breviary, it begins
instead with the Feast of St Thomas à Becket (folio 234v, December
29); a half-length image of St Thomas appears in the historiated 'P' of
the second column. This significant departure from normal liturgical
practice suggests either that St Thomas à Becket was the patron saint
of the owner, or of the Carthusian house to which he belonged.

Surrounding the text of folio 234v is an architectural structure
drawn in sepia and lightly coloured with delicate watercolour tints.
Unfluted columns support projecting sections of an entablature, and
the entire edifice rests on a high base. The parchment page of text
appears to hang from beaded cords tied to the columns. In the frieze a
pair of golden winged sea centaurs flank an altar; by the columns
winged putti dance and play a flute. In front of the base, seven putti
torment a fallen satyr, their musical instruments momentarily strewn
on the ground.

The Sanctorale frontispiece has strong stylistic affinities both to a
Venetian incunable dated 1476 and to a manuscript of St Jerome's *Let-
ters*, both executed for Venetian patrons by the same miniaturist. The
satyr and putti, which are inspired by figures from Roman sarcophagi
(Armstrong 1981, p. 58), were plausibly first used by the Master of the
London Pliny in a Virgil of 1476 where a Classical scene is more
appropriate (cat. 90). Simultaneously the architectural components
and the dignified musical putti resemble those in *St Jerome Receiving
Venetian Clients* in the Berlin Jerome manuscript (cat. 28).

The decoration of the Bodleian Breviary is linked to descriptions of
works by Jacometto Veneziano (see Armstrong 1981, pp. 33-4, 49),
who was called in 1497 '*el primo homo del mondo*' ('the first man in the
world') as a miniaturist. Marcantonio Michiel, observer of many
works of art in Venetian collections in the first third of the 16th cen-
tury, noted particularly Jacometto's drawings of animals and can-
delabra in chiaroscuro. Furthermore, Michiel twice singled out '*li
quattro principi de uno officiolo in capretto inminiati sottilissimamente e per-
fettamente furono de mano de Jacometto...*' ('the four frontispieces of a
[Book of] Offices in goatskin [parchment] were most subtly and per-
fectly illuminated by the hand of Jacometto') (Frimmel 1888, p. 94) –
which could well refer to the Bodleian Breviary. This idea was earlier
postulated by Otto Pächt (in Oxford 1948, no. 69), and should again
be given consideration, particularly since the identification of the Mas-
ter of the London Pliny with Gaspare da Padova must now be rejected
(see cat. 39).

Provenance: A Carthusian monastery (folios viii verso, xii verso, 1),
perhaps Sant'Andrea della Certosa, Venice.

Exhibitions: Oxford 1948, no. 69; Stockholm 1962, no. 32.

Bibliography: Mariani Canova 1969, pp. 64, 66, 155, figs 98, 101, 103-4;
Alexander 1969a, p. 19 n. 10; Pächt and Alexander 1970, pp. 45, 56,
no. 563; Armstrong 1981, pp. 32-8, 49, 127-9, no. 39, pl. II, figs 91-6.

 L. A.

92

Plutarch, *Parallel Lives*

Plutarchus, *Vitae illustrium virorum*, printed in Venice by Nicolaus Jenson,
2 January 1478. Roman type (H. 13127)

2 volumes: 233 and 226 fols. 404 x 259 mm. On parchment [London only]

Illumination attributed to the Master of the London Pliny, Venice, c. 1478

DUBLIN, BOARD OF TRINITY COLLEGE, Fag. GG. 2.1, 2

Nicolaus Jenson's edition of Plutarch's *Vitae illustrium virorum* in 1478
revived a handsome format that the great printer had found successful
in the early 1470s (see p. 35). The text is set in Roman type in a single
block; the generously spaced headings employ the beautiful capital

letters Jenson had earlier used repeatedly for Latin authors. Twelve lines are indented at the beginning of each Life, leaving a blank space for the initials to be added by hand. Volume I begins with the Life of Theseus, while volume II opens with that of Cimon. In fact, Jenson lifted most of the Lives directly from an edition printed in Rome by Ulrich Han around 1470, omitting the dedicatory material of that edition to obscure the pirating (Lowry 1991, p. 122).

Several copies of the 1478 Plutarch were printed on parchment and handsomely decorated, but none so splendidly as the two volume copy in Dublin and the copy divided between Paris and New York (cats 94, 95; see also cat. 102). Both volumes of the Dublin copy were illuminated by the Master of the London Pliny (see cats 46, 90, 91); each contains a hand-illuminated frontispiece and painted initials at the beginning of each Life.

The architectural frontispiece of volume II (folio 1[A1]) exhibits a sophisticated deployment of *all'antica* motifs. In the lower margin two elegantly proportioned blond centaurs, each carrying a palm branch, support a wreath surrounding the Agostini of Venice coat of arms. Golden bronze candelabra rise in the side margins before a porphyry stele; above the green entablature pairs of winged sea creatures are silhouetted against an intense blue sky. The striking sea creatures may have inspired one of the most beautiful carved and gilded frames to have survived in Venice, that of Giovanni Bellini's Frari Altarpiece, dated 1488 (Goffen 1989, pl. 116). Such a source for the virtually identical motifs atop the altarpiece is not improbable, given that Giovanni Bellini and Nicholas Jenson were members of the same Venetian confraternity, the Scuola Grande di San Marco (Lowry 1991, p. 112).

In contrast to the 'architectural frontispiece' of volume II, the opening folio of volume I (folio 1[a2]) favours a combination of jewels and cameos popularised by Girolamo da Cremona (cat. 93). Mythological episodes depicted in the four corners are (clockwise from the upper left): *Hercules and the Nemean Lion, Rape of Europa, Birth of Aesculapius* and *Apollo and Daphne*. All these subjects were drawn by the Master of the London Pliny in incunables published earlier in the decade (Armstrong 1981, figs 51, 83, 85, 86).

Within the œuvre of the Master of the London Pliny, the volume I frontispiece most closely resembles the Berlin Jerome border, where similar metallic elements and golden dolphins frame allegorical figures in grisaille (cat. 28). The jewels and pearls reflect similar combinations evident in Girolamo da Cremona's St Augustine, *De civitate Dei* frontispiece of 1475, a volume also printed by Nicolaus Jenson (cat. 93). Around 1478 Girolamo also illuminated another two volume copy of the Jenson Plutarch for a member of the Agostini family (cats 94, 95). Thus it is not surprising that the Master of the London Pliny would have emulated the more famous miniaturist by adapting some of Girolamo's decorative motifs to his own style.

In volume I, in addition to the frontispiece, there are 29 large painted initials 10 to 12 lines high, and 8 smaller ones. Likewise in volume II, there are 25 large and 3 small painted initials. Almost all the initials throughout both volumes appear to be three-dimensional coloured cylinders with gold finials and joints; they are set on rectangular plaques of contrasting colours on which floral or *all'antica* motifs appear as if carved in relief (volume II, folio 6; see Armstrong 1986, fig. 63; 12 initials from volume I are illustrated in colour and 2 from volume II in black and white in Abbott 1905). Only two are drawn in pen and ink and coloured wash (volume II, fols 210, 216; Armstrong 1986, figs 55, 60). As is usual in the works of the Master of the London Pliny, most of the images evoke the Classical era rather than literally illustrate the text: tritons (volume I, folio 16; volume II, folio 210), satyrs (volume I, folios 71v, 80 [Abbott 1905, colour pl.]; volume II, folio 216), profile busts of a man and a woman on either side of a palm tree with winged serpents at the base and the initials 'DP' and 'DC' (Life of Lucullus, volume II, folio 6), a nude sacrificing a goat (Life of Nicias, volume II, folio 20), trophies (Life of Photion, volume II, folio 92), a putto on a dolphin (volume II, folio 181), *Rape of Europa* (Life of Evagoras, volume II, folio 199v [Abbott 1905]), a profile bust of a bearded man with the initials 'FVR' and 'CAM' (Life of Rufus de Regia, volume II, folio 206v [Abbott 1905]); a rider in Classical armour (Life of Charlemagne, volume II, folio 220).

Both the Trinity College Plutarch and the copy divided between Paris and New York display the same coat of arms, those of a non-noble merchant banking family of Venice, the Agostini (see p. 43). Illuminated incunables may well have been partial payment for financial backing, an arrangement also probably applicable to the spectacular volumes bearing the arms of Peter Ugelheimer (cats 96-101).

Provenance: Coat of arms of the Agostini of Venice (*per fess dancetty or and azure each point terminating in a roundel counterchanged*); Boendermaker, 1723; Dalman, 1723; Greffier Fagel, the Hague, before 1802; purchased 1802.

Bibliography: Abbott 1905, p. 147, no. 434; Armstrong 1986.

<div align="right">L. A.</div>

93

St Augustine, *The City of God*

Aurelius Augustinus, *De civitate Dei*, printed in Venice by Nicolaus Jenson, 2 October 1475. Gothic type (HC 2051; GW 2879; Goff A-1235)

306 fols. 285 x 190 mm. On parchment [New York only]

Illumination attributed to Girolamo da Cremona, Venice, c. 1475

NEW YORK, THE PIERPONT MORGAN LIBRARY, PML 310 (ChL f760)

The early printers in Italy not only printed writings of the pagan authors of Greece and Rome, but also brought out many editions by Patristic writers – Augustine, Lactantius, Eusebius, Jerome, Cyprian – in effect, a Christian parallel to the revival of Classical authors. Although the very first editions of these writers were frequently set in the new Roman fonts, by 1475 Nicolaus Jenson chose to print his *City of God* in a Gothic typeface. The page is composed in two columns of text in a format long associated with Christian Bibles and liturgical texts. In the copy printed on parchment in the Morgan Library, the analogy to a precious religious manuscript is furthered by the addition of a beautiful illuminated frontispiece (folio 17), 22 large painted initials, and dozens of red and blue initials flourished in contrasting penwork of purple and red ink.

On 15 January 1476 (15 January 1475, *more veneto*) and again on 1 June 1476, one Benedetto da Cepperello wrote from Venice to Lucretia de' Medici in Florence, speaking of a Missal that was being illuminated for her by '*M. Jeronimo miniatore*', that is Girolamo di Giovanni dei Corradi da Cremona (doc. 1458-d. aft. c. 1483; Levi d'Ancona 1964, docs 104, 105). Girolamo had been one of the miniaturists illuminating the Choir Books for Siena Cathedral (cat. 121) in the early 1470s before transferring to Venice. The works of this distinguished illuminator are well represented in this exhibition (cats 94-96, 99, 101, 123), including the Morgan Augustine.

Girolamo's rich decorative borders for the 1475 Augustine are characterised by clusters of heavy jewels in leafy gold settings, mythological creatures also painted in gold, and roundels with deer and putti in tiny landscapes. In the lower margin, St Augustine stands on a platform in front of a scholarly study outfitted with beautiful books and a writing desk. Steps lead down to a green lawn inhabited by rabbits and deer; beyond them a river curves into the distant landscape. Above this exquisitely detailed scene hovers Augustine's vision of the Heavenly City; angel guardians stand at the gates which appear at intervals in the golden walls. In the space left empty for the first initial are painted two larger angels flanking a tower with an entrance gate; the vertical motif of the slender tower doubles as the capital 'I' required to complete the first word, *[I]nterea*.

Unobtrusively set in the central decorative border are the coat of arms of the noble Mocenigo family of Venice. Since Pietro Mocenigo

93 folio 17r

was the Venetian Doge from 1474 to 1476, it seems likely that the beautiful Morgan Augustine of 1475 was a presentation copy for him. A number of other Venetian books with classicising illumination are known that bear these same arms, including two others in the exhibition (cats 28, 104), testifying to the refined taste of members of this noble family.

Provenance: Coat of arms of the Mocenigo of Venice, folio 17 (*per fess azure and argent, two roses palewise counterchanged*), perhaps of Doge Pietro Mocenigo (r. 1474-1476); Earl of Sunderland; Theodore Irwin; purchased by John Pierpont Morgan (1837-1913) in 1900.

Exhibitions: New York 1939, no. 241; New York 1984, no. 35; New York 1992-3 (no catalogue).

Bibliography: Thurston and Bühler 1939, no. 760; Levi d'Ancona 1964, p. 69; Mariani Canova 1969, pp. 62, 120, 153; Mariani Canova 1988a, pp. 47-9.

L. A.

95 folio 2

94

Plutarch, *Parallel Lives*

Plutarchus, *Vitae virorum illustrium*, printed in Venice by Nicolaus Jenson, 2 January 1478. Roman type (H. 13127)

Volume I: 234 fols (of which a1 and b7 blank). 402 × 270 mm. On parchment [New York only]

Illumination attributed to Girolamo da Cremona, Venice, c. 1478

PARIS, BIBLIOTHÈQUE NATIONALE, Vélins 700

Nicolaus Jenson's 1478 edition of Plutarch's *Parallel Lives* was designed to be bound in two volumes, the first beginning with the Life of Theseus and the second with the Life of Cimon. One of the most splendidly decorated copies of this edition is divided between the Bibliothèque nationale, Paris (volume I, this entry) and the Pierpont Morgan Library, New York (volume II, cat. 95). Like the Morgan volume, the Bibliothèque nationale copy was illuminated by Girolamo da Cremona (cats 93, 95, 96, 101, 123). The Paris frontispiece (folio 1[a1]) is

an architectural monument framing the first page of the Life of Theseus text. The basic slab of the monument or stele is a greyish purple, its surface enlivened with monochromatic floral motifs, vases, and a string of trophies. On the base of the same colour are crowds of nymphs and satyrs. Apparently hung in front of the monument are huge clusters of jewels – grey-white pearls, coloured gems, and cameos in fantastic gold settings consisting of dolphins, dragons, cornucopias, and satyrs. The monument is set on a rocky ledge strewn with pebbles, inhabited by a lion and lioness, two stags, two does, and a bearded satyr balancing a basket on his head. Another satyr sits on the monument base, and as in the Morgan Library frontispiece to volume II, a thin slice of landscape is visible at the right.

As Jonathan Alexander has pointed out (1969a, p. 10), the satyr with a basket on his head emulates an over life-sized Antique statue of Pan, one of a pair now in the Capitoline Museum in Rome (fig. 29). Girolamo's attraction to this figure is demonstrated by its reappearance in the Morgan Aristotle frontispiece of 1483 (cat. 101a). The Pan statues may have been known in North Italian humanist circles through drawings, since the famous antiquarian Ciriaco d'Ancona (*c.* 1391-1455) drew them as early as 1432 (Bober and Rubinstein 1986,

no. 75). Alternatively, it is not impossible that Girolamo went to Rome, perhaps on a trip made during his documented stay in Siena in 1470 and 1472-4 (Eberhardt 1983).

The grisaille scene in the upper right corner depicts the rare mythological subject of *Vulcan Forging the Wings of Cupid*, also found in the contemporary Ovid manuscript illuminated by the Master of the London Pliny (cat. 46), and later in one of Vittore Carpaccio's episodes of the *Legend of St Ursula*, thus showing its special popularity in Venice (Armstrong 1981, pp. 75-6).

The twelve line initial 'Q' painted at the beginning of the text is similar in type to those found in the Morgan half of the Plutarch. The letter seems to be composed of faceted grey segments linked by bejewelled gold joints. Along with four cameo profile heads and a grisaille image of *Plutarch in his Study*, all framed in gold, the initial 'Q' appears to exist in front of a green plaque. Subsequent Lives open with similar initials, often accompanied by jewels or cameos.

Both the Paris and New York volumes were owned by a member of the Venetian merchant banking family, the Agostini, who possessed many books illuminated by Girolamo and by the Master of the London Pliny (see cats 90, 92; Armstrong 1986; p. 43). Yet another copy of the same edition was owned by the famous humanist, Giovanni Pico della Mirandola (cat. 102).

Provenance: Coat of arms of the Agostini family of Venice, folio 1[a1], damaged, and [m10], in monochrome green; Count MacCarthy-Reagh (*Catalogue des livres* 1815, no. 5368); Bibliothèque du Roi by 1817.

Exhibitions: Paris 1926, no. 377; Paris 1935, no. 2346; Paris 1950, no. 230; Paris 1984, no. 117.

Bibliography: Van Praet 1822, pp. 47-8; Alexander 1969a, p. 10; Mariani Canova 1969, pp. 64, 154; Armstrong 1986, pp. 88-95; *Catalogue des incunables* 1982, P-491.

L. A.

95

Plutarch, *Parallel Lives*

Plutarchus, *Vitae virorum illustrium*, printed in Venice by Nicolaus Jenson, 2 January 1478. Roman type (H. 13127)

Volume II: 228 fols. 405 x 280 mm. On parchment [New York only]

Illumination attributed to Girolamo da Cremona, Venice, c. 1478

NEW YORK, THE PIERPONT MORGAN LIBRARY, PML 77565 (ChL ff767)

The Morgan copy of Plutarch's *Parallel Lives* is the second volume of a set now divided between New York and Paris and, like the Bibliothèque nationale copy (cat. 94), it was decorated by Girolamo da Cremona for a member of the Agostini family of Venice, whose coat of arms appears in both volumes (see p. 43). The style of Girolamo da Cremona is easily recognisable in the frontispiece of the Morgan volume (folio 2 [A1]; see cats 93, 94, 96, 99, 101, 123 on Girolamo). A purple-red monochromatic border with flowers on twisting vines surrounds the text; symmetrically placed on the border are clusters of gems, pearls, and cameos surrounded by curling golden acanthus leaves, while paired gold harpies flank the Agostini arms. Grisaille heads of men and women are contrasted to black grounds on which Girolamo has characteristically inscribed tiny capital letters in white; the meaning of the initials is not known. Along the right edge of the frontispiece is a slice of landscape, with ducks in a pool and in the blue sky above; a villa with a tower appears in the middle distance. Gradually one becomes aware of the miniaturist's subtle joke. The gold corner motifs and the gold-bronze edge of the border make the ensemble appear to be a richly decorated book cover; the precious volume rests on the pebble-strewn ground and seems to loom above the countryside like a giant sculpture by Claes Oldenburg.

Including the capital 'P' of the frontispiece, there are 26 large ten to twelve line painted initials and two smaller ones. The stems of the initials appear to be crystal or metal cylinders with gold terminals. These three-dimensional letters stand in front of monochromatic plaques coloured blue, green, or purple-red on which floral motifs appear as if in relief. A few of the initials are further enhanced with jewels or classicising motifs such as a mermaid (folio 7 [A6]), a caduceus (folio 49 [E8]), or a winged putto head and the Agostini arms (folio 133v [pp2v]).

A further detail suggests that Nicolaus Jenson reserved this copy for a member of the Agostini family. The name 'Agustini' appears informally written in the lower margin of folios 20 [B9] and 71 (H2) (see p. 43).

Provenance: Coat of arms of the Agostini of Venice, folios 2 [A1], 133v [pp2]; Borghese library bookplate (Rome 1892 sale, part 1, lot 12); Clara and Irwin Strasburger; Pierpont Morgan Library, 1982.

Exhibitions: New York 1984, no. 36; New York 1992-3, (no catalogue); New York 1994a, p. 25.

Bibliography: New York, 1982b, lot 113; Armstrong 1986, pp. 87-8; Lowry 1991, pp. 121-3.

L. A.

96

Gratian, *Decretum*

Gratianus, *Decretum (Concordantia discordantium canonum)*, with the gloss of Bartholomaeus Brixiensis, printed in Venice by Nicolaus Jenson in 1477. Gothic type (HC 7890 = H 8003)

410 fols, the first blank, lacking fol. 411 with register. 425 x 280 mm. On parchment. Venetian late 15th-century binding attributed to the Ugelheimer Binder

Illumination attributed to Girolamo da Cremona and the Master of the Seven Virtues, Venice or Padua, c. 1477

GOTHA, LANDESBIBLIOTHEK, Mon. Typ. 1477, 2° (12)

The four volumes on canon and civil law printed by Nicolaus Jenson and his associates that were bound and decorated for Peter Ugelheimer form without doubt the most sumptuous Italian incunable ensemble surviving from the 15th century (see also cats 97, 98 and Gotha, Landesbibliothek, Mon. Typ. 1479, 2° [4]). The complex project which resulted in these treasures, now housed in the Landesbibliothek, Gotha, is a fascinating tale of business, patronage, and artistic creation (pp. 43-4). The successful printer Nicolaus Jenson (*c.* 1435-1480) dominated the production of legal texts in Venice, meeting a constant demand from scholars and students of the near-by University of Padua and other universities all over Europe (Lowry 1991, pp. 137-72). His business associate, Peter Ugelheimer, must in part have been repaid for his investment by receiving illuminated copies of Jenson's newly edited texts. This exhibition reunites the largest group of Ugelheimer books known to have been together since the 15th century (cats 96-101), and thus provides a vivid insight into the taste of this noble businessman.

The *Decretum* of Gratian (*c.* 1140) is a basic text in the corpus of canon (ecclesiastical) law studied at medieval universities, along with the *Decretales* of Pope Gregory IX (r. 1227-1241), the *Decretales* of Pope Innocent IV (r. 1243-1254), the *Liber sextus decretalium* of Pope Boniface VIII (r. 1294-1303) and the *Constitutiones* of Pope Clement V (r. 1305-1314). Texts of canon and civil law were normally accompanied by elaborate commentaries, and in Bolognese 13th- and 14th-century manuscripts a sophisticated lay-out was developed with the commentary surrounding the basic text (Conti 1981, pls XX, XXVI, XXVIII, XXIX; Melnikas 1975, *passim*). Early printers followed this same format, using different sizes of Gothic fonts to distinguish between the two categories of text.

The gifted miniaturist Girolamo da Cremona painted the frontispiece for the opening page of the Gratian text (folio 2 [a2]). The words appear as if printed on an exceptionally ragged piece of parchment. Near the top, a rectangular opening reveals a stately interior, beyond which is a glimpse of a colonnaded cloister. At the left, the enthroned Pope leans forward to bless the kneeling monk, Gratian, and to receive the *Concordance of Canon Law*, the *Decretum Gratiani*. Behind Gratian kneels an older man in brown flowing robes, perhaps Bartholomew of Brescia, who elaborated the commentary in the 13th century. Seated by the Pope are two Cardinals in scarlet robes, while other tonsured clerics stand solemnly around, the spaces between them beautifully calibrated. The colours and light are particularly effective, contrasting gold and blue, black and red, interior light and exterior light.

The quiet presentation scene stands in contrast to the exuberance of the margins. A grand monument appears to rest on an improbably small golden base encrusted with gems, pearls and cameos. Satyrs, nymphs and fat putti with blond hair and 'widow's peaks' frolic in the landscape on either side of the base and on the monument. These creatures, painted in naturalistic colours, play off against others apparently modelled in gold, or carved in the cameos embedded in the clusters of jewels.

Like other frontispieces in Ugelheimer books, the Gratian includes inscriptions in gold letters referring to the owner (see esp. cats 99-101). The words 'BONIS PREMIUM / MALIS ODIUM' ('reward for the good, hatred for the bad') appear above the papal presentation scene and could reasonably refer to the text, but the inscription in the centre of the page, 'PERFICE PRINCIPIO FLORENS CELEBRIMA PETRE' ('Flourishing in the beginning, Peter brings the celebrated [things] to completion') must signify the role of Peter Ugelheimer as business partner and proud owner.

Not content with a single elaborate frontispiece, five of the Ugelheimer books have full-page miniatures opposite the opening page of text, as well as decorative and historated initials throughout (cats 96-100). Of these, the most impressive is the allegorical *Monument of the Seven Virtues* in the Gratian (folio 1v [a1v]), painted by an anonymous miniaturist named the Master of the Seven Virtues because of this remarkable composition. Set in a deep landscape is an astonishing architectural construction on which stand or sit seven female figures and one male. Enthroned under a Classical aedicula is Justice, wearing a helmet and a brilliant red dress and holding a sword, certainly the appropriate central Virtue for a book on law. To her right and left stand Fortitude, embracing one of the piers, and Prudence gazing into a convex mirror. Grouped with these figures, but seated on the landing of a zigzagging set of stairs, is the fourth Cardinal Virtue, Temperance, arm raised to empty a vase. Seated directly above Justice is Faith, her importance dramatised by her central position under the arch and by the huge chalice and wafer that she holds. To the left and right are Hope, hands folded in prayer, and Charity, who reaches down to assist a cripple. The figures are unusually monumental, their carefully ponderated poses exaggerated by their long legs revealed through slits in the wind-blown gowns. A prominent feature of the ensemble are the two shields with the Ugelheimer arms blazoned on them. The shields seem to be attached to the architecture, much in the way that the gold framed cameos with *all'antica* profile heads and other curious ornaments of gold and fruit enrich the flat planes of the structure.

It is surprising that the Master of the Seven Virtues has not yet been positively identified with a named artist, given how distinctive his style is. Mariani Canova (1969, pp. 56-62; 1988a, pp. 53-8) has drawn attention to the Ferrarese qualities of the figure and drapery style, finding analogies in the paintings of Cosimo Tura (*fl. c.* 1450-*d.* 1495) and Ercole de' Roberti (*fl. c.* 1475-*d.* 1496), but to date no more precise identification has been possible.

In addition to the splendid paired frontispieces in the Gotha Gratian, there are large painted initials at the beginning of each *Causa* in the text. The initials appear to be carved out of crystal and completed with gold joints and finials, sometimes decorated with jewels and pearls. These apparently three-dimensional letters are affixed to green, blue, or reddish purple plaques on which images are outlined and modelled

in gold as if they were carved reliefs. Subjects of the reliefs include satyrs (folio k7 v), male nudes (folios q2v, 18, s4v, x3v, ff1, gg1, LL4); putti (folios q5v, x7, cc4v, dd5); and dolphins (folios s1, bb10v).

Not only is the Ugelheimer Gratian richly illuminated but it is also magnificently bound. The type of binding is inspired by Mamluk and Ottoman bindings and is first found in northern Italy in books associated with the scribe and antiquarian Felice Feliciano (1435-1478/9; Hobson 1989, pp. 41-8, 50-4). The principal areas of the cover are red leather with gold tooled borders, and 'Chinese lotus' motifs are tooled in gold and black; central medallions of tan leather are cut in filigree patterns, revealing blue silk and gold beneath. Completing the complex work are raised areas of red leather imprinted with profile busts from Roman coins, thus ensuring that the owner's knowledge of the Classical past was subtly flattered.

Provenance: Peter Ugelheimer of Frankfurt, coat of arms twice on folio 1v (a1v) (*or on a fess azure a bow(?) or*), and named in inscription, folio 2 (a2).

Exhibition: Paris 1935, no. 2347.

Bibliography: Van Praet 1822, VI, p. 48; Jacobs and Uckert 1838, III, p. 254; Goldschmidt 1928, pp. 90-1 (binding); De Marinis 1960, II, no. 1635, pls CCLXXXIX-CCXC (binding); Rothe 1968, p. 261, pl. 102; Mariani Canova 1969, pp. 56-62, 66-8, 117-22, 153-4, pls 21, 25, 89, 107; Mariani Canova 1988a, pp. 53-8, figs 28-9, 35; Hobson 1989, pp. 50-4, fig. 44 (binding).

L. A.

97

Justinian, *The Digest*, with the *Commentary* of Accursius of Florence

Justinianus, *Digestum novum*, with the *Glossa ordinaria* of Accursius, printed in Venice by Nicolaus Jenson in 1477. Gothic type (H. 9581; GW 7702)

410 fols, the first blank. 425 x 287 mm. On parchment. Late 15th-century binding attributed to the Ugelheimer Binder

Illumination by Benedetto Padovano (Benedetto Bordon), signed on folio 2 [a2], Venice or Padua, c. 1477

GOTHA, LANDESBIBLIOTHEK, Mon. Typ. 1477, 2° (13)

The *Digestum novum* of Justinian is the last section of a fundamental text of civil law, normally appearing in a separate volume from the preceding two segments, the *Digestum vetus* and the *Infortiatum*. The early printers were quick to realise that legal texts would find a ready market at universities, and Nicolaus Jenson was particularly successful in producing the weighty tomes in the late 1470s (Lowry 1991, pp. 137-72).

Copies of such legal and philosophical texts were extravagantly illuminated and bound for Jenson's business associate, Peter Ugelheimer of Frankfurt (see p. 43-4). Although the older artist Girolamo da Cremona may have been the leading miniaturist in the group working on the Ugelheimer incunables (cats 96, 99, 101), it was a young illuminator at the beginning of his career who proudly signed the frontispiece of the Justinian, 'BENEDIT./PATAV./OPVS'-the work of Benedetto Padovano (folio 2 [a2]). The signature is widely accepted as that of Benedetto Bordon, a miniaturist documented in Padua and Venice over the long period from 1480 to 1530 (Billanovich 1968; Mariani Canova 1968-9b, Mariani Canova 1969, pp. 68-74, 122-30, 156; see cats 104, 118).

Many similarities link the dramatic opening folios of the Justinian to the other Ugelheimer books (cats 96, 98-100). An architectural frontispiece surrounds the first page of text, and opposite it is a full-page miniature. The full-page miniature (folio 1v [a1v]) is dominated by a Roman triumphal arch in front of which is suspended an enormous shield bearing the Ugelheimer coat of arms. The family blazon is repeated several times – on the cornice and keystone of the arch, and again on the shields held by two Roman soldiers. Making even more

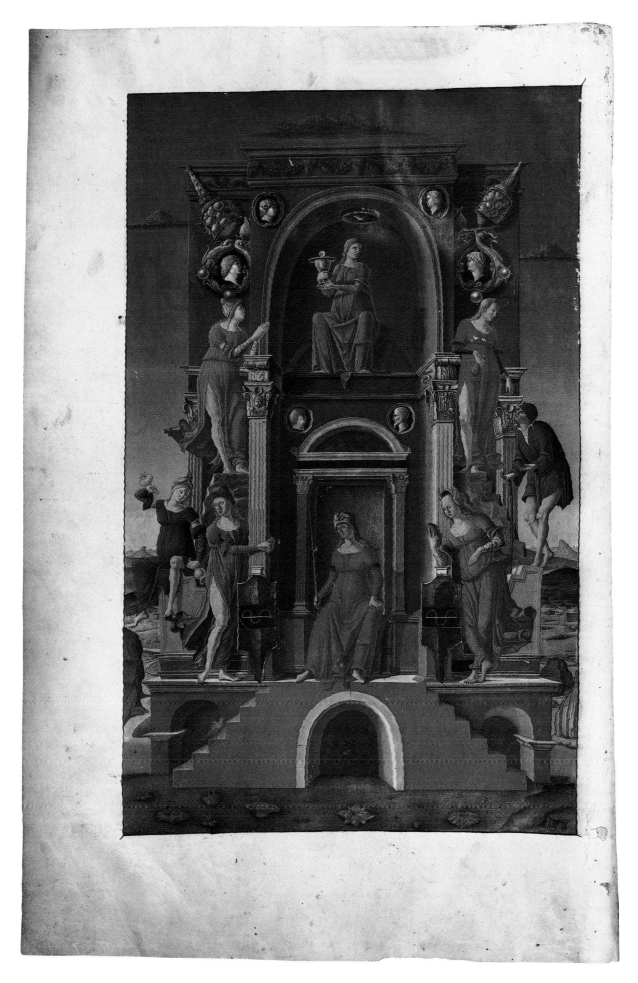

explicit the owner's goal is an inscription below the miniature: '.PETRVS UGELHEIMER FRANCFORDENSIS BENE NATVS./POST-ERIS HVNC LIBRUM VOLVIT ESSE SUIS.' ('Peter Ugelheimer of Frankfurt, well born, desires this book for his descendants [for posterity]'). Evocative of Andrea Mantegna's fresco *St James Led to Execution* in the Eremitani Church in Padua, or of contemporary frescoes in the Palazzo Schifanoia in Ferrara (Lightbown 1986, fig. 14; Varese 1989, pp. 334, 343, 346), Benedetto paints the upper storeys of contemporary palaces receding behind the colonnaded wall that separates his triumphal arch from the distant cityscape.

The glorification of Peter Ugelheimer is more muted in the architectural frontispiece of folio 2 (a2). A putto peeking from behind the page between the columns of text supports the ubiquitous Ugelheimer coat of arms. Just below him is Peter Ugelheimer's motto, 'MIT ZITT' ('with time'), and in roundels on the base is Benedetto Padovano's signature. In front of the monument are an active band of mythical creatures: a satyr is about to loose an arrow from his bow, while two others hail him as if to inhibit his action. Like the wounding of a satyr painted by Girolamo da Cremona in Ugelheimer's Aristotle (cat. 101a), these violent actions remain unexplained by the text or known tastes of the owner.

Closely linked to the text, however, is the miniature in the reserved space by the beginning of the text proper. Figures stand on a platform that appears to be the 'upper storey' of the architectural monument. An urban setting is suggested by the buildings behind them. The Emperor Justinian is depicted in discussion with a builder, behind

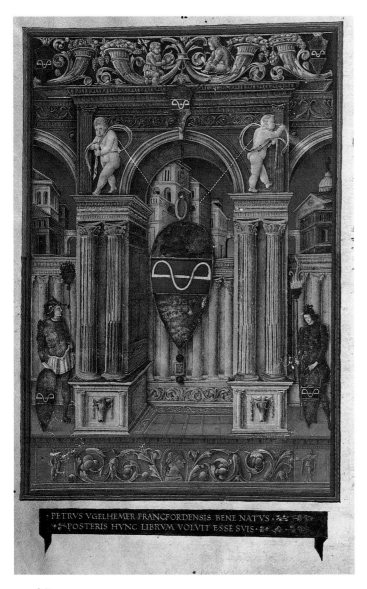

97　folio 1v

whom is a stonecarver chiselling a marble capital (Mariani Canova 1988a, pp. 60-1). Points of law concerning new construction (*De operibus novis nuntiatione, Digestum novum*, Book I, that is *Digestum*, Book XXXVIII) are expounded to a surrounding crowd of scholars whose red robes contrast to the gold brocade of Justinian's rich garment. The carefully designed buildings, and the pose of the builder with his weight shifted to his rather stiff left leg, are both characacteristic of later works by Benedetto Bordon (cats 104, 118).

Each of the remaining eleven books of the *Digestum novum* was provided with a miniature related to the following text. Many of these show seated judges listening to clients, and in one such scene the lawyer unrolls a scroll on which is inscribed '*bene[d]itus pinxit*' (folio s1, Book VI, that is XLIIII; Mariani Canova 1988a, p. 61). The miniatures are: Book II=XL (folio e3), a master seated outside frees a kneeling slave in the presence of two citizens and bearded older man; Book III=XLI (folio h4), young man on horseback carrying a hawk and accompanied by a dog; Book IV=XLII (folio l5), Justice, crowned and carrying a sword and scales, sits enthroned between two female figures; Book V=XLIII (folio n7), a magistrate seated outside refuses a petition, landscape with city walls beyond; Book VI=XLIV (folio s1): a client hands a scroll inscribed '*bene[d]itus pinxit*' to a man seated on a stool decorated with a harpy, behind him a youth tips his hat to another man, a landscape behind; Book VII=XLV (folio u3), a King enthroned in an interior and accompanied by young men is approached by two bearded men; Book VIII=XLVI (folio z4), an enthroned Emperor accompanied by two older and two younger men; Book IX=XLVII (folio A2), an enthroned judge confronts a bound prisoner who stands between two soldiers, behind them an archway; Book X=XLVIII (folio K1), three standing men observe a hanged man by a broken arch; Book XI=XLIX (folio I1), two judges enthroned at the left, a crowd of clients at the foot of the throne before a barrel vaulted archway, beyond is a landscape with a city; Book XII=L (folio L7v), a man in a brocaded robe greets a man standing in a boat, on the far shore, a castle. The miniatures are very finely executed in brilliant colours, although the slender figures are sometimes awkwardly designed. The groupings and poses resemble later compositions by Benedetto Bordon, and this visual evidence, together with the inscribed miniature on folio s1, supports the attribution of the scenes to Bordon.

The Ugelheimer Justinian is fully rubricated with red and blue initials elaborately flourished in contrasting purple and red inks. The presence of up to 35 such flourished initials on a given opening contributes to the extraordinary richness of this volume.

A final detail is of great interest for demonstrating the complex business relations between the printer Nicolaus Jenson and his business associates. The coats of arms on the frontispieces assure that the Justinian belonged to Peter Ugelheimer. However, on the lower right corner of folios 6 and A1 is written '*B. agustini*'. The Agostini were also business associates of Jenson, and their name is similarly inscribed in margins of many books they owned (cats 94, 95; see p. 43). The presence of the '*B. Augustini*' inscription in the Ugelheimer copy raises the possibility that the Gotha volume was originally meant for B. Agostini, rather than for Ugelheimer.

The Justinian in Gotha was exquisitely bound with red and tan leather tooled in gold and cut in filigree patterns to reveal a layer of blue or white silk, or an area of gold, a technique reflecting the influence of Ottoman Turk bindings (Hobson 1989, pp. 52-4). Impressions of Roman coins contribute a Classical component, and join the exotic elements to create a sumptuous effect.

Provenance: Peter Ugelheimer of Frankfurt, coat of arms on folio 1 [a1]v and 2 [a2] (*or on a fess azure a bow (?) or*), named on folio 1 [a1]v.

Exhibition: Paris 1935, no. 2408.

Bibliography: Jacobs and Uckert 1838, p. 254; De Marinis 1960, II, no. 1634, pls CCXCI, CCXCII (binding); Levi d'Ancona 1967a, pp. 21-42; Billanovich 1968, p. 206; Mariani Canova 1968-9b, pp. 99-121, esp. 114-15; Mariani Canova 1969, pp. 68-74, 122-30, 156, pl. 29, figs 108, 109; Mariani Canova 1988a, pp. 25-69, esp. 60-2; Hobson 1989, pp. 50-4.

L. A.

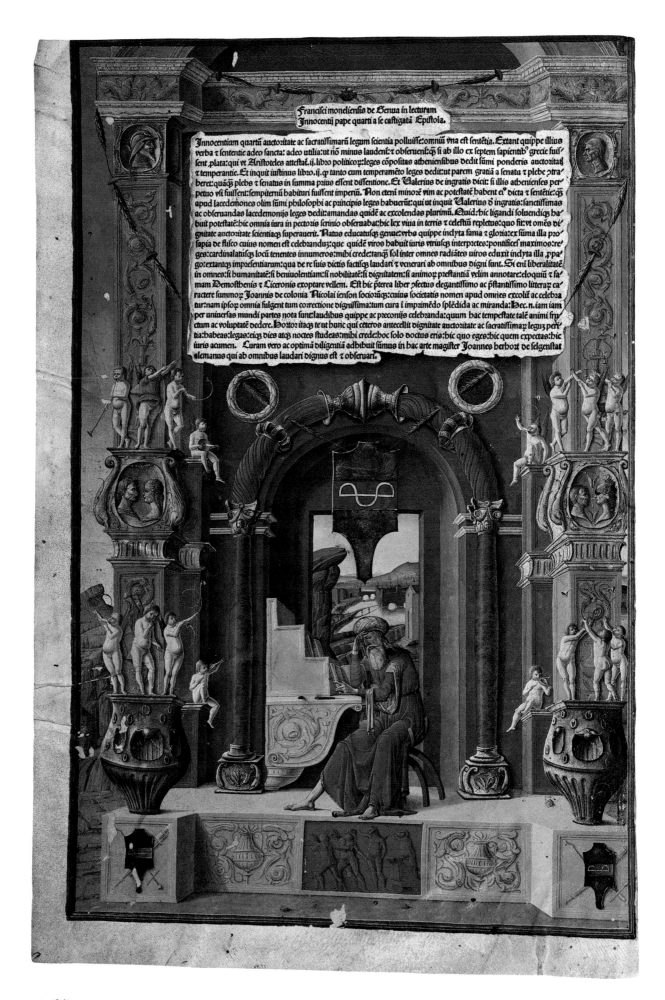

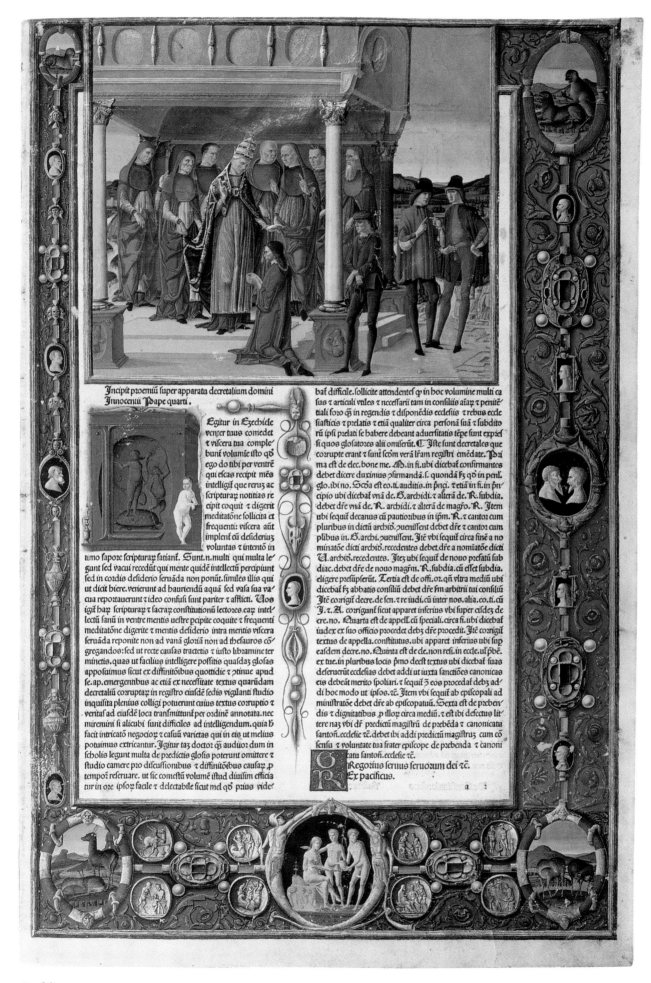

98

Pope Innocent IV, *Commentary on Papal Decrees*

Innocentius IV, Pontifex Maximus (Sinibaldo Fieschi), *Decretales*, or *Apparatus super libros Decretalium*, edited by Franciscus Moneliensis, printed in Venice by Johannes Herbort de Seligenstadt for Johannes de Colonia, Nicolaus Jenson, et Socii, 15 June 1481. Gothic type (HC 9192)

[261] fols. 440×285mm. On parchment. Late 15th-century Venetian binding

Illumination attributed to the Master of the Seven Virtues, Venice, c. 1481

GOTHA, LANDESBIBLIOTHEK, Mon. Typ. 1481, 2° (10)

The *Decretales* of Pope Innocent IV (r. 1243-1254) is one of four legal texts magnificently illuminated and bound for Peter Ugelheimer of Frankfurt, a nobleman and business associate of the printer Nicolaus Jenson (cat. 96 and pp. 43-4). For a short while after Nicolaus Jenson's untimely death in 1480, his collaborators employed the printer Johannes Herbort, but continued to use Jenson's name along with their own as the publishers. They also provided their financial backer, Peter Ugelheimer, with illuminated copies of the legal texts they printed (cats 96-98; and Gotha, Landesbibliothek, Mon. Typ. 1479, 2° [4]).

The opening miniatures and borders in Ugelheimer's copy of Innocent IV were painted by the artist known as the Master of the Seven Virtues (see cats 96, 100), and they show the miniaturist's familiarity with artistic currents in Venice, Ferrara and Padua in the third quarter of the Quattrocento (Mariani Canova 1969, pp. 56-8, 66-8, 121-2, 155; Mariani Canova 1988a, pp. 58-9). The presentation scene on the first text page (folio 2 [a2]) shows the Pope standing under an open portico blessing a kneeling author, perhaps the editor, Franciscus Moneliensis. Giordana Mariani Canova (1987, pp. 125-6; 1988a, pp. 29-34, 58-60) has suggested that the composition, with its casual arrangement of the attendant clergy and young noblemen, is indebted to the copy of Jenson's 1474 Gratian illuminated for Filiasio Roverella, Bishop of Ravenna (1475-1519) or Niccolò Roverella, Abbot General of the Olivetan Order, both members of a powerful Ferrarese family. Undeniably Ferrarese characteristics of the figure style relate to the paintings of Cosimo Tura (fl. c. 1450-d. 1495) and Ercole de' Roberti (fl. c. 1475-d. 1496), and support the notion that the Master of the Seven Virtues emerged from the Ferrarese artistic milieu.

Other aspects of the Innocent IV illuminations are more clearly Venetian or Paduan in origin. The painted borders of the first text page (folio 2 [a2]) are Venetian; the combination of monochromatic grounds with symmetrical floral motifs simulating relief, and the overlying cameos, crystal and gems framed in gold, appears in work of the London Pliny Master in the second half of the 1470s (cat. 28). The architectural monument of the opposite folio (folio 1 [a1]v) is a well-established Veneto-Paduan genre. Distinctive to the Master of the Seven Virtues, however, are the great golden vases situated on projecting parts of the base, and the oddly non-architectural components of the 'archivolt' over the central arch – a pair of gold vases, red and blue cylindrical units of a torsade column that are curved rather than straight, and gold and green wreaths encircling the cylinders.

As in the other books presented to Peter Ugelheimer in the years 1477 to 1483, the illuminations glorify the recipient. The Ugelheimer coat of arms hangs prominently in the center of the architectural monument and also appears on two shields on the base (folio 1 [a1]v). The notion of a noisy triumph is implied by the swarm of nude putti, most of whom blow on slender curving horns. The seated white-bearded man wearing a turban is something of a puzzle. Giordana Mariani Canova (1988a, pp. 59-60) has identified the scholar as Aristotle, arguing that his presence underlines the continuity of law from the Classical era into the Christian, represented by the Pope on the opposite folio.

However, by 1483 the white-bearded wise man wearing a turban has definitively become Averroës rather than Aristotle. In the scene of debate between Aristotle and the great Islamic commentator Averroës, painted by Girolamo da Cremona in the Aristotle of the Morgan

Library, the latter wears the white turban and Aristotle wears a hat with a dome-like crown and a peaked visor, a type of headgear designating a Greek in Venetian art (cat. 101, Volume I, folio 2 [AA2]). Perhaps in 1481 the team of miniaturists illuminating the Ugelheimer books had not yet been called upon to distinguish between Greek and Islamic philosophers, and thus the Master of the Seven Virtues represented Aristotle in a turban in the Innocent IV miniature.

The Innocent IV is also beautifully bound in tan leather with a gold stamped border and central medallion with gold stamped patterns; the corners and 'Chinese lotus' motifs are stamped in black.

Provenance: Peter Ugelheimer of Frankfurt, coat of arms three times on folio 1 [a1]v (*or on a fess azure a bow (?) or*).

Exhibition: Paris 1935, no. 2348.

Bibliography: Jacobs and Uckert 1838, III, p. 254; Goldschmidt 1928, pp. 90-1 (binding); De Marinis 1960, II, no. 1637, pls CCXCV-CCXCVI (binding); Mariani Canova 1969, pp. 56-8, 66-8, 121-2, 155, pls 27, 28, figs 106, 107; Mariani Canova 1988a, pp. 55-60, figs 36-8; Hobson 1989, pp. 52 (binding).

L. A.

99

Petrus de Abano, *Commentary on the Problemata of Aristotle*

Petrus de Abano, *Expositio problematum Aristotelis cum textu*, printed in Venice by Johannes Herbort de Seligenstadt, 25 February 1482. Gothic type (HC 17)

316 fols of which fols 1, 315-316 blank. 342×234 mm. On parchment

Illumination attributed to Girolamo da Cremona and the Master of the Pico Pliny, Venice, c. 1482

THE HAGUE, KONINKLIJKE BIBLIOTHEEK, 169 D 2

The three beautiful volumes decorated for Peter Ugelheimer of Frankfurt and now in the Koninklijke Bibliotheek (cats 99, 100 and 169 D 1), are far less well known than the four illuminated for the same patron in the Landesbibliothek, Gotha (cats 96-98). The books in the Hague are philosophical rather than legal texts; the two exhibited here both are commentaries on Aristotle or pseudo-Aristotelian works written by Petrus de Abano (1275-1315), a professor of medicine and philosophy at the University of Padua.

The *Expositio* opens with a magnificent double-page illumination with the first text page painted by Girolamo da Cremona (see cats 93-95, 101, 123) and the opposing full-page miniature by the anonymous miniaturist known as the Master of the Pico Pliny (cat. 102; fig. 28). Girolamo's frontispiece (folio 2 [a2]) shows a relatively simple monument, or stele, but its form is obscured by heavy clusters of jewels. Coloured gems, pearls, and cameos appear in gold setttings shaped in the form of satyrs, cupids and dolphins. Aristotle (or Averroës) sits on the stone-strewn ground; he calmly inhabits the same world as four reclining deer and a lively satyr blowing a horn. In the space reserved for the first capital letter, the portrait of Petrus de Abano appears as if behind the torn parchment page. Large books bound in red, green and blue leather and gold bosses stand on a ledge behind the author, giving evidence of how books were shelved in the late 15th century (figs 9, 10).

Balancing Girolamo's frontispiece is a full-page miniature by the Master of the Pico Pliny, a miniaturist whose illuminations appear in a great many Venetian manuscripts and incunables dating from 1469 to 1494 (Armstrong 1990a). As in the other incunables illuminated for Peter Ugelheimer, the miniature is devoted to the glorification of the Ugelheimer family. A rather delicate monument sits in a barren landscape; in its central niche the Ugelheimer arms hang from a garland of fruit and leaves. Pretty coloured birds alight on the fronds projecting from vases on the cornice, and swaying boneless putti blow slender

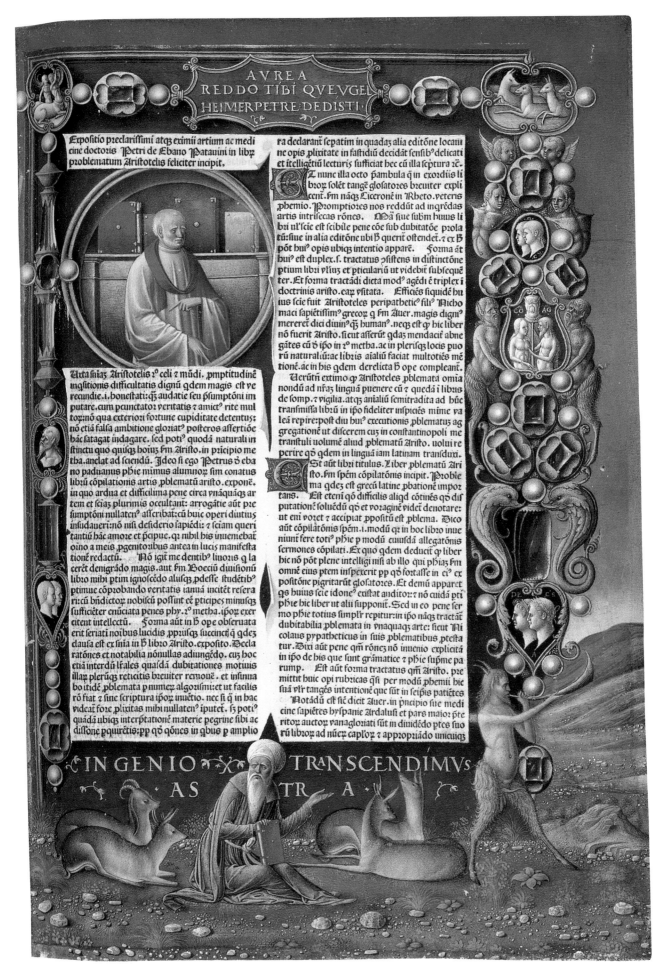

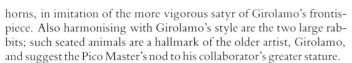

99 folio 1v

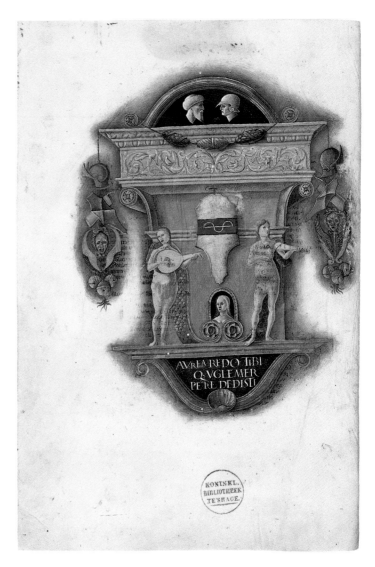

100 folio 1v

horns, in imitation of the more vigorous satyr of Girolamo's frontis-
piece. Also harmonising with Girolamo's style are the two large rab-
bits; such seated animals are a hallmark of the older artist, Girolamo,
and suggest the Pico Master's nod to his collaborator's greater stature.

The inscriptions in gold on the frontispieces of both volumes in the
Hague are of particular importance (see also cat. 100). On the architec-
tural monument painted by the Pico Master is inscribed: 'SIGNUM.
ASPICITO/ENIGMATVM.SO/LVTIO.' ('the solution of the riddles
looks to the sign'). At the top of Girolamo's composition is: 'AVREA/
REDDO TIBI QVE VGEL/HEIMER PETRE DEDISTI.' ('I give back to
you the gold [things] that Peter Ugelheimer gave [to me]'); at the bot-
ton while at the bottom appears 'INGENIO TRANSCENDIMVS
ASTRA' ('we transcend the stars through genius'). The 'AVREA REDDO
TIBI' inscription is repeated in the second volume in the Hague, which
also adds 'DIV QVE FELIX' ('for a long time and happy'). It can be sur-
mised that the inscriptions refer to Peter Ugelheimer's relationship to
the printing of the two philosophical texts by Johannes Herbort. The
'riddles' must be the problems of publishing the books; the 'sign'
which is the 'solution' is the Ugelheimer coat of arms, hence the mer-
chant himself. At the death of the great printer Nicolaus Jenson in
1480, Ugelheimer had inherited the valuable punches Jenson used to
produce his famous typographical fonts. In turn, the printer Herbort

was enabled by Ugelheimer to use the font in the Petrus de Abano edi-
tions. The 'gold' of the inscriptions would refer to the investment by
Ugelheimer in the edition, and to the lavish use of gold by Girolamo
da Cremona on the frontispiece, which is the gift of the printer to his
financial backer. Finally 'INGENIO TRANSCENDIMUS ASTRA' may
be the justifiable pride of all concerned in the evident mastery of the
new invention of printing.

Although the Petrus de Abano *Expositio problematum Aristotelis* has
no further miniatures or historiated initials, it contains dozens of three
line initials painted in tempera on gold ground. Its hundreds of red and
blue initials are elaborately flourished with purple and red ink, again
testifying to the extraordinary quantity of hand-work incorporated
into the parchment copies of Venetian law books executed for special
patrons.

Provenance: Peter Ugelheimer of Frankfurt, coat of arms on folio 1 [a1]v (*or
on a fess azure a bow (?) or*), named on folio 2 [a2]; Abbey of Tongerlo, Bel-
gium; acquired from Tongerlo, 1828.

Exhibition: The Hague 1980, no. 60.

Bibliography: Van Thienen 1980, p. 483, no. 8; *Incunabula in Dutch Libraries*
1983, no. 3604; Armstrong 1990a, pp. 19–21, 35, no. 69, figs 26, 27.

 L. A.

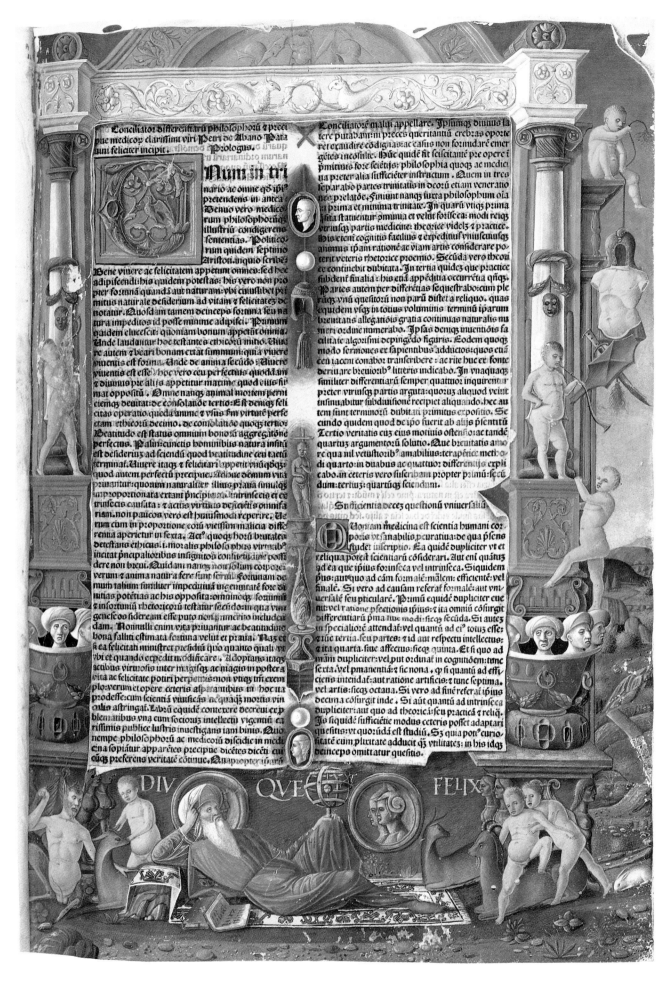

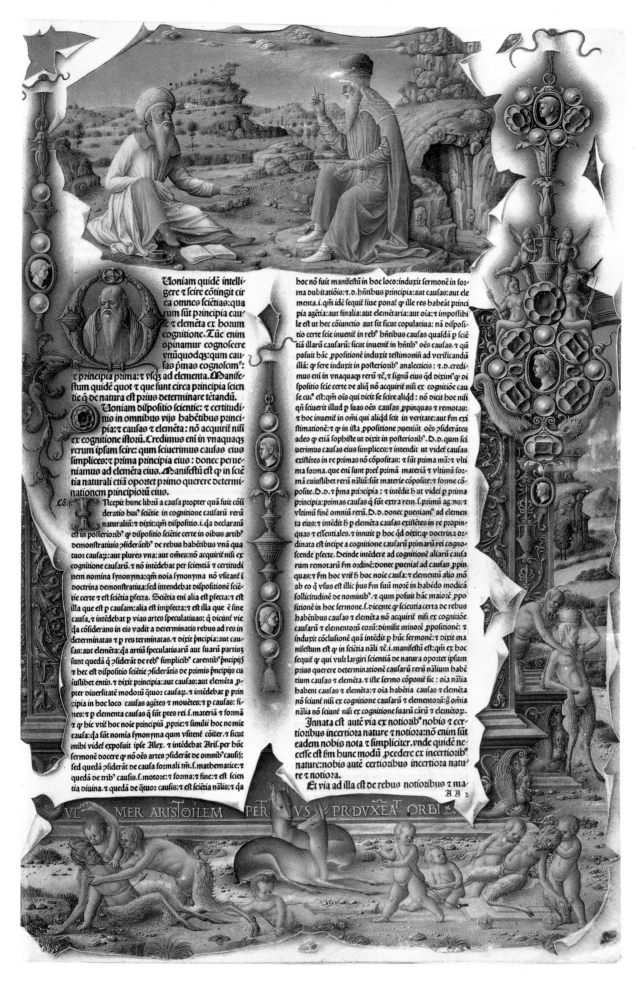

Uoniam quidé intelligere τ scire cōtingit circa omnes scietias: quarum sūt principia caure τ elemēta ex horum cognitione. Tūc enim opinamur cognoscere vnūquodqz: qum causas pmas cognoscum̄: τ principia prima: τ vsqz ad elementa. Manifestum quidé quot τ que sunt circa principia scientie q̄ de natura est prius determinare tētandū.

Uoniam dispositio scientie: τ certitudinis in omnibus vijs habētibus principia: τ causas τ elemēta: nō acquirit nisi ex cognitione istorū. Credimus eni in vnaquaqz rerum ipsam scire: qum sciuerimus causas eius simplices: τ prima principia eius: donec perueniamus ad elemēta eius. Manifestū est ꝙ in scientia naturali etiā oportet primo querere determinationem principiorū eius.

Łō.ꝭ Ncepit hunc librū a causa propter quā fuit cōsideratio hū scietie in cognitione causarū rerū naturaliū: τ dixit: qm dispositio.i.ꝗa declaratū est in posteriorib ꝙ dispositio scietie certe in oibus artib demonstratiuis ꝑsiderātib de rebus habētibus vnā quatuor causaꝝ: aut plures vna: aut omēs: nō acquirit nisi ex cognitione causarū. τ nō intēdebat per scientiā τ certitudinem nomina synonyma: qm noia synonyma nō vsitant̄ i doctrina demonstratiua: sed intendebat dispositione scietie certe τ est scietia pfecta. Scietia eni alia est pfecta: τ est illa que ē p causam: alia est impfecta: τ est illa que ē sine causa. τ intēdebat p vias artes speculatiuas: ꝗ dicunt̄ vie ꝗa cōfiderans in eis vadit a determinatis rebus ad res indeterminatas τ p res terminatas. τ dixit pncipia: aut causas: aut elemēta: ꝗa artiū speculatiuarū aut suarū partiuz sunt quedā ꝗ ꝑsiderāt de rebꝰ simplicib carentibꝰ pncipijs τ hec est dispositio scietie ꝑsiderātis de primis pncipijs cuiuslibet entis. τ dixit principia: aut causas: aut elemēta ꝓpter diuersitaté modorū ꝗtuoꝛ causaꝝ. τ intēdebat p principia in hoc loco causas agētes τ mouētes: τ p causas: fines: τ p elementa causas ꝗ sūt ptes rei.s. materiā τ formā τ ꝙ hic vtīt hoc noie principij .ꝓprie: τ similit hoc noie causa: ꝗa sūt nomia synonyma qum vsitent̄ cōiter. τ sicut mihi videt̄ exposuit ipse Alex. τ intēdebat Arist. per hūc sermonē docere ꝙ nō oēs artes ꝑsiderāt de omnibꝰ causis: sed quedā ꝑsiderāt de causa formali tm.s. mathematice: τ quedā de trib causis.s. motoꝛ: τ forma: τ finc: τ est scientia diuina. τ quedā de ꝗtuoꝛ causis: est scietia nāliz: ꝗa

hoc nō fuit manifestū in hoc loco: induxit sermonē in forma dubitatiōis: τ.ꝟ.bītibus principia: aut causas: aut elementa.i. qm idē sequit siue ponat ꝙ ille res habeat principia agētia: aut finalia: aut elemētaria: aut oia: τ imposfible est ut hec cōiunctio aut sit sicut copulatiua: nā dispositio certe scie inuenit in reb bītibus causas quasdā p scietiā illarū causarū: sicut inuenit in bītib oēs causas: ꝙ qui posuit hāc ꝓpositionē induxit testimoniū ad verificandū illā: ꝙ sere induxit in posteriorib analecticis: τ.ꝟ.credimus eni in vnaquaqz rerū τc. τ signū huius ꝙ diximꝰ ꝙ vi spositio scie certe ꝙ te elementa nō acquirit nisi ex cognitione cause eū est: qm ois qui dicit se scire aliꝗd: nō dicit hoc nisi qn sciuerit illud p suas oēs causas ꝓpinquas τ remotas: τ hoc inuenit in omni qui aliꝗd scit in veritate: aut sin ex existimatione: τ ꝙ in ista ꝓpositione pueniūt oēs ꝑsiderātes adeo ꝙ etiā sophiste ut dixit in posteriorib. D.o. qum sciuerimus causas eius simplices: τ intendit ut videt causas existētes in re propinquā: τ sūt prima mā: τ vltima forma. que eni sunt pter primā materiā τ vltimā formā cuiuslibet rerū nāliū: sūt materie cōposite: τ forme cōposite. D.o. τ pma principia: τ intēdit h ut videt p prima principia: τ sūt extra rem.f. primū aḡ: ne: τ vltimū finē omniū rerū. D.o. donec pueniaз ad elementa eius: τ intēdit h p elemēta causas existētes in re propinquas τ essentiales. τ innuit p hoc ꝙ dixit: ꝙ doctrina ordinata est incipe a cognitione causarū primarū rei cognoscende pfecte. Deinde intēdere ad cognitione altarū causarum remotarū sm ordinē: donec pueniaз ad causas ꝓpinquas: τ hoc vtīt h hoc noie causa: τ elementū alio mō ab eo ꝗ vsus est illic pꝰ sm suū morē in habēdo modicā sollicitudinē de nominibꝰ. τ qum posuit hāc maioꝛē ꝓpositionē in hoc sermone.f. vicente ꝙ scietia certa de rebus habētibus causas τ certa est nō acquirit nisi ex cognitiōe causarū τ elementoꝛū eoꝝ: dimisit minorē ꝓpositione: τ induxit cōclusionē quā intēdit p hūc sermonē: τ dixit manifestum est ꝙ in scietia nāli τc.i. manifestū est: qm ex hoc sequit ꝙ qui vult largiri scientiā de natura oportet prius querere determinatione causarū rerū nāliū habētium causas τ elemēta. τ iste sermo cōponit sic: oia nālia habent causas τ elemēta: ꝙ oia habētia causas τ elemēta nō sciunt nisi ex cognitione causarū τ elementoꝛū: ꝗ omnia nālia nō sciunt nisi ex cognitione suarū cārū τ elemētoꝛ.

Innata est autē via ex notioribꝰ nobis τ certioribus incertiora nature τ notiora: nō enim sūt eadem nobis nota τ simpliciter. vnde quidē necesse est sin hunc modū ꝓcedere ex incertioribꝰ nature: nobis autē certioribus incertiora nature τ notiora.

Et via ad illa est de rebus notioribus τ maA A ꝭ

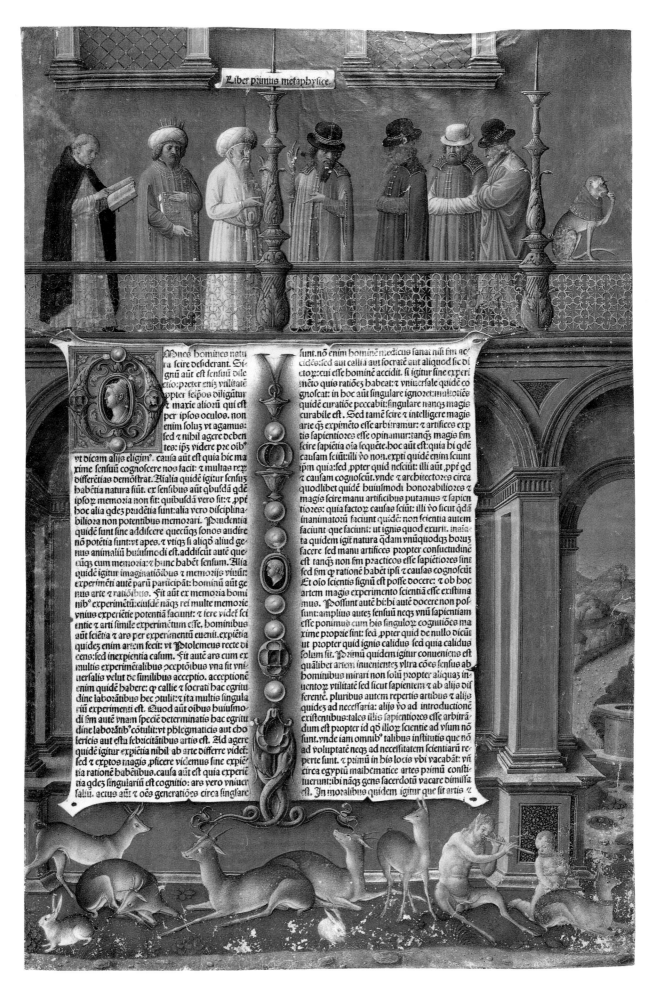

100

Petrus de Abano, *Reconciliation of the Differences of Philosophers and Physicians*

Petrus de Abano, *Conciliator differentiarum philosophorum et medicorum*, edited by Franciscus Argilagnes, printed in Venice by Johannes Herbort de Seligenstadt, 5 February 1483. Gothic type (HC6)

284 fols, the first blank. 347×240 mm. On parchment

Illumination attributed to the Master of the Seven Virtues, Venice, c.1484

THE HAGUE, KONINKLIJKE BIBLIOTHEEK, 169 D 3

Like several other incunables illuminated in Venice for Peter Ugelheimer of Frankfurt (cats 96-99), the Petrus de Abano *Conciliator differentiarum philosophorum et medicorum* in the Hague begins with a full-page miniature facing an elaborately painted first text page. The Ugelheimer coat of arms forms the focal point of the miniature (folio 1 [a1]v), hanging in the center of a classicising wall monument on whose base is inscribed in gold letters: 'AVREA REDO TIBI Q[VE] VGLEMER PETRE DEDISTI' ('I give back to you the gold [things] that Peter Ugelheimer gave [to me']). The same inscription is spelled out more fully in the second volume of Petrus de Abano's works in the Hague, the *Expositio problematum Aristotelis* (cat.99), in which it is made even clearer that the book decorated in gold is probably the thing 'given back' to Ugelheimer, presumably in return for his financial support of the publication.

The illuminator of both the miniature and of the architectural frontispiece opposite (folio 2 [a2]) is the anonymous artist known as the Master of the Seven Virtues, so named for the exceptional figures of Virtues he painted in another book for Ugelheimer, the Gratian *Decretum* in Gotha (cat.96). The long-legged nude musicians of the *Conciliator* resemble the female allegorical figures in the Gratian not only in their overall monumentality, but also in details of their contrapposto poses and the turn of their heads. The miniaturist's figures tend to be somewhat harshly modelled, accentuating the sculptural qualities of their bony features. The Master of the Seven Virtues' taste for the macabre is evident in the skulls hanging from the wall monument, and even more so in the bizarre circle of white heads that forms part of the architectural frame on the opposite page. The heads seem to emerge from a pair of red cauldrons part way up the complex base of the monument; similar vessels painted in gold appear in the Innocent IV in Gotha (cat.98).

Like Girolamo da Cremona (cat.99), the Master of the Seven Virtues incorporates the image of a white-bearded savant at the bottom of the architectural frontispiece, accompanied by deer, putti and a satyr. In the *Conciliator* version, the turbaned figure reclines on a brilliant oriental carpet and holds an armillary sphere on his knee, pausing to contemplate some problem encountered in reading the open book at his side. The exotic scholar may be Averroës, the 12th-century Islamic commentator on the works of Aristotle, rather than Aristotle himself (see cats 98, 101).

The condition of the folio on which the architectural frontispiece is painted is problematic (folio 2 [a2]). The area bearing the text has been cut out of another copy of the edition and patched into the folio with the painted frame, from which the original text has been excised. On the recto the patch was carefully obscured by the miniaturist, who has painted over the seam between the two pieces of parchment; the seam is more clearly visible on the verso. Since there is also a lot of offset printing on the opposite folio with the wall monument (folio 1 [a1]v), it may be that substantial damage was done to the text of original first page even after the painting of the border and miniatures had been begun. The Master of the Seven Virtues salvaged the architectural border he had already painted by inserting the new leaf of text, and then painted over the jointure between the two.

Throughout the text, two line capitals have been supplied in red and blue ink; hundreds of initials are flourished in purple and red ink to 'finish' the appearance of the Ugelheimer presentation volume.

Provenance: Peter Ugelheimer of Frankfurt, coat of arms and inscription on folio 1 [a1]v; Abbey of Tongerlo, Belgium; acquired from Tongerlo, 1828.

Bibliography: Van Thienen 1980, p.483, no.9; *Incunabula in Dutch Libraries* 1983, no.3602; Armstrong 1990a, pp.19-21.

L.A.

101

Aristotle, *Works*; Porphyrius, *Isagoge*

Aristoteles, *Opera* (with commentary of Averroës); Porphyrius, *Liber quinque praedicabilium*, printed in Venice by Andreas Torresanus de Asula and Bartholomaeus de Blavis (in part for Johannes de Colonia), 1483. Gothic type (HC1660; GW2337; Goff A-962)

Edition issued in three volumes, each with two parts. Volume I (containing volume I, part 2; volume II, parts 1 and 2): 375 fols. 409×272 mm. Volume II (containing volume III, parts 1 and 2; volume I, part 1): 348 fols. 414×280 mm. On parchment [Vol. II New York only]

Volume I: *illumination attributed to Girolamo da Cremona and assistants, Venice, c.1483;* Volume II: *illumination attributed to Girolamo da Cremona, Antonio Maria da Villafora, and Benedetto Bordon, Venice, c.1483*

NEW YORK, THE PIERPONT MORGAN LIBRARY, PML 21194, 21195 (ChL ff907)

Of the many spectacular books owned by Peter Ugelheimer of Frankfurt, the two volume Morgan Aristotle is doubtless the most lavishly decorated. Three frontispieces with elaborate borders and intriguing figural groups plus 80 painted initials, over half also containing figures, attest to the richness of the programme and of the patron.

The two principal frontispieces may be attributed to Girolamo da Cremona and are the latest dated illuminations by this gifted artist, whose activities stretch back to 1458 (see p.31, cats 93-96, 99, 123). The volume I frontispiece initiating the *Physics* (folio 2 [AA2]) is an exuberant version of the Veneto-Paduan architectural frontispiece, complete with a grandiose golden bronze monument set on pebbly ground, apparently seen behind a torn piece of parchment on which the text is printed. Familiar clusters of jewels in gold settings hang from red strings mysteriously tied to the parchment leaf.

In front of the monument two mock-tragic events take place. To the left a putto and a satyr comfort another satyr, wounded by an arrow shot by an unknown assailant. A third satyr, equally collapsed, is drawn by putti on a low wheeled cart. Undisturbed by these occurrences are two reclining deer and two more satyrs, one of whom bears a basket of fruit on his head. The hairy legs of the satyrs are painted in Girolamo da Cremona's characteristic blond colors, as is the hair of the putti, also distinguished by a pointed 'widow's peak' formed in the center of the forehead. Although not a direct copy of a known Antique work, the putti supporting the dying satyr echo figures from a sarcophagus then in Santa Maria Maggiore, Rome; the motifs were more directly copied by another miniaturist, Gaspare da Padova, in a manuscript written by the scribe Bartolomeo Sanvito for Giuliano de' Medici in 1474 (Rubinstein 1992, pp.71-3). More immediately based on a famous Classical statue is the satyr with a basket on his head. Like the similar figure painted by Girolamo in the 1478 Plutarch owned by the Agostini (cat.94), the satyr depends on an over life-sized pair of Pan statues in the Museo Capitolino in Rome (Bober and Rubinstein 1986, no.75; Alexander 1977a, p.72; fig.29).

The two column text of the *Metaphysics* at the beginning of volume II also opens with an architectural frontispiece (folio 1 [i1]). In this case, the structure appears to be an oddly designed palace façade. Shallow barrel vaults resting on square piers support a balcony beneath partially visible windows. A torn piece of parchment hangs by red strings from bronze candelabra on the balcony. In front of the building is a narrow area of green grass on which disport two rabbits, six deer, a satyr playing a flute and a putto; one of the archways to the right is open, revealing a well-head and a rocky road stretching into a distant landscape.

The frontispiece compositions of both volumes clearly differentiate the scenes with mythical creatures from the human beings represented above. In volume I, a rocky landscape irrationally appears above the architectural structure, as if seen through the illusionistically torn parchment page (folio 2 [AA2]). Two bearded figures in long robes are seated, disputing with each other. The man at the right wears a peaked round-domed hat, denoting Greek nationality in Venetian painting; he is seated in the more dominant position and must represent Aristotle. Confronting him at the left and wearing a white turban is his great Spanish Muslim commentator, Averroës. In volume II, Averroës appears again near the center of the disputing wisemen (folio 1 [i1]). The wonderfully varied group also includes a Dominican at the left, probably Thomas Aquinas. Next is a regal figure wearing a crowned turban, similar to representations of Solomon or David in Venetian manuscript illumination. To the right are four more savants, all wearing round Greek hats. Although his hair is now brown rather than white, the centrally placed Greek may again be Aristotle, whose writings are incorporated into the Venetian edition.

Peter Ugelheimer was a nobleman from Frankfurt who was the 'dearly beloved' partner of the printer Nicolaus Jenson (see pp. 43-4). Jenson willed to him the precious punches from which the matrices for his famous fonts were made (Lowry 1991, p. 231). In turn, Andrea Torresano acquired Jenson's fonts and used them in printing some of his editions. Ugelheimer's ownership of the Morgan Aristotle, and in fact his probable financial support for the publication, is indicated by the Latin inscription on the frontispiece of volume I 'VLMER ARISTOTILEM PETRVS PRODVXE[R]AT ORBI' ('Peter Ugelheimer has brought [this] Aristotle forth to the world'). The Ugelheimer coat of arms appears modestly in one of the painted initials near the end of the volume II (folio 55, second foliation). It is likely that the splendidly illuminated books were partial payment for Ugelheimer's participation in the Torresanus publishing venture.

Many of the painted initials in volume I of the Morgan Aristotle contain bust-length portraits of Greeks in black hats, and occasionally a turbaned white-bearded Arab. All of these are painted in the style of Girolamo da Cremona, but their somewhat lower quality suggests that they were assisted by another member of the workshop. More surprises appear in volume II. A third fully illuminated border provides a frontispiece for the text of Porphyrius' *Liber quinque praedicabilium* (folio 1 [i1], second foliation; Mariani Canova 1990, fig. 39), painted in the style of Benedetto Bordon, the Paduan miniaturist who collaborated in decorating other books for Ugelheimer (cat. 97). Rectangular borders incorporate symmetrically arranged *all'antica* motifs in white or gold which contrast to solid blue or reddish purple backgrounds. The miniature in the lower margin shows a Greek philosopher reading in a landscape dominated by trees with highly unusual yellow foliation. The scene is the earliest datable appearance of the colour scheme used in the mature works of Bordon (cats 104, 118). Historiated initials in volume II appear in this style, as well as others showing the participation of a third well-known miniaturist, Antonio Maria da Villafora (see cat. 7). The Morgan Aristotle thus represents the continued collaboration of prominent miniaturists working to produce exceptionally grand incunables for Peter Ugelheimer.

Provenance: Peter Ugelheimer of Frankfurt, frontispiece inscription, volume I, folio 2 [AA2], coat of arms, volume II, folio 55, second foliation (*argent, on a fess azure a bow (?) or*); Bertram, 5th Earl of Ashburnham; Henry Yates Thompson; purchased by John Pierpont Morgan, Jr (1867-1943) in 1919.

Exhibitions: New York 1939, no. 242; New York 1957, no. 48; New York 1984, no. 37; New York 1992-3 (no catalogue); New York 1994a, p. 25.

Bibliography: Thompson 1906; Levi d'Ancona 1964, pp. 71-2; Mariani Canova 1969, pp. 62-4, 120-1, 154, pls 22, 23, figs 90, 94; Alexander 1977a, pp. 72-5, pls 17, 18; Mariani Canova 1990, p. 196, fig. 39.

L. A.

102

Plutarch, *Parallel Lives*

Plutarchus, *Vitae virorum illustrium*, printed in Venice by Nicolaus Jenson, 2 January 1478. Roman type (H. 13127)

Volume II only: 228 fols. 410×268 mm. On paper [New York only]

Illuminations attributed to the Master of the Pico Pliny, Venice, c. 1478

BERLIN, STAATLICHE MUSEEN ZU BERLIN, PREUSSISCHER KULTURBESITZ, KUPFERSTICHKABINETT, MS 78 D 16

Among the copies of Nicolaus Jenson's 1478 edition of Plutarch's *Parallel Lives* in this exhibition (cats 92, 94, 95), the Berlin example can claim the most famous owner, the humanist Giovanni Pico della Mirandola (1463-1494). A younger son of the Lords (*signori*) of Mirandola, in north-eastern Italy, Giovanni became an apostolic protonotary at the tender age of ten (Garin 1937, p. 4). The honour was conferred in 1473 by Cardinal Francesco Gonzaga, patron of the scribe Bartolomeo Sanvito and of the illuminator Gaspare da Padova (Chambers 1992, pp. 56-64; and see esp. cat. 39). Much later Pico wrote his well-known treatise, *On the Dignity of Man*, and amassed an exceptionally large library of about 1,000 volumes, which he had with him in Florence when he died there in 1494 (Kibre 1936).

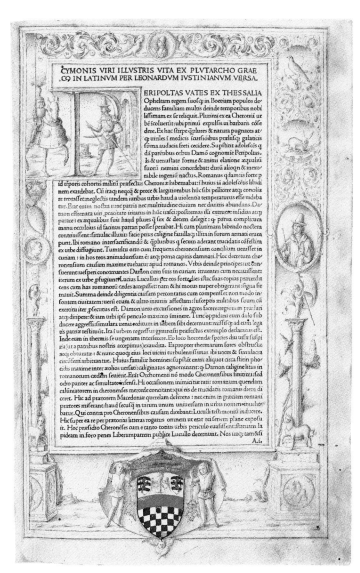

102 folio 1r



Giovanni Pico della Mirandola owned at least three books illuminated by the anonymous miniaturist known as the Master of the Pico Pliny (Armstrong 1990a). The earliest, a richly painted copy of Macrobius, *In somnium Scipionis*, printed by Nicolaus Jenson in 1472 (Cambridge, Trinity College Library, Trin. VI.18.52), was probably given to him soon after his appointment as protonotary, since its frontispiece shows the Pico della Mirandola arms surmounted by the appropriate black ecclesiastical hat (Armstrong 1991, fig. 6.4). Unfortunately, only volume II of Pico's copy of the 1478 Plutarch is known, but on its frontispiece (folio 1 [A1]), a similar black hat is visible above his arms despite a later attempt to conceal it with red paint. The latest of the three books illuminated by the Pico Master for the humanist is the great Pliny manuscript dated 1481 (fig. 28); Venice, Biblioteca Marciana, Lat. VI, 245 [= 2976); the scribe's colophon ensures that this manuscript was written for Pico.

The frontispiece and historiated initials of the Berlin Plutarch are drawn in pen and sepia ink over preliminary sketches in metalpoint (see p. 36). The inventive frontispiece composition includes some awkward yet charming figures characteristic of the Pico Master (folio 1 [A1]). Column monuments rise in both lateral margins; on each base prances a large-eyed horse and on top is a putto waving a banner with the faint traces of the Pico arms. A curious portrait of Plutarch is presented in the oval to the right; his Greek nationality is signalled by the tall conical hat. The warrior in Antique armour drawn by the first initial is also identified as Greek by a similar incongruous hat and must be Cimon, subject of the first Life in volume II.

103 folio ii v

Although many Venetian printed books received painted or drawn frontispieces, relatively few had complex figural compositions in the spaces left blank for capital letters. The Berlin Plutarch is an exception. In the reserved spaces at the beginning of each Life are drawn a faceted epigraphic capital and figures. Unlike the military figure of Cimon, most of the 28 scenes bear no obvious relation to Plutarch's text; often in fact the images are quite bizarre. A sampling of the subjects follows. Life of Lucullus (folio A6): a nude older man tied to the capital 'L', guarded by a soldier in *all'antica* armour (Meiss 1957, fig. 75); Nicias (folio B10): 'Q', a nude putto on a horse chased by another youth (Armstrong 1990a, fig. 22); Agisilas (folio E2): a boy in a tunic stands on a capital and plays a fiddle while two others, one with a sword, lean against the letter 'N', listening; Alexander (folio G6v): a man wearing a turban rides a camel (fig. 24d); Photion (folio K6): 'D', a bearded elder in a turban drives an elephant ridden by a boy; Brutus (folio N9v): the left vertical stroke of the 'M' pierces the body of a dolphin on which is standing a blindfolded Cupid holding bow and arrows, to the left a woman in a long dress holds a vase with foliage; Demosthenes (folio PP2v): the only historiated initial painted with full colours and gold, the gold 'D' surrounding Demosthenes, who stands on a platform before a listening audience (fig. 24c); Demetrius (folio Q8): 'P', a boy rides on two barrels strapped to a donkey; Artaxerxes (folio T7v): 'A', a nude boy pours grapes into a vat where another is treading, a clothed boy drinks; Aratus (folio V4): 'C', a ship on wheels on dry land is drawn by a dolphin into the water, a nude boy holds a sail aloft (Wescher 1931, fig. 102); Galba (folio X4): 'E', a bespectacled singing-master points to a choir book on which is written '*Mainert Tenor*', while three choristers support the book; Evagoras (folio Y2v): 'C', a hermit sits reading outside a cave; Aristotle (folio &&1): 'A', three scholars reading.

In 1478 when the Jenson Plutarch was published in Venice, Giovanni Pico della Mirandola was only fifteen, although from 1477 to 1479 he studied canon law at the University of Bologna (Garin 1937, pp. 4-5). Despite what must be considered the seriousness of these studies, one is tempted to imagine that the whimsical drawings in the Berlin Plutarch were designed to appeal to a still very young patron. Alternatively, an impulse to illustrate Plutarch with bizarre scenes may have been associated with Jenson's edition, since even stranger images initiate the Lives in a copy executed by the Master of the Seven Virtues for Girolamo Rossi, a nobleman of Pistoia who became a prominent member of the Dominican Order (Dillon Bussi 1989, pp. 40-3).

Provenance: Coat of arms on folio 1 (A1) of the Pico della Mirandola family, surmounted by the black hat of an apostolic protonotary, Giovanni Pico della Mirandola (1463-1494).

Bibliography: Wescher 1931, pp. 111-13, fig. 102; Meiss 1957, p. 65, fig. 75; Armstrong 1991, pp. 19, 33, figs 22, 23.

L. A.

103

Dante, *Divine Comedy*

Dante Alighieri, *La Commedia* (with commentary of Cristoforo Landino), edited by Piero da Figino, printed in Venice by Bernardinus Benalius and Matteo Capcasa, 3 March 1491. Roman type (HCR 5949; GW 7969).

3 full-page woodcuts (1 repeated twice) in a woodcut architectural border, 238 x 150 mm; and 97 narrative woodcuts, each *c.* 65 x 65 mm

Woodcut designs attributed to the Master of the Pico Pliny

Copy A: 291 fols, imperfect copy, wanting fols I-V, [6-10], and 277 of the original 302 fols. 314 x 216 mm. On paper [London only]

LONDON, THE BRITISH LIBRARY BOARD, IB. 22339

Copy B: 292 fols, wanting fols I-V, [6-10]. 297 x 202 mm. On paper
[New York only]

NEW YORK, THE PIERPONT MORGAN LIBRARY, PML 15417 (ChL f927)

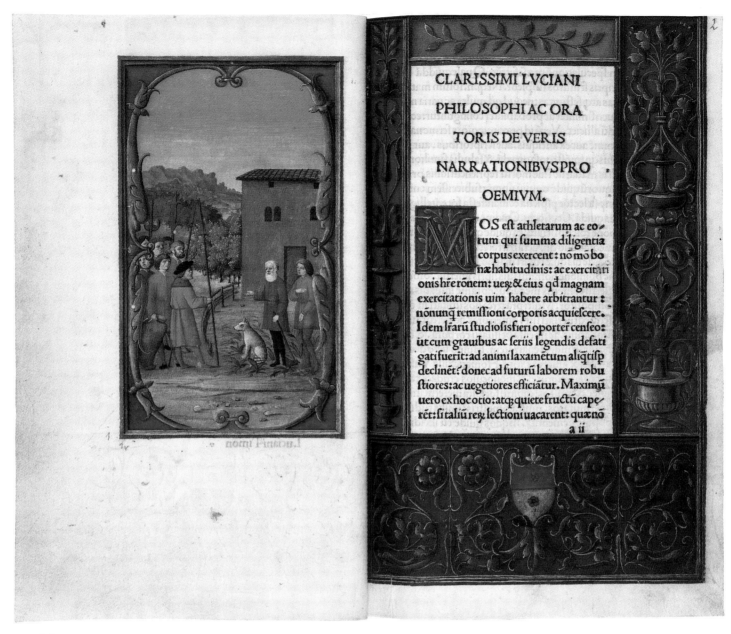

104 folio 1v-2r

The inclusion in this exhibition of a Dante *Divine Comedy* illustrated with woodcuts suggests the continuity from the manuscript tradition to that of the printed book fully illustrated by mechanical means. Until about 1490 very few woodcuts were included in Venetian printed books, even though the technology of printing relief woodblocks and types in the same matrix was well established in northern Europe in the 1470s. After 1490 both religious and secular texts printed in Venice were provided with woodcut frontispieces and dozens of smaller narrative scenes. The Dante printed in 1491 by Bernardinus Benalius and Matteo Capcasa is a handsome example of the new art which ultimately signalled the end of the illuminator's trade (p. 45). However, the designers of the woodcuts in Venetian illustrated books of the late 1480s and 1490s were probably a small number of miniaturists, already habituated to working with printers in the hand-illumination of printed books. Drawings by these miniaturists would have been turned over to a professional cutter, and the resulting blocks could provide illustrations for every copy of a given edition.

The woodcuts in the 1491 Dante belong to a large group whose designer is identified by several writers on illustrated books, but is perhaps best known by A. M. Hind's name, the 'Popular Designer' (Hind 1935, pp. 464-87). The artist was responsible for the designs of

at least four very popular architectural border woodcuts, used as frontispieces for a variety of texts in the early 1490s (Hind 1935, pp. 503-4; Armstrong 1990a, p. 37). The 'Popular Designer' has been identified with the miniaturist known as the Pico Master, one of the most prolific illuminators working in Venice from 1469 to 1494 (Armstrong 1990a). Probably because he had provided so much hand-work for printed books, the artist understood that illustration in the future would necessarily be the result of a mechanical process. Since both miniatures and woodcuts require preliminary designs (cat. 107; see figs 24c, 24d), the transition from illumination to woodcut would not have involved an alien process.

The full-page woodcuts in the 1491 Dante consist of two parts, the narrative woodcuts and the architectural border, the latter characterised by columns topped by crouching youths. Three different large narrative woodcuts appear at the beginning of the *Inferno*, the *Purgatorio* (folio 188 [s2]v), and the *Paradiso*, while the architectural border is the same for each of the three *cantiche*. The columns surrounded by wreaths, the vases with topiary-cut shrubs and the slender putti flanking the empty shield are all motifs found in the frontispieces of the Pico Master, as are the sirens, strings of beads, elongated dolphins, winged putto heads, and the scallop shells (cats 99, 102; fig. 28).

Not surprisingly, the *Divine Comedy* of Dante Alighieri (1265-1321) was a very popular text in Quattrocento Italy. The 1491 edition is the twelfth out of fifteen printed in the 15th century (GW 7958-72), the fourth to appear with the commentary of the Florentine humanist Cristoforo Landino (1424-1492), and the third to be extensively illustrated by prints (Castelli 1989-90). The first edition with Landino's commentary, printed in Florence by Niccolò di Lorenzo in 1481, was planned to be illustrated with engravings now attributed to Baccio Bandini, perhaps based on drawings by Botticelli (1445-1510) (Foligno, Ravenna and Florence 1989-90, p. 134). These proved difficult to incorporate, and of the 19 completed, most were tipped in rather than printed on the same page as the text (fig. 27). The more satisfactory medium of woodcuts was chosen for the Brescia edition of 1487 (Sander 1942, no. 2312); 68 full-page narrative scenes were provided, but this series also stops at the beginning of the *Paradiso*. Thus the 3 full-page woodcuts and the 97 small narratives in the 1491 Dante are the first to illustrate every canto in the poem.

The Pico Master's compositions follow in the tradition of manuscripts of the *Divine Comedy* (Brieger, Meiss and Singleton 1969, I, esp. 234-9, 332-9); and they reflect knowledge of the 1487 Brescia edition. The woodcut opening the *Purgatorio* (folio 188 [s2]v) includes three moments in the following canto. At the lower right, Dante and Virgil emerge from the cave of the underworld and gaze up at the stars; to the centre left they encounter Cato; and in the upper right Virgil washes Dante's face with the morning dew. Four stars in the sky direct their rays down to Cato's head. Like the border, the figures and landscape features are rendered with simple outlines and very little shading, the whole harmonising well with the black and white of the opposing text.

Provenance: Copy A: bought in July 1855. Copy B: inscriptions on rear free endleaf verso, '*D. Ant[on]ii de Gilbertoz; Pred[icato]re Cappuccino P[adre] Salvatore da Martenengo; ex dono P[at]ris Virgilii Giannote[?] . . ., mihi Joanni Baptistae Marinelli Arniengol . . . 1689*'; purchased by John Pierpont Morgan (1837-1913) in 1907 from Canessa (?).

Bibliography: Essling 1907-14, no. 531; BMC, V, 373 (Copy A); Hind 1935, p. 483, figs 248-9, 251; Sander 1942, no. 2313; Goff D-32 (Copy B); Castelli 1989-90, pp. 109-113, 139; Armstrong 1990a, p. 37.

L. A.

104

Lucian, *Works*

Lucianus Samosatensis, *Opera (Vera historia)*, translated into Latin by Lilius Castellanus, printed in Venice by Simon Bevilaqua, 25 August 1494. Roman type (HC 10261)

112 fols. 235 x 143 mm. On parchment [New York only]

Illumination attributed to Benedetto Bordon, Venice, c. 1494

VIENNA, ÖSTERREICHISCHE NATIONALBIBLIOTHEK, Inc. 4. G. 27

The Vienna Lucian is a unique presentation copy printed on parchment for a member of the noble Mocenigo family, whose coat of arms appears on the first text folio (folio 2 [a2]). As in the case of many illuminated Venetian incunables, the arms only serve to identify the family, not a specific membr. Two Mocenigo Doges had reigned in the preceding decades, Pietro (r. 1474-1476) and Giovanni (r. 1478-1485), and they had probably been the recipients of beautifully illuminated books (cats 28, 93), so the owner of the Lucian followed a family tradition. It has been suggested that the collector was one Alvise di Tommaso Mocenigo, to whom an edition of the *Letters* of Pliny the Younger was dedicated by the famous printer Aldus Manutius (c. 1450-1515; Lowry 1991, p. 171).

The decorative borders of the first text page and the miniature on the opposite verso are carefully designed to compliment each other (folios 1v-2 [a1v-a2]). The borders appear to be edged in thin bronze bars. Within the bars are symmetrically arranged vine, flower, and dolphin motifs rising from Classical vases, also in golden bronze; these motifs contrast to solid backgrounds of green, blue and violet. The miniature on the opposite page is framed by related designs; two pairs of bronze dolphins with extended tails form an inner frame within a metallic rectangle.

As Hermann J. Hermann (1931, p. 221) pointed out in the Vienna catalogue many years ago, the miniature illustrates an episode from the first book of the *De veris narrationibus* in which Lucian and his companions, in the belly of a whale, encounter Scintharus and his son in a farmyard. The slightly stiff figures are typical of the Paduan miniaturist Benedetto Bordon, as are the intense colours of the costumes. The landscape with its blue craggy mountains and characteristic fluffy trees are also elements found in his other works (cat. 118). The innovative format of the two-page opening is one that Bordon will develop further in books printed by Aldus Manutius around 1500 (Szepe 1994; p. 46-7).

The Lucian texts are illustrated with miniatures painted in the lower margins, again an ingenious format for a small printed book (all miniatures described and illustrated in Hermann 1931, pp. 220-5). Like the opening miniature, the fifteen narrative scenes are edged with golden brown frames softened by paired leaf and dolphin motifs. In most of the scenes solemn groups of figures stand in the foreground; beyond them are delicate landscapes that often include intense blue mountains far in the distance and feathery trees highlighted in gold. The curious subjects are either dressed in Classical armour or Renaissance costumes (folios 88v-89). A nude Venus appears in the clouds interrogating three youths dressed in fashionable fur-trimmed coats and elegant hats (folio 88v); and Mercury in bright red and yellow military garb leads Plutus, god of riches, to Timon (folio 89). The brilliant colours of the costumes contrast to the blue of the sky and the greens of the landscape.

The career of Benedetto Bordon is better documented than that of almost any other miniaturist from Padua or Venice (Billanovich 1968), and yet many disputes remain concerning his œuvre (Levi d'Ancona 1967; Mariani Canova 1969, pp. 68-74, 122-30, 156-7). Born in Padua around 1450-5, Bordon is always referred to as *miniator* in documents dating from his marriage in 1480 to his second and final will of 9 February 1530 (*more veneta* 1529). Two incunables illuminated for Peter Ugelheimer and dated 1477 (cat. 97) and 1479 are inscribed 'BENEDIT PATAV OPVS' and are almost universally accepted as Bordon's early works. What complicates the understanding of Bordon's career is that his only other signed work was executed over 45 years later, the Evangeliary now in Dublin (cat. 118), which was illuminated for Santa Giustina in Padua between 1523 and 1525 (Mariani Canova 1984b, pp. 499-502). Midway between these works is the 1494 Lucian, in which the figure style, landscapes, colours, and even the decorative borders bear many similarities to the Dublin Evangeliary.

Stylistic evidence, however, is not the only reason for attributing the miniatures in the Vienna Lucian to Benedetto Bordon. At the end of the 1494 Lucian appears a petition from *Benedictus miniator* requesting a privilege to publish the translated texts which he says he has collected with great labour and expense. The positive response to the petition follows. The assumption that the miniatures in this presentation copy were painted by the publisher-miniaturist seems well founded when these documents are combined with the formal evidence.

Provenance: Coat of arms of the Mocenigo family of Venice (*per fess azure and argent, two roses palewise counterchanged*), folio 2 [a2].

Bibliography: Hermann 1931, pp. 220-5, pls LXIX-LXXII; Billanovich 1968; Mariani Canova 1968-9b, pp. 103-5; Mariani Canova 1969, pp. 74, 123-4, 167, pl. 44, figs 121-3, 213-16; Lowry 1983, pp. 180-1; Lowry 1991, p. 171; Szepe 1994.

L. A.

Illuminators and their Methods of Work

One indication of a growing self-consciousness accompanied by a greater status for illuminators is an increase in signed miniatures, of which a number of examples are displayed in this section. At the same time the improved survival rate of written records, for example in the treasury accounts of regional rulers or of ecclesiastical authorities, means increased documentation on scribes and artists, many of whom are thus identifiable as responsible for surviving works. Scribes and artists also belonged to organised guilds which protected their interests (cat. 105).

Two manuscripts have been included to show aspects of production. One is a pattern-book of an artist who specialised in penwork decoration, Guinifortus de Vicomercato (cat. 109). The other is an unfinished miniature by a Neapolitan artist, Giovanni Todeschino, which shows the stages of work from preliminary drawing to finished painting (cat. 106). Two other drawings, one for an architectural frontispiece (cat. 107), the other for an initial (cat. 108) may be either preliminary studies or possibly maquettes for a patron.

105

Liber jurium et privilegiorum notariorum Bononie

262 fols. 314 x 227 mm. On parchment [London only]

Written and illuminated in Bologna, 1474-82, with later additions

BOLOGNA, MUSEI CIVICI D'ARTE ANTICA, MS 644

The manuscript contains the rules and privileges of the guild of notaries in Bologna. It opens after the list of contents with a frontispiece in two registers separated by a prayer on a scroll, folio 3. Above is the Virgin and Child between SS. John and Thomas, and, below, a group of kneeling notaries. On folio 3v Rolandino Passaggeri (or Orlandinus) is shown teaching at a high lectern in the centre with two groups of students seated below to either side, and on folio 4, Pietro da Unzola (or Anzola, Unciola) is similarly represented. These were two famous early 14th-century Bolognese jurists, works by whom were still current in the 15th century, since they were soon printed, for example the former's *Summa artis notariorum* in 1480, and the latter's *Apparatus notularum* in Bologna in 1479. On folio 4v is a generalised portrait of a notary with the arms of the city and of the guild flanking him. On folio 5 a border surrounds the text. An initial 'I', made up of a dragon and the guild arms is on folio 9 and another initial is on folio 16. To folio 54v there are also a number of penwork initials, some with fine grotesque heads. Various textual additions continue to folio 249 and the manuscript ends on folio 262.

Neither artist nor scribe has so far been identified. The manuscript belongs to a tradition in Bologna of guild books which from the 14th century onwards contain miniatures showing both their members and their trades or activities, the latter often in a strikingly realistic way.

Exhibition: Rome 1953, no. 589.

Bibliography: Fava 1932, pp. 22, 357, fig. 9, 208; Palmieri 1933, p. 192, illus.; Salmi 1957, pl. LIX; Medica, forthcoming.

J. J. G. A.

106

Pliny the Elder, *Natural History*

64 fols. 420 x 285 mm. On parchment [London only]

Written in Naples, c. 1485-95, with illumination attributed to Cola Rapicano and Giovanni Todeschino

VALENCIA, BIBLIOTECA GENERAL DE LA UNIVERSIDAD, MS 691
(G. 1803)

This manuscript is made up of incomplete fragments of two manuscript copies of the same text, Pliny's *Natural History*. Pages are cut out and a detailed codicological examination of the textual contents has not yet been made to determine the relationship between the two fragments. Though written by different scribes, they both contain 41 lines to a page. The texts are not complementary, however, but overlap.

The illumination of both copies is unfinished. Spaces are left for illuminated initials, either twelve or three lines high. On folio 1 is a

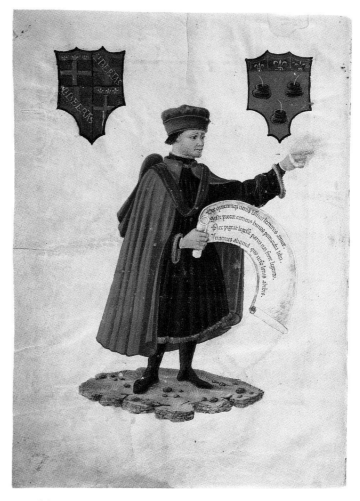

105 folio 4v

fully painted frame with foliage inhabited by putti, animals and birds, and roundels with the *imprese* of Alfonso, Duke of Calabria (1448-1494), and his motto '*No son tales amores*' (see also cat. 76). His arms are in a roundel with five putti in a landscape in the centre of the lower border. The text of the opening of Pliny's Preface is written in minuscule, but the title and the opening words ('*Plinius secundus Vespasiano suo salutem l[ibros naturalis]*') are only sketched in pencil in capitals, preliminary no doubt to being written in gold on a colour ground. Folio 3 is a second opening for the Preface, this time with an architectural frontispiece. A triumphal arch is drawn and partly painted with, at the top, the arms of Naples surmounted by a crown, a group of musical putti and two standing figures, the left a male nude, the right a female figure holding spear and shield. A sculpted frieze and standing figures are also drawn on the arch, together with bust heads in roundels and two winged Victory figures in the spandrels. Through the arch in a landscape can be faintly seen Pegasus and the Nine Muses. Pegasus has the device of the Accademia Pontaniana in Naples. Below in front of the arch an enthroned figure receives a book from a kneeling figure. Courtiers stand around. De Marinis (1947-52, II, pp. 129-30) has

suggested some possible identifications from the Naples court: the seated figure to the King's left may be his son Frederick, by comparison with his medal (Hill 1930, no. 312); the leading figure at the left may be Alfonso, Duke of Calabria, by comparison again with his likeness on a medal (Hill 1930, no. 745); thirdly, and least convincingly, the figure with a turban behind the throne may, De Marinis suggests, be Ferdinand's bastard son, who returned in 1487 from the Sultan and appeared at the court in Naples in Eastern attire according to a contemporary account. The scene thus represents at the same time Pliny presenting his work to Vespasian and King Ferdinand receiving the present manuscript.

The style of the first frontispiece is that of the Neapolitan illuminator Cola Rapicano (see cats 9, 10). The second frontispiece is by the same artist as the Berlin Horace (cat. 45) and the Munich Flavio Biondo (cat. 61), plausibly to be identified as Giovanni Todeschino. Its unfinished state gives a good indication of the artist's working method from preliminary drawing to finished painting.

It seems that we have here fragments of two Plinys, one intended for King Ferdinand I (r. 1458-1494), the other for his son and successor,

106 folio 3r

107

Alfonso, Duke of Calabria, who succeed as King (*r.* 1494-1495). Both must have been incomplete and combined at a later point in the history of the Naples library. One possibility is that the copies had been given to the two illuminators but were not completed. It is tempting to connect the interruption of the Duke's copy with Cola Rapicano's death in 1488 and of the King's copy with his death in 1494 and the fall of the Kingdom of Naples to the French.

Provenance: Arms, *imprese* and motto of Alfonso, Duke of Calabria (*r.* 1494-1495), folio 1, and of King Ferdinand I of Naples (*r.* 1458-1494), folio 3; De Marinis 1947-52, II, inventories B, no. 162, G, no. 387; Cherchi and De Robertis 1990, pp. 217-18, 220, inventory of 1527, no. 169; bequeathed to San Miguel de los Reyes, Valencia, by Ferdinand of Aragon, Prince of Taranto in 1550.

Bibliography: Gutiérrez del Caño 1913, no. 1803, pl. XX: Bordona 1933, II, no. 2070, figs 706-8; De Marinis 1947-52, I, pp. 40, 74 n. 29, 146-7, 161 n. 9, 229, II, pp. 129-30, pls 193-4 (as Valencia, MS 787); Toscano 1993, p. 280, fig. 6.

J. J. G. A.

107

Single leaf without text, design for a frontispiece

253 x 186 mm. On paper

Rome ?, late 15th to early 16th century

NEW YORK, THE PIERPONT MORGAN LIBRARY, 1979.13

This leaf contains an ink drawing, apparently a design for a frontispiece miniature. An architectural structure frames the page with a space for script or print in the centre. At the top of the page two putti flank a shield for a coat of arms with probably a cardinal's hat lightly sketched above. Two other putti lean down as if from the hemicycle to grasp the edge of the blank rectangle, as if it were a placard. To right and left on the pilasters are four roundels containing bust heads framed by panels of foliage with putti and sphinxes. Two blank roundels below are on either side of the podium base of the structure, and in the central space there are four figures standing before a seated figure at a desk with an open book before him.

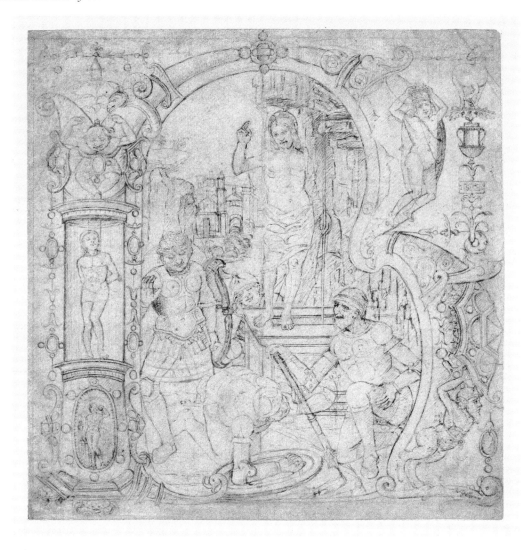

108

Architectural frontispieces of this type are especially characteristic of manuscripts and printed books produced in the region of Padua and Venice from *c.* 1470 onwards, an early example being the Ravenna Pliny printed in 1469 (cat. 78). The classicising decorative motifs are also found in works illuminated by this group of artists. The style was brought to Rome by illuminators trained in northern Italy, especially Gaspare da Padova (cat. 39) and via works by the Master of the London Pliny (cat. 46), and was later widely adopted by artists in Naples (cat. 106). It was also adopted in the north of Italy, for example the Choir Books from Cesena (cat. 125). Illuminations executed in the 1480s by the Master of the della Rovere Missals, especially the frontispiece in the Theophylact in the Vatican (cat. 37), can be compared to the present design. The figure style, with tall bodies and small heads, is also comparable to his work (see also cat. 4). The decorative forms are not like those used by that artist, however, and resemble more those of the 'Paduan' group, Gaspare da Padova and others, including their Neapolitan imitator Giovanni Todeschino (cats 45, 61, 106).

The fact that there is no text and that the drawing is on paper suggests that this is either a maquette or some form of study, rather than an unfinished page removed from an actual manuscript or printed volume. Certainly one would expect any manuscript illuminated in this way to be on parchment, and even printed copies of books with hand illumination are more usually on parchment. If this is a maquette intended for a patron's approval, it is a very unusual survival.

Provenance: Paul Fatio, Geneva; Janos Scholz, New York; acquired by the Pierpont Morgan Library in 1979.

Exhibitions: New York 1961, no. 1; Houston 1966, no. 6; Los Angeles, Seattle and Albuquerque 1967-8, no. 7.

Bibliography: Scholz 1976, no. 29; Ryskamp 1981, p. 199.

J. J. G. A.

108

Drawing for an initial 'R', *Resurrection*

185 x 185 mm. On paper [New York only]

Attributed to Antonio da Monza, probably Rome, early 16th century

BERLIN, STAATLICHE MUSEEN ZU BERLIN, PREUSSISCHER KULTUR-BESITZ, KUPFERSTICHKABINETT, MS 612

The drawing is of an initial 'R' enclosing the resurrected Christ, who stands above the tomb with three soldiers below. The initial form and the composition of the scene inside it are practically identical with the fully painted 'R' found in the Gradual in the J. Paul Getty Museum, whose illumination is attributed to Antonio da Monza (cat. 126). It is uncertain what the purpose of the drawing is. Is it a record of a composition, a working out of a design, or even a maquette to show to a client? As with the drawing of a frontispiece design from the Pierpont Morgan Library (cat. 107) it is on paper, which militates against it being an unfinished initial cut from a manuscript.

Bibliography: Wescher 1931, p. 100, fig. 89; Von Euw and Plotzek 1979, I, pp. 270-5.

J. J. G. A.

109

Pattern-book of Guinifortus de Vicomercato

19 fols. 368 x 260 mm. On parchment [New York only]

*Illuminated by Guinifortus de Vicomercato, either in Lombardy
or Ferrara, 1450*

BLOOMINGTON, INDIANA, THE LILLY LIBRARY, INDIANA
UNIVERSITY, MS Ricketts 240

This is an artist's pattern-book with designs for penwork borders and
initials executed in various coloured inks – red, blue, olive green and
brown as well as some gold. They do not occur on every page,
folios 2v, 5v, 6v, 7v, 8v, 9v, 10v, 11v, 13v, 14v, being blank. There are
alphabets with two or three lines of letters to a page, the letters varying
in size, sometimes only two, sometimes as many as seven letters to a
line. There are also designs for borders and on some pages the letters
make words: folio 5, '*Hiesus*'; folio 7, '*Cristus*'; folio 8, '*Deus*'; folio 12,
'*Dio*'; folio 14, '*Maria Virgo*'. On folio 13 an initial 'F' is framed with a
four sided border and in a roundel below is the artist's signature:
'*Guinifortus de Vicomercato mediolanensis fecit hoc opus 1450 die primo
aug'i*'. On folio 15 there are designs placed side by side for openings,
presumably of an Hours, each with the word '*Domine*' framed by a
four sided border. On folio 16v a full-page 'Q' has along its diameter
on each side the words '*Basilius de Gallis*'.

There appear to be two other styles in addition to that of Guinifor-
tus. A second artist seems to be responsible for the floral border strips
on folios 4v, 5, 15v, 16, 17v and 18v. A third is responsible for folios 16v,
18 and 19, and perhaps the words '*Jeus splendor*', which appear to be
added on folio 7. He is presumably identifiable as Basilius de Gallis.

Guinifortus de Vicomercato also signed penwork initials in two of
the Choir Books made for the Olivetan monastery of San Giorgio
fuori le mura at Ferrara which are now in the Museo Civico di Palazzo
Schifanoia, Ferrara. He gives dates there also: folio 29v, Corale L, '*1449
aug.*'; and Corale N, '*1449 die primo decembris*' (see Hermann 1900,
pp. 131, 138-9, fig. 5). A Bartolomeo di Boniforte da Vimercate was
responsible for penwork initials and borders in Choir Books executed
for the Badia Fiesolana in 1460 (cat. 120; Landi 1977, p. 8, pls 2-4).
These look very similar in style, and it seems very likely that the two
artists are father and son. For further penwork decoration in Tuscan
manuscripts which has been attributed to Bartolomeo di Boniforte,
see Ciardi Dupré dal Pogetto 1982, pp. 432, 443, 446-7, 453.

Medieval and Renaissance illuminators' pattern-books are rare sur-
vivals (see Scheller 1963) and their purpose and function are often
uncertain. The designs here are very finished and look more like pat-
terns for apprentices to copy or samples to show to a possible patron
than records of the work of other artists, sketched out ideas or trial
pieces.

Provenance: Sir Thomas Gage sale, London, Sotheby's, 25 June 1867, lot
457; W. H. Crawford of Lakelands sale, London, Sotheby's, 12 March 1891,
lot 3248; Robert Hoe, New York, 1892; his sale, New York, 24 April, 1991,
lot 2182; C. L. Ricketts, Chicago, from whom acquired by Indiana Univer-
sity in 1961.

Exhibitions: New York 1892, p. 15; Baltimore 1965, no. 38, illus.

Bibliography: Bierstadt 1895, p. 24; De Ricci 1935-40, I, p. 655, no. 240;
Faye and Bond 1962, p. 539; Drogin 1978, pl. 125; Alexander 1993, p. 175
n. 34.

J. J. G. A.

109 folio 12r

109 folio 13r

110

Giovanni Boccaccio, *Decameron*, in Italian

170 fols. 360 x 264 mm. On parchment [London only]

Illuminated by Taddeo Crivelli in Ferrara, 1467

OXFORD, BODLEIAN LIBRARY, MS Holkham misc. 49
(formerly Holkham Hall 531)

The manuscript was executed for Teofilo Calcagnini (1441-1488) of Ferrara, who was a close friend of Borso d'Este. The Duke of Ferrara took a particular interest in his welfare, appointing him *cavaliere* in 1464 and presenting him with castles in Reggio, the Modenese and Romagna. As Bertoni (1925) observed, besides the device of the *paraduro* (folio 5), used by Borso and his courtiers (a drainage dike symbolised by a palisade, with a hanging pumpkin being used as a hydrometer, and the motto '*fido*'), we also find Calcagnini's personal device (a swan with its neck knotted and padlocked, with the motto '*li e bien secrete*'; folios 5, 118v). Recognition of the purchaser endorses the identification of this manuscript as the Boccaccio mentioned in the registers of the d'Este archives; it was executed for Calcagnini and illuminated by Taddeo Crivelli (*doc.* 1452-1476) in 1467. The artist, far the most typical representative of the 15th-century school of Ferrara, is here at the peak of his maturity. We know from his studio records and from the registers (now in the Archivio di Stato, Modena) that, in 1452, when he was working for Domenico Malatesta Novello, Lord of Cesena, he was already recognised as a master illuminator and that in 1455, with Franco dei Russi and others, he started work on the Bible of Borso d'Este (Modena, Biblioteca Estense, MSS Lat. 422-3, figs. 3, 4, 15), one of the masterpieces of Italian Renaissance illumination, completed in 1461. In that Bible, Crivelli, though showing the influence of the Ferrarese illuminator Giorgio d'Alemagna (*doc.* 1441-1479) and of Belbello da Pavia from Lombardy, also makes plain his allegiance to contemporary Ferrarese painting. At first he echoes the fanciful, eccentric style of the Hungarian painter Michele Pannonio (*doc.* in Ferrara, 1446-1464), then later, in the second volume and in the first five pages of the first volume (which were executed last), he adopts the visual language of Cosimo Tura (1430-1495); though more modern in its amplitude and suppleness, his style remains highly elaborate and expressive.

The influence of Tura can be detected in the splendid figurative illuminations done for the *Decameron*: the opening illustration showing the meeting of the ten young protagonists in the church of Santa Maria Novella in Florence (folio 5), and the wonderful portraits of the individual narrators for each day, placed in the initial letters on folios 9v, 20v, 46, 64v, 80v, 96v, 105, 118, 137 and 148. As in his work in the Borso Bible and in the Falletti Hours (see cat. 111), the Calcagnini manuscript illustrates how Taddeo anticipates the decorative paintings by Francesco Cossa in the Salone dei Mesi in the Palazzo Schifanoia, for example in the monumental quality of the figures, the sober, stately style and above all in the courtly manner of representation. Excellent examples of this can be found in the portraits of Fiammetta (folio 80v), Elissa (folio 96v) and Dioneo (folio 105). The ornamentation is typical of Crivelli as well: borders with leaves, flowers and gold buds intertwined, encircling illustrations of animals, coats of arms and fanciful compositions of birds, satyrs, scrolls and clouds, the latter emitting golden rays painted with great delicacy and with a lively sense of colour. Worthy of note are the white Classical building and the inscription in capital letters, 'S. MARIA NOVELA', in the illustration to folio 5; here as elsewhere Crivelli manifests the influence of the architecture of Leon Battista Alberti.

Provenance: Executed for Teofilo Calcagnini (1441-1488), courtier of Duke Borso d'Este; library of the Franciscan monastery of Santo Spirito in Reggio Emilia (ex-libris '*Di. S. Spirito di Reggio*'); probably acquired by Thomas Coke, Earl of Leicester, during his travels in Italy between 1714 and 1717; from the library of Lord Leicester at Holkham Hall it entered the Bodleian Library in 1981.

Bibliography: Dorez 1908, pp. 71-74, pls XLVI-XLIX; Mercati 1917, pp. XXXVII-XXXVIII; Frati 1918, p. 374; Bertoni 1925, pp. 19-21, pl. VII; De Ricci 1932, p. 47; Branca 1950, p. 90; Hassall 1954, pp. 18-24, pls 2, 3; Branca 1956, pp. 222-8, colour pl.; Boskovits 1978, 381; de la Mare 1982, pp. 334-5; Hassall 1983, p. 85, pls I-III; Eleen 1985, p. 158; Mariani Canova 1991, p. 116.

F. T.

111

Book of Hours, Use of Rome

148 fols. 135 x 97 mm. On parchment

Illumination attributed to Taddeo Crivelli in Ferrara, c. 1461

NEW YORK, THE PIERPONT MORGAN LIBRARY, M. 227

The purchasers, or at least the first owners of this small but priceless manuscript, which is still relatively unknown to scholars, were the Falletti family, Ferrarese aristocrats. Their coat of arms appears with colours reversed on fol. 13. Information about the family is scarce and it is therefore not possible to be sure for which member this manuscript was executed, although the inclusion of portraits of SS. Julia and Catherine on fol. 13 might suggest female ownership. That the manuscript comes from Ferrara is confirmed by the prominence given in the Calendar to the feast days of St Maurelius, Bishop of Ferrara (7 May) and St George, patron saint of the city, both days marked in red. The same two saints are mentioned in the Litany. The Calendar also affords an indication of the date of the manuscript since the Feast of St Vincent Ferrer (6 April) is marked; as he was canonised in 1455 the manuscript must have been executed after that date.

In fact, detailed study of the decoration indicates clearly that it belongs to the Ferrarese school of the 15th century. The initial pages of the Hours of the Virgin (folio 13), the Seven Penitential Psalms (folio 75), the Hours of the Cross (folio 92) and the Office of the Dead (folio 101) have initial letters showing respectively the Virgin and Child, King David kneeling before the altar in prayer, the Crucifix in a landscape and lastly a bier with a skull on top. These pages are embellished on all four sides with elaborate borders containing stylised leaves and flowers intertwined with gold buds; this filigree work encircles medallions containing pictures of saints and prophets or animals, and also includes illustrations of cherubs, dragons, birds, urns and scrolls. The lower half of the pages contain complete miniature paintings: an example is the beautiful landscape (folio 13) in which two cherubs support the coat of arms of the family, set in a meadow where parrots and rabbits play. Other pages of the manuscript bear undecorated initial letters and much simpler borders, the latter still ornamented in the style typical of the Ferrarese school.

The choice of decorative forms (richly inventive and imaginative) as well as the style and quality of the painting suggest attribution to the Ferrarese illuminator Taddeo Crivelli (*doc.* 1452-1476); by comparing this with his other documented work it is possible to date this manuscript to his mature period. The Pierpont Morgan manuscript is contemporary with Crivelli's later illuminations in the Bible of Borso d'Este (Modena, Biblioteca Estense, MSS Lat. 422 and Lat. 423), begun in 1455 and completed in 1461, as well as with the illuminations accompanying the *Decameron*, now in Oxford, executed for Teofilo Calcagnini in 1467 (see cat. 110). Folio 13 of the Book of Hours and the first page of Genesis in the Borso Bible (volume I, folios 5-6) have many features in common, in particular the scenes of the Creation and, in the borders, cherubs, dragons and scrolls. In the *Decameron* the female portraits in the decoration near the beginning are stylistically very close to the profiles of SS. Julia and Catherine. In all these examples of work done during the late 1460s, Crivelli exhibits great familiarity with the style of the Ferrarese artist Cosimo Tura (1430-1495), echoing the monumental stability of Tura's figures as well as the vigour of his line and the luminosity of his colours. Confirmation of the influence of Tura on Crivelli is to be found in the *Virgin and Child* on folio 13, in which Crivelli quotes directly from Tura's painting of the

Comincia illibro chiamato decameron cognominato prencipe galeotto nelquale sicontengono Cento nouelle in dieci di dette da septe donne & da tre giouani huomini :: Proemio :::::

Vmana cosa e la uere compassione ad gliaf flicti et come ad ciascke duna per sona sta bene ad coloro maximamente richiesto liquali gia anno di conforto mestieri auto & anno lo tronato in alcuno. fra ghiquali se alcu no mai nebbe bisogno o glifu caro o gia ne ricevette piacere. io sono uno di que gli percio che dala mia prima giouanecca insino ad questo tempo oltre ad modo essen do stato acceso da altissimo et nobile amo re forse piu assai chella mia bassa condi tione non parrebbe narrandolo io sirichie dessi quantunque appo coloro che discre ti erano. et alla cui notitia peruenne io ne fossi lodato & da molto piu reputato non dimeno mi fu egli di grandissima fatica ad sofferire. Certo non per crudelta de la donna amata ma per soperchio amo re nella mente concepto da poco regolato appetito ilquale percio caunno conuene uole termine milasciaua contento stare piu di noia che bisogno nomera & spesse uolte sentire mi faceuan. Nella qual noia & tanto refriggerio mi porsono i piaceuoli ragionamenti dalcuno amico & le sue laureuoli consolationi che io porto fortis sima oppinione per quello essere aue nuto che io non sia morto. Ma si come ad colui piacque dilquale essendo egli ifi nito uicie per legge incomutabile ad tutte le cose mondane auere fine. il mio amore oltre adognialtro feruentemente & ilquale niuna forza di proponimento o di consiglio o diuergogna euidente o pericolo che seguire nepotesse auea potuto nerompere nepiegare perse medesimo

processo di tempo si diminui in guisa che so lo dise nellamente ma alpresente. lasciato quel piacere che usaro diporgere ad chi trop po nonsimette ne suoi piu cupi pelaghi & nauicando per che doue faticoso essere solea ogni affanno toglienduouia delectevole isen to essere rimaso ma quantunque cessata & sia la pena non percio e la memoria fugg ta debenfitia gia riceuuti datui da coloro da quali per beniuolenza da coloro ad me por tata. Erano graui le mie fatiche ne passera mai si como credo senon per morte. Et pero chella gratitudine secondo che io credo fra al tre uirtu e somamente da comendare e ilcon trario da biasimare per non parere ingrato o mecostesso proposto diuolere inquel poco che pme sipuo incambio dicio chio ricevetti ora che libero dire mi posso & se non ad coloro che me ataron alliquali peraduentura p lo loro seno o p la loro buona ventura non be sogni ad quegli almeno aquali fa luogo al cuno alleggiamento prestare. Et quantun que il mio sostenemento o conforto che uo gliamo dire possa essere & sia abisognosi assai poco. Non dimeno parmi quello doverisi piu tosto porgere doue ilbisogno apparisce magio re. siche peche piu utilita usfara essi anchora p che piu usfia caro auuto. Et chi neghera que sto quantunque egli siia non molto piu alle uaghe donne che ad gliuomini conuenirsi do nare. Et se ue tenuto auilicati petti temento & uergognando tenghono lamorose fiame na scofe lequali quanto piu di forza amo chelle palesi coloro il sanno che lino prouato & pro uano. Et oltre adcio ristrette daiuolen da piaceri da comandamenti de padri delle ma dri de fratelli & de mariti in picciol tempo nel loro circhuito delle loro camere racchiuse di moramo et quasi oriose setentosi uolento & non uolento in una medesim hora seco ri uolgono diuersi pensieri. liquali non e pos sibile che sempre strano allegri. Esse per quello mossa da focoso uisto alcuna malinco nia sopraviene nelle loro menti inquelle conuiene che con graue noia si dimori se da nuoui ragionamenti non e rimossa sanza chelle sono molto meno forti che gliuomini & da sostenere doche degli innamorati huomini non auuiene. si come noi possiamo apertamé ne uedere essi se alcuna malinconia o grauezza

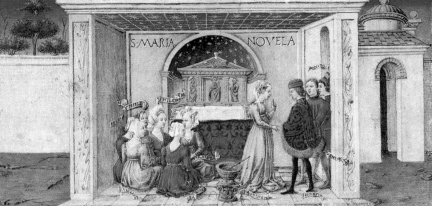

S·MARIA NOVELA

L·F·BIEN·SECRETE

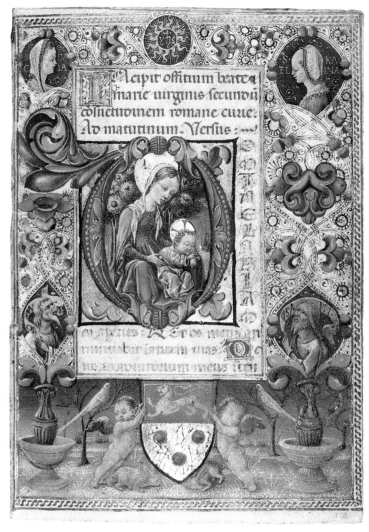

111 folio 13

same subject, now in the National Gallery, Washington. Further confirmation of the date can be obtained by comparing the Morgan illuminations with the *Crucifixion* on folio 126v of a Missal (New York, Pierpont Morgan Library, M. 518), dated 1463 and generally attributed to Taddeo Crivelli.

Provenance: Arms of the Falletti family of Ferrara, on folio 13; Henry Gee Barnard (*c.* 1830); Richard Bennett (1844-1900); purchased by John Pierpont Morgan (1837-1913) in 1902.

Exhibition: New York 1984, no. 41.

Bibliography: James 1906, p. 137, no. 91; De Ricci 1935-40, II, p. 1408; Voelkle 1980, p. 10, fiche 3D5-3D7; Toniolo 1994, p. 34.

<div align="right">F. T.</div>

112

Book of Hours, Use of Rome

211 fols. 108 x 79 mm. On parchment [New York only]

Illumination attributed to Taddeo Crivelli and Guglielmo Giraldi in Ferrara, c. 1469

MALIBU, THE J. PAUL GETTY MUSEUM, MS Ludwig IX 13

The manuscript contains the coat of arms of the Gualenghi family, an aristocratic family of Ferrara. Von Euw and Plotzek (1982) suggest convincingly that the manuscript may have belonged to Andrea Gualenghi (*doc.* 1460-*d.* 1480), a diplomat at the d'Este court who carried out numerous missions for Borso d'Este and for Ercole I; it may have been commissioned on the occasion of Andrea's marriage in 1469 to Orsina d'Este, the illegitimate daughter of Niccolò III. Scholars have identified the two figures on folio 199v as Andrea and Orsina; the couple are kneeling in front of San Bellino, Bishop of Padua, and the two children kneeling beside them have been identified as Orsina's children from her previous marriage to Aldobrandino Rangoni. This suggested identification is also based on the inclusion of silver eagles in the illuminations to the manuscript (they are also to be found in the coat of arms of the d'Este family) and on the inclusion of a portrait of the Blessed Catherine of Bologna (folio 185v), an Augustinian nun to whose cult the d'Este family were particularly devoted. The manuscript must date from sometime after her death in 1463. She lived in Ferrara for many years and was lady-in-waiting to Margherita d'Este, daughter of Niccolò III and sister of Orsina.

The aristocratic ownership of the manuscript is confirmed by the opulence of the decoration. About twenty of the pages are completely illuminated; each bears a rectangular frame containing a portrait of the saint to whom the prayers on the opposite page are dedicated (folios 3v, 154v, 156v, 159v, 162v, 172v, 174v, 178v, 180v, 183v, 185v, 188v, 190v, 192v, 193v, 195v, 197v, 199v, 201v, 204v). There are borders of two types: frames with filigree patterns or with animals, cherubs, scrolls and flowers, or simpler frames with a scrolled or key-pattern edge in gold leaf. Other pages have the filigree borders and decorative brushstrokes along all four sides, but only the initial letters are illuminated (folios 4, 78v, 102v, 106). Many other pages bear only one or two small illuminated letters.

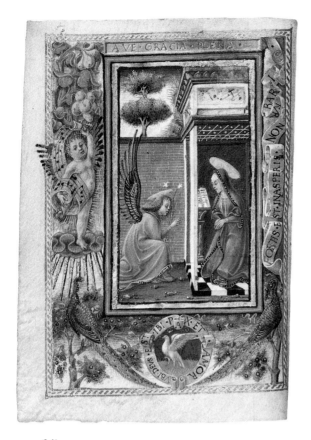

112　folio 3v

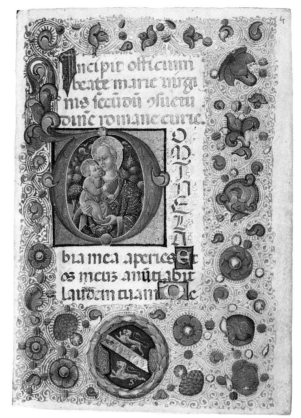

112　folio 4r

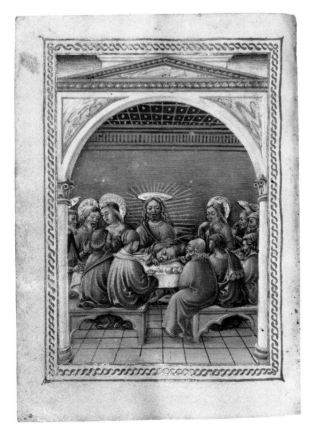

112　folio 162v

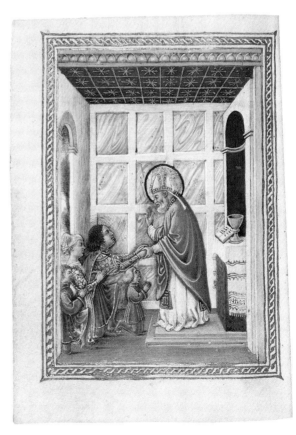

112　folio 199v

The illumination of this manuscript has been attributed to the two great 15th-century Ferrarese illuminators, Taddeo Crivelli (*doc.* 1452-1476) and Guglielmo Giraldi (*doc.* 1445-1480). The majority of the illuminations are by Crivelli: folios 3v, 162v, 172v, 199v, 204v are examples of his work. The borders reiterate the decorative themes to be found in all his work of the 1460s: the Bible of Borso d'Este (Modena, Biblioteca Estense, MSS Lat. 422-3, figs. 3, 15), the Falletti Hours (cat. 111) and the Oxford *Decameron* (cat. 110). Compared with Crivelli's work in these three manuscripts, the illuminations in this Book of Hours are strongly expressive, even sentimental, and are characterised by agitated, almost aggressive outlines reminiscent of paintings of the same period by Cosimo Tura, for example his organ front depicting *St George Slaying the Dragon* paid for in 1464 and now in the Museo del Duomo in Ferrara. Stylistically these minatures are very close to Crivelli's five miniatures painted in Bologna in 1476 for the Graduals of San Petronio (Bologna, Museo di San Petronio, Gradual VI, 98, Gradual II, 94). Crivelli moved to Bologna from Ferrara in 1473. The present Hours is also stylistically akin to the single miniature of *St Jerome in the Desert*, now in the Cleveland Museum of Art (47. 64), which has been correctly dated and attributed to Crivelli.

The date of *c.* 1469 suggested for this manuscript is compatible with the career of the other artist involved, Guglielmo Giraldi, whose style is exemplified in the *Virgin and Child* inside the 'D' on folio 4, and in the *All Saints* on folio 159v. These illustrations have features in common with the illuminations in the Bible of the Certosa of Ferrara, now in the Museo Civico di Palazzo Schifanoia; the third volume of the Bible is dated 1469. Giraldi's miniatures are easily distinguishable from those of Crivelli. He has an almost Classical sense of rhythm, painting most of his figures with vertical drapery. The light that suffuses his warm palette is strongly reminiscent of Piero della Francesca; he is closer to the Ferrarese painter Francesco del Cossa than to Cosimo Tura.

Provenance: Arms of the Ferrarese family Gualenghi, folio 4, probably Andrea Gualenghi and his wife, Orsina d'Este; the Reverend Walter Sneyd (*ex-libris* on the flyleaf); Charles Fairfax Murray; C. W. Dyson Perrins (*ex-libris* and inv. no. 72 on the flyleaf); Otto Schäfer; Peter and Irene Ludwig, Aachen; acquired by the J. Paul Getty Museum in 1983.

Exhibition: London 1908, no. 235, pl. 152.

Bibliography: Warner 1920, no. 72, pl. LXXII a-c; Loperfido 1961, pp. 18-19; Von Arnim and Lauter 1970, no. 7; Boskovits 1978, p. 381; Von Euw and Plotzek 1982, pp. 207-16, figs 303-18; Eleen 1985, p. 159; Toniolo 1994, 37.

<div align="right">F. T.</div>

113

Cutting, *Triumph of an Academic*

279 × 85 mm. On parchment

Illuminated, probably in Padua, by Franco dei Russi, c. 1465-70

LONDON, THE BRITISH LIBRARY, Additional MS 20916, folio 1

Within a painted architectural structure an academic procession is depicted as if it were the triumph of a hero of Antiquity. Against a landscape background a figure dressed as a doctor '*iuris divini ac humani*' or '*in artibus*' is seated on a chariot in the Classical style. Two active putti are tying small owls, symbols of Minerva, goddess of wisdom, to the wheels of the chariot. Other putti follow the procession. One is carrying a shield bearing a bas-relief of a battle scene painted in trompe l'oeil. On the projecting wings of the architectural structure we see Hercules in combat with the Hydra, symbolising strength, and a philosopher writing on a scroll, symbol of wisdom. The fragment is signed in the centre below '*Dii faveant opus Franchi miniatoris*'.

The signature, plus the style, indicate the work of Franco dei Russi, one of the greatest miniaturists of the Bible of Borso d'Este (see figs 3, 14-17), who moved to Padua in the 1460s (cats 71, 82, 83). Judging by its Classical theme and the energy of the well-rounded figures, this fragment belonged to an illuminated manuscript executed in Padua, where such themes had been popular since the last years of Carrara rule. The illumination celebrates humanistic and academic culture and may therefore have belonged to the diploma of an academic at the University of Padua. The painted architectural structure may on the other hand be the base of an elaborate title-page for a manuscript or Venetian incunable (see cats 77, 80, 84, 96-101). In that case the doctor of law sitting on the chariot would be the author of the text.

Provenance: Acquired in 1855.

Bibliography: *Catalogue of Additions* 1875, p. 289; Serafini 1912, p. 422; Bonicatti 1957, p. 206; Bonicatti 1957-9, pp. 111-12; Levi d'Ancona 1960, p. 36; Salmi 1961, pp. 46-7; Mariani Canova 1969, pp. 23-4, 104-6, 145; Alexander 1970a, p. 32; Armstrong 1981, p. 8, fig. 134; Mariani Canova 1984a; pp. 341-2; Toniolo 1990-3, pp. 228-30.

<div align="right">G. M. C.</div>

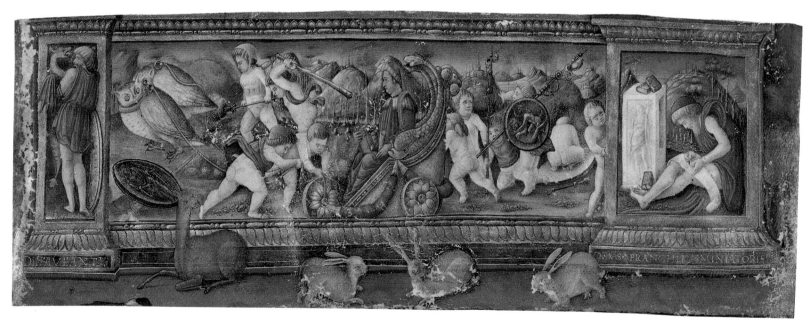

113 folio 1r

114

Single leaf, probably from a Book of Hours, *Pietà*

171 x 122 mm. On parchment [New York only]

Illumination attributed to Francesco dai Libri, c. 1475-85

CLEVELAND, THE CLEVELAND MUSEUM OF ART, Wade n. 51.394

This leaf of unknown provenance shows the *Pietà* in an unusual composition with the Virgin holding the dead Christ on her lap, two women beside her and St John standing with clasped hands in front. A kneeling figure with a lance no doubt represents Longinus. Two other related miniatures, both with similar illusionistic moulded frames, are clearly by the same illuminator. They show the *Entombment* (London, Courtauld Institute Galleries, Princes Gate Collection 346, 171 x 122 mm) and the *Adoration of the Magi* (Paris, Musée Marmottan, Wildenstein Collection). No doubt all three leaves come from the same Hours. The artist shows an intimate knowledge of Mantegna's work.

The three leaves have recently been convincingly attributed to Francesco dai Libri by Gino Castiglioni (1986). Little is known of Francesco, whose son Girolamo dai Libri, trained according to Vasari by his father, is more famous. They collaborated on the Choir Books of Santa Maria in Organo, Verona, and other projects. Attributions to Francesco dai Libri depend on a manuscript of Johannes Jacobus de Padua, *Liber perfectionis vitae* (Padua, Biblioteca del Seminario, MS 432). The scribe signs this in 1503 and states that the illumination is by '*Franciscus miniator de sancto Paulo Veronae*'. Giordana Mariani Canova (1976, p. 160) first connected this manuscript with Francesco

115

dai Libri; other works have been attributed to him by Gino Castiglioni, particularly a Psalter in the Biblioteca Trivulziana, Milan (MS 2161). Francesco's date of birth is unknown. He was dead by 1506.

Provenance: Botkine collection, St Petersburg.

Bibliography: Milliken 1952, pp. 172–4, illus.; Meiss 1957, p. 91 n. 47; Castiglioni 1986, pp. 83–4, pl. III. 50; Lightbown 1986, p. 495, fig. 254.

J. J. G. A.

115

Cutting, initial 'B' from a service book, *King David*

278 x 272 mm. On parchment

Attributed to Girolamo dai Libri, c. 1495

LONDON, VICTORIA AND ALBERT MUSEUM, E. 1168–1921

The initial 'B' encloses a crowned figure of King David as Psalmist reclining on a rich carpet and playing a stringed instrument. Four turbaned figures, presumably his accompanying musicians stand behind him. An interior space opens onto a landscape beyond. On the steps in front a little dog and a monkey with ball and chain play. The letter form is made up of a magnificent half-length atlantid figure for the upright and two monstrous scaly dragons for the bowl. Foliage and a pecking bird extend from the letter, which is set on a gold reticulated ground. The cutting has been stuck down on card and no text is visible on the back. It probably comes from a large choir Psalter. There is a small piece of damage made good by repainting on the card at the top. Otherwise the painting is of wonderful freshness. The cutting has been convincingly attributed to Girolamo dai Libri of Verona by Mirella Levi d'Ancona (1970) and Ulrike Bauer-Eberhardt (in Verona 1986) and dated *c.* 1495 by the latter. Girolamo was born in 1474 and his early style is still close to that of his father, Francesco dai Libri (see cat. 114).

Provenance: David M. Currie, 1921.

Exhibitions: London 1893–4, p. 137, no. 1318; Verona 1986, no. 57.

Bibliography: *Catalogue of Miniatures* 1923, p. 90, illus.; Levi d'Ancona 1970, pp. 70, 74.

J. J. G. A.

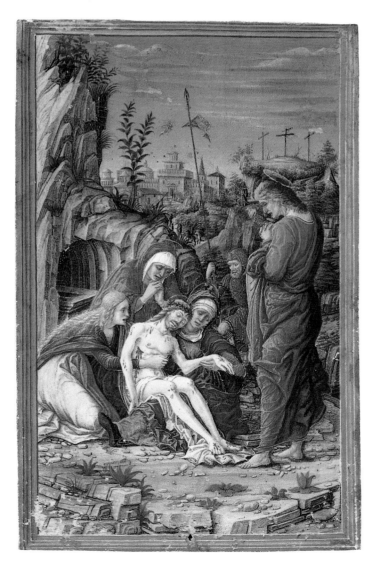

114

116

116

Cutting from a Gradual, *Adoration of the Magi*

220 x 208 mm. On parchment

Written in Milan, c. 1500, with illumination by Master B. F.

NEW YORK, THE PIERPONT MORGAN LIBRARY, M. 725

This cutting and about two dozen others from the same set are by a Lombard master who signed some of them with the initials B. F. This miniature, for example, is signed beneath the left hand of the kneeling Magus. Paul Wescher (1960) has suggested that this Master B. F. is Francesco Binasco because no other Lombard illuminators with the initial 'B' are known (except for Giovan Pietro Birago, whose style is quite different), and Binasco was an illuminator at the court of Francesco II Sforza, Duke of Milan from 1522 to 1535. The identification has not been widely accepted, however, because no documented works by Binasco survive, and he is not recorded before 1513, when he was employed by Duke Massimiliano Sforza, the son of Lodovico il Moro, as an engraver for the mint of Milan. He was also recorded as a jeweller and excellent draughtsman. Although the broken folds of drapery and the graphically rendered ringlets of golden hair of this cutting may suggest the hand of an engraver, the identification with Binasco seems unlikely because of chronological considerations. Master B. F., for instance, decorated a manuscript of Hugo de Balma's *De mystica theologia* (Oxford, Bodleian Library, Ms Canon. Misc. 534), which was written in 1500 by Frater Stephanus de Alemania in the Olivetan monastery of SS Michele e Niccolò at Villanova-Sillaro, the same monastery for which Master B. F. illuminated the magnificent set of Choir Books from which the Morgan miniature was cut. The cutting came from a Gradual, as is confirmed by the text on the back, part of the Introit for Epiphany *(et potestas et impe[rium])*.

Master B. F., in any case, was certainly fond of engravings, for the group of German houses in the background of this *Adoration* is derived from Albrecht Dürer's engraving of the *Prodigal Son*, and the castle on the hilltop is based on Dürer's engraving of the *Sea Monster*. The two prints, dating from about 1496 and 1498, provide a *terminus post quem* for the miniature. (After Dürer's first trip to Italy his graphic works became better known and were increasingly used by illuminators, including Giulio Clovio [see cat. 132]; later, indeed, Vasari was to specifically note, among others, the above-mentioned works by Dürer, praising 'the fine old German cottages which embellished the landscape of the Prodigal Son'.) Master B. F. was also influenced by Leonardo da Vinci; the kneeling Magus has been compared with the one in Leonardo's unfinished *Adoration* in the Uffizi. The kissing of Christ's foot may have a textual source, for the 13th-century mystical text known as the *Meditations on the Life of Christ* describes the Magi and others kissing the Child's feet and playing with him. A rarer detail is the servant removing the spurs from the youngest Magus.

Provenance: Olivetan monastery of SS Michele e Niccolò at Villanova-Sillaro (near Lodi); William Young Ottley (1771-1836); his sale, London, Sotheby's, 11 May 1838 (possibly lot 85); Robert S. Holford (1808-1892); Sir George Holford (1860-1926); his sale, London, Sotheby's, 12 July 1927, lot 29; purchased at the sale by John Pierpont Morgan, Jr (1867-1943).

Exhibitions: New York 1984, no. 29; Austin, Berkeley and New Haven 1988-9, no. 56 (exhibited in Austin and New Haven only).

Bibliography: De Ricci 1935-40, II, pp. 1488-9; Harrsen and Boyce 1953, no. 99, pl. 63; Wescher 1960, pp. 87-90, fig. 8; Bond and Faye 1962, p. 355; Levi d'Ancona 1970, pp. 97, 101-2, 104, fig. 15 (six cuttings from the Holford sale, 1927, lots 31, 35, were resold in London, Sotheby's, 20 January 1951, lots 41, 42; two cuttings, New York, Parke-Bernet Galleries, 22 October 1970, lots 58, 59, were in the Northwick sale, London, Sotheby's, 16 November 1925, lot 130); Mariani Canova 1978 a, pp. 60-1, fig. 108 n; Voelkle 1980, p. 44, fiche 10 G 7; Alexander 1991 b, p. 225, fig. 5; Mulas 1991, pp. 148, 192 n. 29, fig. 6.

W. M. V.

117 folio 15v

117

Hours of Bonaparte Ghislieri, Use of Rome

137 fols. 205 x 149 mm. On parchment. Original binding with covers and doublures over fabric and painted grounds. Painted medallions on the upper and lower covers of the Angel and the Virgin Annunciate. Plaquettes of Julius Caesar on both doublures

Script attributed to Pierantonio Sallando, Bologna, c. 1500, with two miniatures signed by Amico Aspertini and Pietro Perugino respectively, and other illumination attributed to Matteo da Milano

LONDON, THE BRITISH LIBRARY, Yates Thompson MS 29

The patron of this Book of Hours was apparently Bonaparte Ghislieri, a member of a prominent senatorial family in Bologna. The coat of arms of Ghislieri is painted on folio 16, accompanied by the initials 'BP', 'GI', and it is also included on a pediment in the miniature on folio 74v. A collect on folio 124v for '*famulo pape nostra A*' has been thought to refer to Pope Alexander VI (r. 1492–1503), and thus to suggest a date of c. 1500. Whether this is conclusive or not, such a date is quite plausible on stylistic grounds. However, a portrait in the Calendar on folio 7 adds a further problematic note, since it would seem likely to be of the owner of the manuscript. It represents an older man, and, as Mark Evans has pointed out (in Malibu, New York and London 1983–4, no. 16), fits Virgilio, Bonaparte's father, who was murdered in 1523, better than Bonaparte, who only became a member of the Senate in Bologna in 1523 and died in 1541. On this figure's sleeve are initials which have been read as 'A. S.' under a crown, but the reading and their significance are equally uncertain.

117 folio 132v

The Calendar, folios 1–12, contains roundels with bust figures of saints on the rectos and also the already mentioned portrait bust. On folio 15v is a miniature of the *Adoration of the Shepherds* with a complex border with trophies of arms, candelabra, *grotteschi* and architectural decoration reminiscent of early Imperial Roman wall-paintings. It is signed by Amico Aspertini on a plaque in the right border, '*Amicus Bononiensis*'. Aspertini, whose life was written by Vasari, was born c. 1464 and studied with Lorenzo Costa. He worked with Costa, Francia, Ercole de'Roberti and others in Santa Cecilia in Bologna in 1506. He died in Rome in 1552. The border decoration belongs to a type of ornament known in the Renaissance as *grotteschi*, which became fashionable especially after the discovery in the 1480s of the stuccoes and paintings in Golden House of Nero in Rome. The most famous examples of such ornament are in the Vatican Loggie decorated by Raphael and his pupils (Dacos 1969). The trophies in the left border derive from an Antique stucco copied by Aspertini in the Codex Wolfegg, one of three surviving sketchbooks in which he recorded motifs from the Antique (Bober 1957).

On folio 16, Matins of the Virgin is introduced by an initial 'D' with the *Virgin and Child*, surrounded by a border with flower and fruits; in the centre below are the arms of Ghislieri of Bologna and the initials 'BP' 'GI'. Psalms to be said on Tuesdays and Fridays follow on folio 23, the initial 'E' with a youthful saint with sword; for the Psalms to be said on Wednesdays and Saturdays on folio 27v, there is a 'C' with St Catherine of Alexandria. There then follow the remaining Hours: folio 36, Lauds, 'D', St Catherine of Siena; folio 48, Prime, 'D', St John the Baptist; folio 52, Terce, 'D', St Francis; folio 55v, Sext, 'D', St Peter; folio 58v, None, 'D', St Jerome; folio 62, Vespers, 'D', St Clare; and folio 69, Compline, 'C', St Barbara.

Matins of the Virgin from Advent to Christmas starts on folio 75 with the *Virgin and Child* shown in an initial 'D'. A full-page framed miniature of the *Annunciation* is opposite on folio 74v. On folio 101, the Mass of the Virgin, an initial 'S' also shows the *Virgin and Child*. The Seven Penitential Psalms follow, introduced by a full-page framed miniature of King David with a psaltery on folio 104v. The Litany is on folios 117–126. The Hours of the Cross is introduced, folio 127v, by a full-page, framed miniature of *St Jerome in Penitence*, with an initial 'D', on folio 128 in a half-length St Mary Magdalene. The Hours of the Holy Spirit has a 'D' showing the Holy Spirit descending on the Virgin and the Apostles, all half-length. The text ends on folio 135v with two blank, ruled leaves following.

A full-page miniature, now detached but originally folio 132v, shows the *Martyrdom of St Sebastian* with a narrow border in a different style from the remaining miniatures. Two executioners shoot arrows at the saint, who is tied to a tall tree trunk and flanked by two angels. The miniature is signed in capitals in the foreground '*Petrus P[e]rusinus pinxit*'. Pietro Perugino was born c. 1450 and died in 1524. From c. 1500 to c. 1504 he was at work on the fresco cycle in the Collegio del Cambio in Perugia and at this time Raphael was a pupil in his shop.

Apart from the two signed miniatures by Aspertini and Perugino, the main illumination can be attributed to Matteo da Milano, who is documented from payments between 1502 and 1512 for work on the Breviary of Alfonso I d'Este (Modena, Biblioteca Estense, MS Lat. 424; fig. 4). It is likely that he began his career in Milan in the 1490s and he may have left as a result of the fall of Duke Lodovico il Moro (Sforza) when the French captured Milan in 1499. His work on the present Book of Hours was probably done before he reached Ferrara. His career probably ended in Rome, where his major work was the Missal of Cardinal Giulio de' Medici of 1520 (cat. 128). Generally accepted as being by him are the saints in the Calendar, all the historiated initials and the miniature of the *Annunciation*. The miniatures of King David and St Jerome are more problematic and have been attributed to a variety of artists by different authorities. They do not seem to be by the same illuminator, and, in agreement with Mark Evans (in Malibu, New York and London 1983–4, no. 16), it seems possible that the David is by Aspertini and the Jerome by Matteo, though they have also been attributed to Lorenzo Costa or a pupil (Tosetti Grandi 1985). Evans has gone on to suggest that the presence of signed miniatures by Aspertini and Perugino may indicate that the patron was self-con-

sciously collecting work by noted artists, and thus comparable in ambition, though on a lesser scale, to Isabella d'Este.

The script was attributed by James Wardrop (1946) to Pierantonio Sallando, who appears in documents of the University of Bologna as teacher of grammar in 1489 and later as professor *'ad artem scribendi'* between 1508 and 1539-40. He signed and dated several manuscripts between 1490 and 1496, though Albinia de la Mare (written communication) has established that the earlier manuscripts attributed to him by Wardrop and others were copied by a different scribe.

Provenance: Virgilio or Bonaparte Ghislieri, early 16th century; bought in 1838 from Prince Albani in Rome by James Dennistoun, who sold it in 1847 to Bertram, 4th Earl of Ashburnham; acquired from the latter's son by Henry Yates Thompson in 1897, MS XCIII; bequeathed to the British Museum in 1941 by Mrs Yates Thompson.

Exhibition: Malibu, New York and London 1983-4, no. 16.

Bibliography: *Palaeographical Society* 1884-94, II, pl. 38; Thompson 1907, pp. 145-52 (entry by S. C. Cockerell); Serafini 1912, pp. 237-8; Venturi 1914, VII, pp. 1012-13, fig. 757; Thompson 1916, pp. 36-42, frontisp., pls LXXIX-LXXXVIII; D'Ancona 1925, pp. 73, 88, pls LXVIII, LXXXV; Canuti 1931, II, p. 333 n. 56; Wardrop 1946, pp. 15-6, fig. 14; Bober 1957, p. 36, fig. 135; Salmi 1957, pp. 57, 64, figs 72, 80; De Marinis 1960, II, pp. 57, 81, pls CCC-CCCI; *Reproductions from Illuminated Manuscripts* 1965, pp. 23-5, pls XLV-XLVI; Dacos 1969, p. 82; Alexander 1977a, pls 38-9; Tosetti Grandi 1985, pp. 334-42, 351-2, fig. 7; Hobson 1989, pp. 54, 105-6, 221 (Census 15 g), pls 85-6; Alexander 1992, p. 41, fig. 28.

J. J. G. A.

118

Evangeliary for Santa Giustina, Padua

Two detached bifolios (from a total of 77 fols), 335 × 239 mm.
On parchment

Written in Padua in Gothic rotonda script by Laurentius Gazius Cremonensis (Lorenzo Gaddi of Cremona), 1523-25, with illumination by Benedetto Bordon

DUBLIN, CHESTER BEATTY LIBRARY, MS W. 107, fols 3v-4 and 64v-65

The exhibited miniatures from the Evangeliary for Santa Giustina, Padua are the most famous works of the Paduan miniaturist Benedetto Bordon (*c.* 1450/55-1530; see cats 97, 104). Together with Bordon's illuminations in an Epistolary for the same Benedictine monastery (London, The British Library, Additional MS 15 815), the Evangeliary miniatures were long considered to be among the outstanding artistic creations in Padua (Billanovich 1968, pp. 211-15; Mariani Canova 1968-9b, pp. 110-11). Like many illuminated manuscripts, the Evangeliary and Epistolary were dispersed after the suppression of the monasteries in the Napoleonic era. At present, a number of the Evangeliary leaves have been detached from their binding, enabling the exhibition of two bifolios.

An early source identifies the scribe of the Santa Giustina Evangeliary as Lorenzo Gaddi da Cremona (Cavaccio 1606, p. 267, cited by Mariani Canova 1968-9b, p. 103), and the contract dated 2 April 1523 between Andrea da Venezia, Abbot of Santa Giustina, and Benedetto Bordon for the illumination of both the Evangeliary and the Epistolary has also survived (Billanovich 1968, app. doc. II). Bordon is to paint *'hystoriis operi pertinentibus cumque ornamentis'* ('pertinent narratives and ornaments') using *'maxime de azuro ultramarino fino ... auro macinato et aliis coloribus generis sortisque et condictionis necessariis'* ('maximum amounts of ultramarine blue ... ground gold and other ... necessary colours'). For his labours and materials he was to be paid the handsome sum of 70 ducats. Substantiating the evidence of the documents are Bordon's signatures prominently displayed on two miniatures in the Evangeliary (folios 3 v, 65).

Many of the 74 miniatures in the Evangeliary fill half or a third of the page and are accompanied by decorative borders, certainly fulfilling the contract specifications. The style and iconographic programme of the original volume have been masterfully analysed in several publications by Giordana Mariani Canova, who has particularly clarified the emphasis on saints and feasts significant to the Benedictines of Santa Giustina (1968-9b; 1969; 1980; 1984b). Of the two illuminated folios exhibited here, one clearly has universal Christian significance, the *Nativity* (folio 3v), while the elaborate composition of the other, the *Martyrdom of Santa Giustina* (folio 65), is explicable only in terms of the patrons.

In the *Nativity*, Joseph, Mary and the Christ Child are traditionally grouped in the foreground of a scene whose deep landscape is reminiscent of Giorgione and early works by Titian. Bordon's name is inscribed on a sarcophagus placed behind the Virgin. The illusion that the ragged parchment page is suspended on an architectural monument recalls Bordon's frontispieces of the 1470s (cat. 97). The architectural detailing, however, resembles the informed Classicism of 16th-century Venetian altarpiece frames (see Humfrey 1993, figs 110, 130, 221, 301).

The *Martyrdom of Santa Giustina* is even more clearly a Cinquecento composition, echoing not only North Italian artists, but also Central Italian painters such as Pinturicchio (1454-1513) and Raphael (1483-1520), whose works were popularised in prints by Marcantonio Raimondi (*fl.* 1500-*c.* 1534). Certainly North Italian Renaissance art had prototypes for the asymmetrically composed judgement scene, including Mantegna's *Judgement of St James* (Lightbown 1986, fig. 13) and Giorgione's *Testing of Moses* in the Uffizi (Pignatti 1971, pl. 25).

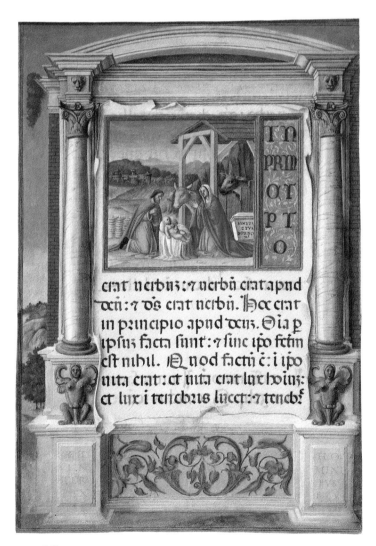

118 folio 3v

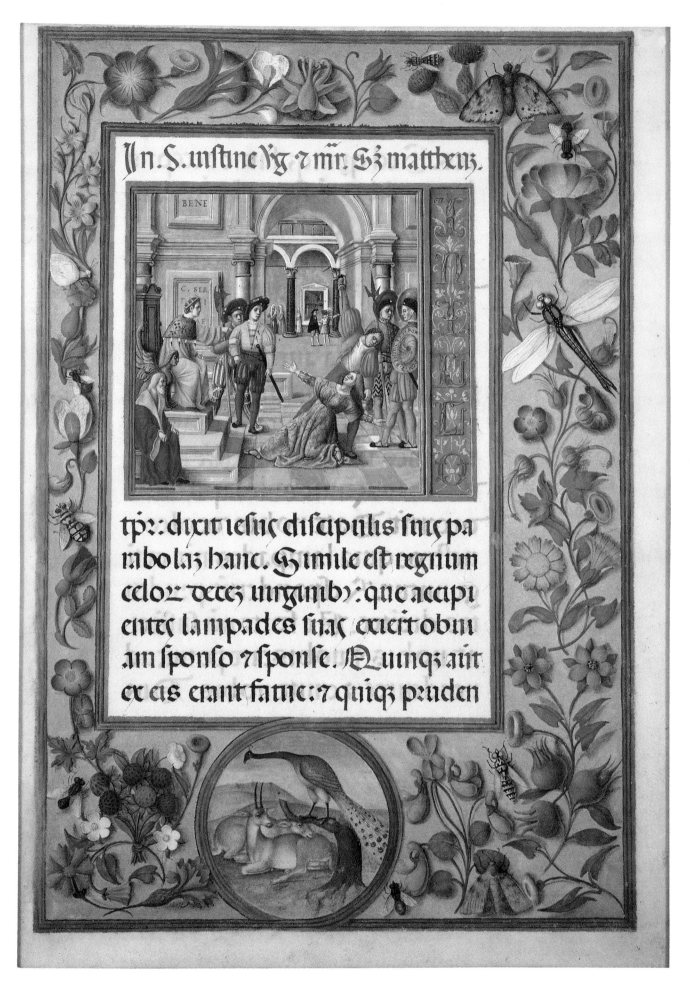

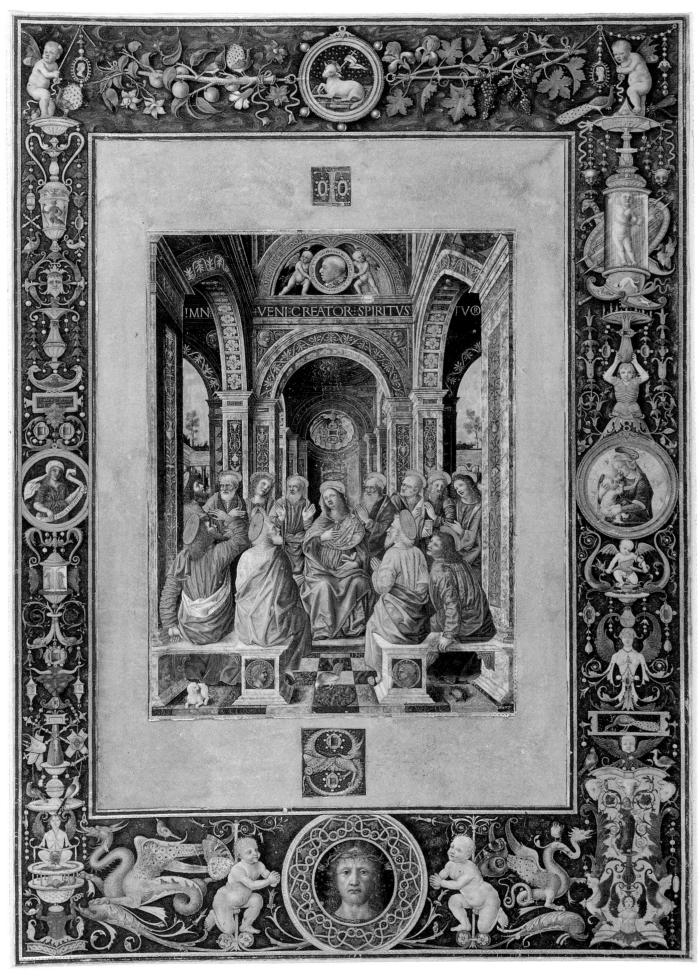

But Bordon's grandiose architectural structures, the chequered floor of the plaza, and the bright colours of the foppish dandies are even more similar to Pinturicchio's *Emperor Frederick III Crowing Aeneas Silvius Piccolomini with Laurel* in the Piccolomini Library, Siena Cathedral (Carli 1960, pl. 129). Given that Bordon certainly knew Girolamo da Cremona, one of the miniaturists who illuminated the Choir Books for the Siena Cathedral (cat. 121), might he even have travelled to Tuscany to see those famous books, housed in the Piccolomini Library whose walls are filled with the Pinturicchio frescoes? Marcantonio's engraving of Raphael's *Massacre of the Innocents* (Jones and Penny 1983, pls 96-97) became the basis for Bordon's miniature of the same subject in the Evangeliary (folio 6v; Mariani Canova 1969, fig. 112), and the pose of the executioner in the *Martyrdom of Santa Giustina* is also modelled on the dramatic nude on the left of Marcantonio's print. These Central Italian sources suggest the more fluid movement of artistic styles characteristic of the 16th century.

Further evidence of this diversity is to be found in the borders of the *Martyrdom of Santa Giustina* folio. The three-dimensionally rendered flowers and insects in natural colours against a uniform yellow background explicitly imitate Flemish late Renaissance manuscript illumination. Flemish Books of Hours with similar borders were doubtless available in Padua by 1523, but one particularly famous manuscript may have been the immediate source for Bordon. Before 1520, the Venetian Cardinal Domenico Grimani had acquired a magnificent Flemish Breviary (Venice, Biblioteca Marciana, Lat. I, 99 [=2138]), illuminated by the greatest artists of the so-called Ghent-Bruges school: Gerard Horenbout, and Alexander and Simon Bening (Marcon, in Zorzi 1988, pp. 192-5; Limentani Virdis 1981, pp. 87-92). The general resemblance of Bordon's border to those in the Grimani Breviary supports the idea that he had studied it, and even more persuasive is the striking resemblance of certain details such as depiction of the dragonfly in both books (Limentani Virdis 1981, p. 28).

Provenance: Santa Giustina, Padua, 1525; Lt-Col. Sir George Holford (d. 1908); Sir Alfred Chester Beatty (1875-1968)

Exhibitions: London 1908, no. 196; London 1912, no. 46.

Bibliography: Benson 1927, I, pp. 32-3, pls L-LII; Levi d'Ancona 1967a, pp. 21-2; Billanovich 1968, pp. 211-15; Mariani Canova 1968-9b, pp. 103, 110-11, figs 1, 2, 6-11, 13-14; Mariani Canova 1969, pp. 72-3, 126-7, 156-7, figs 110, 112, 114, 117-20; Mariani Canova 1980, pp. 80-4, figs 20-23; Limentani Virdis 1981, p. 28; Mariani Canova 1984b, pp. 482, 499-502, figs 45-52.

L. A.

119

Cutting, miniature and border from a service book, *Pentecost*

336 x 260 mm. On parchment [London only]

Illuminated in Rome, c. 1492-1503, by Fra Antonio da Monza

VIENNA, GRAPHISCHE SAMMLUNG ALBERTINA, Inv. 1764

The miniature shows *Pentecost* with the Apostles receiving the gift of the Holy Spirit. They are seated on benches with the Virgin in the centre. Arches open onto a landscape to left and right. In the lunette at the top in the centre is an inscribed medallion with a profile portrait of Roderigo Borgia, Pope Alexander VI (r. 1492-1503). The rich border with a ground simulating porphyry contains naturalistic peach and vine scroll, putti, dragons and *grotteschi*, and roundels with, above and below, the Lamb of God and the *Facies Christi*, and to left and right the Tiburtine Sybil and the Virgin and Child.

The manuscript from which this miniature was cut is referred to in the library of the Franciscans in Santa Maria in Aracoeli, Rome, in 1736. An inscription running round the frame of the lunette with the papal portrait reads: 'F. Antonii de Modoetia minoriste opus. G. de'. No documentation has yet been found on Fra Antonio da Monza, but a Missal also for Pope Alexander VI, with his arms and emblems (Vatican, Biblioteca Apostolica Vaticana, Borg. lat. 425), has been convincingly attributed to him (Gualdi Sabatini 1985; Cologne 1992, no. 85). The probability is, therefore, that it and the present fragment were executed in Rome rather than Lombardy, as was also, no doubt, the Choir Book from the J. Paul Getty Museum (cat. 126). A Psalter in the Biblioteca Nazionale Braidense, Milan (ARM 117) may perhaps have been illuminated by Fra Antonio in Milan or Lombardy on his return from Rome (Casciaro and Rossi, 1990). A cutting from a Choir Book showing the *Flagellation*, formerly in the Kann and Norton Simon collections, is now in the Elmer Belt Library of Vinciana, Los Angeles (Armstrong 1967). So far no certain early works executed in Milan have been identified, though it is possible that his hand can be found in the Antonio Minuti, *Life of Muzio Attendolo* of 1491 (cat. 15) and in the Sforza Hours in the British Library (Additional MS 34294). David Brown (1978) has noted that the pose and pointing gesture of one of the Apostles on the right derives from Leonardo da Vinci's *Virgin of the Rocks* in the London version, which, Brown is thus able to argue, must have been already in existence when Leonardo left Milan in 1499. This also assumes that Fra Antonio was still in Milan at this date.

Provenance: Franciscans of Santa Maria in Aracoeli, Rome, by 1736.

Bibliography: Venturi 1898, p. 160; Venturi 1899, p. 114; Kristeller 1901, p. 161; Malaguzzi Valeri 1913-23, III, pp. 152-6, pl. VI, figs 159-61; Malaguzzi Valeri 1916, p. 28; Stix and Spitzmüller 1941, p. 36, no. 386, pl. 84; Koschatzky and Strobl 1969, p. 316, colour pl.; Armstrong 1967; D'Ancona and Aeschlimann 1969, p. 11, pl. IV; D. A. Brown 1978, pp. 167-77, pl. II.6-7; Gualdi Sabatini 1985, pp. 727-31, figs 6, 7; Casciaro and Rossi 1990, pp. 21, 27, pl. III.

J. J. G. A.

Choir Books

The sung parts of the Mass and the Office, the Gradual responses and Antiphons, were gathered into special volumes with the necessary musical notation. Since they had to be legible by a small group of four or five singers gathered round a lectern, they were written in large script and are usually heavy, thick tomes bound in wooden boards with metal corner pieces and bosses to protect them. They were produced in sets for the Feasts of the liturgical year and every great cathedral, abbey and major church aspired to own such volumes. Those made for the Cathedral of Siena are justly famous (cats 121, 122). They were illuminated by different artists, some local, but the most famous coming from North Italy, Liberale da Verona and Girolamo da Cremona. The accounts with details of payment survive in the Cathedral archive. The Antiphonary commissioned for Santiago de los Españos in Rome by the Emperor Charles V (cat. 127) is a documented work by Vincenzo Raimondi, papal illuminator in Rome, but originally from Lodève in France. Many such Choir Books were mutilated for collectors, so that they only survive as fragments, single pages or cut-out initials (cat. 122), scattered in libraries, print rooms and private collections throughout the world.

120

Antiphonary

176 fols. 608 × 437 mm. On parchment [London only]

Illuminated in Florence, 1463, by Ser Ricciardo di Nanni, Francesco d'Antonio del Chierico and Bartolomeo di Boniforte da Vimercate. Binding of brown leather with metal bosses, probably contemporary

FLORENCE, ARCHIVIO CAPITOLARE DI SAN LORENZO, Corale 207 H

This Antiphonary containing Feasts from the Sanctorale is one of a set of Choir Books made for the Badia of Fiesole under the patronage of Cosimo de' Medici. In the surviving accounts payment is made to Bartolomeo di Boniforte da Vimercate for penwork initials from 1460 onwards, this Antiphonary being paid for in 1463. It seems probable that Bartolomeo is the son of the Guinifortus de Vicomercato who signed his name in two Choir Books now in Ferrara and in the Lilly Library pattern-book of 1450 (cat. 109).

There are historiated initials and borders: folio 4, *Annunciation*; folio 22, SS. Philip and James; folio 36, Holy Cross; folio 53 v, St Michael (but with the scene of *Tobit and the Angel*); folio 71 v, St John the Baptist; folio 76, *Birth of St John the Baptist*; folio 113 v, *Calling of Andrew and Peter*; folio 134, St Paul; folio 157 v, *Visitation*. On folio 4 God and the Dove of the Holy Spirit are placed in the border above the initial 'M' which frames the *Annunciation*, set in an interior with a distant landscape visible in the centre. The Medici arms are in the lower border. There are also fine quality penwork initials and borders.

Payments in the Badia accounts are also made to other artists working on the Antiphonaries, including Filippo Torelli, Francesco d'Antonio del Chierico and Ser Ricciardo di Nanni. Annarosa Garzelli (1975) has assigned the historiated initials in the present Antiphonary to Ser Ricciardo di Nanni (see cats 34, 68), except for those on folios 71 v, 76, 113 v, 134, which she attributes to Francesco d'Antonio del Chierico (see cats 36, 50, 59, 62, 69). A note on folio 176 v states that the volume was corrected according to the Breviary of Clement VIII in 1554.

Provenance: Made for the Badia, Fiesole; after the suppression of the convent (1778) passed to the Biblioteca Laurenziana, 1783; from there in 1803 to the Basilica di San Lorenzo, Florence.

Bibliography: D'Ancona 1914, I, p. 61, II, no. 1083; Garzelli 1975, I, pp. 24-37, figs 4, 7, 14, 16-17, II, p. 30, fig. 32; Landi 1977, p. 8, figs 2, 8; Morandini 1978, p. 294; Garzelli 1985 b, pp. 440-2, 446, pls 1, 3, 4; Garzelli and de la Mare 1985, pp. 60, 63, 104-6, 117, pls 169, 174, 224, 226.

J. J. G. A.

121

Gradual of the Cathedral of Siena

129 fols. 834 × 587 mm. On parchment

Written in Siena by Don Andrea d'Alemagna, with illumination by Liberale da Verona, c. 1467-70

SIENA, MUSEO DELL'OPERA DELLA METROPOLITANA, Cod. 20.5

The project of providing a set of new Choir Books for the Cathedral of Siena was initiated by the rector of the Opera del Duomo, Christoforo Felici, in a document dated 17 June 1457 in which twelve volumes were commissioned from the scribe, a Servite monk, Fra Gabriele Mattei. From 1462 to 1466 another twelve volumes were written by the scribe Don Andrea d'Alemagna. The present Gradual is evidently among these latter. The Cathedral account books provide much information on the whole enormous project, giving the names of the artists, the rates of payment and the dates of completion, though there are gaps and uncertainties. Today twenty-nine of the resulting Choir Books are displayed in the Cathedral in the Piccolomini Library beneath the frescoes by Pinturicchio, and are one of the most impressive and memorable ensembles of illuminated manuscripts to be encountered anywhere in the world.

The illumination of the volumes consists of historiated, painted and penwork initials, many being of great size and accompanied by three or four sided borders. A large number of different artists from both Siena and Florence, but also from further away, attracted by the commission, worked on the project. They included specialists of penwork (see cat. 109) as well as illuminators for the fully painted work. Among the latter the three most important were all from the north of Italy, Liberale da Verona, Girolamo da Cremona and Venturino da Milano.

The first payments for illumination are from 1464 and are to Sienese illuminators with whose work, however, the authorities seem not to have been satisfied. Early in 1467 a new artist, the young Liberale da Verona, only twenty-two years old, appears in the account books and does his first work (cat. 122). In 1465 he had appeared as a witness in Verona at the Olivetan monastery of Santa Maria in Organo. This is significant since the next year he worked on the illumination of four of the Choir Books of Monte Oliveto Maggiore, the mother house of the Order, situated outside Siena. These are today in the Cathedral of Chiusi. Liberale continued to work in Siena from 1467 until 1476, when the Cathedral project began to fail, no doubt for lack of funds. He died in Verona at some time between 5 August 1527, when he made his will, and 16 May 1529 (Eberhardt 1971).

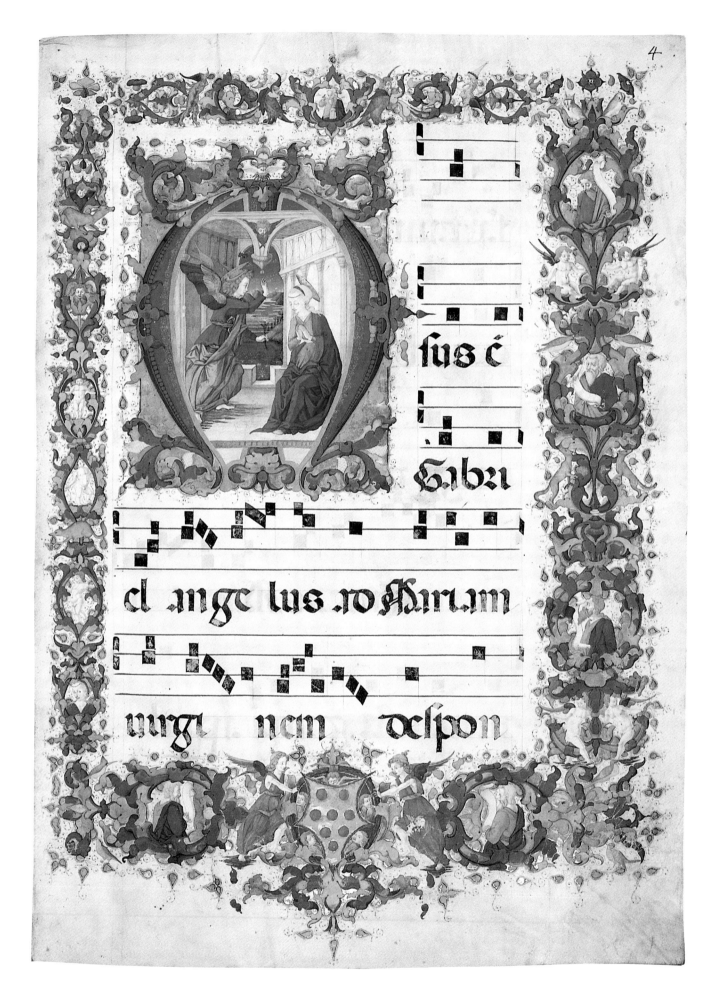

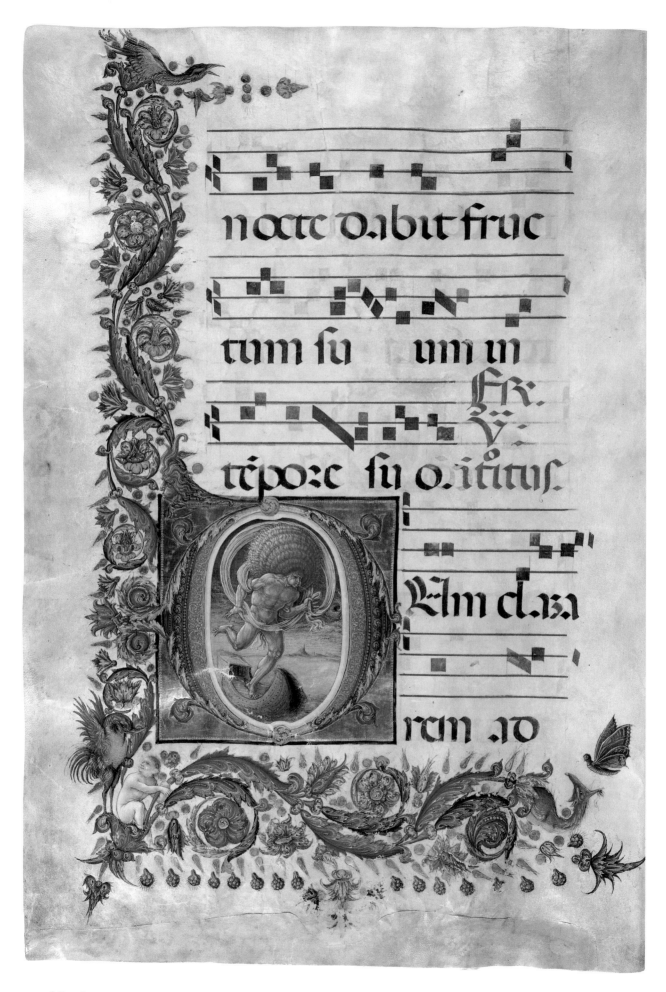

nocte dabit fruc

tum su um in

FR.
V.

justitia sij oritur.

Alm clara

rem ad

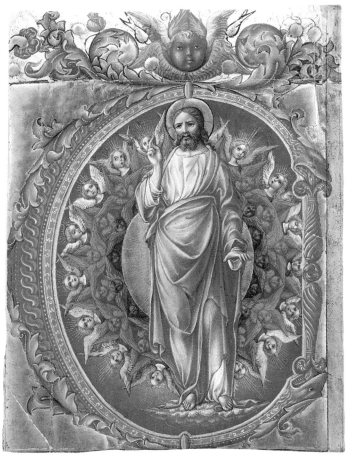

122

vant. Carlo del Bravo (1967) pointed out that the centurion's faith was linked to Isaiah XLIX, 12, where the words 'these shall come from far: and, lo, these from the north and the west', were taken as prophetically referring to the conversion of the Gentiles. That Liberale here resorted to a symbolic figure rather than a straightforward narrative scene suggests that a clerical advisor may have produced a programme for the illumination. Eberhardt (in Verona 1986) has suggested that Liberale may have known an engraving of the *Flood* attributed to the Florentine artist Francesco Rosselli, with whom Liberale was already collaborating on the illumination of the Siena Choir Books in the second half of 1470. Gilbert (1981) has offered a further interpretation of the image, seeing the North as the symbolic space from which evil comes. In any event Liberale has here created one of the most memorable images of the Quattrocento.

Provenance: Cathedral of Siena.

Exhibition: Verona 1986, no. 32, illus.

Bibliography: Milanesi 1850, pp. 213 ff.; Brenzoni 1930; Lusini 1939; Carli 1953, pls XIII, XV; Longhi 1955, p. 5; Del Bravo 1960, pp. 20, 22, pls 23 b, 24 a; Del Bravo 1967, pp. 17-9, pls XXXVI-XLI, CLX; Ciardi Dupré dal Poggetto 1972, pp. 34-5, pls 240-58; Gilbert 1981, pp. 217-21; Eberhardt 1983, pp. 66-76.

J. J. G. A.

122

Cutting, initial 'C' from a Gradual, *Blessing Christ*

274 x 215 mm. On parchment [London only]

Illuminated by Liberale da Verona in Siena, 1467

The initial 'C' shows the standing, blessing Christ in a blue robe over pink with a golden aureole behind, surrounded by two concentric rings of cherub heads in shades of blue on a brilliant red ground. The initial is set on a burnished gold square and there is a blue cherub mask above with flanking green foliage.

Carlo del Bravo (1963) first reported Luciano Bellosi's correct attribution of this initial to Liberale da Verona. Hans-Joachim Eberhardt (1983) has argued that the initial should be connected with a document of 24 January 1467 in the account books of Siena Cathedral which relates to the illumination of the great set of Choir Books recently written for the Cathedral (see cat. 121). In this document it is recorded that a '*giovanetto Lombardo*' has been given '*2 carte delli antifanari grandi perchè facesse uno minio mezano d'una lettera C*', and also that the leaves have been returned. Eberhardt argues that the young Lombard is Liberale, aged twenty-two, who had come from working on the Choir Books of Monte Oliveto Maggiore which are today in the Cathedral of Chiusi. The initial is thus datable after 24 January and before 13 February, when Liberale received a further batch of folios to work on. Eberhardt argues that in effect this was the test piece for the young artist, on the satisfactory completion of which Liberale da Verona's whole career in Siena was founded. The view is persuasive and fits into the stylistic chronology of the artist's work. The standing figure of Christ can be also compared to the similar figure in the Pala di Viterbo dated 1472, formerly attributed to Girolamo da Cremona, but convincingly given to Liberale by Eberhardt (1985).

Provenance: Bought from the custodian of the Gallery in Siena by James Dennistoun in 1838; London, Sotheby's, 1-2 February 1960, lot 250, illus.; from whom acquired by the Barber Institute.

Bibliography: Del Bravo 1963, p. 48; Del Bravo 1967, pp. lxxxviii-ix; Brigstocke 1973, pp. 242-4, fig. 4; Eberhardt 1983, pp. 48, 56-61, 69-70, 74, 96, 229, doc. 16; Eberhardt 1985, pp. 420-1, fig. 1; De Marchi 1993, p. 231, fig. 3.

J. J. G. A.

The illumination of the present Gradual, which contains chants for Masses from Septuagesima to Quadragesima, has been dated by Hans-Joachim Eberhardt (1983; and in Verona 1986, no. 32) from examination of the Cathedral accounts to between late 1467 and October 1470. Liberale signs in a roundel in the lower border on folio 2, '*Opus Liberalis Veronensis*'. Eberhardt argues that the work was done probably in three stages, with intervals during which Liberale may have been absent from Siena. All critics have noted a development in his style during the illumination of the Gradual, changes often accounted for by the arrival of Girolamo da Cremona who, however, is first recorded in Siena only in early 1470 (cat. 122).

The illumination consists of historiated initials with rich borders: folio 2, 'C', *Parable of the Vineyard*, the workers being paid; folio 9v, 'E', *Parable of the Sower*, a man scattering corn; folio 16v, 'E', *Christ Curing the Blind Man*; folio 29, 'M', Ash Wednesday, a priest with acolyte sprinkling ashes on two kneeling figures; folio 36v, 'D', an enigmatic nude figure with puffed out cheeks and a huge wig-like fan of hair who seems to run forward poised above a boat with a seascape behind; folio 45v, 'I', *Temptation*, Christ with the Devil pointing to stones; folio 96, 'R', *Transfiguration*. There are also thirteen large painted initials with borders but without figures: folio 41v, 'A'; folio 57v, 'S'; folio 62, 'D'; folio 66, 'R'; folio 73v, 'C'; folio 77v, 'D'; folio 81, 'I'; folio 102v, 'R'; folio 107, 'T'; folio 110v, 'N'; folio 115, 'O'; folio 120v, 'E'; folio 124 'L'.

Most of the scenes here and elsewhere in the Choir Books can be connected with the Gospel readings for the church Feasts at which the Antiphons or Graduals are sung. The famous figure on folio 36v has no obvious narrative content, however. It has generally been held to represent a Wind from its puffed out cheeks and more specifically Aquilo, the North Wind. The Antiphon is that for the Thursday after Ash Wednesday in Lent, and the Gospel text read on that day is Matthew VIII, 5-13, the account of the healing of the centurion's ser-

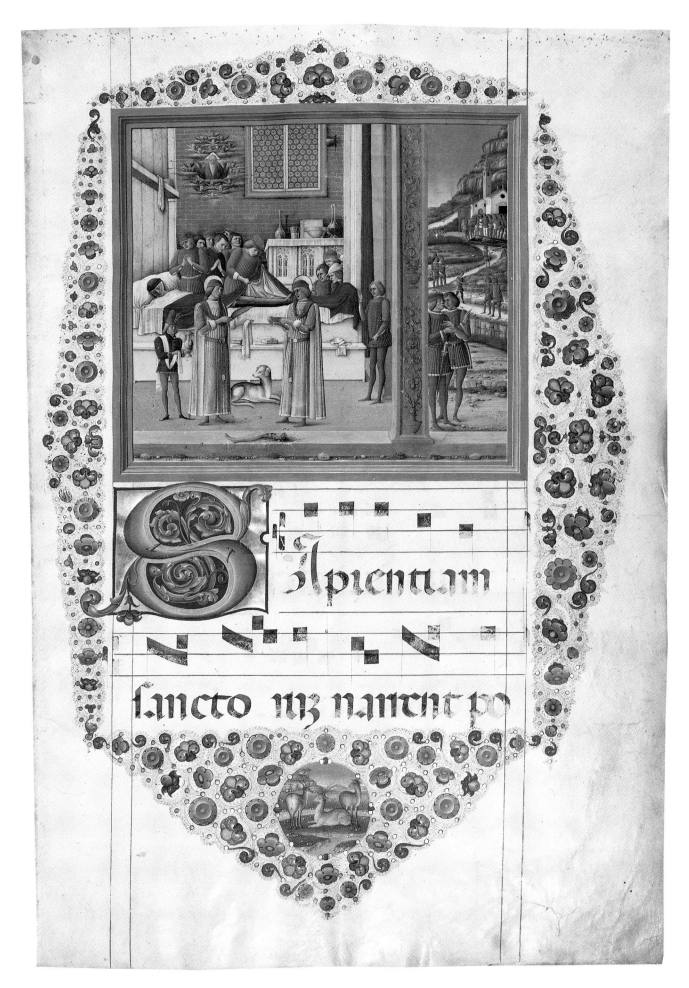

123

Gradual, Antiphonary

62 fols. 380 × 260 mm. On parchment [London only]

*Written probably in Padua, 1460-70, with illumination attributed to
Girolamo da Cremona and an illuminator very close to Franco dei Russi*

LONDON, SOCIETY OF ANTIQUARIES OF LONDON, MS 450

The first part of this Choir Book contains the sung parts of the Mass
and the Antiphons of the Office of SS. Cosmas and Damian and also
the Antiphons for the Office of the Translation of the two martyr
saints, folios 1-33. The bodies of SS. Cosmas and Damian were
brought from the East to Venice in the Middle Ages and placed in the
Benedictine monastery of San Giorgio Maggiore, Venice. The Anti-
phon for the Office of the Translation includes a passage in praise of
Venice, folios 32v-33.

The first miniature, folio 1, represents a famous miracle by the two
saints, who were doctors. They are shown after having miraculously
substituted the leg of a black man who had died shortly before for the
amputated leg of a sick white man while he was asleep. The scene takes
place in a bedchamber and is observed by a group of doctors and
friends of the sick man. In the distance can be seen a group who have
opened the tomb of the black man and found him to be without one of
his legs. A second miniature shows the Torture of SS. Cosmas and
Damian, folio 19, and there are historiated initials of their beheading,
folio 24v, funeral, folio 27v, and the Translation of their bodies to the
church of the Benedictine monastery, folio 32v.

The second part of the Choir Book, folios 33v-61v, is devoted to the
Feasts of the Virgin Mary, with historiated initials of the *Assumption*,
folio 34v, and the *Birth of the Virgin*, folio 39. At the opening of the
Salve Regina the Virgin is shown surrounded by a group of kneeling
Benedictine nuns, folio 51v. On folio 15v an initial added in the 16th
century with classicising ornament is signed by a Fra Jacopo da Man-
tova and bears an inscription: '*Magister Andreas et Franciscus de Mantinea
ornarunt cartas artibus egregiis*'. Possibly the Choir Book, whose illumi-
nation is close in style to Mantegna, was executed for the Benedictine
nuns of Santa Maria della Misericordia in Padua, where the cult of SS.
Cosmas and Damian was solemnly introduced in 1462. According to
the 17th-century guidebooks on Padua, the nuns possessed a precious
Choir Book of the school of Mantegna.

The miniatures of the miracle and torture of the saints are attributa-
ble to Girolamo da Cremona, who signed an initial in similar style
showing a female saint disputing (London, Victoria and Albert
Museum, 817-1894; fig. 20). As a young man he probably collabo-
rated on the Borso Bible in 1458-60 (fig. 16), and in 1461 he began work
on the Missal of Barbara of Brandenburg, Marchioness of Mantua
(Mantua, Archivio Capitolare), taking over from Belbello da Pavia.
Girolamo seems to have worked for the Benedictine monks of the
abbey of Santa Giustina, with whom he may have come into contact
via the monks of San Benedetto al Polirone, near Mantua. The monas-
tery of Santa Maria della Misericordia was adjacent to Santa Giustina.

In the two miniatures Girolamo paints interiors and urban views
with greater monumentality and attention to detail than in the Bible of
Borso d'Este. He no doubt learnt from Mantegna's frescoes in the
Eremitani, Padua. The torture scene especially recalls the *Martyrdom of
St Christopher* there. The almost Flemish detail of the room in the mira-
cle scene, with the open window and the careful geometry of the
wooden bed, may owe something to the *tarsie* executed from 1462 for
the choir of Sant' Antonio, Padua, by Lorenzo Canozi da Lendinara.
The other scenes of SS. Cosmas and Damian seem to be by col-
laborators rather than by Girolamo himself, as is the miniature of the
beheading of the saints in the Breviary of San Giorgio, Venice (Lon-
don, British Library, Additional MS 36933). San Giorgio, where the
saints' bodies were preserved, was closely allied to Santa Giustina.

The initials of the Feasts of the Virgin have been attributed to Franco
dei Russi, who transferred to the Veneto in the early 1460s (cats 26, 71,
82-3, 113). They are certainly close to him in style, but it is doubtful if

they are really by him, since they seem more sensitive and softer in
style. They are certainly by the same artist as a Breviary executed pre-
sumably in Padua for the family of the della Torre of Friuli, which has
also been attributed to Franco (Udine, Biblioteca Archivescovile, MS
12). A date in the second half of the 1460s seems reasonable.

Provenance: Thomas Brooke of Huddersfield, 1891; by whom bequeathed
to the Society of Antiquaries of London in 1908.

Bibliography: *Catalogue of the Manuscripts* 1891, pp. 19-21; *New Palaeographi-
cal Society* 1903-12, II, pp. 396-403, pls 171-3; Levi d'Ancona 1964, p. 55;
Ker 1969, p. 313; Alexander 1969 c, pp. 385-87; Mariani Canova 1984 a,
pp. 331-46; De Marchi 1993, p. 228.

<div align="right">G. M. C.</div>

124

Antiphonary of San Pietro, Perugia

172 fols. 565 × 400 mm. On parchment. Original boards recovered, with
original metal bosses reused [New York only]

*Written in Perugia by Don Alvige, with illumination by Jacopo Caporali,
c. 1472-6*

NEW YORK, COLUMBIA UNIVERSITY LIBRARY, RARE BOOK AND
MANUSCRIPT LIBRARY, MS Plimpton 41

This manuscript contains the Antiphons for the Sanctorale from the
Vigil of St Andrew (29 November) to SS. John and Paul (26 June). The
opening rubric specifies that the text is of the Use of the Congregation
of Santa Giustina, a reform movement originating in the monastery
dedicated to that saint in Padua. On folios 1 and 166v is the contempo-
rary ownership inscription of the Benedictine abbey of San Pietro at
Perugia, a member house of the Order.

The decoration consists of an ornate, fully painted framed page with
borders of flowers, foliage and spirals inhabited by putti and birds and
with figure roundels of Santa Giustina at the top, St Benedict at the
right and St Paul in the centre below. The initial 'M' shows Christ on
the lakeside calling St Andrew, who stands in a boat. There are large,
fine quality penwork initials in red and blue, sometimes with leaf
forms washed in yellow, green and violet. They are of the height of
two lines of text and the musical staves accompanying them: folios 2v,
9, 13v, 16, 33v, 48, 51, 65v, 67v, 70v, 77v, 86, 94v, 101v, 106v, 112v, 118v,
125v and 140. The 'H' on folio 133v contains a figure of St John the
Baptist in hairskin cloak, with an inscription, '*Ecce agnus Dei*'.

Entries in the abbey's accounts, to be published in full by Jane
Rosenthal and Carl Strehlke (see also Zinanni, in Milanesi 1850, p. 318;
Manari 1865), record payments for a set of Choir Books for San
Pietro, Perugia, from 1471 on. The scribe mentioned is Don Alvige,
who evidently came from elsewhere. Among the illuminators men-
tioned is Jacopo (Giapeco) Caporali, to whom payments are recorded
in 1472, 1473 and 1476. He is responsible for the first page of the pre-
sent manuscript. He was *camerlinga* of the guild of miniaturists in
Perugia until his death in 1478, when he was succeeded by his brother,
Bartolomeo, also a painter and miniaturist. Payments for '*669 lettere
minute*' to Tommaso de Mascio and Archolano '*suo compagno*' are
recorded in 1473. It is unclear if Tommaso or Jacopo was responsible
for the fine quality large penwork initials in the present manuscript.
The remaining Choir Books, volumes I, L and M, are still in Perugia.

Provenance: Marked on the cover as volume K; fraudulently removed from
San Pietro at Perugia by Dr Oddi, physician to the prior, Padre Rossi, who
died in 1906; the loss was discovered in 1907 (*La Bibliofilia*, IX, 1907-8,
p. 113; *Bollettino d'Arte*, II, 1908, p. 279); sold New York, Anderson and
Co., 7 March 1911, lot 593; obtained by George A. Plimpton; by whom
bequeathed to Columbia University in 1936.

Exhibitions: New York 1981, no. 13; New York 1985, no. 20, illus.

Bibliography: Piscicelli Taeggi 1887, pls I-VI; Serafini 1912, pp. 105-8, 435,
fig. 12; De Ricci 1935-40, II, p. 1760; Gualdi 1967, pp. 304, 306, 309, fig. 18;
Lunghi 1984, p. 152; J. Rosenthal 1991, pp. 36, 38, pls 38-9.

<div align="right">J. J. G. A.</div>

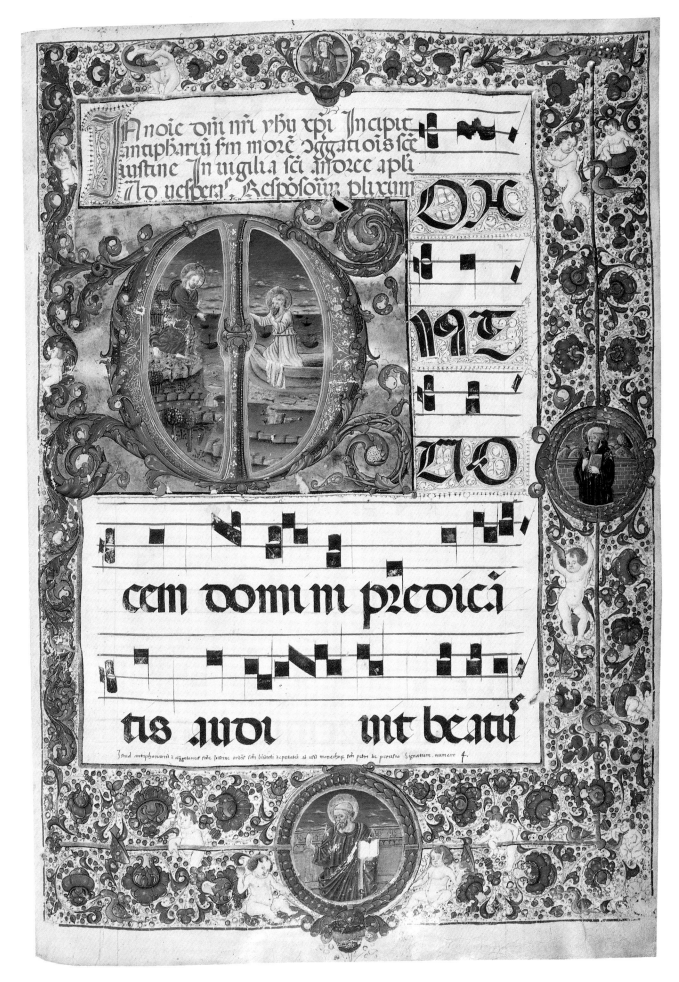

125

Gradual

142 fols. 870×600 mm. On parchment

*Written by Henry of Amsterdam in Cesena, 1486, with illumination
attributed to two anonymous illuminators*

CESENA, BIBLIOTECA COMUNALE MALATESTIANA,
CAPITOLO DELLA CATTEDRALE, Corale D

The volume containing the *Commune sanctorum* is part of a series of
Choir Books made for the Duomo in Cesena (Biblioteca Malatestiana,
Corali A, B, C, D, E, F, G). The illumination of the manuscripts bears
characteristic signs of the work of various artists working in and
around Cesena between 1485 and 1495. All the volumes, on the other
hand, were written by a single *scriptor*, Henry of Amsterdam, who was
the scribe responsible for copying the Choir Books of San Petronio in
Bologna between 1469 and 1484. His elegant Gothic script is easily
recognisable, and his signature is to be found on folio 141v of
Corale D, the volume exhibited here. He notes that he copied all eight
volumes for the Cathedral and that he finished this work in 1486.
The books in Cesena also bear the information that the series was com-
missioned by the Bishop of Cesena, Giovanni Venturelli di Amelia,
and the canons of the Cathedral; the only canon whose name has come
down to us is Cordato Isolani who, according to the inscription on
folio 1 of Corale D, was personally responsible for financing this vol-
ume. Corale C *(Proprium sanctorum)* and Corale D are the most
elaborate volumes of the series. The magnificent title-page bears an
imposing and highly complex architectural design; over the top of this
a torn sheet of parchment is superimposed, containing the *incipit* of the
Commune sanctorum and the initial letter 'E' *(Ego autem sicut oliva)* with
a figure of St John the Evangelist. The scroll is suspended from ribbons
held by eight angels and cherubs. The architectural structure is deco-
rated with bands of inscription and Classical bas-reliefs, medallions
bearing effigies of the Emperors Caligula and Nero, candelabra, fes-
toons, ribbons and suits of armour. Round the edges of the structure
and in the arches there are saints, Fathers of the Church and other
religious figures; at the top can be seen St Paul, the *Annunciation* and
St Peter. Below them stand St John the Baptist, St Andrew, St James
and St Sebastian. In the space between the two frames are heads of
St Jerome and St Augustine. Lower down, on pedestals, there are half
figures of other saints with the figure of the sponsor, Cordato Isolani,
kneeling and surrounded by symbols of learning (books, a set square,
compasses) and symbols of the faith, including a peacock.

The architecture, the taste for Antiquity and the trompe l'oeil paint-
ing of the sheet of parchment link this miniature to the schools of
illumination active in Padua and Venice between 1475 and 1485,
though here the Roman influence of works such as the codices attri-
buted to the anonymous illuminator of the Vatican Theophylact (see
cat. 37) is evident, as is a certain stateliness of perspective reminiscent
of the style of Melozzo da Forlì. There are many direct allusions, espe-
cially in the figure drawing, to contemporary Bolognese and Ferrarese
painting, particularly to the work of Ercole de' Roberti and Lorenzo
Costa. The influence of Roberti's altarpiece, the Pala Portuense, now
in the Brera, Milan, can be seen here as well as of Costa's *St Sebastian*
in Dresden: the same St Sebastian can be found on the right hand side
of the title-page. This eclecticism, the at times quite crude narrative
style, the perspective that does not quite fit together and most of all the
bright colours suggest that the author of the title-page was probably a
local artist from the Romagna active in Cesena at the end of the 1480s.
Conti's hypothesis (1989) that he can be identified with the anonym-
ous author of the Bertoni altarpiece now in the Pinacoteca in Faenza is
an ingenious one.

The decorated initial letters, six in all, are by another illuminator,
also presumably active in Cesena; here the elegant composition, the
delicate brushstrokes, and the dark colours hark back to Classicism
but at the same time are imbued with Umbrian, Tuscan and Bolognese
feeling (Perugino, Ghirlandaio, Francesco Francia). The capital letter

'P' on folio 30 *(Protexisti me Deus)* is very characteristic of this
illuminator's style (it shows a Bishop), as is the letter 'D' *(Dilexi ius-
titiam)* on folio 110v, with its illustration of three saints. This manu-
script and the others in the series also contain large numbers of illumi-
nated letters, with and without decorative borders.

Provenance: This volume, as noted in the inscription on fol. 141v ('*Hoc
graduale speciosum Reverendissimus Dominus Johannes de ameria episcopus
Cesene Canonici et capitulum eiusdem suis sumptibus ediderunt octo voluminibus
per me Henricum Amsterdammis de Hollandia diocesis traiectensis Innocentio
octavo pontifice maximo. Anno domini MCCCCLXXXVJ*'), was written in
1486 by Henry of Amsterdam for the Duomo in Cesena and more espe-
cially, as noted in another inscription, folio 1, for canon Cordato Isolani
('*...Cordatus insulanus [iu]ris utriusque doctor canonicus Cesene hoc c[a]ntici
volumen aere me d...*'); Cathedral archives, Cesena; from 1918, held in the
Biblioteca Malatestiana.

Exhibitions: Modena 1928, p. 34; Forlì 1938, p. 204, illus.; Rome 1953,
no. 592; Cesena 1989, Corale D, illus.

Bibliography: Braschi 1738, pp. 338-9; Zaccaria 1779, p. 67; Zazzeri 1890,
pp. 337-78; Mazzatinti 1897-9, p. 39; Campana 1932, pp. 105-6; Salmi
1932, 360; Salmi 1957, p. 64; Ciucciomini 1986, pp. 29-35; Conti 1989,
pp. 11-18; Ciucciomini 1989, pp. 37-46; Tambini 1991, pp. 7-27 *(Addenda,
p. 267)*

F. T.

126

Antiphonary

188 fols. 635×435 mm. On parchment [New York only]

*Written probably in Rome, late 15th to early 16th century, with illumination
attributed to Fra Antonio da Monza*

MALIBU, THE J. PAUL GETTY MUSEUM, MS Ludwig VI 3

This Antiphonary contains the Proper for the Temporale from Easter
Saturday to the 24th Sunday after Pentecost (folios 1-186), with Votive
Mass for Pentecost to Easter (folios 186v-188v).

On folio 16 for the Introit of Easter Sunday an initial 'R' shows the
resurrected Christ standing above the tomb in a landscape with four
soldiers, one asleep behind, one standing to the left and two in con-
torted poses in front of the sarcophagus. The upright of the 'R' con-
tains a bound naked St Sebastian pierced with arrows as if enclosed in a
crystal column. Below him is a cameo figure of Mercury with a bull's
head. There are also three grotesque figures, attached as it were to the
initial, one above and two to the right. The ornate frame is decorated
with *grotteschi*. To left and right are medallions with the Angel Annun-
ciate and the Virgin, while in the centre below is a half-length frontal
bust figure of Christ. Two larger foliage initials introduce the Introits
for the Ascension ('V', folio 54) and Pentecost ('S', folio 62), and there
are numerous smaller initials.

The illumination has been attributed to Fra Antonio da Monza, who
signed the miniature of the *Pentecost* now in the Albertina, Vienna
(cat. 119). Since the miniature contains a medallion of Pope Alexan-
der VI it must have been executed during his pontificate, 1492-1503. A
Missal in the Vatican (Biblioteca Apostolica Vaticana, Borg. lat. 425)
attributed to Fra Antonio was illuminated for the same Pope. It is
likely that the Antiphonary was also illuminated in Rome, most prob-
ably late in the Pope's reign, whereas the Missal is earlier in date (Rossi
1990). Von Euw and Plotzek (1979) have suggested on the basis of
saints included in the Litany (Louis, Francis, Anthony, Bernard and
Dominic) that the Antiphonary was made for the Franciscans of Santa
Maria in Aracoeli, Rome, where the manuscript, from which the
signed *Pentecost* miniature came, is recorded in 1736. A drawing on
paper in the Kupferstichkabinett, Berlin (cat. 108) seems to be a study
for the scene of the *Resurrection* in the initial 'R'.

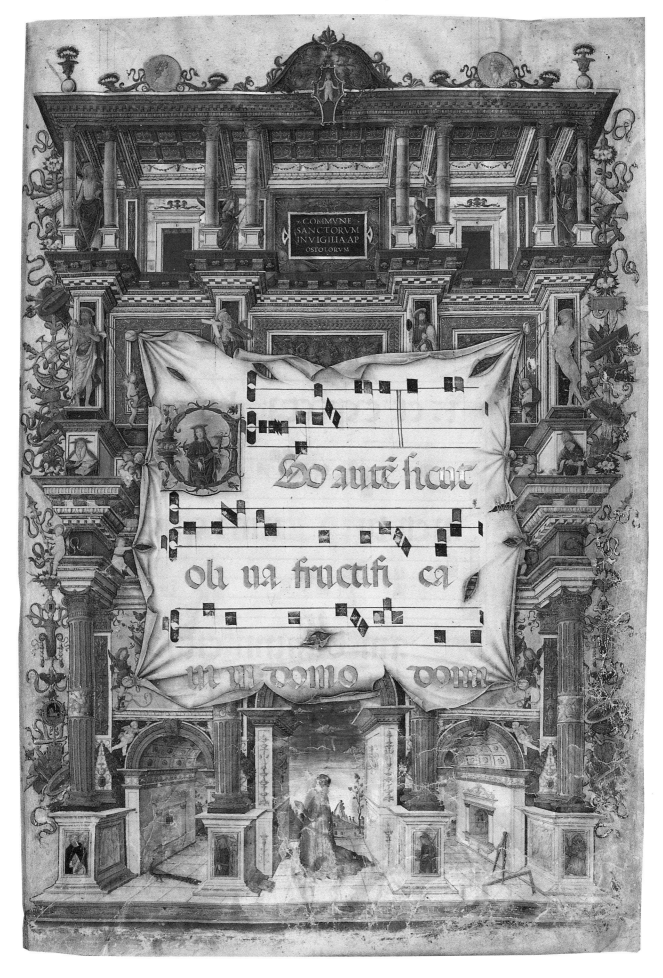

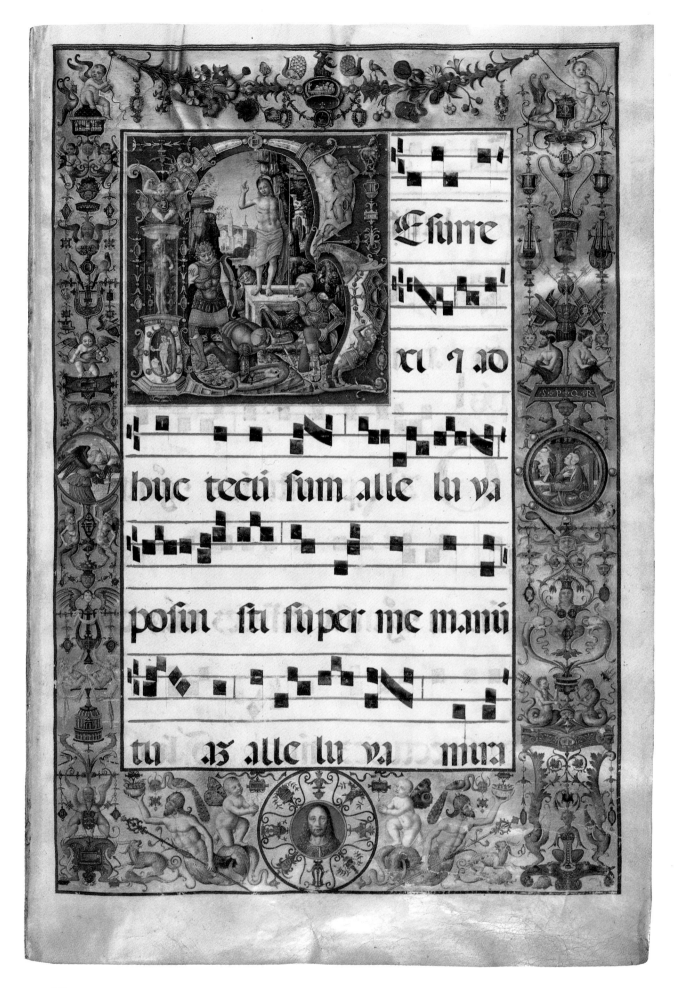

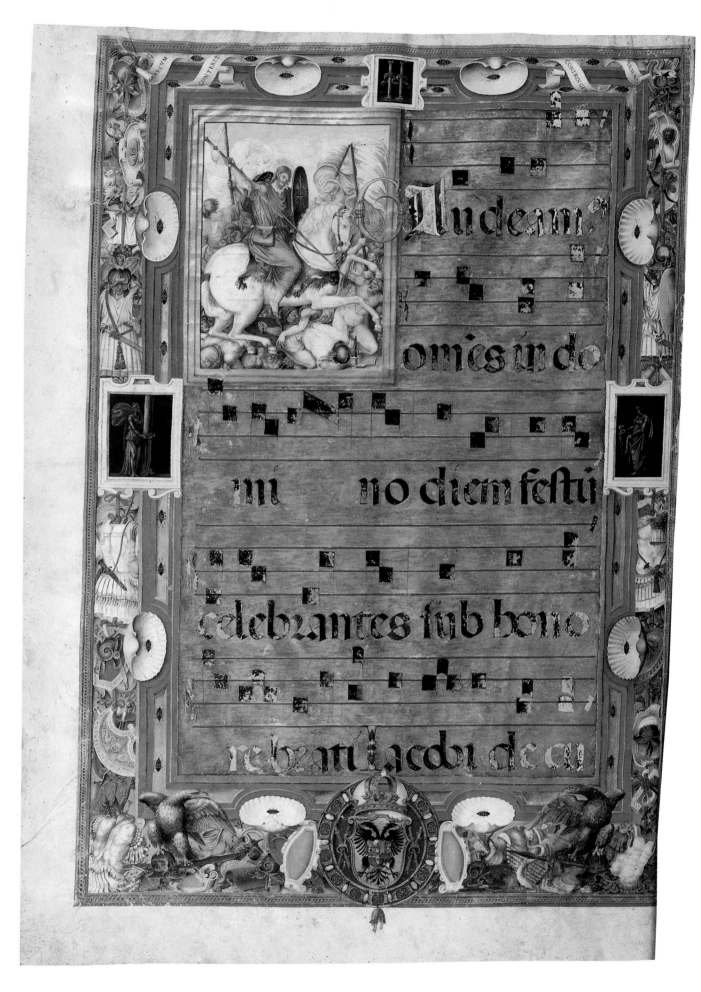

No certain documented works by Fra Antonio executed in Lombardy have so far been discovered, though his knowledge of works by Leonardo da Vinci during the latter's stay in Milan, for example the *Madonna of the Rocks*, seems to confirm that he was trained as an artist in that city (see D. A. Brown 1978). In the lower left border on folio 16 is written on a red tablet the letters 'O. L. D. V' and in the frame below, only legible under magnification, '*Leonardo*'. Von Euw and Plotzek (1979) suggest the initials stand for O(pus) L(eonardi) D(a) V(inci) and consider that Fra Antonio may himself have been responsible for the inscriptions as a sort of homage. However, another possibility is that the initials are additions of 18th- or 19th-century date made by someone interested in adding prestige or value to the manuscript.

Provenance: Alexandrine de Rothschild, and possibly earlier members of the family (James and Edmond de Rothschild) in the 19th century; sold, Paris, Palais Galliera, 24 June 1968, lot 8; bought by Peter Ludwig from H. P. Kraus (Cat. 1974, no. 42); acquired with the Ludwig Collection by the J. Paul Getty Museum in 1983.

Bibliography: D. A. Brown 1978, p. 175 n. 24; Kraus 1978, p. 214, no. 86; Von Euw and Plotzek 1979, I, pp. 270-5, pls on pp. 271, 273, figs 176-7; Casciaro and Rossi 1990, pp. 27-9.

<div style="text-align:right">J. J. G. A.</div>

127

Choir Book of Santiago de los Españos, Rome

173 fols. 733 x 537 mm. On parchment. Original binding with metal central boss and corner pieces of interlaced foliage [London only]

Written and noted in Rome, c. 1538-40, by Juan de Escobedo, papal scriptor and chaplain of the church, and illuminated by Vincenzo Raimondi

MADRID, BIBLIOTECA NACIONAL, MS Vit. 16-1

This huge Choir Book, a combined Gradual-Antiphonary, contains chants for the Feasts of Corpus Christi, St James the Greater, for Holy Week, for Christmas and the Feasts immediately following to Epiphany, for the Assumption of the Virgin and for the Ascension. There are four square miniatures the height of two lines of text with their respective musical staves. The first two are for Corpus Christi: folio 1v, *Melchisedech and Abraham*; folio 5v, the *Last Supper*. The sec-

ond two are for St James the Greater: folio 12v, *St James Preaching*; folio 20v, *St James Fighting the Moors (St James Matamoros)*.

The miniatures have four sided borders of great richness, in each of which the Imperial arms of Emperor Charles V (r. 1519-1556) are painted in the centre below. He must therefore be considered the patron of the manuscript. There are also two painted initials, containing the arms of Antonio Pérez de la Salde, on folio 19v, and Luis de Torres, apostolic protonotary, on folio 18. These men were administrators of the Spanish Church in Rome and presumably they oversaw the commission.

In the border on folio 1v are two medallions with unidentified scenes and two other medallions with the Emperor's *impresa*, the Pillars of Hercules. On folio 5v nineteen small scenes of the Passion are similarly inserted in cartouche frames. On folio 12v there are still-life motifs in the border of baskets of fruit and flowers, putti and birds as well as *grotteschi*, all reminiscent of the Vatican Loggie painted by Raphael and his pupils (see also cat. 117). The Virtues of Prudence and Justice are shown in grisaille on black on each side. On folio 20v the border motifs include trophies of arms, shells and ladybirds. The Virtues represented here are Fortitude and Temperance. Up to folio 100 there are numerous gold strapwork initials on blue or crimson, then fine quality penwork in Spanish style.

The manuscript is of great importance as it is documented as being written by Juan de Escobedo, cleric of the diocese of Toledo and chaplain of the Spanish Church from 1533 (d. 1566), and illuminated by Vincenzo Raimondi, papal miniaturist from 1549, but active in Rome earlier (see cats 129, 130). Vincenzo acknowledged receipt of 280 *scudi 4 juli* on 16 August 1540 for the miniatures and initials in an '*Officia Corporis Christi, Sancti Jacobi et Ebdomade Sancte*' and in an '*Officium Salve Regine*' from the administrators of the Spanish Church (Paz y Mélia 1907; Dorez 1909, app. I, no. II, though apparently unaware of Paz y Mélia; Talamo 1989 also refers to the manuscript as untraced). As in his other works, Raimondi shows the influence of High Renaissance painting in Rome.

Provenance: Arms and emblems of Emperor Charles V (r. 1519-1556) included in the borders; arms of D. Luis de Torres with the black hat of an apostolic protonotary, folio 18, and of Antonio Pérez de la Salde, folio 19v.

Bibliography: Paz y Mélia 1907, pp. 201-5, pls IV-VIII; Bordona 1933, I, p. 356, no. 903, fig. 300; Anglés and Subirá 1946, pp. 129-31; Janini and Serrano 1969, pp. 223-4.

<div style="text-align:right">J. J. G. A.</div>

The invention of printing, which mechanized both the writing and the illustration of books and resulted in a new mass production, made manuscripts an uneconomic luxury. Only in exceptional circumstances for particular patrons were *de luxe* illuminated manuscripts still produced, for example the Missal of Cardinal Giulio de' Medici, written in Rome in 1520 by Lodovico Arrighi (cat. 128) and the Missal illuminated by Agostino Decio in Milan in 1535 (cat. 131). The Popes and Cardinals in Rome continued into the 17th century to order handwritten and hand-decorated copies of liturgical service books. Giulio Clovio, who worked for the Cardinals Grimani (cat. 133) and Farnese (cats 132, 134) was renowned in his own day, and his life was included by Vasari with those of his famous contemporaries. Vasari referred to him in fact as '*piccolo e nuovo Michelangelo*'. During the same years Vincenzo Raimondi and Apollonio de' Bonfratelli were in turn appointed papal miniaturists (cats 129, 130, 136, 137).

128

Missal of Cardinal Giulio de' Medici

411 fols. 380 x 270 mm. On parchment [London only]

Written in Rome, 1520, by Lodovico Arrighi, with illumination attributed to Matteo da Milano and Giovanni Battista Cavalletto

BERLIN, STAATLICHE MUSEEN ZU BERLIN, PREUSSISCHER KULTUR-BESITZ, KUPFERSTICHKABINETT, MS 78 D 17

This magnificent Missal was written for the future Pope Clement VII (r. 1523-1534), one of the major patrons of the arts in High Renaissance Rome. A colophon, folio 404v, gives the scribe's name, '*Ludovicus Vicentinus*', that is Lodovico Arrighi, and the date, 1520. Arrighi published a famous writing book in Rome in 1522 and describes himself as a papal *scriptor* (see cat. 130).

The decoration includes a full-page framed miniature of the *Crucifixion* at the Canon of the Mass, folio 182v. On the recto opposite, folio 183, the *Elevation of the Host* is shown above at the top of the page, while a smaller miniature shows a priest at the altar saying the Canon. The matching frame contains the Medici arms with cardinal's hat and also the Medici *imprese* – the ring, feathers and motto '*Semper*'. These are also painted in the frame on folio 182v, where the instruments of the Passion are included below – the column, ladder, lance, sponge, dice and seamless robe of Christ.

The text of the Missal begins after the Calendar with a framed page, folio 10, on which the parchment is shown illusionistically as if torn and curling up, partly overlapping the architectural frame and partly revealing a landscape behind in which a kneeling figure of King David prays to the Lord, who appears from a cloud above to the right. In medallions imposed on the architecture, half-length or bust figures are shown, two prophets, SS. John the Baptist and Jerome, another prophet and, above, SS. Paul and Peter. To the left is a coin type portrait of the Roman Emperor Hadrian. There are also simulated cameos and jewels. The Medici arms with cardinal's hat are painted in the centre below and the same *imprese* to the right.

There are also numerous historiated initials, some like the striking initial 'R' with a seated figure of Death, folio 377v, with framed borders. The main illuminator can be identified as Matteo da Milano, whose name occurs in the accounts of the d'Este at Ferrara from 1502 to 1512, including payments for the Breviary (fig. 4) started for Duke Ercole I (r. 1471-1505) and completed for Duke Alfonso I (r. 1505-1534). Matteo's facial types are easily recognisable, and in his borders he typically mixes *grotteschi*, combinations of humans, dragons, fish and snails with still-life motifs, scattered small red and blue flowers, strawberries, simulated pearls and jewels. He also often inserts roundels with inscriptions in capital letters. His career probably began in Milan in the 1490s, and he moved to Ferrara in about 1502, probably via Bologna (see cat. 117). The Missal of Cardinal Giulio belongs with a group of later works made in Rome, which form the climax of Matteo's career. It is not known when he was born or when he died.

A second artist was responsible for historiated initials and borders on a number of pages, for example the *Adoration of the Magi* on folio 28. Ulrike Bauer-Eberhardt (1993) has recently convincingly identified him with Giovanni Battista Cavalletto, who signed the *Statuti dei mercadanti e drappieri di Bologna* (Bologna, Museo Civico Medievale, MS 97), which is dated 1523.

Provenance: Giulio de' Medici, created Cardinal by Pope Leo X in 1513, succeeded as Pope Clement VII in 1523, died in 1534; bought with other manuscripts from the library of the 10th Duke of Hamilton (1767-1852) by the Prussian Government in 1882 (no. 442).

Exhibition: Berlin 1994, no. I.15.

Bibliography: Wescher 1931, pp. 104-7; Alexander 1991a, p. 689, fig. 20; Lodigiani 1991, 289; Reiss 1991, pp. 107-28, pl. I, figs 11, 14, 17-24, 27; Alexander 1992, p. 34, figs 9-12; Bauer-Eberhardt 1993, pp. 70-1, pl. II, figs 19, 20.

J. J. G. A.

129

Psalter of Pope Paul III

219 fols. 370 x 255 mm. On parchment [New York only]

Written in Rome, 1542, by Federico Mario da Perugia 'camerarius', with illumination attributed to Vincenzo Raimondi

PARIS, BIBLIOTHÈQUE NATIONALE, latin 8880

The manuscript contains the Psalms (folios 1-181v), Hymns (folios 183-207v), Litany (folios 208-210), and Prayers (folios 210-213). On folio 1, the Preface, '*Ordo Psalterii*', has a cartouche frame with a portrait bust, with the date 1542, of Pope Paul III (Farnese) supported by angels in the centre below. The initial 'B' for Psalm 1 is of seven lines and contains a kneeling King David. Other historiated initials for the liturgical divisions, all seven lines high, are: folio 40v, Psalm 26, 'D', with David in prayer; folio 60, Psalm 38, 'D', with David playing a stringed instrument; folio 75, Psalm 52, 'D', with David playing the psaltery; folio 88, Psalm 68, 'S', with the Prayer of the Chalice and a

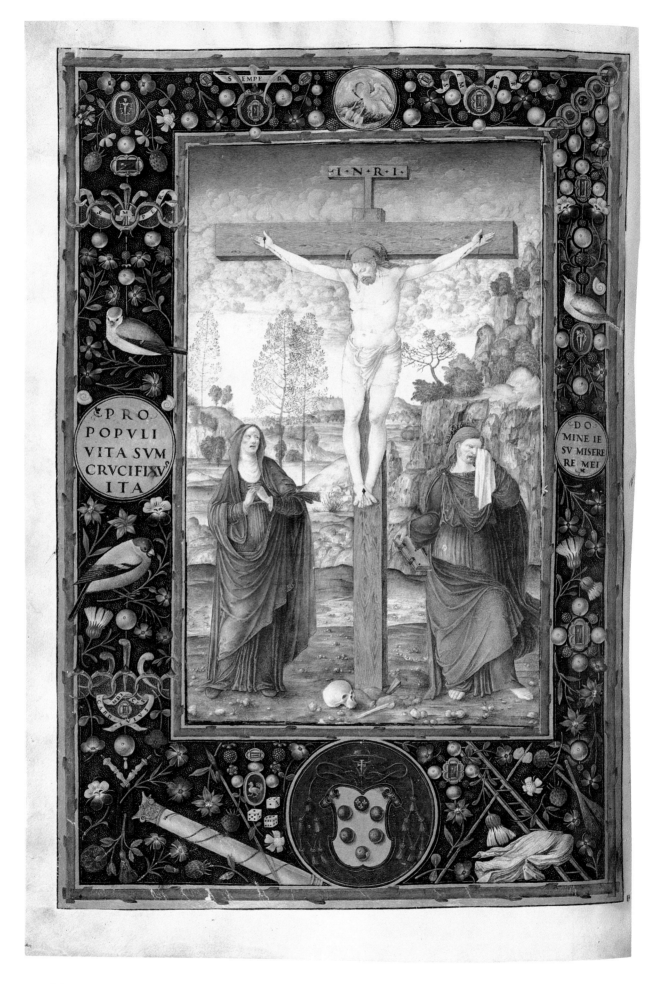

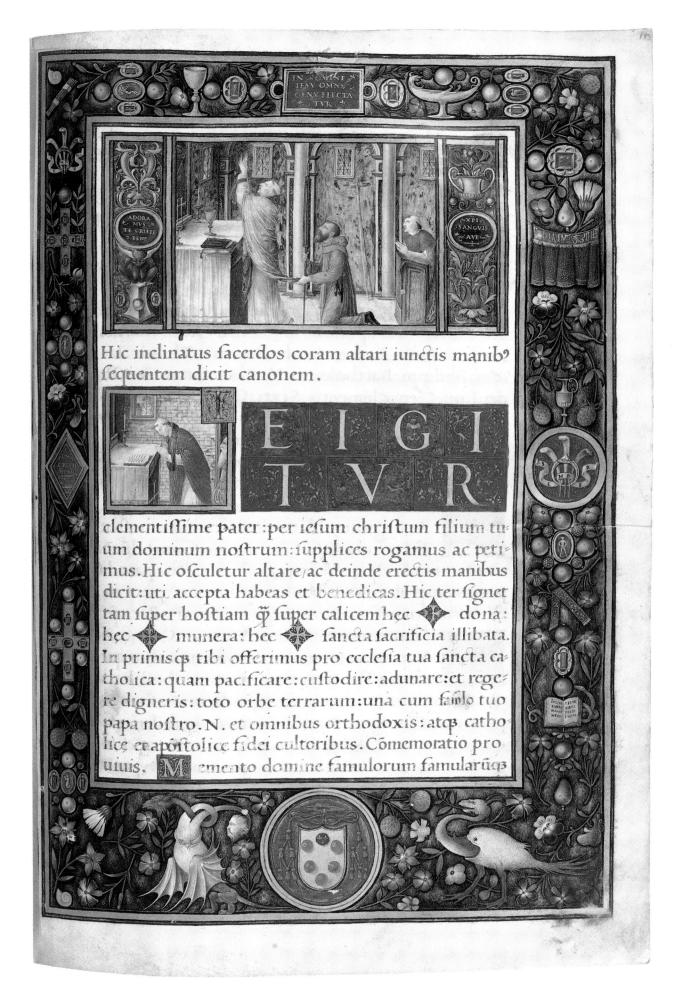

Hic inclinatus facerdos coram altari iunctis manib⁹
fequentem dicit canonem.

EIGI TVR

clementiffime pater:per iefum chriftum filium tu-
um dominum noftrum:fupplices rogamus ac peti-
mus.Hic ofculetur altare/ac deinde erectis manibus
dicit:uti accepta habeas et benedicas. Hic ter fignet
tam fuper hoftiam ꝗ̃ fuper calicem hęc ✦ dona:
hęc ✦ munera: hęc ✦ fancta facrificia illibata.
In primiſ ꝗ tibi offerimus pro ecclefia tua fancta ca-
tholica:quam pacificare:cuftodire:adunare:et rege-
re digneris:toto orbe terrarum:una cum famlo tuo
papa noftro.N. et omnibus orthodoxis:atꝗ catho-
licę et apoftolicę fidei cultoribus. Cõmemoratio pro
uiuis. M emento domine famulorum famularũꝗ

praying figure; folio 107v, Psalm 80, 'E', with a praying figure; folio 123, Psalm 97, 'C', with a standing figure; folio 153, Psalm 109, 'D', with King David playing the harp. Also seven lines high is the 'L' with praying figure on folio 143, Psalm 118. On folio 183, the Hymn for Vespers of the First Sunday in Advent, '*Conditor almae syderum*', also has a seven line inital 'C' and this is framed with a border with *grotteschi* and the Pope's emblem of a rainbow with three irises and his motto in Greek, '*Dikes Krinon*'. On the preceding verso a full-page miniature shows God creating sun, moon and earth, a figure reminiscent of Michelangelo's Creator on the Sistine Ceiling. This has a matching ornate cartouche frame with a portrait of the Pope in the upper border and the papal arms in the lower border. The Four Evangelists are represented at the upper corners of verso and recto. There are numerous other smaller initials, many of which are historiated, especially in the Hymns, for example Pope Paul III before the Trinity on folio 193.

On folio 213 a colophon addressed by 'Silvester' to the reader records that the manuscript was written by Federicus Perusinus for Pope Paul III in 1542. 'Silvester' is the papal chamberlain Eurialo Silvestri de Cingoli. Federico Mario of Perugia is recorded as papal *scriptor* in papal accounts from 1541 to 1546, writing liturgical manuscripts and Choir Books for the Cappella Sistina.

Dorez (1909) attributed the illumination to Vincenzo Raimondi, a Frenchman from Lodève, who is documented from payments in the papal accounts from 1535 to 1549, and who was active in Rome from the time of Pope Leo X (*r.* 1513-1521) onwards. He received the appointment of papal illuminator by a *motu proprio* in 1549, the last year of Paul III's reign, but died in 1557 (Vian 1958). Though there is no specific payment recorded for the present work, a body of illumination certainly by the same hand has been convincingly assembled (see cat. 130). This includes the Madrid Choir Book executed for Emperor Charles V, for which payment is specifically recorded to him (cat. 127) and a number of papal Choir Books, for example Biblioteca Apostolica Vaticana, Cap. Sist. 4 of *c.* 1532-4 (Cologne 1992, no. 88). Cuttings from a Missal for Pope Clement VII (New York 1992, no. 90) may represent the earlier style of this artist.

The decorative forms used in the initials of the Psalter, for instance the small flowers and the grotesque masks, are reminiscent of the work of Matteo da Milano, with whose Roman works, such as the Missal of Cardinal Giulio de' Medici of 1520 (cat. 128), Vincenzo was undoubtedly familiar. Vincenzo borrows compositions and decorative motifs, for example the *grotteschi*, from the High Renaissance painters active in Rome in these years. He must also have known the work of his contemporary, Giulio Clovio (cats 132-35), who is listed with him as one of five outstanding illuminators by Francisco de Hollanda in 1548. Also on the list are Antonio de Hollanda, Francisco's father, Attavante (see cats 1, 3, 4), and Simon Bening of Bruges.

Provenance: Arms and portraits of Pope Paul III (*r.* 1534-1549), folios 1, 182v; given to Pope Pius VI (*r.* 1775-1799) by Cardinal Casali, inscription on folio A, and embroidered binding with the Pope's arms; taken from Rome in 1798 to Paris with part of the library of Pius VI.

Exhibition: Paris 1984, no. 149, illus.

Bibliography: Waagen 1839, pp. 394-5; Bradley 1891, pp. 147, 149, 208, 262; Dorez 1909; Vian 1958; Llorens Cistero 1958-61, pp. 477, 482; Talamo 1989, p. 164.

J.J.G.A.

130

Hours of Eleanora Gonzaga, Duchess of Urbino, Use of Rome

144 fols. 152×94 mm. On parchment [London only]

Script attributed to Lodovico Arrighi and illumination to Vincenzo Raimondi in Rome, before 1527 (?)

OXFORD, BODLEIAN LIBRARY, MS Douce 29

This small Hours has a series of openings with full-page framed miniatures in pairs on verso and recto, representing a typological scheme of Old Testament prefigurations of New Testament events. On folio i verso is a full-page coat of arms of Eleonora Ippolita Gonzaga (1493-1543) and her husband, Francesco Maria I, Duke of Urbino. On folio ii is an inscription on a shield: '*Leonore Gonzage Urbini Duci*'. Both pages are framed with trophies of arms on a gold ground. The couple married in 1509 and he died in 1538.

The miniatures for the Hours are: folios iv verso-1, Matins, *Moses and the Tablets of the Law* and the *Annunciation*; folios 14v-15, Lauds, *Anna and Joachim at the Golden Gate* and the *Visitation*; folios 23v-24, Prime, *Birth of St John the Baptist* and the *Nativity of Christ*; folios 27v-28, Terce, *Jacob's Dream* and the *Annunciation to the Shepherds*, folios 31v-32, Sext, *Solomon and the Queen of Sheba* and the *Adoration of the Magi*; folios 35v-36, None, *Presentation of Samuel in the Temple* and the *Presentation of Christ in the Temple*; folios 45v-46, Compline, *Solomon's Dream* and *Christ Teaching the Doctors in the Temple*.

Other miniatures are: folios 55v-56, for the Mass of the Virgin, the *Israelites Gathering Manna* and the *Last Supper*; folios 60v-61, for the Seven Penitential Psalms, the *Destruction of Sodom and Gomorrah* and *David Praying*; folios 76v-77, for the Office of the Dead, *Expulsion from Paradise* and the *Entombment*; folios 110v-111, for Matins of the Cross, *Christ Bearing the Cross* and the *Sacrifice of Isaac*; folios 131v-132, for Matins of the Holy Spirit, the *Sacrifice of Elijah* and *Pentecost*.

The miniatures have borders with still-life motifs reminiscent of the Vatican Loggie, for example the fish, tortoises and snails on folios 110v-111. In some there are also small scenes, for example the *Four Evangelists* and the *Four Doctors*, folios 23v-24, and eight scenes from the *Resurrection* to *Pentecost* on folios 131v-132.

The illumination was attributed to Vincenzo Raimondi of Lodève by Otto Pächt (in Oxford 1948, no. 76). Vincenzo is documented as working in Rome for the Papacy from the time of Pope Leo X (*r.* 1513-21) and payments are recorded in papal accounts for the illumination of service books from 1535 to 1549. In 1542 he executed the Psalter of Pope Paul III (cat. 129) and he died in 1557. The script of the Hours has been attributed by Alfred Fairbank (1974) to Lodovico Arrighi of Vincenza, who printed a famous writing manual in Rome in 1522 in which he refers to himself as a Vatican *scriptor* (see cat. 129). Since there is no mention of Arrighi after *c.* 1526, it has been assumed that he was killed in the Sack of Rome in 1527. This, if true, would provide a *terminus ante quem* for the present manuscript, and place it early in Vincenzo Raimondi's career. However, Raimondi's oeuvre still awaits detailed study of its chronology and sources as well as his links to his native France. Another Hours with miniatures by him is also in the Bodleian Library (MS Douce 19; Oxford 1984, no. 85). It may have been made for a French patron, perhaps even in France.

Provenance: Arms of Eleanora Gonzaga, Duchess of Urbino (1493-1543); Francis Douce (1757-1834), bequeathed to the Bodleian Library, with a note by him 'purchased in Italy by Henrietta Louisa Countess of Pomfret', who died in 1761.

Exhibitions: Oxford 1948, no. 76, pl. XX; Oxford 1984, no. 85.

Bibliography: Bradley 1891, pp. 316-23; Fairbank and Hunt 1960, pl. 13; Pächt and Alexander 1970, no. 1006, pl. LXXXII; Fairbank 1972, p. 272; Fairbank 1974, pp. 551-2.

J.J.G.A.

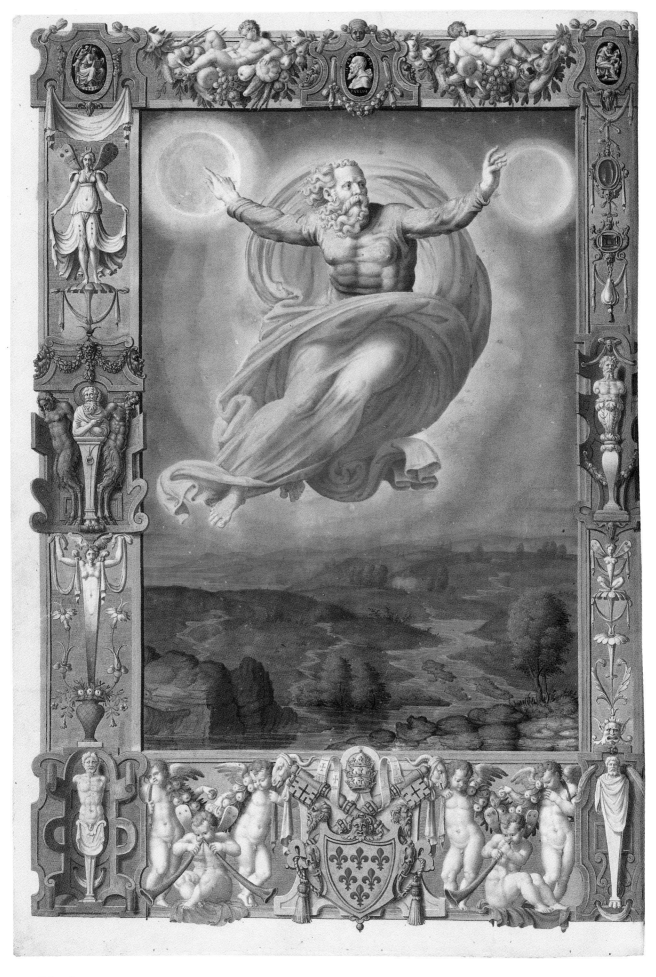

129 folio 182v

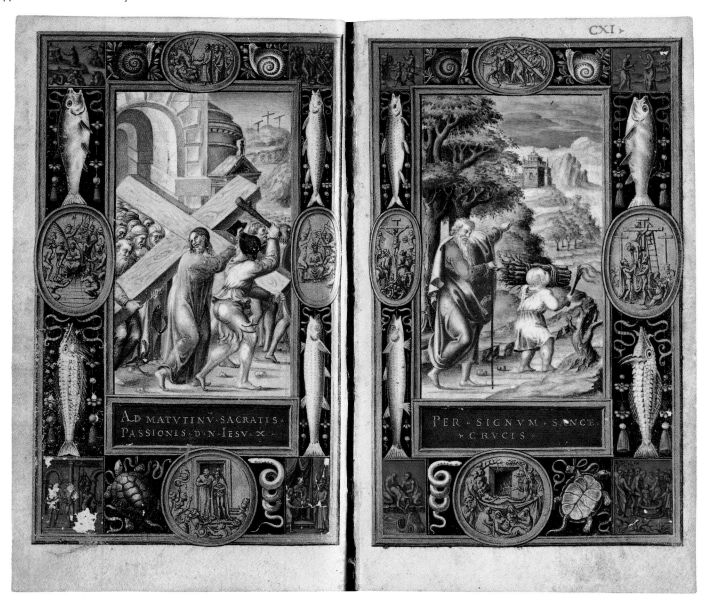

130 folio 110v-111r

131

Missal, Ambrosian Use

105 fols. 352×255 mm. On parchment. Brown morocco gilt Roman binding, 16th-century

Written in Milan, dated 1534, with illumination (one miniature signed and dated 1535) attributed to Agostino Decio

NEW YORK, THE PIERPONT MORGAN LIBRARY, M. 377

According to the dated rubric on the first leaf (13 March 1534), this Missal was written for use in the Ambrosian rite at the order of Girolamo Mattia, first prior of Santa Maria della Scala in Milan. That church had just been restored under the auspices of Francesco II Sforza, Duke of Milan, who also granted the church various privileges, the most important of which was exemption from archiepiscopal jurisdiction. (Although demolished in the 18th century, the memory of the church lives on in the popular name given to the opera house now occupying its former site, La Scala ['The Stairs'].)

The manuscript's most impressive illumination is the full-page *Crucifixion* (folio 59v) illustrating the Canon of the Mass. The miniature is dated 1535 (beneath the skull) and signed *'Decius Fa[ciebat]'* ('Decius made this'). The artist also painted the small miniature of the *Adoration of the Shepherds* on folio 1v. These miniatures have been attributed to Agostino Decio, from the family of Milanese artists active in the 15th and 16th centuries. According to Paolo Lomazzo, his contemporary and author of a treatise on painting, Agostino worked for the Emperor Rudolph II (r. 1576-1612) and for the Dukes of Savoy. Agostino is also said to have been summoned to Rome with his son, Ferrante, by Pope Gregory XIV, and to have returned to Milan after the Pope's death in 1591. If the latter is true, Agostino's working career spanned some 60 years, making him as long-lived and active as his Venetian contemporary, Titian (c. 1490-1576). Agostino would thus have been for Milan what Giulio Clovio was for Rome (see cat. 132), its last great illuminator. Lomazzo, indeed, composed a sonnet (printed by D'Adda and Mongeri 1885, p. 786; De Marinis 1908, p. 26) in Decio's honour, describing him as brighter than the noonday sun and comparing him with Giulio Clovio. Agostino illuminated many of the Choir Books now in the Certosa at Pavia and the Cathedral of

Vigevano. The unnamed scribe of this Missal also collaborated with Decio on a Missal and Lectionary for the Cathedral. It has been suggested that he may be Benedetto Cremonese, who signed an Evangeliary of 1531 also attributed to Decio (Milan, Biblioteca Trivulziana, MS 2148), but the hands are not identical.

Provenance: Santa Maria della Scala, Milan; Marchese Girolamo d'Adda (1815–1881); Charles Fairfax Murray (1849–1919); purchased by John Pierpont Morgan (1837–1913) in 1909.

Exhibitions: New York 1934, no. 143; New York 1984, no. 30; Austin, Berkeley and New Haven, 1988–9, no. 59.

Bibliography: D'Adda and Mongeri 1885, pp. 784–5; De Marinis 1908, p. 26, no. 46, pl. 11; De Ricci 1935–40, II, p. 1436; Tornielle 1946, p. 45; D'Ancona 1949, p. 60; Harrsen and Boyce 1953, no. 101, pl. 72; Santoro 1958, p. 45; Levi d'Ancona 1970, p. 9; Voelkle 1980, p. 20, fiche 5 D 4; Ryskamp 1984, p. 11. For other works by Decio, see Malaguzzi Valeri 1913–23, III, pp. 203, 224, 227, figs 228–32.

W. M. V.

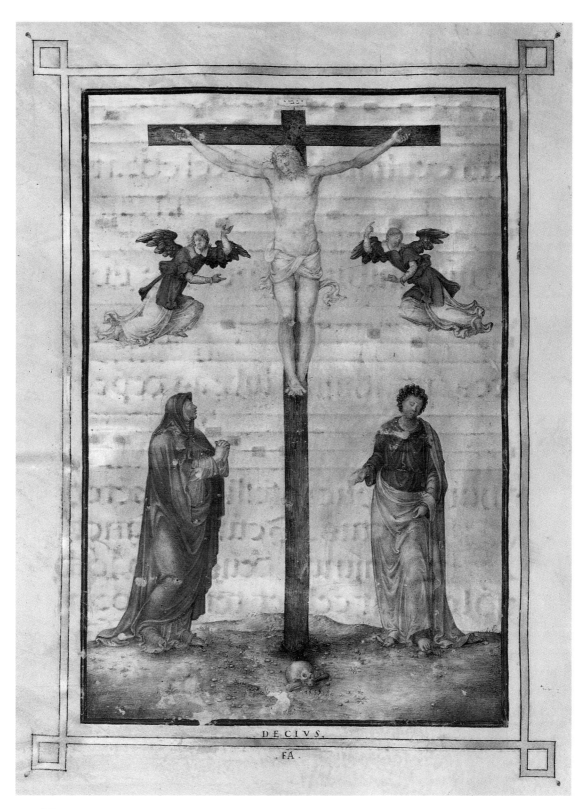

131 folio 59v

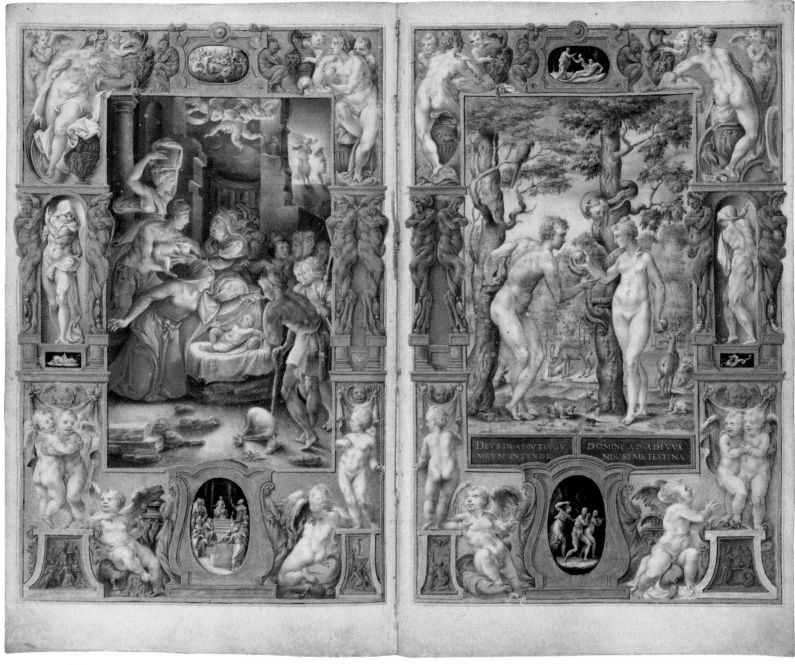

132 folio 26v-27r

132

Hours of Cardinal Alessandro Farnese, Use of Rome

114 fols. 173 x 110 mm. On parchment. Gilt silver binding by Antonio Gentili (c. 1519-1609) added by Cardinal Odoardo Farnese (1573-1626) after 1591

Written in Rome by Francesco Monterchi, dated 1546, with illuminations by Giulio Clovio

NEW YORK, THE PIERPONT MORGAN LIBRARY, M.69

The Farnese Hours is, quite simply, the most famous manuscript of the Italian High Renaissance. Its fame was virtually assured by Giorgio Vasari's high praise in the second edition of his *Lives of the Painters* (1568). The manuscript, he said, 'was executed by Don Giulio in a period of nine years and required such study and labour that it would

never be possible to pay for the work, regardless of the price; nor is it possible to see elsewhere any more strange and beautiful variety than there is in all its scenes. There is an abundance of bizarre ornaments and various movements and postures of nudes, which are studied and appropriately placed in the borders. Such a diversity of things infuses so much beauty into the work that it appears a thing divine and not human, and all the more because the colours and manner of painting have made the figures, buildings, and the landscapes recede and fade into the distance with all those considerations that perspective requires. In the stories and inventions may be seen design, in the composition order and variety, and in the vestments unexcelled richness. All is executed with such beauty and grace of manner that it seems impossible that they could have been fashioned by the hand of man. Thus we may say that Don Giulio has surpassed in this field both the ancients and the moderns, and that he has been in our times a new, if smaller, Michelangelo. There has never been, nor perhaps will there ever be for many centuries, a more rare or more excellent miniaturist,

132 folio 72v–73r

or we would rather say, painter of little things, than Don Giulio Clovio'. Vasari, in fact, held Clovio's undisputed masterpiece in such high esteem that he felt obliged to describe all its full-page miniatures, arguing that in this way a private treasure might be shared with everyone. Vasari regarded the manuscript as one of the sights of Rome, saying that Clovio (1498-1578), in his old age at the Farnese Palace, took great delight in showing it to visitors, an act recorded in El Greco's portrait of him in Naples.

Since all the miniatures and decorated borders, which are either of iconographical or topographical interest, are reproduced in Webster Smith's facsimile (1976; and Cionini Visani and Gmulin 1980), they will not be listed here. Most of the 26 full-page miniatures are grouped typologically, pairing a New Testament event with an Old Testament antecedent. Reproduced here, for example, marking the beginning of the hour of Prime for the Hours of the Virgin, the *Adoration of the Shepherds* is paired with the *Fall of Man*. In the former, two details derive from the *Revelations of St Bridget*: the light emanating from the

body of Christ, and the Virgin's revealing the sex of the Child to the shepherds. According to the *Revelations* (VII, 23), the shepherds were not told whether the newborn child was a saviour or saviouress. Clovio was familiar with prints – according to Vasari he began as an illuminator with a Virgin taken from Albrecht Dürer's *Life of the Virgin* – and doubtless expected the viewer to recognise his clever use of them in the *Fall of Man*. The basic composition and the upper torso of Eve are from Dürer's famous engraving of 1504, as are the cat and mouse, rabbit, reclining ox, and parrot. The placement of the two trees, crossed legs of Adam and Eve, and form of the serpent, however, derive from Marcantonio's print after Raphael's *Adam and Eve*.

Our second illustration, spread over two facing pages, is probably the most original and elaborate ever conceived for a Litany. As described by Vasari, Clovio depicted, with the minutest detail, the Corpus Christi procession enacted in Rome, complete with Old St Peter's, the firing of cannons from the Castel Sant' Angelo, and the Tiber. Pope Paul III himself is shown carrying the Holy Sacrament.

Above, in the clouds, the Trinity is adored by apostles and saints, and the kneeling Virgin is surrounded by female saints.

Cardinal Farnese owned two Clovio manuscripts and apparently held them in special esteem; they were the only items singled out in his will of 1587. The Farnese Hours was to be kept in the Farnese Palace in perpetuity, and his Gospel Lectionary (cat. 134) was left to the College of Cardinals, to be housed in the Sistine Chapel (C. Robertson 1992).

Provenance: Cardinal Alessandro Farnese, grandson of Pope Paul III; Odoardo I Farnese (1573-1626), Cardinal Deacon of San Eustachio (grand-nephew of Cardinal Farnese and heir to his estates); Odoardo II Farnese, Duke of Parma (d. 1646); Elizabeth Farnese (1692-1766); King Francesco II of Naples (d. 1894); Naples, Reale Museo Borbonico; Prince Alphonse de Bourbon, Count of Caserta, son of Ferdinand II of Naples by his second wife, Marie Theresa, Archduchess of Austria; purchased by John Pierpont Morgan (1837-1913) in 1903.

Exhibitions: New York 1913, p. 52; New York 1934, no. 144, pls 95-6; Baltimore 1957, no. 18, pl. IX; San Francisco 1977, no. 244, fig. 109; New York 1984, no. 59, and facing illus.

Bibliography: De Ricci 1935-40, II, pp. 1378-9; D'Ancona 1949, p. 49; Harrsen and Boyce 1953, no. 102, pls 5, 6, 74, 75; Bond and Faye 1962, p. 336; Trapier 1958, pp. 73-7, 80, 84, fig. 3; Mirth 1962-3, pp. 104-10, figs 2-4; Fairbank 1971, p. 12 and facing illus.; Smith 1976; Needham 1979, no. 99, pl. 99; Cionini Visani and Gmulin 1980, pp. 8, 15-16, 18, 36, 53-62, 92-94, illus. pp. 43-59; De Tolnay 1980, pp. 616-23, figs 21-31; Voelkle 1980, pp. 4-5, fiche I G 8-2 B 3; Candedy 1981, p. 35; Cerney 1984; Simon 1989, p. 484, fig. 45; C. Robertson 1992, pp. 29-35, figs 17, 18, pl. I.

W. M. V.

133

Marino Grimani, *Commentary on St Paul's Epistle to the Romans*

142 fols. 345 x 245 mm. On parchment

Written probably in Perugia, c. 1537-8, and signed by Giulio Clovio

LONDON, TRUSTEES OF SIR JOHN SOANE'S MUSEUM, SOANE MUSEUM Vol. 143 (formerly MS 11)

This manuscript, made for Cardinal Marino Grimani (d. 1546), is recorded by Vasari in his Life of Clovio. At the end of the text on folio 142 is an inscription referring to the correction of the text: '*Librum hunc post ejus primam scriptionem castigatiorem reddidimus*'. Did the Cardinal perhaps write this himself? Another inscription on the tablet, placed obliquely in the bottom right corner of the miniature on folio 7v, reads: '*Marino Grimano car. et legato Perusino Patrono suo Iulius Crovata pingebat*'. This provides a date for the manuscript, since Cardinal Grimani was papal legate in Perugia in 1537-8. For Clovio's career see the entries on the Farnese Hours (cat. 132) and on the Towneley Lectionary (cat. 134).

The border to the *Epistola in Commentarios* on folio 1 is composed of a variety of classicising motifs and *grotteschi*, some of which are based directly on the *grotteschi* in the Vatican Loggie executed by Raphael and his school (Millar 1914-20, pl. XLVIII b). At the bottom left is a larger figure with a spindle, in the lower centre an extended landscape with a seaport, and there are also three medallions, one of the Three Graces, the second of a female figure with a cup and the third of a helmeted bust figure, based on the Antique cameo of Athena, of which a version was in the Medici collection (see cat. 3). A drawing by Clovio of the same head is in the Royal Library at Windsor Castle. The title of the text is rendered as if on a plaque, and the text is made to seem as if written on parchment which is curling forward at the top. An initial 'I' is composed of a human figure in gold. On folio 2v, the Preface to the Epistle to the Romans, an initial 'C' is composed of two figures, and there is gold filigree ornament with a simulated cameo of a cavalry battle, painted white on a black ground.

The first of St Paul's Epistles, that to the Romans, is prefaced with a full-page miniature on folio 7v of the *Conversion of Saul*, who falls to the ground from his horse in the centre. This follows the composition by Raphael for one of the Sistine Chapel tapestries, the cartoon for which was owned by Cardinal Domenico Grimani, uncle of Cardinal Marino (Millar 1914-20, pl. L). In the frame there are roundels showing, at the top, the Trinity, at the right St Paul standing, holding a sword and a book, at the left St Paul preaching, and below the *Stoning of St Stephen*. This latter follows the composition of a painting by Giulio Romano for Cardinal Giuliano de' Medici which is today in Geneva (Millar 1914-20, pl. LI). Also in the border are putti with trophies of arms, three ignudi above reminiscent of Michelangelo's Sistine Ceiling and a nude female figure with a torch, which she is holding to a pile of arms and armour, therefore representing Peace.

The title '*Marini Grimani Veneti S. R. E. Cardinalis et Patriarchae Aquileiae in Epistola Pauli ad Romanos Commentariorum Cap. primum*' is on folio 8 on an plaque held by two putti accompanied by two female figures, one holding a cross, the other a chalice. In roundels are, below in the centre, the Cardinal's arms held by two putti with the motto '*Prudentes*' flanked by two dragons, to the right a half-length portrait of the Cardinal, at the top a figure seated at a table surrounded by books with various figures standing around, presumably again the Cardinal, and to the left a figure with a jug inscribed '*Pastoris munus*'. The male figure in armour representing War is a pendant to the figure of Peace on the opposite verso.

Provenance: Arms of Cardinal Marino Grimani, Patriarch of Aquileia, created Cardinal in 1527, died 1546; Consul Joseph Smith of Venice (1682-1770); John Strange, sale, London, Sotheby's, 19 March 1801, lot 735; Frederick Webbe; 1st Duke of Buckingham (1776-1839); acquired by Sir John Soane in 1833.

Bibliography: Vasari and Milanesi 1906, VII, p. 560; Waagen 1860, pp. 326-7; Bradley 1891, pp. 146, 244-53; Millar 1914-20, pp. 116-28, pls XLVII-LII; Levi d'Ancona 1950, p. 71; Cionini Visani 1971, figs 168, 169; Munby 1972, pp. 9, 26, pl. 5; Smith 1976, p. 166; Cionini Visani and Gmulin 1980, pp. 38, 42-6, 88, illus. pp. 34, 35, 37; Thornton and Dorey 1992, pp. 56-7, colour pls.

J. J. G. A.

134

Lectionary of Cardinal Alessandro Farnese (The Towneley Lectionary)

28 fols. 492 x 325 mm. On parchment

Written in Rome, c. 1550-60, and illuminated by Giulio Clovio

NEW YORK, NEW YORK PUBLIC LIBRARY, ASTOR, LENOX AND TILDEN FOUNDATIONS, Rare Books and Manuscripts Division, MS 91

The Lectionary bears the Farnese arms, though erased, and was evidently made for Cardinal Alessandro Farnese (1520-1589). It contains six full-page miniatures on versos, and opposite them are or were (the folios were rearranged at some point) smaller miniatures of the relevant Evangelist functioning at the same time as an initial 'I' to introduce the text of the particular Lection. Originally the first miniature was the *Last Judgement*, now folio 23v, but originally preceding the present folio 4, showing St Luke, introducing the Gospel for the First Sunday in Advent. Then came the *Nativity*, folio 5v, preceding the present folio 2, showing St John, Gospel for the third Mass at Christmas. The remaining miniatures are still opposite their correct Lections. The *Resurrection* is shown on folio 16v opposite folio 17, which depicts St Mark, Gospel for Easter Sunday. The *Pentecost* on folio 20v is shown opposite folio 21, showing St John, Gospel for Pentecost. *Christ Giving the Keys to St Peter*, folio 11v, is opposite folio 12, showing St Matthew, Gospel for the Feast of St Peter (either in Chains or Peter and Paul). *The Sermon on the Mount*, folio 6v, is opposite folio 7, showing St Matthew, Gospel for All Saints. The manuscript has recently been disbound and these observations, based on the collation, are due to William Voelkle.

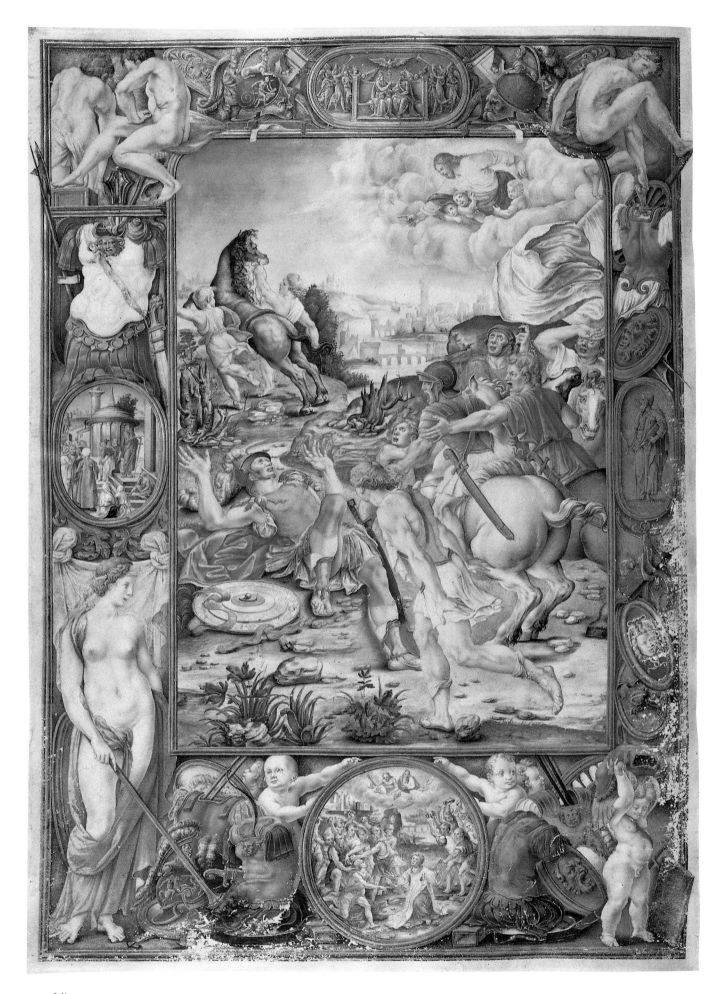

133 folio 7v

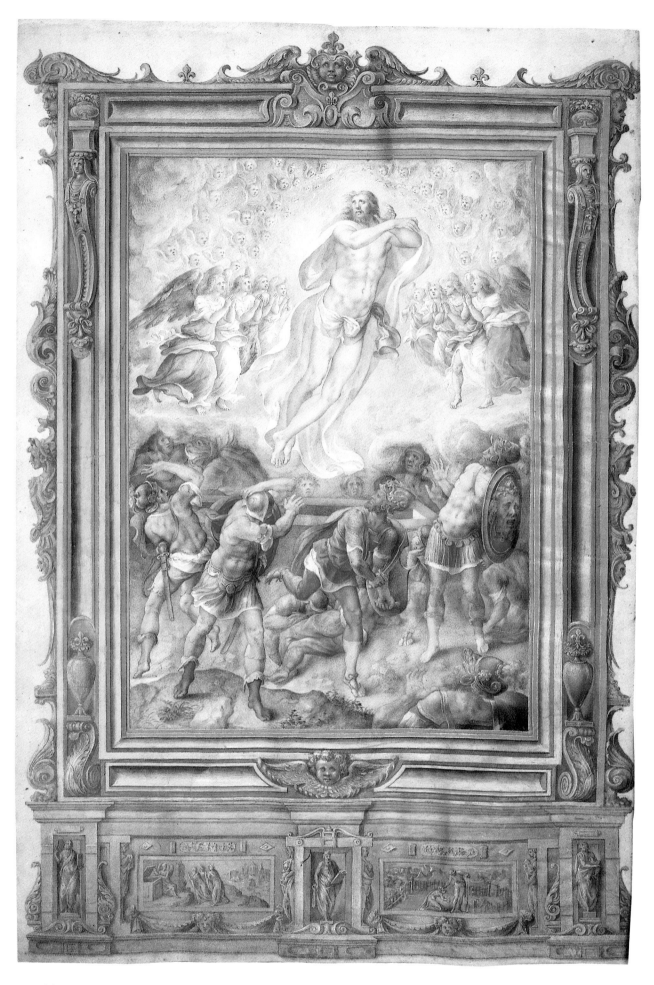

134 folio 16v

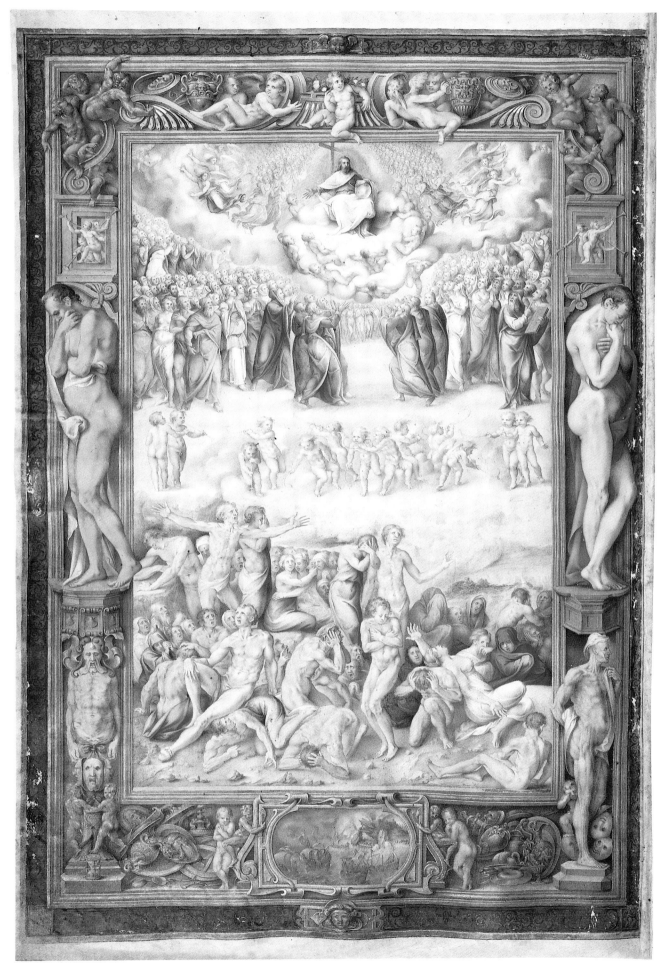

The miniatures have ornate frames, sometimes with small subsidiary scenes in gold grisaille in cartouches: for example on folio 5v, the *Circumcision, Adoration of the Magi*, and *Presentation in the Temple*; folio 11v, *St Peter Walking on the Water*; folio 16v, *Three Marys at the Tomb* and *Noli me tangere*; and folio 20v, *St Peter Healing the Lame Man*. A number of folios are written in a different but still 16th-century script on a whiter parchment: folios 9v-10, 14-15, 18-19v, 24-27.

In his Life of Giulio Clovio published in the second edition of his *Vite* of 1568, Vasari appears to refer to the present manuscript. 'In two large sheets for a Missal done for the cardinal, he has represented Christ teaching the Gospel to the Apostles, and the Last Judgement, so stupendous and wonderful, that I am confounded at thinking of it and feel sure that nothing more beautiful can be imagined in a miniature'. The Gospel Lectionary is identifiable, as Mirella Levi d'Ancona (1950) has pointed out, in the 1718 catalogue of the manuscripts of the Cappella Sistina. The description lists the miniatures and confirms the above reconstruction of the correct original order of the folios.

The Gospel Lectionary has been variously dated by critics, but recent opinion places it in the decade 1550-60. Charles de Tolnay (1965) has proposed to see a collaboration with Peter Brueghel the Elder, who was in Rome in 1553, in the seascape at the bottom of the folio with the *Last Judgement* (folio 23v) and in certain other of the small framed scenes. However, similar seascapes occur in the Hours of Cardinal Farnese (cat. 132). Vasari refers to Clovio's friendship with Giulio Romano and also to the influence of Michelangelo, which is particularly apparent in the *Last Judgement* page, with its framing ignudi reminiscent of the Sistine Chapel ceiling.

Provenance: Arms of Cardinal Alessandro Farnese (created Cardinal 1534, died 1589), on folios 6v, 7, erased; the Farnese lily also figures in several of the frames; left in the Cardinal's will of 1587 to the College of Cardinals; Cappella Sistina inventory of 1718, B.I. 20; presumably looted by the French troops in 1798; said by Dibdin (1817) to have been bought in Rome in 1800 by Charles Towneley (1731-1805), but more likely acquired by his uncle, John Towneley (1731-1813); furnished with a spectacular metal binding on red velvet, perhaps to be connected with Jeffry Wyatt's alterations at Towneley Hall, Lancashire, for Peregrine Towneley between 1812 and 1819; Towneley sale, 27 June 1883, lot 84, to Quaritch; sold in 1889 to Robert Lenox Kennedy.

Bibliography: Vasari Milanesi 1906, VII, p. 568; Dibdin 1817, I, p. clxxxviii; Waagen 1854, II, p. 334; Bradley 1891, pp. 254-60; Bye 1916-17, pp. 88-99; De Ricci, 1935-40, II, p. 1329; Levi d'Ancona 1950, pp. 57-74; De Tolnay 1965, pp. 110-14, figs 2, 3, 9-12; Levi d'Ancona 1969, pp. 206-8; Smith 1976, pp. 30, 167; Cionini Visani 1971, pp. 16-18, figs 185-7, 191; Cionini Visani and Gmulin 1980, pp. 16-18, 68-72, 92, pls on pp. 67, 69, 71, 73; Hindman and Heinlen 1991, pp. 172-3, fig. 14; C. Robertson 1992, p. 34.

J.J.G.A.

135

Single leaf with initial 'D' and border, *King David as Psalmist*

687 × 510 mm. On parchment [London only]

Illumination attributed to Giulio Clovio in Rome, 1569

BERLIN, STAATLICHE MUSEEN ZU BERLIN, PREUSSISCHER KULTURBESITZ, KUPFERSTICHKABINETT, 13794

The initial 'D' shows King David accompanied by a second figure to whom he points out the fool in the background to the right. The latter plays with a hobby horse and a whirligig, child's toys, while a dog barks and a naked child stands by. The opening words of Psalm 52, 'The fool hath said in his heart: There is no God', are inscribed below in gold capitals within a cartouche frame with two female caryatids flanking it. The ornate border with groups of putti singing or playing musical instruments contains three medallions with female figures, at the left Faith holding a cross, above Charity nursing a baby, and to the

right Hope with hands in prayer. Below is a portrait medallion of a Pope, inscribed '*Pius V Pontifex maximus Anno III sui Pontificatus*', that is 1569. This magnificent leaf must have come from a papal service book, presumably one of those looted in Rome in 1798 (see cats 134, 136-7). It was attributed to Giulio Clovio (see cats 132-4) by Wescher (1931) but appears to have been ignored in more recent literature.

Provenance: Pope Pius V (r. 1566-1572); bought in London, 1899.

Exhibition: Berlin 1994, no. I.16.

Bibliography: Wescher 1931, p. 88, fig. 73.

J.J.G.A.

136

Two single leaves from a papal service book for Pope Pius IV, *Crucifixion* and *Lamentation*

333 × 238 mm. On parchment

Illuminated by Apollonio de' Bonfratelli in Rome, 1564

LONDON, THE BRITISH LIBRARY, Additional MS 21412, folios 42, 43

The first of these two miniatures shows the *Crucifixion* with the Virgin fainting below. The second shows the *Lamentation* with Christ laid on a bier covered with cloths beneath the cross, the Virgin and the Holy Women surrounding him. Angels crowd around the cross in the sky. In both miniatures distant landscape details with figures and the city of Jerusalem are faintly visible. The elaborate gold cartouche frames include scenes painted with minute figures in gold monochrome. On folio 42 these are the *Agony in the Garden, Betrayal, Christ before Caiaphas* and the *Flagellation*. On folio 43 the scenes are the *Coronation of the Virgin, Resurrection, Christ before Pilate, Harrowing of Hell*, and the *Four Evangelists*. On folio 43 there are also reclining prophet figures with texts from Amos, Ezekiel, Hosea and St John.

The illuminator's signature '*A. P. [F?] E*' can be read below the left foot of the figure holding a ladder on folio 42. Apollonio de' Bonfratelli is documented as papal miniaturist from 1554, when he is described as '*coadiutore nell'ufficio del miniatore*' to Vincenzo Raimondi (cats 127, 129, 130). He succeeded Raimondi as papal miniaturist in 1556 and served until his death in 1575. The present two miniatures, with another now in Philadelphia showing the *Deposition* (cat. 137), and a smaller one of the *Adoration of the Shepherds* (London, British Library, Additional MS 21412, folio 36; D'Ancona and Aeschlimann 1949, pl. XVIII; Talamo 1989, p. 165, pl. 33, miscaptioned), together with various borders which have been mutilated and cut up (British Library, Additional MS 21412, folios 36*bis*, 37-39, 40, 40*bis*, 41, 41*bis* and 44), evidently came from a Sistine Chapel service book looted during the French invasion of Italy in 1798. The fragments came to England with the collection of the Abate Celotti, sold at Christie's in 1825, and the present leaves were acquired by the British Museum in 1856 at the sale of Samuel Rogers, the poet.

Many of the Celotti cuttings have modern inscriptions written in capitals that name the Popes for whom the manuscripts from which they come were made. It remains to be established when and where these inscriptions were written, but perhaps they were added at the instance of Celotti himself or perhaps of William Young Ottley, who catalogued the Celotti sale. It has been supposed that they copy information available in the original manuscripts and for the present leaves this can be confirmed. The modern inscriptions record Apollonio as the artist and name Pope Pius IV as the patron (folios 37, 38, 44) and give a date, 1561 (folio 38) and 1564 (folios 37, 44). This information is partially confirmed by Apollonio's signature on folio 43, by the papal arms of Pius IV which occur on folios 36, 40 and 44, and by original inscriptions with Pius IV's name on folios 40 and 42. The date is also confirmed by an original inscription on folio 37, '*Anno V*' and '*MDLXIIII*'.

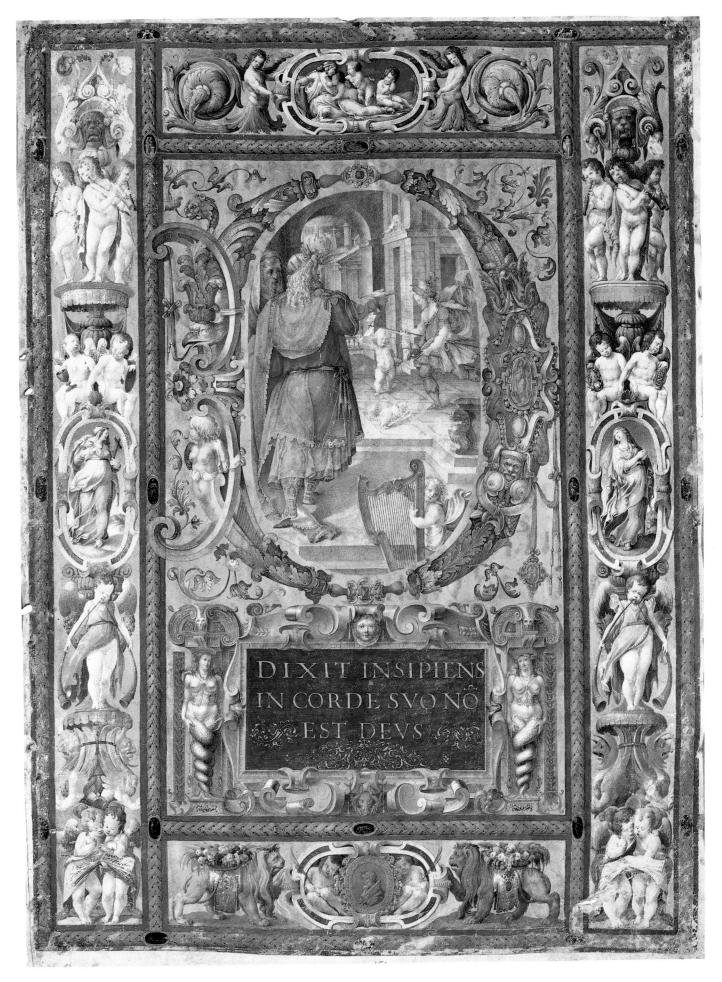

DIXIT INSIPIENS
IN CORDE SVO NŌ
EST DEVS

135

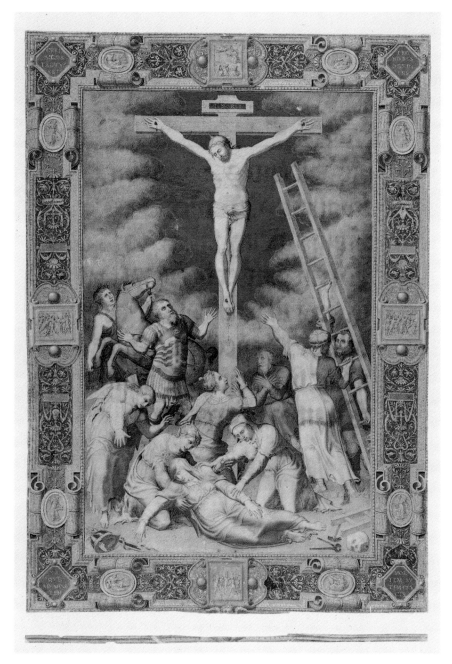

136 folio 42r

A number of manuscripts still in the Vatican, including four volumes of the five volume Missal of Cardinal Juan Alvarez, who died in 1557 (Biblioteca Apostolica Vaticana, Vat. lat. 3805; Talamo 1989; Evans, in Cologne 1992, no. 87), and two Choir Books dated 1563 (Biblioteca Apostolica Vaticana, Cap. Sist. 38 and 39) have been convincingly attributed to Apollonio. The Choir Books each contain a miniature signed, like the *Lamentation* leaf and the Philadelphia leaf, with the artist's initials (Llorens Cistero 1958-61; Talamo 1989). Another miniature attributable on stylistic grounds to Apollonio shows the *Pietà*. It is now in Canberra, Australian National Gallery, having belonged to Sir Thomas Phillipps (London, Sotheby's, 30 November 1976, lot 893; Manion and Vines 1984, no. 34, pl. 24; Talamo 1989, pl. 34, miscaptioned). It is, however, smaller in size (248 x 165 mm) and has a simpler frame. It seems, therefore, that more than one papal service book illuminated by Apollonio was dismembered.

The inventory of the Cappella Sistina service books of 1718 in fact lists two Missals with illumination by Apollonio, one for Pope Pius V (r. 1566-1572) and one for Pope Gregory XIII (r. 1572-1585). Since some cuttings in the Fitzwilliam Museum (Marlay Italian 29-31) have arms and inscriptions of Pius V they are likely to come from the former Missal, and it may be that that is also the origin of the Canberra leaf, though unfortunately the inventory does not give the subjects of the Missal's three miniatures, only the folios.

Apollonio's stylistic and compositional debts to High Renaissance painting in Rome are evident, both to earlier artists of the school of Raphael, to Michelangelo and to contemporary artists such as Vasari.

Provenance: Pope Pius IV (r. 1559-1565); Abate Celotti sale, London, Christie's, 26 May 1825, lots 79, 80; Samuel Rogers sale, London, Christie's, 28 April, 1856, lots 1005 and 1009.

Bibliography: *Catalogue of Additions* 1875, pp. 377-8.

J.J.G.A.

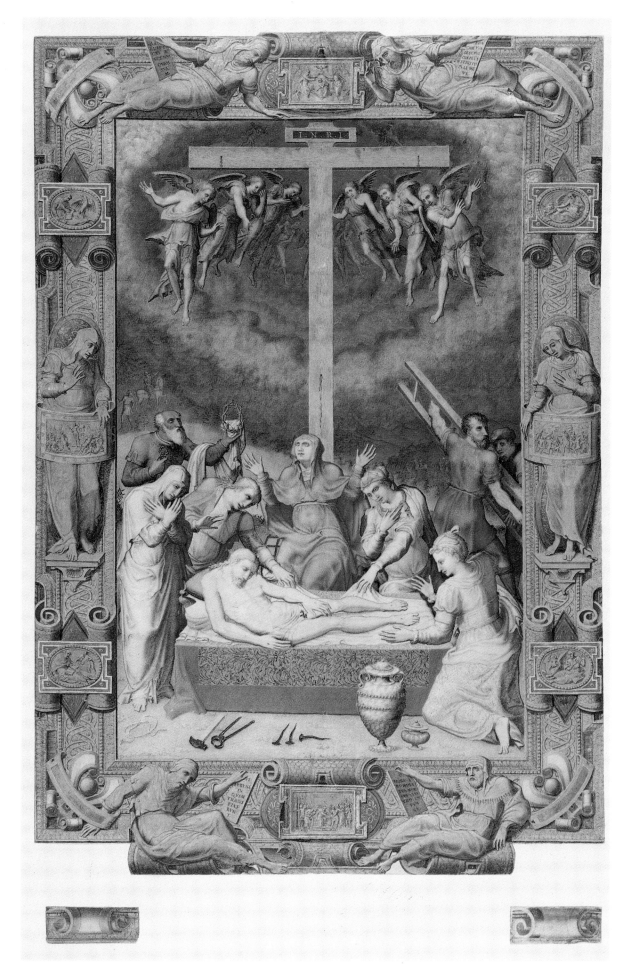

137

137

Single leaf from a papal service Book for Pope Pius IV, *Deposition*

332 × 241 mm. On parchment [New York only]

Illuminated by Apollonio de' Bonfratelli in Rome, 1564

PHILADELPHIA, ROSENBACH MUSEUM AND LIBRARY, 54.663

The leaf shows the *Deposition* of Christ from the cross. Flanking figures on ladders hold the extended arms of the body of Christ. Mary Magdalene embraces the cross below, and the Virgin and the other Holy Women are to the left. In the frame a number of small scenes are painted in gold monochrome, each with texts surrounding them. Those that are identifiable include the *Samaritan Woman at the Well* and the *Carrying of the Cross*.

The leaf was in the Abate Celotti sale at London, Christie's, in 1825, when it accompanied the two leaves from the British Library (cat. 136). Its size also tallies. Moreover it is signed, as is the *Lamentation*, with the illuminator's initials 'A. P. f.'. It therefore came, like them, from a papal service book illuminated by Apollonio de' Bonfratelli for Pope Pius IV in 1564, which was looted during the French invasion of Italy in 1798. Other fragments of borders are also in the Rosenbach Museum and Library (54.224 and 54.226). These have the modern inscription, identical to the British Library fragments, attributing them to Apollonio and to Pope Pius IV.

Provenance: Pope Pius IV (r. 1559-1565); Abate Celotti sale, London, Christie's, 26 May 1825, lot 84; Lord Northwick sale, London, Sotheby's, 16 November 1925, lot 107; given by John F. Lewis of Philadelphia to Dr. A. S. W. Rosenbach.

Bibliography: De Ricci 1935-40, II, p. 2077, no. 341 (incorrectly as in the Free Library of Philadelphia); Hindman and Heinlen 1991, pp. 171-2, fig. 13.

J. J. G. A.

Bibliography

See also the note on further reading on page 20

Abbott, T. K., *Catalogue of Fifteenth-Century Books in the Library of Trinity College, Dublin*, London, 1905.

Affo, I., *Basini Parmensis Opera*, Rimini, 1794.

Alessio, G. C., 'Per la biografia e la raccolta libraria di Domenico della Rovere', *Italia medioevale e umanistica*, XXVII, 1984, pp. 175-231.

Alexander, J. J. G., 'Notes on Some Veneto-Paduan Illuminated Books of the Renaissance', *Arte Veneta*, XXIII, 1969, pp. 9-20 (1969 a).

–, 'A Virgil Illuminated by Marco Zoppo', *The Burlington Magazine*, CXI, 1969, pp. 514-17 (1969 b).

–, 'The Provenance of the Brooke Antiphonal', *The Antiquaries Journal*, XLIX, 1969, pp. 385-7 (1969 c).

–, 'A Manuscript of Petrarch's Rime and Trionfi', *Victoria and Albert Yearbook*, II, 1970, pp. 27-40 (1970 a).

–, 'Venetian Illumination in the Fifteenth Century', *Arte Veneta*, XXIV, 1970, pp. 272-5 (1970 b).

–, 'The Illustrated Manuscript of the Notitia Dignitatum', *British Archaeological Reports*, XV, 1976, pp. 11-19.

–, *Italian Renaissance Illuminations*, London and New York, 1977 (1977 a).

–, 'The Scribe of the Boccaccio *Filocolo* Identified', *Bodleian Library Record*, IX, no. 5, 1977, pp. 303-4 (1977 b).

–, *The Decorated Letter*, New York, 1978.

–, 'The Illustrations of the Anonymous "De rebus bellicis"', in *De rebus bellicis*, ed. M. W. C. Hassall and R. I. Ireland (British Archaeological Reports, International Series, 63), Oxford, 1979, pp. 11-15.

–, *Catalogue of Cuttings from Illuminated Manuscripts in the Wallace Collection*, London, 1980.

–, 'Artists and the Book in Padua, Venice and Rome in the Second Half of the Fifteenth Century', *Sandars Lectures*, Cambridge University, June 1985 (typescript) (1985 a).

–, 'Italian Illuminated Manuscripts in British Collections', in *La miniatura italiana tra gotico e rinascimento: Atti del II Congresso di storia della miniatura italiana, Cortona, 1982*, ed. E. Sesti, Florence, 1985, I, pp. 99-126 (1985 b).

–, 'Constraints on Pictorial Invention in Renaissance Illumination: The Role of Copying North and South of the Alps in the Fifteenth and Early Sixteenth Centuries', *Miniatura*, I, 1988, pp. 123-35 (1988 a).

–, 'Initials in Renaissance Illuminated Manuscripts: The Problem of the So-called *littera mantiniana*', in *Renaissance- und Humanistenhandschriften*, ed. J. Autenrieth (Schriften des Historischen Kollegs, Kolloquien, 13), Munich, 1988, pp. 145-55 (1988 b).

–, 'Illuminations by Matteo da Milano in the Fitzwilliam Museum', *The Burlington Magazine*, CXXXIII, 1991, pp. 686-90 (1991 a).

–, 'The Livy (MS 1) Illuminated for Gian Giacomo Trivulzio by the Milanese Artist "B. F."', *Yale University Library Gazette*, LXVI, supplement, 1991, pp. 219-34 (1991 b).

–, 'Matteo da Milano, Illuminator', *Pantheon*, L, 1992, pp. 32-45.

–, *Medieval Illuminators and their Methods of Work*, New Haven and London, 1993.

Alexander, J. J. G., and A. C. de la Mare, *The Italian Manuscripts in the Library of Major J. R. Abbey*, London, 1969.

Alzati, G. C., *La biblioteca di S. Giustina di Padova: Libri e cultura presso i Benedettini padovani in età umanistica*, Padua, 1982.

Ames-Lewis, F., *The Library and Manuscripts of Piero di Cosimo de' Medici*, London and New York, 1984 (1984 a).

–, 'Matteo de' Pasti and the Use of Powdered Gold', *Mitteilungen des Kunsthistorischen Institutes in Florenz*, XXVIII, 1984, pp. 351-64 (1984 b).

Anderson, L. A., 'Copies of Pollaiuolo's *Battling Nudes*', *Art Quarterly*, XXXI, 1968, pp. 155-67.

Anglés, H., and J. Subirá, *Catálogo musical de la Biblioteca Nacional de Madrid*, I, Barcelona, 1946.

Anzelewsky, F., 'Tod des Orpheus', in *Dürer Studien*, Berlin, 1983, pp. 15-25.

Armstrong, C. E., 'Copies of Ptolemy's Geography in American Libraries', *New York Public Library Bulletin*, LXI, 1962, pp. 105-14.

Armstrong, L., 'The Flagellation by Antonio da Monza from the Norton Simon Foundation', *Wellesley College Friends, Newsletter*, III, February 1967.

–, *The Paintings and Drawings of Marco Zoppo*, New York, 1976.

–, *Renaissance Miniature Painters and Classical Imagery: The Master of the Putti and his Venetian Workshop*, London, 1981.

–, 'The Illustration of Pliny's *Historia naturalis*: Manuscripts before 1430', *Journal of the Warburg and Courtauld Institutes*, XLVI, 1983, pp. 19-39 (1983 a).

–, 'The Illustration of Pliny's *Historia naturalis* in Venetian Manuscripts and Early Printed Books', in *Manuscripts in the First Fifty Years of Printing*, ed. J. B. Trapp, London, 1983, pp. 97-106 (1983 b).

–, 'The Agostini Plutarch: A Decorated Venetian Incunable', in *Treasures of the Library, Trinity College Dublin*, ed. P. Fox, Dublin, 1986, pp. 86-96.

–, 'Il Maestro di Pico: Un miniatore veneto del tardo quattrocento', *Saggi e memorie di storia dell'arte*, XVII, 1990, pp. 7-39 (1990 a).

–, '*Opus Petri*: Renaissance Miniatures from Venice and Rome', *Viator*, XXI, 1990, pp. 385-412 (1990 b).

–, 'The Impact of Printing on Miniaturists in Venice after 1469', in *Printing the Written Word: The Social History of Books, circa 1450-1520*, ed. S. Hindman, Ithaca, 1991, pp. 174-202.

–, 'Marco Zoppo e il *Libro dei Disegni* del British Museum: Riflessioni sulle teste "all'antica"', in *Marco Zoppo, Cento 1433-1478 Venezia: Atti del Convegno internazionale di studi sulla pittura del quattrocento padano, Cento, 1993*, ed. B. Giovannucci Vigi, Bologna, 1993, pp. 79-95 (1993 a).

–, 'The Master of the Rimini Ovid: A Miniaturist and Woodcut Designer in Renaissance Venice', *Print Quarterly*, X, 1993, pp. 327-63 (1993 b).

Arnold, E., *et al.*, *Das Gebetbuch Lorenzos de' Medici 1485: Handschrift Clm 23639 der Bayerischen Staatsbibliothek München*, Frankfurt a. M., 1991.

Ashburnham, *Catalogue of the Manuscripts at Ashburnham Place: Appendix*, London, 1861.

Backhouse, J., *Books of Hours*, London, 1985.

Balogh, J., *Die Anfänge der Renaissance in Ungarn. Matthias Corvinus und die Kunst*, Graz 1975.

Banti, L., 'Agnolo Manetti e alcuni scribi a Napoli nel secolo XV', *Annali della R. Scuola Normale Superiore di Pisa: Lettere, storia e filosofia*, ser. II, 8, 1939, pp. 389-92.

Battisti, E., 'Due codici miniati del quattrocento', *Commentari*, VI, 1955, pp. 18-26.

Bauer-Eberhardt, U., 'Die Rothschild Miscellanea in Jerusalem: Hauptwerk des Leonardo Bellini', *Pantheon*, XLII, 1984, pp. 229-37.

–, 'Lauro Padovano und Leonardo Bellini als Maler, Miniatoren und Zeichner', *Pantheon*, XLVII, 1989, pp. 49-82.

–, 'Giovanni Francesco Maineri als Miniator', *Pantheon*, XLIX, 1991, pp. 89-96.

–, 'Matteo da Milano, Giovanni Battista Cavaletto und Martino da Modena: Ein Miniatoren-Trio am Hofe der Este in Ferrara', *Pantheon*, LI, 1993, pp. 62-86.

Beer, R., 'Les principaux manuscrits à peintures de la Bibliothèque impériale de Vienne', *Bulletin de la Société française de reproductions de manuscrits à peintures*, III, 1913, pp. 5-55.

Bellosi, L., 'Il "vero" Francesco di Giorgio e l'arte a Siena nella seconda metà del quattrocento', in *Francesco di Giorgio e il Rinascimento a Siena 1450-1500*, exh. cat., ed. L. Bellosi, Chiesa di Sant' Agostino, Siena, 1993, pp. 19-89.

Bénédictins de Bouveret, *Colophons de manuscrits occidentaux des origines au XVIe siècle* (Spicilegia Friburgensia Subsidia, 2-8), 7 vols, Fribourg, 1965-79.

Benson, R., *The Holford Collection, Dorchester House*, Oxford, 1927.

Berg, K., *Studies in Tuscan Twelfth-Century Illumination*, Oslo, 1968.

Berkovits, I., *Illuminated Manuscripts from the Library of Matthias Corvinus*, Budapest, 1964.

Bertaux, E., and G. Birot, 'Le missel de Thomas James, évêque de Dol', *Revue de l'art ancien et moderne*, XX, July-December 1906, pp. 129-46.

Bertoni, G., *Il maggior miniatore della Bibbia di Borso d'Este, Taddeo Crivelli*, Modena, 1925.

Bertoni, G., and C. Bonacini, *Il manoscritto Estense 'De Sphaera'*, Modena, 1914.

Biagi, G., *Cinquanta tavole in fototipie da codici della R. Biblioteca Medicea Laurenziana* (also issued as *Fifty Plates from the Manuscripts of the R. Laurentian Library*), Florence, 1914.

Bianca, G., 'La biblioteca di Andrea Matteo Acquaviva', in *Gli Acquaviva d'Aragona, duchi di Atri e conti di S. Flaviano (Teramo, Morra d'Oro, Atri, Giulianova, 13-15 ottobre 1983)*, Teramo, 1985, pp. 159-73.

Bierstadt, O. A. *The Library of Robert Hoe*, New York, 1895.

Billanovich, M., 'Benedetto Bordone and Giulio Cesare Scaligero', *Italia medioevale e umanistica*, XI, 1968, pp. 187-256.

Blume, D., 'Beseelte Natur und ländliche Idylle', in *Natur und Antike in der Renaissance*, exhibition cat., ed. H. Beck and D. Blume, Liebieghaus, Museum alter Plastik, Frankfurt am Main, 1986, pp. 173-97.

BMC = *Catalogue of Books Printed in the XVth Century now in the British Museum*, Parts I-XII, London, 1908-85.

Bober, P. P., *Drawings after the Antique by Amico Aspertini*, London, 1957.

Bober, P. P., and R. Rubinstein, *Renaissance Artists and Antique Sculpture*, London, 1986.

Bologna, G., *Libri per un'educazione rinascimentale: Grammatica del Donato, Liber Jesus*, Milan, 1980.

Bond, W. H., and C. U. Faye, *Supplement to the Census of Medieval and Renaissance Manuscripts in the United States and Canada*, New York, 1962.

Bonicatti, M., 'Contributi al Giraldi', *Commentari*, VIII, 1957, pp. 195-210.

–, 'Aspetti dell'illustrazione del libro nell'ambiente padano del secondo '400', *Rivista d'Arte*, XXXII, 1957-9, pp. 107-49.

–, *Aspetti del umanesimo nella pittura veneta dal 1455 al 1515*, Rome, 1964.

Bordona, J. D., *Manuscritos con pinturas: Notas para un inventario de los conservados en colecciones públicas y particulares de España*, 2 vols, Madrid, 1933.

Born, W., *Incunabula Guelferbytana (IG): Blockbücher und Wiegendrucke der Herzog August Bibliothek Wolfenbüttel. Ein Bestandsverzeichnis*, Wiesbaden, 1990.

Borrelli, L., 'Un incunabolo miniato dal Maestro dei Putti nella Biblioteca Comunale di Trento', in *Per Giuseppe Sebesta: Scritti e nota bio-bibliografica per il settantesimo compleanno*, Trento, 1989, pp. 49-62.

Borsook, E., 'Documenti relativi alle cappelle di Lecceto e delle Selve di Filippo Strozzi', *Antichità viva*, IX, no. 3, 1970, pp. 3-20.

Boskovits, M. 'Ferrarese Painting about 1450: Some New Arguments', *The Burlington Magazine*, CXX, 1978, pp. 370-85.

Bradley, J. W., *Giorgio Giulio Clovio Miniaturist, 1498-1578: His Life and Works*, London, 1891; reprt. Amsterdam, 1971.

Branca, V., 'La prima diffusione del Decameron', *Studi di filologia italiana*, VIII, 1950, p. 29-143.

–, *Boccaccio medioevale*, Florence 1956.

–, ed., *G. Boccaccio Decameron*, 2 vols., Florence, 1966.

Branner, R., *Manuscript Painting in Paris during the Reign of St. Louis: A Study of Styles*, Berkeley and Los Angeles, 1977.

Braschi, G., *Memoriae caesenates sacrae et profanae per secula distributae*, Rome, 1738.

Brenzoni, R., *Liberale da Verona 1445-1526*, Milan, 1930.

Brieger, P., M. Meiss and C. S. Singleton, *Illuminated Manuscripts of the Divine Comedy*, 2 vols, Princeton, 1969.

Brigstocke, H., 'James Dennistoun's Second European Tour, 1836-9', *Connoisseur*, CLXXXIV, 1973, pp. 240-9.

Brilliant, R., 'Ancient Roman Monuments as Models and as Topoi', *Umanesimo a Roma nel quattrocento*, and Rome ed. P. Brezzi, M. de Panizza Lorch New York, 1984, pp. 223-34.

Brown, D. A., 'The London Madonna of the Rocks in the Light of Two Milanese Adaptations', in *Collaboration in Italian Renaissance Art*, ed. W. S. Sheard and J. T. Paoletti, New Haven, 1978, pp. 167-77.

Brown, H. F., *The Venetian Printing Press*, London, 1891.

Bruschi, A., 'Orientamento di gusto e indicazioni di teoria in alcuni disegni architettonici del quattrocento', *Quaderni dell'Istituto di Storia dell'architettura*, XIV, 1967, pp. 41-52.

Bühler, C., *The Fifteenth Century Book: The Scribes, the Printers, the Decorators*, Philadelphia, 1960.

Bye, A., 'Two Clovio Manuscripts in New York', *Art in America*, V, 1916-17, pp. 88-99.

Cahn, W., *Romanesque Bible Illumination*, Ithaca, 1982.

Calvesi, M., *Il Sogno di Polifilo prenestino*, 2nd rev. ed., Rome, 1983.

–, '*Hypnerotomachia poliphili*: Nuovi riscontri e nuovi evidenze documentarie per Francesco Colonna, signore di Preneste', *Storia dell'Arte*, LX, 1987, pp. 85-136.

Campana, A., 'Biblioteche della provincia di Forlì', in *Tesori delle biblioteche d'Italia, Emilia, Romagna*, Milan, 1932, pp. 81-130.

Canedy, N. W., 'Pieter Bruegel or Giulio Clovio,' *The Burlington Magazine*, CXXIII, 1981, p. 35.

Canuti, F., *Il Perugino*, 2 vols, Siena, 1931.

Cappi, A., *La Biblioteca Classense*, Rimini 1847.

Carli, E., *Miniature di Liberale da Verona dai corali per il Duomo di Siena*, Milan, 1953.

–, *Il Pintoricchio*, Milan, 1960.

Carosi, G. P., *Da Magonza a Subiaco: L'introduzione della stampa in Italia*, Busto Arsizio, 1982.

Casato, S., *Manoscritti liturgici bresciani nel quattrocento alla Biblioteca Queriniana*, Ph. D. diss., University of Padua, 1990-1.

Casciaro, R., and M. Rossi, 'Miniature rinascimentali inedite alla Biblioteca Braidense', *Quaderni di Brera*, VI, 1990, pp. 13-39.

Casella, M. T., and G. Pozzi, *Francesco Colonna: Biografia e opere*, 2 vols, Padua, 1959.

Castellani, C., *La stampa in Venezia dalla sua origine alla morte di Aldo Manuzio*, Venice, 1889.

Castelli, M. C., 'Immagini della "Commedia" nelle edizioni del rinascimento', in *Pagine di Dante: Le edizioni della Divina Commedia dal torchio al computer*, exh. cat., Oratorio del Gonfalone, Foligno, Biblioteca Classense, Ravenna, 1989, Florence, 1990, pp. 105-14.

Castiglioni, G., 'Un secolo di miniatura veronese 1450-1550', in *Miniatura veronese del rinascimento*, exh. cat., ed. G. Castiglioni and S. Marinelli, Museo del Castelvecchio, Verona, 1986, pp. 47-99.

–, '"Frixi e figure et miniadure facte de intajo": Tra silografia e miniatura in alcuni incunaboli veneziani', *Verona illustrata*, II, 1989, pp. 19-27.

Catalogue des incunables, *Bibliothèque nationale, Paris*, Paris, 1981-92.

Catalogue des livres *rares et précieux de la bibliothèque de feu M. le comte de Mac-Carthy Reagh*, 2 vols, Paris, 1815.

Catalogue of Additions *to the Manuscripts of the British Museum in the Years 1841-5*, London, 1850.

Catalogue of Additions *to the Manuscripts of the British Museum in the Years 1846-7*, London, 1864.

Catalogue of Additions *to the Manuscripts of the British Museum in the Years 1854-60, Additional Mss. 19,720-24,026*, London, 1875.

Catalogue of Miniatures, *Leaves and Cuttings from Illuminated Manuscripts, Victoria and Albert Museum*, London, 1923.

Catalogue of the Manuscripts *and Printed Books Collected by Thomas Brooke, F. S. A., Preserved at Armitage Bridge House, Near Huddersfield*, I, London, 1891.

Cavaccio, G., *Historia coenobii D. Justinae Patavinae*, Venice, 1606.

Cerney, M., *The Farnese Hours: A Sixteenth-Century Mirror*, Ph. D. diss., Ohio State University, Columbus, 1984.

Chambers, D. S., 'Giovanni Pietro Arrivabene (1439-1505): Humanistic Secretary and Bishop', *Aevum*, LVIII, 1984, pp. 397-438.

–, *A Renaissance Cardinal and his Worldly Goods: The Will and Inventory of Francesco Gonzaga (1444-1483)* (Warburg Institute Surveys and Texts, XX), London, 1992.

Cherchi, P., and T. de Robertis, 'Un inventario della Biblioteca Aragonese', *Italia medioevale e umanistica*, XXXIII, 1990, pp. 109-347.

Chiarlo, C., 'Li fragmenti della sancta antiquitate: Studi antiquari e produzione delle immagini da Ciriaco d'Ancona a Francesco Colonna', *Memoria dell'antico nell'arte italiana, 1984-86, I: L'uso dei classici*, Turin, 1984, pp. 271-9.

ChL = A. Thurston and C. F. Bühler, *A Checklist of Fifteenth Century Printing in the Pierpont Morgan Library*, New York, 1939.

Ciardi Dupré dal Poggetto, M. G., *I corali del Duomo di Siena*, Milan, 1972.

–, 'Piero e le corti rinascimentali', in *Piero e Urbino: Piero e le corti rinascimentali*, exh. cat., Palazzo Ducale, Urbino, 1992, pp. 326-7.

Ciardi Dupré dal Poggetto, M. G., *et al.*, *Codici liturgici miniati dei Benedettini in Toscana*, Florence, 1982.

Cicogna, E. A., *Delle inscrizioni veneziane*, VI, Venice, 1853.

Cionini Visani, M., 'Di alcuni codici quattro-centeschi della Biblioteca Capitolare di Padova', *Arte Veneta*, XXI, 1967, pp. 21-49.

–, 'Un itinerario del manierismo italiano: Giulio Clovio', *Arte Veneta*, XXV, 1971, pp. 119-44.

Cionini Visani, M., and G. Gmulin, *Giorgio Clovio: Miniaturist of the Renaissance*, New York, 1980.

Ciucciomini, M.F., 'Su alcune pagine miniate della Biblioteca Malatestiana di Cesena', *Paragone*, nos 431-3, 1986, pp. 29-33.

–, 'La serie dei corali del duomo nella miniatura dell'ultimo trentennio del quattrocento', in *Corali miniati del quattrocento nella Biblioteca Malatestiana*, exh. cat., Biblioteca Malatestiana, Cesena, 1989, pp. 37-46.

Clough, C.H., *Pietro Bembo's Library as Represented in the British Museum*, London, 1971.

–, 'Federigo da Montefeltro's Patronage of the Arts, 1468-1482', *Journal of the Warburg and Courtauld Institutes*, XXXVI, 1973, pp. 129-44.

Cogliati Arano, L. 'Due codici corvini: Il Filarete marciano e l'epitalamio di Volterra', *Arte Lombarda*, LII, 1979, pp. 53-62.

Colvin, S., *A Florentine Picture Chronicle*, London, 1898.

Conti, A., 'Una miniatura ed altre considerazioni sul Pisanello', *Itinerari*, XI, 1979, pp. 67-76.

–, *La miniatura bolognese: Scuole e botteghe, 1270-1340*, Bologna, 1981.

–, 'Andrea Mantegna, Pietro Guindaleri ed altri maestri nel "Plinio" di Torino', *Prospettiva*, LIII-LVI, 1988-9 (Scritti in ricordo di Giovanni Previtali), pp. 264-77.

–, 'Saggio introduttivo', in *Corali miniati del quattrocento nella Biblioteca Malatestiana*, exh. cat., Biblioteca Malatestiana, Cesena, 1989, pp. 9-18.

Cook, C.S., 'The Paris Suetonius of Bartolomeo Sanvito and Early Renaissance Illumination of the Lives of the Twelve Caesars', *Manuscripta*, XXIV, 1980, pp. 5-6.

Corbett, M., 'The Architectural Title Page', *Motif*, XII, 1964, pp. 49-62.

Couderc, C., *Album de portraits d'après les collections du département des manuscrits*, Paris, 1908.

Csapodi, C., *The Corvinian Library: History and Stock*, Budapest, 1973.

Csapodi, C., and K. Csapodi-Gárdonyi, *Biblioteca Corviniana: The Library of King Matthias Corvinus of Hungary*, 2nd rev. ed., Budapest, 1969.

Csapodi-Gárdonyi, K., 'Castello, Francesco', in *Dizionario biografico degli italiani*, XXI, Rome, 1978, pp. 794-5.

–, *Die Bibliothek des Johannes Vitéz*, Budapest, 1984.

Dacos, N., *La découverte de la Domus Aurea et la formation des grotesques à la renaissance*, London, 1969.

Dacos, N., A. Giuliano and U. Pannuti, *Il tesoro di Lorenzo il Magnifico, I: Le Gemme*, Florence, 1973.

D'Adda, G., 'Lodovico Maria Sforza e il convento di Santa Maria delle Grazie', *Archivio storico lombardo*, I, 1874, pp. 25-53.

D'Adda, G., and G. Mongeri, 'L'arte del minio nel ducato di Milano dal secolo XIII al XVI', *Archivio storico lombardo*, XII, 1885, pp. 330-56, 528-57, 760-95.

D'Ancona, P., 'Nuove ricerche sulla Bibbia dos Jeronymos e dei suoi illustratori', *La Bibliofilia*, XV, 1913, pp. 205-12.

–, *La miniatura fiorentina*, 2 vols, Florence, 1914.

–, *La miniatura italienne du Xe au XVIe siècle*, Paris, 1925.

D'Ancona, P. and E. Aeschlimann, *Dictionnaire des miniaturistes du moyen âge et de la renaissance dans les différentes contrées de l'Europe*, Milan, 1949; reprt. Nendeln, 1969.

–, *The Art of Illumination*, London, 1969.

Danesi Squarzina, S., 'Francesco Colonna, principe, letterato, e la sua cerchia', *Storia dell'Arte*, LX, 1987, pp. 137-54.

Daneu Lattanzi, A., 'Di alcuni miniatori lombardi della seconda metà del secolo XV: Riesaminato Francesco da Castello', *Commentari*, XXIII, 1972, pp. 225-60.

–, 'La miniatura nell'Italia meridionale e in Sicilia tra il gotico e il rinascimento', in *La miniatura italiana tra gotico e rinascimento: Atti del II Congresso di storia della miniatura italiana, Cortona, 1982*, ed. E. Sesti, Florence, 1985, II, pp. 751-85.

Dearden, J.S., 'John Ruskin the Collector', *The Library*, XXI, 1966, pp. 124-54.

Degenhart, B., and A. Schmitt, *Corpus der italienischen Zeichnungen 1300-1450. Teil II. Venedig. Addenda zu Süd- und Mittelitalien. 4. Band. Katalog 717-719. Mariano Taccola*, Berlin, 1982.

De Hevesy, A., 'Les miniaturistes de Mat. Corvin', *Revue de l'art chrétien*, LXI, 1911, pp. 109-20.

–, *La bibliothèque du roi Matthias Corvin*, Paris, 1923.

De Kunert, S., 'Un padovano ignoto ed un suo memoriale de' primi anni del cinquecento (1505-1511) con cenni su due codici miniati', *Bolletino del Museo Civico di Padova*, X, 1907, pp. 1-16, 64-73.

–, 'Due codici miniati da Girolamo Campagnola', *Rivista d'Arte*, XII, 1930, pp. 51-80.

De Laborde, A., *Les manuscrits à peinture de la Cité de Dieu*, 3 vols, Paris, 1909.

de la Mare, A.C., 'Messer Piero Strozzi, a Florentine Priest and Scribe', *Calligraphy and Palaeography: Essays Presented to Alfred Fairbank on his Seventieth Birthday*, ed. A.S. Osley, London, 1965, pp. 55-68.

–, 'Florentine Manuscripts of Livy in the Fifteenth Century', *Livy*, ed. T.A. Dorey, London, 1971, pp. 177-99.

–, 'Poggio's Earliest Manuscript?', *Italia medioevale e umanistica*, XVI, 1973, pp. 179-95.

–, 'The Library of Francesco Sassetti (1421-1490)', in *Essays in Honour of Paul Oskar Kristeller*, ed. C.H. Clough, Manchester, 1976, pp. 160-201.

–, 'Humanistic Script: The First Ten Years', in *Das Verhältnis der Humanisten zum Buch*, ed. F. Kraft and D. Wuttke (Deutsche Forschungsgemeinschaft, Kommission für Humanismus Forschung, Mitteilung, IV), Boppard, 1977, pp. 89-110.

–, 'Further Manuscripts from Holkham Hall', *Bodleian Library Records*, X, 1982, pp. 327-38.

–, 'Scrittura e manoscritti a Milano al tempo degli Sforza', in *Milano nell'età di Lodovico il Moro: Atti del Convegno internazionale 1983*, Milan, 1983, pp. 399-408.

–, 'The Florentine Scribes of Cardinal Giovanni of Aragon', in *Il libro e il testo: Atti del Convegno internazionale, Urbino, 1982*, ed. C. Questa and R. Raffaelli, Urbino, 1984, pp. 245-93.

–, 'Vespasiano da Bisticci e i copisti fiorentini di Federico', in *Federico da Montefeltro: Lo stato, le arti, la cultura*, ed. G.C. Baiardi, G. Chittolini and P. Floriani, Rome, 1986, III, pp. 81-96.

de la Mare, A.C., and C. Reynolds, 'Illustrated Boccaccio Manuscripts in Oxford Libraries', *Studi sul Boccaccio*, XX, 1991-2, pp. 45-72.

Del Bravo, C., 'Liberale a Siena', *Paragone Arte*, XI, no. 129, 1960, pp. 16-38.

–, 'Liberale in patria', *Arte Veneta*, XVII, 1963, pp. 41-9.

–, *Liberale da Verona*, Florence, 1967.

Delisle, L., *Le cabinet des manuscrits de la Bibliothèque impériale (nationale)*, 3 vols, Paris, 1868-81.

–, 'Le missel de Thomas James, évêque de Dol', *Bibliothèque de l'École de chartes*, XLIII, 1882, pp. 311-15.

De Marchi, A., 'I miniatori padani a Siena', in *Francesco di Giorgio e il rinascimento a Siena 1450-1500*, exh. cat., ed. L. Bellosi, Chiesa di Sant'Agostino, Siena, 1993, pp. 228-37.

De Marinis, T., *Manuscrits et livres rares, catalogue VIII*, Florence, 1908.

–, *La Biblioteca Napoletana dei Re d'Aragona*, 4 vols, Milan, 1947-52.

–, *Un manoscritto di Tolomeo fatta per Andrea Matteo Acquaviva e Isabella Piccolomini (Nozze Bodmer-Stahel)*, Verona, 1956.

–, *La legatura artistica in Italia nei secoli XV e XVI*, 3 vols, Florence, 1960.

–, *La Biblioteca Napoletana dei Re d'Aragona: Supplemento*, 2 vols, Verona, 1969.

De Ricci, S. *A Handlist of Mss. in the Earl of Leicester's Library*, Oxford, 1932.

–, *Census of Medieval and Renaissance Manuscripts in the United States and Canada*, 3 vols, New York, 1935-40.

Derolez, A., *Codicologie des manuscrits en écriture humanistique sur parchemin* (Bibliologia, 5-6), 2 vols, Turnhout, 1984.

De Tolnay, C., 'Newly Discovered Miniatures by Pieter Bruegel the Elder', *The Burlington Magazine*, CVII, 1965, pp. 110-14.

–, 'Further Miniatures by Pieter Bruegel the Elder', *The Burlington Magazine*, CXXII, 1980, pp. 616-23.

Dibdin, T.F., *The Bibliographical Decameron*, 3 vols, London, 1817.

–, *A Bibliographical, Antiquarian and Picturesque Tour in France and Germany*, 3 vols, London, 1829.

Dillon, G., 'Sul libro illustrato del quattrocento: Verona e Venezia', in *La stampa degli incunaboli nel Veneto*, Vicenza, 1984, pp. 81-96.

Dillon Bussi, A., 'I libri decorati di Girolamo Rossi: Illustrazione libraria a Venezia nella seconda metà del quattrocento', *Verona illustrata*, II, 1989, pp. 29-51.

–, 'Aspetti della miniatura ai tempi di Lorenzo il Magnifico', *All'ombra del lauro: Documenti librari della cultura in età Laurenziana*, exh. cat. Biblioteca Medicea-Laurenziana, Florence, 1992.

Dodgson, C., *A Book of Drawings formerly Ascribed to Mantegna*, London, 1923.

Donati, L., 'I fregi xilografici stampati a mano negl'incunabuli italiani', *La Bibliofilia*, LXXIV, 1972, pp. 157-64, 303-27; LXXV, 1973, pp. 125-74.

Dorez, L., *Les manuscrits à peinture de la bibliothèque de Lord Leicester à Holkham Hall, Norfolk*, Paris, 1908.

–, *Psautier de Paul III: Reproduction des peintures et des initiales du manuscrit latin 8880 de la Bibliothèque nationale*, Paris, 1909.

Dos Santos, R., 'Les principaux manuscrits à peintures conservés en Portugal', *Bulletin de la Société française de reproductions de manuscrits à peintures*, XIV, 1930, pp. 1-35.

Drogin, M., *Medieval Calligraphy: The History and Technique*, Montclair, New Jersey, 1978.

Dupré, L., *Passage to Modernity: An Essay in the Hermeneutics of Nature and Culture*, New Haven and London, 1993.

Durrieu, P. 'Le Strabon du roi René', *Le Manuscrit*, II, 1895, pp. 2-5, 17-21.

–, 'Le Strabon d'Albi', in *Trèsors des bibliothèques de France*, Paris, 1929, II, pp. 15-20.

Dykmans, M., 'Le missel du Cardinal Dominique de la Rovère pour la Chapelle Sixtine', *Scriptorium*, XXXVII, 1983, pp. 205-38.

Eberhardt, H.-J., 'Das Testament des Liberale da Verona', *Mitteilungen des Kunsthistorischen Institutes in Florenz*, XV, 1971, pp. 219-25.

–, 'Liberale da Verona und die Aesop-Illustrationen von 1479', *Gutenberg Jahrbuch*, 1977, pp. 244-50.

–, *Die Miniaturen von Liberale da Verona, Girolamo da Cremona und Venturino da Milano in den Chorbüchern des Doms von Siena: Dokumentation – Attribution – Chronologie*, Munich, 1983.

–, 'Sull'attività senese di Liberale da Verona, Girolamo da Cremona, Venturino da Milano, Giovanni da Udine e prete Carlo da Venezia', in *La miniatura italiana tra gotico e rinascimento: Atti del II Congresso di storia della miniatura italiana, Cortona, 1982*, ed. E. Sesti, Florence, 1985, I, pp. 415-34.

Edler de Roover, F., 'Storia dell'arte della stampa in Italia: Come furono stampati a Venezia tre dei primi libri in volgare', *La Bibliofilia*, LV, 1953, pp. 107-15.

Ehwald, R. *Beschreibung der Handschriften und Inkunabeln der Herzogl. Gymnasialbibliothek zu Gotha*, Gotha, 1893.

Eisler, C., *The Genius of Jacopo Bellini*, New York, 1989.

Eleen, L. 'Crivelli, Taddeo', in *Dizionario biografico degli italiani*, XXXI, Rome, 1985, pp. 156-60.

Erdreich, E. C., *"Qui hos cultus... pinxerit": Illumination associated with Bartolomeo Sanvito (c. 1435-c. 1512)*, Ph. D. diss., Johns Hopkins University, Baltimore, 1993.

Essling, prince d', *Les livres à figures vénétiens de la fin du XV siècle et du commencement du XVI siècle*, 3 vols, Florence, 1907-14.

Essling, prince d', and E. Müntz, *Pétrarque: Ses études d'art*, Paris, 1902.

Evans, M., 'Italian Manuscript Illumination, 1460-1560', in *Renaissance Painting in Manuscripts: Treasures from the British Library*, exh. cat., ed. T. Kren, J. Paul Getty Museum, Malibu, 1983, Pierpont Morgan Library, New York, 1984, and British Library, London, 1984, pp. 89-95.

–, 'Bartolomeo Sanvito and an Antique Motif', *British Library Journal*, XI, 1985, pp. 123-30.

–, 'New Light on the "Sforziada" Frontispieces of Giovan Pietro Birago', *British Library Journal*, XIII, 1987, pp. 232-47.

–, 'Die Miniaturen des Münchner Medici-Gebetbuchs Clm 23639 und verwandte Handschriften', in *Das Gebetbuch Lorenzos de'Medici 1485: Handschrift Clm 23639 der Bayerischen Staatsbibliothek München*, ed. E. Arnold, Frankfurt am Main, 1991, pp. 169-275.

–, *The Sforza Hours*, London, 1992.

Fahy, E., *The Medici Aesop*, New York, 1989.

Fairbank, A., 'Bartolomeo Sanvito', *Journal of the Society for Italic Handwriting*, no. 28, 1961, pp. 12-13.

–, 'Bartolomeo Sanvito and Antonio Tophio', *Stained the Water Clear: Festschrift for L. J. Reynolds*, Portland, 1966, pp. 3-5.

–, 'Francesco Monterchi,' *Journal of the Society for Italic Handwriting*, no. 68, 1971, pp. 12-3.

–, 'The Arrighi Style of Book-hand', *Calligraphy and Palaeography: Essays Presented to Alfred Fairbank on his seventieth birthday*, ed. A. S. Osley, London, 1972, pp. 271-2.

–, 'Another Arrighi Manuscript, Douce 29', *The Book Collector*, XXIII, 1974, pp. 551-2.

Fairbank, A., and R. W. Hunt, *Humanistic Script of the Fifteenth and Sixteenth Centuries*, Oxford, 1960; reprt. Oxford, 1993.

Fairbank, A., and B. Wolpe, *Renaissance Handwriting: An Anthology of Italic Scripts*, London, 1960.

Fava, D., *Tesori delle biblioteche d'Italia: Emilia e Romagna*, Milan, 1932.

Fava, D., M. Salmi and E. Pirani, *I manoscritti miniati della Biblioteca Estense di Modena*, Milan, 1973.

Fava, M., and G. Bresciano, *La stampa a Napoli nel XV secolo*, 2 vols, Leipzig, 1911-13.

Faye, C. U., and W. H. Bond, *Supplement to the Census of Medieval and Renaissance Manuscripts in the United States and Canada*, New York, 1962.

Feld, M. D., 'Sweynheym and Pannartz, Cardinal Bessarion, Neoplatonism: Renaissance Humanism and Two Early Printers' Choice of Texts', *Harvard Library Bulletin*, XXX, 1982, pp. 282-335.

–, 'A Theory of the Early Italian Printing Firm, Part I: Variants of Humanism'; 'Part II: The Political Economy of Patronage', *Harvard Library Bulletin*, XXXIII, 1985, pp. 341-77; XXXIV, 1986, pp. 294-332.

Ferrari, D., ed., *Giulio Romano: Repertorio di fonti documentarie*, 2 vols, Rome, 1992.

Fiocco, G., Review of Meiss 1957, *Paragone*, IX, no. 99, 1958, pp. 55-8.

Fiorio, M. T., 'Marco Zoppo et le livre padouan', *Revue de l'Art*, LIII, 1981, pp. 65-73.

Fischer, J., 'An Important Ptolemy Manuscript with Maps in the New York Public Library', *United States Catholic Historical Society: Historical Records and Studies*, VI, no. 2, 1913, pp. 216-34.

–, *Claudii Ptolemaei Geographiae, Codex Urbinas Graecus* (Codices e Vaticanis selecti, 19), Leiden, 1932.

Fletcher, H. G., *New Aldine Studies*, San Francisco, 1988.

Fletcher, J. 'The Painter and the Poet: Giovanni Bellini's Portrait of Raffaele Zovenzoni Rediscovered', *Apollo*, CXXIV, Sept. 1991, pp. 153-8.

Frati, L. 'Un codice miniato del 'Decameron' e la Biblioteca di S. Spirito di Reggio', *La Bibliofilia*, XIX, 1918, p. 374.

Frimmel, T., *Der Anonimo Morelliano (Marcantonio Michiel's 'Notizia d'opera del disegno')*, in *Quellenschriften für Kunstgeschichte und Kunsttechnik des Mittelalters und der Neuzeit*, Vienna, 1888.

Ganda, A., *I primordi della tipografia milanese: Antonio Zarotto da Parma (1471-1507)*, Milan, 1984.

Garin, E., *Giovanni Pico della Mirandola: Vita e dottrina*, Florence, 1937.

–, 'Ritratto di Poggio', *La storia del Valdarno*, II, no. 16, 1991, pp. 376-87.

Garzelli, A., 'Codici miniati laurenziani: Per un catalogo, 1, 2', *Critica d'Arte*, XL, no. 143, 1975, pp. 19-38; no. 144, 1975, pp. 25-41.

–, *La Bibbia di Federico da Montefeltro*, Rome, 1977.

–, 'Arte del "libro d'ore" e committenza medicea (1485-1536)', *Atti del I Congresso Nazionale di storia dell'arte (Roma 1978)*, Rome, 1980, pp. 475-90.

–, 'Sulla fortuna del Gerolamo mediceo del van Eyck nell'arte fiorentina del quattrocento', in *Scritti di storia dell'arte in onore di Roberto Salvini*, Florence, 1984, pp. 347-53.

–, 'Miniatura fiorentina del rinascimento 1440-1525: Un primo censimento', in *La miniatura italiana tra gotico e rinascimento: Atti del II Congresso di storia della miniatura italiana, Cortona, 1982*, ed. E. Sesti, Florence, 1985, II, pp. 465-72 (1985a).

–, 'Note su artisti nell'orbita dei primi Medici: Individuazioni e congetture dai libri di pagamento della Badia fiesolana (1440-1485)', *Studi medioevali*, XXVI, 1985, pp. 435-82 (1985b).

–, 'I miniatori fiorentini di Federico', in *Federico da Montefeltro: Lo stato, le arti, la cultura*, ed. G. C. Baiardi, G. Chittolini and P. Floriani, Rome, 1986, III, pp. 113-30.

Garzelli, A., and A. C. de la Mare, *Miniatura fiorentina del rinascimento 1440-1525: Un primo censimento*, 2 vols, Florence, 1985.

Gaye, G., *Carteggio inedito d'artisti dei secoli XIV, XV, XVI*, Florence, 1839-40.

Gerulaitis, L. V., *Printing and Publishing in Fifteenth-Century Venice*, Chicago, 1976.

Gianelli, C., *Codices Vaticani Graeci 1485-1683*, Vatican City, 1950.

Giannetto, N., *Bernardo Bembo, umanista e politico veneziano* (Civiltà veneziana. Saggi, 34), Florence, 1985.

Gilbert, C., 'Liberale da Verona's Picture of the North', *Ars Auro Prior: Studia Ioanni Białostocki sexagenario dicata*, Warsaw, 1981, pp. 217-21.

Giordano, L., ed., *B. F. e il Maestro di Paolo e Daria: Un codice e un problema di miniatura lombarda*, Pavia, 1991.

Giovanucci Vigi, B., *Il Museo della Cattedrale di Ferrara: Catalogo generale*, Bologna, 1989.

–, ed., *Marco Zoppo, Cento 1433-1478 Venezia: Atti del Convegno Internazionale di studi sulla pittura del quattrocento padano, Cento, 1993*, Bologna, 1993.

Giustiniani, V. R., 'Sulle traduzioni latine delle "Vite" di Plutarco nel quattrocento', *Rinascimento*, I, 1961, pp. 4-59.

Gnoli, U., *Pittori e miniatori nell'Umbria*, Spoleto, 1923.

Goff = F. R. Goff, comp. and ed., *Incunabula in American Libraries: A Third Census of Fifteenth-Century Books Recorded in North American Collections*, Millwood, NY, 1973.

Goffen, R., *Giovanni Bellini*, New Haven, 1989.

Goldschmidt, E. P., *Gothic and Renaissance Bookbindings*, London, 1928.

–, *The Printed Book of the Renaissance: Three Lectures on Type, Illustration, Ornament*, Cambridge, 1950.

Gombrich, E. H., 'The Early Medici as Patrons of Art', *Italian Renaissance Studies: A Tribute to the late Cecilia M. Ady* (1960), reprt. in *Norm and Form: Studies in the Art of the Renaissance*, London, 1966, pp. 35-57.

Grafton, A., and L. Jardine, *From Humanism to the Humanities*, Cambridge, MA, 1986.

Gualdi, F., 'Contributi alla miniatura umbra del rinascimento', *Commentari*, XVIII, 1967, pp. 297-321.

Gualdi Sabatini, F., 'Il "Messale Pontificis in Nativitate Domini" Borg. Lat. 425 della Biblioteca Vaticana', in *La miniatura tra gotico e rinascimento: Atti del II Congresso di storia della miniatura italiana, Cortona, 1982*, ed. E. Sesti, Florence, 1985, II, pp. 719-50.

Gullick, M., *Calligraphy*, London, 1990.

Gundersheimer, W. L., *Ferrara: The Style of a Renaissance Despotism*, Princeton, 1973.

–, 'Clarity and Ambiguity in Renaissance Gesture: The Case of Borso d'Este', *Journal of Medieval and Renaissance Studies*, XXIII, 1993, pp. 1-17.

Günther, H., *Das Studium der antiken Architektur in den Zeichnungen der Hochrenaissance*, Tübingen, 1988.

Gutiérrez del Caño, M. *Catálogo de los manuscritos existentes en la Biblioteca Universitaria de Valencia*, 3 vols, Valencia, 1913.

GW = *Gesamtkatalog der Wiegendrucke*, vols I-VII, Leipzig, 1925-40; vol. VIII, New York, 1978.

H = L. R. T. Hain, *Repertorium Bibliographicum*, 2 vols in 4, Stuttgart, 1826-38; W. A. Copinger, *Supplement*, London, 1895-1902; D. Reichling, *Appendices*, Munich, 1905-14.

Habicht, V. C., 'Miniaturen von Benedetto Bordone in des venetianischen Bibeldruck von 1471', *Zeitschrift für Bücherfreunde*, XXXVI, 1932, pp. 264-71.

Hain. See H.

Hargreaves, G. D., 'Florentine Script, Paduan Script, and Roman Type', *Gutenberg Jahrbuch*, 1992, pp. 15-34.

Harrsen, M., and G. K. Boyce, *Italian Manuscripts in the Pierpont Morgan Library: Descriptive Survey of the Principal Illuminated Manuscripts of the Sixth to Sixteenth Centuries, with a Selection of Important Letters and Documents*, New York, 1953.

Hartig, O., 'Die Gründung der Münchener Hofbibliothek durch Albrecht V. und Johann Jakob Fugger', *Abhandlungen der Kgl. Bayerischen Akademie der Wissenschaften, Phil.-Hist. Kl.*, XXVII. 3, Munich, 1917.

Hassall, A. G., and W. O. Hassall, *Treasures of the Bodleian Library*, London, 1976.

Hassall, W. O. 'XVth-Century Ferrarese Illumination at Holkham Hall, Norfolk', *The Connoisseur*, 1954, pp. 18-24.

–, *The Holkham Library: Illumination and Illustration in the Manuscript Library of the Earl of Leicester*, Oxford, 1970.

–, 'Holkham Manuscripts Acquired for the Nation', *Apollo*, CCLII, 1983, pp. 83-6.

HC, HCR. See H.

Heinemann, O., *Die Handschriften der Herzöglichen Bibliothek zu Wolfenbüttel*, 2 vols, 1894-1903; reprt. Frankfurt, 1966.

Herbert, J. A., *Illuminated Manuscripts*, London, 1911.

Hermanin, F., 'Le miniature ferraresi della Biblioteca Vaticana', *L'Arte*, III, 1900, pp. 341-73.

Hermann, H. J., 'Miniaturhandschriften aus der Bibliothek des Herzogs Andrea Matteo III Acquaviva', *Jahrbuch der kunsthistorischen Sammlungen des allerhöchsten Kaiserhauses*, XIX, 1898, pp. 147-216.

–, 'Zur Geschichte der Miniaturmalerei am Hofe der Este in Ferrara: Stilkritische Studien', *Jahrbuch der kunsthistorischen Sammlungen des allerhöchsten Kaiserhauses*, XXI, 1900, pp. 117-271.

–, *Beschreibendes Verzeichnis der illuminierten Handschriften in Österreich VIII. Die illuminierten Handschriften und Inkunabeln der Nationalbibliothek in Wien. Teil VI: Die Handschriften und Inkunabeln der italienischen Renaissance. 2: Venetien*, Leipzig, 1931.

–, *Beschreibendes Verzeichnis der illuminierten Handschriften in Österreich VIII. Die illuminierten Handschriften und Inkunabeln der Nationalbibliothek in Wien. Teil VI: Die Handschriften und Inkunabeln der italienischen Renaissance. 4: Unteritalien*, Leipzig, 1933.

Hill, G. F., *A Corpus of the Italian Medals of the Renaissance before Cellini*, 2 vols, London, 1930.

Hind, A. M., *An Introduction to a History of Woodcut*, New York, 1935; reprt. 2 vols, New York, 1963.

Hindman, S., ed. *Printing the Written Word: The Social History of Books, circa 1450-1520*, Ithaca, 1991.

Hindman, S., and M. Heinlen, 'A Connoisseur's Montage: The Four Evangelists Attributed to Giulio Clovio', *The Art Institute of Chicago, Museum Studies*, XVII, 1991, pp. 154-78.

Hirsch, R., *Printing, Selling and Reading, 1450-1550*, Wiesbaden, 1974.

Hobson, A. R. A., *Humanists and Bookbinders: The Origins and Diffusion of the Humanistic Bookbinding 1459-1559*, Cambridge, 1989.

HR. See H.

Huelsen, C., *La Roma antica di Ciriaco d'Ancona*, Rome, 1907.

Humfrey, P., 'The *Life of St. Jerome* Cycle from the Scuola di San Girolamo di Cannaregio', *Arte Veneta*, XXXIX, 1985, pp. 41-6.

–, *The Altarpiece in Renaissance Venice*, New Haven, 1993.

Incunabula in Dutch Libraries: A Census of Fifteenth-Century Printed Books in Dutch Public Collections, 2 vols, Nieuwkoop, 1983.

ISTC = *Incunabula Short Title Catalogue*, database, British Library, Department of Incunabula.

Indice generale degli incunaboli delle biblioteche d'Italia, 6 vols, Rome, 1943-81.

Ingamells, J. I., *The Wallace Collection, Catalogue of Pictures, I: British, German, Italian, Spanish*, London, 1985.

Jacobs, F., and F. A. Uckert, *Beiträge zur älteren Literatur... der... Bibliothek zu Gotha*, III, Leipzig, 1838.

Jacoff, R., 'Charles Eliot Norton's "Medicean Dante"', *Harvard Library Bulletin*, 1994, forthcoming.

James, M. R., *Catalogue of Manuscripts and Printed Books from the Libraries of William Morris, Richard Bennett, Bertram Fourth Earl of Ashburnham, and Other Sources now Forming a Portion of the Library of J. Pierpont Morgan*, London, 1906.

Janini, J., and J. Serrano, *Manuscritos liturgicos de la Biblioteca Nacional, Madrid*, Madrid, 1969.

Joly, H., *Le missel d'Attavante pour Thoms James, évêque de Dol*, Lyons, 1936.

Jones, R., and N. Penny, *Raphael*, New Haven, 1983.

Joost-Gaugier, C. L., 'A Pair of Miniatures by a Panel Painter: The Earliest Works by Giovanni Bellini', *Paragone*, no. 357, 1979, pp. 48-71.

Kauffmann, M. C., *The Baths of Pozzuoli: A Study of the Medieval Illuminations of Peter of Eboli's Poem*, Oxford, 1959.

Ker, N. R., *Medieval Manuscripts in British Libraries, I: London*, Oxford, 1969.

Kibre, P., *The Library of Pico della Mirandola*, New York, 1936.

King, M. L., *Venetian Humanism in an Age of Patrician Dominance*, Princeton, 1986.

–, *The Death of the Child Valerio Marcello*, Chicago, 1994.

Kolendic, P., 'Slikar Jurai Culinovic u Sibeniku', *Vjesnik za Arheologiju i Historiju Dalmatinsku*, XLIII, 1920, pp. 117-90.

Koschatsky, W., and A. Strobl, *Die Albertina in Wien*, Salzburg, 1969.

Kraus, H. P., *In Retrospect: 100 Outstanding Manuscripts Sold in the Last Four Decades*, New York, 1978.

Kristeller, P., 'Fra Antonio da Monza incisore', *Rassegna d'Arte*, I, 1901, pp. 161-4.

Kristeller, P. O., *Studies in Renaissance Thought and Letters*, Rome I, 1956, II, 1985.

–, *Iter Italicum*, 6 vols, London and Leiden, 1963-93.

Landi, E., 'I corali medicei della Badia fiesolana. I: I documenti', *Prospettiva*, VIII, 1977, pp. 7-17.

Langedijk, K., *The Portraits of the Medici, 15th-18th Centuries*, 3 vols, Florence, 1981-7.

Lawrence, E. B., 'The Illustrations of the Garrett and Modena Manuscripts of Marcanova', *Memoirs of the American Academy in Rome*, VI, 1927, pp. 127-31.

Leroquais, V., *Les sacramentaires et les missels manuscrits des bibliothèques publiques de France*, 4 vols, Paris, 1924.

Levi d'Ancona, M., 'Illuminations by Giulio Clovio Lost and Found', *Gazette des Beaux-Arts*, XXXVII bis, July-September 1950, pp. 55-76.

–, 'Le Maître des Missels della Rovere: Rapports entre la France et l'Italie vers la fin du XVe et le début du XVIe siècle', *Actes du XIXe Congrès International d'histoire de l'art*, 1959, pp. 256-63.

–, 'Contributi al problema di Franco dei Russi', *Commentari*, XI, 1960, pp. 33-45.

–, *Miniatura e miniatori a Firenze dal XIV al XVI secolo: Documenti per la storia della miniatura*, Florence, 1962.

–, 'Postille a Girolamo da Cremona', in *Studi di bibliografia e di storia in onore di Tammaro de Marinis*, Verona, 1964, III pp. 5-104.

–, 'Francesco Rosselli', *Commentari*, XVI, 1965, pp. 56-76.

–, 'Benedetto Padovano e Benedetto Bordone: Primo tentativo per un corpus di Benedetto Padovano', *Commentari*, XVII, 1967, pp. 21-42 (1967a).

–, Un libro d'ore di Francesco Marmita da Parma e Martino da Modena al Museo Correr, II', *Bolletino dei Musei Civici Veneziani*, XII, 1967, pp. 9-28 (1967b).

–, 'Un libro scritto e miniato da Giulio Clovio', *Contributi alla storia del libro italiano: Miscellanea in onore di Lamberto Donati*, Florence, 1969, pp. 206-8.

–, *The Wildenstein Collection of Illuminations: The Lombard School*, Florence, 1970.

–, 'Giovanni Vendramin da Padova', *Arte Veneta*, XXXII, 1978, pp. 39-45.

'Libreria Domini'. I manoscritti della Biblioteca Malatestiana: Atti del Convegno Internazionale di studi, Cesena, 1989, ed. P. Lucci and F. Lollini, forthcoming.

Lightbown, R., *Mantegna*, Oxford, 1986.

Limentani Virdis, C., *Codici miniati fiamminghi e olandesi nelle biblioteche dell'Italia nord-orientale*, Vicenza, 1981.

Llorens Cistero, J. M., 'Miniaturas de Vincent Raymond en los manuscritos musicales de la Capilla Sixtina', *Miscelánea en homenaje a Monseñor Higinio Anglés*, Barcelona, 1958-61, I, pp. 475-98.

Lodigiani, M. P., 'Per Matteo da Milano', *Arte Cristiana*, LXXIX, 1991, pp. 287-300.

Lohr, P., ed., *Cristoforo Landino, Disputationes Camaldulenses*, Florence, 1980.

Lollini, F., 'Scheda Bessarione 4', in *Corali miniati del quattrocento nella Biblioteca Malatestiana*, exh. cat., Biblioteca Malatestiana, Cesena, 1989, pp. 109-10.

Longhi, E., 'Per la miniatura umbra del quattrocento', *Atti Accademia Properziana del Subasio*, VIII, 1984, pp. 151-97.

Longhi, R., 'Un apice espressionistico di Liberale da Verona', *Paragone Arte*, VI, no. 65, 1955, pp. 3-7.

Loperfido, F., 'La miniatura nella cultura ferrarese del rinascimento', *Rivista del Comune*, I, 2, 1961, pp. 3-19.

Lopez, G., 'Una signoria fra due epoche', in *Gli Sforza a Milano*, Milan, 1978, pp. 7-103.

Lowry, M., *The World of Aldus Manutius*, Ithaca, 1979.

–, 'The Social World of Nicholas Jenson and John of Cologne', *La Bibliofilia*, LXXXIII, 1981, pp. 193-218.

–, 'Aldus Manutius and Benedetto Bordone: The Quest for a Link', *John Rylands University Library Bulletin*, LXVI, 1983, pp. 173-97.

–, *Nicholas Jenson and the Rise of Venetian Publishing in Renaissance Europe*, Oxford, 1991.

Lusini, V., *Il Duomo di Siena: Parte secunda*, Siena, 1939.

Malaguzzi Valeri, F., *La corte di Lodovico il Moro*, 4 vols, Milan, 1913-23.

–, 'Sul miniatore Frate Antonio da Monza', *Rassegna d'Arte*, XVI, 1916, pp. 28-37.

Mallett, M., and J. R. Hale, *The Military Organization of a Renaissance State: Venice c. 1400 to 1617*, Cambridge, 1984.

Manari, L., 'Documenti e note ai cenni storico-artistici della basilica di S. Pietro di Perugia', *Apologetico*, IV, 1865, pp. 249-53.

Manion, M. M., and V. F. Vines, *Illuminated Manuscripts in Australian Collections*, Melbourne, 1984.

Mann, N., *Petrarch Manuscripts in the British Isles* (Censimento dei codici petrarcheschi, 6), Padua, 1975.

Mantovani, G., L. Prosdocimi and E. Barile, *L'umanesimo librario tra Venezia e Napoli: Contributi su Michele Salvatico e su Andrea Contrario* (Istituto Veneto di scienze, lettere ed arti, Memorie. Classe di scienze morali, lettere ed arti, XLV), Venice, 1993.

Marcon, S., 'Esempi di xilominiatura nella Biblioteca di S. Marco', *Ateneo Veneto*, XXIV, 1986, pp. 173-93 (1986a).

–, 'Per la biblioteca a stampa del Domenicano Gioachino Torriano', *Miscellanea Marciana*, I, 1986, pp. 223-48 (1986b).

–, 'I libri del Generale Domenicano Gioachino Torriano († 1500) nel convento veneziano di San Zanipolo', *Miscellanea Marciana*, II-IV, 1987-9, pp. 81-116.

Mardersteig, G., *Liberale ritrovato nell'Esopo Veronese del 1479*, Verona, 1973.

Mariani Canova, G., 'Le origini della miniatura rinascimentale veneta e il Maestro dei Putti (Marco Zoppo?)', *Arte Veneta*, XX, 1966, pp. 73-86.

–, 'Per Leonardo Bellini', *Arte Veneta*, XXII, 1968, pp. 9-20.

–, 'La decorazione dei documenti ufficiali in Venezia dal 1460 al 1530', in *Atti del Istituto Veneto di scienze, lettere, ed arte*, CXXVI, 1968-9, pp. 319-34 (1968-9a).

–, 'Profilo di Benedetto Bordone, miniatore padovano', *Atti Istituto Veneto di scienze, lettere ed arti*, CXXVI, 1968-9, pp. 99-121 (1968-9b).

–, *La miniatura veneta del rinascimento: 1450-1500*, Venice, 1969.

–, 'La miniatura rinascimentale a Padova', in *Dopo Mantegna: Arte a Padova e nel territorio nei secoli XV e XVI*, exh. cat., Palazzo del Raggione, Padua, 1976.

–, 'Una illustre serie liturgica ricostruita: I corali del Bessarione già dell'Annunciata di Cesena', *Saggi e memori di storia dell'arte*, XI, 1977, pp. 9-20, 129-45.

–, *Miniature dell'Italia settentrionale nella Fondazione Giorgio Cini*, Vicenza, 1978 (1978a).

–, 'Un saggio di gusto rinascimentale: I libri miniati di Iacopo Zeno', *Arte Veneta*, XXXII, 1978, pp. 46-55 (1978b).

–, 'Manoscritti miniati dei monasteri Benedettini Padovani', in *I Benedettini a Padova e nel territorio padovano attraverso i secoli*, Padua, 1980, pp. 75-87.

–, 'Girolamo da Cremona in Veneto: Una nuova ipotesi per l'antifonario dei santi Cosma e Damiano', in *Studi di storia dell'arte in memoria di Mario Rotili*, Naples, 1984, pp. 331-46 (1984a).

–, 'La miniatura nei manoscritti liturgici della congregazione di S. Giustina in area padana: Opere e contenuti devozionali', in *Riforma della Chiesa. Cultura e spiritualità nel quattrocento Veneto: Atti del Convegno per il VI centenario della nascita di Ludovico Barbo, 1382-1443, Padova, Venezia, Treviso, 1982*, Cesena, 1984, pp. 475-502 (1984b).

–, 'I Corali', *La Basilica di San Petronio*, Milan, 1984, II, pp. 249-68 (1984c).

–, 'Un quattrocentesco salterio miniato dell'Osservanza francescana a Vicenza', *Le Venezie francescane*, II, 1985, pp. 171-92.

–, 'Libri miniati in Friuli e problemi di miniatura in Veneto: Franco dei Russi, Antonio Maria da Villafora, il *Decretum Gratiani* Roverella', in *Miniatura in Friuli crocevia di civiltà: Atti del Convegno*, ed. L. Menegazzi, Pordenone, 1987, pp. 119-37.

–, 'Da Bologna a Padova, dal manoscritto alla stampa: Contributi alla storia dell'illustrazione degli incunaboli giuridici', in *Rapporti tra le università di Padova e Bologna* (Contributi alla storia dell'Università di Padova, 20), Padua, 1988, pp. 25-69 (1988a).

–, 'Nuovi contributi per Giovanni Vendramin, miniatore padovano,' *Miniatura*, I, 1988, pp. 81-109 (1988b).

–, 'Antonio Grifo, illustratore del Petrarca Queriniano', in *Illustrazione libraria, filologia e esegesi petrarchesca tra quattrocento e cinquecento: Antonio Grifo e l'incunabolo queriniano G V 15* (Studi sul Petrarca, 20), Padua, 1990, pp. 147-200.

–, 'La committenza dei codici miniati alla corte estense al tempo di Leonello e di Borso', in *Le muse e il principe: Arte di corte nel rinascimento padano. Saggi*, ed. A. Mottola Monfrini and M. Natale, 2 vols, Modena, 1991, pp. 87-117.

–, 'Marco Zoppo e la miniatura,' in *Marco Zoppo, Cento 1433-1478 Venezia: Atti del Convegno Internazionale di studi sulla pittura del quattrocento padano, Cento, 1993*, ed. B. Giovannucci Vigi, Bologna, 1993, pp. 121-35.

–, 'Iginus, De Sideribus: Tracce dell'antico nella miniatura umanistica padovana', in *Testo e immagine nel codice miniato rinascimentale: Atti del IV Convegno di storia della miniatura (Cortona, 1993)*, forthcoming.

Massing, J.-M., 'Jacobus Argentoratensis: Etude préliminaire', *Arte Veneta*, XXXI, 1977, pp. 42-52.

–, '*The Triumph of Caesar* by Benedetto Bordone and Jacobus Argentoratensis: Its Iconography and Influence', *Print Quarterly*, VII, 1990, pp. 2-21.

Mazzatinti, G., *Gli archivi della storia d'Italia*, 2 vols, Rocca di San Casciano, 1897-9.

McAndrew, J., *Venetian Architecture of the Early Renaissance*, Cambridge, MA, 1980.

Medica, M., 'In margine all'attività bolognese de Taddeo Crivelli: Il caso del Maestro del Libro dei Notai', *Arte a Bologna: Bollettino dei Musei Civica d'arte antica*, 3, forthcoming.

Meiss, M., *Andrea Mantegna as Illuminator*, New York, 1957.

–, 'Toward a More Comprehensive Renaissance Palaeography', *Art Bulletin*, XLII, 1960, pp. 97-112.

Melnikas A., *The Corpus of the Miniatures in the Manuscripts of Decretum Gratiani*, 2 vols, Rome, 1975.

Melograni, A., 'Appunti di miniatura lombarda: Ricerche sul "Maestro delle Vitae Imperatorum"', *Storia dell' Arte*, LXXIX, 1990, pp. 273-314.

Mercati, G. 'Il Decameron de S. Spirito in Reggio', *Atti e memorie della deputazione di storia patria di Modena e Parma*, X, 1917, pp. xxxvii-xxxviii.

Merisalo, O., ed., *Poggio Bracciolini, De varietate fortunae*, Helsinki, 1993.

Meroni, U., *Mostra dei codici Gonzagheschi 1328-1450*, exh. cat., Biblioteca Comunale, Mantua, 1966.

Michelini Tocci, L., *Il Dante Urbinate della Biblioteca Vaticana (Codies e Vaticanis selecti, XXIX)* Vatican City, 1965.

–, 'Dalla miniatura all'incisione: Un manoscritto di dedica e un' "editio princeps" romani', *Studi storia dell'arte, bibliologia ed erudizione in onore di Alfredo Petrucci*, Milan and Rome, n. d., pp. 81-8.

Milanesi, G., *Nuove indagini con documenti inediti per servire alla storia della miniatura*, Florence, 1850.

–, *Nuovi documenti per la storia dell'arte toscana dal XII al XV secolo*, Florence, 1901.

Milano, E., *Biblioteca Estense, Modena*, Florence, 1987.

Millar, E. G., 'Les manuscrits à peintures des bibliothèques de Londres: Les manuscrits à peintures de la bibliothèque du musée Sir John Soane, Lincoln's Inn Fields, Londres, Soane Museum', *Bulletin de la Société française de reproductions de manuscrits à peintures*, IV, 1914-20, pp. 83-149.

Milliken, W. M., 'The "Pietà" by Andrea Mantegna', *Bulletin of the Cleveland Museum of Art*, XXXIX, 1952, pp. 172-4.

Mirth, K. M., 'Two Manuscripts of Giulio Clovio in America', *Journal of Croatian Studies*, III-IV, 1962-3, pp. 102-13.

Mitchell, C. 'Archaeology and Romance in Renaissance Italy', *Italian Renaissance Studies*, ed. E. F. Jacob, London, 1960, pp. 455-84.

–, 'Felice Feliciano *antiquarius*', *Proceedings of the British Academy*, XLVII, 1961, pp. 197-221 (1961 a).

–, *A Fifteenth-century Italian Plutarch (British Museum Add. Ms. 22318)*, London, 1961 (1961 b).

Moffatt, C. J., *Heraldic Imagery at the Sforza Court in the 1490s: Documents for a Study of Political Symbolism in the Renaissance*, M. A. thesis, University of California, Los Angeles, 1986.

Molajoli, R. M., *L'opera completa di Cosmè Tura e i grandi pittori ferraresi del suo tempo: Francesco Cossa ed Ercole de' Roberti*, Milan, 1974.

Morandini, A. 'Note su alcune corali conservati nell' archivio di Capitolo di San Lorenzo di Firenze', *Miscellanea di studi in memoria di Anna Saitta Revignas*, Florence, 1978, pp. 289-95.

Morando di Custoza, E., *Armoriale veronese*, Verona, 1976.

–, *Libro d'arme di Venezia*, Verona, 1979.

–, *Blazonario veneto*, Verona, 1985.

Moretti, L., 'Di Leonardo Bellini, pittore e miniatore', *Paragone*, IX, no. 99, 1958, pp. 58-66.

–, 'Bellini, Leonardo', in *Dizionario biografico degli italiani*, VII, Rome, 1965, pp. 712-13.

Mortara Ottolenghi, L., 'The Illumination and the Artists', in *The Rothschild Miscellany*, London, 1989, pp. 127-252.

Motta, E., 'Pamfilo Castaldi – Antonio Planella – Pietro Ugelheimer ed il vescovo d'Aleria', *Rivista storica italiana*, I, 1884, pp. 252-72.

Mulas, P. L., 'Un problema di miniatura lombarda tra quattro e cinquecento,' in *B. F. e il Maestro di Paolo e Daria: Un codice e un problema di miniatura lombarda*, ed. L. Giordano, Pavia, 1991, pp. 133-212.

Munari, F., *Catalogue of the Mss. of Ovid's Metamorphoses, University of London, Institute of Classical Studies, Bulletin, Supplement*, no. 4, 1957, pp. 1-74.

Munby, A. N. L., *Connoisseurs and Medieval Miniatures 1750-1850*, Oxford, 1972.

Müntz, E., *La collection Spitzer: Antiquité, moyen-âge, renaissance*, 6 vols, Paris and London, 1890-2.

Murray, C. F., *Catalogo dei libri provenienti dalla biblioteca del Marchese Girolamo d'Adda*, London, 1902.

Narkiss, B., *Hebrew Illuminated Manuscripts*, Jerusalem, 1969.

Needham, P., *Twelve Centuries of Bookbindings 400-1600*, New York, 1979.

New Palaeographical Society, *Facsimiles of Ancient Manuscripts, First Series*, London, 1903-12.

Newton, S. M., *The Dress of the Venetians, 1495-1525*, Aldershot, Hants, 1988.

Pächt, O., 'Notes and Observations on the Origin of Humanistic Book-Decoration', *Fritz Saxl 1890-1948: Memorial Essays*, ed. D. J. Gordon, London, 1957, pp. 184-94.

Pächt, O., and J. J. G. Alexander, *Illuminated Manuscripts in the Bodleian Library, Oxford*, vol. II: *Italian Manuscripts*, Oxford, 1970.

Pächt, O., and A. Campana, 'Giovanni da Fano's Illustrations for Basinio's Epos *Hesperis*', *Studi Romagnoli*, II, 1951, pp. 91-111.

Palaeographical Society: *Facsimiles, Second series*, London, 1884-94.

Palmieri, A., *Rolandino Passaggeri*, Bologna, 1933.

Paltsits, V. H., 'A Renaissance Illuminated Ms. of Valerius Maximus', *New York Public Library Bulletin*, XXXIII, 1929, pp. 847-53.

Panofsky, E., *Renaissance and Renascences in Western Art*, Stockholm, 1960.

Pasini, P. G., 'Matteo de' Pasti: Problems of Style and Chronology', in *Italian Medals* (Studies in the History of Art, 21), ed. J. G. Pollard, Washington, D. C., 1987, pp. 143-59.

Pastore, G., 'Girolamo da Cremona', in *Il Messale di Barbara*, by G. Pastore and G. Manzoli, Mantua, 1991, pp. 119-72.

Pastore, G., and G. Manzoli, *Il Messale di Barbara*, Mantua, 1991.

Paterson, S., *Bibliotheca Fageliana: A Catalogue of the valuable and extensive Library of the Greffier Fagel, of the Hague . . .*, Part I, London Christie's, 1 March 1802, p. 109, no. 2394.

Paz y Mélia, A., 'Códices más notables de la Biblioteca Nacional IV: Sonetos, canciones y Triumfos de Petrarca', *Revista de archivos, bibliotecas y museos*, V, 1901, pp. 145-51.

–, 'Códices más notables de la Biblioteca Nacional, VII: Commedias de Plauto', *Revista de archivos, bibliotecas y museos*, VI, 1902, pp. 17-20.

–, 'Códices más notables de la Biblioteca Nacional', *Revista de archivos, bibliotecas y museos*, XVII, 1907, pp. 201-5.

Pellegrin, E., *La bibliothèque des Visconti et des Sforza, ducs de Milan, au XVe siècle*, Paris, 1955.

–, *Manuscrits de Pétrarque dans les bibliothèques publiques de France*, Padua, 1966.

–, *La bibliothèque des Visconti et des Sforza, ducs de Milan, au XVe siècle: Supplément*, Paris, 1969.

–, *Les manuscrits classiques latins de la Bibliothèque Vaticane*, Paris, I, 1975.

Perrocco, G., *Carpaccio nella Scuola di S. Giorgio degli Schiavoni*, Venice, 1964.

Petrucci, A., ed., *Libri, scrittura e pubblico nel rinascimento*, Rome and Bari, 1979.

Pignatti, T., *Giorgione*, 2nd ed., Milan, 1978.

Pincus, D., *The Arco Foscari: The Building of a Triumphal Gateway in Fifteenth Century Venice*, New York, 1976.

Piscicelli Taeggi, O., *Le miniature nei codici cassinesi*, ser. 2, fasc. 13-15, *I libri corali di S. Pietro di Perugia*, Montecassino, 1887.

Pope-Hennessy, J., *Italian Renaissance Sculpture*, 3rd ed., New York, 1985.

–, *Paradiso: The Illuminations to Dante's Divine Comedy by Giovanni di Paolo*, London, 1993.

Pozza, N., *et al.*, *La stampa degli incunaboli nel Veneto*, Vicenza, 1984.

Pozzi, G., and L. Ciapponi, *Hypnerotomachia Poliphili: Edizione critica e commento*, Padua, 1980.

Pratili, L., 'Felice Feliciano alla luce del suoi codici', *Atti del R. Istituto veneto di scienze, lettere ed arti*, XCIX, 1939-40, pp. 33-105.

Pugliese Carratelli, G., 'Due epistole di Giovanni Brancati su la *Naturalis historia* di Plinio e la versione di Cristoforo Landino', *Atti del Accademia pontaniana*, III, 1950, pp. 179-93.

Puliatti, P., *Il 'De Sphaera' Estense*, Bergamo, 1969.

Puppi, L., 'Osservazione sui riflessi dell'arte di Donatelleo tra Padova e Ferrara', in *Donatello e il suo tempo* (Atti del 8° Convegno internazionale di studi sul Rinascimento, 1966), Florence, 1968, pp. 307-29.

Putaturo Murano, A., *Miniature napoletane del rinascimento*, Naples, 1973.

–, 'Ipotesi per Gaspare Romano, miniatore degli Aragonesi', *Archivio storico per le Provincie Napoletane*, XIV, 1975, pp. 95-110.

Quazza, A., 'La biblioteca del Cardinale Domenico della Rovere: I corali miniati di Torino', in *La miniatura italiana tra gotico e rinascimento: Atti del II Congresso di storia della miniatura italiana, Cortona, 1982*, ed. E. Sesti, Florence, 1985, II, pp. 655-78.

–, 'La committenza di Domenico della Rovere nella Roma di Sisto IV', in *Domenico della Rovere e il Duomo Nuovo di Torino: Rinascimento a Roma e in Piemonte*, ed. G. Romano, Turin, 1990, pp. 13-40.

Rahir, E., 'Manuscripts', in *Catalogue of the Rodolfe Kann Collection*, vol. III: *Objets d'Art*, part I, *Middle Ages and Renaissance*, Paris, 1907.

Raidelius, G. M., *Commentatio critico-literaria de Claudii Ptolemaei geographia ejusque codicibus*, Nuremberg, 1737.

Reeve, M. D., 'The Transmission of Livy 26-40', *Rivista di filologia e istruzione classica*, CXIV, 1986, pp. 129-72.

Reiss, S., 'Cardinal Giulio de' Medici's 1520 Berlin Missal and Other Works by Matteo da Milano', *Jahrbuch der Berliner Museen*, XXXIII, 1991, pp. 107-28.

Reproductions from Illuminated Manuscripts: *Series I*, British Museum, London, 1907.

Reproductions from Illuminated Manuscripts: *Series II.*, 3rd ed., British Museum, London, 1923.

Reproductions from Illuminated Manuscripts: *Series III*, 3rd ed., British Museum, London, 1925.

Reproductions from Illuminated Manuscripts: *Series V*, British Museum, London, 1965.

Reynolds, L. D., and N. G. Wilson, *Scribes and Scholars: A Guide to the Transmission of Greek and Latin Literature*, 2nd ed., Oxford, 1974, 3rd ed., Oxford, 1991.

Rhodes, D. E., *Gli annali tipografici fiorentini del XV secolo*, Florence, 1988.

Ricci, C., *Pintoricchio*, Perugia, 1912.

–, 'Di un codice malatestiano', *Accademie e biblioteche d'Italia*, V-VI, 1928, pp. 20-48.

Robertson, C., *'Il Gran Cardinale,' Alessandro Farnese, Patron of the Arts*, New Haven, 1992.

Robertson, G., *Giovanni Bellini*, Oxford, 1968.

Rodakiewitz, E., 'The *editio princeps* of Roberto Valturio's "De re militari" in Relation to the Dresden and Munich Manuscripts', *Maso Finiguerra*, XVIII-XIX, 1940, pp. 15-82.

Rogledi-Manni, T., *La tipografia a Milano nel secolo XV*, Florence, 1980.

Rosenberg, C., 'The Bible of Borso d'Este: Inspiration and Use', in *Cultura figurativa ferrarese tra XV e XVI secolo: Arte e grafica*, Venice, 1981, pp. 51-73.

Rosenthal, E., 'The German Ptolemy and its World Map', *New York Public Library Bulletin*, XLVIII, February 1944, pp. 135-47.

Rosenthal, J., 'Illuminated Manuscripts at Columbia University', *Medieval and Renaissance Manuscripts at Columbia University* (Rare Book and Manuscript Occasional Publication, 1), ed. B. Terrien-Somerville, New York, 1991, pp. 27-38.

Rössl, J., and H. Konrad, *Tacuinum Sanitatis: Vollständige Faksimileausgabe in Originalformat des Codex 2396 der Österreichischen Nationalbibliothek. Kommentarband* (Codices selecti LXXVIII, LXXVIII*), Graz, 1984.

Rothe, E., *Medieval Book Illumination in Europe*, trans. M. Whittall, London, 1968.

Rouse, M. A., and R. H. Rouse, *Cartolai, Illuminators and Printers in Fifteenth-Century Italy: The Evidence of the Ripoli Press* (UCLA, University Research Library, Department of Special Collections, Occasional Papers, 1), Los Angeles, 1988, pp. 13-94.

Rubinstein, R., 'A Drawing of a Bacchic Sarcophagus in the British Museum and Folios from a Renaissance Sketchbook', in *Cassiano dal Pozzo's Paper Museum*, Milan, 1992, I, pp. 66-78.

Ruhmer, E., *Marco Zoppo*, Vicenza, 1966.

Ruysschaert, J., 'Miniaturistes "romains" à Naples', in T. de Marinis, *La Biblioteca Napoletana dei Re d'Aragona: Supplemento*, Verona, 1969, I, pp. 261-74.

–, 'Il copista Bartolomeo San Vito miniatore padovano a Roma dal 1469 al 1501', *Archivio della Società di storia patria*, CIX, 1986, pp. 37-47.

Ryskamp C., ed., *Eighteenth Report to the Fellows of the Pierpont Morgan Library, 1975-1977*, New York, 1978.

–, *Nineteenth Report to the Fellows of the Pierpont Morgan Library, 1978-1980*, New York, 1981.

–, *Twentieth Report to the Fellows of the Pierpont Morgan Library, 1981-1983*, New York, 1984.

Sabbadini, R., 'Ciriaco d'Ancona e la sua descrizione autografa del Peloponneso trasmessa da Leonardo Botta', in *Miscellanea Ceriani: Nel III Centenario della Biblioteca Ambrosiana*, Milan, 1910, pp. 183-247.

Salmi, M., 'La miniatura', in D. Fava, *Tesori delle biblioteche d'Italia: Emilia Romagna*, Milan, 1932, pp. 265-374.

–, *Italian Miniatures*, New York, 1957.

–, *Pittura e miniatura a Ferrara nel primo rinascimento*, Milan, 1961.

–, 'I Trionfi del Petrarca nel primo rinascimento', in *Atti e memorie dell'Accademia Petrarca di lettere, arti e scienze*, XLI, 1973-5, pp. 165-71.

Samaran, C., and R. Marichal, *Catalogue des manuscrits en écriture latine portant des indications de date, de lieu ou de copiste*, vol. II: *Bibliothèque nationale, fonds latin (nos. 1-8000)*, ed. M. Mabille, M.-C. Garand and J. Metman, Paris, 1962.

–, *Catalogue des manuscrits en écriture latine portant des indications de date, de lieu ou de copiste*, vol. III: *Bibliothèque nationale, fonds latin (nos. 8001 à 18613)*, ed. M.-T. d'Alverny, Paris, 1974.

Samek Ludovici, A., *Il 'De Sphaera' Estense e il iconografia astrologica*, Milan, 1958.

Sander, M., *Le livre à figures italien depuis 1467 jusqu'en 1530*, 6 vols, Milan, 1942.

San Juan, R. M., 'The Illustrious Poets in Signorelli's Frescoes for the Cappella Nuova of Orvieto Cathedral', *Journal of the Warburg and Courtauld Institutes*, LII, 1989, pp. 71-84.

Santoro, C., *I codici miniati della Biblioteca Trivulziana*, Milan, 1958.

Saxl, F., and H. Meier, *Verzeichnis astrologischer und mythologischer illustrierter Handschriften des lateinischen Mittelalters, III: Handschriften in englischen Bibliotheken*, ed. H. Bober, 2 vols, London, 1953.

Scalabroni, L., 'Il sarcofago bacchico di S. Maria Maggiore', in *Da Pisanello alla nascita dei Musei Capitolini: L'antico a Roma alla vigilia del rinascimento*, exh. cat., Musei Capitolini, Rome, 1988, pp. 161-71.

Scheller, R. W., *A Survey of Medieval Model Books*, Haarlem, 1963.

Schmitt, A., 'Zur Wiederbelebung der Antike im Trecento', *Mitteilungen des Kunsthistorischen Institutes in Florenz*, XVIII, 1974, pp. 167-218.

Scholderer, V., 'Printing at Venice to the End of 1481', *The Library*, V, 1924, pp. 129-52.

Scholz, J., *Italian Master Drawings 1350-1800 from the Janos Scholz Collection*, New York, 1976.

Schönbrunner, J., and J. Meder, *Handzeichnungen alter Meister aus der Albertina und anderen Sammlungen*, VI, Vienna, 1901.

Schröter, E., 'Eine unveröffentlichte Sueton-Handschrift in Göttingen aus dem Atelier des Bartolomeo Sanvito', *Jahrbuch der Berliner Museen*, XXIX-XXX, 1987-8, pp. 71-121.

Serafini, A., 'Ricerche sulla miniatura umbra: I miniatori umbri prima di P. Perugino', *L'Arte*, XV, 1912, pp. 98-121; 'Ricerche sulla miniatura umbra (secoli XIV-XVI): La scuola peruginesca', pp. 232-62; 'I maestri urbinati e le influenze ferraresi nell' Umbria', pp. 417-39.

Settis, S., 'Von auctoritas zu vetustas: Die antike Kunst in mittelalterlicher Sicht', *Zeitschrift für Kunstgeschichte*, LI, 1988, pp. 157-79.

Shapley, F. R., *Catalogue of the Italian Paintings, I: Washington, National Gallery of Art*, Washington, D.C., 1979.

Sheppard, L. A., *Catalogue of XVth Century Books in the Bodleian Library*, n. d. (unpublished manuscript).

Simon, R. B., 'Giulio Clovio's Portrait of Eleanora di Toledo', *The Burlington Magazine*, CXXXI, 1989, pp. 481-5.

Smith, W., *The Farnese Hours*, New York, 1976.

The Spencer Collection of Illustrated Books, New York, 1928.

Stapleford, R., 'Intellect and Intuition in Botticelli's *Saint Augustine*', *Art Bulletin*, LXXVI, 1994, pp. 69-80.

Stechow, W., 'Shooting at Father's Corpse', *Art Bulletin*, XXIV, 1942, pp. 213-25.

Steingräber, E., 'Zwei "libri d'ore" des Lorenzo Magnifico de' Medici', in *Studien zur toskanischen Kunst: Festschrift für Ludwig. H. Heydenreich*, ed. W. Lotz and L. L. Möller, Munich, 1964, pp. 303-13.

Stevenson, E. L., and J. Fischer, *Geography of Claudius Ptolemy*, New York, 1932.

Stix, A., and A. Spitzmüller, *Beschreibender Katalog der Handzeichnungen in der Staatlichen Graphischen Sammlung Albertina. Band VI: Die Schulen von Ferrara, Bologna, etc.*, Vienna, 1941.

Stornajolo, C., *Codices Urbinates Latini*, I, Vatican City, 1902.

Suida, W., 'Italian Miniature Paintings from the Rodolfe Kann Collection', *Art in America*, XXXV, 1947, pp. 19-33.

–, 'Giovanni Ambrogio de Predis miniatore', *Arte Lombarda*, IV, 1959, pp. 67-73.

Szepe, H. K., *The Polifilo and Other Aldines Reconsidered in the Context of the Production of Decorated Books in Venice*, Ph. D. diss., Cornell University, Ithaca, 1991.

–, 'The Book as Companion, The Author as Friend: Aldine Octavos Illuminated by Benedetto Bordon', *Word and Image*, 1994, forthcoming.

Talamo, E. A., 'I messali miniati del cardinale Juan Alvarez de Toledo', *Storia dell'Arte*, LXVI, 1989, pp. 159-69.

Thomas, H. M., 'Ein "Ratschluss" des Ludovico il Moro', *Libri e documenti*, VII, no. 2, 1981, pp. 30-3.

Thompson, H. Yates, 'The Most Magnificent Book in the World?', *The Burlington Magazine*, IX, 1906, pp. 16-21.

–, *Descriptive Catalogue of Twenty Iluminated Manuscripts: Series III*, Cambridge, 1907.

–, *Illustrations from One Hundred Manuscripts: Series VI*, London, 1916.

Thornton, P., and H. Dorey, *A Miscellany of Objects from Sir John Soane's Museum*, London, 1992.

Thorp, N., *The Glory of the Page: Medieval and Renaissance Illuminated Manuscripts from Glasgow University Library*, exh. cat., Art Gallery of Ontario *et al.*, London, 1987.

Thurston, and A., C. F. Bühler, *A Checklist of Fifteenth Century Printing in the Pierpont Morgan Library*, New York, 1939.

Toesca, I., 'In margine al "Maestro delle Vitae Imperatorum"', *Paragone*, no. 237, 1969, pp. 73-7.

Toesca, P., *La pittura e la miniatura nella Lombardia dai più antichi documenti alla metà del quattrocento*, Milan, 1912.

Toniolo, F., 'A proposito del libro d'ore di Alfonso I', *Miniatura*, II, 1989, pp. 149-51.

–, *La Bibbia di Borso d'Este e i suoi miniatori*, Ph. D. diss., Università di Padova, 1990-3.

–, 'L'antifonario certosino D del Museo Civico di Schifanoia: Proposte per il catalogo di Tommaso da Modena miniatore alla corte estense di Ferra', *Miniatura*, III-IV, 1993, pp. 62-86.

–, 'Un libro d'ore di Niccolò di Leonello d'Este', *Musei Ferraresi*, XVII, 1994, pp. 37-41.

Tornielle, A., *I corali miniati di Vegevano*, Milan, 1946.

Toscano, G., 'La librairie des rois d'Aragon à Naples', *Bulletin du Bibliophile*, II, 1993, pp. 265-83.

Tosetti Grandi, P., 'Lorenzo Costa miniatore', in *La miniatura italiana tra gotico e rinascimento: Atti del II Congresso di storia della miniatura italiana, Cortona, 1982*, ed. E. Sesti, Florence, 1985, II, pp. 329-53.

Trapier, E. 'El Greco in the Farnese Palace', *Gazette des Beaux-Arts*, LI, 1958, pp. 73-90.

Trapp, J. B., *Erasmus, Colet and More: The Early Tudor Humanists and their Books* (Panizzi Lecture, 1990), London, 1991.

Ullmann, B. L., *The Origin and Development of Humanistic Script*, Rome, 1960.

Vailati Schoenburg Waldenburg, G., 'La libreria di coro di Lecceto', in *Lecceto e gli eremiti agostiniani in terra di Siena*, Siena, 1990, pp. 331-572.

Van Mater Dennis 3d, H., 'The Garrett Manuscript of Marcanova', *Memoirs of the American Academy in Rome*, VI, 1927, pp. 113-26.

Van Moé, E., 'Les trionfes de Pétrarque d'après le manuscrit italien 545 de la Bibliothèque nationale', *Trésors des bibliothèques de France*, XIII, 1931, pp. 3-15.

Van Praet, J. B. B., *Catalogue des livres imprimés sur vélin de la Bibliothèque du Roi*, 6 vols, Paris, 1822, 1828.

Van Thienen, G., 'Incunabula from the Abbey of Tongerlo: The Provenance of Part of the Collection of Incunables in the Koninklijke Bibliotheek, The Hague', in *Hellinga: Festschrift/Feestbundel/Mélanges*, Amsterdam, 1980, pp. 481-92.

Varese, R., ed., *Atlante di Schifanoia*, Modena, 1989.

Vasari, G., and G. Milanesi, *Le opere di Giorgio Vasari con nuovi annotazioni e commenti di Gaetano Milanesi*, 9 vols, Florence, 1906.

Vattasso, M., and P. F. de' Cavalieri, *Bibliotecae Apostolicae Vaticanae Cod. Manu Scripti Recensiti. Codices Vaticani Latini, 1, Cod. 1-678*, Rome, 1902.

Venturi, A., 'Il pontificale di Antonio da Monza nella Biblioteca Vaticana', *L'Arte*, I, 1898, pp. 154-64; ibid, II, 1899, 114.

–, *Storia dell'arte italiana: La pittura del quattrocento*, VII, Milan, 1914.

–, 'Francesco di Giorgio Martini scultore', *L'Arte*, XXVI, 1923, pp. 197-228.

–, 'Un grande miniatore quattrocentesco', *L'Arte*, XXVIII, 1925, pp. 191-4 (1925a).

–, 'Per Francesco di Giorgio Martini', *L'Arte*, XXVIII, 1925, pp. 51-8 (1925b).

–, *La Bibbia di Borso d'Este riprodotta integralmente per mandata di Giovanni Treccani con documenti e studio storico di Adolfo Venturi*, 2 vols, Milan, 1937, 2nd ed., 1961.

Via, C. C., 'Ipotesi di un percorso funzionale e simbolico nel Palazzo Ducale di Urbino attraverso le immagini', in *Federico da Montefeltro: Lo stato, le arti, la cultura*, ed. G. C. Baiardi, G. Chittolini and P. Floriani, Rome, 1986, II, pp. 47-64.

Vian, N., 'Disavventure e morte di Vincent Raymond, miniatore papale', *La Bibliofilia*, LX, 1958, pp. 356-60.

Vitali, M., 'L'umanista padovano Giovanni Marcanova (1410/18-67) e la sua biblioteca', *Ateneo Veneto*, XXI, 1983, pp. 127-61.

Viti, P., in *Consorterie politiche e mutamenti istituzionale in età laurenziana*, ed. M. A. Morelli Timpanaro *et al.*, Archivio di stato di Firenze, Florence, 1992.

Vivian, F., *Il console Smith, mercante e collezionista*, Vicenza, 1971.

Voelkle, W. M., ed., *The Pierpont Morgan Library: Masterpieces of Medieval Painting. The Art of Illumination*, Chicago, 1980.

Von Arnim, M., and A. Lauter, *A Selection of Illuminated Manuscripts, Printed Books, and Bindings in the Otto Schäfer Collection Schweinfurt*, Schweinfurt, 1970.

Von Euw, A., and J. M. Plotzek, *Die Handschriften der Sammlung Ludwig*, I, Cologne, 1979.

–, *Die Handschriften der Sammlung Ludwig*, II, Cologne, 1982.

Waagen, G. F., *Kunstwerke und Künstler in Paris*, Berlin, 1839.

–, *Treasures of Art*, II, London, 1854.

–, 'Über ein Manuscript mit Miniaturen des Don Giulio Clovio', *Deutsches Kunstblatt*, VI, no. 37, 1856, pp. 326-7.

Wallis, A., *Examples of the Book-Binder's Art of the XVI. and XVII. Centuries*, London and Exeter, 1890.

Wardrop, J., 'Pierantonio Sallando and Girolamo Pagliorolo, Scribes to Giovanni II Bentivoglio', *Signature*, II, 1946, pp. 4-30.

–, *The Script of Humanism*, Oxford, 1963.

Warner, G. F., *Miniatures and Borders from the Book of Hours of Bona Sforza, Duchess of Milan*, London, 1894.

–, *Illuminated Manuscripts in the British Museum: Series IV*, London, 1903.

–, *Descriptive Catalogue of Illuminated Manuscripts in the Library of C. W. Dyson Perrins*, Oxford, 1920.

Warner, G. G., and J. P. Gilson, *Catalogue of Manuscripts in the Old Royal and King's Collections*, 4 vols, London, 1921.

Weiss, R., 'Lineamenti per una storia degli studi antiquari in Italia dal dodecesimo secolo al sacco di Roma del 1527', *Rinascimento*, IX, 1959, pp. 41-4.

–, *The Renaissance Discovery of Classical Antiquity*, 2nd ed., Oxford, 1988.

Weller, A. S., *Francesco di Giorgio 1439-1501*, Chicago, 1943.

Wescher, P., 'Eine Miniaturen-Handschrift des Benedetto Padovano im Berliner Kupferstichkabinett', *Der Cicerone*, XXI, 1929, pp. 345-47.

–, *Beschreibendes Verzeichnis der Miniaturen, Handschriften und Einzelblätter des Kupferstichkabinetts der Staatlichen Museen Berlin*, Leipzig, 1931.

–, 'Francesco Binasco, Miniaturmaler der Sforza', *Jahrbuch der Berliner Museen*, II, 1960, pp. 75-91.

–, 'Binasco, Francesco', in *Dizionario biografico degli italiani*, X, Rome, 1968, pp. 487-8 (1968 a).

–, 'Birago, Giovanni Pietro da', in *Dizionario biografico degli italiani*, X, Rome, 1968, pp. 592-3 (1968 b).

Wieck, R. S., *Late Medieval and Renaissance Illuminated Manuscripts 1350-1525, in the Houghton Library*, Cambridge, MA, 1983.

Wittgens, F., 'Cristoforo de Predis', *La Bibliofilia*, XXXVI, 1934, pp. 341-70.

Wittkower, R., *Art in Italy, 1600-1700*, New York, 1982.

Wright, C. E., *Fontes Harleianae*, 2 vols, British Museum, London, 1972.

Wyss, R. L., *Die Caesarteppiche und ihr ikonographisches Verhältnis zur Illustration der 'Fait des Romains' im 14. und 15. Jahrhundert*, Bern, 1957.

Zaccaria, F. A., *Series episcoporum caesenatium a Ferdinando Ughellio contexta a Nicola Coleto aliquantulum aucta et emendata: Nunc a Francesco Zaccaria ut fieri restituta*, Cesena, 1779.

Zapperi, R., 'Botta, Leonardo', in *Dizionario biografico degli italiani*, XIII, Rome, 1971, pp. 374-9.

–, 'Campora (Canfora), Giacomo', in *Dizionario biografico degli italiani*, XVII, Rome, 1974, pp. 581-4.

Zazzeri, R., *Storia di Cesena dalla sua origine fino ai tempi di Cesare Borgia*, Cesena, 1890.

Zinanni, B., 'Brevi notizie sui libri corali del monastero di San Pietro di Perugia', in G. Milanesi, *Storia della miniatura italiana con documenti inediti*, Florence, 1850.

Zorzi, M., ed., *Biblioteca Marciana di Venezia*, Florence, 1988.

Zuffi, S., 'Araldica ducale nei codici miniati milanesi del XV secolo,' *Rinascimento in miniatura dedicato a Stella Matalon* (Quaderni di Brera, VI), Florence, 1990, pp. 50-62.

Addenda

Courcelle, P. J. Courcelle, *Lecteurs païens et lecteurs chrétiens de l'Eneide, 2. Les manuscrits illustrés de l'Eneide du X^e au XV^e siècle*, Paris 1984.

Tambini, A., 'Pittura nel secondo Quattrocento in Romagna', *Faenza e mi paes*, XVIII, 1991, pp. 7-27.

Exhibition Catalogues

Austin, Berkeley and New Haven 1988-9 *The Sforza Court: Milan in the Renaissance 1450-1535*, cat. by A. Norris, Archer M. Huntington Art Gallery, University of Texas at Austin; University Art Museum, University of California, Berkeley; Yale University Art Gallery, New Haven, 1988-9.

Baltimore 1949 *Illuminated Books of the Middle Ages and Renaissance*, cat. by D. Miner, Walters Art Gallery, Baltimore, 1949.

Baltimore 1957 *The History of Bookbinding 525-1950 A.D.*, cat. by D. Miner, Baltimore Museum of Art, Baltimore, 1957.

Baltimore 1965 *2000 Years of Calligraphy*, cat. by D. E. Miner, V. I. Carlson, P. W. Filby, Walters Art Gallery, Baltimore, 1965.

Baltimore 1984 *The Taste of Maryland*, Walters Art Gallery, Baltimore, 1984.

Barcelona 1988 *La corona de Aragón en el Mediterraneo, legado común para Italia y España 1282-1492*, Barcelona, 1988.

Berlin 1975 *Zimelien: Abendländische Handschriften des Mittelalters und den Sammlungen der Stiftung Preussischer Kulturbesitz*, Staatliche Museen, Berlin, 1975.

Berlin, 1994 *Meisterwerke aus zehn Jahrhunderten im Berliner Kupferstichkabinett*, ed. T. Joksch, Staatliche Museen, Kupferstichkabinett, Berlin, 1994.

Blois and Paris 1992 *Des livres et des rois: La bibliothèque royale de Blois*, cat. by U. Baurmeister and M.-P. Lafitte, Château de Blois; Bibliothèque nationale, Paris, 1992.

Brooklyn 1936 *An Exhibition of European Art 1450-1500*, Brooklyn Museum, New York, 1936.

Brussels 1963 *Trésors des bibliothèques d'Ecosse*, Bibliothèque Royale Albert Ier, Brussels, 1963.

Brussels 1969 *La miniature italienne du Xe au XVIe siècle*, Bibliothèque Royale Albert Ier, Brussels, 1969.

Brussels 1985 *Les rois bibliophiles, Europalia 85: España*, Bibliothèque Royale Albert Ier, Brussels, 1985.

Budapest 1983 *Matyas Kiraly és a Magyarorszagi Reneszansz 1458-1541*, Budapest, 1983.

Budapest 1990 *Bibliotheca Corviniana 1490-1990. International Corvina Exhibition on the 500th Anniversary of the Death of King Matthias*, cat. by C. Csapodi, K. Csapodi-Gárdonyi, National Széchényi Library, Budapest, 1990.

Cambridge 1955 *Illuminated and Calligraphic Manuscripts*, Harvard College Library, Cambridge, MA, 1955.

Cambridge 1983 See Bibliography: Wieck 1983.

Cesena 1989 *Corali miniati del quattrocento nella Biblioteca Malatestina*, Biblioteca Malatestina, Cesena, 1989.

Cleveland 1971 *Florence and the Arts: Five Centuries of Patronage*, cat. by E. P. Pillsbury, Cleveland Museum of Art, 1971.

Cologne 1992 *Biblioteca Apostolica Vaticana: Liturgie und Andacht im Mittelalter*, ed. J. M. Plotzek and U. Surmann, Erzbischöfliches Diözesanmuseum Köln, Cologne, 1992.

Denver 1993 *Vatican Treasures: 2000 Years of Art and Culture in the Vatican and Italy*, ed. G. Morelli, Denver, 1993.

Dublin 1964 *Treasures from Scottish Libraries*, Trinity College Library, Dublin, 1964.

Edinburgh 1979 *Treasures of the National Library of Scotland*, National Library of Scotland, Edinburgh, 1979.

Florence 1949 *Mostra della biblioteca di Lorenzo nella Biblioteca Medicea-Laurenziana*, cat. by T. Lodi and S. Vagaggini, Biblioteca Medicea-Laurenziana, Florence, 1949.

Florence 1972 *Il tesoro di Lorenzo il Magnifico: Le gemme*, cat. by N. Dacos, A. Giuliano and U. Pannuti, Palazzo Medici Riccardi, Florence, 1972.

Florence 1975 *Mostra di manoscritti, documenti e edizioni: I manoscritti e documenti (VI Centenario della morte di Giovanni Boccaccio)*, Biblioteca Medicea-Laurenziana, Florence, 1975.

Florence 1982 *Codici liturgici miniati dei Benedettini in Toscana*, Centro d'Incontro della Certosa di Firenze, Florence, 1982.

Florence 1987 *Uomini, bestie e paesi nelle miniature laurenziane*, cat. by L. Bigliazzi and A. Giannozzi, Biblioteca Medicea-Laurenziana, Florence, 1987.

Florence 1989 *La collezione di Angelo Maria d'Elci*, cat. by A. Dillon Bussi *et al.*, Biblioteca Medicea-Laurenziana, Florence, 1989.

Florence 1990 *Pittura di luce: Giovanni di Francesco e l'arte fiorentina di metà quattrocento*, cat. by L. Bellosi, Casa Buonarroti, Florence, 1990.

Florence 1992 a *All'ombra del lauro: Documenti librari della cultura in età laurenziana*, Biblioteca Medicea-Laurenziana, Florence, 1992.

Florence 1992 b *Consorterie politiche e mutamenti istituzionali in età laurenziana*, cat. by A. M. Morelli Timpanaro, R. Manno Tolu and P. Viti, Archivio di Stato, Florence, 1992.

Florence 1992 c *Lorenzo dopo Lorenzo: La fortuna storica de Lorenzo il Magnifico*, ed. P. Pirolo, Biblioteca Nazionale, Florence, 1992.

Foligno, Ravenna and Florence 1989-90 *Pagine di Dante: Le edizioni della Divina Commedia dal torchio al computer*, Oratorio del Gonfalone, Foligno, 1989; Biblioteca Classense, Ravenna, 1989; Florence, 1990.

Forlì 1938 *Mostra di Melozzo e del quattrocento romagnolo*, Palazzo dei Musei, Forlì, 1938.

The Hague 1980 *Schatten van de Koninklijke Bibliotheek*, Rijksmuseum Meermanno-Westreenianum, The Hague, 1980.

Houston 1966 *Builders and Humanists*, University of St Thomas, Art Department, Houston, 1966.

London 1893-4 *Exhibition of Early Italian Art from 1300-1550*, New Gallery, London, 1893-4.

London 1908 *Exhibition of Illuminated Manuscripts*, Burlington Fine Arts Club, London, 1908.

London 1912 *Early Venetian Pictures and Other Works of Art*, Burlington Fine Arts Club, London, 1912.

London 1980 *The Universal Penman: A Survey of Western Calligraphy from the Roman Period to 1980*, cat. by J. I. Whalley and V. C. Kalen, Victoria and Albert Museum, London, 1980.

London 1981 *Splendours of the Gonzaga*, ed. D. Chambers and J. Martineau, Victoria and Albert Museum, London, 1981.

London 1982 *Virgil: His Poetry through the Ages*, ed. R. D. Williams, British Library, London, 1982.

London and New York 1992 *Andrea Mantegna*, ed. J. Martineau, Royal Academy of Arts, London; Metropolitan Museum of Art, New York, 1992.

Los Angeles 1987 *Illumination in Early Printed Books*, checklist and descriptions by R. H. Rouse, University Research Library, University of California at Los Angeles, 1987.

Los Angeles, Seattle and Albuquerque 1967-8 *Tuscan and Venetian Drawings of the Quattrocento from the Collection of Janos Scholz*, Los Angeles, Seattle, Albuquerque, 1967-8.

Lyons 1920 *Catalogue exposition manuscrits à peintures, Bibliothèque de Lyon*, cat. by V. Leroquais, 1920.

Malibu, New York and London 1983-4 *Renaissance Painting in Manuscripts: Treasures from the British Library*, ed. T. Kren, J. Paul Getty Museum, Malibu, 1983-4; Pierpont Morgan Library, New York, 1984; British Library, London, 1984.

Mantua 1966 *Mostra dei codici Gonzagheschi 1328-1450*, ed. U. Meroni, Biblioteca Comunale, Mantua, 1966.

Milan 1958 *Arte lombarda dai Visconti agli Sforza*, Palazzo Reale, Milan, 1958.

Milan 1991 *Le muse e il principe: Arte di corte nel rinascimento padano*, ed. A. Mottola Monfrini and M. Natale, Milan, Museo Poldi-Pezzoli, 1991.

Modena 1928 *Mostra del libro emiliano della Reale Biblioteca Estense di Modena*, Biblioteca Estense, Modena, 1928.

Munich 1983 *Thesaurus librorum: 425 Jahre Bayerische Staatsbibliothek*, Bayerische Staatsbibliothek, Munich, 1983.

New York 1892 *Catalogue of an Exhibition of Illuminated and Painted Manuscripts*, Grolier Club of New York, 1892.

New York 1913 *Ecclesiastical Books and Manuscripts*, Avery Library, Columbia University, New York, 1913.

New York 1923 *Exhibition of the Arts of the Italian Renaissance*, Metropolitan Museum of Art, New York, 1923.

New York 1924 *A Guide to an Exhibition of the Arts of the Book*, cat. by W. M. Ivins, Jr, Metropolitan Museum of Art, New York, 1924.

New York 1934 *The Pierpont Morgan Library: Exhibition of Illuminated Manuscripts Held at the New York Public Library*, cat. by B. Da Costa Green and M. P. Harrsen, New York Public Library, New York, 1934.

New York 1939 *The Pierpont Morgan Library: Illustrated Catalogue of an Exhibition Held on the Occasion of the New York World's Fair, 1939*, Pierpont Morgan Library, New York, 1939.

New York 1940 *The Pierpont Morgan Library: Illustrated Catalogue of an Exhibition Held on the Occasion of the New York World's Fair, 1940*, Pierpont Morgan Library, New York, 1940.

New York 1947 *The Bible*, Pierpont Morgan Library, New York, 1947.

New York 1949 *The First Quarter Century of the Pierpont Morgan Library*, Pierpont Morgan Library, New York, 1949.

New York 1957 *Treasures from the Pierpont Morgan Library: Fiftieth Anniversary Exhibition*, Pierpont Morgan Library, New York, 1957.

New York 1961 *Italian Drawings from the Janos Scholz Collection*, Staten Island Museum, New York, 1961.

New York 1963 *Books and Manuscripts from the Heineman Collection*, Pierpont Morgan Library, New York, 1963.

New York 1964 *Liturgical Manuscripts for the Mass and the Divine Office*, cat. by J. Plummer and A. Strittmatter, Pierpont Morgan Library, New York, 1964.

New York 1975 *The Secular Spirit: Life and Art at the End of the Middle Ages*, introd. T. B. Husband and J. Hayward, Metropolitan Museum of Art, New York, 1975.

New York 1980 *Flowers in Books and Drawings ca. 940-1840*, cat. by H. B. Mules, Pierpont Morgan Library, New York, 1980.

New York 1981 *A Selection of Medieval and Renaissance Manuscripts at Columbia University*, cat. by J. Rosenthal, Low Memorial Library, Columbia University, New York, 1981.

New York 1982 *The Last Flowering: French Painting in Manuscripts, 1420-1530, from American Collections*, cat. by J. Plummer and G. Clark, Pierpont Morgan Library, New York, 1982.

New York 1984, *Italian Manuscript Painting, 1300-1550*, cat. by W. M. Voelkle and G. Clark, Pierpont Morgan Library, New York, 1984.

New York 1985 *Collections and Treasures*, Rare Book and Manuscript Library of Columbia University, New York, 1985.

New York 1988 *Painting in Renaissance Siena 1420-1500*, cat. by K. Christiansen, L. B. Kanter and C. B. Strehlke, Metropolitan Museum of Art, New York, 1988.

New York 1991 *Naples, The Lost Renaissance: Neapolitan Books and Manuscripts from the Collections of the New York Public Library*, cat. by W. E. Coleman and G. D. Piltch, New York Public Library, 1991.

New York 1992 *The Bernard Breslauer Collection of Manuscript Illuminations*, cat. by W. M. Voelkle, R. S. Wieck and M. F. P. Saffiotti, Pierpont Morgan Library, New York, 1992.

New York 1992-3 *Printers and Miniaturists: Illuminated Books from Venice 1469-1483* (no catalogue), Pierpont Morgan Library, New York, 1992-3.

New York 1994a *Gutenberg and the Genesis of Printing*, gallery guide by H. G. Fletcher, Pierpont Morgan Library, New York, 1994.

New York 1994b *Petrus Christus: Renaissance Master of Bruges*, cat. by M. W. Ainsworth, Metropolitan Museum of Art, New York, 1994.

Northampton 1978 *Antiquity in the Renaissance*, cat. by W. S. Sheard, Smith College Museum of Art, Northampton, MA, 1978.

Oxford 1948 *Italian Illuminated Manuscripts*, cat. by O. Pächt, Bodleian Library, Oxford, 1948.

Oxford 1984 *The Douce Legacy: An Exhibition to Commemorate the 150th Anniversary of the Bequest of Francis Douce (1757-1834)*, Bodleian Library, Oxford, 1984.

Padua 1976 *Dopo Mantegna: Arte a Padova e nel territorio nei secoli XV e XVI*, Palazzo del Ragione, Padua, 1976.

Paris 1926 *Le livre italien (manuscrits, livres imprimés, reliures)*, cat. by S. de Ricci, Bibliothèque nationale, Musée des arts décoratifs, Paris, 1926.

Paris 1935 *Exposition de l'art italien de Cimabue à Tiepolo*, Petit Palais, Paris, 1935.

Paris 1950 *Trésors des bibliothèques d'Italie*, Bibliothèque nationale, Paris, 1950.

Paris 1984 *Dix siècles d'enluminure italienne (VIe-XVIe siècles)*, cat. by F. Avril et al., Bibliothèque nationale, Paris, 1984.

Paris 1993 *Les manuscrits à peintures en France, 1440-1520*, cat. by F. Avril and N. Reynaud, Bibliothèque nationale, Paris, 1993.

Philadelphia and New York 1988 *Rosenbach Abroad: In Pursuit of Books in Private Collections*, cat. by L. A. Morris, Rosenbach Museum and Library, Philadelphia, 1988; Pierpont Morgan Library, New York, 1988.

Rimini 1970 *Sigismondo Malatesta e il suo tempo: Mostra storica*, cat. by F. Arduini et al., Palazzo dell'Arengo, Rimini, 1970.

Rome 1953 *Mostra storica nazionale della miniatura*, ed. G. Muzzioli, Palazzo Venezia, Rome, 1953.

Rome 1988 *Da Pisanello alla nascita dei Musei Capitolini: L'antico a Roma alla vigilia del rinascimento*, Musei Capitolini, Rome 1988.

San Francisco 1977 *The Triumph of Humanism: A Visual Survey of the Decorative Arts of the Renaissance*, introd. D. Graeme Keith, California Palace of the Legion of Honor, San Francisco, 1977.

Schallaburg 1982 *Matthias Corvinus und die Renaissance in Ungarn*, Schloß Schallaburg, 1982.

Siena 1993 *Francesco di Giorgio e il rinascimento a Siena 1450-1500*, ed. L. Bellosi, Chiesa di Sant' Agostino, Siena, 1993.

Stockholm 1962 *Konstens Venedig*, ed. P. Grate, Nationalmuseum, Stockholm, 1962.

Toronto et al. 1987-9 *The Glory of the Page: Medieval and Renaissance Illuminated Manuscripts from Glasgow University Library*, cat. by N. Thorp, The Art Gallery of Ontario, Toronto, et al., 1987-9.

Urbino 1992 *Piero e Urbino: Piero e le corti rinascimentali*, ed. P. dal Poggetto, Palazzo Ducale, Urbino, 1992.

Vatican 1950 *Miniature del rinascimento*, Biblioteca Apostolica Vaticana, Vatican City, 1950.

Vatican 1972 *Il libro della bibbia*, Biblioteca Apostolica Vaticana, Vatican City, 1972.

Vatican 1975 *Quinto centenario della Biblioteca Apostolica Vaticana, 1475-1975*, Biblioteca Apostolica Vaticana, Vatican City, 1975.

Vatican 1985 *Raffaello e la Roma dei papi*, ed. G. Morelli, Salone Sistino, Vatican City, 1985.

Verona 1986 *Miniatura veronese del rinascimento*, ed. G. Castiglioni and S. Marinelli, Museo del Castelvecchio, Verona, 1986.

Vienna 1969 *Grosse Bibliophile des 18. Jahrhunderts*, Österreichische Nationalbibliothek, Vienna, 1969.

Vienna 1975 *Wissenschaft im Mittelalter*, cat. by O. Mazal, Österreichische Nationalbibliothek, Vienna, 1975.

Vienna 1986 *Biblioteca Eugeniana: Die Sammlungen des Prinzen Eugen von Savoyen*, Österreichische Nationalbibliothek, Vienna, 1986.

Venice 1994 *Rinascimento da Brunelleschi e Michelangelo: La rappresentazione dell'architettura*, ed. H. Millon and V. Magnano Lampugnani, Palazzo Grassi, Venice, 1994.

Wolfenbüttel 1981 *Die Welt in Büchern: Aus den Schätzen der Herzog August Bibliothek Wolfenbüttel*, Wolfenbüttel, 1981.

Wolfenbüttel 1989 *Wolfenbütteler Cimelien: Das Evangeliar Heinrichs des Löwen in der Herzog August Bibliothek*, Herzog August Bibliothek, Wolfenbüttel, 1989.

Washington 1993 *Rome Reborn: The Vatican Library and Renaissance Culture*, ed. A. Grafton, Library of Congress, Washington, D. C., 1993.

Glossary

Antiphonary – A *Choir Book* containing the musical chants (Antiphons) to be sung at the Daily *Offices* throughout the liturgical year of the Catholic Church.

bas-de-page – The wide lower margin of a *folio* in a manuscript or early printed book.

bianchi girari – White interlacing vine-stems, a pattern frequent in borders and initials of Italian Renaissance manuscripts.

bifolio (bifolium) – A large sheet of parchment or paper, folded in half to form two *folios*, or four pages (in contemporary terms).

Book of Hours – The book containing the Hours of the Virgin Mary, that is prayers and psalms to be said at the hours of Matins, Lauds, Prime, Terce, Sext, None, Vespers and Compline. It will normally also contain a Calendar of Church festivals and saints' days, the Office of the Dead, and the Penitential and Gradual Psalms. In addition there may be other Hours (of the Trinity, the Holy Spirit, etc.).

Breviary – The book containing all the *Offices* for the Daily Hours of the liturgy of the Catholic Church.

cartolaio – A bookseller who coordinated the production of manuscripts with scribes, illuminators and binders. He might either arrange for a manuscript to be made for a particular patron, sell manuscripts ready-made, or stock the materials for making manuscripts. The best-known such *cartolaio* was Vespasiano da Bisticci (1421-1498) in Florence.

camïeu d'or – Golden cameo; a term used to describe an image painted in gold on a monochromatic background.

catchword – A word written in the lower margin of the last page of a gathering, which is the first word of the text of the following gathering; it assists in collating the text for binding.

chiaroscuro – Literally 'light-dark'; a term used to indicate shading of an object; more particularly in manuscript illumination, a monochromatic image.

Choir Book – A book containing musical chants to be sung at Mass (*Gradual*) or at the Daily *Offices* (*Antiphonary*) of the Catholic liturgy.

Common of Saints – The part of the *Breviary* or *Missal* which contains the liturgy for saints not specified by name in the *Sanctorale*. They are classed as Apostles, Martyrs, Confessors or Virgins.

epigraphic letter – A capital letter imitating Roman inscriptional capitals.

Epistolary – The book containing the passages from the Epistles read at Mass on particular *Feasts* of the Catholic Church's liturgical year.

Evangeliary – The book containing the passages from the Gospel read at Mass on particular *Feasts* of the Catholic Church's liturgical year.

Feast – A saint's day or festival in the Catholic Church's liturgical year.

folio – A sheet of parchment or paper in a manuscript (or an early printed book), usually half of a *bifolio*, traditionally numbered only on the *recto*; hence, folio 10 (recto), folio 10 (verso). In the present catalogue the recto designation is omitted, following conventional use.

gathering – *Bifolios*, commonly four or five of parchment or paper assembled as a convenient unit in anticipation of collation and binding.

glair – Egg white used as a binder for pigments.

Gradual – A *Choir Book* containing the musical chants to be sung at Mass throughout the liturgical year of the Catholic Church.

grissaille – Greyish; term used to describe an image predominantly painted in grey and black with white highlights.

grotteschi – A form of classicising decoration based on Antique stuccoes and paintings. It became very fashionable as a result of the discovery of the Golden House of Nero in Rome in the 1480s. The most famous Renaissance *grotteschi* were in the Vatican Loggie, painted by Raphael and his school beginning around 1515.

historiated initial – A capital letter around which or in which is painted a human figure or a narrative scene.

impresa (imprese) – A pictorial device usually accompanied by a motto (*divisa*). When accompanying a coat of arms *imprese* therefore served to identify a particular individual in a family.

incipit – The opening words of a text (literally in Latin: 'it begins').

incunable (or incunabulum, incunabula) – Any book printed in Europe before the end of 1500 (from the Latin for 'things in the cradle', i. e., during the infancy of printing).

intarsia – Inlaid woodwork typically used for Italian Renaissance choir stalls and famously in the *studioli* of Federigo da Montefeltro in Urbino and Gubbio.

leaf – See *folio*.

littera mantiniana – A capital letter painted or drawn to look as if it were a faceted bronze or marble object, standing in an illusionistically three-dimensional space.

Missal – The book containing the Masses for the Feast days and saints' days of the Catholic Church, with other special votive masses.

Office, or Divine Office – A religious service consisting of prayers, psalms, hymns and antiphons, traditionally recited or sung eight times a day at the Canonical Hours (see *Book of Hours*).

Psalter – The book containing the Psalms of David from the Old Testament.

putti – Cherubs.

quire – See *gathering*.

recto – The upper side of a *folio*, appearing on the right of an opening of a manuscript book.

rubric – A chapter heading or instruction, usually written in red ink, from the latin for red, *rubrica*

Sanctorale – The part of the *Breviary* or *Missal* containing the *Feasts* of named Saints.

sepia – Reddish-brown coloured ink.

tempera – Pigment mixed with egg yolk (egg tempera) or egg white (glair).

Temporale – The part of the *Breviary* or *Missal* containing the *Feasts* of the Church in temporal sequence throughout the liturgical year of the Catholic Church.

tooling – A line or decorative pattern stamped with a warmed metal tool into a leather binding. *Blind tooling* refers to patterns without additional color; *gold tooling* refers to patterns with applied gold leaf.

Use of – Particular texts, especially of *Books of Hours*, were linked to geographical areas. In Italy the commonest Use was of Rome, but liturgical and devotional books could also be of Franciscan or Dominican Use, of the Use the Congregation of Santa Giustina (cat. 124), etc.

verso – The reverse side of a *folio*, appearing on the left of an opening of a manuscript book.

Index of Manuscripts

Numbers refer to page numbers unless preceded by 'cat.', in which case they refer to the catalogue number for an exhibited manuscript. References in the introductory essays to manuscripts included in the exhibition have been indexed, but the cross-references included in the catalogue descriptions of exhibited manuscripts and books have not been indexed.

Index of Printed Books

Numbers refer to page numbers unless preceded by 'cat.', in which case they refer to the catalogue number for an exhibited book. References in the introductory essays to books included in the exhibition have been indexed, but the cross-references included in the catalogue descriptions of exhibited manuscripts and books have not been indexed.

Index
Illuminators, Scribes, Patrons

Only manuscripts and printed books included in the Exhibition have been listed. Numbers refer to catalogue entries.

Photographic Credits

All works are reproduced by kind permission of the owners. Specific acknowledgements are as follows:

Alain Noël Photo, Albi cat 29
Jorg P. Anders, Berlin cat 28, 45, 102, 108, 128, 135
Foto Studio C.N.B. & C., Bologna cat 105
Studio Gian Piero Zangheri, Cesena cat 125
Photo Display Images, Dublin cat 118
AIC Photographic Services, Edinburgh cat 89
Donato Pineider, Florence cat. 31, 34, 35, 50, 120
E. Renno, Weimar cat 96, 97, 98
The Israel Museum, Jerusalem fig. 26
Jean-Louis Coquerel, Le Havre cat 3 b
Geremy Butler, London cat 123, 133
The Conway Library, Courtauld Institute of Art, London fig. 1

The Wallace Collection fig. 7
Foto Saporetti, Milan fig 5
Fotografo Roncaglia, Modena fig 3, 4, 14-17; cat 2, 18, 66
Bodleian Library, Oxford fig. 24 b, 25, 32; cat 85, 22, 30, 91, 110
Alinari/Art Resource, New York fig. 9, 10, 29
David A. Loggie, The Pierpont Morgan Library, New York cat 4, 6, 13, 17, 20, 23, 24, 81, 83, 93, 95, 101, 107, 111, 116, 131, 132
Ken Pelka, New York cat. 7, 41, 51, 54, 56, 134
Foto 3 di Lensini Fabio & C., Siena cat 121
Foto Toso, Venice fig. 11, 28

FRIENDS OF THE ROYAL ACADEMY

SPONSORS OF PAST EXHIBITIONS

The Council of the Royal Academy thanks sponsors of past exhibitions for their support. Sponsors of major exhibitions during the last ten years have included the following:

ALITALIA
Italian Art in the 20th Century 1989

AMERICAN EXPRESS FOUNDATION
Masters of 17th-Century Dutch Genre Painting 1984
'Je suis le cahier' The Sketchbooks of Picasso 1986

ARTS COUNCIL OF GREAT BRITAIN
Peter Greenham 1985

THE BANQUE INDOSUEZ GROUP
Pissarro: The Impressionist and the City 1993

BANQUE INDOSUEZ AND W. I. CARR
Gauguin and The School of Pont-Aven:
Prints and Paintings 1989

BAT INDUSTRIES PLC
Paintings from the Royal Academy US Tour 1982/84
RA 1984

BBC RADIO ONE
The Pop Art Show 1991

BECK'S BIER
German Art in the 20th Century 1985

BMW 8 SERIES
Georges Rouault: The Early Years, 1903-1920 1993

ROBERT BOSCH LIMITED
German Art in the 20th Century 1985

BOVIS CONSTRUCTION LTD
New Architecture 1986

BRITISH ALCAN ALUMINIUM
Sir Alfred Gilbert 1986

BRITISH PETROLEUM PLC
British Art in the 20th Century 1987

BT
Hokusai 1991

CANARY WHARF DEVELOPMENT
New Architecture 1986

THE CAPITAL GROUP COMPANIES
Drawings from the J. Paul Getty Museum 1993

THE CHASE MANHATTAN BANK
Cézanne: the Early Years 1988

CLASSIC FM
Goya: Truth and Fantasy, The Small Paintings 1994
The Glory of Venice: Art in the Eighteenth Century 1994

THE DAI ICHI KANGYO BANK LIMITED
222nd Summer Exhibition 1990

THE DAILY TELEGRAPH
American Art in the 20th Century 1993

DEUTSCHE BANK AG
German Art in the 20th Century 1985

DIGITAL EQUIPMENT CORPORATION
Monet in the '90s: The Series Paintings 1990

THE DUPONT COMPANY
American Art in the 20th Century 1993

THE ECONOMIST
Inigo Jones Architect 1989

EDWARDIAN HOTELS
The Edwardians and After: Paintings and Sculpture
from the Royal Academy's Collection, 1900-1950 1990

ELECTRICITY COUNCIL
New Architecture 1986

ELF
Alfred Sisley 1992

ESSO PETROLEUM COMPANY LTD
220th Summer Exhibition 1988

FIAT
Italian Art in the 20th Century 1989

FINANCIAL TIMES
Inigo Jones Architect 1989

FIRST NATIONAL BANK OF CHICAGO
Chagall 1985

FONDATION ELF
Alfred Sisley 1992

FORD MOTOR COMPANY LIMITED
The Fauve Landscape: Matisse, Derain, Braque
and their Circle 1991

FRIENDS OF THE ROYAL ACADEMY
Peter Greenham 1985
Sir Alfred Gilbert 1986

GAMLESTADEN
Royal Treasures of Sweden, 1550-1700 1989

JOSEPH GARTNER
New Architecture 1986

J. PAUL GETTY JR CHARITABLE TRUST
The Age of Chivalry 1987

GLAXO HOLDINGS PLC
From Byzantium to El Greco 1987
Great Impressionist and other Master Paintings
from the Emil G. Bührle Collection, Zurich 1991
The Unknown Modigliani 1994

THE GUARDIAN
The Unknown Modigliani 1994

GUINNESS PLC
Twentieth-Century Modern Masters:
The Jacques and Natasha Gelman Collection 1990
223rd Summer Exhibition 1991
224th Summer Exhibition 1992
225th Summer Exhibition 1993
226th Summer Exhibition 1994

GUINNESS PEAT AVIATION
Alexander Calder 1992

HARPERS & QUEEN
Georges Rouault: The Early Years, 1903-1920 1993
Sandra Blow 1994

THE HENRY MOORE FOUNDATION
Henry Moore 1988
Alexander Calder 1992

HOECHST (UK) LTD
German Art in the 20th Century 1985

THE INDEPENDENT
The Art of Photography 1839-1989 1989
The Pop Art Show 1991

THE INDUSTRIAL BANK OF JAPAN
Hokusai 1991

INTERCRAFT DESIGNS LIMITED
Inigo Jones Architect 1989

JOANNOU & PARASKE-VAIDES (OVERSEAS) LTD
From Byzantium to El Greco 1987

THE KLEINWORT BENSON GROUP
Inigo Jones Architect 1989

LLOYDS BANK
The Age of Chivalry 1987

LOGICA
The Art of Photography, 1839-1989 1989

LUFTHANSA
German Art in the 20th Century 1985

THE MAIL ON SUNDAY
Royal Academy Summer Season 1992
Royal Academy Summer Season 1993

MARTINI & ROSSI LTD
The Great Age of British Watercolours, 1750-1880 1993

MARKS & SPENCER PLC
Royal Academy Schools Premiums 1994
Royal Academy Schools Final Year Show 1994

MELITTA
German Art in the 20th Century 1985

PAUL MELLON KBE
The Great Age of British Watercolours, 1750-1880 1993

MERCEDES-BENZ
German Art in the 20th Century 1985

MERCURY COMMUNICATIONS
The Pop Art Show 1991

MERRILL LYNCH
American Art in the 20th Century 1993

MIDLAND BANK PLC
The Art of Photography 1839-1989 1989
Lessons in Life 1994

MITSUBISHI ESTATE COMPANY UK LIMITED
Sir Christopher Wren and the Making of St Paul's 1991

MOBIL
Modern Masters from the Thyssen-Bornemisza
Collection 1984
From Byzantium to El Greco 1987

NATIONAL WESTMINSTER BANK
Reynolds 1986

OLIVETTI
Andrea Mantegna 1992

OTIS ELEVATORS
New Architecture 1986

PARK TOWER REALTY CORPORATION
Sir Christopher Wren and the Making of St Paul's 1991

PEARSON PLC
Eduardo Paolozzi Underground 1986

PILKINGTON GLASS
New Architecture 1986

REDAB (UK) LTD
Wisdom and Compassion: The Sacred Art of Tibet 1992

REED INTERNATIONAL PLC
Toulouse-Lautrec: The Graphic Works 1988
Sir Christopher Wren and the Making of St Paul's 1991

REPUBLIC NATIONAL BANK OF NEW YORK
Sickert: Paintings 1992

ARTHUR M. SACKLER FOUNDATION
Jewels of the Ancients 1987

SALOMON BROTHERS
Henry Moore 1988

SIEMENS
German Art in the 20th Century 1985

SEA CONTAINERS LTD.
The Glory of Venice: Art in the Eighteenth Century 1994

SILHOUETTE EYEWEAR.
Egon Schiele and His Contemporaries: From the Leopold
Collection, Vienna 1990
Wisdom and Compassion: The Sacred Art of Tibet 1992
Sandra Blow 1994

SOCIÉTÉ GÉNÉRALE DE BELGIQUE
Impressionism to Symbolism: The Belgian Avant-Garde
1880-1900 1994

SPERO COMMUNICATIONS
The Schools Final Year Show 1992

SWAN HELLENIC
Edward Lear 1985

TEXACO
Selections from the Royal Academy's Private
Collection 1991

THE TIMES
Old Master Paintings from the Thyssen-Bornemisza
Collection 1988
Wisdom and Compassion: The Sacred Art of Tibet 1992
Drawings from the J. Paul Getty Museum 1993
Goya: Truth and Fantasy, The Small Paintings 1994

TRACTEBEL
Impressionism to Symbolism: The Belgian Avant-Garde
1880-1900 1994

TRAFALGAR HOUSE
Elisabeth Frink 1985

TRUSTHOUSE FORTE
Edward Lear 1985

UNILEVER
Frans Hals 1990

UNION MINIÈRE
Impressionism to Symbolism: The Belgian Avant-Garde
1880-1900 1994

VISTECH INTERNATIONAL LTD
Wisdom and Compassion: The Sacred Art of Tibet 1992

WALKER BOOKS LIMITED
Edward Lear 1985

OTHER SPONSORS

*Sponsors of events, publications and other items
in the past two years:*

Academy Group Limited
Air Namibia
Air Seychelles
Air UK
Alitalia
American Airlines

Arthur Andersen
Austrian Airlines
Berggruen & Zevi Limited
British Airways
Bulgari Jewellery
Cable & Wireless
Christies International plc
Citibank N. A.
Columbus Communications
Condé Nast Publications
Brenda Evans
Fina Plc
Forte Plc
The Four Seasons Hotels
Häagen-Dazs
Tim Harvey Design
Hyundai Car (UK) Ltd
IBM United Kingdom Limited
Inter-Continental Hotels
Intercraft Designs Limited
Jaguar Cars Limited
A. T. Kearney Limited
KLM
The Leading Hotels of the World
Magic of Italy
Martini & Rossi Ltd

May Fair Inter-Continental Hotel
Mercury Communications Ltd
Merrill Lynch
Midland Bank Plc
Anton Mosimann
NK
Novell U. K. Ltd
Patagonia
Penshurst Press Ltd
Percy Fox and Co
Polaroid (UK) Ltd
The Regent Hotel
The Robina Group
Royal Mail International
Sears Plc
Swan Hellenic Ltd
Mr and Ms Daniel Unger
Kurt Unger
Venice Simplon-Orient Express
Vista Bay Club Seychelles
Vorwerk Carpets Limited
Louis Vuitton Ltd
Warner Bros.
White Dove Press
Winsor & Newton
Mrs George Zakhem